NINETEENTH CENTURY BRITISH PAINTING

Luke Herrmann is Emeritus Professor of the History of Art at the University of Leicester, and has taught and lectured on British art for many years. Before joining the History of Art Department at Leicester in 1967, he worked for a decade in the Department of Western Art at the Ashmolean Museum in Oxford. He has published numerous books and articles, including *Ruskin and Turner* (1968), *British Landscape Painting of the Eighteenth Century* (1973), *Turner* (1975), *Paul and Thomas Sandby* (1986) and *Turner Prints* (1990). He is a Fellow of the Society of Antiquaries and Honorary Editor of the Walpole Society.

Nineteenth Century British Painting

by

Luke Herrmann

dlm

First published in 2000
by Giles de la Mare Publishers Limited
53 Dartmouth Park Hill, London NW5 1JD

Typeset by Tom Knott
Printed in Hong Kong
by Colorcraft Limited
All rights reserved

A CIP record of this book is available
from the British Library

ISBN 1–900357–17–8 paperback

Contents

Preface

Despite its title, this book begins with the last decade of the eighteenth century, for the academic traditions of British painting of that century, personified by Sir Joshua Reynolds, persisted and dominated well into the next century. Actual Victorian art and taste, for which the nineteenth century is best known, only came to maturity relatively late and that taste was already changing well before the end of the long reign of Queen Victoria. In the last twenty years there has been an almost overwhelming revival of appreciation, scholarship and connoisseurship of Victorian painting, accompanied by an explosion of books, articles and exhibitions devoted to Victorian art, on both sides of the Atlantic. This survey volume presents Victorian painting in its art-historical context, thus making the understanding of the relatively brief period of 'high' Victorian art much easier.

The author has had to be highly selective, concentrating on the major figures in what was an astonishingly prolific and diffuse century of British painting. Each major artist is introduced in a biographical context, and the biographical information provides the framework for the discussion of the artist's work. The majority of the paintings and drawings examined in detail are reproduced, and thus the actual works of art are the core of the book. There was no central or consistent pattern of development in British painting in the nineteenth century, and there is no specific style or theme to bring together the numerous directions taken by painters during the century. Most of the Victorian period was a time of great social, economic and political change, and of rapid growth and expansion, especially in the wealth and influence of the middle classes. The visual arts, long mostly the preserve of the aristocracy, were much affected by these factors, which resulted in the unprecedented broadening of patronage and the growth of commercialisation, with the consequent expansion in the number of professional artists. The nine separate Parts of this volume have been designed to identify the small amount of cohesion that there was among artists. But there can be no central argument or overall unity in the story of British painting in the nineteenth century – there was simply too much art, and of this huge quantity the majority lacked true quality.

Based on the looking, reading and teaching of several decades this book is indebted to many people and institutions. The British Library, the National Art Library at the Victoria and Albert Museum, the libraries at the University of Leicester and the Paul Mellon Centre in London and elsewhere have been helpful and co-operative, as have numerous museums and galleries. I am most grateful to members of staff of these, in

particular to those in the public collections which were understanding and generous in the matter of reproduction fees, an ever-growing problem in the publication of heavily illustrated art books. Among those who have been especially helpful and whom I would like to thank individually are Brian Allen, David Blayney Brown, Colin Harrison, Evelyn Joll, Jane Munro, Henry Wemyss and Alison Yarrington. Emma Lauze has looked after the gathering of photographs, transparencies and reproduction permissions, and I owe her a special debt of gratitude for doing all this with great efficiency. I must also thank Giles de la Mare, John Taylor and Tom Knott, who have made an excellent team in designing and creating this volume, and Ann Barrett for her admirable index. As always my wife has had to suffer the vicissitudes of this book with me, and as always I am enormously grateful to her.

L.H.

The Coombes
January 2000

Part One

The Legacy of Sir Joshua Reynolds

Introduction

On 10 December 1790, Sir Joshua Reynolds delivered his fifteenth and final Discourse at the Distribution of the Prizes at the Royal Academy. The first had been delivered nearly twenty-two years earlier at the Opening of the Royal Academy on 2 January 1769. In the fifteenth Discourse the Founder President recommended to young students 'an implicit obedience to the Rules of Art, as established by the practice of the great MASTERS', and that 'those models, which have passed through the approbation of ages, should be considered by them as perfect and infallible guides; as subjects for their imitation, not their criticism'.[1]

This remained the principal theme throughout the *Discourses*, and it was emphasised again in the fifteenth, which Reynolds, who was by then sixty-six years old and whose sight was failing, correctly introduced as probably his last. To emphasise this message the President devoted the second half of his talk to a passionate exposition of the outstanding qualities of Michelangelo, and ended it with the famous passage, 'I reflect not without vanity, that these Discourses bear testimony of my admiration of that truly divine man, and I should desire that the last words which I should pronounce in this Academy, and from this place, might be the name of – Michael Angelo.'[2]

The foundation of the Royal Academy under the patronage of George III in 1768 and the notable Presidency of Joshua Reynolds were the dominant factors in the background of the art scene in England, and in London in particular, in the last quarter of the eighteenth century. There had been a number of earlier relatively low-key attempts to create a representative and influential exhibiting institution, notably the Society of Artists, founded in London in 1760 and surviving until 1791. However, the King's active involvement and the firm hand of Joshua Reynolds quickly ensured that the RA's annual exhibition was seen as a reliable and regular platform for the artists, and a fashionable and exclusive venue for their public. The RA Schools also became *the* place for the training of painters and sculptors, and for more than a century membership of the Royal Academy was considered almost essential for an effective career as an artist.

The status of Royal Academician also brought the rank and title of Esquire, which was of great importance for the prestige of the artists, the majority of whom came from a lower social class and most of whom never rose above the standing of artisans and craftsmen. Throughout the nineteenth century the English were extremely class-

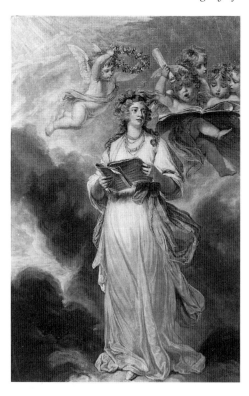

(1) Sir Joshua Reynolds, *Mrs Billington as St Cecilia* (RA 1790). Oil on canvas; 239.7×148cm. (Gift of Lord Beaverbrook; The Beaverbrook Art Gallery, Fredericton, New Brunswick, Canada)

conscious, as they had been in the eighteenth, and for those elected the 'promotion' that went with membership of the Royal Academy was the easiest way up the social ladder. It will be noted later in this volume that many of the painters discussed began their working lives as apprentices to printers, engravers, china painters and the like. The existence of the free RA Schools and the possibility of social advancement through membership of the Royal Academy were certainly factors in persuading many of them to attempt to join the more respected world of the professional artist. As the nineteenth century progressed an increasing number of artists were awarded knighthoods and other honours by the monarch, and in the later years of Queen Victoria many artists were recognised as leading members of London society. The success and authority of the Royal Academy, which had moved into its impressive specially designed rooms in Somerset House in 1780, also greatly strengthened the position of the capital as the centre of artistic activity in the country, though cities such as Bristol, Norwich and, of course, Edinburgh, continued to have their own active and successful artistic circles.

Reynolds, whose failing sight had forced him to stop painting in 1790, was persuaded to withdraw his resignation as President after a fiercely disputed election to a vacant Academicianship early that year. In the 1790 summer exhibition he showed for the last time, and the seven paintings which he sent to Somerset House proved once again his mastery of all aspects of traditional portraiture, from the simple and graceful half-length of the drawing master, Thomas Tomkins, to the grand and flamboyant full-length of the idolised singer, Mrs Billington, as St Cecilia [PL.1]. Critics compared the latter rather unfavourably with the young Thomas Lawrence's celebrated portrait of

the actress Elizabeth Farren [COL.PL.3], which has always been regarded as one of his masterpieces.

In December 1791 Reynolds was again persuaded to stand for re-election, but he died within two months. Three weeks later the American-born Benjamin West, who had been settled in London since 1763, and had established his reputation as a history painter, was elected President almost unanimously; the only rival candidate was the miniaturist Richard Cosway, who received just one vote. West refused a knighthood, but he tried to add dignity to the office of President by wearing his hat on all formal occasions at the Academy, 'to do honour to the office', something which his predecessor had not done.

These changes in the world of British art coincided with much greater changes in the world of European politics. The fall of the Bastille in Paris on 14 July 1789 heralded the French Revolution, which reached its climax with the execution of Louis XVI in January 1793. Britain then went to war with the French Republic, though at first these political events seem to have had scant effect on the London art world. However, as the war with France progressed and Napoleon Bonaparte rapidly rose to supreme power, becoming First Consul in 1799 and Emperor five years later, there were various repercussions. The exploits of the British heroes of the war provided new and popular subjects for the painters of contemporary history, and their memorials brought numerous commissions to the country's sculptors. The virtual cessation of travel to the Continent meant that art students could no longer study in Rome or elsewhere abroad, and the travelling public were largely confined to the British Isles. This provided a considerable boost to the employment of topographical and landscape artists, whose paintings and drawings were sought after as British travellers perforce became more interested in the sights of their own country. There were, of course, economic casualties, including the print trade, which suffered greatly from the loss of the French market.

Half a generation before the French Revolution the American colonies had successfully freed themselves from the British Crown – the Declaration of Independence was passed and signed at Philadelphia on 4 July 1776. Their loss was a considerable blow to the standing of George III, who had succeeded his grandfather in 1760, and who rapidly established himself as the most cultured British monarch since Charles I. George III suffered his first attacks of illness causing mental derangement in 1788, and the second bout led to the Regency Act, which established the Prince of Wales as Prince Regent. The future George IV surpassed his father as a patron of artists and architects, as is shown by the fact that stylistically the closing years of the eighteenth century and the opening years of the nineteenth came to be known as 'Regency'. It is a remarkable fact that at this time of both political and artistic change the new President of the Royal Academy was American-born. However, West had for some thirty years been the monarch's favourite artist, and was widely recognised as the leading history painter of the British school of his day.

In his *Discourses* Reynolds had frequently stressed the place of history painting, largely based on Italian Renaissance and post-Renaissance example, as the prime genre. Much of the advice which he gave to students was aimed at helping them to achieve success in this genre, something he himself had largely failed to do. However, painting in the grand classical manner, often based on long study of antiquity and of the

Renaissance masters in Italy, and especially Rome, was beyond the skills of most British artists, though many produced ambitious exhibition pictures illustrating heroic scenes from the Bible, literature or ancient and modern history. Few of these were successful, and, in addition, except for that of George III, there was very little active patronage for contemporary history painting among British collectors, who preferred portraits of themselves, their houses and their animals. The history paintings they acquired for their houses were usually 'old masters' by established Italian artists.

Throughout the eighteenth century it was the painting of portraits that provided most patronage for the majority of British painters, and their sculptor colleagues relied largely on commissions for portrait and memorial pieces for their living. The tradition of great portrait painting had been established in Britain at the time of Charles I by the Flemish genius Sir Anthony van Dyck (1599–1641), and continued later in that century by the Dutch-born Sir Peter Lely (1618–80). There were no comparable masters in the first half of the eighteenth century, and portraiture made little progress until the advent of Reynolds and his rival Thomas Gainsborough (1727–88). These two ranked with the leading contemporary portrait painters of Europe, and laid the foundations for the continued success of British portrait painting throughout most of our period.

While portrait painting stood well below history painting in the hierarchy of the different genres, the painting of landscape stood even lower in ranking. It was again Gainsborough who helped to elevate landscape with his fluent and evocative landscape compositions, much influenced by the small but brilliant corpus of landscape painting of Sir Peter Paul Rubens (1577–1640). Richard Wilson (1713/14–82), on the other hand, painted almost exclusively landscape, and made his major contribution to this genre in British art by adapting the Italianate 'classical' landscape art of the French artist Claude Lorrain (1600–82), whose work, like that of Rubens, was much favoured by later eighteenth-century British collectors. Despite the achievements of Gainsborough and Wilson and of their even greater successors, Constable and Turner, landscape painting was never highly regarded within the Royal Academy during most of the nineteenth century. On an even lower plain in the ranking of the genres came animal painting, of which George Stubbs (1724–1806) was the greatest British exponent. However, the British artistocracy and landed classes provided ample patronage for the specialist animal painters, for they coveted 'portraits' of their horses, prize cattle and, later, in our period, pets.

1 Benjamin West, PRA (1738–1820)

Benjamin West was born in Pennsylvania of Quaker stock; his precocious artistic talents were encouraged by family and patrons, and he acquired the rudiments of a classical education and of training as a painter in Philadelphia, where he began his career as a portraitist. To broaden his experience he sailed for Italy in 1760, and after three years there, during much of which he was ill, he travelled to London, where he decided to settle after the success of his three exhibits at the Society of Artists in 1764. West was joined in London by his American fiancée; they were married in September 1764 and the painter never returned to America. By 1768 he was sufficiently well established,

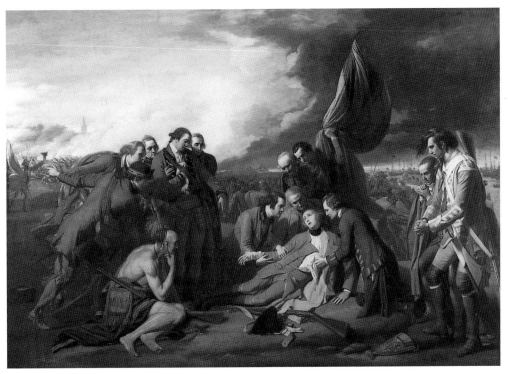

(2) Benjamin West, *The Death of General Wolfe* (RA 1771). Oil on canvas; 152.6×214.5 cm.
(National Gallery of Canada, Ottawa)

largely as a portrait painter, to become one of the thirty-four Founder Members of the Royal Academy. At the same time he established himself as the foremost history painter in London, and his first two RA exhibits were both in that genre, one illustrating a mythological subject and the other a scene from Roman history. This, *The Departure of Regulus from Rome* (The Royal Collection), was commissioned by the King, who suggested the subject and instructed West to show the huge painting at the Royal Academy's first exhibition. In 1772 West was appointed Historical Painter to the King, and he retained George III's favour and patronage for the next twenty years, producing several outstanding royal portraits, especially of the royal children, a series of scenes from classical history in a neo-classical style with borrowings from Poussin and Raphael, a number of subjects from British history in a looser and more romantic manner, and finally a series of vast religious paintings for the projected private chapel at Windsor Castle, plans for which were abandoned in the 1790s, largely because of the King's illness. In the majority of West's history and religious paintings the some-what static figures are arranged in frieze-like compositions; there is little depth or atmosphere and the colours are muted.

However, West's most famous and influential painting of his early years was not painted for the King, though he ordered a second version after the great success of the original at the Royal Academy exhibition of 1771, where it had been bought by Lord Grosvenor. The important feature of this skilfully composed painting of *The Death of General Wolfe* [PL.2], which recorded, though not very accurately, a famous moment of

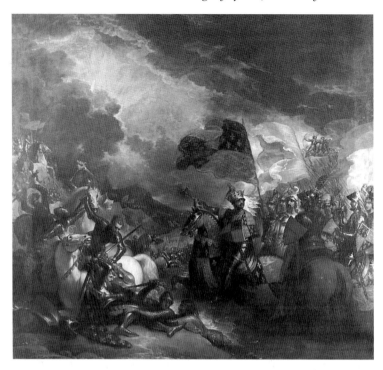

(3) Benjamin West, *Edward III crossing the Somme* (RA 1792). Oil on canvas; 137.2×149.9cm. (The Royal Collection)

heroism during the war for Canada with France, was the use of contemporary costume. While not entirely novel by this time, this was a controversial feature. Reynolds and others tried to dissuade West from abandoning classical costume, but the painter responded by stating that, 'The same truth that guides the pen of the historian should govern the pencil of the artist. I consider myself as undertaking to tell this great event to the eye of the world; but if, instead of the facts of the transaction, I represent classical fictions, how shall I be understood by posterity?'[3]

West painted several replicas of *The Death of General Wolfe*, including that for the King, and William Woollett's engraving of it was one of the most commercially successful prints published in the eighteenth century. The success of this print, which was published in 1776, had a lasting effect on West's own future work, and also on that of his fellow history painters. As often as not it was the engraving rather than the history painting itself that brought widespread fame and material success to the artist, though it frequently took a decade or more for the large and complex copper engravings to be completed. Another American artist, John Singleton Copley (1738–1815), who settled in London in 1775, rivalled West in the 1780s with several telling depictions of contemporary events, including the vast *Death of Major Peirson* (Tate Gallery, London), painted in 1783 for Alderman Boydell, and skilfully engraved on a large scale by James Heath, but this plate was not completed until 1796. Unlike West, Copley rarely exhibited his history paintings at the Royal Academy, to which he was elected in 1779 and where he showed largely portraits. Copley was a pioneer of the custom of exhibiting his major history paintings individually, sometimes even in tents, in London and the provinces. Subjects from recent and contemporary history became increasingly popular with both

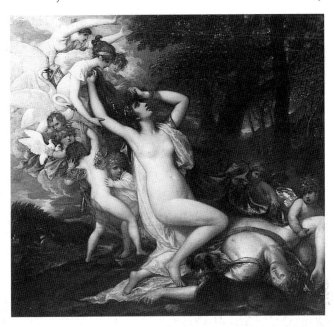

(4) Benjamin West, *Venus lamenting the Death of Adonis* (RA 1804). Oil on panel; 39.3×42.5 cm. (Jane Voorhees Zimmerli Museum, Rutgers University, New Brunswick, NJ)

painters and engravers, reaching their apogee during this period with the large number of paintings and prints recording the death of Lord Nelson at Trafalgar in 1805. West's own vast composition of this event (Walker Art Gallery, Liverpool) was ready for exhibition in his own studio in the summer of 1806, but James Heath's engraving after it was not published until 1811, the year in which the canvas was shown at the Royal Academy.

In 1792, at the first summer exhibition after his election as President of the Royal Academy, Benjamin West showed six paintings, of which two, including the dramatic *Edward III crossing the Somme* [PL.3], illustrated events from the reign of Edward III while the others were all of biblical subjects. Of these six, three were painted for George III: the two historical subjects, which were hung in the King's Audience Chamber at Windsor, and the huge *Triumph of Moses over Pharaoh and his Host*, which was one of the paintings for the Chapel at Windsor which were never delivered. This 1792 group of exhibits was fairly typical of West's annual contributions to the RA exhibitions in the remaining years of his long life, but he also continued to paint classical and mythological scenes, if much less effectively than during his prime in the 1770s and 1780s. His rather vacuous yet elegant later manner is well shown by a painting dated 1803, *Venus lamenting the Death of Adonis* [PL.4], which, though exhibited at the Royal Academy in 1804 and at the British Institution two years later, remained in the artist's studio as did many other examples of his later work.

After West's death his two sons quickly built a large gallery in the garden of his Newman Street house, and exhibited some hundred paintings. After initial interest the number of visitors, who paid one shilling for admission, quickly tailed off. West had always enjoyed a high reputation in his native United States, but in 1826 his sons failed to persuade the US Government to purchase the London studio contents as the foundation for a national gallery of America, and their collection was finally dispersed

at auction in 1829. Benjamin West had enjoyed great fame and considerable material success during his lifetime, but surprisingly his own work had little impact on his fellow artists in Britain. In his discourses to the students of the Royal Academy, which were never published as such though many were cited in the second volume of John Galt's *Life*, published in 1820, the second President constantly emphasised the importance of emulating the old masters. Thus West maintained the tradition of Reynolds, whose continued influence on the British School was still strongly felt at the time of his successor's death nearly thirty years after his own.

2 Henry Fuseli, RA (1741–1825)

Joshua Reynolds also played an important part in the painting career of Henry Fuseli, who was born into an artistic and literary family in Zürich in 1741. Although a precocious artist he was destined by his painter father for the church, and Fuseli was ordained a Zwinglian minister in 1761. Trained by two leading Swiss scholars, Bodmer and Breitinger, the young Fuseli (then known as Füssli) combined classical philology and literary aestheticism with theology and a republican outlook. In 1763 he was involved in a public attack on a corrupt magistrate and had to leave Switzerland. After a few months in Germany, he travelled to London in 1764, and quickly became involved in the literary and artistic life of the capital. He had already decided to abandon theology when he met Jean-Jacques Rousseau during a visit to France, and in 1767 he published his *Remarks on the Writings and Conduct of J. J. Rousseau*, which, like his translation of one of Winckelmann's books two years earlier, failed to receive much notice. In 1768 Fuseli met Reynolds, who encouraged him to become a painter, and two years later he went to Rome, where he devoted himself to his new career with great energy and success.

In Rome Fuseli rapidly became a leading figure among the international gathering of artists, and, strongly influenced by Michelangelo and classical sculpture, and also, to a lesser extent, by Mannerism, he developed his own very idiosyncratic style which he was to retain for most of his life. This focused on the human figure as the only vehicle of expression, and the figure or figures were often placed against featureless backgrounds of almost total darkness. Architecture and landscape played no role in his compositions, and, except in some of his drawings, Fuseli ignored the impact of nature. This somewhat stark manner was combined with the use of a limited palette, so that pose, gesture and facial expression were Fuseli's principal means of achieving effect. All this coincided with, but remained outside, the Storm and Stress (*Sturm und Drang*) movement current in Europe, which successfully combined classicism and romanticism, and of which the German poet and scholar Goethe, who admired and collected the work of Fuseli, was one of the leading exponents.

Fuseli left Rome in the autumn of 1778, and after a few months in Zürich he returned to London where, already famous on the Continent, he quickly made his mark. His reputation was confirmed by the exhibition at the Royal Academy in 1782 of the notorious *Nightmare*, now in Detroit, which Horace Walpole, one of the most influential connoisseurs and scholars of the day, found 'shocking', and the symbolism and eroti-

cism of which has caused fruitful discussion for over two centuries. However, at this time much of his subject matter came from Shakespeare, and in 1787 he was one of the artists present at a dinner party given by the nephew and partner of the highly successful print publisher Alderman John Boydell when the idea of the 'Shakespeare Gallery' was conceived. This ambitious scheme gained widespread support from both artists and public; 'in a country where Historical Painting is still but in its infancy' it was designed 'to advance that art towards maturity, and establish an *English School of Historical Painting'*.⁴ Most of the leading artists of the day, including Reynolds, Romney, Opie and West, contributed paintings, and the specially built Gallery in Pall Mall opened in 1789 with thirty-four pictures, which rose to sixty-five in the following year.

Boydell paid exceptionally high commissions for the paintings, ranging from 1000 guineas to Reynolds and West to £300 to the less distinguished artists. Though he was unable to employ most of the best engravers, who were already fully occupied, the publication of the individual engravings also began in 1789, and culminated with the appearance in 1802 of the beautifully designed and printed folio edition of Shakespeare's works in nine volumes with 100 plates, and in the following year of a luxury edition of the plates only in two huge 'Atlas' volumes.

At first this ambitious and pioneering scheme of patronage was enthusiastically received and resulted in widespread discussion. At the Royal Academy Banquet of 1789 Alderman Boydell, who was to become Lord Mayor of London in the following year, was toasted as 'the commercial Maecenas of England'. However, the success and enthusiasm were relatively short-lived, and Boydell's Shakespeare Gallery and his whole business were among the casualties of the French Revolution and the Napoleonic Wars. The home market for expensive engravings declined, and the foreign market disappeared. Furthermore the Revolution and its consequences brought many of the great continental collections of old masters onto the market. British collectors were active buyers and were thus diverted from what little patronage of their own history painters they had practised. In 1804 Boydell was on the brink of bankruptcy, and he obtained permission to dispose of the gallery by lottery, which raised £45,000, far less than the £300,000 that he claimed that the whole scheme had cost him. John Boydell died in December 1804, and in the following May the 170 Shakespeare paintings, which had been won by the wax medallion maker William Tassie, were sold at auction for only £6181 18s 6d.

Fuseli's role in all this was an important one; he is said to have claimed that he was the originator of the idea of a Shakespeare Gallery, to which he contributed a total of nine compositions. Since his arrival in London he had shown several Shakespearian subjects at the Royal Academy exhibitions, and these were well received. He was elected ARA in 1788 and RA in 1790, confirmation that he had become a central figure in the London art world, where he stood out as the most knowledgeable art historian among his fellow artists as well as being the most literarily gifted among them. The best-known of his Boydell compositions is the large and elegant *Titania, Bottom and the Fairies* [COL.PL.1], now in the Tate Gallery, of which he himself wrote, 'This is the creation of a poetic painter. . . . The soft and insinuating beauty, the playful graces here displayed would, without reflection, scarcely be expected from the daring pencil that appears ever on the stretch to reach the upmost boundary of nature.'⁵ This was one

of two scenes from Act IV of *A Midsummer Night's Dream* in which Fuseli was able to combine mystery and grace with charm and eroticism to produce two of his most attractive Shakespeare Gallery compositions. Much more dramatic are his illustrations of scenes from *King Lear*, *Macbeth* and *Hamlet*, in which the artist's rendering of gesture and expression is especially impressive. As well as Fuseli's paintings of Shakespearean subjects there are many illustrations of themes and characters from the plays among his drawings. Fuseli was a fluent and prolific draughtsman, and his drawings are on the whole more attractive to the modern eye than his paintings, which often appear laboured and coarse in technique. It should also be remembered that it was through his idiosyncratic drawing style that he exerted most influence on his fellow artists, especially Romney and William Blake.

Many of Fuseli's most notable drawings are studies of women, and his wife, Sophia Rawlins, whom he married in 1788, was frequently the model. Elaborate and sensuous coiffures or hats are often features of these studies, sometimes adding to the erotic undertones of the composition, as in *Mrs Fuseli seated in the Corner of a Sofa, in a wide-brimmed Hat* [PL.5], which dates from about 1795. The Greek inscription at the bottom of the sheet reads, 'Restlessly I chased the image of my dream through the passing fashions.' This enigmatic quotation adds to the mystery of the drawing, and contradicts, as do so many of his works, Fuseli's maxim at the beginning of his Lecture IV as Professor of Painting at the Royal Academy, to which office he was elected in 1799, after the expulsion of James Barry. 'The first demand of every work of art,' he stated, 'is that it constitute one whole, that it fully pronounce its own meaning, and that it tell itself; it ought to be independent; the essential part of its subject ought to be comprehended and understood without collateral assistance, without borrowing its commentary from the historian or the poet.'[6]

Fuseli's Academy lectures were authoritative and influential, and his position became even more important when he was elected Keeper, that is head of the RA Schools, in 1804. This office he retained until his death, as he did the Professorship of Painting, after a short interlude between 1805 and 1810, when John Opie and Henry Tresham briefly filled the post. Thus Fuseli was a leading figure at the very centre of the British art world, and his teaching and example had a prime influence on numerous aspiring painters in the first quarter of the nineteenth century. Fuseli's strong impact as a teacher is vouched for by Benjamin Robert Haydon, who joined the Schools in 1804. On 11 July 1810, he wrote the following in his diary: 'I spent five hours with Fuzeli Sunday last spouting Homer, Virgil, Dante and Milton. I flatter myself I can adopt so much of Fuzeli's fire & pungency as I find necessary for my own purposes, without suffering him to lead me astray, by his enthusiasm.… I have now known Fuzeli five years – and consider his Friendship … a very, very great acquisition – no man has like Fuzeli the power of directing your fancies to a point – Fuzeli is such a man as does not appear in two centuries – and that they'll think when he is dead.'[7]

As a practising painter Fuseli's success was far more limited. In 1790, no doubt fired by the critical acclaim for Boydell's Shakespeare Gallery, Fuseli decided to launch his own Milton Gallery, which became the focal point of his work for the next ten years or so. The artist's first idea was to produce thirty compositions of Miltonic subjects for engraving, but this was superseded by the more ambitious scheme of a series of large

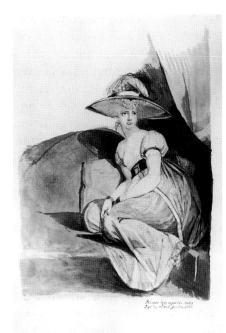

(5) Henry Fuseli, *Mrs Fuseli seated in the Corner of a Sofa, in a wide-brimmed Hat* (c.1795). Watercolour; 48×31.2 cm. (Kunsthaus, Zürich)

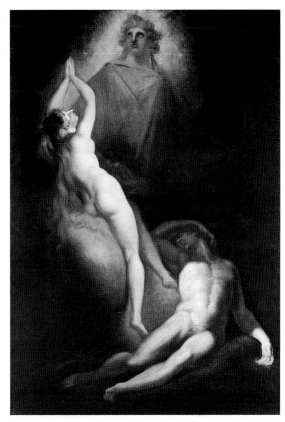

(6) Henry Fuseli, *Creation of Eve* (1793). Oil on canvas; 307×207 cm. (Kunsthalle, Hamburg)

paintings, of which he completed forty-seven, exhibiting the first group at Christie's in Pall Mall in 1799. Though well received by many of his fellow artists, the exhibition was not a success with the general public and was closed after only two months; a re-opening in the following year was again a failure: some of the main works were bought by friends and leading collectors, including John Julius Angerstein, who acquired the elegant but gloomy *Creation of Eve* [PL.6], painted in 1793.

Despite its failure in material terms, the Milton Gallery was certainly important in Fuseli's artistic career. As the painter himself stressed repeatedly in his letters to Thomas Roscoe, the Liverpool banker and collector who backed the scheme, there were many similarities between his own difficulties while working on his Milton compositions and those of the poet while writing *Paradise Lost.* There were also more general similarities in the lives and careers of the two men, who 'both came from Puritan backgrounds and were destined to be clergymen.... Both studied extensively in the classics in their youth and retained throughout their lives a love of antiquity. Both, in their creative work, continually drew on the heritage of the classical world. Travel in Italy had developed in both a heightened awareness of the classical tradition. Both had unhappy love affairs...'[8]

In the last two decades of his long life Fuseli continued to paint and draw ex-

tensively, taking his subjects mostly from Homer and other classical authors, Dante, the Bible, and romantic Northern texts. His art was relatively old-fashioned, but his imagination and powers of invention were as vivid as ever, and his draughtsmanship was still fluent and effective. He continued to deliver his Royal Academy lectures, which remained influential despite his increasing pessimism, although it seems that he became ever more neglectful of his duties as Keeper of the RA Schools. Fuseli had kept alive the tradition of Reynolds throughout the first quarter of the nineteenth century. Like the first President he had, to use Haydon's words, 'the power to invigorate the conceptions, enlarge the views, or inspire the ambition of the students'.[9] During his lifetime Fuseli was regarded as one of the leading intellectual and literary figures of the day, but that reputation did not really extend to his art, which soon was largely forgotten.

While his contemporary and fellow Academician, Thomas Stothard (1755–1834), was a lesser artist and personality than Fuseli, his work was remembered for longer, because it was more in keeping with the taste of the time and because so much of it was engraved for book illustrations. However, Stothard also had ambitions as a history painter. His manner was rococo rather than classical, and was often also reminiscent of Rubens, though largely lacking the power of that master, who was his inspiration when he decorated the walls of the so-called 'Hell Staircase' at Burghley House, Lincolnshire, around 1800. A study for one of his huge Burghley House compositions, *Intemperance : Mark Antony and Cleopatra*, is one of six paintings by him in the Vernon Gift at the Tate Gallery, where he is remarkably well represented by a group of eighteen paintings and numerous drawings illustrating every aspect of his charming but lightweight art. By contrast there are only four paintings and one drawing by Fuseli in the Tate's collections.

3 Sir Henry Raeburn, RA (1756–1823)

The Instrument of Foundation of the Royal Academy, approved and signed by George III on 10 December 1768, laid down the rules for the new institution, among which it was stipulated that a new member 'shall not receive his Letter of Admission, till he has deposited in the Royal Academy, to remain there, a Picture, Bas-relief, or other specimen of his abilities, approved of by the then sitting Council of the Academy.' This letter, signed by the Sovereign, is known as the Diploma, and the 'specimens' presented are called Diploma Works. The Diploma Collection as a whole provides a fascinating survey of the range and development of members' work during the last two centuries, and there is usually a selection of works from it on view in the corridors and on the staircases at Burlington House. In this collection there could hardly be a greater contrast than that between Fuseli's large, powerful and ambitious *Thor Battering the Midgard Serpent* presented in 1790, and the small and gentle *Boy and Rabbit*, which was Raeburn's Diploma Work after the Council's initial refusal of a self-portrait in 1816. Fuseli, taking his subject from Northern mythology, has created a romantic masterpiece still firmly based in the classical tradition; the dynamic figure of Thor owes much to Michelangelo. Raeburn's charming portrait of his deaf and dumb grandson represents the other aspect

(7) Sir Henry Raeburn, *Sir John and Lady Clerk of Penicuik* (1792). Oil on canvas; 145×206 cm.
(National Gallery of Ireland, Dublin)

of romantic art – the sentimental and emotional, with its roots in the portraiture of Reynolds. Both these largely self-taught artists were steeped in the classical tradition as disseminated by Reynolds, but while Fuseli devoted his talents to history painting, Raeburn painted almost exclusively portraits.

Little is known about Henry Raeburn's early years: born in Edinburgh and left an orphan at the age of six, he was brought up by his elder brother, who apprenticed him to an Edinburgh goldsmith in 1772. At this time Raeburn began to paint miniatures and came into contact with various Edinburgh artists, including the portrait painter David Martin, who had trained in the studio of Allan Ramsay. In 1780 Raeburn married a rich widow, and they had two sons. In 1784 the artist and his family moved to London, where it is thought that he spent two months as a pupil in Reynolds's studio. In July of that year, encouraged by Reynolds, Raeburn travelled, alone, to Rome, but again little is known about his time there. Returning to Edinburgh in the summer of 1786, he quickly established himself as the leading portrait painter and developed a mature and individual style with remarkable rapidity. The essence of Raeburn's portraits lies in their directness and realism, achieved by the combination of a fluent yet firm use of paint with an exceptional feeling for light and design. He never made preliminary drawings nor did he draw on the canvas, and one of his finest qualities is the distinctive painterliness of so many of his portraits. One can trace numerous influences in Raeburn's work, ranging from Raphael's famous portrait of Pope Julius II, through the Dutch seventeenth century, especially Rembrandt, to Reynolds, but each of his portraits is

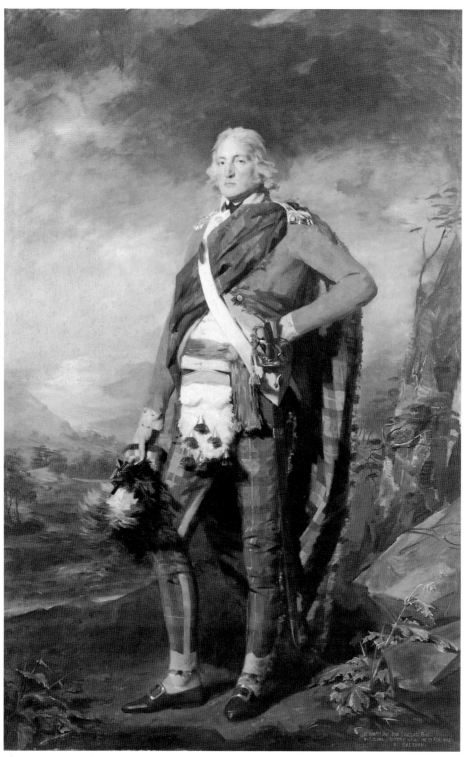

(8) Sir Henry Raeburn, *Sir John Sinclair of Ulbster* (*c*.1794). Oil on canvas; 237.5×153.7 cm
(National Gallery of Scotland, Edinburgh)

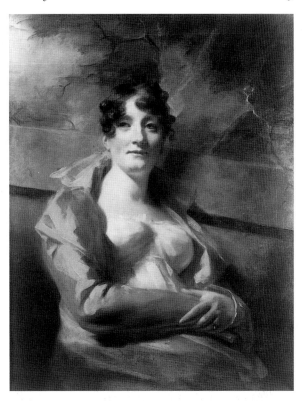

(9) Sir Henry Raeburn, *Lady Elibank*
(*c*.1805). Oil on canvas; 91.4×71.1 cm.
(Philadelphia Museum of Art: The
John Howard McFadden Collection)

very positively a 'Raeburn' and the finest of them show him as a master of character-
isation and of effective lighting.

Both these qualities are seen at their best in the imposing double portrait of Sir
John and Lady Clerk of Penicuik [PL.7], which was exhibited at Boydell's Shakespeare
Gallery in 1792 having arrived too late for inclusion in the Royal Academy. This was the
first work by Raeburn to make an impression in London, where he had also shown for
the first time at the Royal Academy that year. Though the influence of both Reynolds
and Ramsay can be traced in this work, its successful combination of overall visual
unity with penetrating individual characterisation is very much Raeburn's own. These
qualities are also to be found in many of Raeburn's grand full-length portraits, such as
that of Sir John Sinclair, 1st Baronet of Ulbster [PL.8], which was probably painted in
about 1794. The baronet is shown in the ornate and colourful uniform of the Rothesay
and Caithness Fencibles which he raised in 1794. Here, as in other formal portraits of
Scottish lairds, Raeburn makes the fanciful uniform appear totally natural, and, despite
the stiff pose and all the other distractions, the features of the person portrayed stand
out as the principal element of the canvas.

It is not surprising that Raeburn is even more successful in his depiction of charac-
ter in his smaller informal portraits, such as the serene and slightly mysterious *Lady
Elibank* [PL.9], which is dated to about 1805. The self-possession and contentment of this
young woman, wearing a plain informal dress and no jewellery other than her wedding
ring, are emphasised by the dramatic lighting of the sky and the mellow golden colours.
Raeburn painted numerous such direct and convincing portraits of women, both young

and old; among the latter the half-length portrait of *Mrs James Campbell* (Private Collection), comfortable in her cap and shawl, is one of the most memorable. Against a bare dark background the face and headdress of this homely elderly lady, who is reputed to have been the mother of sixteen children, are built up with a series of bold bands of paint. The same method brings to life the features, wig and robes of *Lord Newton* [COL. PL.2], seated in an armchair in a pose reminiscent of Raphael's *Julius II*. The powerful lawyer is portrayed just as convincingly as the proud laird, the serene bride, or the homely housewife, and it is not surprising that Raeburn enjoyed acclaim and material success in Edinburgh. Lord Newton was the artist's neighbour in York Place, in Edinburgh's fashionable New Town. In 1798 Raeburn had built his own painting and exhibition rooms at No. 32 (which still survive today), and here was able to control the light by which he worked, as well as enjoying the view over the Firth of Forth.

When Joseph Farington visited Raeburn's studio on 21 September 1801 the artist was away, but, as he recorded in his *Diary*, he found his house 'excellent & built by himself. His Show Room is lighted from the top. His painting room commands a view of the Forth and the distant mountains. Some of Mr Raeburn's portraits have an uncommonly true appearance of Nature and are painted with much firmness.' Farington also commented on Raeburn's success, but despite this the Scottish painter contemplated a move to London in 1810, believing that he might profitably set up a studio there following the death of Thomas Lawrence's only serious rival, John Hoppner. However, he did not stay, though from now on he regularly sent portraits to the Royal Academy exhibitions; he was elected ARA in 1812 and RA three years later. He was knighted by George IV at the time of his State Visit to Edinburgh in 1822, and was appointed the King's Limner for Scotland, but did not live long enough to paint a portrait of the King. While Allan Ramsay (1713–84) enjoyed great success in London, becoming the King's Principal Painter in 1761, Raeburn was the first Scottish artist to be fully recognised and honoured in England. However, he spent nearly all his working life in Scotland. Here he had no serious rival of his own generation, but he himself did much to encourage younger artists, such as John Watson Gordon (1788–1864). As we shall see one of Raeburn's much younger fellow-countrymen, David Wilkie, was even more successful, but he left Scotland for London when he was only twenty years old.

4 Sir Thomas Lawrence, PRA (1769–1830)

Thomas Lawrence was certainly the greatest of the British portrait and figure painters to continue the tradition of Joshua Reynolds, and his work was as significant in the wider context of European painting as was that of his two contemporary landscape painters, Constable and Turner. As it had been in the eighteenth century, the painting of portraits was the most regular and profitable activity for British artists throughout the nineteenth. This was the case even in the second half of the century, when photography came into its own. After Benjamin West most of the nineteenth-century Presidents of the Royal Academy were primarily portrait painters. Among all these British painters of portraits Thomas Lawrence stands out as the only artist of international stature and of true originality.

Lawrence was born in Bristol in 1769, the year that also saw the birth of Napoleon and Wellington. His family was a respectable one, but his father was something of a failure and became an innkeeper. In 1773 the family moved to the Black Bear at Devizes, a popular coaching inn on the Bath to London road, regularly patronised by the nobility and gentry. It was here that Thomas's precocious gift of drawing likenesses developed at a very early age, apparently entirely without instruction, and was quickly exploited by his father. He was encouraged to draw portraits of the guests, and when Lawrence senior again went bankrupt he devoted himself to becoming his son's impresario, and, after 'seasons' in Oxford and Weymouth, the family settled in Bath, where the young artist advanced from pencil portraits to pastels. It seems that during these years Lawrence received little formal education or artistic training, though while in Bath he was able to study, and copy in, the collections of old masters in the area.

In 1787 Lawrence, still only eighteen years old, showed seven works at the Royal Academy, and the family moved to London, where the prodigy, whose reputation as a pastellist had gone before him, began to paint in oils. He was admitted a student at the Royal Academy Schools, and was invited by Sir Joshua Reynolds to study and copy in his studio. Not surprisingly Lawrence was somewhat vain and extravagant, but as well as being a natural artist he was also an instinctive scholar. In addition he was good-looking and had all the social graces, and for the rest of his life he was one of the central figures in the artistic and social life of the capital. In 1787 Lawrence wrote to his mother, 'excepting Sir Joshua, for the painting of a head, I would risk my reputation with any painter in London.'[10] Gainsborough died in the following year, Reynolds was losing his sight and died five years later, leaving only John Hoppner, who was eleven years his senior, to rival Lawrence's rapidly rising star.

It was a meteoric rise. By 1790 all Lawrence's twelve RA exhibits were in oils; they included the masterly portrait of Queen Charlotte, now in the National Gallery, and the exquisite and sensitive portrayal of the actress, Miss Farren [COL.PL.3], in which the twenty-one-year-old artist displays his full genius. The commission to paint the Queen was impressive enough, but the confidence of the resulting full-length portrait and the quality of *Elizabeth Farren* brought widespread praise, including that of the critic of the *English Chronicle,* who described Lawrence as 'a youth of extraordinary genius who has not only outstripped all the junior artists, but, in portrait painting, may at this moment stand in competition with the President himself'.[11] Furthermore it is reported that Reynolds was moved to declare, 'In you, sir, the world will expect to see accomplished what I have failed to achieve'.[12]

There can be no doubt that the young Lawrence was influenced by the example of Reynolds and considered himself his follower and successor, but it is equally certain that he was sufficiently talented and confident to develop his own natural skills. Lawrence was an instinctive draughtsman, and his portraits were based on a combination of careful drawing and the masterly and varied handling of paint; Reynolds was a poor draughtsman, who painted directly on the canvas and on occasion applied his paint in a dull and conventional manner.

How Lawrence learnt his painting technique can only be guessed at, but it has been justifiably described as perfect, and it is seen at its best in *Elizabeth Farren.* The lovely actress's shimmering white satin dress and cloak, her gloves, her furs and

especially the muff, are all painted with consummate skill, and are set off by the tones and movement of the sky and landscape behind her. She looks round at us somewhat coyly, her hair ruffled by the wind, and as the critic of the *Public Advertiser* wrote, 'We have seen a great variety of pictures of Miss Farren, but we never before saw her mind and character upon canvas. It is completely Elizabeth Farren; arch, spirited, elegant and engaging.'[13] Despite the apparent facility of his portraits, it is known that Lawrence worked slowly and deliberately. Some years later he declared himself 'as much the slave of the picture I am painting as if it had living, personal existence, and had chained me to it'.[14] He was very fastidious about his sitters' costume, as we know from a letter written to Joseph Farington before his first sitting in May 1794, politely asking his friend and fellow artist 'to put on a blue coat'.[15] When Farington entered that first sitting in his *Diary* on 7 May, he recorded, 'This morning I sat to Lawrence when he drew in my portrait with black chalk on the Canvass, which employed him near 2 Hours. He did not use colour today. – This is his mode of beginning.'

Lawrence's rapid progress continued, much aided by his handsome appearance and his elegant and well-mannered demeanour, though his vanity was a disadvantage. He was elected ARA in 1791, and became a full member in 1794. On the death of Reynolds in 1792 the twenty-three-year-old artist was immediately appointed his successor as Painter-in-Ordinary to the King, and elected to succeed him as Painter to the influential Society of Dilettanti. The commissions flooded in, and from now on he regularly employed apprentices or assistants, and engaged paying pupils. Lawrence's portraits continued to excel in quality, but in his private life he was troubled by financial problems resulting from his constant extravagance, and by unsuccessful affairs of the heart. He had, however, formed an enviable circle of friends, including important members of the banking world, such as the Angersteins and the Barings. Perhaps his most important friend was Joseph Farington, twenty-two years his senior and a powerful member of the Royal Academy, though never, as so often stated, its Secretary. The two artists saw each other frequently, and much of what we know about the life and work of Lawrence, who kept no records himself, has been culled from Farington's invaluable *Diary*.

Each year Lawrence showed a large group of portraits at the Royal Academy, but never again quite as many as the twelve in 1790. In 1792 pride of place was given to the 'oversize' and brilliantly painted state portrait of George III in Garter robes, which was commissioned by its Members of Parliament for the City of Coventry. However, much more appealing is the half-length portrait of Georgiana, Lady Apsley (Earl Bathurst), in which the beautiful young woman gazes down at her sewing. In this intimate study Lawrence has created a masterly composition, focusing the viewer's eyes on the simple piece of material and the exquisitely painted hands to achieve overall unity. The Los Angeles County Museum's famous *Arthur Atherley* [PL.10] was also included in this exhibition. The young Etonian is wearing a bright red coat and shown against a lowering sky, and this strong yet delicate portrait is an early example of Lawrence's exceptional gift for portraying children and young adolescents. Much less successful among the 1792 exhibits was the languorous full-length portrait of Romney's favourite model (and Nelson's future mistress), Emma, Lady Hamilton, which was described in the catalogue as 'a lady of fashion as La Penserosa'. In this

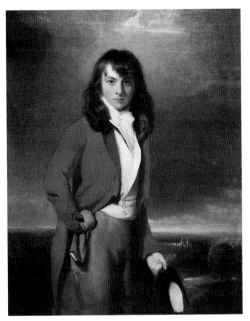

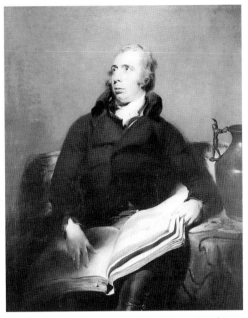

(10) Sir Thomas Lawrence, *Arthur Atherley* (RA 1792). Oil on canvas; 127×102 cm. (Los Angeles County Museum)

(11) Sir Thomas Lawrence, *Richard Payne Knight* (RA 1794). Oil on canvas; 127×102 cm. (Whitworth Art Gallery, University of Manchester)

Lawrence already shows some of the weaknesses of exaggeration that undermined his attempts at history painting a few years later.

It has been claimed that he would have preferred to be a successful history painter rather than a portrait painter, and it is certain that Lawrence was strongly influenced by Fuseli, who became another of his closer friends. Something of his desire to escape from producing portraits only can also be detected in his Diploma work, *A Gipsy Girl*, painted in 1794. Reminiscent of the fancy pictures of Gainsborough and Reynolds, this rather feeble composition of a scantily dressed girl modestly clutching a chicken to her bosom, was not exhibited at the time and was actually returned to Lawrence to 'reconsider' as it was thought 'very slight', but he made 'no alteration'.[16] This small canvas has darkened and deteriorated considerably with time, as has Lawrence's most ambitious history painting, *Satan summoning his Legions*, which was exhibited in 1797, and which Fuseli understandably considered to be a pastiche of his own work, while at the time Lawrence considered it his masterpiece. This enormous canvas was the artist's last attempt of this kind, though he did achieve something of the same dramatic effect in his three vast portraits of the famous Shakespearean actor John Philip Kemble in character, which were shown at the RA in 1798, 1800 and 1801 (the last now Tate Gallery, London). These canvases were not commissioned, but were painted for prestige and exhibition purposes, and all were ultimately sold.

Among Lawrence's most remarkable commissioned portraits of this time was that of Richard Payne Knight [PL.11], which was exhibited at the Academy in 1794. The notable collector and connoisseur is shown in a moment of reflection, a tome on his lap and one of his bronzes at his side. This is a powerful character study of an arrogant and

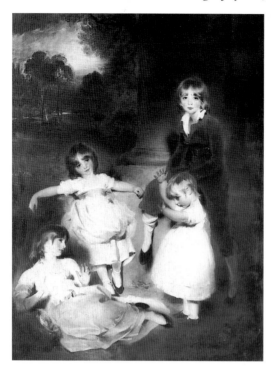

(12) Sir Thomas Lawrence, *The Children of Ayscoghe Boucherette* (RA 1800). Oil on canvas; 1.95×1.46 cm. (Musée du Louvre, Paris)

difficult man, with whom Lawrence must have felt some affinity as a fellow collector. During his own lifetime the painter formed an unrivalled collection of old master drawings in the tradition of earlier artist-collectors such as Lely and Reynolds. Gradually his collection became one of Lawrence's ruling passions, and one of the reasons for his always being in debt was the enormous prices he was prepared to pay for drawings which he coveted. Most of the great masters of the Italian, French and Netherlandish Schools were represented by fine groups of drawings; pre-eminent among these were the then unrivalled representations of Michelangelo and Raphael, now in the Ashmolean Museum, Oxford. Tragically the rest of the collection was gradually dispersed after Lawrence's death, despite the artist's plans for preserving it for the nation.[17] It was as a collector that Lawrence's scholarly characteristics came into their own, and the high quality and range of his collection of drawings reflects the depth of his knowledge of art history and the sureness of his eye.

Many of Lawrence's portraits reveal a very different aspect of his character – his obvious love of and sympathy for children, another feature which he shared with his fellow bachelor, Joshua Reynolds. The *Arthur Atherley* of the 1792 exhibition was followed by the even more famous *Pinkie* (Sarah Moulton Barrett) in 1795. This elegant portrayal of the girl (who had died just before the exhibition) almost 'floating' in a panoramic landscape, makes a wonderful companion to Gainsborough's famous *Blue Boy*, also in the Huntington Gallery in California. Equally vivid, but more down-to-earth, are *The Children of Ayscoghe Boucherette* [PL.12], exhibited in 1800 and subtitled *The Little Orator*, which is now in the Louvre. In this enchanting composition the son and heir, dressed in a fine red velvet suit, is entertaining his younger sisters, all dressed in white, and they react to his tale with earnestness and wonder. This group was for long

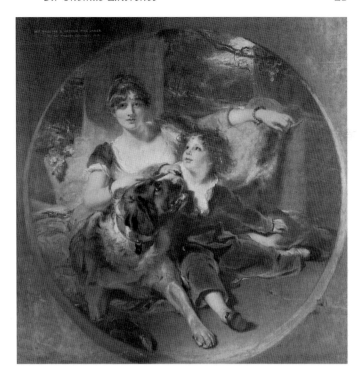

(13) Sir Thomas Lawrence, *Mrs Maguire and her Son* (RA 1806). Oil on canvas; 165.1 cm. diam. (The Duke of Abercorn)

wrongly identified as the children of John Angerstein, who were, in fact, much younger and painted by Lawrence in an equally attractive composition, which was exhibited in 1808 and is now in Berlin. In this painting the four children, wielding broom and spade, are gardening, and the slight stiffness of the earlier group has been overcome.

The later 1790s and the first years of the new century were difficult ones for Lawrence, whose debts and other personal problems continued to increase. As a result he undertook too many commissions and depended excessively on his assistants. However, by 1806 things were better, and one of his RA exhibits that year again won the critical acclaim that had been lacking for some time. This was the vivacious and colourful portrayal of Mrs Maguire and her son [PL.13], exhibited as 'A Fancy group' and often known simply as the 'Circular Picture'. The sitters were Mrs Maguire, mistress of the 1st Marquess of Abercorn, and her son Arthur Fitzjames, who are shown seated on the ground together with a large and eager Newfoundland dog. The tightly knit composition is complex but effective, and all its components – among them hair, velvet, dog's shaggy coat, and grapes – are executed with wonderful painterly panache. Actually painted in 1805, but not exhibited that year at the Marquess's request, the 'Circular Picture' was very warmly approved of by Henry Fuseli, whose enthusiastic comments were recorded by Farington in his *Diary* on 29 April of that year; 'Fuseli … had seen yesterday Lawrence's circular picture … & said that such a picture had not been painted these 100 years. That Sir Joshua Reynolds could not have done it, – that it was singly worth all the pictures Gainsborough had ever painted, – that it was like a charm having all that *mind* & the *pencil* could do, – that it exhibited the most exquisite ideas of pleasure without exciting any vicious feelings.'

Lawrence's principal exhibit of the following year was his ambitious triple portrait

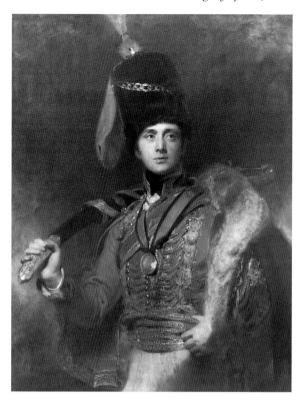

(14) Sir Thomas Lawrence, *Lieutenant-General the Hon. Sir Charles Stewart* (RA 1813). Oil on canvas; 127×101.7 cm. (The Marquess of Londonderry)

of Sir Francis Baring, founder of the financial house of Baring Brothers, with his brother and son-in-law, which was commissioned by the Baronet as a companion piece to Reynolds's triple portrait of Lord Lansdowne, Lord Ashburton and Colonel Barre, which he owned. This was again well received, and Fuseli recorded that Benjamin West, when asked what he thought of the picture, 'replied in the warmest terms of approbation' and commented that 'that picture, & his Circular one exhibited last year, puts them all at a distance.'[18] Other successes followed, and Lawrence's confidence was again at its height. His technique tended to become freer and looser, and his style more overtly romantic, as in the fine 'Byronic' half-length portrait of the 4th Earl of Aberdeen when a young man, who had just travelled in Greece. Even more of its time is the dashing *Lieutenant-General the Hon. Sir Charles Stewart* [PL.14], which was painted in about 1811 and shown at the RA two years later. Portrayed in the colourful and decorative uniform of a Hussar, with his sword in its scabbard carried proudly over his shoulder and the Peninsular medal hanging on his chest, the handsome officer gazes out at us with easy confidence, expressing, as Michael Levey has put it, 'a generation as well as a man'.[19]

Stewart was Wellington's adjutant-general and was the half-brother of Lord Castlereagh, the Foreign Secretary of the day, whom he succeeded as the 3rd Marquess of Londonderry in 1822. After his successful military career he was appointed Ambassador at Vienna in 1814, and was the British Plenipotentiary at the Congress of Vienna. He sat to Lawrence for several portraits, and the two men became friends. It was to be a most significant friendship, for it was Stewart who presented the painter to the Prince

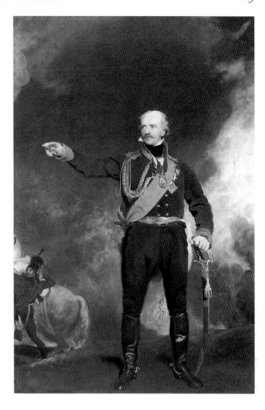

(15) Sir Thomas Lawrence, *Field Marshal von Blücher*
(1814). Oil on canvas; 269.9×178.4 cm.
(The Royal Collection)

Regent at a levée in 1814, and persuaded the Prince to sit for a full-length portrait, which was exhibited at the Royal Academy in 1815 (The Marquess of Londonderry). The Prince had not previously sat to Lawrence; John Hoppner had held the position of Portrait Painter to the Prince of Wales from 1789 until his death in 1810. With Hoppner's death Lawrence's only serious rival in London had been removed, and though Raeburn was tempted to establish himself in London, he did not pursue this plan. In Lawrence's first portrait of him the Prince is shown in Field Marshal's uniform, with the bright stars of the Garter and other Orders on his chest, and at his neck the Golden Fleece, which he had been awarded in 1814. He is standing proudly with right hand on sword, a stormy sky behind him; this is a truly heroic – and flattering – portrayal, and the congenitally vain sitter was delighted.

The mood of the portrait was in keeping with the events of the time, for Napoleon's defeat was at hand; the Emperor surrendered and abdicated on 11 April 1814, and was sent to Elba. When some of the allied heads of state and military leaders assembled in London that summer, the Regent persuaded them all to give sittings to Lawrence, who had recently moved to new and spacious premises in Russell Square. Four of the resulting portraits (now all in The Royal Collection) were also shown at the RA in 1815, and with the portrait of the Prince they must have made an impressive display. The largest and grandest was that of Napoleon's conqueror, the Duke of Wellington, shown holding aloft the Sword of State which he had carried at the Thanksgiving Service at St Paul's Cathedral, visible in the background. Count Platov, Hetman of the Cossacks, is standing proudly beside his grey charger, and Field Marshal von Blücher [PL.15], who

led the army of Silesia into Paris, has the smoke and flames of battle behind him. The fourth in this group, much smaller and less grand, was a three-quarter-length of Prince Metternich, the Austrian statesman, who is in court dress wearing numerous Orders, and comfortably seated in an armchair. By the time these portraits were exhibited Napoleon had escaped from Elba, and again ruled as Emperor from Paris. The 'Hundred Days' ended with his final defeat at Waterloo on 18 June 1815, and it was possible to resume the Prince Regent's plan of employing Lawrence to continue the series of portraits of allied rulers, statesmen and military leaders which he had begun in London. In April 1815 Lawrence was knighted in anticipation of his official task, but it was not until over three years later that the artist set out for Aix-la-Chapelle to begin his work.

The concept of this magnificent royal commission was in keeping with the pride and optimism of the time, and Lawrence was exactly the right man to undertake it. It provided a fitting climax for his distinguished career, and just as Van Dyck immortalised the court of Charles I, so Lawrence achieved a superb record of the stirring events and leading personalities of the opening years of the nineteenth century. He was on the Continent for eighteen months; after eight weeks at Aix, he spent five months in Vienna, followed by nearly ten in Rome. As well as making numerous drawings of his sitters, he also painted or began the final canvases of many of them, and undertook several private commissions in Vienna. During these months his sitters included the Emperors of Austria and Russia, the King of Prussia, and various diplomats and military men, such as Prince Hardenberg, Count Nesselrode, Prince Schwarzenberg and General Uvarov.

In Rome he was warmly received by the Pope, Pius VII [COL.PL.4], and his Secretary of State and confidant, Cardinal Consalvi (The Royal Collection), and in his portraits of these great clerics Lawrence achieved two of his outstanding masterpieces. He was provided with a suite of rooms in the Palazzo Quirinale, and both men gave him ample sittings. The elderly Pope, who was in his later seventies, is enthroned, dressed in a gleaming white cassock and an ermine-edged red cape; behind him are sumptuous red velvet draperies and a view into the Braccio Nuovo, a sculpture gallery which was being built at the time, with the *Laocoön* and the *Apollo Belvedere* seen in the sunlight. Amid all this finery and detail it is the calm and slightly wistful features of the Pope that really catch the eye. It is not surprising that Lawrence, as vain as ever, wrote from Rome to his confidante Miss Croft, 'I have completed the Pope's portrait with that of Cardinal Consalvi, and visited for a few days Naples. I am very happy to tell you that I have completely succeeded in the former Picture, to the utmost of my expectation and almost of my wishes. I think it now the most interesting and best head that I have painted, and the general opinion is in unison with this belief; for it is thought the best and happiest resemblance of the Pope [who had also been painted by the French artist Jacques Louis David, among others] that has ever been painted.'[20] The portrait of the Cardinal, who is dressed entirely in red, is in some ways even grander, but lacks the penetrating revelation of that of the Pope.

Lawrence left Rome just before Christmas and was back in England at the end of March 1820. Earlier that month Benjamin West, President of the Royal Academy, had died, and Lawrence was elected to succeed him. The unfortunate George III, who had been permanently deranged since 1811, had died at the end of January, and the Prince

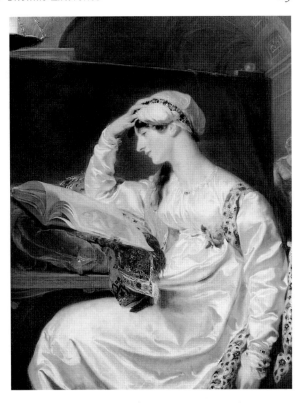

(16) Sir Thomas Lawrence, *Mrs Jens Wolff*
(RA 1815). Oil on canvas;
128.2×102.4 cm. (The Art Institute
of Chicago)

Regent, already in his fifty-eighth year, at last came into his own as George IV. Both monarch and painter had another ten years to live, and for Lawrence they were years of continued success, in which he produced numerous scintillating portraits of the great, the famous, and the beautiful.

Throughout this period he was at work in completing the portraits undertaken during his Continental travels; some remained unfinished when he died, at which time the whole group was still in his studio. They were then delivered to the King, who had ordered his architect, Sir Jeffrey Wyatville, to design the Waterloo Gallery or Chamber on the site of the former Horn Court as part of his extensive alterations and additions at Windsor Castle. The room was not completed until the reign of William IV, and was opened in 1831 with some thirty portraits on the walls. Others were soon added, including some not by Lawrence. The Waterloo Chamber is the only place in Britain where a large group of high-quality Lawrence portraits can be seen, for he is very poorly represented in the national museums.

There are, of course, no women in Lawrence's Waterloo series, but during these final years many exciting female portraits continued to flow from his brush (or pencil, as it was still called during the earlier years of the nineteenth century). One of his most remarkable portrayals of a woman, *Mrs Jens Wolff* [PL.16], had been included in the 1815 RA Exhibition, at which his first Waterloo portraits were also shown. Begun in 1803, it was not completed until twelve years later, by which time Mrs Wolff had separated from her husband, who was the Danish Consul in London. A close, and possibly intimate, friendship had developed between Lawrence and Mrs Wolff, who was an ex-

(17) Sir Thomas Lawrence, *Lady Peel*
(RA 1827). Oil on canvas; 91×71 cm.
(Frick Collection, New York)

ceptionally clever woman. In her sparkling white satin dress she studies a volume of en-
gravings after Michelangelo and is seated in the pose of that master's Erythraean Sibyl
from the Sistine Chapel ceiling. Both as a composition and in its painterly qualities this
shows Lawrence at his best. While in Vienna he painted the charming half-length por-
trait of Lady Selina Meade (Private Collection), and soon after his return to London the
beautiful Marguerite, Countess of Blessington sat to him (Wallace Collection, London).

In about 1826 Sir Robert Peel, the statesman and collector who had become one of
Lawrence's foremost patrons, as well as a friend, commissioned a second portrait of his
wife [PL.17], who had already been painted by Lawrence two years earlier. This was to
hang as a pendant to Rubens's *Chapeau de Paille*, which was then in his collection. The
resulting masterpiece displays absolute confidence and virtuosity, and it must have
given Lawrence exceptional pleasure to paint such a beautiful sitter as a companion-
piece to a great work by one of the artists he had most admired since his early days in
Bath.

Reference to Bath reminds us of Lawrence the draughtsman, and of the impor-
tance of drawing to him throughout his career. This is confirmed in a letter which Sir
Robert Peel wrote to Lawrence in January 1825, at a time when he had just completed
his first portrait of Lady Peel, which Sir Robert considered 'eminently beautiful'. He
apologised for discussing the painting in front of Lawrence with the politician John
Wilson Croker in French, and reported that Croker had said that 'you [Lawrence]
attributed your success in expressing perfect identity of character, to skill in drawing,
and that you thought this – namely skill in drawing, a less important branch of the art

(18) Sir Thomas Lawrence, *The Duchess of Wellington* (1814). Red and black chalk; 29.8×21.9cm. (The Duke of Wellington)

of painting than some others, such as colouring, &c.... He said, you always appeared to throw away the first two hours of a sitting, because you made little use of that which you then sketched in, – but you were in fact studying the expression and character of the person, and that they were the two most important hours.'[21] These perceptive comments must have pleased Lawrence, whose drawings have been compared with those of Ingres, as his delightful study of the Duchess of Wellington [PL.18] might well be. Lawrence's drawings are largely unknown today.

In 1829 Lawrence wrote to a member of the Angerstein family, 'I shall live and die in harness', and this he did. He was hard at work until shortly before his sudden death in January 1830, his painting as good as ever. However, he also remained unbusiness-like throughout his career, and when he died there were some 150 unfinished portraits in his studio; there is ample evidence of his frequent reluctance or inability to finish portraits on time. As President of the Royal Academy he seems to have made little mark, simply following the traditional procedures and being present when required. He was always careful to welcome and assist visiting artists, among whom were Géricault and Delacroix, who both admired him.

Lawrence retained his high reputation on the Continent, and enhanced it with his exhibits at the Paris Salon, where he showed three portraits in 1824, when Constable's *Hay Wain* was also shown, and the popular *Master Lambton* in 1827 (Earl of Durham). In 1825 he himself had been in Paris for a short visit, taking with him the circular portrait of the *Calmady Children*, now in New York. Both these highly sentimental portraits of children were received with great enthusiasm in the French capital, and a colour

print of the latter was quickly produced and proved extremely popular. Lawrence had gone to Paris to fulfil George IV's commission for a full-length portrait of Charles X, which now hangs in the Waterloo Chamber. Lawrence also painted the French king's daughter-in-law, the Duchesse de Berri, who wears a flamboyant tartan toque and holds an eyeglass, a tactful reference to a defect in her vision. This was again one of Lawrence's totally successful portrayals of a handsome woman; except in a few grand formal portraits he was rarely as good with men as he was with women and children, and his reputation has rested very largely on paintings of the latter. That reputation has been at an undeservedly low ebb for some time; in the context of this volume Lawrence stands out as the greatest British portrait painter of the nineteenth century, and as the last great artist who directly enhanced the legacy of Sir Joshua Reynolds, taking it out of the eighteenth into the nineteenth century. Lawrence's most personal contribution to the Reynolds tradition was the romantic element of much of his work. His instinct for the mood and sensibility of his time encouraged him to introduce romantic qualities into many of his portraits – in the pose, in the vivid use of light and shade, in his often emotional rendering of character – so that he can be claimed as having a place in the Romantic Movement. That movement is notoriously difficult to define; its roots go back into the eighteenth century and in Britain elements of romanticism can be found in the work of Reynolds and some of his contemporaries. Romanticism is essentially a state of mind, and for many British painters of the first decades of the nineteenth century their adoption of that state of mind was instinctive rather than deliberate.

Three other portrait painters who belonged to the Reynolds tradition must also be briefly discussed here. One of them, John Hoppner (1758–1810), has already been referred to as Lawrence's chief rival in London after the death of Reynolds. Born in London of a German mother (rumour had it that he was a natural son of the future George III, and nothing is known about his mother's husband), Hoppner was brought up as a chorister in the Chapel Royal. He entered the Royal Academy Schools in 1775, and started exhibiting at the RA five years later. By 1785 he was working for the royal family, and in that year he exhibited portraits of three of the Princesses, in which he displayed his ability to combine naturalism and charm with attractive decorative detail. It seemed as if Hoppner was set to succeed Reynolds as the leading portrait painter in London, and as the King's official artist, but the precocious Lawrence's arrival and George III's apparent dislike of Hoppner's rather flamboyant style changed the situation. Furthermore Hoppner was a Whig, and this was certainly a strong factor in his appointment as Portrait Painter to the Prince of Wales in 1793. The political divisions affected every element of court life, including artistic patronage, and the same artist could not easily serve both King and Prince.

Hoppner's manner was far more in keeping with the taste and lifestyle of the Prince of Wales, than it was with that of the dull and strait-laced family life of the King. In fact, Hoppner's earlier promise did not materialise and his later style was both sober and dull, and often reminiscent of Reynolds at his least effective. Something of this unfortunate decline can be seen if the delightful royal portraits of 1785 are compared with *Miss Harriet Cholmondley* [PL.20], which was exhibited at the Royal Academy in 1804. Though this is still a charming portrait of a small girl, it lacks the vivacity and directness

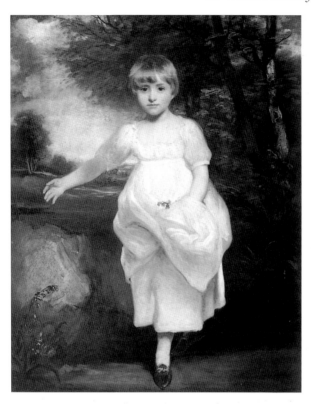

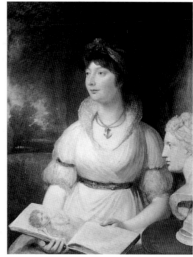

(19) Sir William Beechey, *Princess
Augusta* (RA 1797). Oil on canvas;
92.1×68.6cm. (The Royal Collection)

(20) John Hoppner, *Miss Harriet
Cholmondley* (RA 1804). Oil
on canvas; 128.3×102.2cm.
(Tate Gallery, London)

of the earlier works, of which there are also several in the Tate Gallery, including the
very fetching *Mrs Williams*, which dates from about 1790, and seems to indicate that
the younger Hoppner must have looked at the work of Hogarth.

It was not only Lawrence and Hoppner who dominated the post-Reynolds por-
trait painting scene at Court, for there was also Sir William Beechey (1753–1839), who
became Queen Charlotte's favourite artist, being appointed her Portrait Painter in 1793.
Born in Oxfordshire, Beechey started life working in the law, but entered the Royal
Academy Schools in 1772, and exhibited at the RA from 1776. For a time he set up a
successful portrait practice in Norwich, painting conversation pieces in the manner of
Zoffany, but he was back in London by 1787, simultaneously with Lawrence, and, as
with Hoppner, his hopes of real success were frustrated by the young prodigy's career.
Beechey's portraits were reliable and dull, but these qualities exactly suited the King
and Queen. He enjoyed considerable royal patronage and is strongly represented in the
royal collection. Rather surprisingly he painted a set of portraits of the six Princesses for
their brother the Prince of Wales, and all but one of these were exhibited at the Royal
Academy in 1797. The pleasing portrait of Princess Augusta, holding a sketch-pad
[PL.19], belongs to this group, which shows that Beechey was happier painting informal
half-lengths than full-lengths such as those of the King and Queen, which were painted
at about the same time. When Beechey was elected RA in 1798, the year in which he was
also knighted, he chose a portrait of the Prince of Wales [PL.21] as his Diploma Work. In
this he succeeded in presenting the Prince as an heroic and romantic figure. Except for
its paint quality, this does stand comparison with some of Lawrence's work at this time.

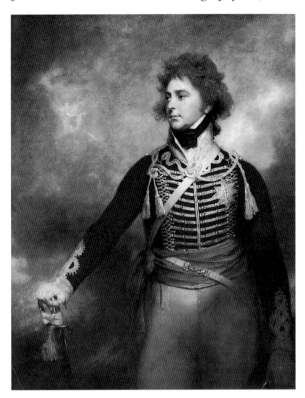

(21) Sir William Beechey, *George IV as Prince of Wales* (RA 1797). Oil on canvas; 141.4×117.6cm. (Royal Academy, London)

Despite his advanced years Beechey continued to paint royal portraits until the 1830s and exhibited at the Royal Academy until the year of his death, when he was eighty-six. However, in the 1830 election for Lawrence's successor as President of the Royal Academy he was beaten into second place by Martin Archer Shee, who 'although he had no particular claims for the honour, his dignified bearing and Irish tongue were great assets and he proved to be an energetic and tenacious President.'[22] Sir Martin Archer Shee (1769–1850) was born in Dublin in the same year as Lawrence, and came to London in 1788. He started exhibiting at the Royal Academy in the following year, was elected ARA in 1798, and a full Member two years later. He rapidly became an active participant in the disputes that racked the Academy in the early 1800s. With very few exceptions his exhibits were all portraits, and his sitters became steadily more eminent, though his portraits rarely rose above the mediocre. The first royal portraits were of the Duke of Clarence in 1800 and 1801, and when the Duke became king as William IV in 1830, Shee was soon commissioned to paint his state portrait in Garter robes.

In 1836 he was summoned to Windsor to paint Queen Adelaide [PL.22]; the result was received with 'high approbation', and was exhibited at the Royal Academy in 1837. In the Queen Shee had a remarkably plain sitter, and his down-to-earth portrayal of her is typical of his work, which seldom showed signs of imagination or originality. A few years later Shee painted the young Queen Victoria for the Royal Academy, but, like many artists during her long reign, in his later years he proved more effective as an administrator and public figure than as a painter, and it was he who successfully master-minded the move of the Royal Academy from Somerset House to its new

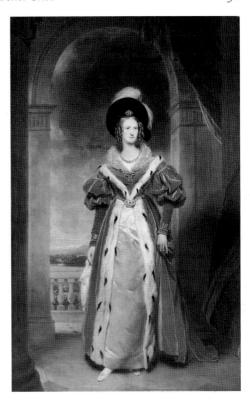

(22) Sir Martin Archer Shee, *Queen Adelaide*
(RA 1837). Oil on canvas; 252×162cm.
(The Royal Collection)

premises in Trafalgar Square, next to the National Gallery, of which he was a Trustee. Benjamin Haydon was probably not far off the mark when he wrote in his *Diary* on 29 January 1830, about Shee's election as PRA: 'A man of such keen perception of what is gratifying to the envious is sure to be popular, and he will be the most popular President that the Artists have ever had; but the precedent established, viz., that high talent is not necessary to the highest rank in the Art, is one of the most fatal blows ever inflicted on the dignity of the Academy since it has been established.'[23]

The RA's exclusive position of power and its monopoly of public exhibitions in London had already long been challenged, partly because of constant squabbles within its own ranks. Another reason was certainly the fact that during the war years the art-loving public could not travel abroad, and thus there was more demand for art activity in London. The 'British School', an almost forgotten London enterprise for 'the advancement of the Fine Arts' was formed in 1802, but failed in 1804 after only two exhibitions.[24] The highly successful Society of Painters in Water-Colours, which will be discussed in detail in Part Two, was founded in 1804, and the British Institution for Promoting the Fine Arts in the following year. This was largely the brainchild of a group of mainly aristocratic connoisseurs and collectors, and its principal aim was to promote history painting and to provide an alternative and less exclusive opportunity for artists to show and sell their work. The opening exhibition at 52 Pall Mall in 1806 was an outstanding success, and the British Institution remained a major force in the London art world for several decades, finally closing in 1867. In its early years it awarded premiums and other prizes to encourage contemporary art, but in 1815 the British

Institution held the first of its series of loan exhibitions of old master paintings, largely from the collections of its Directors. This antagonised some of the artists, even though the object was to provide young artists with material for studying and copying, as an aid to their own painting of 'history'. The British Institution's policy is yet another example of the continued high standing given by those in authority to history painting, success in which still largely eluded British painters.

The next major London exhibiting body was not founded until 1823, when the Society of British Artists, which still exists today, was formed with Royal and aristocratic patronage but largely controlled by the artists. Also during these years a considerable number of painters arranged their own 'one-man' exhibitions, some of which will be discussed below. A further feature of the 1820s and 1830s was the beginning of commercial exhibitions arranged by print publishers and art dealers. However, despite all these rival organisations and attractions the Royal Academy remained essentially the most powerful and influential art institution in London throughout the nineteenth century.

Notes to Part One

1　*Discourses on Art*, ed. Robert R. Wark, 1975, p.17
2　*Discourses*, loc.cit., p.282
3　John Galt, *The Life, Studies and Works of Benjamin West*, 1820, Vol.I, p.48
4　Preface to the Catalogue of the 1789 Shakespeare Gallery Exhibition; reprinted in *The Boydell Shakespeare Prints*, 1979
5　*Analytical Review*, Vol.IV, May 1789, p.110
6　First given in 1804; *Lectures on Painting by the Royal Academicians*, ed. Ralph Wornum, 1848, p.435
7　Quoted in J. Joliffe, *Neglected Genius – The Diaries of Benjamin Haydon*, 1990, pp.11–12
8　Marcia Pointon, *Milton and English Art*, 1970, p.108
9　J. Joliffe, loc.cit., p.100
10　G. S. Layard, *Sir Thomas Lawrence's Letter-Bag*, 1906, p.8
11　W. T. Whitley, *Artists and their Friends in England, 1700–1799*, 1928, Vol.II, pp.130–1
12　Whitley, loc.cit., p.129
13　Quoted by Michael Levey in *Sir Thomas Lawrence*, National Portrait Gallery, London, 1979, p.27
14　Levey, loc.cit., p.9
15　Layard, loc.cit., pp.23–4
16　*Farington Diary*, 3 December 1794
17　For an account of Lawrence's collection, see K. T. Parker, *Catalogue of the Collection of Drawings in the Ashmolean Museum*, Vol.II, 1956, pp.xii–xx
18　*Farington Diary*, 7 April 1807
19　Loc.cit., p.19
20　Layard, loc.cit., p.145
21　Layard, loc.cit., pp.191–2
22　S. C. Hutchison, *The History of the Royal Academy, 1768–1986*, 2nd edn, 1986, p.83
23　J. Joliffe, loc.cit., p.121
24　See John Gage, '*The British School* and the British School' in *Towards a Modern Art World*, ed. Brian Allen, 1995, pp.109–20

Part Two

Artists in Watercolour

Introduction

It has long been recognised that the advances made by watercolour artists in the later years of the eighteenth century were among Britain's most important and original contributions to the history of European art. The brief career of Thomas Girtin, the first artist to be discussed in depth in this Part, was of vital importance for the development of the British watercolour school. At the time of his birth in 1775, two months before that of J. M. W. Turner, Paul Sandby was at the height of his powers, and artists such as Michael Angelo Rooker, Thomas Hearne and Thomas Malton were in mid-career. These men, all born in the 1740s, had raised the art of the topographical tinted watercolour drawing to new heights. Most of their drawings were of architectural or topographical subjects, which were first of all outlined in pencil or pen, then washed with a mono-chrome underpainting (usually grey) to indicate tone, over which local colour was added. It was the change from this disciplined and controlled use of the medium, in which the pigment is mixed with pure water, to the much freer application of the water-colour washes, without any underpainting, on well-dampened white paper, which enabled artists to make full use of the fluid and transparent qualities of the medium. These technical changes coincided with a broadening of subject matter – the depiction of pure landscape for its own sake grew increasingly popular.

The impact of these changes of technique and content was much enhanced by the important theoretical writings of the Revd William Gilpin (1724–1804), pioneering schoolmaster, parish priest and amateur artist, who was largely responsible for dis-seminating the theory of the 'Picturesque'. While headmaster of Cheam School, Gilpin undertook a number of tours in various parts of Britain in search of the Picturesque. After circulating in manuscript for some years, the first of his 'Picturesque Tours', of *The River Wye and Several Parts of Wales*, was published in 1783. This was followed three years later by the most popular of these books, *Observations on Several Parts of England particularly the Mountains and Lakes of Cumberland and Westmoreland, relative Chiefly to Picturesque Beauty*, and a total of eight such 'Picturesque Tours' were published. Gilpin proposed a new pursuit for travellers, 'that of examining the face of a country *by the rules of picturesque beauty*', and he defined 'picturesque beauty' very simply as 'that kind of beauty which *would look well in a picture*', with the quality of 'roughness', as in a ruin or a gnarled tree, emphasised as an essential element. These theories were summed up

in Gilpin's *Three Essays: On Picturesque Beauty; On Picturesque Travel; and On Sketching Landscape*, first published in 1792. In the last of these he wrote: 'The art of sketching is to the picturesque traveller, what the art of writing is to the scholar. Each is equally necessary to fix and communicate its respective ideas.' Gilpin illustrated his books with aquatints after his own suitably 'rough' pen, ink and wash drawings, which record the broad character rather than the topographical details of a scene.

At a time when, because of the Napoleonic wars, most people were unable to go abroad, these simple, but novel, ideas and methods did much to popularise both travel in the British Isles and landscape sketching by amateurs. Wales, Derbyshire, and above all the Lake District provided the chief attractions for travellers in search of the picturesque. By making the study and depiction of British landscape a fashionable pursuit Gilpin also helped professional watercolour artists, many of whom adopted his picturesque theories in their work, to find a wider market for their drawings, as well as an ever-increasing demand for lessons in drawing. Most of the watercolour artists discussed below relied on their activities as drawing masters to supplement their income, and the majority of their pupils were genteel amateurs.

In the closing years of the eighteenth century, there was considerable controversy as to what was truly 'picturesque', in which two verbose Herefordshire squires, Richard Payne Knight [PL.11] and Sir Uvedale Price, were deeply involved. Their prime interest was, however, the impact of landscape painting on the 'improvers' of actual landscape – that is the landscape gardeners and designers – which was another factor in the mounting interest in all aspects of landscape during these decades. Though the landscape artists were not greatly involved in this controversy, all these factors also helped to broaden the market for their work, and certainly contributed to the growing popularity of watercolour drawings.

Another major figure in these developments was John Robert Cozens (1752–97), whose highly individual drawings of scenes in Switzerland and Italy were of great importance for the next generation of artists, including Girtin and Turner. The son of Alexander Cozens, an influential drawing master and author of several important treatises on the art of drawing, J. R. Cozens was trained by his father. From 1776 to 1779 he accompanied Richard Payne Knight on a journey through Switzerland to Rome, and he undertook a similar expedition with William Beckford three years later.

During these travels Cozens drew and sketched assiduously, and in the next decade he produced numerous imposing watercolours based on his continental drawings. He developed a very personal style, and with a palette often consisting largely of blues, greens and greys, his impressive compositions successfully recorded the atmosphere and detail of scenes ranging from the Alps to the Colosseum in Rome. He frequently produced several versions of such compositions, as in the case of *The Lake of Nemi looking towards Genzano* [PL.23], of which at least seven other versions are known today. Based on a study from his first Italian tour, this beautifully balanced view of one of the most popular sites in the Alban Hills near Rome, combines line, tone and colour to evoke its character and feeling. As the number of versions of this composition indicates, such drawings, though unusual, were popular with the connoisseurs and collectors of the day, and they were also to have a great influence on the next generation of watercolour artists.

(23) John Robert Cozens, *The Lake of Nemi looking towards Genzano* (c.1790). Watercolour; 36×52.8 cm. (Whitworth Art Gallery, University of Manchester)

Somewhat neglected in modern times, John 'Warwick' Smith (1749–1831), who was taught drawing by William Gilpin's father, and who also travelled in Italy at much the same time as Cozens, was another influential watercolour artist in the late eighteenth century. His tightly composed and drawn watercolours of Italian buildings and views were his best work, but his active career lasted over fifty years, and throughout that time he largely adhered to the topographical tradition in which he had been trained. To that tradition he added a new strength and originality in the use of colour, which was directly applied and thus became stronger and more natural in his drawings, many of which were on a small scale. 'Warwick' Smith was one of the most successful drawing masters of his day.

The work of Edward Dayes (1763–1804) acted as a link between his slightly older contemporaries and the generation of Girtin, who was apprenticed to him in 1788. A difficult and disappointed man (he took his own life), Dayes was a competent draughtsman in the eighteenth-century topographical tradition, but he also made considerable innovations in the use of watercolours – innovations that were important in the development from the tinted drawing to the more spontaneous and atmospheric application of the pigment, which allowed the colour and texture of the paper to play their part in the final effect.

5 Thomas Girtin (1775–1802)

Thomas Girtin was born in Southwark, the son of a brush-maker, who died when his son was only three years old. His mother's second husband was a pattern draughts-man, and thus Girtin grew up among artist-craftsmen, a group to which Edward Dayes and many of his fellow topographical artists also belonged. However, in the last quarter of the eighteenth century many of them came to rank, like portrait and history painters, among the professional classes. When Girtin was apprenticed to Dayes he was setting out on a craftsman's career; by the time he died only fourteen years later his position in society had risen to vie with the professional and gentlemen classes, as it had done for most successful artists of relatively lowly birth during these years. Girtin did not succeed in gaining election to the Royal Academy and thus failed to achieve the coveted title of Esquire which was a privilege that came with membership of the Royal Academy.

Girtin's relationship with Dayes was an uneasy one, but his early work was closely related to that of his master, and it seems likely that he served out his seven-year apprenticeship. His watercolours of the early 1790s, such as the Yale Center's view of Rochester, owe much to Dayes's manner, which combined balanced and often broad composition with effective and subtle colouring. Girtin exhibited at the Royal Academy for the first time in 1794, showing a view of Ely Cathedral [PL.24], which was based on a sketch by James Moore, an antiquarian publisher and amateur artist for whom both Dayes and Girtin did much work. During these formative years Girtin produced a number of such impressive and relatively large-scale close-up views of cathedrals and other great buildings, several of which were also exhibited at the Royal Academy.

The *Ely Cathedral* already has that quality of tonality, especially in the rendering of the stonework of the building, which was to distinguish Girtin's watercolours. It is remarkable that he could have achieved such an effective result without having seen the actual cathedral, and this aspect of the drawing shows how 'mechanical' the working methods of a topographical artist could be at this time. However, also in 1794, Girtin accompanied James Moore on a tour in the Midlands, during which they visited Lincoln, Lichfield, Warwick and Peterborough. From now on most of the young artist's compositions were based on his own sketches, and in 1795 he exhibited views of Warwick Castle, and of Lichfield and Peterborough Cathedrals at the RA. One of these was the dramatic *West Front of Peterborough Cathedral* [COL.PL.6], which is based on a large pencil study now at Yale and is one of several versions of this striking compo-sition, with its skilful mastery of perspective and its vivid and colourful depiction of masonry. In addition to the influences already referred to, Girtin may well have been familiar with the architectural compositions of Piranesi, whose powerful etchings of buildings and ruins in Rome, of which Edward Dayes owned a set, were very popular with British grand tourists.

A comparison between the drawings of the cathedrals at Ely and Peterborough illustrates the great advances that Thomas Girtin's art was making within the tradition of architectural topographical drawing. Like the best of his older contemporaries, he began to show more of the surroundings of the buildings which he was recording, and he quickly proved himself a master in the depiction of landscape. The exciting factor in

(24) Thomas Girtin, *Ely Cathedral* (RA 1794). Watercolour; 38×47cm. (Ashmolean Museum, Oxford)

the art of Thomas Girtin is to see it developing so rapidly and achieving so much in the few years remaining to him; such progress was, of course, also being made by J.M.W. Turner (who is the subject of Chapter 10), but for him it was only one element in a long career of pioneering development in the art of landscape. If Turner had also died in 1802, it is probable that Girtin's achievements would have gone down in history as the greater, and it is not surprising that Turner is reported to have said at a later stage of his own career, 'if Girtin had lived, I should have starved'.

The two young artists were brought together in the mid-1790s by the patronage of Dr Thomas Monro, physician to Bethlem Hospital, amateur artist and connoisseur. At his fashionable Thames-side house in the Adam brothers' new Adelphi Terrace, they were among numerous artists employed in copying the work of a variety of their predecessors. Outstanding among these were the drawings of J.R.Cozens, who had become insane and spent the last three years of his life in the doctor's care. Known as the 'Monro Academy', or occasionally as his 'Manufactory', they met, as Joseph Faring-ton recorded, at least once a week 'to draw at his house in the evenings. They went at 6 and staid till Ten. Girtin drew in outlines and Turner washed in the effects. They were chiefly employed in copying the outlines or unfinished drawings of Cozens &c &c of which copies they made finished drawings. Dr Monro allowed Turner 3s. 6d. each night. – Girtin did not say what He had.'[1] Thus in their most formative years Girtin and

(25) Thomas Girtin, *On the Wharfe* (1798). Watercolour; 47×61.5 cm.
(Victoria and Albert Museum, London)

(26) Thomas Girtin, *Appledore, North Devon* (*c.*1798). Watercolour with some white bodycolour;
24×47 cm. (Courtauld Institute Galleries, London)

Turner not only worked side by side in a highly stimulating environment – the students apparently sat facing each other at double desks sharing a candle – but also came into close contact with the work of the most advanced artists among their immediate predecessors. In addition there were drawings by foreign artists such as Canaletto, also collected by Dr Monro and by John Henderson, the doctor's neighbour and an amateur artist, and another patron of the young Girtin and Turner. At this time there was often close similarity between the drawings of the two men, and the precise attribution of the 'Monro School' drawings is contentious and unresolved.[2]

After his 1794 Midlands tour with James Moore, Girtin continued to undertake an annual summer sketching tour, making his first visit to the North of England and Scotland in 1796. It was here that he was to find some of his greatest inspiration, and also, in Yorkshire, some of his most important patronage. This came from Edward, Viscount Lascelles, eldest son of the 1st Earl of Harewood, at whose home, Harewood House, Girtin stayed several times, teaching members of the family and making drawings of the house and its surrounding countryside. Among these was the sensitive view *On the Wharfe* [PL.25], which is usually dated 1798 and which belonged to Viscount Lascelles. This very direct and simple composition, in which the hatched treatment of the foliage shows the strong influence of Dr Monro's own technique, is an early example of Girtin's eye for the possibilities of depicting pure landscape, which was to develop so dramatically.

On the Wharfe is a relatively large drawing, and also demonstrates Girtin's masterly rendering of light, in achieving which he made full use of both the texture and the tonality of the paper, often leaving large areas without any pigment, and creating highlights by scratching out the colour to reveal the white of the paper. These successful methods are found again in one of the earliest of his effective panoramic coastal views, *Appledore, North Devon* [PL.26], which was for long identified as a view of Exmouth. This is executed on very rough paper, of the kind that Girtin was to use frequently in his later years. Based on a study made on his 1797 tour of south-west England, this striking watercolour renders the effects of light and atmosphere in the sea and sky with the utmost economy of colour, and large areas of the paper have been left untouched by any pigment. The subtle play of the sunlight reflected on the houses of the town has largely been achieved by scratching out, though some white bodycolour has also been used.

The view of Appledore again probably dates from 1798, and from then on Girtin produced a succession of outstanding drawings, in which his growing confidence and mastery were displayed. It is not surprising that in January 1799 Joseph Farington reported his fellow academician James Northcote as saying that in 'the drawings of Girtin, there is evidently genius and feeling, from which much may be expected'.[3] In 1798 Girtin paid his first visit to North Wales, an area popular with artists since its 'discovery' by Paul Sandby some thirty years earlier. In the following year he exhibited two drawings entitled *Beth Kellert, North Wales,* at the Royal Academy, and it is probable that the British Museum's *Near Beddgelert* [PL.27] was a study for one of these. In it Girtin captures the grandeur and sublimity of the Welsh mountain scenery, and subtly records the damp and misty atmosphere in which it is usually seen, with Snowdon largely hidden by clouds.

The less grand but equally spacious scenery of Yorkshire inspired some of the

(27) Thomas Girtin, *Near Beddgelert, North Wales* (*c*.1798). Watercolour; 29.1×43.3 cm.
 (British Museum, London)

(28) Thomas Girtin, *Kirkstall Abbey, Yorkshire: Evening* (*c*.1800). Watercolour; 31.7×52 cm.
 (Victoria and Albert Museum, London)

outstanding landscape compositions of Girtin's final years. Among these are a number of evocative views of Kirkstall Abbey, the imposing Cistercian ruin near Harewood House and now a part of the city of Leeds. The best known of the several versions of this composition is that in the Victoria and Albert Museum [PL.28], of which a luminous mezzotint engraving by S.W.Reynolds was very popular in the nineteenth century. With the placid waters of the River Aire in the foreground, the mellow evening scene is dominated by the great abbey tower in the centre of the panoramic composition with gently undulating fields and wooded hills beyond it. All this is achieved with total economy of line and with a limited range of rather muted colours. With simplicity and directness and with the minimum of staffage, Girtin displays all that he learnt from J.R.Cozens, and has produced a telling record of the Yorkshire landscape in keeping with that artist's Swiss and Italian compositions. Perhaps even more impressive are such 'pure' landscape compositions as *Stepping Stones on the Wharfe, above Bolton, Yorkshire* [COL.PL.5], in which there are no buildings and only the slightest human and animal content. The two tiny fishermen near the stepping stones help to emphasise the peace and solemnity of the sunset scene, which is based on a very small and rapid watercolour sketch in the British Museum, probably drawn on the spot during Girtin's final visit to Yorkshire during the spring of 1801.

In his watercolours Girtin had elevated topography to landscape art, but landscape was still allocated a lowly place in the hierarchy of painting. Edward Dayes devoted much energy in his later years to producing elaborate watercolour compositions of historical or biblical subjects, such as *The Fall of the Rebel Angels*, which was exhibited at the Royal Acdemy in 1798 and was acquired by the Tate Gallery in 1988. The urge to raise the standing of watercolour is also reflected in the formation in 1799 by a group of young artists, among them Thomas Girtin, of a sketching club, called 'The Brothers', the aim of which was to establish a 'school of Historic landscape'. Meeting in the evenings at the house of every member in turn, they each produced a drawing illustrating the 'poetick' subject set by the host, who kept the evening's drawings and provided simple food and drink at the close of the session. That club was short-lived, but it was the forerunner of a new Sketching Society, which, in one form or another, existed until the 1850s.[4] The surviving drawings of the original club show the strong influence of Girtin's fluid style, and his own contributions demonstrate his ready response to the inspiration of a literary theme.

Girtin never showed anything other than landscapes at the Royal Academy, and with one exception all of these were in watercolour. The exception was a lost oil of Bolton Bridge in Yorkshire, his only exhibit in 1801. In that year Girtin was an unsuccessful candidate for Associate Membership of the Royal Academy. He had married his Islington landlord's daughter in the previous year, and soon moved to the much more fashionable St George's Row, Bayswater, where the elderly Paul Sandby was his neighbour. Girtin was doing well and was rising in the world, but his growing success was to be short-lived for his health was rapidly failing. During these final years Girtin continued to produce magnificent watercolours of subjects in Wales, Yorkshire, Scotland and elsewhere, among which *The Village of Jedburgh, Roxburgh* [PL.29] is one of the most powerful and evocative. Signed and dated 1800, and probably the *Jedburgh* exhibited at the RA that year, this panoramic composition is based on a pencil drawing

(29) Thomas Girtin, *The Village of Jedburgh, Roxburgh* (1800). Watercolour; 30.3×52 cm.
(National Gallery of Scotland, Edinburgh)

dated 1795, which is in the British Museum. As was forcefully pointed out by Thomas
Girtin (a great-grandson of the artist) and David Loshak in 1954[5] this dramatic com-
position is of the *village*, and totally omits the *abbey*, for which Jedburgh was best
known, and of which Girtin had also made a number of drawings. In devoting such an
important sheet to the depiction of an ordinary place in its attractive setting, the artist
was ignoring the normal topographical tradition, and, as in his pure landscapes, was
breaking new ground and strengthening the art of natural and romantic landscape.

A major feature of *The Village of Jedburgh* is the panoramic presentation of the
scene, viewed from above, and it should be remembered that at about the time when he
executed this drawing Girtin was concerned with his *Eidometropolis*, or large-scale
panorama of London, for which only the studies survive, most of them in the British
Museum. Girtin's viewpoint was from the top of a building at the south end of Black-
friars' Bridge, close to where he was born. There has been much disagreement about the
date of the execution of this ambitious enterprise, which was not actually exhibited at
Spring Gardens in London until shortly before the artist's death in 1802. Recently a later
date than the 1797–8 proposed by Girtin and Loshak has been preferred. That later date
also coincides better with the execution of Girtin's most famous panoramic London
subject, the beautiful *The White House, Chelsea* (Tate Gallery, London), which is dated
1800 and which was especially admired by Turner.

The panoramic view has a long tradition in both Eastern and Western landscape
art, but it was not until the mid-1780s that the Edinburgh artist Robert Barker (1739–
1806) invented the all-round (360 degrees) depiction of a place which gave the spectator
standing in its centre the feeling that he was on the spot. Barker patented his idea (the
name 'panorama' was first used in 1791) in 1787, and his first exhibited example was a

view of Edinburgh, shown there and in Glasgow in 1788 and in London in 1789. In the next two or three decades panoramas were all the rage, especially in London, where the first purpose-built rotunda – 'The Panorama' – was opened in 1793, and panoramas were exhibited in the Great Room, Spring Gardens, from 1796 onwards.[6]

Because of his poor health late in 1801 Girtin was 'advised to go into the country for a little while', and it is surprising that in November of that year he travelled to Paris, staying there until the following May. Such a journey is all the more remarkable as the Peace of Amiens, which brought a fourteen-month cessation of the war with France, was not signed until 25 March 1802. Soon after this numerous British artists rushed to Paris and travelled further afield on the Continent, and it is not clear how Girtin was able to travel there several months before the treaty. Girtin's plan to exhibit the *Eidometropolis* in Paris did not succeed, but during his stay he made the pencil studies which he used as the basis of a series of prints of the city, in soft ground etching and aquatint, which he himself etched between June and October 1802. They were published posthumously by his brother John in March 1803, with the title *A Selection of Twenty Picturesque Views in Paris and its Environs*. These were Girtin's only prints, and his work on them provides further proof that he was determined that his art should be in the van of fashion. The Paris series provided, as it were, a Panorama for the home (while in Paris he investigated the possibility of executing an actual panorama of the city), and used the modern printing technique of aquatint, which had been pioneered by Paul Sandby in the 1770s. Though the twenty views of Paris do not join together to provide an all-round depiction of the city, the individual compositions are extensive and informative.

Despite the panoramic activities of his final years, Girtin still had time to produce some of his greatest individual watercolours during this time. In these his technique is still rougher and freer than before, the surfaces broken up and fragmented; his colours are more intense and his depiction of atmosphere and weather even more effective. All these advances can be seen in the large and imposing *Bridgnorth* [PL.30], which is dated 1802. This must be one of Girtin's last finished watercolours and it is also one of his most monumental, elevating the status of the watercolour landscape to the level of an oil painting, something that Turner was also achieving during these opening years of the nineteenth century. This is Girtin's most ambitious surviving watercolour, 'imbued with a mysterious, brooding quality of dramatic power',[7] and is an indication of what might have been had Girtin lived longer. It shows again how anxious the artist was to advance his standing and to be a leader among his contemporaries at this time.

Perhaps more in keeping with the overall achievement of his landscape art is one of Girtin's last pure landscape compositions, the evocative *Landscape with Stormy Sky* [PL.31] with its bold rendering of a passing rainstorm. The site of this broad stretch of country has not been identified, but it has been suggested that the drawing was made in the vicinity of north London, not far from Islington, where Girtin spent the last months of his life at the house of his parents-in-law. Despite his early death Girtin's influence on the future development of British watercolour art was paramount, and his reputation was enormous. The Redgrave brothers described him as 'the first to give a full idea of the *power* of water-colour painting … to the poetry of the art, as practised by Cozens, Girtin added power – power of effect, power of colour and tone, and power of

(30) Thomas Girtin, *Bridgnorth* (1802). Watercolour; 24.2×55.3cm.
(British Museum, London)

(31) Thomas Girtin, *Landscape with Stormy Sky* (c.1802). Watercolour; 19.7×35.6cm.
(National Museum of Wales, Cardiff)

execution.'[8] There have been many contradictions in descriptions of Girtin the man, but it is generally agreed that he was a carefree extrovert, very generous to his fellow artists, and modest and self-critical about his own art. He was certainly energetic and hard-working, and though ambitious he must have been something of a loner, for many of his greatest drawings evoke both the emptiness and the grandeur of some especially beautiful areas of British landscape scenery.

6 John Sell Cotman (1782–1842)

John Sell Cotman was born in Norwich, seven years after Girtin and Turner, and the work of these two precocious artists was to have a strong influence on him. The son of a barber, who became a haberdasher, Cotman came from a very similar, though provincial, background to his two predecessors, but, unlike them, he appears to have been entirely self-taught. He moved to London, against his family's advice, in 1798, and worked for a short time for Ackermann, the print publisher and dealer. In 1799 he joined Dr Monro's circle and presumably was also employed in copying drawings at the evening meetings of the 'Monro Academy' at his house. In 1800 Cotman exhibited for the first time at the Royal Academy, was awarded the large silver palette of the Society of Arts, and undertook his first tour in Wales, exhibiting Welsh subjects at the RA in the next two years; in 1802 he became a member of the Sketching Society ('The Brothers'). Cotman's watercolours during these early years were mostly nervous in line and sombre in colour, but already showed an advanced sense of composition, and a real feeling for the medium in which Girtin was certainly the strongest influence. This can be seen in *St Mary Redcliffe, Bristol; Dawn* [PL.32], which probably dates from 1802. In this effective composition Cotman has captured the tentative light of dawn and the misty atmosphere of a great industrial city dominated by the fine Gothic tower of its principal church.

Thus at the age of twenty all seemed set for a successful career as a watercolour artist, and the next three or four years were to be the most fruitful and contented of Cotman's troubled life. In 1803 he made his first visit to Yorkshire, where, through the good offices of the antiquary Sir Henry Englefield, he had an introduction to the Cholmeley family of Brandsby Hall, with whom he stayed, teaching drawing to members of the family and soon to be regarded as a family friend, a rare privilege for the drawing master. Brandsby became something of a second home for Cotman, as another Yorkshire house, Farnley Hall, was to become for Turner a few years later. He used Brandsby as a base for extensive tours in the surrounding area and was taken by his hosts to visit several of their neighbours, such as the Morritts of Rokeby Hall, with whom he stayed for several weeks in 1805. Cotman's three visits to Yorkshire, in 1803, 1804 and 1805, were a vital factor in his artistic development and life. Here he experienced the inspiration and encouragement that led to his most significant drawings, which have allowed posterity to place him among the greatest masters of British watercolour art. For Cotman his 'Yorkshire Period' was perhaps even more important than the 'Shoreham Period' was to be for Samuel Palmer some twenty years later.

In Yorkshire Cotman was stimulated by the normal antiquarian scenes such as

(32) John Sell Cotman, *St Mary Redcliffe, Bristol; Dawn* (c.1802). Watercolour; 37.1×53.4 cm. (British Museum, London)

(33) John Sell Cotman, *The Shady Pool, where the Greta joins the Tees* (1808). Pencil and watercolour; 45.4×35.2 cm. (National Gallery of Scotland, Edinburgh)

Rievaulx and Fountains Abbeys, of both of which he exhibited watercolours at the Royal Academy in 1804, as well as by totally ordinary and featureless landscape themes, such as the corner of a field seen in the *Near Brandsby, Yorkshire* [COL.PL.7], which is dated *July 16th 1805*. Here he records an everyday event during his last visit to the Cholmeleys, with the dog patiently guarding a picnic while Cotman and his companions are sketching; though unfinished, 'it remains', as Cotman's biographer Sydney Kitson has so aptly described it, 'a fascinating example of the translation of an ordinary scene into a patterned harmony at the hands of an inspired artist'.[9] Cotman chose many such modest landscape subjects in the grounds and neighbourhood of other Yorkshire houses where he stayed, such as the British Museum's *The Drop Gate, Duncombe Park*, which again shows his ability to create a compelling composition of tones and forms from the most undistinguished material.

It was during his third and last extended visit to Yorkshire that Cotman stayed for several weeks at Rokeby Hall, and then at the inn in the nearby village of Greta Bridge, on the Yorkshire/Durham border. The Palladian mansion, where the London National Gallery's *Rokeby Venus* by Velázquez was soon to hang, is set in fine parkland on the banks of the River Greta, close to its junction with the Tees. Cotman has immortalised this mellow river scenery with a series of watercolours in which he combines with great mastery a close and deeply felt understanding of nature with a harmonious and personal quality of abstraction. *Hell Cauldron*, traditionally called *The Shady Pool, where the Greta joins the Tees* [PL.33] is an outstanding example from this series, in which Cotman made use of the reflections in the calm waters of the river to enhance a powerfully designed composition, executed in very simple colours applied with a broad and wet brush.

There has been much discussion as to whether such watercolours were completed, including the colours, on the spot or in the studio. Cotman wrote to his Norfolk patron Dawson Turner from Yorkshire in 1805 that his 'chief study has been colouring from Nature' and making 'close copies of that ficle Dame'.[10] This indicates that he was executing at least coloured studies on the spot, though it has been argued that these include drawings such as *The Shady Pool*, while other scholars insist that these must have been executed, or at least completed, in the studio. There can probably never be a final answer to this dilemma, but it should be remembered that at this very time, around 1805, other artists, such as J.M.W.Turner, William Turner of Oxford, John Linnell and William Delamotte, were beginning to paint outdoors in oils, a fashion that culminated in Constable's oil sketches from nature in the last years of the decade. Another factor that strengthens the 'on-the-spot case' for some of the Greta watercolours is that Cotman himself on his return to Norwich in 1806 painted a number of outdoor oil sketches.

However, the justly famous *Greta Bridge* [PL.34] is based on a careful pencil drawing made in 1805, which is also in the British Museum, and it was certainly produced in the studio, perhaps as late as 1807. The elegant one-arched bridge, which spans the Greta at the south gates of Rokeby Hall, was designed by John Carr of York and built in 1773. Cotman contrasts the smooth forms of the man-made bridge and house with the rough and random shapes of the rocks in the river and the trees in the background, to produce a subtle and beautifully balanced composition, which has long been considered one of his outstanding achievements.

(34) John Sell Cotman, *Greta Bridge* (1807). Pencil and watercolour; 22.7×32.9cm.
(British Museum, London)

From Greta Bridge Cotman moved on to Durham, only a few miles away, where he
spent about a week. He had been reluctant to follow Mrs Cholmeley's advice to visit the
cathedral city, writing to her son at the end of August, 'what have I to do with Durham?
Am I to place it on my studies of trees like a Rookery?' However, once arrived he was
suitably impressed by the great cathedral and its majestic setting, and made at least five
views of it, one of which, perhaps the *Durham Cathedral* illustrated here [PL.35] was
among the six drawings that he showed at the Royal Academy in 1806, the last year in
which he exhibited there. Here again the artist has achieved a powerful composition
based on somewhat stylised and abbreviated forms, and largely omitting complex
detail.

Such an approach to the depiction of topography can also be found in the work of
the Devonshire artist Francis Towne (1739/40–1816), which belongs essentially to the
eighteenth-century watercolour tradition. After years of lack of recognition, Towne took
the then unusual step in 1805 of holding a one-man exhibition in London, at the gallery
in Lower Brook Street in which the first exhibition of the Old Water-Colour Society
was to be held later that year. He showed nearly two hundred drawings of 'the most
picturesque scenes in the neighbourhood of Rome, Naples and other parts of Italy,
Switzerland, etc., together with a select number of views of the Lakes, in Cumberland,
Westmoreland and North Wales. The whole drawn on the spot....' Towne had visited
Italy and Switzerland in 1780–1, and, as in his British drawings, he worked in a dis-
tinctive and sensitive style emphasising the essential structure and form of the scene

(35) John Sell Cotman, *Durham Cathedral* (?RA 1806). Pencil and watercolour; 43.6×33 cm.
(British Museum, London)

he was depicting. His great Alpine scenes of 1781, with their fluent sense of space and light, are much ahead of their time and rank among the masterpieces of British landscape art. However, Towne met with scant success in his own lifetime – the 1805 exhibition was barely noticed – was quickly totally forgotten and was virtually redis-covered by Paul Oppé in the early years of the twentieth century.[11] Though there is no evidence for this, it seems likely that Cotman visited the Towne exhibition, and there are certainly considerable similarities between the manner and technique of the two artists. Unfortunately Cotman's career also resembles that of Towne in its lack of recognition and success. Apparently his 1806 RA exhibits did not make any impact, and at the same time Cotman failed in his bid to be elected a member of the new Society of Painters in Water-Colours (Old Water-Colour Society), which had been founded in 1804.

It was largely the Royal Academy's lack of proper recognition for watercolour artists and their work (a painter *had* to exhibit in oils to qualify for election) that led to the creation of the OWCS, which was the brainchild of Turner's friend, Frederick William Wells. The new society was an immediate success, and the opening exhibition, at which the sixteen founder members showed 275 drawings, very largely of British landscape subjects, made a profit of nearly £272 because of the high number of visitors (nearly 12,000 in seven weeks) who paid for admission. For a few years the annual watercolour exhibitions challenged the popularity of those of the RA, and a rival group, the Associated Artists in Water-Colours, held its first exhibition in 1808. No actual reason is known to account for Cotman's failure to gain election to the OWCS in 1806, and it can only be assumed that his very individual work did not meet with the approval of the founder members, as it had failed to do with the London connoisseurs and collectors. The high hopes Cotman had placed that summer on the results of an invitation to Trentham Park, the Staffordshire seat of the Marquis of Trafford, one of the leading patrons of the day, were also unfulfilled.

That autumn Cotman went home to Norwich for his annual visit to his parents, and began to paint seriously in oils. Within a few weeks he had decided to abandon the struggle for recognition and success in London, and had 'taken a house in Wymer Street, for the purpose of opening a School for Drawing and Design'. This proved to be an ill-fated decision, and 'in making it Cotman condemned himself unwittingly to a sentence of life-long drudgery as a drawing master'.[12] Drawing lessons had be-come increasingly fashionable among the aristocracy and gentry, and especially with their ladies. As a result more and more watercolour artists came to rely on teaching for their regular income, and they were also able to sell their own work to their pupils and their families.

Norwich had become something of an art centre in the previous decade, as witness the formation of the Norwich Society of Artists in 1803. However, the prosperity of the city was on the decline, and what patronage there remained was largely reserved for John Crome, who had never left Norwich. However, Cotman struggled on, continuing to gain experience in oil painting, and even trying to establish himself as a portrait painter. In 1807 he exhibited for the first time with the Norwich Society of Artists, and in the following year he showed as many as sixty-seven works, many of them portraits. He married early in 1809, and also launched a circulating library of drawings to be copied. Another venture was the publication of volumes of prints, and the first of these,

(36) John Sell Cotman, *Interior of the Nave,*
Norwich Cathedral (1807). Pencil and
watercolour; 33.1 × 22.1 cm.
(Cecil Higgins Art Gallery, Bedford)

the *Miscellaneous Etchings*, appeared in instalments in 1810 and 1811, the year in which
he also became President of the Norwich Society of Artists.

All these varied, and often frenzied activities, which began to be interrupted by
bouts of illness, still left Cotman time to produce a number of masterly watercolours.
These were mostly much firmer and more forceful, especially in colour, than his York-
shire drawings, perhaps because of the impact of his concurrent work in oils, which at
this period he also applied in a smooth and even manner, as in the Tate Gallery's small
Seashore with Boats. One of the most memorable compositions of this 'first Norwich
period' is *The Ploughed Field* [COL.PL.9], which is thought to date from 1808. This evoca-
tive and balanced rendering of a basically featureless fieldscape, contrasts with the
artist's similarly effective views of the crowded Market Place at Norwich. The earlier
of these, in the Abbot Hall Art Gallery, Kendal, is dated *1807*, while the later, in the Tate
Gallery, was probably included in the 1809 Norwich exhibition.

The variety of Cotman's compositional skills at this time is further illustrated
by his execution of a number of sea and shorescapes, some drawings of historical
and pastoral themes, and, above all, by the series of powerful interiors of Norwich
Cathedral dating from 1807–8. Among these is the stark but wholly convincing *Interior*
of the Nave, Norwich Cathedral [PL.36]. This shows two pillars on the northern side
immediately west of the organ screen, and demonstrates the artist's ability to create a
complete and poetic composition out of a relatively dull corner of the great building by
making the most of the play of light on stone. One of Cotman's largest and most vivid
watercolours of this busy period is *The View of Jungfrau-Horn, a Glacier in the Canton*

of Bern, Switzerland (Norwich Castle Museum), which was exhibited at the Norwich Society in 1810. This was an entirely new departure for Cotman (who never himself visited Switzerland) and the attractive drawing is a close copy of a coloured aquatint by the Swiss artist, J. L. Aberli. It is yet another example of the artist's determination to try all possible means to gain patronage and recognition during these years.

By 1812 Cotman had come to the end of his endeavours to make a success of his career in Norwich, and he took the momentous decision to move to Yarmouth, relying very largely on the support of Dawson Turner, the banker and antiquary who had been his patron since 1804. With the help of a loan from his old friend Francis Cholmeley, Cotman bought a new house at Southtown, which he described as 'really heavenly' in an enthusiastic letter written shortly after his move, to which, however, he added after the address the somewhat rueful comment, 'This must be my address till I am more notorious.'[13] For the next eleven years Cotman, in between further periods of illness, was largely occupied in teaching members of Dawson Turner's family, and in producing antiquarian publications, illustrated with his own etchings. The plates of the *Miscellaneous Etchings* were somewhat tentative, but those in the *Architectural Antiquities of Norfolk*, which he published in ten parts between 1812 and 1818, were much more ambitious and confident. In this work Cotman too was strongly influenced by Piranesi, but he was also well informed about current developments in British topographical publications, especially those engraved and published by the Cooke brothers, with whom he was on friendly terms.

As the publication of the *Antiquities of Norfolk* was drawing to a close, Cotman began work on an even more ambitious undertaking, the *Architectural Antiquities of Normandy*, of which the individual parts appeared between 1819 and 1822. In that year the ninety-seven plates were published in two luxurious royal folio volumes, with a text by Dawson Turner. It has long been thought that it was Dawson Turner who initiated and controlled this ambitious publication, but more recent research has revealed that Cotman was largely responsible for all aspects of the work, including the choice of the subjects to be illustrated.[14]

To collect the material for his plates Cotman undertook three extensive tours in Normandy in the summers of 1817 (five and a half weeks), 1818 (over eleven weeks) and 1820 (eleven weeks). Travelling mostly on his own, he made pencil studies on the spot, sometimes using a camera lucida, and apparently did not make any wash or watercolour drawings during his actual travels. The whole work was very firmly devoted to the architecture of Normandy, for there was at the time a lively controversy among antiquarians as to whether the development of Gothic architecture owed more to France or to England. Dawson Turner was certainly closely involved in such discussions, and it may well have been at his suggestion that Cotman undertook his work on Normandy. However, the artist's plates were definitely not designed to illustrate a specific text by the banker, who had published his rather discursive *Account of a Tour in Normandy; undertaken chiefly for the purpose of investigating the Architectural Antiquities of the Duchy* in two large octavo volumes in 1820. These were 'principally addressed to those readers who find pleasure in the investigation of architectural antiquity', and were illustrated with fifty small plates many based on drawings by Cotman, and all etched by ladies of the Dawson Turner family.

(37) John Sell Cotman, *Street Scene at Alençon* (1828). Pencil and watercolour; 43.2×58.4cm.
(Birmingham Museums and Art Gallery)

Cotman's work on these architectural volumes, as well as on plates for other topographical publications, left the artist with little time for finished watercolours and the like. However, in 1823 Cotman moved back to Norwich, and opened a new drawing school. The next decade was to be one of increasing despondency, marked by frequent bouts of depression as his efforts to make a living and a reputation proved ever less successful. He resumed his work as a watercolour artist, and his manner was now more conventional and much stronger both in line and colour than it had been. These changes proved advantageous in attracting patrons and purchasers. He began to exhibit profusely again at the Norwich Society of Artists, and in 1825 he was at last elected an Associate of the Old Water-Colour Society, where he now also exhibited fairly regularly, though he never became a full member. Many of his exhibits were based on his Normandy sketches, such as the *Street Scene at Alençon* [PL.37], which is dated *1828* and was exhibited at Norwich that year. This is an exceptionally well-preserved example of Cotman's distinctive style of the 1820s, with bold and flat washes of watercolour applied over vigorous pencil drawing.

From the firm technique seen in the lively street scene in Alençon, Cotman changed a few years later to a much looser and freer drawing style using a variety of media, and also resumed painting in oils. His oil painting technique was again close to that of his watercolours, which were now tacky and heavily impasted, and his paintings completely lacked the influence of the detailed and precise Dutch style which domi-

nated the work of other Norwich School artists at this time. In 1834 Cotman undertook the last move of his troubled life, a move that gave him renewed hope. He was appointed drawing master at King's College School in London, where he found a house in Bloomsbury. Here he proved a popular figure, and when he himself was unwell he was often assisted by his eldest son, Miles Edmund, who, like his younger brother John Joseph, was an able watercolour artist working in a style reminiscent of his father's late manner. That manner is perhaps more attractive in the oil paintings of J.S. Cotman's final years than it is in the rather laboured watercolours of this time. Cotman was only sixty when he died of 'Natural Decay', having apparently lost the will to live. His life had been a constant struggle, and his tragedy was that he never received the recognition or support that he so craved. However, posterity has treated him rather better, and his outstanding drawings of the first decade of the nineteenth century have earned him a permanent place as one of the great masters of British watercolour.

7 John Varley, David Cox, Peter de Wint and their Followers

By contrast, John Varley (1778–1842), who was in his own days one of the most influential of the watercolour artists, has been relatively poorly treated by posterity. For instance, there has been no major exhibition of his work for many years. Born in Hackney in easy circumstances, he was not allowed by his father to follow his early bent for drawing. The father died when Varley was only thirteen, leaving his family – there were two brothers and two sisters – in straitened circumstances. Varley's mother, however, encouraged him to draw, and after a brief period working with a portrait painter, he joined a drawing school run by Joseph Charles Barrow, who took Varley on his initial sketching tour, to Peterborough. In 1798 or 1799 Varley made his first tour of Wales, which 'laid the foundations of his art in providing him with inspiration and subject matter which he was to draw upon throughout his career'.[15] At about this time Varley also became a member of the 'Monro Academy', and experienced the same stimuli which had already inspired Girtin and Turner, his elders by three years. Varley also visited Dr Monro at his country home near Leatherhead in Surrey, and sketched with him in its vicinity.

By the beginning of the century Varley was established among the rising younger watercolour artists in the capital, and was already taking pupils. He was to be one of the most successful and popular London drawing masters of the day, including in later years such future leading professional artists as Copley Fielding, Turner of Oxford, and John Linnell among his students. In 1802, the year of his second Welsh tour, he became a member of the Sketching Society. On 2 November of that year Joseph Farington, the barometer of the London art scene, dined at Dr Monro's and noted in his *Diary*: 'Much was said about the singularities of Varley an ingenious Young Man who has been making drawings in Wales'. The early Welsh compositions, such as the poetic *Harlech Castle and Twgwyn Ferry* [PL.38], show the strong influence of Girtin, and rival the atmospheric and evocative qualities of his later work. The *Harlech Castle* is dated *1804* and was exhibited at the first exhibition of the Old Water-Colour Society, of which Varley was a Founder Member, in the following year. Varley showed forty-two drawings in 1805,

(38) John Varley, *Harlech Castle and Twgwyn Ferry* (1804). Watercolour and bodycolour over pencil; 39.7×51.2cm. (Yale Center for British Art, Paul Mellon Collection)

and a total of over 700 during his lifelong membership. *Harlech Castle* was bought at the exhibition by Lord Ossulston, son of the 4th Earl of Tankerville and typical of the aristocracy and landed gentry who bought Varley's drawings, which were modestly priced, during the earlier years of the OWCS.

John Varley's landscape style remained very similar for the next ten years or so, but during these years he was also producing architectural drawings and townscapes, such as the sunny view of Cheyne Walk, Chelsea [PL.39], which is dated *1811*, and was probably shown at the OWCS in 1812. By that time the great popularity of watercolours was on the wane, and in that year Varley sold only fifteen of his forty-three exhibits. As has been pointed out by Michael Kauffmann, the public was probably getting bored, for as the critic of Ackermann's *Repository* had written of the Exhibition in 1810: 'The first thing that strikes an observer … is the overwhelming proportion of landscapes: a proportion almost as unreasonable as that of the portraits at Somerset House [the Royal Academy]'.[16] In addition there came economic factors that affected the market, and in reaction to this decline in the market Varley's output gradually diminished and his style changed. The fluent and restrained manner of his early work gave way to more laboured classical compositions using smaller brushstrokes of colour, to which he often added considerable quantities of gum arabic. This technique became even more stylised

(39) John Varley, *Cheyne Walk, Chelsea* (1811). Watercolour; 36×50cm.
(Victoria and Albert Museum, London)

(40) John Varley, *Harlech Castle with Snowdon in the Distance* (c.1835). Watercolour;
26.5×37cm. (Victoria and Albert Museum, London)

in his later years, during which, however he continued to produce numerous Welsh views, such as *Harlech Castle with Snowdon in the Distance* [PL.40], which dates from the mid-1830s.

During most of the second half of his working life things were not good for Varley, and as a result he was constantly in debt, being declared bankrupt and sent to gaol in 1820. His interest in astrology brought him comfort in his misfortunes, which he felt were foretold by the stars. However, he remained active as a teacher of drawing, and in 1815 he started to publish a number of drawing manuals, of which the *Treatise on the Principles of Landscape Design; with General Observations and Instructions to Young Artists* (1816–18) was the most significant. Illustrated with sixteen sepia aquatints after his drawings, mostly engraved by F.C.Lewis, this, as its title indicates, gave instruction in landscape design and composition, and not technique. Its plates were very influential in popularising the somewhat formal classical (Claudian) mode which Turner was also reviving in some of his contemporary *Liber Studiorum* plates. While much of his own work was now in the old-fashioned vein of his treatise, Varley was, at the same time, beginning to produce natural and informal views of unspectacular London scenes, such as the Museum of London's *Millbank Penitentiary*, some of which he appears to have exhibited.

In the late 1830s Varley's style and technique again underwent changes; he used coarser paper and brighter colours, and once more his OWCS exhibits were a great success. In 1841, when he showed thirty watercolours of which he sold twenty-four, the most expensive was bought by Prince Albert, for thirty-five guineas. John Varley died in the following year, and when ten watercolours were shown as a memorial at the OWCS exhibition of 1843, eight were sold, and Queen Victoria, Prince Albert and the Bishop of Winchester were among the buyers.

This revival in John Varley's reputation was relatively short-lived, and in modern times it has been his scientifically minded younger brother Cornelius (1781–1873), who has attracted more attention from scholars and collectors. Cornelius is best known as a maker of optical instruments and the inventor, in about 1809, of an improved version of a long-established mechanical aid to drawing, the 'camera lucida', which he patented in 1811 as *Varley's Patent Graphic Telescope*. Cornelius, who only started to draw in 1800, worked mostly from nature, using a light and fluid range of watercolours. He joined his brother on sketching tours, belonged to the Monro circle and was a Founder Member of the Old Water-Colour Society, where he exhibited for some years as well as showing sporadically at the Royal Academy and elsewhere. A considerable collection of his drawings was rediscovered in the early 1970s, and these fuelled the fashion for his fresh and sensitive landscape drawings, such as *Part of Cader Idris and Tal-y-Llyn* [PL.41], which, like most of his similar studies, is fully inscribed with the location and date, in this case *1803*.

When David Cox (1783–1859), who was born near Birmingham, came to London in 1804, he had already received some training and had worked as a scene painter with Astley's Theatre. In the following year he made his first trip to Wales and showed for the first time at the Royal Academy. At around this time he took lessons with John Varley, who was only five years his senior. Thus Cox quickly found his place in the London art world as a watercolour artist in the Girtin tradition, both in topographical

(41) Cornelius Varley, *Part of Cader Idris and Tal-y-Llyn* (1803). Watercolour; 25.4×36.8cm.
(Victoria and Albert Museum, London)

(42) David Cox, *In Windsor Park* (1807). Watercolour; 35.5×50.5cm.
(Victoria and Albert Museum, London)

and landscape subjects, with an exceptional gift for classically balanced composition. This can be seen in the romantic *In Windsor Park* [PL.42], which is dated *1807*; the composition is freely adapted from a study with Kenilworth Castle in the distance, itself probably based on a painting by Gaspard Poussin. Cox had joined the Associated Artists (later Painters) in Watercolours, formed in 1807 as a rival to the successful Old Water-Colour Society and to provide an open exhibition for those not elected to the senior group. He became President in 1810, but the new society collapsed after its fifth exhibition in 1812. In that year Cox was elected an Associate of the OWCS, becoming a full Member in 1813 and from then on exhibited annually, with two exceptions, until his death.

David Cox had also become active as a drawing master, and in 1811 he began to contribute to drawing manuals, for which there was by then an enormous demand. Cox himself was involved in several such publications, of which the most important was *A Treatise on Landscape Painting and Effect in Water Colours*, which was first issued in twelve parts in 1813 and 1814; a reissue appeared in 1840–1. Illustrated with twenty-four soft-ground etchings and thirty-two aquatints (sixteen of them coloured) this was a handsome and successful publication, which did much to shape the development of watercolour art during the first half of the nineteenth century. The book was recommended by its publishers 'not only to the fashionable Amateur, but to the young Artist whose disposition and ambition urge him on in the pursuit of professional eminence'. Cox was also involved in another exceptionally successful manual, *A Series of Progressive Lessons Intended to Elucidate the Art of Painting in Water Colours*, of which no less than nine editions appeared between 1811 and 1845. Generally known as 'Cox's Progressive Lessons', it was not, however, till the fifth edition in 1823 that his name was included in the book, and it has been suggested that he may not have been involved at all in some of the earlier and much less impressive editions. There is also uncertainty as to how far Cox himself was responsible for the texts of these publications.[17]

In 1814 Cox somewhat surprisingly moved to Hereford, where he had accepted the situation of drawing master at Miss Croucher's girls' school, and also undertook teaching at the Grammar School and elsewhere. He remained in Hereford until 1827, when he returned for some years to London, which he left again in 1841 and settled at Harborne, near Birmingham, where he lived for the remainder of his long life. While he continued to teach throughout most of his career, he also undertook numerous sketching tours and produced great numbers of watercolours. In 1826 he visited Belgium and Holland, and twice travelled in France, in 1829 and 1832. Both in his rapid on-the-spot drawings, most frequently in black chalk or very soft pencil, and in his finished watercolours Cox developed an individual manner characterised by a somewhat nervous and broken line and by the free and irregular application of colour, with small and large brushstrokes and much scratching out to achieve powerful effects of atmosphere and colour, often enhanced by being on rough Scottish wrapping paper, the use of which he discovered in 1836. This manner is well illustrated in two contrasting compositions of Welsh subjects, both dating from the 1830s: the dramatic view of *Rhaiadr Cwm, North Wales* [PL.43] and the stormy and really wet view of *Laugharne Castle, Carmarthenshire* [PL.44]. Both these compositions show Cox at his most powerful in capturing the essential character of his subject in very specific weather conditions. He was truly a master

(43) David Cox, *Rhaiadr Cwm, North Wales* (*c.*1835). Watercolour over pencil; 20.4×28.5 cm.
(British Museum, London)

(44) David Cox, *Laugharne Castle, Carmarthenshire* (*c.*1835). Watercolour and bodycolour; 20.9×30.5 cm.
(Birmingham Museums and Art Gallery)

(45) David Cox, *Rhyl Sands* (1854). Oil on canvas; 45.7×59.7 cm. (Manchester City Art Galleries)

in the depiction of stormy and rainy skies, as can be seen again in the series of free and atmospheric beach scenes inspired by the extensive Ulverston and Lancaster Sands, on the north-west coast, which he first visited in 1834.

In his rendering of wet weather and storm Cox must certainly have had in mind numerous earlier watercolours of a comparable nature by Turner, with whom he is said to have been on friendly terms. In some of the watercolours resulting from his continental travels Cox was surely also aware of the work of the short-lived R.P.Bonington, who had died in 1828, the year before his own first visit to France. This can be seen in the lively Parisian street scene, *Near the Pont d'Arcole* (Tate Gallery, London), which he drew while incapacitated with a sprained ankle during this visit. However, despite such echoes of the work of some of his contemporaries, Cox's vigorous style and adventurous technique were very much his own, and he excelled in depicting the frequently damp atmosphere of the British countryside. He produced some of the finest watercolours of the first half of the nineteenth century, of which the wonderfully evocative *Sun, Wind and Rain* [COL.PL.8] is one of the best known.

What is not so well known is that there is also an oil version of this composition, dated 1845, in the Aberdeen Art Gallery, for, when already approaching sixty, David Cox began to paint in oils. In 1839 he took a number of lessons from the much younger Bristol artist, W.J.Müller, whose work he admired. Cox rarely exhibited his oils, and they are relatively little known, but some of them, particularly the sparkling beach scenes inspired by Rhyl Sands in North Wales [PL.45], could be considered as his most

advanced contributions to British landscape art, bringing to mind the work of a decade or more later of Eugène Boudin and some of the early French Impressionists. However, Cox's best-known oil painting is the sombre *Welsh Funeral*, of which the prime version, dating from 1848, is also in the outstanding collection of his work at Birmingham. This was inspired by an event during one of his visits to Betwys-y-Coed, the small Caernarvonshire village where he spent a few weeks each summer from 1844 to 1856, usually staying at the Royal Oak. Here the elderly artist was totally at his ease, and though his work was by now often somewhat mannered, he continued to produce drawings and watercolours that were among the most popular of the day. Cox's output was as varied as it was prolific, and he had certainly advanced the art of water-colour and of landscape well beyond the eighteenth-century traditions in which he was reared.

Born in Staffordshire nine months after David Cox, Peter de Wint (1784–1849) was the son of a doctor of Dutch extraction. He abandoned his own medical studies to become an apprentice with the London mezzotint engraver and painter John Raphael Smith in 1802, with whom, however, he stayed only for four years. Having decided to become a painter rather than an engraver, De Wint was quickly assimilated into the circle of Dr Monro and took lessons in watercolour from John Varley. He became a student at the Royal Academy in 1809, and struck up a close friendship with William Hilton (1786–1839), a fellow student at the RA Schools, whose sister he married in 1810. Hilton, now largely forgotten, was to have a successful career as a history painter, being elected RA in 1820 and Keeper of the Royal Academy in 1827. De Wint, however, de-voted himself to landscape, at first painting almost as much in oils as in watercolours, but gradually concentrating on the latter and becoming a member of the Old Water-Colour Society in 1811. He exhibited a total of over 400 watercolours with the Society, and also showed from time to time at the Royal Academy, the British Institution, and elsewhere.

De Wint also became a successful drawing master, and often travelled to teach his students while they were at their country estates. He usually combined such journeys with sketching tours in England and Wales, but he made only one excursion to the Continent, to Normandy in 1828. Though the De Wints lived in London, from 1814 they also had a house in Lincoln, home of the Hilton family, where they spent some time each year. Throughout his career De Wint produced numerous drawings for the en-gravers, including, on four occasions, the first in 1827 and the last in 1841, Oxford views for the headpieces of the *Oxford Almanack*.

Peter de Wint's life was well ordered and without notable highlights, and to a large extent his work in watercolours reflected this. At first he was strongly influenced by Girtin, as can be seen in a number of early townscapes and landscapes, such as *A Bridge over a Branch of the Witham, Lincoln* [PL.46]. De Wint soon developed a style and technique of his own, which he improved but never greatly changed or developed as he grew older, making it very difficult to arrive at anything like a precise chronology for his watercolours, which he dated only very rarely.[18] The outstanding feature of De Wint's drawings is his fluid and spontaneous application of large and small areas of colour with a broad wet brush on very wet, often rough, paper, with a bare minimum or total absence of drawing. De Wint also made full use of the white of the paper to

(46) Peter de Wint, *A Bridge over a Branch of the Witham, Lincoln* (*c.*1810). Watercolour; 41.7×51.6cm.
(Tate Gallery, London)

strengthen the highlights of his composition, often leaving quite large areas bare of any pigment. In his technique he achieved a translucency and a realisation of atmosphere that few other watercolour artists have equalled, and that has been a prevailing influence on numerous later British watercolour artists up to the present day. An outstanding example of all this is the imposing *Gloucester from the Meadows* [COL.PL.11], which is dated *1840* and presents a beautifully balanced composition with apparently consummate ease. De Wint worked with great rapidity and absolute confidence in his medium, and must surely have completed many of his fluent landscape watercolours on the spot. This certainly applies to his still-life, plant and flower studies in watercolour, in which again his flowing mastery has resulted in beautiful drawings which are at once spontaneous and convincing. Perhaps more than any of his contemporaries, this follower of Girtin and student of Varley advanced the art of watercolour drawing and sketching into its modern era, as is seen yet again in *Brougham Castle, Westmorland* [PL.47], an outstanding watercolour probably executed at about the time when the photographing of landscape was just beginning.

Several other prominent watercolour artists of the first half of the nineteenth century were pupils of John Varley, among them William Havell, William Turner of Oxford and William Henry Hunt. A founder member of the Old Water-Colour Society,

(47) Peter de Wint, *Brougham Castle, Westmorland* (*c*.1848). Watercolour; 29.1×45.9cm.
(Fitzwilliam Museum, Cambridge)

(48) William Turner of Oxford, *Pope's Tower, the Old Kitchen, etc., Stanton Harcourt, Oxfordshire* (1822).
Watercolour; 49×73cm. (Worcester College, Oxford)

William Havell (1782–1857) developed a very solid manner, totally different to that of De Wint, but often closely resembling his work in oils. In this he completed many impressive landscape compositions in the classical tradition, such as the Laing Art Gallery's *Keswick Lake* of 1810. Turner of Oxford (1789–1862), as he is known to differentiate him from his more famous namesake, began in a vein similar to Havell's, but developed a lighter and brighter palette, often using bodycolour and favouring broad, panoramic compositions. He spent most of his life in or near Oxford, where he had a busy practice as a drawing master. He was a Member of the Old Water-Colour Society, and exhibited there annually throughout his life. Like many of the landscape artists of his time he frequently included harvest scenes in his compositions, including *Pope's Tower, the Old Kitchen, etc., Stanton Harcourt, Oxfordshire* [PL.48], which dates from 1822.

William Henry Hunt (1790–1864), the last of the three Varley pupils referred to above, was a much more varied artist than his fellow pupils. After beginning in a topographical manner similar to theirs, to which, however, he often added the nervous outline technique of Canaletto, he developed a very personal specialisation of highly detailed figure and still-life compositions in watercolour and bodycolour. His most popular still lifes featured naturalistic and realistic representations of fruit, flowers and, above all, birds' nests. He began to exhibit these around 1830, and came to be known as 'Bird's Nest' Hunt. *Bird's Nest with Sprays of Apple Blossom* [COL.PL.10] is a typical example, executed in watercolour heightened with white, and dating from about 1845. In the absolute realism of these drawings – his rendering of the bloom on a grape or a plum can be amazingly convincing – he was anticipating the work of the Pre-Raphaelites. In his precise technique he was one of the first artists to take the medium into its 'high' Victorian mannerisms, which totally ignored the fluidity and spontaneity with which watercolour is traditionally associated. The translucent medium of watercolour is, of course, especially suited to the depiction of the damp British landscape. It was when the artists became interested in depicting actual landscape rather than architectural topography, that they abandoned the tinted drawing for the use of the pure medium.

The changes illustrated by the highly realistic 'watercolours' of 'Bird's Nest' Hunt were partially caused by the continuing decline in the popularity of pure watercolours and the consequent drop in their sales and the need for artists in that medium to emulate oil paintings in order to attract buyers. The collecting of oil paintings had again become far more prevalent than in the early years of the century, and was much furthered by the growing number of picture dealers. To satisfy the demand painters were working on a smaller and more domestic scale. Throughout the nineteenth century it was the British public rather than the artists that usually set the fashion, and the day of the highly successful radical artist was still to come. However, there remained a host of watercolour specialists, among them Joshua Cristall (1768–1847), Robert Hills (1769–1844), George Fennel Robson (1788–1833) and Anthony Vandyke Copley Fielding (1787–1855), who continued to advance the depiction of landscape in watercolours in the great, and originally radical, tradition of J.R.Cozens, Thomas Girtin and J.M.W.Turner.

8 William Blake (1757–1827) and Samuel Palmer (1805–81)

William Blake was an eccentric and a genius, and as is often the case with such men his work does not fit easily into an historical account. He was unique, and the imaginative and inventive power of much of his visual work is often essentially private and hard to understand. At once poet, painter, engraver, designer, printer, mystic and philosopher, William Blake was as much decried as admired in his own day, and the same has applied to his posthumous reputation. He is included in this section on 'Artists in Watercolour' because so much of his best work as an artist was executed in watercolours, but that work is entirely out of context with the landscape and topographical watercolours that are the main theme of this section. In character, thought and behaviour Blake was a visionary and a revolutionary, and he developed and used 'revolutionary' methods in his paintings, watercolours and prints to express his ideas.

Born in Soho, the son of a hosier, Blake had already written a fair amount of poetry and spent some time at Henry Pars's drawing school in the Strand, when he was apprenticed to the engraver James Basire in 1772. The apprenticeship was for seven years, during which Blake lived in Basire's house and became wholly imbued with the life, philosophy and methods of a somewhat old-fashioned craftsman. While more up-to-date engravers were incorporating ever more etching in their plates, and thus greatly speeding up the process, Basire retained the traditional and laborious use of the burin, and seems not to have shared in the boom that copper engraving was enjoying during the 1770s and 1780s. In many ways Blakes's training and practice as an engraver was the basis of all his work as an artist, and could be said to account for the essentially linear nature of his drawings and for the subservient place of colour in these. In addition, of course, Blake continued to use various print-making techniques throughout his long life, most notably in his illuminated books.

Another formative experience of his apprenticeship was the drawing of tombs and other medieval features of Westminster Abbey for engravings in Richard Gough's *Sepulchral Monuments in Great Britain.* This task familiarised Blake with the linear qualities of the Gothic, which served as a basis for his adoption a few years later of the up-to-date outline drawing style of such neo-classical artists as Fuseli and the sculptor John Flaxman, a fellow student at the Royal Academy Schools, which Blake attended briefly when his apprenticeship with Basire was completed in 1779. These first stylistic developments and the young artist's ambition to receive recognition as a history painter, are reflected in his early exhibits at the Royal Academy, where he showed three biblical subjects from the story of Joseph in 1785. Among these was *Joseph ordering Simeon to be bound* [PL.49], a succinct and emotive composition in watercolours showing Blake at his most neo-classical, with clear references both to antique reliefs and to Raphael, while the elaborate background has Gothic characteristics.

Blake's first volume of poems, *Poetical Sketches*, was printed in 1783, though most of the contents dated from much earlier. This was the only book of his poetry to be 'published' in the proper sense of the word during his lifetime. These precocious poems prove that Blake's poetic gifts flowered well before his development as an artist. He first combined the two sides of his genius in the late 1780s, when he began to design and produce illuminated books of his own poetry, of which the *Songs of Innocence* first pro-

(49) William Blake, *Joseph ordering Simeon to be bound* (RA 1785). Indian ink and watercolour;
40.5×56cm. (Fitzwilliam Museum, Cambridge)

duced in 1789 was one of the earliest and one of the most popular. In this text and illustration were given equal prominence and were printed in relief etching or stereotype, bringing together both the medieval, in the decorative borders, and the neo-classical, in the figure compositions. Blake and his wife coloured each copy by hand, so no two copies are identical. Basically pastoral in style and ostensibly aimed at children, *Songs of Innocence* was followed by *Songs of Experience* and *The Book of Thel*, which were similar in character. All these illuminated books were produced by hand for collectors in very limited numbers, and thus most of Blake's writing was never really published or made available to a wider readership during his lifetime.[19]

However, the texts of Blake's illuminated books, such as *America, A Prophecy* and its companion *Europe, A Prophecy*, of 1793 and 1794, soon became more sophisticated and reflected his increasing political and religious involvement. At this time he was closely associated with the radical circle of the publisher Joseph Johnson, which included Joseph Priestley and Thomas Paine. A dissenter by family background, Blake was also connected with followers of Emanuel Swedenborg, the influential Swedish visionary, though he was never himself a member of the New Church, and attacked Swedenborg in his *The Marriage of Heaven and Hell*, begun in 1790. His own poetry became increasingly prophetic and mystical, and he invented a cast of characters on which to focus his ideas, among them 'Los', 'Orc' and 'Urizen'.

Alongside these developments the illustrations assumed greater prominence and

importance, and the page size of the volumes grew larger. Instead of colouring the illustrations by hand in watercolours Blake began to use a type of colour printing of his own invention. In this thick and sticky pigments, perhaps mixed with carpenter's glue, were applied to the engraved plate, already used for the text and outlines, from which an impression was then taken. The rich and tactile effect is seen at its best in the illustrations of *The First Book of Urizen*, which was produced in 1794–5, and of which only seven copies are known. Urizen, the 'primeval priest', was for Blake the embodiment of unenlightened reason and consequently of intellectual oppression.

The First Book of Urizen is one of Blake's most sombre and sinister writings, and the dark and powerful illustrations reflect this, as can be seen in *Urizen and his Book of Brass* [PL.50], which shows the priest with his 'Book of Brass' in which are written 'the secrets of wisdom, the secrets of dark contemplation'. However, as in many of these illuminated volumes, Blake's compositions and line still appear rather cramped and naïve. All such problems seem to vanish when the artist moved on in 1795 to his Large Colour Prints, which were issued independently of text and illustrate subjects from various sources, including the Bible, Milton and Shakespeare, as well as Blake's own writings. Twelve different subjects are known today, of which some exist in as many as three impressions. These vivid and fluent compositions represent not only the culmination of Blake's colour printing experiments of the 1790s, but also herald the accomplishment of the artist's personal style and idiom, free at last from the shackles imposed on Blake the artist by Blake the writer. It is still possible to trace close parallels with *The First Book of Urizen* as well as numerous other artistic influences in these compositions, as in the Michelangelesque origins of the famous image of 'Newton', but in all of them it is Blake the artist that first commands attention. These qualities are clearly seen in *God judging Adam* [COL.PL.12], a marvellously balanced composition both in line and form. It seems that these works, which have also been called 'colour-printed drawings', were produced by pure colour printing, without previous printed outlines; the design was painted in thick oil colours, usually on millboard, from which the impressions were made.

Eccentric and reclusive – though very happily married in 1782 to Catherine Boucher who supported him nobly throughout his life – William Blake was steeped in Christianity and the Bible from an early age, but broadened his religious beliefs and enthusiasms by a combination of reading and visions. For Blake art, in every medium, was the product of genius, and only true artists – not priests – were man's real link with God. Thus his poetry and his painting, drawing and engraving were linked, and behind all of them lay didactic justification. He was, in his way, a preacher and a teacher, but most of his messages were so personal and individualistic that only a few fellow spirits could truly share them with him. Devout, honest and sincere, Blake often escaped from the traumas of real life into the spheres of vision and imagination – his art reflects all this, and for many it is difficult to comprehend.

Throughout these years of development Blake had from time to time continued to engrave book illustrations after designs by other artists, among them Fuseli, Stothard and Conrad Metz. He had also produced his own designs for book illustrations, including ten, of which five were engraved, for an edition of Mary Wollstonecraft's *Original Stories*, published by Joseph Johnson in 1791. In about 1795 he was commis-

(50) William Blake, *Urizen and his Book of Brass* (1794–6; Plate 6 of *Urizen*, Copy B). Colour-printed relief etching finished in pen and watercolour; 26.5×18.5 cm. (Pierpont Morgan Library, New York)

sioned by the bookseller Richard Edwards to provide illustrations for a new de luxe edition of Edward Young's *Night Thoughts*, first published in 1742–5. For this Blake produced no less than 537 large watercolour drawings, using sheets of Whatman paper, onto which printed pages of an earlier edition of the book had been set off-centre, and drawing and colouring his designs on the irregular margins that were left. Thus the illustrations literally surround the text, and Blake made full use of flowing line and gentle form to create compositions that were on the whole harmonious and elegant, though they were frequently repetitive. In the event the adverse economic conditions, which were affecting many publishing and engraving ventures at this time, meant that only one of the four projected volumes was published, in 1797, and Blake engraved a mere forty-three of his designs. The sculptor John Flaxman, a friend of Blake's since their student days, was clearly impressed by the *Night Thoughts* illustrations, and he commissioned similar illustrations to the collected poems of Thomas Gray, based on an edition of 1790. Blake completed 116 illustrations, but there was no plan to engrave this series. These two series represent over a quarter of Blake's total surviving output of paintings and drawings, and they mark considerable advances in his work as an illustrator.

Flaxman may well have placed his commission in order to help his impecunious friend, though he paid him only ten guineas. Blake was continuously hard-up, but for over ten years from 1799 he enjoyed a small but fairly regular income through the patronage of Thomas Butts, a clerk in the office of the Commissary General of Musters. On 26 August 1799 Blake wrote enthusiastically to his friend George Cumberland, 'As to Myself, about whom you are so kindly Interested, I live by Miracle. I am Painting small pictures from the Bible.... My Work pleases my employer, & I have an order for Fifty small Pictures at One Guinea each, which is Something better than mere copying from another artist.'[20] The majority of these paintings survive; they were executed in tempera on canvas or, in a few cases, on copper, in a technique similar to that used for the large colour prints of 1795. Unfortunately, Blake's use of carpenters' glue in place of the traditional size or egg medium has resulted in considerable darkening and cracking in many of them, as can be seen in *Christ blessing the little Children* [PL.51], which is one of ten works in the series dated 1799. This naïve yet complex composition, in which the scale relationship of the figures is haphazard, is given unity by the harmonious landscape background, somewhat reminiscent of the Quattrocento Venetian landscape tradition. Many of this tempera series illustrate the life of Christ, and thus Blake had an enormous fund of earlier prototypes to inspire him. Many influences can be identified and, as a whole, the series is stylistically very eclectic, though it is given some homogeneity by an overall feeling of medievalism.

Thomas Butts must have been satisfied with the paintings, for he went on to commission an even larger number of watercolour compositions of biblical subjects. Totalling over eighty, these were mostly executed between 1800 and 1805, and mark notable advances in Blake's stylistic development, and in his assimilation of the many influences which his close study of Raphael, Michelangelo, Dürer and other Northern artists, imposed upon him. The artist was certainly more at ease and more proficient technically with watercolour than with paint, and these masterly Bible illustrations – powerful and sensitive in line and composition and usually delicate and pale in colour

(51) William Blake, *Christ blessing the little Children* (1799). Tempera on canvas; 27×39cm.
 (Tate Gallery, London)

– herald the start of Blake's major achievements as a watercolour artist. In *David pardoning Absalom* [PL.52] these qualities combine to achieve a graceful and emotional rendering of a touching scene in the Second Book of Samuel.

During the years that he was working on these Bible illustrations Blake, who was now in his mid-forties, was living at Felpham, near Chichester, where he had been persuaded to move by the poet and man of letters, William Hayley, who lived there. Hayley wanted to help Blake by employing him to assist with various artistic enterprises, including the illustration of his own poems and biographies, and the decoration of his library with eighteen panels featuring the heads of poets. The relationship was a failure, and after three years Blake returned to London, where, however, Hayley generously continued to support him.

In about 1805 Thomas Butts gave Blake another important commission, which until the recent researches of Martin Butlin had always been considered to date from some fifteen years later.[21] This was for the set of twenty-one illustrations to the Book of Job, now in the Pierpont Morgan Library in New York. This series of sensitive and emotive compositions played an important role in Blake's later career, for when John Linnell saw it in 1821, he commissioned a second set of watercolours. These were painted by Blake over tracings made by Linnell from the Butts set, and engravings from them were commissioned by Linnell and published in 1826. For the engravings Blake added decorative borders and texts, and the prints show his engraving technique at its best. As well as illustrations these Job designs are also Blake's own critical commentaries on the text.

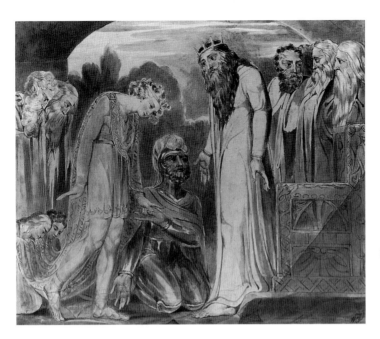

(52) William Blake, *David pardoning Absalom* (c.1805). Watercolour; 31.8×37cm. (Cecil Higgins Art Gallery, Bedford)

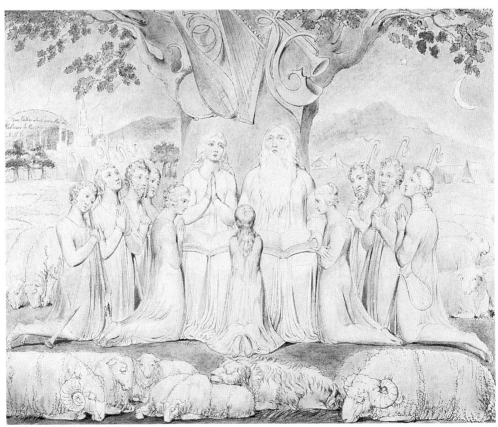

(53) William Blake, *Job and his Family* (c.1805–6). Pen and watercolour; 22.5×27.4cm. (Pierpont Morgan Library, New York)

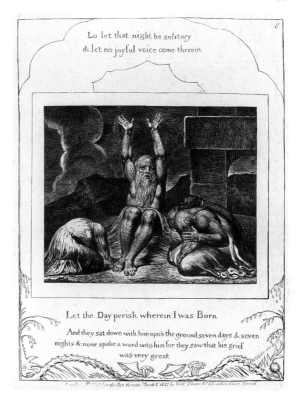

(54) William Blake, *Job's Despair* from *Illustrations to the Book of Job* (1823–6). Line engraving; 19.7×15 cm. (Tate Gallery, London)

The Butts series of Book of Job illustrations are among Blake's most successful and compelling drawings. Between the peaceful and harmonious opening and closing scenes, *Job and his Family* [PL.53] and *Job and his Family restored to Prosperity*, the suffering and anguish of the Old Testament patriarch are depicted with telling effect, as in the effectively simple composition of five figures illustrating *Job's Despair* [PL.54]. Job's despair is emphasised not only by his expression and gesture, but also by his isolation in the group, in which his face alone is depicted. The vegetation in the lower border – toadstools, briars, thistles and withered fruit – and, of course, the texts, all add to the force of the illustration. There have been many discussions and varied interpretations of the Job illustrations; the final engravings, published in the year before his death, represent a culmination of Blake's art and are a telling record of his philosophy of life.

In 1808 Blake, by now in his fifties and still without real recognition as an artist, exhibited again at the Royal Academy, where his work had last been seen in 1800. He showed three watercolours, two of them outstanding examples from the Bible illustrations for Thomas Butts, and the third a crowded and complex composition of *The Vision of the Last Judgement* [PL.55]. This had been commissioned by the Countess of Egremont in 1807 on the recommendation of the portrait painter Ozias Humphry, and is still at Petworth House in Sussex. Strongly influenced by Michelangelo's Sistine Chapel fresco, it is one of some ten versions of this subject which Blake completed between 1806 and 1827. Blake wrote a long description of the Petworth drawing in a letter to Ozias Humphry, in which he explained the symbolism of the numerous elements of the composition, and he wrote a fuller account of his ideas in a notebook of

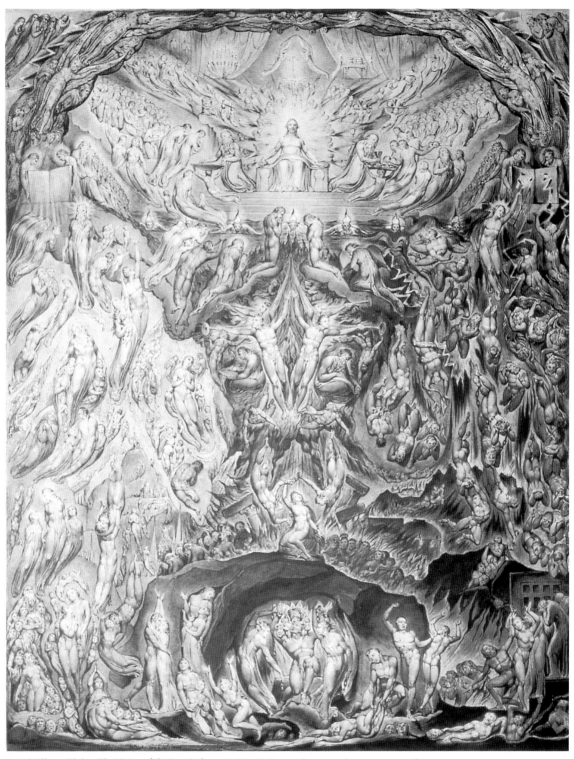

(55) William Blake, *The Vision of the Last Judgement* (1808). Pen and watercolour over pencil; 51×39.5 cm.
(Petworth House, Egremont Collection, National Trust)

about 1810. Here he described the Last Judgement as the triumph of art, for 'The Last Judgement is an overwhelming of bad art and science', with art itself symbolised in the painting by a Gothic church. In this frequently repeated composition Blake was summing up many of his beliefs and hopes, and it is not surprising that there were few who could readily follow the complexity of his visionary ideas.

The Royal Academy exhibits received little attention, and not much more was paid to Blake's own exhibition of his work which opened at his brother's house, 28 Broad Street, Golden Square, in May of the following year, and remained on view well into 1810. All three 1808 RA exhibits were shown again in this exhibition, to which admission was by means of Blake's ambitious *Descriptive Catalogue*, which cost 2s 6d. It also included four more watercolours, and a group of nine tempera paintings, of which only five are known today. The best known of these paintings, the unusual technique of which Blake described as 'the Ancient method of Fresco Painting Restored', is the large processional scene, *Sir Jeffery Chaucer and Nine and Twenty Pilgrims on their Journey to Canterbury* (Pollok House, Glasgow), which clearly demonstrates Blake's interest in the Parthenon Marbles, which had recently been put on view in London. The exhibition was a complete failure, and there was only one – adverse – review. In his *Descriptive Catalogue* Blake attacked 'the eye that can prefer the Colouring of Titian and Rubens to that of Michael Angelo and Rafael', and expressed his preference for the Florentine rather than the Venetian School. For Blake colour was always of less importance than line and form. It was also at about this time that Blake made the famous annotations in his copy of the still very influential *Discourses* of Sir Joshua Reynolds, of whom he wrote 'This Man was Hired to Depress Art'. Though agreeing with much of Reynolds's teaching, especially the superiority of history painting and the merit for all art students of copying from the best masters, Blake disagreed with the fundamental tenet of the importance for the artist of studying from nature in order to achieve perfection.

Blake's own interests and preferences are seen in the increasingly 'classical' character of much of his work, which was very much in keeping with the neo-classical developments of the time. This is demonstrated in the splendid combination of classical and romantic in the later series of imposing illustrations to Milton, such as the twelve large watercolours for *Paradise Lost* made for Thomas Butts in 1808. *Satan arousing the Rebel Angels* [PL.56] from this series is a compact and refined composition, in which firm line and shading are combined to achieve 'expressive poses stemming by way of Michelangelo from the Antique'.[22] The poetry of John Milton continued to inspire Blake until his final years, and his illustrations provide a succinct survey of the artist's later development towards a more fluent and colourful style. This is seen in the set of twelve small watercolours illustrating *Paradise Regained* made between 1816 and 1820, which were bought by John Linnell in 1825, and are now in the Fitzwilliam Museum, Cambridge.

The landscape painter John Linnell had been introduced to Blake in 1818 and became a close friend as well as the principal patron of his final years. It was Linnell who introduced Blake to several other artists, including John Varley, for whom he drew the series of remarkable 'Visionary Heads', and Constable, and such younger men as Samuel Palmer and George Richmond, on whom he had a profound influence. Thus in his closing years Blake found not only material support but also admiration and en-

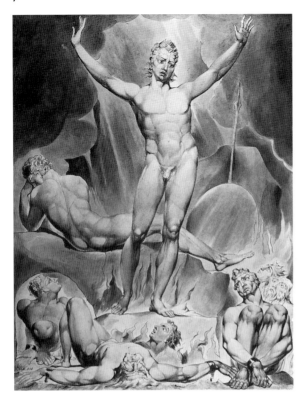

(56) William Blake, *Satan arousing the Rebel Angels* (1808). Pen and watercolour; 51.8×39.3 cm. (Victoria and Albert Museum, London)

couragement, all of which he had so sorely lacked throughout most of his career. In 1824 Linnell commissioned from Blake the set of illustrations to Dante's *Divine Comedy*, which it was planned to engrave, but which was unfinished at the time of the artist's death in 1827. As well as a number of related pencil sketches there are today 102 Dante drawings of the same size, in varying degrees of completion and mostly including watercolour. Among them are some of Blake's finest achievements in that medium, such as *Beatrice addressing Dante from the Car* [COL.PL.13], which depicts Dante's first meeting with Beatrice in the Earthly Paradise as described in cantos 29 and 30 of *Il Purgatorio*. This intricate and colourful composition is considered to be one of the key works in which Blake expresses his opposition to Dante's ideas, for, as in the case of the illustrations to the Book of Job, Blake's designs were as much critical commentary of the text as illustrations of it. In these outstanding Dante watercolours Blake's genius and individuality as an artist are seen at their best, and they remind us that as well as a great artist William Blake was a great poet and thinker. His greatness as an artist is often overshadowed by the elusiveness of his images, but, however hard they are to 'read', the power and directness of these images is usually sufficient to confirm the genius of the artist.

Samuel Palmer was only nineteen when he met Blake, and his friendship with the elderly and ailing artist was to have a profound effect on him. Like Blake, Palmer received scant recognition during his lifetime, which was largely one of struggle and hardship, and it is only since his virtual rediscovery in the 1920s that he has become one of the most popular of nineteenth-century British artists. Palmer was introduced

to Blake by John Linnell, whom he had met two years earlier, and who was to have an even more profound influence on his life and art, and became his father-in-law. Until quite recently it was only the 'visionary' works of the first decade or so of Palmer's career that won widespread acclaim, but today much of his later imaginative and romantic work has also become popular.

Samuel Palmer was born into a dissenting upper-middle-class family in London; his scholarly father was a not very successful bookseller, and his mother, Martha Giles, came from a well-to-do banking family. From the age of three the somewhat sickly Samuel was looked after by Mary Ward, an unusually characterful and intelligent nurse, who was a Baptist with an intimate knowledge of the Bible and the works of Milton, which she shared with her young charge. Thus Samuel Palmer grew up in a cultured and religious environment, though he himself rejected the dissenting in-fluences and became a devout member of the Church of England. He showed early signs of his artistic ability, and was placed in the hands of an obscure drawing master, William Wate, who probably used David Cox's *Treatise* of 1813 as a textbook. Palmer sold his first picture, at the British Institution, in 1819, and exhibited three works at the Royal Academy in the same year. When visiting that exhibition the young artist was much moved by Turner's *Entrance of the Meuse: Orange-Merchant on the Bar* (Tate Gallery, London), with its magnificent stormy sea and sky. As well as the influence of Turner, Palmer's own work at this time showed his own particular study of the sky and of weather effects.

Relatively little of Palmer's work of the early 1820s has survived, but these were the years when he met and impressed John Linnell, who took him under his wing and greatly broadened his artistic circle. By this time Linnell had proved himself as a more than competent landscape artist, both in oils and watercolours, and from about 1805 to 1815 he had been one of the leading figures among the group of younger painters working direct from nature. He also practised as a miniaturist and painter of small-scale portraits, and it was largely these that he was exhibiting at the Royal Academy at this time. Still only in his teens, Palmer was understandably much influenced by the older man, who introduced him to the broader study of the old masters, especially of the Northern schools, as well as advising him to work from nature. In September 1824 Palmer wrote to Linnell from Shoreham, 'while I am drawing from Nature, vision seems foolishness to me, the arms of an old rotten tree trunk more curious than the arms of Buonaroti's [*sic*] Moses'.[23] Palmer met Blake in 1824, and in that year also he paid his first visits to Shoreham, a large village in the hilly valley of the River Darent in Kent. This became Palmer's 'Valley of Vision', graphically recorded in the famous sketchbook begun that year and now in the British Museum.[24] Though the young artist followed Linnell's advice and drew from nature in the surrounding countryside, he was far more influenced by Blake, and particularly by his tiny emotive woodcuts of 1821 illustrating Dr Thornton's *Pastorals of Virgil*, in finding at Shoreham inspiration for his visionary and imaginary genius.

In the spring of 1826 Palmer, who had received a small legacy from his grandfather Giles, moved to Shoreham, with his father. Here the delicate, eccentric and somewhat dandyish young artist became the centre of a circle of fellow spirits, who dubbed them-selves 'the Ancients'. Most of them were also artists, including Edward Calvert, George

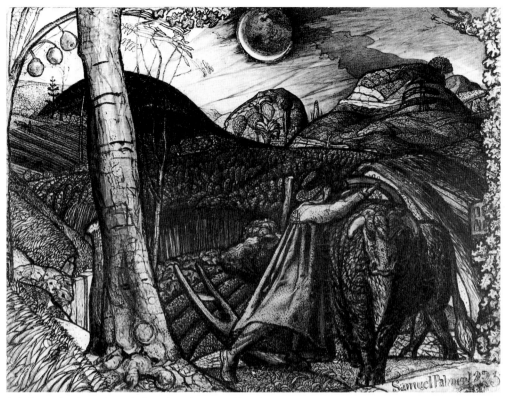

(57) Samuel Palmer, *A Rustic Scene* (1825). Pen and brush in brown watercolour, mixed with gum
and varnished; 17.9×23.6 cm. (Ashmolean Museum, Oxford)

Richmond, Henry Walter, and F.O. Finch, and all of them were fired and inspired by
Palmer's infectious enthusiasm for these idyllic surroundings. They bathed in the river,
walked, talked and worked during the day and even during the night, as well as read-
ing and composing poetry and making music. This existence was essentially romantic,
and so was the art which it fostered. That Palmer's own visionary and romantic art was
already fully developed before he actually settled at Shoreham, is proved by the famous
group of six highly stylised and detailed varnished drawings of 1825 in the Ashmolean
Museum, Oxford. Fascinating in their detail, much of which shows echoes of Blake's
imagery, and flowing and harmonious in their composition, these memorable drawings
are executed in an experimental technique, using pen and brush with ink and thickly
loaded sepia mixed with gum, and covered in a thin layer of varnish.

Now yellowish in tone and suggestive of ivory, the six richly drawn images,
in some ways reminiscent of engravings, have become the 'benchmark' of Palmer's
visionary work, and they were certainly of vital importance to Palmer himself. The
artist signed and dated most of them, and wrote biblical or literary inscriptions on the
old mounts of all but one of them. In the case of *A Rustic Scene* [PL.57], which was one of
the two from the series exhibited at the Royal Academy in 1826, the quotation is in Latin
from Virgil's *Georgics*. At once dynamic and static, this is the only one of the six com-
positions in which there is human action; the movement of the farmer placing the yoke
contrasts with the threatening stance of the expectant ox and the total peace and calm of

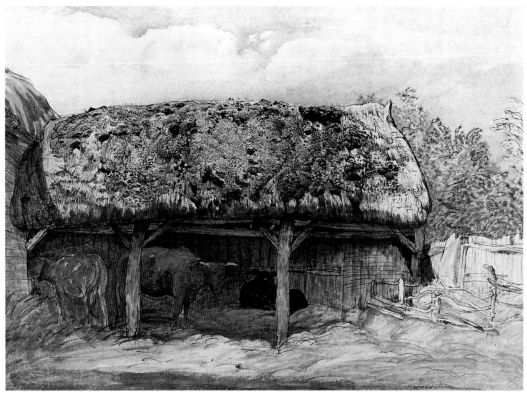

(58) Samuel Palmer, *A Cow-Lodge with a Mossy Roof* (c.1829). Pen and black ink with watercolour and bodycolour; 26.7×37.5 cm. (Yale Center for British Art, Paul Mellon Collection)

the rolling countryside. Similar contrasts are achieved through the weather effects in *The Valley with a bright Cloud*, but the other four compositions are images of absolute pastoral peace and restfulness.

Most of Palmer's Shoreham drawings are in monochrome, in black or brown ink, and also echo the characteristics of Northern engravings and woodcuts, though demonstrating an increasingly personal manner. On a few occasions, towards the end of his stay, he used rich watercolour and bodycolour to capture the abundant fruitfulness of nature in the valley. Among such works is the Ashmolean Museum's *Pastoral with a Horse-Chestnut Tree* [COL.PL.14] which repeats motifs from the 1824 sketchbook. In its luxuriant combination of idyllic peace and abundance this harmonious composition captures all the qualities that make Palmer's Shoreham drawings so compelling. But this is not an imaginary scene, and is essentially a study from nature, influenced by Linnell's repeated advice to draw from nature on the spot, advice which the older artist will certainly have stressed during his own visit to sketch at Shoreham in 1828.

That advice must also have been in Palmer's mind when he made his detailed drawings of Sepham Barn, and other buildings, houses and ancient trees in and around the village. Among these are two minutely observed watercolours of farm buildings with mossy roofs at Yale [PL.58], in which he used a variety of unorthodox techniques, including 'dotting and dabbling', to achieve almost photographic realism. In December 1828 Palmer wrote a long letter to Linnell, which reveals the thinking behind his draw-

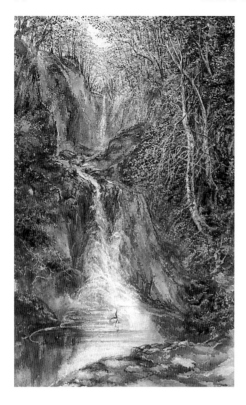

(59) Samuel Palmer, *The Black Waterfall (Rhaeadr Ddu),
 near Dolgelly* (1835). Watercolour and bodycolour;
 34.5×21.5 cm. (Courtauld Institute Galleries,
 London)

ings of this period and his continued concern about the tensions he felt when com-
paring imaginative with realistic art. 'I can't help seeing,' he wrote, 'that the general
characteristics of Nature's beauty not only differ from, but are, in some respects, op-
posed to those of Imaginative Art.'[25]

At the end of that letter Palmer reveals that he already has thoughts about going to
Rome, but several more years were to pass before he made that journey. The inspiration
of Shoreham gradually waned, and Palmer was now constantly short of money. In 1832
he purchased a London house, though he continued to spend much time in Kent, and
to make such wonderful drawings as *The Weald of Kent* at Yale, which are no longer as
intense and are in a much more flowing style than the Shoreham drawings of earlier
years. On rare occasions at this time Palmer also painted in oils, usually on a small scale.
In 1833 Palmer visited Devon for the first time, and two years later he made an ex-
tensive sketching tour in Devon, Somerset and Wales, where he was especially attracted
by the streams and waterfalls, making such beautiful drawings as *The Black Waterfall
(Rhaeadr Ddu), near Dolgelly* [PL.59]. These evocative and romantic compositions may
well have been influenced by the contemporary watercolours and engravings of Turner,
a supposition confirmed by the fact that in a letter written to Linnell from Rome in
February 1838 Palmer's reference to two of his Welsh waterfall drawings immediately
precedes his advice to his father-in-law, as he had now become, to visit 'the fine
collection of Turner's drawings at Mr. Windas's [*sic*]'.[26]

Palmer had fallen in love with Hannah, Linnell's eldest daughter and herself a
competent artist, and they were married in September 1837, leaving for Italy a few days

later. They travelled to Rome with George Richmond, by then a successful artist, and his wife and son, and visited Paris, Milan and Florence *en route*. In the letter already cited written to Linnell from Rome in February 1838 Palmer reported about six weeks of 'the worst possible weather', but added 'when the surprise at Italian sunshine is a little abated one is almost equally delighted with the fullness of matter – figures and buildings seem as if they had been contrived to meet all the wants and desires of the painter.'[27] Palmer had yet to gain recognition as an artist and was determined to produce impressive and saleable watercolours of Italian scenes. Three of these were hung in the Rome Academy exhibition in 1838, but none was sold. One of them was *A View of Ancient Rome* [COL.PL.31], a complex and crowded composition designed as a companion to the similar *View of Modern Rome during the Carnival*, also at Birmingham. In June 1838 Palmer wrote to Linnell, 'I have had a hard grapple with ancient Rome – for I was determined to get the whole of the grand ruins, which I believe has not yet been done.'[28] Having fixed the height of the horizon, the artist had great difficulties with the foreground, but 'it came suddenly all right'. Palmer completed a considerable number of such ambitious compositions of scenes in and around Rome, Tivoli, Florence and elsewhere, in many of which he got bogged down in the detail and had problems with perspective. He exhibited examples at the Royal Academy and the Old Water-Colour Society, of which he became an Associate in 1843, and a full Member eleven years later, but few found buyers. While Samuel was busy with his topographical drawings, Hannah spent much time and energy making copies in the Vatican and elsewhere for her father and others, and it was her earnings that helped sustain the Palmers during their travels.

The couple returned to London at the end of November 1839, and Samuel soon began to establish a teaching practice, which grew steadily, once again with help from John Linnell, who actually outlived his son-in-law, and continued to overshadow Palmer's life and work. In the 1840s John Linnell's realistic and romantic landscape paintings became popular and sold for high prices; he was able to abandon portraiture and was recognised as one of the leading landscape artists of the day. On the other hand the remainder of Palmer's career was punctuated by a series of failures and disappointments, and it has for long been usual to dismiss the paintings and drawings which he executed during the last four decades of his career as weak and insignificant when compared with those of his great visionary years. However, taste has changed and much of the work of Palmer's middle and later years has now come into its own with connoisseurs and collectors.

The artist continued to travel in England in search of material, especially to Devon and Cornwall, and spent long periods at Margate and other places in Kent. In 1861 the Palmers, grieving at the death of their eldest son, left London for good, and moved to Surrey, finally settling in Furze Hill House, a suburban villa with fine views in a country setting between the small towns of Reigate and Redhill. Here the artist rediscovered something of the rural tranquillity of his Shoreham days, and soon after his move he at last found a supportive patron, Leonard Rowe Valpy, whose first purchase was *Twilight – The Chapel by the Bridge* (untraced today), one of the watercolours which Palmer showed at the OWCS in 1863.

Valpy was John Ruskin's solicitor, and may have had his attention drawn to

(60) Samuel Palmer, *The Bellman* (1881). Watercolour and bodycolour; 50.6×70.5 cm.
 (Devonshire Collection, Chatsworth)

Palmer by the critic, who himself seems to have lost interest in the artist after greatly
praising him in an addition to the third and fourth editions (1846 and 1848) of Volume I
of *Modern Painters,* which was, however, omitted from subsequent editions. It was
Valpy who in 1864 commissioned the series of large watercolours illustrating John
Milton's *L'Allegro* and *Il Penseroso,* which enabled Palmer to create his most significant
late work. Milton had always been a central figure in Palmer's life and work, and in the
1850s he had already produced a small series of watercolours illustrating *Comus.* In the
eight Valpy drawings, on which he worked for some seventeen years, 'Palmer strained
watercolour to its limit to give it richness of texture close to that of oil painting; straight-
forward watercolour wash and point of brush, body colour and gum are all combined
to this end. At the same time he still continued to use to excellent effect his perennial
dappling and dotting.'[29] The vivid qualities of these compositions are beautifully dis-
played in *The Bellman* [PL.60], now at Chatsworth, which illustrates two lines from *Il
Penseroso:* 'And the Bellman's drowsy charm / To bless the doors from Nightly harm'.

 The Bellman was the last of the Milton series, and was shown posthumously at the
OWCS in 1882. In 1879 Palmer had already used the composition for one of his most
successful etchings, about which he wrote to the critic and etcher P.G.Hamerton, 'I am
very glad that you like my *Bellman....* It is a breaking out of village-fever long after
contact – a dream of that genuine village where I mused away some of my best years.'[30]

The inspiration of Shoreham had outlived long years of disappoinment and frustration, and in his sixties and seventies Samuel Palmer was again able to draw on it for the Milton series, his own Virgil illustrations, and other watercolours and etchings. The power of the etchings – Palmer published his first four in 1850, the year in which he was elected a member of the Etching Club – was rediscovered in the early years of the twentieth century, when they exerted strong influence on artists such as Graham Sutherland and F.L.Griggs. It has taken longer for the later drawings and paintings to gain recognition, but today Palmer's work is at last seen as a whole, and for many students of British art his contribution is considered equal to that of his mentor, William Blake.

9 Samuel Prout (1783–1852), David Roberts (1796–1864) and later Topographical Artists

While the major developments in the art of watercolour in the early nineteenth century were in the representation of landscape, drawings of architectural and topographical subject matter always remained in demand. One reason for this was the growing fashion for a variety of books and other publications with topographical illustrations, which replaced the larger single copper engravings that had been so popular before the Napoleonic Wars. Samuel Prout and David Roberts were among the most successful artists in fulfilling this new demand, which reached its peak in the 1820s and 1830s, especially after the introduction of steel plates for engraving made larger editions viable.

Samuel Prout was born in Plymouth, where his artistic skills were discovered in 1801 by the antiquary John Britton, who immediately employed him to make drawings for his ambitious and successful series, the *Beauties of England and Wales*. Prout's early work was essentially in the eighteenth-century tradition and very eclectic, showing the influence of Thomas Hearne, Girtin, and others, and often remarkably similar to the early drawings of Cotman. From 1802 to 1805, when he had to return to Plymouth because of ill-health, Prout was in London working for Britton, and he began to exhibit at the Royal Academy. He returned to London in 1808, resumed his exhibiting at the RA and from 1810 showed prolifically at the Associated Artists in Water-Colours, the short-lived rival to the Old Water-Colour Society. From 1815 until the last year of his life he exhibited annually at the OWCS, of which he became a member in 1819. In all he showed nearly 550 drawings at the Society, and the great majority of these were sold at the exhibitions.[31]

The early exhibits included many west country scenes, and his most frequent subjects were picturesque cottages, and views of coast, beach and boats. A typical example is *On St Michael's Mount, Cornwall* [PL.61].[32] While the composition is somewhat basic, the convincing rendering of detail is impressive. At this period and throughout his career, Prout's draughtsmanship was frequently of a higher standard and more individualistic than his application of colour. It was his pencil drawings, often on grey paper, that John Ruskin especially admired and praised. Prout generally used the effective and distinctive broken outline found in the drawings of Canaletto and developed by Girtin, but in his later work this technique became somewhat mannered.

(61) Samuel Prout, *On St Michael's Mount, Cornwall* (*c*.1815). Watercolour and bodycolour; 26.1×34.7cm. (Victoria and Albert Museum, London)

(62) Samuel Prout, *Street View with St Laurent, Rouen* (*c*.1820). Watercolour; 40×33cm. (Manchester City Art Galleries)

It was certainly the strong draughtsmanship that underlay his watercolour and sepia compositions that made the artist so popular with publishers and engravers throughout his career. The first book wholly illustrated by Prout himself – *Picturesque Delineations in the Counties of Devon and Cornwall* – was published by T. Palser in 1811/12, and consisted of twenty-four quite large soft-ground etchings. In the following year Ackermann published the first of Prout's popular drawing manuals, *Rudiments of Landscape: In Progressive Studies. Drawn and etched in imitation of chalk,* which consisted of sixty-four plates – soft-ground etchings, sepia aquatints and coloured aquatints – and was issued in twelve parts. Published during the years of the Napoleonic Wars when travel abroad was virtually impossible, these early books were illustrated with British scenes and buildings. However, in 1819 Prout undertook the first of his many Continental tours, and from then on his exhibits and his publications were largely based on subjects sketched on his tours abroad, which were much more adventurous than his relatively limited tours in the British Isles.

Prout's 1819 tour took him to Normandy and Paris, and the Gothic churches and public buildings and the elaborate and often rickety urban houses of Normandy were to become one of the favourite themes of his exhibits and publications. Half of his seventeen Old Water-Colour Society exhibits in 1820 were of Normandy subjects, and in 1821 Prout published a series of eight lithographs entitled *Picturesque Buildings in Normandy*. This was Prout's second lithographic publication, and from now on the majority of prints after his drawings were produced by lithography, which reproduced his elaborate architectural compositions with great accuracy. This new technique, based on drawing on very smooth stone with greasy chalk or with ink, was invented in France by Alois Senefelder in 1798, and introduced into England in 1801. Lithography was particularly suitable for the reproduction of drawings and watercolours.

A second Normandy tour in 1820 was followed in 1821 by Prout's first visit to Germany, where the Rhineland and later also Bavaria and Saxony were to provide ample material for the picturesque architectural subjects that brought the artist most acclaim, sales and commissions. In 1824 a tour in Switzerland and Italy broadened the scope of Prout's subject matter, and his continental tours continued at intervals until 1846, though by then the fashion for his drawings and prints had waned, partially, no doubt, because of the growing impact of photography.

Street View with St Laurent, Rouen [PL.62] probably dates from the 1820s and illustrates Prout's skill in including a great deal of finicky detail, often outlined with a reed pen, in a composition that is balanced and attractive as a whole. These rather stylised Normandy compositions owed much to the example of Henry Edridge (1769–1821), a brilliant draughtsman who had visited Normandy two years before Prout, and showed several Normandy watercolours at the Royal Academy in 1819 and 1820. Edridge's death in the following year left that route open for Prout, whose elaborate pencil drawings were in their turn to have some influence on the early Normandy drawings of R. P. Bonington, who is said to have sketched with Prout in Normandy in 1822. There is no concrete evidence of this, but Prout certainly befriended the younger artist, and was one of his executors. The work of the two men was seen in the same exhibition at the renowned so-called 'English Salon' in Paris in 1824, in which Constable's *Hay Wain* was also shown. This was exhibited by the dealer John Arrowsmith, who

also showed four of Prout's watercolours, three of them of German subjects. He had purchased these earlier in the year at the OWCS Exhibition, to which Prout sent twenty-eight drawings, all of which were sold. Among the distinguished buyers were the Duke of Norfolk, Lord Brownlow, and the sculptor, Francis Chantrey. The attractive composition of *Ulm Cathedral: View from the West Porch* [PL.63] probably dates from about this time, and demonstrates Prout's fluent ability to combine overall effect with picturesque detail.

In 1824 Prout visited Italy for the first time, and from then on Italian, and especially Venetian, scenes also featured frequently among his exhibits and publications. The 1820s and 1830s were prosperous years for Prout, who was appointed Painter in Water-Colours in Ordinary to His Majesty by George IV in 1829, by William IV in 1835, and the honour was renewed by Queen Victoria in 1837, the year of her accession. It seems that Prout was the first artist to hold this Royal appointment, and that this may have been created for him. The 1830s saw the publication of a variety of annuals, illustrated with small and precise steel engravings, devoted solely to landscape. Of these the *Landscape Annual*, published by Robert Jennings, was both the first and the longest-lived, appearing each year from 1830 to 1839. It says much for Prout's outstanding reputation that he was commissioned to provide drawings for all the plates for the first two volumes in this series, *The Tourist in Switzerland and Italy* in 1830 and *The Tourist in Italy* in the following year. These popular volumes spread Prout's reputation even more widely, and it was further enhanced in the artist's closing years by the enthusiastic friendship and praise of the young John Ruskin. In 1844 Prout moved to his final home, in Denmark Hill, and became a neighbour of the Ruskin family. From then on he was a regular guest at John Ruskin's annual birthday parties, and died within a few hours of attending one of these in February 1852. Turner was also a frequent guest at these parties, and the two artists must have known each other quite well. There could hardly be a greater contrast than that between their mature work, but it should be remembered that Ruskin's support of Prout came second only to his praise of Turner. This was no doubt one of the principal reasons for a revival in Prout's reputation in the decades after his death, but in modern times his work, and Ruskin's praise of it, are largely neglected.

In contrast to this David Roberts has enjoyed a great revival of popularity in recent years, largely because much of his subject matter was Middle Eastern. He is included in this section because his watercolours of the Holy Land and the lithographs taken from them are his most lasting contribution to the topographical art of his day. Thirteen years younger than Prout, David Roberts was born in Edinburgh of humble stock, and began his working life as a house-painter, from which he graduated to scene-painting in Glasgow and Edinburgh, where he met the rising London scene-painter Clarkson Stanfield (1793–1867) in 1820. Two years later he sailed to London to join Clarkson Stanfield, with whom he formed a most successful partnership. However, both artists had their sights set on higher things than the lowly career of scene-painting, and in the 1820s they began to paint and exhibit oil paintings, at first largely at the newly formed Society of British Artists, and then more regularly at the Royal Academy, of which both ultimately became honoured Members.

David Roberts was a man of many parts – house-painter, scene-painter, architect,

(63) Samuel Prout, *Ulm Cathedral: View from the West Porch* (*c.*1824). Watercolour and bodycolour; 54.6×41.6 cm. (Victoria and Albert Museum, London)

painter in oils, watercolour artist and topographical draughtsman – and his rapid rise in a varied career reflects the great changes that overtook the world of art in the capital and elsewhere in Britain in the post-Napoleonic era. No longer was an interest and involvement in art largely confined to the aristocracy and gentry, but a far wider public took advantage of the greater availability of art, as exhibitions, commercial galleries and publications increased. Among the varied art spectacles that developed during these years were panoramas, dioramas and the like,[33] and David Roberts was also active in the production of several of these.

In both his oils and watercolours Roberts achieved impressive compositions though using only muted colours and abbreviated detail. His topographical work combined something of the solidity of Prout with the fluidity of Turner, and like both these artists he enlivened his pictures with well-observed and attractive figure groups. Roberts travelled abroad, to Normandy, for the first time in 1824, and from then on he visited Northern Europe almost every year. On his travels he made hundreds of on-the-spot sketches, many of them coloured. His first extended tour was in Spain and Morocco for nearly a year in 1832 and 1833. There was at the time a growing fashion for Spanish art and architecture, and from then on he concentrated for some years on Spanish subjects in his oils and watercolours, and these greatly enhanced his reputation. He was involved in a surprisingly large number of books featuring Spain, including four volumes of Jennings's *Landscape Annual* from 1834 to 1838, and a more ambitious volume of thirty-seven lithographs, *Picturesque Sketches in Spain,* published in 1837. The intricate detail of Spanish Gothic and the powerful Moorish architecture of southern Spain provided Roberts's somewhat theatrical style with ideal subject matter. This can be seen in the telling watercolour of *The Grand Staircase, Burgos Cathedral* [PL.64], dated *1836* and engraved as one of the plates in the *Landscape Annual* of 1837.

The success of his Spanish exhibits led to Roberts's election as ARA in 1838, no mean achievement for an entirely self-taught artist who had started life as a house-painter. Later that year the artist began the most ambitious and most significant of all his tours and travelled extensively for eleven months in the Near East – visiting Egypt, Syria, the Holy Land, Jordan and Lebanon. This arduous journey in an area as yet little explored by topographical artists was the turning point in Roberts's career. He exhibited five Near Eastern scenes at the Royal Academy in 1840, was elected RA, and cemented his standing as *the* artist of the Bible lands by the publication of *The Holy Land and Egypt,* a series of 248 lithographic plates issued in forty-one parts between 1842 and 1849. This justly famous work was published by F.G. Moon, and Roberts's atmospheric and often delicate drawings were skilfully reproduced by Louis Haghe (1806–85), the one-handed Belgian-born lithographer and watercolour artist. For this major undertaking Roberts completed a new set of drawings from the sketches he had made on his tour, and he was paid £3000 for the use of these. In the Near East Roberts was inspired as much by the landscape as by the monuments and architecture, as is seen in the view of *Jerusalem from the Mount of Olives* [PL.65], one of the lithographs from *The Holy Land.*

Though now in his mid-fifties and enjoying great popular success, David Roberts continued his travels in search of new subject matter, visiting Italy for the first time in 1851, and then more extensively two years later. From then on the majority of his Royal Academy exhibits were of Italian subjects, many of them of Rome, but there were to be

(64) David Roberts, *The Grand Staircase, Burgos Cathedral* (1836). Watercolour and bodycolour; 35.6×27.9cm. (Whitworth Art Gallery, University of Manchester)

(65) David Roberts, *Jerusalem from the Mount of Olives, April 8, 1839*. Lithograph; 22.5×32.3cm. Plate 13 in Vol.I of *The Holy Land*. (Victoria and Albert Museum, London)

no publications with illustrations after his Italian studies. The demand for such series of topographical engravings and lithographs had largely ceased, another result of the invention and development of photography.

The announcement of Louis Daguerre's invention of the Daguerreotype in Paris, in January 1839, was rapidly followed by the introduction of further discoveries, including those of the English astronomer Sir John Herschel, who read a paper 'On the Art of Photography' to the Royal Society on 14 March. The most famous of the English pioneers of photography, W.H. Fox Talbot, published the first book with photographic illustrations, *The Pencil of Nature*, in 1844. Photographs of various types were shown at the Great Exhibition of 1851, and the growing interest in this new phenomenon was summed up as follows in an article entitled 'Recent Discoveries in Photography' in the first volume of the *Illustrated Exhibitor and Magazine of Art*, which appeared in January 1852: 'One of the most interesting discoveries of the present day, is that of taking pictures, whether landscape or portrait, by means of light. The most truthful and expressive term for these is "sun-pictures"; and although the sun is not a member of the Royal Academy, and therefore cannot attach RA to his name, yet nowhere can we find more faithful and truthful representations than those taken by this really great artist.'

The work of the topographical artist and of the miniaturist was hardest hit by photography, and in the event many practitioners of these art forms were among the earliest professional photographers in the 1850s and 1860s. However, such established artists as David Roberts and Clarkson Stanfield were not seriously affected, though both of them quickly learnt to adjust by adding more sentiment and narrative to their later landscape compositions. The same development took place in the work of other topographical artists who had been involved with the *Landscape Annuals* and similar publications. Among these were Anthony Vandyke Copley Fielding (1787–1855), J.D. Harding (1797–1863), and James Holland (1799–1870). Copley Fielding, a member of a family of artists, specialised in marine subjects and coastal scenes, and was also one of the British artists represented in the 1824 Paris Salon. He was a prolific exhibitor at the OWCS, of which he became President in 1831. J.D. Harding was taught by Samuel Prout, and like him travelled extensively in Europe. He himself became a renowned drawing master, numbering John Ruskin among his pupils and publishing several influential drawing manuals. Some of these were illustrated with lithographs, a technique which he practised with proficiency. James Holland was born at Burslem and began his working life as a flower painter in a ceramics factory. He moved to London in 1819, and began to paint and draw landscapes. He too travelled extensively on the Continent, and his colourful paintings and watercolours of Venice were especially sought after. These were vividly described by J.L. Roget as displaying 'his greatest power in the assortment of rich and radiant hues. The gem of the Adriatic inspired him with the poetry of the palette...'[34] The much greater use of strong colour in the depiction of landscape in the second half of the nineteenth century was certainly also due to the rivalry of photography. During these years most landscape photographs were printed in sepia, giving an effect not far removed from palely painted landscapes. Practical colour photographs were not known until the final decade of the century, and, thus, by enhancing their colours, painters of landscape could most easily answer the challenge of the photographer.

Notes to Part Two

1 *Farington Diary*, 12 November 1798

2 See Andrew Wilton, 'The "Monro School" Question: Some Answers', in *Turner Studies*, Vol.4, No.2 (1984), pp.8–23

3 *Farington Diary*, 21 January 1799

4 Jean Hamilton, *The Sketching Society, 1799–1851*, Victoria and Albert Museum, 1971

5 T.Girtin and D.Loshak, *The Art of Thomas Girtin*, 1954, pp.74–6

6 For full details of the history of the panorama see Ralph Hyde, *Panoramania*, Barbican Art Gallery, London, 1988

7 L.Stainton, *British Landscape Watercolours, 1600–1860*, British Museum, London, 1985, No.84

8 Samuel and Richard Redgrave, *A Century of British Painters*, new edn, 1947, pp.154 and 159

9 S.D.Kitson, *The Life of John Sell Cotman*, 1937, p.78

10 Kitson, loc.cit., p.80

11 A.P.Oppé, 'Francis Towne – Landscape Painter', in *The Walpole Society*, VIII (1919–20), pp.95–126

12 Kitson, loc.cit., p.99

13 Adele M.Holcomb, *John Sell Cotman in the Cholmeley Archive*, North Yorkshire County Record Office, 1980, pp.50–3

14 Andrew Hemingway, 'Cotman's "Architectural Antiquities of Normandy": Some amendments to Kitson's account', in *The Walpole Society*, XLVI (1976–8), pp.164–85

15 C.M.Kauffmann, *John Varley*, Victoria and Albert Museum, London, 1984, p.13

16 Kauffmann, loc.cit., p.50

17 For an excellent survey of the development and importance of Drawing Manuals see: Peter Bicknell and Jane Munro, *Gilpin to Ruskin – Drawing Masters and their Manuals, 1800–1860*, Fitzwilliam Museum, Cambridge, 1987

18 Hammond Smith in his 1982 monograph on de Wint has attempted a chronology, and suggests dates for many of the works reproduced

19 For a radical revision of our knowledge of how Blake produced his illuminated books see Joseph Viscomi, *Blake and the Idea of the Book*, 1993

20 *The Complete Writings of William Blake*, ed. Sir Geoffrey Keynes, 1957, p.795

21 Martin Butlin, *The Paintings and Drawings of William Blake*, 1981, Vol.I, p.411

22 Martin Butlin, *William Blake*, Tate Gallery Exhibition, 1978, No.216

23 *The Letters of Samuel Palmer*, ed. Raymond Lister, 1974, Vol.I, p.8

24 *Samuel Palmer's Sketch-book – 1824*, facsimile edn, published by the Trianon Press for the William Blake Trust, 1962

25 *Letters*, p.47

26 *Letters*, p.115

27 *Letters*, p.113

28 *Letters*, p.146

29 Raymond Lister, *Catalogue Raisonné of the Works of Samuel Palmer*, 1988, p.8

30 *Letters*, p.970

31 For a full list of Prout's exhibits see Richard Lockett, *Samuel Prout*, 1985, pp.176–87

32 This was reproduced in reverse as plate 13 of Prout's *Studies of Rural Scenery*, published by Ackermann in 1816

33 See Richard Altick, *The Shows of London*, 1978

34 J.L.Roget, *A History of 'The Old Water-Colour' Society*, Vol.II, 1891, p.252

Part Three

Painters of Landscape

According to the *Oxford English Dictionary* the word 'landscape' was introduced into the English language early in the seventeenth century as 'a technical term of painters'. Surprisingly the first definition of 'landscape' given in the 1971 edition of the *OED* refers to painting; it is 'a picture representing natural inland scenery, as distinguished from a sea picture, a portrait, etc.'. Only the third definition in the dictionary refers to the major modern usage of the word, 'inland natural scenery', and even then 'or its representation in painting' is added as a corollary. However, despite the apparent linguistic importance of the genre, the actual painting of landscape was usually given a lowly status in Britain throughout the nineteenth century. Nevertheless, the three major artists who feature in Part Three – Turner, Constable and Bonington – were all primarily landscape artists and are today considered the outstanding British painters of the first half of the century. It must, however, be remembered that during these years, both in Britain and on the Continent, painters of landscape were on the whole not highly regarded by their fellow artists, and it was only very recently that a landscape painter was elected as President of the Royal Academy. This was Sir Roger de Grey (1918–95), who was PRA from 1984 to 1993.

10 J.M.W. Turner, RA (1775–1851)

J.M.W. Turner began his career as a watercolour artist, and throughout the sixty years of his working life watercolours were a central element of his practice and development as an artist. Turner's public career was focused on the Royal Academy, and it was in order to achieve membership that the young watercolour artist began to paint in oils, for though watercolours could be exhibited at the Royal Academy it was impossible for a painter to become a Member unless he also exhibited oils. However, it is essential for an understanding of Turner's art to remember that his training was largely as a topographical artist in watercolours, and that his early progress as such coincided with a time when the greatest advances in British landscape art were being made in that medium.

Joseph Mallord William Turner was born in Covent Garden, the son of a barber, and London remained his home throughout his life. In 1775, the year of his birth, the American War of Independence had just begun, and the Royal Academy in London under the Presidency of Sir Joshua Reynolds was only seven years old. When Turner

died, in December 1851, Napoleon III was seizing power in France, the Great Exhibition had taken place, and Sir Charles Eastlake had recently been elected sixth President of the Royal Academy. In the year of Turner's birth the Norwich coach was waylaid in Epping Forest by seven highwaymen; by the time of his death the chief main lines of the modern railway system of England had been largely completed or authorised. In every sphere Turner's life-span was a period of tremendous change and development. Though Turner's art reflected the spirit of progress of these years, its roots were in the traditions of the eighteenth century, and, as will be seen, those traditions always remained an essential element of his life and work.

Little is known about Turner's early education, but it must have laid good foundations, for in later life Turner read widely, and showed familiarity with mythology, classical history, English literature and poetry, and much more.[1] There are many tales about Turner's precocity as an artist, and the earliest drawings by him in the Turner Bequest are dated 1787. It is interesting to note that among these early drawings are copies after prints by William Gilpin and Paul Sandby, an indication that he was well informed in the most up-to-date developments in topographical art. In 1789 Turner was employed as a draughtsman in various architectural offices, and by the end of that year he was studying with Thomas Malton the Younger (1748–1804), one of the leading architectural draughtsmen of the day, whose precise and effective style he quickly adopted. In December Turner was admitted as a student at the Royal Academy Schools, where he continued for some four years, making figure drawings, at first only from plaster casts of classical sculpture, but from June 1792 also in the 'Life Academy' from nude models. The techniques of painting in oils were not taught at the Royal Academy Schools until much later.

Thus Turner was still a student when he began to exhibit topographical watercolours at the Royal Academy in 1790, showing a single drawing, *The Archbishop's Palace, Lambeth*, now in Indianapolis. This reflects the influence of Paul Sandby as well as demonstrating Turner's early mastery of complex problems of perspective. His progress as a topographical artist was rapid and impressive; he undertook sketching tours in many parts of Britain and soon began to receive lucrative commissions from major patrons for drawings of specific places and buildings, while he was also beginning to work for the engravers. He now exhibited watercolours regularly at the Royal Academy – as many as ten in 1796, the year in which he also showed his first oil painting, *Fishermen at Sea*, which is now in the Tate Gallery.

In his early tinted watercolours Turner quickly mastered all the current fashions, and developed a style and manner of his own, which encompassed the example of older contemporaries such as J. R. Cozens, Edward Dayes and Thomas Hearne, and also showed the influence of several earlier artists, including Rembrandt, Piranesi and Canaletto. Turner's ability to emulate and assimilate so many different influences was part of his genius. To this he added an outstandingly gifted eye for composition and atmosphere, so that by the time he was in his mid-twenties the exceptional quality of his exhibition watercolours was rivalled only by those of his almost exact contemporary Thomas Girtin. As already described, the two young artists were brought together by Dr Thomas Monro,[2] and it was at the doctor's house that Turner was able to study drawings and prints by many of the artists who influenced him.

One of Turner's principal patrons during these formative years was Sir Richard Colt Hoare, of Stourhead in Wiltshire, who commissioned a series of views of Salisbury Cathedral in 1795. The striking *South View from the Cloisters, Salisbury Cathedral* [PL.66], which dates from about 1802, shows how far Turner had advanced from the conventional architectural compositions of the day. When visiting Stourhead Turner would have been able to study the famous classically inspired landscape gardens as well as the notable collections, which included landscape paintings by Richard Wilson and others, prints by Piranesi, and the thirteen large and impressive watercolours by the Swiss landscape artist Louis Ducros (1748–1810) recently acquired by the Baronet. In his *History of Modern Wiltshire*, published in 1822, Colt Hoare claimed that 'the advancements from *drawing* to *painting* in water-colours did not take place till after the introduction into England of the drawings of Louis du Cros'. Much has been made of this claim, though to modern eyes its seems somewhat exaggerated.[3] However, in the case of Turner there can be little doubt that the cultured atmosphere and surroundings of Stourhead as a whole, and the works of Ducros in particular, made a forceful impression, and were a major factor in stimulating the artist's exceptionally rapid development in his early twenties.

Many other factors were also involved, not least among them Turner's extensive travels in England and Wales, during which he made numerous pencil sketches of all kinds of scenery and buildings. Turner never travelled without a variety of sketchbooks – large and small – to hand, and throughout his career thousands of such on-the-spot studies, combined with his remarkable visual memory, provided the raw material for his finished works. In the early years the close observation that they demanded enhanced the artist's understanding of architecture and landscape, and, as with Girtin, gradually it was the latter that became the dominant interest. Thus at the end of the century Turner's art also developed from topography to pure landscape, as is seen especially in his work in Wales, which he visited five times between 1792 and 1799. Among the many Welsh subjects that he exhibited at the Royal Academy during these years was *Abergavenny Bridge, Monmouthshire: Clearing up after a showery Day* [COL. PL.16]. Shown in 1799, and probably executed for Thomas Lawrence, this beautifully composed and atmospheric view demonstrates how similar the work of Turner and Girtin was at this time.

While his watercolour art reached these heights and resulted in ample new commissions, including, in 1798, a most prestigious one from the Oxford University Press for a series of Oxford scenes for engraving on copper as the headpieces of the annual *Oxford Almanack*, Turner also developed his skills in oil painting. Though most of his early exhibited oil paintings were clearly eclectic in style, here also he quickly established his reputation and was elected an Associate of the Royal Academy in 1799, becoming a full Member at the earliest possible age in February 1802. This promotion was a significant achievement for the young cockney-born artist. Throughout his long career Turner remained a loyal and constant exhibitor, officer and supporter of the Royal Academy, which was the focus of his artistic and social life. The main influences on Turner's early oil painting were Claude, Richard Wilson, Cuyp and Poussin in landscape, and Willem van de Velde the Younger in his marines. Nearly half of the paintings which Turner showed at the Royal Academy from 1796 to 1802 were marine or coastal

(66) J.M.W. Turner, *South View from the Cloisters, Salisbury Cathedral* (*c*.1802). Pencil and watercolour; 68×49.6cm.
(Victoria and Albert Museum, London)

scenes, and his first major commission for an oil was from the Duke of Bridgewater, for a pendant to his large Van de Velde seascape, *A Rising Gale,* at Bridgewater House. Turner's huge canvas, *Dutch Boats in a Gale: Fishermen endeavouring to put their Fish on Board* (Private Collection; on loan to the National Gallery, London), became the picture of the year when shown at the Royal Academy in 1801, but was somewhat coolly received by the critics, who complained of its lack of finish and carelessness.

In the summer of 1802 Turner was one of many British artists to take advantage of the short-lived Peace of Amiens, and paid his first visit to the Continent, travelling through France and Switzerland, and returning home via Paris. He was abroad for three months in all, and the greatest impact of his journey was the experience of seeing the awesome scenery of the Alps. His love of mountains had been stimulated by his travels in Wales and more recently, in 1801, in Scotland, and mountain scenery always remained one of his favourite subjects. After his return to London Turner worked hard to prepare for the 1803 summer exhibition, his first as an RA. He showed five oils and two ambitious watercolours, all inspired by his continental travels and certainly carefully chosen by the artist to demonstrate the breadth of his capabilities. The two watercolours and two of the paintings were of Alpine views. While both the Alpine oil compositions were of placid scenes at Bonneville in Savoy, reminiscent of Poussin and contrasting the dominating grandeur of the mountains in the background with the quiet summer scenery at their base, the two watercolours record scenes up in the mountains in stormy weather conditions. In *The Mer de Glace and the Source of the Arveron, Chamonix* [PL.67] there is a wonderful sense of immediacy and movement in the depiction of the stormy weather and trees, rendered by the skilful use of the pen or point of the brush, while the highlights – the snow, the clouds and the goats – are achieved by leaving the white paper bare, and by scratching out. This watercolour, like others based on the experiences of this tour, demonstrates Turner's experimental and innovatory methods and his total mastery of the medium.

Equally atmospheric and masterly is the well-known *Calais Pier, with French Poissards preparing for Sea: an English Packet arriving* [PL.68]. This dramatic seapiece records Turner's own experiences when arriving at Calais at the end of his first Channel crossing, in a storm. The vivid effects of light and atmosphere of the *Calais Pier* provided a striking contrast with the classical calm of the fourth of the 1803 oils, *The Festival upon the Opening of the Vintage at Macon,* now in Sheffield City Art Gallery. The broad and balanced composition of this huge canvas is closely related to the great Claude at Petworth, *Landscape with Jacob and Laban.* Lord Egremont, the owner of Petworth, was to become one of Turner's leading patrons and friends, and it is possible that the artist adapted the composition of the Petworth Claude in order to attract the Earl's interest. It was certainly at about this time that Lord Egremont began to purchase paintings by Turner, of which he finally assembled twenty, all of which are still at Petworth today.[4]

Turner's fifth 1803 exhibited oil was the most unexpected of all, for the *Holy Family* is a small religious painting, strongly influenced by Titian, whose works at the Louvre Turner had studied closely while in Paris. Napoleon's great assemblage of Old Masters from all over the Continent was to be seen in the Louvre at this time, giving Turner and the many other British artists visiting Paris their first opportunity to study their work in

(67) J.M.W. Turner, *The Mer de Glace and the Source of the Arveron, Chamonix* (RA 1803). Watercolour and pencil, with scraping out; 70.6×103.8 cm. (Yale Center for British Art, Paul Mellon Collection)

(68) J.M.W. Turner, *Calais Pier, with French Poissards preparing for Sea: an English Packet arriving* (RA 1803). Oil on canvas; 172×240 cm. (National Gallery, London)

depth. The *Holy Family* is now in the Tate Gallery, for, like, more surprisingly, *Calais Pier*, it was never sold and formed part of the Turner Bequest. Throughout the artist's career many of Turner's Royal Academy exhibits failed to sell, and thus were still in his studio when he died. Sometimes this was because Turner did not wish to sell a canvas, but more often it was because there were no buyers.

As Joseph Farington recorded in several entries in his *Diary* in the spring of 1803, Turner's varied exhibits caused widespread interest among connoisseurs and fellow artists, but most of their comments were critical. Thus the portrait and history painter James Northcote is reported as stating that 'His pictures had produced more effect from their novelty than they were entitled to: that they were too much compounded of Art & had too little of Nature: that they consisted of parts gathered together from various works of eminent Masters'.[5] Such comments were certainly justified, but there can be no doubt that with this remarkable group of exhibits in 1803 Turner succeeded in justifying his early election as an RA, and in establishing his position as the leading young artist of the day. However, the Royal Academy was going through a disruptive period at this time, and there were fears for its survival. This was probably one of the reasons why Turner now began to build a gallery, 70 ft long and 30 ft wide, for the exhibition of his own work at his house in Harley Street. He opened the first exhibition there in April 1804, and continued to hold exhibitions there and in its successor in Queen Anne Street at irregular intervals until the early 1820s.

Except in 1805, 1821, 1824 and 1848, Turner was represented every year in the Royal Academy Summer Exhibition, and from 1806, the year of its foundation, he was also a fairly frequent exhibitor at the British Institution. At the same time he continued to make drawings for engraving, most notably in these early years for the books of the Lancashire antiquarian Dr Thomas Whitaker.[6] From now on his work for publishers and engravers became increasingly important for Turner, and during his lifetime he was involved in the production of some 900 prints based on his paintings, watercolours and drawings. The first engraving after one of his paintings was Charles Turner's fine mezzotint of *The Shipwreck,* the great seapiece exhibited in his own gallery in 1805. After much delay this was published on 1 January 1807, and later that year Turner became his own publisher and launched the ambitious *Liber Studiorum.* This was planned as a series of 100 mezzotint engravings to be published at regular intervals in Parts of five plates, issued without a text. In fact only fourteen Parts were completed, the last dated 1 January 1819, and there were often long intervals between the Parts.

Though certainly emulating the publication of Claude's renowned *Liber Veritatis,* beautifully reproduced in mezzotint by Thomas Earlom in the 1770s, Turner devised his own *Liber* not as a personal record of his actual paintings but as a didactic series, which, as well as providing a platform for his theories of landscape art, gave much wider publicity to his skills as a landscape artist than exhibiting in London could ever do. He divided the engravings into specific categories under the following headings: Historical, Mountainous, Pastoral, Marine and Architectural, designated by an initial in the centre of the upper margin of each plate. An additional category, EP, was added to these five and has been variously interpreted as Epic, Elegant, Elevated or Elegiac Pastoral. Whatever the correct interpretation, the fifteen compositions ultimately published under the heading EP have in common their Claudian characteristics. Part I of

the *Liber Studiorum* included an example of all but one of these categories, and set the pattern for the subsequent parts. Turner himself etched almost all the outlines of these plates, and in eleven cases he himself also carried out the mezzotint engraving.

He kept a very firm control over the production of the whole series, and the experience thus gained in working with a number of engravers stood him in good stead when he was engaged in the great topographical and illustrative series of copper and steel engravings after his drawings in the two decades from about 1816 to 1838. Turner's work for engraving was a central factor of his art, which has been too much neglected in modern times.[7] Not only did the engravings add enormously to his fame and reputation, but the commissions he received often provided the impetus for visiting new areas at home and abroad. In addition these prints, many of them on a tiny scale, gave him the opportunity for compositional experiments and developments, which he usually carried out in watercolours. One of the outstanding features of the engraved work after Turner is the subtle and successful conversion of his coloured designs into black and white prints. This success owed a great deal to Turner's close control and supervision of the craftsmen during all stages of the engraving and printing processes, and it has been rightly claimed that the high standards and international reputation achieved by British engravers on copper and steel in the 1820s and 1830s were in no small measure due to the impact and influence of Turner on so many of them.

Turner's relationship with his engravers was only one example of his natural teaching skills. Though he never had pupils and (in his last years) only one assistant in his studio, he often demonstrated some of his techniques in public, when he was putting the finishing touches to his canvases on Royal Academy varnishing days. In later years he sent in paintings that were barely started, and he then rapidly completed his compositions on the gallery walls in front of an eager audience of fellow artists. Little is known about Turner's activities when he was taking his turn as a Visitor in the Academy Schools,[8] but when he was elected as the Royal Academy's Professor of Perspective in 1807 he became reponsible for a more formal element of the students' training.[9] He took great pains to prepare his lectures, and was not ready to give his first course of six lectures until 1811. After that he delivered at least eleven further courses, the last in 1828, and he finally resigned from the chair in 1837. Turner's lectures were given a mixed reception; it was generally agreed that his delivery was appalling, but that his illustrative diagrams and drawings, many of them still preserved in the Turner Bequest, were superb. It is only in recent years that the actual lectures, the manuscripts of which are in the British Library, have received close study and they have still to be published. They were certainly of great importance to Turner himself, and provide ample evidence of his wide reading of relevant texts, of his detailed knowledge of earlier landscape painting, and of his very distinctive thinking and practice in matters of linear perspective. At this time landscape painting had no role in the courses at the RA Schools, and Turner used his lectures to reinforce his plea that landscape should be given its proper place. At the time of his first perspective lectures Turner was, in fact, making proposals for the establishment of a Professorship of Landscape Painting at the Academy.[10]

Despite all these additional activities his painting did, of course, remain the cen-

(69) J.M.W. Turner, *Fall of the Rhine at Schaffhausen* (RA 1806). Oil on canvas; 148.5×239.8 cm. (Museum of Fine Arts, Boston)

tral factor of Turner's working life, and during these formative years he gained several important new patrons. Among these was Sir John Leicester, later Lord de Tabley (1767–1827), who was one of the leading collectors of contemporary British painting in the early nineteenth century and who purchased the 1805 *Shipwreck* for £315. Two years later Sir John returned this in part exchange for the huge and dramatic *Fall of the Rhine at Schaffhausen* [PL.69], which was the only painting that Turner showed at the RA in 1806. This broadly painted composition, depicting a storm raging above the angry waterfall, was badly hung and was savagely attacked by many critics. On the other hand they were almost unanimous in their praise of *Village Politicians*, the first Royal Academy exhibit of the young Scottish artist David Wilkie, who had recently arrived in London. Turner's reaction was somewhat petty and demonstrates both his single-minded ambition to succeed and his relative lack of self-confidence. In the following year he exhibited two paintings, both reminiscent of seventeenth-century Netherlandish art. The first of these, the uncharacteristic *A Country Blacksmith disputing upon the Price of Iron, and the Price charged to the Butcher for shoeing his Poney* (Tate Gallery, London), was a placid rural genre scene in the manner of Teniers, but certainly inspired by Wilkie's success in the previous year. Equally calm but far more in keeping with Turner's normal subject matter was the wonderfully atmospheric shore scene *Sun rising through Vapour; Fishermen cleaning and selling Fish* (National Gallery, London). Both these works were relatively well received by the critics, and both were ultimately acquired by Sir John Leicester, only to be bought back by Turner at the De Tabley sale in 1827.

The calm atmosphere of these two paintings was repeated in the majority of Turner's exhibits in the next few years, though some of his marines still featured choppy

(70) J.M.W.Turner, *Windsor from Lower Hope* (c.1807). Oil on panel; 32.1×73.7 cm.
(Tate Gallery, London)

and even stormy seas. It was probably during the summer of 1805 that Turner made a series of large oil sketches on canvas and smaller ones on mahogany-veneered panels, mostly direct from nature, along the rivers Thames and Wey, as well as many water-colour studies of the same area.[11] In 1805 he rented Sion Ferry House, on the river at Isleworth, and it seems probable that he kept a boat on the Thames, and that it was from this that he made many of the sketches, including the panoramic view of *Windsor from Lower Hope* [PL.70], with its rapidly painted threatening sky. One of the few Turner Gallery exhibitions of which we have detailed knowledge, thanks to John Landseer's lengthy review in the second issue of his short-lived *Review of Publications of Art,* is that of 1808.[12] Seven of the twelve paintings in that exhibition were scenes on the Thames, including the harmonious and evocative *Pope's Villa at Twickenham* [PL.71], which was bought from the exhibition by Sir John Leicester. This was reported by Landseer, who described the painting as 'not merely a portrait of this very interesting reach of the Thames, but all that a poet would think and feel on beholding the favourite retreat of so great a poet as Pope, sinking under the hand of modern improvement'.

In the following year Turner's four exhibits at the Royal Academy included a remarkable pair of views of Tabley House, the Cheshire seat of Sir John Leicester. Sub-titled 'Windy Day' and 'Calm Morning', these both feature the lake, with its striking round tower, in the foreground, while the great Carr of York house is only seen on the skyline. These canvases were very well received and led to several further commissions for country house portraits, in which Turner also depicted the setting rather than the actual house. While such paintings are again somewhat eclectic in that they were clearly influenced by the work of Aelbert Cuyp, they also demonstrate how successfully Turner could now depict the true feel of English landscape in a finished oil painting, something he had been achieving in his watercolours for several years.

Though Sir John Leicester was such a constant patron, Turner's relationship with him was never a close one. On the other hand the Yorkshire landowner, Walter Fawkes (1769–1825) of Farnley Hall, who bought his first Turner watercolour in 1803, became one of the artist's few close friends, and was certainly his most important patron; by

(71) J.M.W. Turner, *Pope's Villa at Twickenham* (1808). Oil on canvas; 91.5×120.6cm.
(Trustees of the Walter Morrison Picture Settlement)

the time of his death he owned six oil paintings and over 250 watercolours by Turner. *Bolton Abbey from the North* [PL.72], which is dated 1809, was one of ten watercolours purchased by Fawkes early that year for £100. It is based on one of the group of ten large pencil drawings in the Turner Bequest which the artist made during his first visit to Farnley in 1808. From then on until 1824 Turner was entertained at Farnley nearly every year, and treated almost as a member of the family, with a room permanently reserved for him. Here 'he shot and fished and was as playful as a child', and drew and sketched inside and outside the house and in the lovely surrounding countryside, especially the Wharfe and Washburn valleys; here he made his attractive watercolour studies of birds for the family's 'Ornothological Collection'.[13] Walter Fawkes, as well as his family and his beautiful home, played a very special role in Turner's life, and it says much for the artist's sensitivity that after his patron's death he never again visited Farnley, though he did keep in touch with the family.

In addition to his regular visits to Yorkshire, Turner continued to travel to other parts of the country, usually in connection with commissions for paintings of houses or for watercolours for topographical series. Thus in the summer of 1811 he toured Dorset, Devon and Cornwall to collect material for his drawings for the Cooke brothers' ambitious publication *Picturesque Views on the Southern Coast of England*, of which the first Parts were issued in 1814, but which was not completed until 1826 with a total of forty engravings based on watercolours by Turner. After the long enforced delay caused

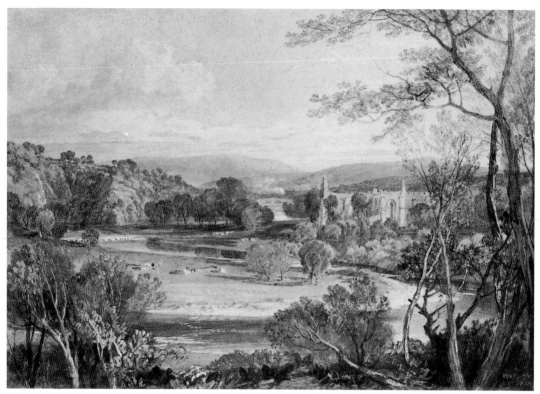

(72) J.M.W. Turner, *Bolton Abbey from the North* (1809). Watercolour and scraping out; 27.8×39.5 cm. (British Museum, London)

by the Napoleonic Wars it was not, however, until 1817 that Turner travelled abroad again, spending just over a month touring in the Netherlands, including a visit to the battlefield at Waterloo, and along the Rhine. On his return he visited Raby Castle in County Durham, collecting material for his beautiful painting of the Earl of Darlington's seat, which was exhibited at the Royal Academy in 1818 and is now in Baltimore. From Raby Castle Turner moved on to Farnley, where he made or completed a set of fifty small finished studies of views on the Rhine, which were bought by Walter Fawkes for £500.[14] Executed in watercolours and bodycolours on white paper prepared with a grey wash, and using a variety of techniques, these were long thought to have been studies made during Turner's tour, and possibly on the spot. The drawings of this deservedly famous series, now dispersed all over the world, are varied in size, format, and above all in mood, and though, except perhaps for the pencil outlines, definitely executed at Raby and Farnley, retain the freshness and directness of on-the-spot sketches.[15]

Another product of Turner's 1817 tour also found a permanent home at Farnley; this was the great *Dort, or Dordrecht, the Dort Packet-Boat from Rotterdam becalmed* [COL. PL.17], now at Yale, which was the second of Turner's three 1818 RA exhibits, and which Fawkes bought at the exhibition for 500 guineas. Clearly painted in homage to the marines of Aelbert Cuyp, a native of Dordrecht, this luminous composition with its calm and atmospheric sky, was also conceived of by Turner as a challenge to his

younger contemporary and follower, Augustus Wall Callcott (1779–1844), one of whose masterpieces, the *Entrance to the Pool of London*, had been especially well received, and much admired by Turner himself, at the Royal Academy of 1816. The quiet beauty of *Raby Castle* and *The Dort* were in striking contrast to Turner's third exhibit that year, the dark and dramatic *The Field of Waterloo*, now in the Tate Gallery. As was usual all three paintings were given a somewhat mixed reception by the critics, though *The Dort* was described as 'one of the most magnificent pictures ever exhibited, and does honour to the age' in the *Morning Chronicle*. Today this celebrated picture is rightly regarded as a key work in Turner's progress towards his mature achievements as a master of colour and light.

Turner also showed one watercolour in 1818, the large and very classical *Landscape: Composition of Tivoli* (Private Colleton), which must have been inspired by his contact with the architect, James Hakewill (1778–1843), who had travelled in Italy in 1816 and 1817. On his return Hakewill engaged Turner to make twenty watercolours from his own pencil sketches, of which eighteen were engraved as plates for *A Picturesque Tour of Italy*, published by John Murray between 1818 and 1820. This work for Hakewill, who provided him with valuable advice and information about the journey, was one factor in persuading Turner to undertake his long-delayed first visit to Italy. Another was the presence in Rome at the time of several of his English artist friends, including the sculptor Francis Chantrey, and Thomas Lawrence, who was there to paint his Waterloo Chamber portraits of Pope Pius VII and Cardinal Consalvi. In fact, in a letter to Joseph Farington dated 2 July, Lawrence had written:

> Turner should come to Rome. His Genius would here be supplied with new Materials, and entirely congenial with it. It is one proof of its influence on my mind, that enchanted as I constantly am whenever I go out, with the beauty of the Hues & forms of the Buildings – with the Grandeur of some, and variety of the Picturesque in the masses of the ordinary Buildings of this City, I am perpetually reminded of his Pencil; and feel the sincerest regret that his Powers should not be excited to their utmost force. He has an elegance and often a Greatness of Invention, that wants a scene like this for its free expansion.[16]

Modern scholars usually disagree with the traditional view that it was Turner's experience of Italy that finally propelled his art towards its individualistic maturity and greatness. That view may well be too simplistic, and there was certainly no sudden 'conversion' in 1819, but Lawrence was definitely correct in his feeling that Turner, who was forty-four years old, needed new stimuli, and that he would find these in Italy and especially in Rome. Even although he would have been further encouraged by Lawrence's letter, Turner's decision to set out for Rome must already have been made when it reached Farington, for he started his journey to Italy on 31 July, but was on the road for some two months before reaching Rome in late September or early October. From Calais he took the most direct route via Paris and Lyon to the Alps, which he crossed by the Mont Cenis pass. He then toured in northern Italy for three or four weeks, visiting Turin, Milan, the lakes and Venice. As was his wont he was drawing incessantly, and during the whole of this journey he used over twenty sketchbooks, some with drawings on more than ninety pages. These were mostly rapid pencil drawings, which became noticeably less detailed as he proceeded on his travels.

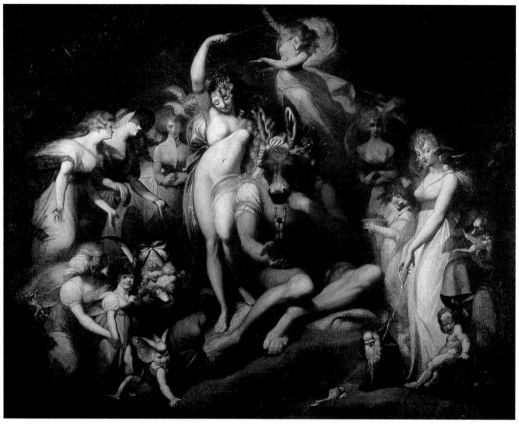

(1) Henry Fuseli, *Titania, Bottom and the Fairies* (*c*.1790). Oil on canvas; 217.2×275.6cm.
(Tate Gallery, London)

(2) Sir Henry Raeburn, *Lord Newton* (1810). Oil on canvas;
127×101.6cm. (The Earl of Rosebery, Dalmeny House)

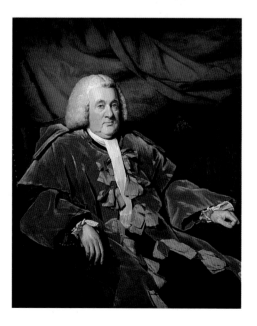

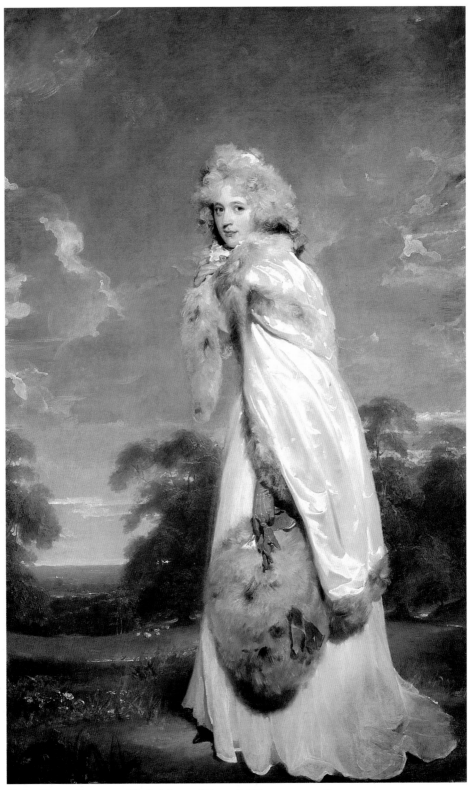

(3) Sir Thomas Lawrence, *Elizabeth Farren* (RA 1790). Oil on canvas; 238×147 cm. (Metropolitan Museum, New York)

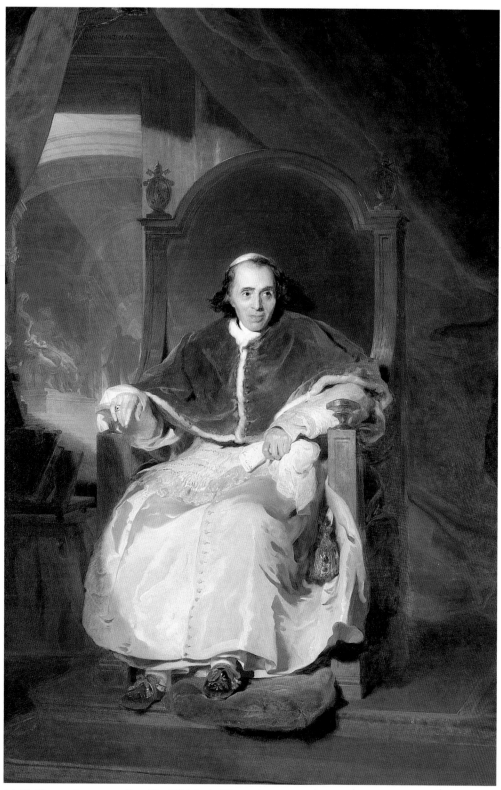

(4) Sir Thomas Lawrence, *Pope Pius VII* (1819). Oil on canvas; 106×70 cm.
(The Royal Collection)

(5) Thomas Girtin, *Stepping Stones on the Wharfe, above Bolton, Yorkshire* (*c*.1801). Watercolour; 32.7×51.8 cm. (National Gallery of Scotland, Edinburgh)

(6) Thomas Girtin, *West Front of Peterborough Cathedral* (1794). Watercolour; 38×28 cm. (Ashmolean Museum, Oxford)

(7) John Sell Cotman, *Near Brandsby, Yorkshire* (1805). Pencil and watercolour; 32.9×22.8 cm. (Ashmolean Museum, Oxford)

(8) David Cox, *Sun, Wind and Rain* (1845). Watercolour and bodycolour; 46.5×60.5 cm. (Birmingham Museums and Art Gallery)

(9) John Sell Cotman, *The Ploughed Field* (1808). Pencil and watercolour; 22.8×35 cm. (Leeds City Art Gallery)

(10) William Henry Hunt, *Bird's Nest with Sprays of Apple Blossom*
(*c*.1845). Watercolour, heightened with white; 25.5×30.7 cm.
(Yale Center for British Art, New Haven, Paul Mellon Collection)

(11) Peter de Wint, *Gloucester from the Meadows* (1840). 46.3×62.2 cm. (Victoria and Albert Museum, London)

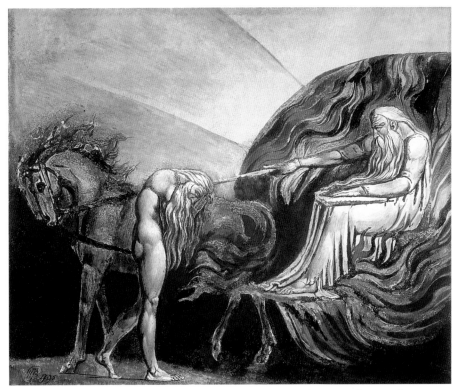

(12) William Blake, *God judging Adam* (1795). Colour print finished in pen and watercolour; 43.2×53.5 cm. (Tate Gallery, London)

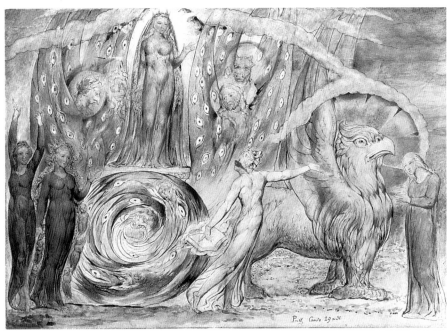

(13) William Blake, *Beatrice addressing Dante from the Car* (1824–7). Pen and watercolour; 37.2×52.7 cm. (Tate Gallery, London)

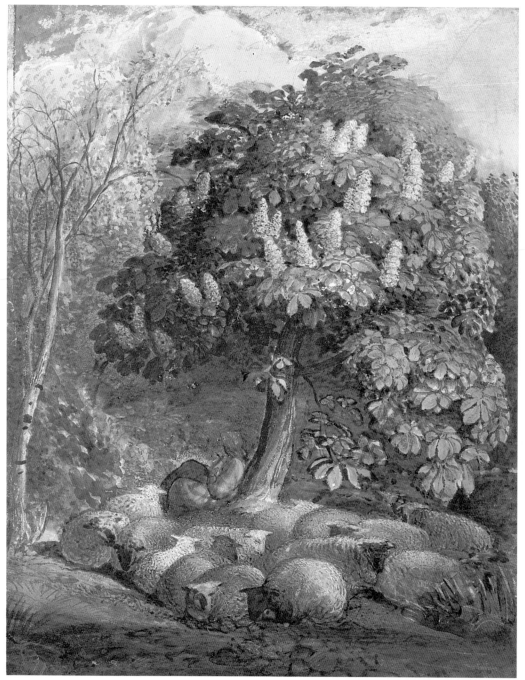

(14) Samuel Palmer, *Pastoral with a Horse-Chestnut Tree* (*c*.1831–2). Watercolour and bodycolour;
33.4×26.8 cm. (Ashmolean Museum, Oxford)

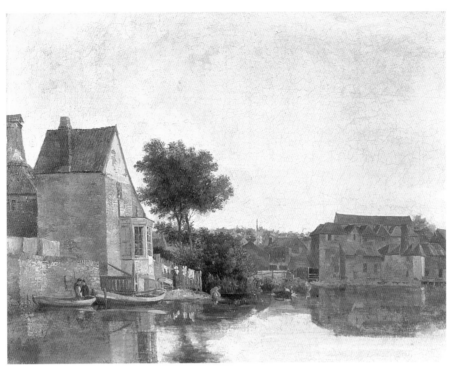

(15) John Crome, *Back of the New Mills, Norwich* (Norwich River: Afternoon; *c.*1819).
Oil on canvas; 71.1×100.3 cm. (Castle Museum, Norwich)

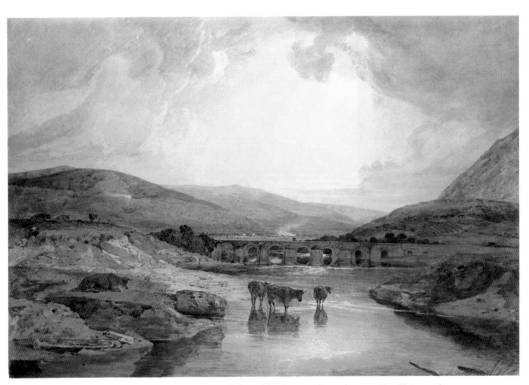

(16) J.M.W.Turner, *Abergavenny Bridge, Monmouthshire: Clearing up after a showery Day* (RA 1799).
Watercolour; 41.3×76 cm. (Victoria and Albert Museum, London)

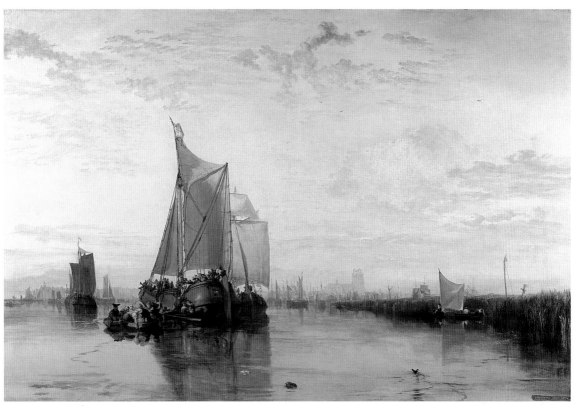

(17) J.M.W. Turner, *Dort, or Dordrecht, the Dort Packet-Boat from Rotterdam becalmed* (RA 1818). Oil on canvas; 157.5×233 cm. (Yale Center for British Art, New Haven, Paul Mellon Collection)

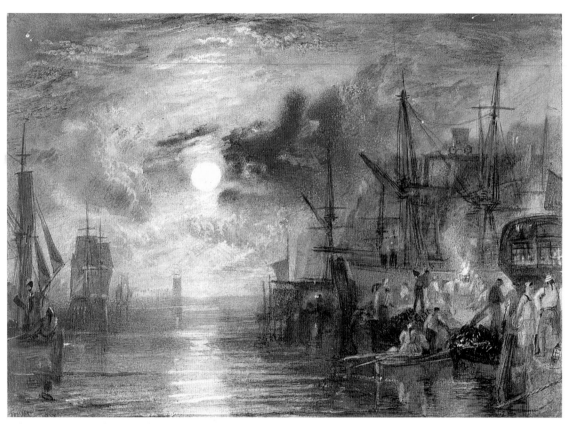

(18) J.M.W. Turner, *Shields, on the River Tyne* (1823). Watercolour; 15.4×21.6 cm. (Tate Gallery, London)

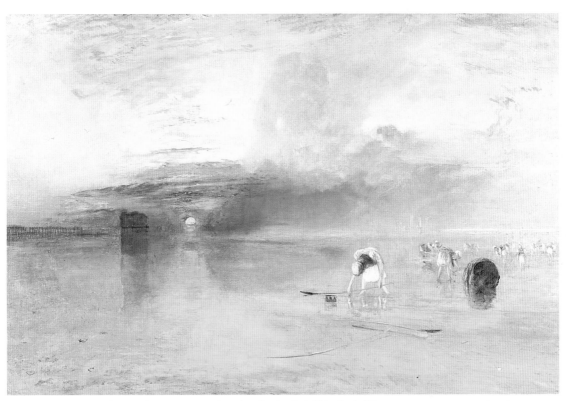

(19) J.M.W. Turner, *Calais Sands, Low Water, Poissards collecting Bait* (RA 1830). Oil on canvas; 73×107 cm.
(Bury Art Gallery and Museum)

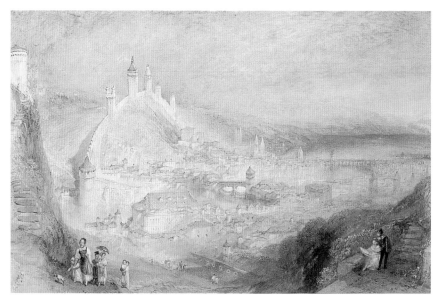

(20) J.M.W. Turner, *Lucerne from the Walls* (1842). Watercolour, with scraping-out; 29.5×45.5 cm. (Lady Lever Art Gallery, Port Sunlight)

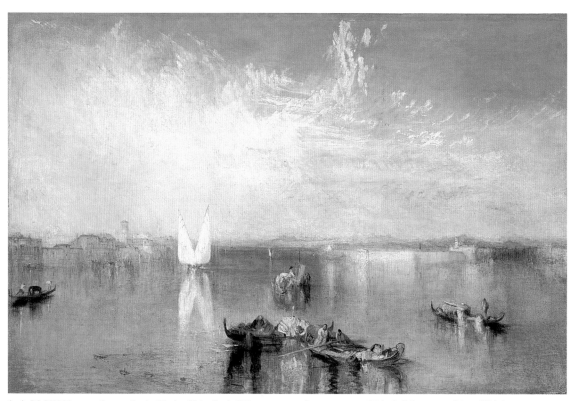

(21) J.M.W. Turner, *Campo Santo, Venice* (RA 1842). Oil on canvas; 62.2×92.7 cm. (Toledo Museum of Art, Ohio)

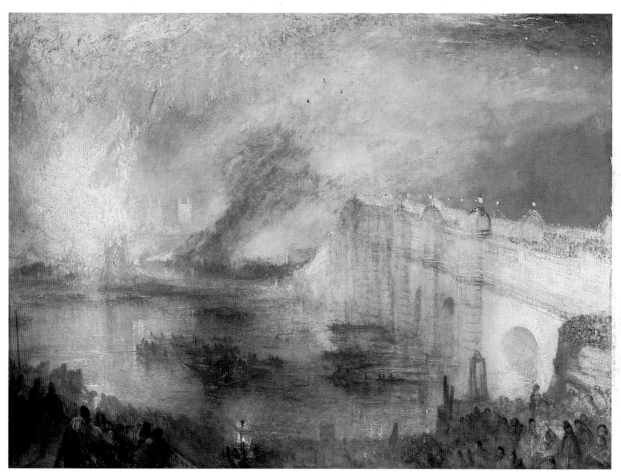

(22) J.M.W. Turner, *The Burning of the House of Lords and Commons, 16th October, 1834* (BI 1835).
Oil on canvas; 92×123 cm. (Philadelphia Museum of Art)

(23) Francis Danby, *Clifton Rocks from Rownham Fields* (1821). Oil on panel; 40×50.8 cm. (Bristol Museum and Art Gallery)

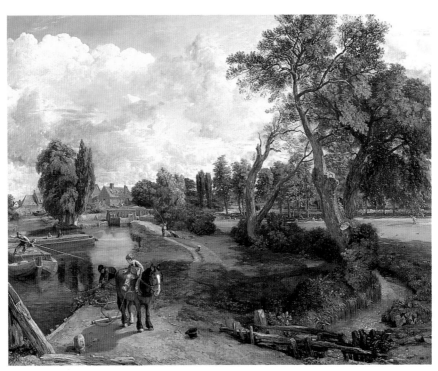

(24) John Constable, *Flatford Mill* ('Scene on a navigable river'; RA 1817). Oil on canvas; 101.7×127 cm. (Tate Gallery, London)

(25) John Constable, *Cloud Study with Birds* (1821). Oil on paper laid on board; 25.5×30.5 cm. (Yale Center for British Art, New Haven, Paul Mellon Collection)

(26) John Constable, *View of Dedham from the Lane leading from East Bergholt Church to Flatford* (c.1809). Oil on paper laid on canvas; 23.9×30.2 cm. (Victoria and Albert Museum, London)

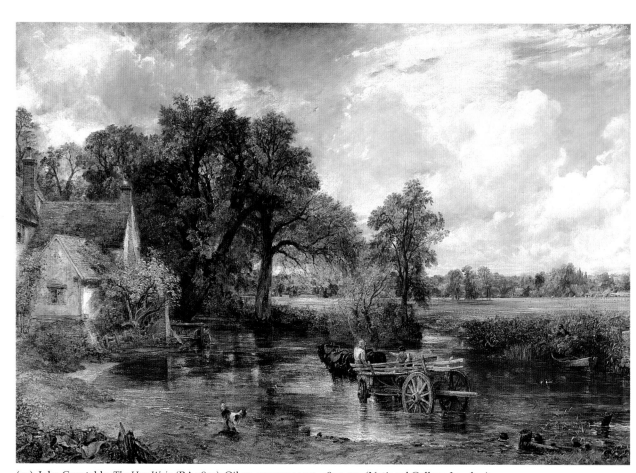

(27) John Constable, *The Hay Wain* (RA 1821). Oil on canvas; 130.5×185.5 cm. (National Gallery, London)

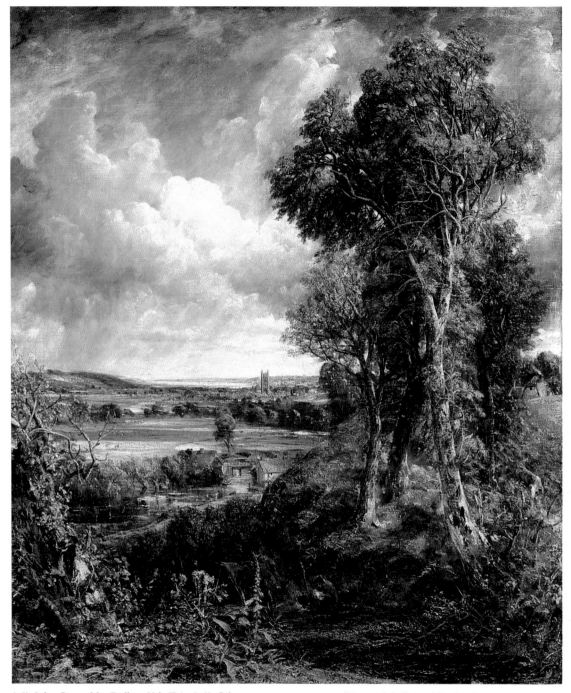

(28) John Constable, *Dedham Vale* (RA 1828). Oil on canvas; 145×122 cm. (National Gallery of Scotland, Edinburgh)

(29) John Constable, *River Scene, with a Farmhouse near the Water's Edge* (c.1834).
Oil on canvas; 25.4×34.9 cm. (Victoria and Albert Museum, London)

(30) John Constable, *Sketch for Hadleigh Castle* (1829). Oil on canvas; 122.5×167.4 cm.
(Tate Gallery, London)

(31) Samuel Palmer, *A View of Ancient Rome* (1838). Watercolour and bodycolour; 41.1×57.8cm.
(Birmingham Museums and Art Gallery)

(32) R.P. Bonington, *A Fishmarket near Boulogne* (Paris Salon 1824). Oil on canvas; 82×122.5cm.
(Yale Center for British Art, New Haven, Paul Mellon Collection)

(33) James Ward, *Bulls Fighting, with a View of St Donat's Castle in the Background* (1803–4). Oil on canvas; 131×227 cm. (Victoria and Albert Museum, London)

(34) William Collins, *As Happy as a King* (RA 1836). Oil on canvas; 71.1×91.4 cm.
(Tate Gallery, London)

(35) R. P. Bonington, *On the Grand Canal, Venice* (1826). Oil on millboard; 23.5×34.8 cm.
(Yale Center for British Art, New Haven, Paul Mellon Collection)

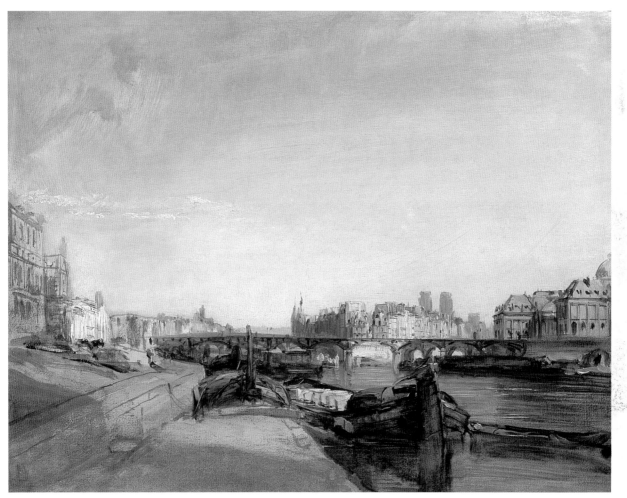

(36) R.P. Bonington, *The Pont des Arts and Ile de la Cité from the Quai du Louvre, Paris* (c.1827–8). Oil on millboard; 35.6×45.1 cm. (Tate Gallery, London)

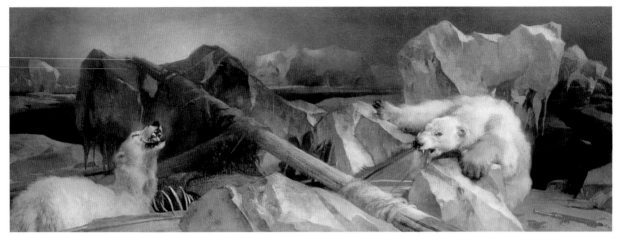

(37) Sir Edwin Landseer, *Man Proposes, God Disposes* (RA 1864). Oil on canvas; 91.4×243.8 cm.
(Royal Holloway and Bedford New College, Egham)

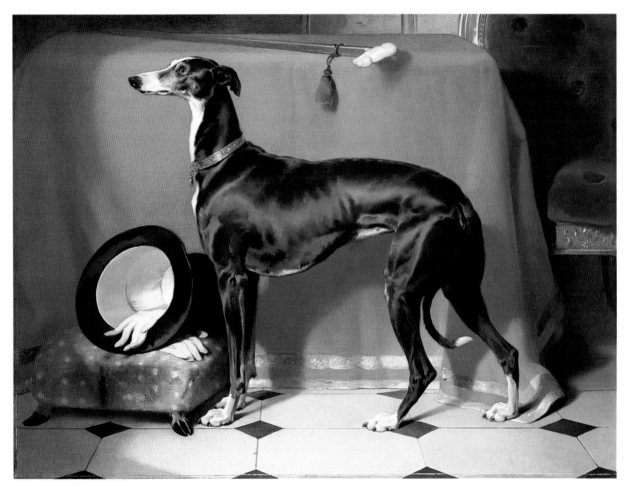

(38) Sir Edwin Landseer, *Eos* (1841). Oil on canvas; 111.8×142.3 cm.
(The Royal Collection)

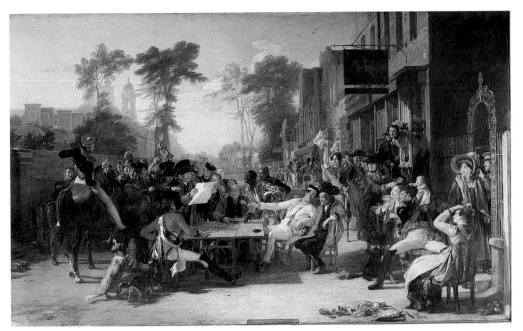

(39) Sir David Wilkie, *The Chelsea Pensioners* (RA 1822). Oil on panel; 97×158 cm. (Victoria and Albert Museum, Apsley House, London)

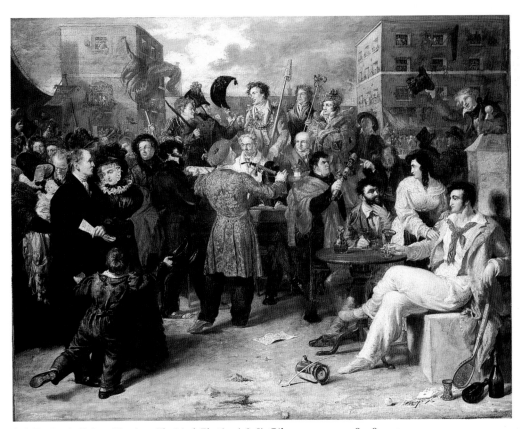

(40) Benjamin Robert Haydon, *The Mock Election* (1828). Oil on canvas; 144.8×185.4 cm. (The Royal Collection)

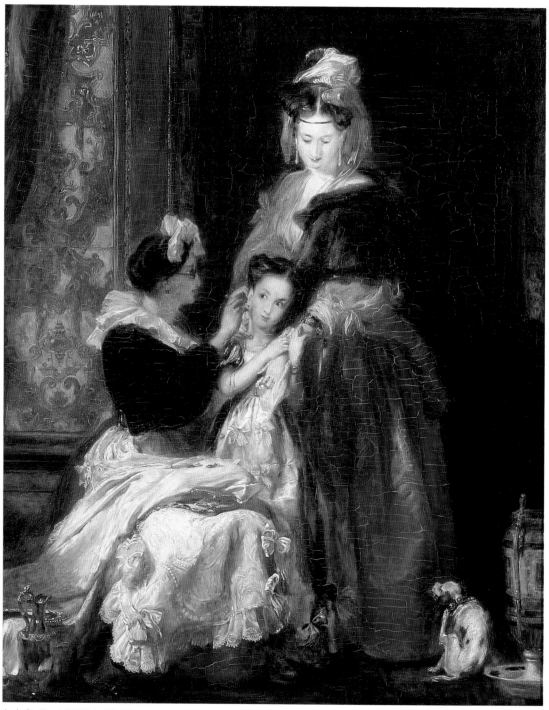

(41) Sir David Wilkie, *The First Ear-Ring* (RA 1835). Oil on canvas; 74.3×60.3 cm. (Tate Gallery, London)

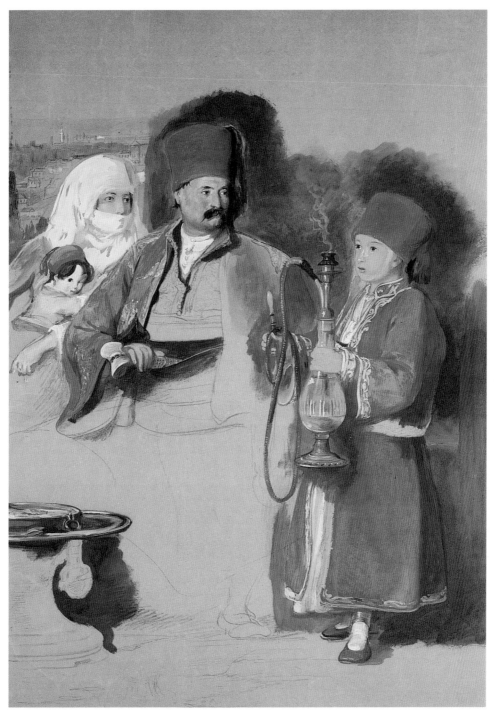

(42) Sir David Wilkie, *Portrait of Sotiri, Dragoman of Mr Colquhoun*. Water and body colours and oil, over pencil, on buff paper; 47.5×32.8 cm. (Ashmolean Museum, Oxford)

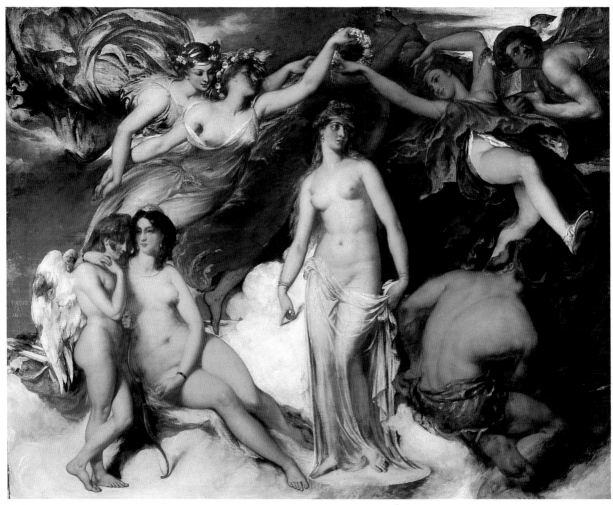

(43) William Etty, *Pandora crowned by the Seasons* (RA 1824). Oil on canvas; 88.3×112 cm.
(Leeds City Art Gallery)

(44) William Mulready, *The Sonnet* (RA 1839). Oil on panel; 35.3×30.2cm.
(Victoria and Albert Museum, London)

(45) Daniel Maclise, *Merry Christmas in the Baron's Hall* (RA 1838). Oil on canvas; 183×366 cm. (National Gallery of Ireland, Dublin)

On a few occasions, using larger sketchbooks, he worked in watercolours, most notably in Venice, but also in Rome, Tivoli and Naples. When he returned to England the ample material which Turner had collected during these months became a major element of his large 'reference library' of sketchbooks, which survives today as the central feature of the Turner Bequest.

Not long after Turner's arrival in Rome Lawrence reported to Farington, on 6 October, 'he feels the beauty of the Atmosphere and Scenery as I knew he would.'[17] The artist recorded his impressions of the Eternal City in eight sketchbooks. On three of these the titles inscribed on the covers by Turner include the term '*C. Studies*', and Cecilia Powell has suggested that the '*C*' indicated that the drawings in them were essentially compositional studies, which Turner then used 'more or less directly' for his Italian watercolours and oils of the 1820s.[18] From Rome Turner made excursions into the Campagna, visited Tivoli, and travelled south through the Alban Hills to Naples, from where he visited Vesuvius and Pompeii, Baiae and Paestum. The artist finally left Rome for his homeward journey in time to spend Christmas in Florence, which he left early in January. He crossed the Mont Cenis pass in extreme weather, and was back in London on 1 February, having been away for exactly six months.

It took some years for Turner to assimilate the full impact of this first Italian visit, but in less than three months he completed the enormous canvas which was his only exhibit at the Royal Academy in 1820, the year which marked the 300th anniversary of Raphael's death. *Rome, from the Vatican. Rafaelle, accompanied by La Fornarina, preparing his Pictures for the Decoration of the Loggia* (Tate Gallery, London) celebrates much more than the Raphael centenary, and has been studied in great detail by several scholars, who have proposed a variety of interpretations of this complex picture.[19] Rightly described by one contemporary critic as 'a strange but wonderful picture', it demonstrates Turner's undigested reactions to his first visit to Rome, and it is also 'regarded as one of Turner's main public statements about alternatives to standard perspective'.[20] When considering this work as a 'statement' it is important to remember that one of the two canvases which he had shown at the Academy in the previous year, when he was certainly already making preparations for his visit to Rome, was the equally large *England: Richmond Hill, on the Prince Regent's Birthday* (Tate Gallery, London) a Claudian composition featuring the famous panorama of the Thames, also seen from a high viewpoint. It seems likely that Turner had already conceived the second composition before his departure for Italy, and meant his public and his critics to think of these two works as a pair – before and after Italy – but this has rarely been done.

Parts XIII and XIV of the *Liber Studiorum* had been published on 1 January 1819, but though six further Parts were planned, no more were issued after the Italian tour, and some twelve plates on which work was well advanced were left unpublished. The *Liber* was clearly out of date by now, both from the point of view of Turner's art at this time and for technical reasons. The introduction of steel plates for engraving in 1820 meant that engraving on copper quickly became uneconomic, for far more good impressions could be taken from a steel plate than from a copper one. Turner was always keen to adopt technical advances in his own work, and it was probably quite soon after the introduction of steel plates that he made his experimental and novel series of so-called *Little Liber* mezzotint engravings on small steel plates. Eleven of these

were completed, but never published, and they show Turner's compositional and tonal powers at their best.[21] While Turner's drawings for the *Liber Studiorum* were in sepia washes, most of the drawings for the black-and-white *Little Liber* prints are in water-colours, and during the 1820s and 1830s Turner was constantly at work producing watercolours for engraving.

It is one of the most notable features of these drawings for the engravers that they became ever more colourful, and that even so they were most effectively reproduced in black and white. An outstanding example of this is *Shields, on the River Tyne* [COL.PL.18], which is dated 1823 and was engraved that year by Charles Turner in mezzotint on steel for W.B.Cooke's *The Rivers of England* series. With its wonderful rendering of both atmosphere and detail, this small watercolour demonstrates Turner's ability to produce a compelling and lively composition on a tiny scale, and it was this skill that made him so popular with engravers and publishers during these years. In about 1825 Turner be-gan work for the most ambitious series of topographical engravings in which he was involved, the *Picturesque Views in England and Wales*, which was the brainchild of the engraver and print-publisher Charles Heath, who proposed a collection of 120 plates all after drawings by Turner. In the event only ninety-six plates were published between 1827 and 1838, and despite its outstanding quality the scheme was a commercial failure, though it was an undoubted triumph from the artistic point of view. This was, of course, a time of considerable recession, following the 'great money panic' of 1825, when over sixty banks failed.

For this series the engravers were again closely supervised by Turner, who pro-duced watercolours that were larger than the plates, among them the lively view of *Stamford, Lincolnshire* [PL.73], with its vivid stormy sky, and the hustle and bustle of the stage coach arrival contrasting with the solid calm of the town and its churches. This plate was very effectively engraved by William Miller (1796–1882), who was one of the most successful and prolific members of what came to be known as the 'Turner School' of engravers, which reached full maturity in this famous series. The *England and Wales* drawings are among Turner's most effective watercolour compositions, combining tell-ing topographical and atmospheric information with lively and harmonious anecdotal content.[22]

Turner had become something of 'a man of property', and was amassing a con-siderable fortune; as early as around 1810 notes in one of his sketchbooks indicated that he considered himself worth £12,000 to £13,000 a year. He had acquired a piece of land at Twickenham where he built a quite substantial villa to his own designs, first known as Solus Lodge, and later renamed Sandycombe Lodge, which was completed in 1812 and sold in 1826. In 1818 the artist acquired additional leases in Queen Anne Street West and Harley Street, and began to rebuild his house and gallery, which was completed in 1822. An exhibition was opened that April, but it is not known what was shown. In February the Cooke brothers had opened an exhibition of watercolours in their Soho Square gallery, which featured a group of some twenty Turner drawings connected with their various publishing ventures. Similar exhibitions, with further groups of Turners, were held in 1823 and 1824 and again received favourable attention. During these years of consolidation Turner showed very little at the Royal Academy, nothing in 1821 and 1824, and only one painting in 1822, 1823 and 1825, when he also exhibited a

(73) J.M.W. Turner, *Stamford, Lincolnshire* (c.1828). Watercolour; 29.3×42 cm.
(Usher Gallery, Lincoln)

watercolour. The 1825 painting was the imposing *Harbour of Dieppe*, which was given a mixed reception by the critics, some of whom were offended by the brightness of the colours. Similar comments were made about the *Dieppe*'s companion piece, *Cologne, the Arrival of a Packet Boat* (both Frick Collection, New York), which was one of Turner's four exhibits in the following year. In making his oil paintings so much more colourful Turner was simply continuing the developments which he had displayed in his water-colours during the last few years; once again a decisive step forward in his art was initiated in watercolour.

Turner continued to travel at home or abroad nearly every summer, often in connection with projects for series of engravings. He visited Paris in 1821, Scotland and Edinburgh during George IV's ceremonial visit in 1822, the Netherlands in 1825, and toured the rivers Meuse, Moselle, Rhine and Loire in 1826. As already noted Turner never again visited Farnley after the death of Walter Fawkes in 1825, but probably from as early as that year onwards he made frequent visits to Petworth, and for the next twelve years Lord Egremont's magnificent house with its somewhat eccentric way of life was to replace Farnley as a second home for Turner. At Petworth, as at Farnley, the artist was allocated his own painting room, the Old Library. It has recently been sug-gested that most of the series of attractive small gouache drawings on blue paper, the majority of them views inside the house, were the result of a 'burst of activity during the visit of 1827' and 'almost a song of joy at re-discovering a friendly environment to which he could escape after the loss of Farnley'.[23] The large-scale rooms of the great house provided Turner with a whole new range of inspiration for his depiction of space

(74) J.M.W.Turner, *Chichester Canal* (*c.*1828). Oil on canvas; 65.5×134.5 cm. (Tate Gallery, London)

and light, and the experience of his sketching at Petworth can be felt in the growing confidence of his art as a whole.

He also made drawings in the beautiful park and surrounding countryside, and in 1828 and 1829 he completed a set of panoramic landscape paintings for the Earl, all of subjects connected with his property or local activities, to be hung on the panelling below the full-length portraits in the Carved Room. Four of these landscapes are now at Petworth, and it is not clear exactly why these were painted to replace the set of more sketchy but closely related compositions which form part of the Turner Bequest. The perfectly balanced composition of *Chichester Canal* [PL.74], which belongs to the first set, is achieved with unprecedented freedom of technique, again showing the influence of Turner's practice in watercolours. Whatever the exact history of this series of evocative elongated compositions, they mark a notable advance in Turner's work in oils, an advance that was confirmed by the paintings made during and after his second visit to Italy.

Turner set out on this journey in early August 1828, and reached Rome in early October. Charles Eastlake had arranged for him to use a spare studio in the house on the Piazza Mignanelli where he himself lived, and had also got canvases and other painting materials ready for him. It was Turner's intention to devote his time to painting a large composition for Lord Egremont as well as some other finished pictures. He set to work immediately on arrival, and in mid-December opened an exhibition of three canvases in the rooms near the Quattro Fontane to which he had moved from the accommodation prepared for him by Eastlake. The three paintings – *View of Orvieto*, *Vision of Medea*, and *Regulus* – all now in the Tate Gallery, were seen by 'more than a thousand persons', as Eastlake reported to a friend in England, adding 'so you can imagine how astonished, enraged or delighted the different schools of artists were, at seeing things with methods so new, so daring and excellences so unequivocal. The angry critics have, I believe, talked most, and it is possible you may hear of *general* severity of judgement, but many did justice, and many more were fain to admire what they confessed they dare not imitate.'[24]

(75) J.M.W.Turner, *Ulysses deriding Polyphemus – Homer's Odyssey* (RA 1829). Oil on canvas; 132.5×203cm. (National Gallery, London)

When asking Eastlake to obtain canvas for him, Turner wrote 'it would give me the greatest pleasure independent of other feelings which modern art and of course artists and I among their number owe to Lord Egremont that the very first brush in Roma on my part should be to begin for him con amore a companion picture to his beautiful *Claude*'.[25] It is generally agreed that the painting for Lord Egremont was the large *Palestrina – Composition* (Tate Gallery, London), which was not among those exhibited in Rome and may, indeed, have been completed in London. Though almost identical in size to the great Claude, *Landscape with Jacob, Laban and his Daughters*, at Petworth, Turner's somewhat heavy-handed *Palestrina* would not have made a good pendant for it, and understandably it was not acquired by Lord Egremont. In the Turner Bequest there are several other canvases – three figure studies and three landscapes – which were painted in Rome, as well as sixteen much smaller landscape sketches, which were originally painted on two large canvases. These Turner probably rolled up to take in his baggage on his return journey, for he used one of these sketches for his major RA exhibit in 1829.[26]

Despite devoting so much time and energy to his painting Turner had a relatively sociable time while in Rome, which he left in January, in time to attend an Academy Council meeting on 10 February 1829. At the Academy exhibition two months later Turner showed one watercolour, which vividly recorded his crossing of the Alps in January, again in a snowstorm, and three paintings. The composition of the largest and most ambitious of these, *Ulysses deriding Polyphemus – Homer's Odyssey* [PL.75], was based on one of the Roman landscape sketches, so it must, like the 1820 *Rome from the Vatican*, have been painted in the few weeks between his return from Italy and the

exhibition. This poetic and richly coloured canvas is painted with great subtlety and strength, and has come to be regarded as one of the artist's major imaginative masterpieces, which Ruskin described as 'the *central picture* in Turner's career'.

That summer Charles Heath, the publisher of the *England and Wales* series, held an exhibition at the Egyptian Hall in Piccadilly at which some forty of Turner's watercolours were shown. While the 1820s closed on a high point from the point of view of Turner's reputation and art, the decade, which had already brought the deaths of several old friends including Joseph Farington, Walter Fawkes and Lord de Tabley, ended in sadness with the death in September of Turner's father, who had been his companion and assistant for many years. The new decade opened with another death which affected him closely, that of Sir Thomas Lawrence in January, and Turner, now in his mid-fifties, found himself the doyen of the surviving RAs. At that year's exhibition he showed a large watercolour of Lawrence's funeral and six canvases, including two of those painted in Rome, *View of Orvieto* and *Palestrina*. One of his 1830 exhibits, the *Calais Sands, Low Water, Poissards collecting Bait* [COL.PL.19], with its exquisite rendering of the reflection of the glowing light of sunset on wet sand, was influenced by the work of Bonington, who had died so young in 1828, and may have been painted as an act of homage to him.

A major occupation for Turner in the 1830s was to provide compositions to illustrate specific works of poetry and literature, rather than topographical illustrations as hitherto. The artist's first venture in this vein was also probably the most successful, namely the twenty-five tiny vignette illustrations for Samuel Rogers's long poem *Italy*, which had originally been published without illustrations in two parts in 1822 and 1828. Rogers had been much impressed by the growing success of the various Annuals with their small steel engravings, some of them after drawings by Turner, from whom he commissioned, probably as early as 1827, the drawings for a lavish illustrated edition of *Italy*, which was published in 1830. This handsome volume was beautifully produced and was very well received, and its success greatly enhanced Turner's popularity as an illustrator. During the 1830s a total of nearly 250 steel engravings after Turner were published as illustrations to a variety of authors, including Byron, Scott and Milton. As in his drawings for Rogers's *Italy*, Turner always succeeded in creating compositions that were pleasing as a whole, and yet also contained a wealth of precise and instructive detail, which was often enhanced by the skilful transfer to steel plates. When considering Turner's literary illustrations it should be remembered that from his early days the artist had himself had literary ambitions, which he exposed to the public in the poetry he composed to appear in the Royal Academy exhibition catalogues, accompanying the titles of some of his exhibits. The first of these lines appeared in 1809, and others, often designated as coming from the *M.S. Fallacies of Hope*, followed throughout the rest of his career.[27]

It was largely through the steel engravings of his literary illustrations that Turner now gained a wider reputation throughout the Western world; a reputation which his continued production of topographical drawings for engraving, now often on steel, also enhanced. The most notable series of these was the three volumes of *Turner's Annual Tour* (generally known as 'The Rivers of France') published in 1833–5. The first volume, with twenty-one engravings, illustrated the Loire, the other two, with twenty en-

gravings each, the Seine. These three volumes were very favourably received, and sold well, but commercially they were not profitable enough to justify the publication of further volumes in what had been conceived as a *Rivers of Europe* project, for which Turner had already made some preparations.

The precision of the actual steel engravings often contrasted considerably with the relative looseness of the watercolour drawings on which they were based. By the 1830s many critics had begun to accept the freedom and eccentricities of Turner's painting technique, as was demonstrated by some of the comments about *Childe Harold's Pilgrimage – Italy* (Tate Gallery, London), Turner's memorable homage to Lord Byron, when exhibited at the RA in 1832. The critic of the *Spectator* remarked that it had 'sated our senses with its luxuriant richness' and advised the reader to get to the exhibition early so that he could

> first go close up … and look at the way in which it is painted; and then, turning his back (as one does sometimes to the sun) till he reaches the middle of the room, look round at the streaky, scrambled, unintelligible chaos of colour, and see what a scene has been conjured up before him as if by magic.… Then he will see that this is no meretricious trick of art – no mad freak of genius – no mere exaggeration of splendour – no outrage of propriety – but an imaginative vision of nature seen by the waking mind of genius, and transferred to canvas by the consummate skill of a master-hand. He will feel that it is the poetry of art and of nature combined – that it bears the same relation to the real scene as does Byron's description.[28]

However much admired, relatively few of these works of poetry and genius sold at the exhibitions, though one subject did sell – views of Venice. Turner exhibited the first two of these – *Bridge of Sighs, Ducal Palace and Custom House, Venice: Canaletti painting* (Tate Gallery, London) and the lost *Ducal Palace, Venice* – at the Royal Academy in 1833. The first of these, which was said to have been painted in a very short time in rivalry to a Venetian scene by William Clarkson Stanfield, was bought at the exhibition by Robert Vernon, who was forming a collection of British painting, which he gave to the nation in 1847 as the nucleus of a National Gallery of British Art. From 1833 to 1846 – with the exception of 1838 and 1839 – Turner showed at least one Venetian subject at the RA each year, and most of these were sold. Among these was the luminous *Campo Santo, Venice* [COL.PL.21], which was bought at the 1842 exhibition by Elhanan Bicknell, a whaling entrepreneur who became one of Turner's principal patrons in the 1840s.

Turner's second visit to Venice did not take place until the autumn of 1833, that is after the exhibition at which the *Bridge of Sighs* was shown. He was there again for about three weeks in the summer of 1840, and it was probably during that visit that he made the series of exceptionally fluent watercolours in roll-sketchbooks, which are among the most attractive and compelling of his late drawings. Another famous group of watercolours is that which depicts the burning of the Houses of Parliament during the night of 16 October 1834. Turner witnessed this dramatic scene from various viewpoints, including, perhaps, a boat on the river which he shared with Clarkson Stanfield. It seems likely that a number of rapid pencil notations in a small sketchbook (Turner Bequest, CCLXXXIV) were made that night, but less likely that the nine rapidly executed watercolours in a larger sketchbook (T.B. CCLXXXIII) were actually drawn on the spot,

though they must have been completed soon after the artist had returned from the river to his studio.[29] In 1835 Turner exhibited two memorable paintings of the scene, the first shown at the British Institution in February, and now in Philadelphia [COL.PL.22], and the second at the Royal Academy two months later, and now in Cleveland. Neither composition makes any direct use of the watercolours. The Philadelphia version, in which the view is taken from the south bank with Westminster Bridge on the right, is a somewhat theatrical composition which we know was painted very largely on the gallery wall of the British Institution during a varnishing day.

The Norfolk artist E.V.Rippingille has left the following memorable record of this occasion, published in the *Art Journal* in 1860:

> Turner was there, and at work before I came, having set-to at the earliest hour allowed. Indeed it was quite necessary to make the best of his time, as the picture when sent in was a mere dab of several colours, and 'without form and void', like chaos before the creation. The managers knew that a picture would be sent there, and would not have hesitated, knowing to whom it belonged, to have received and hung up a bare canvas, than which this was but little better. Such a magician, performing his incantations in public, was an object of interest and attraction. Etty was working by his side and every now and then a word and a quiet laugh emanated and passed between the two great painters. Little Etty stepped back every now and then to look at the effect of his picture, lolling his head on one side and half closing his eyes, and sometimes speaking to someone near him, after the approved manner of painters: but not so Turner; for the three hours I was there – and I understood it had been the same since he began in the morning – he never ceased to work, or even once looked or turned from the wall on which his picture hung. All lookers-on were amused by the figure Turner exhibited in himself, and the process which he was pursuing with his picture. A small box of colours, a few very small brushes, and a vial or two, were at his feet, very inconveniently placed; but his short figure, stooping, enabled him to reach what he wanted very readily.... In one part of the mysterious proceedings Turner, who worked almost entirely with his palette knife, was observed to be rolling and spreading a lump of half-transparent stuff over his picture, the size of a finger in length and thickness. As Callcott was looking on I ventured to say to him, 'What is that he is plastering his picture with?' to which enquiry it was replied, 'I should be sorry to be the man to ask him.' ... Presently the work was finished: Turner gathered his tools together, put them into and shut up the box, and then, with his face still to the wall, and at the same distance from it, went sidling off, without speaking a word to anybody, and when he came to the staircase, in the centre of the room, hurried down as fast as he could. All looked with a half-wondering smile, and Maclise, who stood near, remarked, 'There, that's masterly, he does not stop to look at his work; he *knows* it is done, and he is off.'

This well-known description of Turner at work provides a valuable insight into the unorthodox techniques which he used in his later years. Understandably, there were still viewers and critics who found it impossible to appreciate Turner's work, and the three paintings which he showed at the Academy in 1836 – the last exhibition at Somerset House – were violently attacked in a review by the Revd John Eagles in *Blackwood's Magazine*. Most vituperative were the comments about *Juliet and her Nurse*, now in Argentina, which was one of the two paintings bought at the exhibition by H.A.J. Munro of Novar (1797–1864), who would also have acquired the third, *Mercury and*

Argus, now in Ottawa, except that he was 'ashamed of taking so large a haul'. Munro, who travelled with Turner in the Alps that year, was another of Turner's most important later patrons, and eventually owned sixteen paintings and more than 130 drawings by Turner. The *Blackwood's Magazine* review has become so well known because it inspired the seventeen-year-old John Ruskin, shortly to go up to Oxford, to draft a reply in Turner's defence. On Turner's advice, it was not sent to the magazine, but this was the germ that led to the writing a few years later of the five volumes of *Modern Painters*, published between 1843 and 1860, much of which remains today one of the most perceptive discussions of Turner's work.

For the 1837 exhibition, the first held in the new Royal Academy galleries in Trafalgar Square, Turner was a member of the Hanging Committee, and himself showed four paintings, including another of his great poetic compositions, *The Parting of Hero and Leander – from the Greek of Musaeus* (Tate Gallery, London). This exhibition was opened by the King, William IV, who died some two months later, and was succeeded by his niece, Queen Victoria. The Victorian age had begun, and it opened with disappointment and sadness for Turner. Disappointment, because he was not included in the accession honours – Callcott, the miniaturist William Newton, and the sculptor Richard Westmacott were the artists who received knighthoods. Sadness, because Lord Egremont died at Petworth in November. Turner had been at Petworth in October; he went down for the Earl's funeral on 21 November, but that was to be his last visit to the great house. During his later visits he had painted a number of striking interior scenes in oils, culminating in the *Interior at Petworth* (Tate Gallery, London), which may have been painted as a last act of homage to his old friend and patron. It is difficult to read the details of this canvas, executed with a rapid flurry of paint, and achieving an almost abstract poem of light and colour, but it is possible that the Earl's coffin is shown on the right, surrounded by some of his faithful dogs.[30]

In a letter to his father-in-law John Linnell, sent from Italy in August 1838, Samuel Palmer wrote of the 1837 *Apollo and Daphne*, 'Turner's corruscation of tints and blooms in the middle distance … is nearly, though not quite so much a mystery as ever: and I am inclined to think that it is like what Paganini's violin playing is said to have been; something to which no one ever did or will do the like'.[31] In the remaining years of his long career Turner was to produce many such 'mysteries', which have come to be recognised as some of his greatest masterpieces. *The Fighting Temeraire* (National Gallery, London) was exhibited in 1839, *The Slave Ship* (Museum of Fine Arts, Boston) in 1840, *Peace – Burial at Sea* (Tate Gallery, London) in 1842, *The Sun of Venice going to Sea* (Tate Gallery) in 1843, and *Rain, Steam and Speed* (National Gallery, London) in the following year. These famous paintings were extraordinary achievements for a man in his sixties, and they are only some of the best known of the numerous canvases which he showed during these years.

As in his early years the sea and the seashore featured in many of Turner's late paintings, and continued to give him constant inspiration. It was John Constable who wrote: 'Of all the works of the Creation none is so imposing as the Ocean; nor does nature anywhere present a scene that is more exhilarating than a sea-beach, or one so replete with interesting material to fill the canvas of the painter; the continual change and ever-varying aspect of its surface always suggesting the most impressive and

agreeable sentiments, …'[32] Turner would have agreed absolutely with these sentiments, and it was certainly his love of the sea that led to his many visits to Margate on the north Kent coast, where Mrs Sophia Booth was his landlady in her boarding house on the sea front from about 1830 onwards. When Mrs Booth was widowed in 1833 their relationship became closer and Turner's trips down the Thames by one of the regular steam packets became more frequent. Many of the spectacular studies of sea and shore, such as *Waves breaking on a Lee Shore* (Tate Gallery, London), dating from the ten years around 1840, were probably based on what he had seen at Margate, or perhaps even painted there.

Such studies were not intended for exhibition, but they have become very popular in modern times. However, Turner did exhibit several seascapes that are just as freely and spontaneously painted, best-known among them being *Snow Storm – Steam Boat off a Harbour's Mouth making Signals in Shallow Water, and going by the Lead. The Author was in this Storm on the Night the* Ariel *left Harwich* [PL.76]. When exhibited at the Royal Academy in 1842 one critic described the painting as 'nothing but a mass of soapsuds and whitewash', which Ruskin recorded as greatly upsetting Turner, who was also reported as stating, 'I wished to show what such a scene was like; I got the sailors to lash me to the mast to observe it; I was lashed for four hours, and I did not expect to escape, but I felt bound to record it if I did. But no one had any business to like the picture.' There has been considerable discussion as to the truth of this story, and others relating to this remarkable canvas,[33] of which Ruskin wrote in *Modern Painters* as 'one of the very grandest statements of sea-motion, mist and light, that has ever been put on canvas, even by Turner'.

In 1844 Turner showed seven paintings at the Royal Academy: three seascapes, three views of Venice, and the justly famous *Rain, Steam, and Speed – the Great Western Railway* [PL.77]. This remarkable 'document' of the great age of the Railway Mania was inspired by a journey across Brunel's imposing Maidenhead Bridge over the Thames (completed in 1839) in a rainstorm. As *The Times* critic wrote, 'The railways have furnished Turner with a new field for the exhibition of his eccentric style … the dark atmosphere, the bright sparkling fire of the engine, and the dusty smoke, form a very striking combination.' Much has been written about the symbolism of this painting, and especially its contrasting of the forces of nature and of the works of man – the hare and the railway engine. However, there are no surviving studies or drawings connected with this composition, of which we know for certain that it was one of the paintings on which Turner did much work on the varnishing days. It is remarkable that at the age of nearly seventy Turner was able to create such a masterpiece so rapidly out of his head, and it seems likely that modern critics have exaggerated its symbolic content.

Rain, Steam, and Speed was especially admired by Monet and Pissarro when they were in London in 1870, and the first Impressionist Exhibition held in Paris in 1874 actually included an unfinished etching after the painting by Felix Bracquemond.[34] The importance of Turner's work for the Impressionists has also been frequently discussed. It is confirmed by Camille Pissarro's many references to Turner in the letters to his son, Lucien, and others, but it must be remembered that in 1870 and throughout the rest of the century it was only those paintings in the Bequest that Turner himself had exhibited which would have been on view in London. *Rain, Steam, and Speed* was, of course, one

(76) J. M. W. Turner, *Snow Storm – Steam-Boat off a Harbour's Mouth making Signals in Shallow Water, and going by the Lead* (RA 1842). Oil on canvas; 91.5×122 cm. (Tate Gallery, London)

(77) J. M. W. Turner, *Rain, Steam, and Speed – the Great Western Railway* (RA 1844). Oil on canvas; 91×122 cm. (National Gallery, London)

of these; it was the amazing technique as well as the subject matter of the painting that Pissarro and others admired.

Even more remarkable is the absolute freedom of the brushwork, which verges on the abstract, of the series of two pairs of paintings of whaling subjects which Turner exhibited in 1845 and 1846. The artist has again chosen a new theme, probably inspired by the interests of his last major patron, Elhanan Bicknell, the whaling entrepreneur, who may have commissioned one of the pictures, though he soon returned it to the artist, and it was later bought by Munro of Novar. Several scholars have recently written about the sources and subject matter of this outstanding final series,[35] in which Turner's depiction of weather and light is wonderfully effective. However, after 1846 Turner's RA exhibits declined sharply in quantity and quality, reflecting the deterioration of his health. In 1850 he made one final effort – it was to be the last year in which he exhibited – and showed four gloomy compositions illustrating the story of Dido and Aeneas, and recalling yet again the continuing influence of Claude.

As well as some of his outstanding masterpieces in oils, Turner was producing some of his finest watercolours in the 1840s. From 1841 to 1844 he spent some weeks each summer in Switzerland, usually staying at Lucerne. During these holidays he made numerous fluent watercolour studies of the lake and its surroundings, including a spectacular series of Mount Rigi, on its northern shore, at varying times of day and in different weather conditions. Early in 1842 Turner asked Thomas Griffith, of Norwood, who had been his agent for some years, to find commissions for ten finished water-colours of Swiss subjects, selected from fifteen 'samples' taken from the sketchbooks he had used the previous summer. Griffith persuaded Turner to drop his price from 100 to 80 guineas, but even so only nine were ordered, five by Munro of Novar and two each by Bicknell and John Ruskin. *Lucerne from the Walls* [COL.PL.20] was one of those selected by Ruskin, who considered these drawings to be the greatest watercolours that Turner ever made. He wrote about them enthusiastically on various occasions, including a passage in the first volume of *Modern Painters*, published in 1843. Ruskin had met Turner through Thomas Griffith in June 1840, and from then on the young admirer and the ageing artist were together quite frequently, and were certainly on friendly terms. *Modern Painters* was well received, and gradually Ruskin's eloquent support had a marked effect on Turner's reputation in his closing years. Though long an open secret, Ruskin's authorship of *Modern Painters*, of which the second volume appeared in 1846, was not officially made public until 1849.

Turner produced a second series of six Swiss watercolours in 1843, ten more in 1845, and a final pair specifically for Ruskin early in 1848. While they vary in quality, the majority of these late watercolours are effective and impressive, and justify Ruskin's description as 'the noblest drawings ever made by him for passion and fully developed power'. They do indeed show Turner at the height of his compositional and technical powers, and will always rank among the greatest of British watercolours.

In his will Turner appointed Ruskin as one of his executors, but in the event he declined to act. The artist had signed his first will in 1829, making careful provisions for the distribution of his money and property, including a bequest to the Royal Academy for the creation of a Professorship of Landscape Painting, and a plan for the preservation and display of the contents of his studio and gallery. A second will and several

codicils followed, but when he died Turner's testamentary arrangements were disputed by several distant relatives, and the estate was put in the hands of the Court of Chancery. The suit dragged on for several years, and the compromise decisions made by the court set aside most of Turner's principal provisions. However, the paintings and drawings remaining in his studio did become the property of the nation, and were finally moved from Queen Anne Street to the National Gallery in 1856. Known as the Turner Bequest, the 285 or so oils and the more than 19,000 drawings, have been at the centre of much controversy since then, as they still are. The opening of the specially built Clore Gallery for the Turner Collection, adjoining the Tate Gallery, in 1987, did at last achieve a situation fulfilling some of Turner's most important wishes. Since then the Clore Gallery and its staff have done much to further the appreciation and study of Turner's work, which he had always wanted to be seen 'all together'.

During his final year or two Turner was often ill, and rarely accepted invitations. As he wrote to Hawkesworth Fawkes on 27 December 1850, 'Old Time has made sad work with me since I last saw you in Town'. On the other hand, in the same letter he showed considerable interest in the the progress of the Crystal Palace being erected for the Great Exhibition of 1851, but it is not known whether he was able to visit the exhibition. Turner died in Mrs Booth's house at Chelsea on 19 December 1851, and was buried in the crypt of St Paul's Cathedral ten days later. Throughout his long life he had combined his adherence to tradition with an interest in the most up-to-date and progressive in many different spheres. It was the same combination that formed the basis of his own work, which never forsook its eighteenth-century origins, yet was also some of the most advanced and exciting of his day.

11 John Constable, RA (1776–1837)

John Constable was born some fourteen months after J. M. W. Turner, but only began his professional artistic career over ten years later than his slightly older contemporary. His career always lagged far behind that of his famous colleague, and it is only in the last hundred years or so that Constable and Turner have been thought of on a par as England's greatest landscape painters. It was in 1802, the year in which Turner was elected an RA, that Constable exhibited his first painting at the Royal Academy, and it was not until five years later that any of his exhibited works received critical notice. In May 1807 the critic of *The St James's Chronicle* wrote of two of three Lake District scenes shown by Constable that year, 'No. 52. *View in Westmorland,* J. Constable. – This Artist seems to pay great attention to nature, and this picture has produced a bold effect. We are not quite so pleased with the colouring of 98, *Keswick Lake,* by the same, in which the mountains are discriminated with too hard an outline.'[36] For the next thirty years the critics mixed praise and condemnation, and all too often ignored Constable altogether. His standing at the end of his life was aptly summed up by the obituarist of *The Morning Post* (4 April 1837): 'His mode of painting was peculiar, but it embodied much truth and sound principles of art which will render his works lasting, and far more valuable in years hence than they are at present, though highly esteemed by the best judges.'

Unlike Turner, Constable was very fortunate in his first biographer, and even to-day our thinking about him is strongly influenced by C. R. Leslie's *Memoirs of the Life of John Constable – composed chiefly of his Letters*, first published in 1843, the year in which the first volume of John Ruskin's *Modern Painters* was also published. The American-born Leslie was a fellow-artist and friend, and his classic biography has claims to being the best life of any British artist. In the 1960s and 1970s R. B. Beckett and others edited and published, in eight volumes, the artist's numerous surviving letters, lectures and other writings, and these add enormously to our knowledge of the ideas and back-ground behind Constable's work, though this has not yet received nearly as much attention from modern scholars and students as has the work of Turner.

John Constable was born in East Bergholt in Suffolk, the fourth child and second son of a successful mill- and property-owner and business man. John grew up in com-fortable and prosperous surroundings, in a family closely associated with the life and well-being of the area – the Stour Valley on the Suffolk-Essex border – in which they lived and worked. As Constable wrote to his great friend John Fisher in 1821, 'I should paint my own places best – Painting is but another word for feeling. I associate my "careless boyhood" to all that lies on the banks of the *Stour*. They made me a painter (& I am gratefull) that is I had often thought of pictures of them before I had ever touched a pencil,…'[37] Those lines were written when Constable was at the height of his powers as an artist; as we shall see, it had been something of a struggle to reach that point.

In about 1792, after attending Dedham Grammar School as a day boy, Constable began to work in the family business, which was centred on Flatford Mill, but he was also already sketching in the neighbourhood, and in 1794 went on a sketching tour of Norfolk with one of his father's clerks. In 1796 he met J. T. Smith (1766–1833), the London-based topographical draughtsman and antiquarian, and that meeting and sub-sequent friendship were certainly the most important element in finally persuading Constable's family to allow John to become a full-time artist. Constable was also en-couraged in his artistic endeavours by the influential collector, patron and amateur landscape painter, Sir George Beaumont, whose widowed mother lived at Dedham. Early in 1799, with a small allowance from his father, he moved to London with a letter of introduction to Joseph Farington, who was impressed by the sketches which the young man showed him. In March Constable was admitted as a probationer at the Royal Academy Schools, and was enrolled as a student the following February. He was soon admitted to the life class, where he produced somewhat heavy-handed figure drawings, and he also spent a lot of his time copying from landscape paintings lent to him by Joseph Farington or otherwise available. He exhibited his first painting – probably *Edge of a Wood*, now in Toronto – at the Royal Academy in 1802. Farington thought that it had 'a great deal of merit but is rather too cold' and a few days later he recommended his protégé 'to Study nature & *particular* art less'.[38]

At that time Constable was already in his mid-twenties, and his artistic skills were little further advanced than his career as an artist. Until his arrival in London his draughtsmanship was steeped in eighteenth-century tradition and essentially amateurish, but at the turn of the century the impact of seeing the work of Girtin, Turner and the recently deceased J. R. Cozens quickly made its mark. While the well-known

series of four watercolour drawings of panoramic views of the Stour Valley made as a wedding present for Lucy Hurlock late in 1800 remains somewhat old-fashioned (Victoria and Albert Museum, London (3) and Whitworth Art Gallery, University of Manchester), the landscape drawings and watercolours of the next five years show great advances and Constable's individual qualities begin to become evident. During these years he had also started to paint in oils, and here the impact of the work of Claude, closely studied and copied in Sir George Beaumont's collection, of Jacob Ruisdael, and of the early landscape paintings of his fellow Suffolk artist, Thomas Gainsborough, was strongly felt.

However, the most vital factor in Constable's telling advances in the first years of the century was his continued study of and involvement with the landscape of the Stour Valley. This critical moment in his development is best summed up in his own words, quoting from the revealing letter to his fellow East Bergholt artist, the village artisan John Dunthorne, written in London on 29 May 1802:

> For these few weeks past I beleive I have thought more seriously on my profession than at any other time of my life – that is, which is the surest way to real excellence. And this morning I am the more inclined to mention the subject having just returned from a visit to Sir G. Beaumont's pictures. I am returned with a deep conviction of the truth of Sir Joshua Reynolds's observation that 'there is no easy way of becoming a good painter'. It can only be obtained by long contemplation and incessant labour in the executive part.
>
> And however one's mind may be elevated, and kept up to what is excellent, by the work of the Great Masters – still Nature is the fountain's head, the source from which all originally must spring – and should an artist continue his practice without refering to nature he must soon form a *manner*, …
>
> For these two years I have been running after pictures and seeking the truth at second hand. I have not endeavoured to represent nature with the same elevation of mind – but have neither endeavoured to make my performances look as if really *executed* by other men.
>
> I am come to a determination to make no idle visits this summer or to give up my time to common place people. I shall shortly return to Bergholt where I shall make some laborious studies from nature – and I shall endeavour to get a pure and unaffected representation of the scenes that may employ me with respect to colour particularly and anything else – drawing I am pretty well master of.[39]

The result of Constable's intensive outdoor campaign that summer was a series of small oil studies on canvas, of which three are dated. The earliest of these is the atmospheric *Dedham Vale, Evening, from West Lodge* [PL.78], which is inscribed *July 1802* on the stretcher; it is the most smoothly and fluently painted of the group, and demonstrates that Constable's feeling for light and atmosphere was already well developed by this time. However, he must have been dissatisfied with the relatively broad handling of the landscape and the trees, and most of the other studies in this series are painted and constructed much more tightly and with more concentration on detail, especially in the trees. Dated September, the fine composition of *Dedham Vale* [PL.79] is the most ambitious of all these paintings, and clearly demonstrates the artist's debt to Claude's small masterpiece *Landscape with Hagar and the Angel* (National Gallery, London), which he had studied and copied in the Beaumont Collection. This was a view that Constable

(78) John Constable, *Dedham Vale, Evening, from West Lodge* (1802). Oil on canvas; 31.8×43.2 cm. (Victoria and Albert Museum, London)

(79) John Constable, *Dedham Vale* (1802). Oil on canvas; 43.5×34.4 cm. (Victoria and Albert Museum, London)

(80) John Constable, *A Bridge, Borrowdale* (1806). Pencil and watercolour; 18.9×27.1 cm.
(Victoria and Albert Museum, London)

probably chose because of its likeness to the Claude, and one that he painted again on several occasions in the next twenty-five years [see COL.PL.28].

The productive period of sketching and painting his home area that summer and early autumn (during which he acquired a studio in the centre of East Bergholt) was not repeated for some years, but it provided the essential groundwork for the artist's 'Constable Country' work during the rest of his career. In the course of the next few years Constable's life and work seemed to lack real direction, except for an increased demand for portraits. In the late summer of 1806 he began a seven-week tour of the Lake District, during which he met Wordsworth and Coleridge. He drew assiduously, in pencil, wash and mostly in watercolour, which has faded badly in many cases. On the back of many of these drawings Constable made detailed notes of place, time and weather, as in the stark and effective watercolour of a bridge in Borrowdale [PL.80], which is inscribed *Borrowdale Oct. 2. 1806 – twylight after a very fine day*. Much has been made of the influence of Sir George Beaumont's own Lake District drawings, and of the many Girtins owned by Sir George, on this phase of Constable's drawing. However, despite such influences, the ninety or so known Lake District drawings form the most impressive and individualistic group of Constable's work so far, and there is little sign that he found the area unattractive or uninspiring, as reported by Leslie, though the artist was at something of a disadvantage in being in the area in the autumn.

As already mentioned Constable showed three oil paintings of Lake District subjects at the Royal Academy in 1807, and these gained him his first press attention. He showed more Lake District compositions at the Royal Academy and the British

Institution in the following two years, but few of these seem to have been sold and few have survived. It is not suprising that this lack of success with such fashionable picturesque subjects drove Constable back to his native Suffolk for inspiration.

A few commissions for portraits had made Constable return to Suffolk quite regularly, but it seems that it was not until the end of the decade that he felt able once more to concentrate on the local scenery. In 1809 he began again to make on-the-spot oil sketches, as he had done in 1802, but these were far freer and more spontaneous than the earlier ones. While the 1802 work laid the foundations of Constable's depiction of his 'country', the sketches of 1809 and the following years constituted the real start of the campaign of landscape painting that was to be the focal point of Constable's artistic achievement – an achievement that gave his home locality the epithet 'Constable Country'. Probably dating from 1809 is the very simple *View of Dedham from the Lane leading from East Bergholt Church to Flatford* [COL.PL.26], in which the artist records the distant view behind the dark hedge, as he might have seen it when riding down the lane on horseback. Though essentially a 'classical' composition, this is also a totally natural composition, as are all the on-the-spot studies of these and later years.

A small series of these outdoor sketches, several of them recording specific and transient effects of weather and light, are connected with Constable's major RA exhibit of 1811, *Dedham Vale: Morning* [PL.81], which, though it failed to attract any critical attention, was certainly the artist's most important public statement so far. With overtones of Gainsborough's Suffolk landscapes (and Rubens), this relatively large canvas, which is fully signed and dated, and inscribed *Dedham Vale*, is somewhat dry and laboured when compared with the sketches on which it is based. The painting gained the approval of Thomas Lawrence, the future President of the Royal Academy, but it is not surprising that it did not win for Constable the recognition he had hoped for, and needed, as he was contemplating marriage. In 1809 Constable had fallen in love with Maria Bicknell, daughter of a successful London solicitor, and grand-daughter of Dr Rhudde, the dictatorial Rector of East Bergholt, who did not approve of the artist son of a local tradesman marrying into his family.

The couple's long and often frustrating courtship – they were not able to marry until 1816 – thus coincided with the most formative years of Constable's art. This was also the period during which the closest friendship of his adult life began and developed. In the late summer of 1811 Constable was invited to Salisbury by the Bishop, Dr John Fisher, who until 1803 had been Rector of Langham, a parish not far from East Bergholt. Himself no mean amateur artist, he had befriended and encouraged John Constable. While at Salisbury, where he stayed for three weeks, Constable met the Bishop's nephew, another John Fisher, recently ordained deacon and also an amateur landscape artist. Despite being twelve years younger than Constable, he and the painter proved to be fellow-spirits and they quickly developed a warm friendship, which lasted until the Archdeacon's untimely death in 1832.[40] Over the years John Fisher encouraged and stimulated Constable, not least by being the first serious collector of his paintings. As a result of this friendship Constable visited Salisbury on a number of occasions, and the great cathedral and its surroundings inspired him to make numerous drawings and a considerable number of oil sketches and finished paintings.

Though Constable continued to paint a few portraits, which provided him with

(81) John Constable, *Dedham Vale: Morning* (RA 1811). Oil on canvas; 78.8×129.5 cm.
(Elton Hall Collection)

a small income to supplement his father's allowance, his greatest energies were now devoted to landscape, and during the next few years he drew and sketched assiduously during numerous visits to East Bergholt. The small on-the-spot sketches became bolder and more confident, as can be seen in the *Mill Stream* [PL.82], the composition of which foreshadows the famous *Hay Wain* of some ten years later. Constable's greater confidence as a draughtsman is beautifully illustrated in the two tiny sketchbooks used during the summers of 1813 and 1814, which are among the greatest treasures preserved in the Constable collections at the Victoria and Albert Museum.[41] While the earlier, and slightly larger, book is filled with over a hundred drawings, many of them on a minute scale and often quite detailed and finished compositional studies, in the 1814 book the drawing is bolder and freer, concentrating more on the overall character and tonality of the scenes. In a letter written to Maria Bicknell in March 1814, Constable referred to the 1813 sketchbook: 'You once talked to me about a journal – I have a little one that I made last summer that might amuse you could you see it – you will then see how I amused my leisure walks, picking up little scraps of trees, plants, ferns, distances &c &c.'[42]

One of the rapidly drawn sketches in the 1814 book, which is inscribed *Sepr. 7. 1814. Wednesday*, is a compositional study for *Boat-building near Flatford Mill* [PL.83], shown at the Royal Academy in 1815. The drawing, which is preceded in the sketchbook by two sheets of related and quite slight figure studies, shows a far busier scene with many more figures than the finished composition, which, according to C. R. Leslie, 'was one which I heard him say he painted entirely in the open air'.[43] It seems that Constable worked on *Boat-building*, in which the shadows indicate a time not long after noon, in the afternoons, having devoted the mornings, perhaps also painting largely

(82) John Constable, *The Mill Stream* (*c*.1814). Oil on board; 20.8×29.2cm.
(Tate Gallery, London)

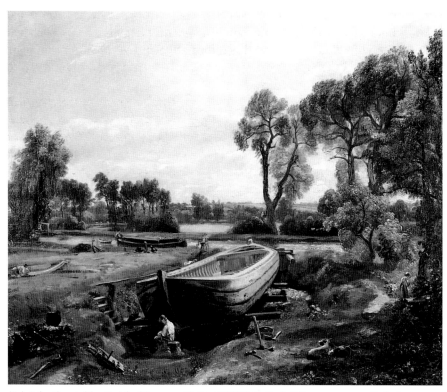

(83) John Constable, *Boat-building near Flatford Mill* (RA 1815). Oil on canvas; 50.8×61.6cm.
(Victoria and Albert Museum, London)

in the open, to the commissioned painting, *The Stour Valley and Dedham Village*, now in Boston, which was also exhibited in 1815. *Boat-building* is certainly the most important of Constable's *plein-air* works, and it is interesting to note that one of the two critics who noticed Constable's RA exhibits that year (there were five paintings and three drawings) referred to the artist's 'constant reference to common nature, seen in the freshness of his trees and his colouring in general', while the other, Robert Hunt in *The Examiner*, wrote of 'much sparkling sun-light, and a general character of truth'.[44] But the first critic complained of 'want of finish', and the second described Constable's brushwork as 'still so coarsely sketchy'.

There were similar complaints in the following year, when Constable showed only two works, including the recently rediscovered *Wheatfield*,[45] on which Robert Hunt commented favourably when it was shown again at the British Institution in the following year, concluding 'In plain words, his finishing and drawing are a little better than formerly, though still far below the standard of his colouring and general effect. These are beautiful, in as much as they are a close portrait of our English scenery.'[46] Constable certainly must have had the earlier criticisms very much in mind during the summer of 1816, for he actually postponed his already long-delayed wedding to Maria in order to do more work on the major canvas, *Flatford Mill* [COL.PL.24], which was exhibited with the title 'Scene on a Navigable River' at the Royal Academy in the following summer. It is now thought that much of the painting of this quite minutely detailed and highly organised composition took place out-of-doors, though Constable did more work on it in his London studio, and then made substantial changes after the exhibition, where once again it had not sold. *Flatford Mill* depicts a spot which had long been a favourite with Constable, and this informative and vivid sunlit composition is certainly the highpoint of Constable's hard work and study in and around East Bergholt that decade.

Another of Constable's 1817 Royal Academy exhibits was the attractive view of *Wivenhoe Park, Essex*, now in the National Gallery in Washington, which had been commissioned by General Rebow the previous summer. The death of Constable's father earlier that year meant a considerable rise in the artist's income, and further encouraged by the Rebow and one or two other commissions, John at last succeeded in persuading Maria that he could now afford to get married, despite the continued opposition of her family and, especially, of Dr Rhudde. The ceremony finally took place on 2 October 1816, when John Fisher married them at St Martin-in-the-Fields. The couple spent the next two months in the company of John Fisher and his wife – they had only been married in July – and most of that time was spent at the vicarage of Osmington, near Weymouth in Dorset, a living which John Fisher had received as a wedding present from his uncle, the Bishop. The powerful beauty of Weymouth Bay and its surroundings in autumn provided Constable with ample new material, and it was here that he painted his first beach scenes, again working largely in the open. One of the most striking of these is *Weymouth Bay* [PL.84] which dramatically records the light and atmosphere of a windy and cloudy autumn day on the English coast. Constable's paintings at Salisbury, Wivenhoe, Weymouth Bay and a few years later at Hampstead more than prove his overall skills as a landscape painter, but these were skills that had been developed by his arduous campaigns of close study in Suffolk.

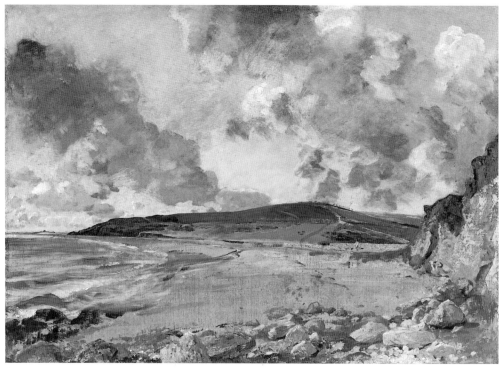

(84) John Constable, *Weymouth Bay* (c.1817). Oil on canvas; 53×75 cm.
(National Gallery, London)

In the summer of 1817 Maria and John spent some three months in East Bergholt, and he made further detailed studies, including a number of large highly finished pencil drawings, of the village, its church and its surroundings. It was during this visit that he made a rapid compositional drawing for *Dedham Lock and Mill*, of which there are three finished and one unfinished versions in oils. The last, in the Tate Gallery, may have been painted during the 1817 visit and is closest to the first finished version, which was probably one of Constable's six 1818 Royal Academy exhibits, there entitled 'Landscape: Breaking up of a shower' [PL.85]. More freely painted than the later 1820 versions (one in the Victoria and Albert Museum and the other in the Currier Gallery of Art, New Hampshire), the canvas received two or three favourable critical comments, including, and this must have surprised the artist, that of *The Literary Gazette*'s critic, who described it as 'a remarkably sweet production; the handling is admirably free, considering the apparent minuteness of this artist's usual manner.'[47]

Ever since Constable's arrival in London Joseph Farington had continued to befriend and encourage him, and to criticise his work, as numerous entries in the *Diary* demonstrate. On 2 April 1819 he called on Constable and 'made some observations on His large landscape'. This was *The White Horse* (Frick Collection, New York), which was his only exhibit at the Academy that year, with the title 'A scene on the river Stour'. It was the first of the 'six-foot' canvases with which Constable was determined to attract more attention and recognition. Though described as 'this young artist' by one of the critics that year, Constable was already in his forty-fourth year and was increasingly

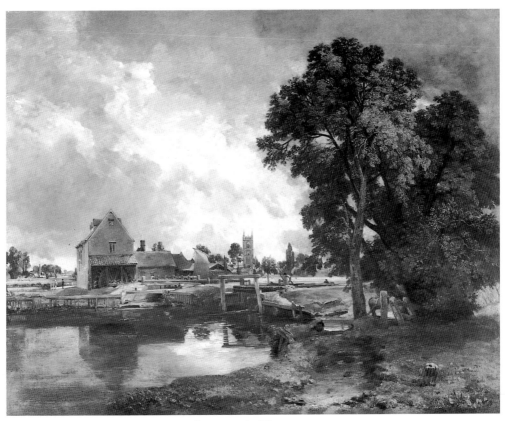

(85) John Constable, *Dedham Lock and Mill* (?RA 1818). Oil on canvas; 70×90.5 cm.
(Mr and Mrs David Thomson)

frustrated by his failure to gain election as an ARA; he had won only one vote the previous year. The painting was well received by the critics and was bought for 100 guineas by John Fisher. That November Constable was at last elected an Associate of the Royal Academy, beating his future biographer C. R. Leslie, who was eighteen years younger, by one vote.

There is a certain lack of focus in the composition of *The White Horse*, which had been painted entirely in Constable's London studio, though there are one or two preliminary oil studies and related drawings. As well as being the first large Suffolk subject completed without any work from the motif, it was also the first for which he made a freely painted full-scale 'sketch' (National Gallery, Washington) before embarking on the more highly finished exhibition canvas. This remained his normal custom when painting the other six-foot canvases in London for exhibition at the Royal Academy in the following years, the next of which was *Stratford Mill* (also known as 'The Young Waltonians'), recently acquired by the National Gallery in London. This is a much more succinct composition, which Constable's admirer Robert Hunt, critic of *The Examiner*, described enthusiastically as having 'a more exact look of Nature than any picture we have ever seen by an Englishman, and has been equalled by very few of the most boasted foreigners of former days, except in finishing. The possessor of this

picture will be envied by the lover of nature and Art.'[48] This canvas was also bought by John Fisher, as a present for his Salisbury lawyer, J. P. Tinney.

However, the third of the six-foot canvases was not sold until a few years after its exhibition in 1821 with the title 'Landscape; Noon'. Long known as *The Hay Wain* [COL.PL.27], this is the most famous of all Constable's paintings, and is the epitome of his 'love affair' with the Stour Valley. Showing Willy Lott's cottage seen from behind Flatford Mill, another of the artist's favourite spots, this harmonious and tranquil composition presents an ideal picture of a peaceful rural scene on a warm summer's day. While the full-scale sketch (in the Victoria and Albert Museum) has a much more threatening sky and is very roughly painted, *The Hay Wain* itself presents a relatively serene midday summer scene. This has become the most popular of all depictions of the English countryside, largely because it is so natural and realistic, and from his correspondence we know that Constable took great pains to achieve this. However, partly because of the totally successful incorporation of the cart, the dog and all the other figures, some of them minute, this great composition combines its realism with definite overtones of romanticism. It might well be described as 'painted poetry', and like good poetry *The Hay Wain* provides ample material for the exercise of speculation and imagination.

It was well received by the critics – Robert Hunt stated that it 'approaches nearer to the actual look of rural nature than any modern landscape whatever'[49] – and it was especially admired by two French visitors to the exhibition, the artist Géricault (as reported by Delacroix) and the critic Charles Nodier. When *The Hay Wain* was shown at the British Institution in 1822 the Paris dealer John Arrowsmith offered Constable £70 for the painting, which he did not accept. However, in the end the artist accepted Arrowsmith's offer of £250 for *The Hay Wain* and two other paintings – the 1822 six-footer, *View on the Stour near Dedham* (now in the Huntington Gallery, San Marino) and a Yarmouth shore scene – and the dealer showed all three at the Paris Salon of 1824. They were received with enthusiasm by critics, artists and the public, and Charles X awarded Constable a gold medal – one of ninety-nine such awards made at this Salon, but only two of them to other British artists, Copley Fielding and Bonington. Constable could not be persuaded to go to Paris to collect his award, and he never did go abroad, but from now on his painting was to have a profound influence on many of the younger French landscape painters, such as Huet and Rousseau. Arrowsmith acquired several further works from Constable, and another Paris dealer, Claude Schroth, also bought a number of paintings.

In the summer of 1819 Constable spent much time in Hampstead, where he had rented a house so that the delicate Maria and their children – there were now two – could live in more healthy and essentially rural surroundings. For the first time Constable was living on relatively high ground – over four hundred feet above sea level. For six of the next seven summers he again rented a house in Hampstead, and in 1827 the family moved there more permanently, leasing a house in Well Walk. Hampstead, the village and the heath, provided Constable with ample new and inspiring material, and he began on-the-spot oil sketching again. In 1821 and 1822 the bulk of these oil sketches – some hundred in all – were devoted to studies of the sky and clouds, and one of the first-fruits of these studies was the highly successful painting of

the sky in *The Hay Wain*. The fascination of these cloud and sky studies is twofold; not only are they especially attractive as works of art, but they have also proved to be very accurate records of the particular weather conditions depicted, often described in some detail in inscriptions by the artist on the verso of the sketch. This aspect of Constable's art has been closely studied by a number of scholars, for it provides valuable insight into Constable's artistic skills as well as revealing his ability and standing as a 'man of science', in keeping with the rapidly developing scientific knowledge and interests of these years. The discovery in 1972 of Constable's annotated copy of the second edition (1815) of Thomas Forster's *Researches about Atmospheric Phaenomena* at last provided factual evidence of the artist's active interest in meteorology, and of his actual familarity with Luke Howard's pioneering cloud classifications.[50]

Constable's original inscription on the back of *Cloud Study with Birds* [COL.PL.25] at Yale read *Sep. 28 1821 Noon – looking North West windy from the S.W. large bright clouds flying rather fast very stormy night followed*, which apparently corresponds closely with the London weather records of that day, confirming the accuracy of the artist's observations. It has been suggested that his deeper interest in the sky was aroused by anonymous criticisms made at Salisbury in 1821 of the painting of the sky in *Stratford Mill*, the 1820 six-foot exhibit, which was bought by John Fisher for Mr Tinney. Constable responded to these criticisms in a letter to Fisher written in Hampstead on 23 October 1821, in which he summed up the basis of his painting of skies as follows:

> I have not been Idle and have made more particular and general study than I have ever done in one summer, but I am most anxious to get into my London painting room, for I do not consider myself at work without I am before a six foot canvas – I have done a good deal of skying – I am determined to conquer all dificulties and that most arduous one among the rest, and now talking of skies – ... That Landscape painter who does not make his skies a very material part of his composition – neglects to avail himself of one of his greatest aids. Sir Joshua Reynolds speaking of the 'Landscape' of Titian & Salvator & Claude – says *'Even their skies seem to sympathise with the Subject'*. I have often been advised to consider my *Sky* – as a *'White Sheet drawn behind the objects'*. Certainly if the Sky is *obtrusive* – (as mine are) it is bad, but if they are *evaded* (as mine are not) it is worse, they must and shall always with me make an effectual part of the composition. It will be difficult to name a class of Landscape, in which the sky is not the *'key note'*, the *standard* of *'Scale'*, and the chief *'Organ of sentiment'*. You may conceive then what a *'white sheet'* would do for me, impressed as I am with these notions, and they cannot be Erroneous. The sky is the *'source of light'* in nature – and governs everything.[51]

The sky plays an essential role in most of Constable's paintings of the landscape of Hampstead and its heath, as in the panoramic view of *Hampstead Heath* [PL.86] in the Fitzwilliam Museum, Cambridge, though this was probably painted before the 'skying' campaigns of 1821 and 1822. The artist's study of the sky was also furthered by another new painting locality which he came to visit frequently because of Maria's continued poor health. This was Brighton, where Maria and the children stayed for lengthy periods in 1824, 1825–6, and 1828. Though at first Constable disliked the fashionable and rapidly developing seaside resort, he soon found ample material for drawing and sketching on the busy beaches and the neighbouring Downs. Some of the Brighton

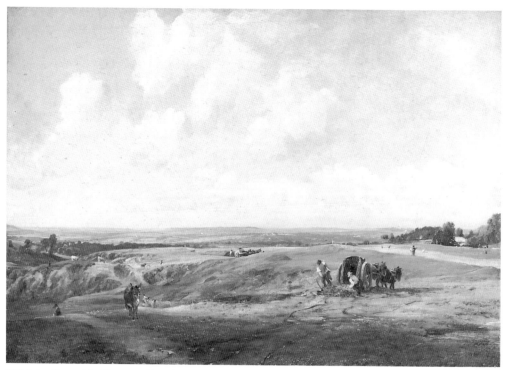

(86) John Constable, *Hampstead Heath* (1821). Oil on canvas; 54×76.9 cm.
 (Fitzwilliam Museum, Cambridge)

beach scenes are the most 'modern' of Constable's works, and they anticipate Boning-
ton's Normandy coast scenes by a year or two, and those of Eugène Boudin by some
forty years. These studies led to one of the most neglected of Constable's six-foot can-
vases, the Tate Gallery's *The Chain Pier, Brighton* [PL.87], which was shown at the Royal
Academy in 1827. Here, probably quite deliberately as with his Lake District landscapes
of twenty years earlier, Constable selected a subject in keeping with the fashion of the
day, though he chose to represent it somewhat unsympathetically under a lowering sky
on a humid and squally day. John Fisher, writing to his wife after seeing the *Brighton* in
Constable's Hampstead studio, commented that 'it is most beautifully executed & in
a greater state of finish and forwardness, than you can ever before recollect. Turner,
Calcott and Collins will not like it.' Once again the picture did not sell, despite the
'usefull change of subject' (to quote Fisher's comment to the artist),[52] but it was the
subject of the first engraving, by Frederick Smith, after a major work by Constable,
which was published by Colnaghi's in 1829.

 After these excursions to Hampstead and Brighton it is time to return to Constable
Country, which remained *the* central factor of Constable's art, and provided the sub-
ject matter for many more of his exhibited works. He had shown no six-foot canvas at
the RA in 1823, when *Salisbury Cathedral from the Bishop's Grounds* (Victoria and Albert
Museum, London), which was painted for the Bishop, was his principal exhibit, and in
1824 it was the relatively small view of Flatford Lock – *The Lock* (Thyssen Collection).
This was bought at the exhibition by James Morison, who was probably impressed by

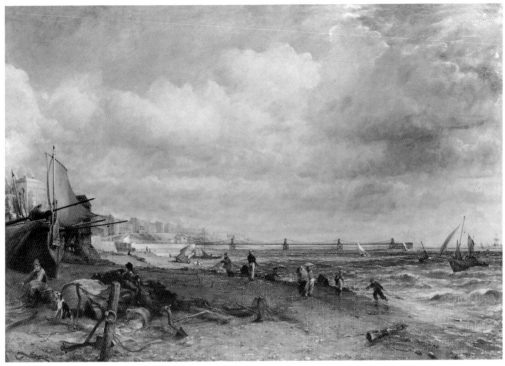

(87) John Constable, *The Chain Pier, Brighton* (RA 1827). Oil on canvas; 127×183 cm. (Tate Gallery, London)

the Claudian character of this upright composition, which Constable painted immediately after his return from a long autumn visit to Coleorton, the Leicestershire seat of Sir George Beaumont. Here Constable had spent a blissful six weeks, studying and copying the Claudes and other works in the collection, painting landscapes with his host, and enjoying the civilised rural life of this most cultured of upper class households. The stimulation of this visit is graphically recorded in a series of letters to Maria, which also make it clear that Constable was quite reluctant to return to home and hearth, where there were now four young children (there were to be seven in all).[53]

The impact of the Coleorton visit was still fresh when Constable was working on the final six-foot Stour scene, which was also the most dramatic and daring of the series, the composing and painting of which gave him a great deal of trouble. There are numerous preliminary drawings and studies for *The Leaping Horse* [PL.88], which depicts a spot some distance upstream from Flatford, right on the border between Suffolk and Essex, and the barge horse is actually shown jumping from Essex into Suffolk. The composition of this powerful canvas, into which the artist has packed a great deal of evocative detail, closely resembles that of one of the paintings which Constable would have seen at Coleorton, Sebastien Bourdon's *The Return of the Ark* (National Gallery, London). This was bequeathed to Sir George Beaumont by Joshua Reynolds, who had referred to it in his Fourteenth Discourse as an example of 'the poetical style of landskip', which he described as a style of painting that 'possesses the ... power of inspiring sentiments of grandeur and sublimity, and is able to communicate them to

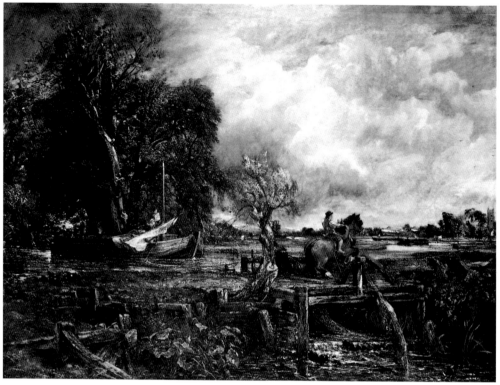

(88) John Constable, *The Leaping Horse* (RA 1825). Oil on canvas; 142.2×187.3cm.
(Royal Academy, London)

subjects which appear by no means adapted to receive them'.[54] It seems likely that in *The Leaping Horse* Constable was deliberately creating not only the most technically advanced and freely painted of the large Stour scenes, but was also making a positive effort to fit the work into the tradition of landscape painting as outlined by Sir Joshua. This was a difficult brief, and it is not surprising that the artist made numerous pentimenti both in the full-scale sketch (V. & A.) and in the exhibited work, including the addition of a strip of canvas at the top and other major changes after its return from the exhibition.

The bravura of *The Leaping Horse*, much of which was painted with the palette knife, contrasts strongly with the restful calm and relatively old-fashioned painterliness of *The Cornfield*, Constable's principal RA exhibit in the following year (National Gallery, London, to which it was presented by a body of subscribers in 1837 to commemorate the artist). However, both paintings have in common the influence of works in the Beaumont Collection, in this case once more that of Sir George's favourite small Claude, *Landscape with Hagar and the Angel*. The same painting provided the pattern for the composition of *Dedham Vale* [COL.PL.28], shown at the RA in 1828, but probably begun late in 1827. It has been suggested that in again paying homage to this beautiful Claude Constable was also commemorating Sir George Beaumont, who had died at the beginning of that year. A curious feature of Beaumont's friendship with and encouragement of Constable was that the collector apparently never acquired an important

painting by the artist. One of the factors that united the two men was their mutual high regard for the teaching and theories of Sir Joshua Reynolds, which remained a powerful force in British painting throughout the first half of the nineteenth century. However, Constable's own painting was clearly not to Sir George's taste, and this difficult situation reflects the dichotomy between old and new in so much of the artist's own work and thinking.

The unexpected traditionalism of much of Constable's outlook is also evident in his political views. He was deeply upset by the radicalism and demands for reform of the 1820s and 1830s, especially as reflected in the agrarian unrest in his native Suffolk, which was hard-hit by poor harvests and the general economic recession in the years after the Napoleonic Wars. The protective Corn Laws, which were not finally repealed until 1846, encouraged instability in the corn trade and thus hardship among those working on the land, while the harsh Settlement Laws discouraged the migration of agricultural workers away from the land. The hardship of the poor was much increased by the Poor Law Amendment Act of 1834, which virtually ended outdoor relief for the able-bodied poor, who from then on had to enter the workhouse to receive assistance. Many of the artist's letters to John Fisher and others demonstrate his largely conservative opinions, and these present a striking contrast with the continuing advances in the radically modern qualities of his art, which many puzzled critics dismissed as a form of idiosyncrasy and 'mannerism'. Thus the critic of *The Sun* described *Hadleigh Castle. The mouth of the Thames – morning, after a stormy night* (Yale Center for British Art), when shown at the Academy in 1829, as 'Full of nature and spirit, and graceful easy beauty; though freckled and pock-marked, after its artist's usual fashion'.[55] Based on a slight pencil drawing made in 1814, this broad and powerful composition and its full-scale sketch [COL.PL.30] were painted at a time of great personal tension and grief, for Maria had died in Hampstead of tuberculosis on 23 November 1828. Less than three months later Constable was at last elected a Royal Academician, but the pleasure that this should have given was overshadowed by 'the loss of my departed Angel' as he wrote to his brother Golding, continuing 'I shall never feel again as I have felt … the face of the World is totally changed to me'.[56]

The gloomy and somewhat ominous atmosphere of the two large-scale versions of *Hadleigh Castle*, and especially of the roughly painted preliminary sketch, has been attributed to Constable's personal desperation at this time of mourning, which his long-delayed election as a full Royal Academician did little to alleviate. We know that Turner was one of the Academicians who called after the election to congratulate Constable, who would probably already have had one or both versions of *Hadleigh Castle* on his easel at the time. One wonders whether it was shown to Turner, and, if so, his comments must have been acceptable, for Constable reported to his friend John Chalon, ARA, 'We parted at one o'clock this morning, mutually pleased with one another.'[57] Certainly *Hadleigh Castle* is the most Turnerian of all Constable's major works, and it does not fit into any of the usual contexts in which the artist produced the great majority of his exhibition pieces. On the other hand as his Diploma Work Constable presented *A Boat passing a Lock*, the horizontal version of his 1824 six-foot Stour scene. This had been commissioned in 1826 by his friend James Carpenter, a Bond Street bookseller, who was persuaded by Constable to let him have it back so that he could use it as his Diploma

picture. Thus a prime Suffolk composition represents Constable in the Diploma Collection, and as the result of gifts from the artist's second daughter, Isabel, and others, there is a significant collection of Constable's work at Burlington House. It was also Isabel Constable who in the late 1880s gave and bequeathed to the Victoria and Albert Museum the nucleus of its great Constable collection.

After 1828 Constable showed few Suffolk subjects at the Royal Academy until he exhibited the Tate Gallery's *The Valley Farm*, which had already been bought by Robert Vernon, in 1835. This was not a six-foot canvas, but Constable had shown works of this size or even larger in the intervening years. The dramatic *Salisbury Cathedral from the Meadows* [PL.89], the imposing culmination of all his views of that great church, was shown in 1831, and in the following year the vast *The Opening of Waterloo Bridge seen from Whitehall Stairs, June 18th 1817* (Tate Gallery, London) was at last exhibited after a gestation period of some thirteen years. The latter was much more colourful than was usual for Constable, but was also finished with the liberal flecks of white paint to which so many of the critics of the day objected, one even suggesting that 'a shower of whitewash had fallen upon it from the ceiling of his new studio'.[58]

As well as four oil paintings, Constable had four watercolours at the Academy in 1832, and he showed only watercolours, including the well-known *Old Sarum* (V. & A.) in 1834, probably because he had been too ill earlier in the year to prepare oil paintings for the exhibition. However, his increasing use of the more fluid medium of watercolour in these later years was certainly also connected with the growing spontaneity of his landscape painting, resulting in the near abstract qualities of some of his late oil sketches, such as the *River Scene, with a Farmhouse near the Water's Edge* [COL.PL.29], which Graham Reynolds sees as one of a small group of drawings and paintings based on the first of the six-foot Stour scenes, *The White Horse*, which Constable had bought back from John Fisher, who was in financial difficulties at the time, in 1829. There are also several very effective sepia wash drawings, somewhat reminiscent of Claude, of this late period, which repeat motifs from some of Constable's favourite Suffolk compositions. The equally bold watercolour study *A Country Lane leading to a Church* [PL.90] is copied from an open-air oil sketch of 1816, and provides yet another example of Constable's retrospective mood of these years.

The main result of this was certainly the series of mezzotint plates by the young engraver David Lucas entitled *Various Subjects of Landscape, Characteristic of English Scenery, From Pictures Painted by John Constable, RA*, the first number of which was issued in June 1830. Based on a varied and wide-ranging selection of finished paintings, oil sketches and drawings, twenty-two prints were issued in five parts between 1830 and 1832, and these were reissued in a second rearranged edition in 1833. For that edition Constable added the phrase 'principally intended to mark the Phenomena of the Chiar'oscuro of Nature' to the title. This series, which the artist himself financed and published, was intended as a pictorial review and justification of his landscape work, as was made clear by the Introduction and notes to some of the plates that Constable issued with the second edition, the composition of which cost him much effort. The powerful black-and-white mezzotints with their wonderful tonal variations justified Constable's claim that the work 'aims to direct attention to the source of one of its [Art's] most efficient principles, the "CHIAR'OSCURO OF NATURE," to mark the influence of

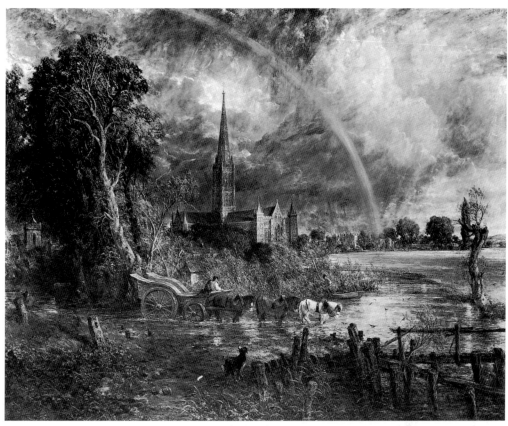

(89) John Constable, *Salisbury Cathedral from the Meadows* (RA 1831). Oil on canvas; 151.8×189.9cm. (Private Collection, on loan to the National Gallery, London)

(90) John Constable, *A Country Lane leading to a Church* (c.1836). Pencil and watercolour; 21.3×18.3cm. (Victoria and Albert Museum, London)

light and shadow upon Landscape, not only in its general impression, and as a means of rendering a proper emphasis on the parts, but also to show its use and power as a medium of expression, so as to note "the day, the hour, the sunshine, and the shade".'

For both artist and engraver *English Scenery* was an all-engrossing project, and it certainly was the central element of Constable's life and work in the early 1830s. Soon after the completion of the first edition Archdeacon Fisher died from cholera while on a visit to Boulogne in August 1832, and, as Constable wrote to C.R.Leslie, 'I cannot say but this very sudden and awfull event has strongly affected me. The closest intimacy had subsisted for many years between us – we loved each other and confided in each other entirely – and this makes a sad gap in my life & worldly prospects.'[59] Not long afterwards Constable suffered another blow, with the death in November of his former studio assistant 'Johnny' Dunthorne, son of his early friend and fellow artist in East Bergholt. Constable attended the funeral at East Bergholt, and, as he recounted in a letter to David Lucas, he had an experience which must have pleased him enormously on his journey back to London: 'In the coach yesterday coming from Suffolk, were two gentlemen and myself all strangers to each other. In passing through the valley about Dedham, one of them remarked to me – on my saying it was beautifull – "Yes Sir – this is *Constable's* country!" I then told him who I was lest he should spoil it.'[60]

In his final years Constable was at last given the recognition as an artist which had so long been his due. *English Scenery* received a number of good reviews, but it sold badly, and there was often tension about its progess between Constable and Lucas. The correspondence between these two reveals clearly what a difficult and moody person Constable must have been, and it was his personality as much as his art which caused problems in his relationships with fellow artists. However, once elected he played an active role at the Royal Academy, and his sudden and unexpected death on 31 March 1837 caused considerable consternation in the world of artists. It was a strange co-incidence that shortly before his death 'it fell to his lot,' to quote from the obituary in *The Examiner*, 'as visitor in the living model school of the Royal Academy, to close on the previous Saturday the last and final session of the studies at Somerset House, the whole establishment being now transferred to the new building in Trafalgar Square'.[61] At the first exhibition in the new galleries Constable was represented by the painting on which he was working at the time of his death, and which he had not quite completed. This was *Arundel Mill and Castle* (Toledo Museum of Art, Ohio), which he had originally intended for the 1836 exhibition, but he then chose to send instead *The Cenotaph* [PL.91], because, as he wrote to his friend George Constable, who lived at Arundel, he 'preferred to see Sir Joshua Reynolds's name and Sir George Beaumont's once more in the cata-logue, for the last time in the old house'.[62]

Based on a drawing made during his 1823 visit to Coleorton, the painting was given the following title in the 1836 catalogue: 'Cenotaph to the memory of Sir Joshua Reynolds, erected in the grounds of Coleorton Hall, Leicestershire, by the late Sir George Beaumont, Bart.', and the text of Wordsworth's commemorative poem in-scribed on the monument and visible in the painting, was also printed in the catalogue. It was another remarkable coincidence that this somewhat sentimental 'memorial' work should also have become the final painting shown at the Royal Academy during the artist's lifetime. This 'very beautiful picture', to quote one of several favourable

(91) John Constable, *The Cenotaph* (RA 1836). Oil on canvas; 132×108.5 cm.
 (National Gallery, London)

reviewers, is in many ways a summing up of Constable's personality and art, combining the respect for tradition and the past with a determination to be up-to-date and modern. Unusually for Constable in his later years, this is an autumn scene, and though there is none of his normal richness of colour there is a wonderful rendering of light and shade.

While *The Cenotaph* was on exhibition in Trafalgar Square Constable delivered a course of four lectures on 'The History of Landscape Painting' at the Royal Institution in nearby Albemarle Street. In his first lecture he described the profession of the painter as *'scientific* as well as *poetic'*,[63] and he closed the final lecture with the following famous lines: 'Painting is a science, and should be pursued as an inquiry into the laws of nature. Why, then, may not landscape be considered as a branch of natural philosophy, of which pictures are but the experiments?'[64] Constable's premature death prevented him from doing more to support this plea for the proper recognition of landscape painting in Britain. Turner had similar ambitions, as witnessed by his still-born plans for the creation of a Professorship of Landscape Painting at the Royal Academy. Landscape painting gained in popularity in Britain throughout the nineteenthth century, but it was not again to have practitioners of real genius, like Constable and Turner. For such, lovers of art now had to look across the Channel, to France.

12 John Crome (1768–1821) and the Norwich School

The Norwich-born J.S.Cotman, who sadly failed to establish himself successfully in the capital, is reported to have said, 'London, with all its fog and smoke, is the only air for an artist to breathe in.' Throughout most of the nineteenth century London dominated the world of British art, and Norwich was unusual in having an independent 'school' of artists, who were content to live and work in their native city.[65] With the exception of the so-called Norwich School's founding father and long-time leader, John Crome, and of J.S. Cotman, the members of the Norwich School were minor artists with a largely provincial outlook. John Sell Cotman was certainly the most significant of all the painters associated with Norwich, and as he was an important formative figure in the development of the early nineteenth-century British watercolour school his life and work have been fully discussed in Chapter 6. John Crome's painting and drawing had little or no impact outside Norwich in his own lifetime, but retrospectively it is of significance in the story of nineteenth-century British landscape art.

Still a prosperous textile and commercial centre, though no longer one of the most powerful of English cities, Norwich at the beginning of the nineteenth century was a surprisingly radical and lively centre, with much cultural, scientific and artistic activity. Born quite close to the Cathedral in the year of the foundation of the Royal Academy, John Crome rarely moved from his native city. His father was a weaver who also kept an alehouse, and having given his son little formal schooling he apprenticed him at an early age to a sign and coach painter. When he had completed his seven-year apprenticeship Crome, despite being without proper art training, set up as an artist and established himself as a drawing master. He had been fortunate in having the support and encouragement of one of the principal local collectors and patrons, Thomas Harvey of

(92) John Crome, *Slate Quarries* (c.1802–5). Oil on canvas; 123.8×158.7cm.
(Tate Gallery, London)

Catton House, whose collection included Wilsons, Gainsboroughs, Hobbemas, and works by other Dutch landscape artists, which Crome was free to study and copy. With these influences in the background, Crome found his active inspiration in the placid scenery of Norwich and its backwaters, and of the surrounding very 'English' countryside. These made him a painter, and largely through his influence they became the staple of the Norwich School artists as a whole.

Little survives or is known of Crome's early work, much of which appears to have been painted in the open, and for various reasons it is difficult to establish a reliable chronology for his work as a whole. The beautiful *Slate Quarries* [PL.92], with its stark rendering of mountainous country on a cloudy day, is generally considered to date from about 1805, and features that broad use of thin paint which is associated with the artist's early style. It may have been based on a sketch made during Crome's 1802 tour of the Lake District, one of his few journeys outside Norfolk, except for fairly regular trips to London. Crome crossed the Channel once, in 1814, largely to see the art treasures assembled in Paris by Napoleon. *Slate Quarries* has the same fine tonal qualities that are to be found in Crome's watercolours of this period, as they are in those that Cotman produced around 1805, especially in Yorkshire (see PLS.33,34).

More typical of Crome's work is *Marlingford Grove* [PL.93], painted for a Great Yarmouth patron in 1815. In this large canvas a peaceful woodland path with its varied

(93) John Crome, *Marlingford Grove* (*c*.1815).
Oil on canvas; 135×100cm. (Lady Lever
Art Gallery, Port Sunlight)

trees and herbage is brought to exciting life by the dashes of flickering sunlight falling through the trees and contrasting with the dark shadowy areas in the foreground and beyond. The sole figure in the composition provides an element of scale, but has no narrative role; Crome usually included figures in his landscapes simply as staffage. Marlingford Grove and similar rural scenes near Norwich were among Crome's favourite subjects, as were the equally quiet backwaters of the River Wensum in the north of the city, as seen in the *Back of the New Mills* [COL.PL.15] which dates from around 1819. Delicate in colouring and quite thickly painted, this again combines considerable detail with a fine rendering of light and atmosphere. Among Crome's other favoured subjects were boating scenes on the River Yare and beach scenes at Great Yarmouth, where that river flows into the sea. Throughout his career he worked in both oils and watercolours.

Between 1806 and 1818 Crome exhibited quite frequently in London at the Royal Academy, where his work seems to have attracted little, if any, notice. However, his principal exhibiting was with the Norwich Society of Artists, which he helped to found with his fellow artist and brother-in-law, Robert Ladbrooke (1770–1842), in 1803. The Society quickly became a focal base for the considerable number of artists, many of them amateurs, and art lovers centred on Norwich, and held regular fortnightly evening meetings for study, discussion and the like. The Society's first public exhibition was held in 1805, and with one or two exceptions the exhibitions continued each year until 1839. Crome was a prolific contributor; he showed twenty-four works in 1805, twenty-nine in the following year, and never less than ten in subsequent years. Except in 1811, hardly any of these paintings were for sale, and it is interesting to note that the

preamble of the catalogue of the first exhibition outlined its aims as follows: 'Public Exhibition, uniting public criticism, and the advantage to artists of comparing their productions, has been considered the surest mode of furthering their progress, by giving the spur to emulation.' John Crome, and several of his fellow Norwich artists, spent much of their time giving drawing and painting lessons in the city and the vicinity, and this, as well as a certain amount of dealing in old masters, provided the basis of the artist's income. Many of his pupils belonged to the same families that bought his paintings, and it seems that for most of his career Crome made quite a comfortable living from all these activities.

In 1808 Crome served for the first time as President of the Norwich Society, and at the time he was already generally accepted as the leading figure among the city's artists. Cotman, disappointed by his failure to find adequate patronage and recognition in London, had returned to his native Norwich in 1806, but failed to challenge Crome's position, despite exhibiting prolifically (344 works in all) with the Norwich Society from 1807 onwards. The older artist's own work had a strong influence on that of other local artists, both professional and amateur, and his regular exhibiting at the annual exhibitions must have enhanced that influence. In 1815 he showed his well-known *Boulevard des Italiens* (Gurney Collection, on loan to Norwich Castle Museum), one of the three major canvases resulting from his 1814 visit to France. Another of these, *The Fishmarket at Boulogne* (Gurney Collection, on loan to Norwich Castle Museum), was shown in 1820. Both these ambitious canvases combine bold composition and much fine detail with some remarkably weak passages, especially among the figures of the *Boulevard des Italiens*. They provide evidence of Crome's limitations, and the artist's relatively early death prevented further development of the promise found in much of his mature work. However, Crome's work was exceptionally well regarded in Norwich, and for his memorial exhibition in 1821 works were lent by no less than thirty-nine individual owners – patrons, friends and fellow artists.[66]

John Thirtle (1777–1839) was another of the artists involved in the beginnings of the Norwich Society, having recently returned to Norwich after a few years apprenticed to a frame-maker in London. He worked very largely in watercolours, and was strongly influenced by Thomas Girtin, who was at the height of his powers while he himself was in London. Thirtle's fresh and fluent on-the-spot watercolour studies have much of the immediacy and balance of Girtin's mature work, but sadly many of the finished exhibition drawings based on them are dull and stylised. This is seen clearly when the attractive and spontaneous *River Scene with Bridge* [PL.94] is compared with the much larger *Evening River Scene*, also at Norwich, which was based on it and probably exhibited in 1816. In addition Thirtle was much influenced by the work of J.S.Cotman after that artist's return to Norwich in 1806, and the two artists married sisters. Thirtle bowed to public taste, as his brother-in-law, to his cost, did not!

Among Crome's many pupils were three who became leading professional painters of the Norwich School. The oldest of these was James Stark (1794–1859), who was only a few days senior to Crome's own eldest son, John Berney (1794–1842). The third of these artists, George Vincent (1796–1832), was born some eighteen months later, but was old enough to be friends with the other two when they were all pupils at Norwich Grammar School. All three boys were taught by John Crome during and

(94) John Thirtle, *River Scene
with Bridge* (c.1816).
Watercolour; 31.3×44.2cm.
(Castle Museum, Norwich)

immediately after their schooldays, and they exhibited at the Norwich Society and at
the Royal Academy from an early age. Sadly, these three 'born' artists, who became the
leading practitioners of the Norwich School in the 1820s, had only limited talent and
lacked the genius of their mentor and teacher. While each of the artists retained some
individuality, on the whole the Norwich School landscape painting of the 1820s and
1830s became rather stereotyped and repetitive, and contributed nothing to the major
contemporary developments in British landscape painting. One aspect of landscape
art where most Norwich artists, again following the lead of John Crome, made more
original contributions was in their etchings and engravings, which were a major
preoccupation for Cotman and others.

James Stark did not study or work exclusively in Norwich, but, after three years at
the Royal Academy Schools, ill health forced him to return there for a period of about
twelve years during which he was an active member of the Norwich Society, becoming
President in 1830. Soon after this he moved back to London, where he had continued to
exhibit regularly and with some success, living near the Thames. He spent the 1840s in
Windsor and returned to London for his final years. Stark's early landscape style was
close to that of Crome, and Norfolk woodland and rural scenes predominated, but with
rather more life and incident in his compositions than was usual with his master.
In later years his work was increasingly reminiscent of Hobbema, but it included
attractive riverside scenes and views of Windsor. The small panel painting *View on the
Yare near Thorpe Church* [PL.95] epitomises the carefully observed and detailed scene that
shows Stark at his most attractive.

John Berney Crome first exhibited with the Norwich Society when he was only
eleven; his career was based largely on Norwich, and was much overshadowed by
his father, who was for long known as 'Old Crome' to differentiate him from his son.
Though J.B.Crome achieved some individuality in his numerous moonlit scenes he is
understandably dismissed by Samuel Redgrave as an artist whose 'works were very
unequal, and he never took any place in art.'[67] On the other hand, of the third and
youngest of these three John Crome students, the short-lived George Vincent, Redgrave
wrote in the same *Dictionary*, 'he had powers, which show that he might have rivalled

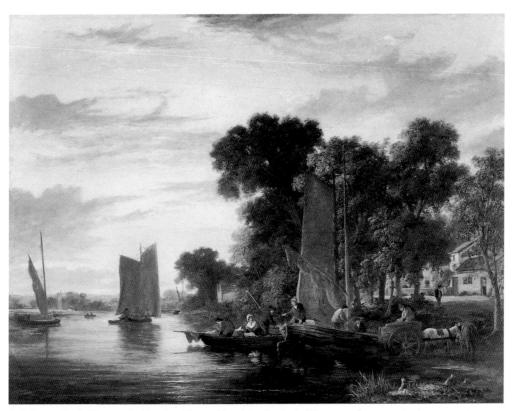

(95) James Stark, *View on the Yare near Thorpe Church* (*c.*1820–30). Oil on panel; 42.5×55.9 cm. (Castle Museum, Norwich)

the great landscape painters of his day.' In 1818 Vincent settled in London, where he had already been exhibiting for some years, but his potentially successful career was marred by dissolute living and mental problems. He exhibited most frequently at the British Institution, where he showed over forty works, including, in 1824, the large and impressive *View of Beachy Head from Pevensey Bay* [PL.96], which was favourably reviewed by the London press and which certainly bears comparison with the current work of Constable and Turner. Vincent had travelled in France, with J.B.Crome, and also visited Scotland, and exhibited a number of paintings resulting from those trips, among them an attractive view in Rouen which is now at Norwich.

Joseph Stannard (1797–1830), who was also born in Norwich and became a pupil of Robert Ladbrooke, was as much of a marine as a landscape artist, whose visit to the Netherlands in 1821 had a strong effect on him. His work was usually highly finished and brightly coloured, using quite thickly applied paint. There are similar qualities in the bold paintwork of the much younger Henry Bright (1810–73), who was actually born in Suffolk, in Saxmundham, but having moved to Norwich was apprenticed to Alfred Stannard, Joseph's younger brother, who was also a painter. Bright spent the central years of his career in London, having moved there in 1836, and owing to ill health returned to Saxmundham in 1858. Not strictly speaking a member of the Norwich School, Henry Bright is always associated with it, included several of the younger Norwich artists among his friends, and is especially well represented in the Norwich Castle Museum collections.[68] His effective paintings of the flat Norfolk landscape, often

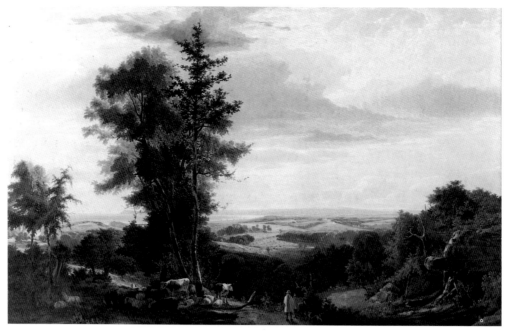

(96) George Vincent, *View of Beachy Head from Pevensey Bay* (BI 1824). Oil on canvas; 146×233.7 cm. (Castle Museum, Norwich)

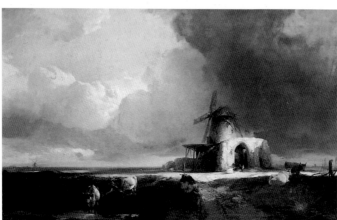

(97) Henry Bright, *Remains of St Benedict's Abbey on the Norfolk Marshes – Thunderstorm clearing off* (RA 1847). Oil on canvas; 80.3×132.9 cm. (Castle Museum, Norwich)

(98) John Middleton, *Alby, Norfolk* (1847). Watercolour; 31.7×48.3 cm. (Castle Museum, Norwich)

shown under threatening skies, are somewhat reminiscent of the adaptation of the Dutch seventeenth-century landscape style by the French landscape artist Georges Michel (1763–1843). Both these artists were pioneers of the tonal landscape manner of the second half of the nineteenth century. These qualities are well illustrated by Bright's ambitious 1847 Royal Academy exhibit, *Remains of St Benedict's Abbey on the Norfolk Marshes – Thunderstorm clearing off* [PL.97]. This was given a very mixed reception by the London critics, and Bright's candidature for election as an ARA that year was not successful. The vivid portrayal of a fleeting light effect was also a feature of many of Bright's watercolours, and the same quality can be found in the watercolours of one of his pupils, John Middleton (1827–56), who was born in Norwich, where he spent most of his short life. Middleton learnt from Bright that fluent and fluid use of watercolour which Peter de Wint and other leading members of the Old Water-Colour Society were also developing during these years. In recent years John Middleton's calm and undemanding studies of country lanes and the like have been among the most popular Norwich School works. The elegant and direct watercolour *Alby, Norfolk* [PL.98], which is dated 1847, may be considered as a pleasing sequel to J. S. Cotman's pioneering Yorkshire watercolours of some forty years before. Just like Cotman's, Middleton's work really lay outside and beyond the somewhat restrictive confines of the Norwich School, and its close adherence to the influence of seventeenth-century Dutch landscape painting. Local piety in the early years of the twentieth century did much to elevate the status of the work of the Norwich School as a major feature of nineteenth-century British landscape art, though in recent years it has come to be considered as an essentially provincial phenomenon.

13 R. P. Bonington (1802–28) and his Followers

Richard Parkes Bonington was a short-lived English-born prodigy the greater part of whose working life was spent in France. He was born in Arnold, near Nottingham, a few days before the death of Thomas Girtin, and in 1817 moved with his family to Calais, where his father, who had practised as a drawing master and portrait painter, hoped to set up a lace-making firm with two partners. The watercolourist F. L. T. Francia, born in Calais in 1772, had recently returned there after many years in London, where he had a successful career working in the manner of Girtin. Francia came across the young Bonington sketching in the harbour, and began to teach him the art of watercolour. In the following year the family moved to Paris, where Bonington was quickly acquainted with several young artists, including Delacroix, and enrolled in the atelier of Baron Gros. Though his studies were largely devoted to figure drawing and painting, Bonington continued to sketch and draw landscape and topographical subjects, mostly in watercolours.

In the autumn of 1821 he undertook his first sketching tour in Normandy, and exhibited a group of Normandy watercolours in a commercial gallery in Paris in the following spring. Two of his watercolours were also shown at the Salon that April, and were well received. From the beginning Bonington's small watercolours of shore and river scenes attracted attention, especially among artists, because of their wonder-

(99) R.P.Bonington, *A Fishing Village on the Estuary of the Somme, near St-Valery-sur-Somme* (c.1821). Watercolour over pencil; 15.7×23.2 cm. (Private Collection)

ful directness and simplicity, which took the English watercolour manner pioneered by Girtin, Turner, Cotman, and others in the first decade of the century to one of its high-points. The impact of drawings like *A Fishing Village on the Estuary of the Somme, near St-Valery-sur-Somme* [PL.99], which probably dates from 1821, is summed up in the following reminiscence by Camille Corot (1796–1875), who was still on the threshold of his own artistic career when by chance he saw a Bonington watercolour in the window of Paul Schroth's Paris gallery: 'No one thought of landscape painting in those days; it seemed to me, in seeing this, a view on the banks of the Seine, that this artist had captured for the first time the effects that had always touched me when I discovered them in nature and that were rarely painted. I was astonished by it. This small picture was, for me, a revelation. I discerned its sincerity, and from that day I was firm in my resolution to become a painter.'[69]

These were the reminiscences of old age, and it should be remembered that in the early 1820s there were other very able British landscape artists working and exhibiting in Paris, especially members of the Fielding family, of whom the best-known is Anthony Vandyke Copley Fielding (1787–1855). In addition some of the leading Parisian dealers, including, of course John Arrowsmith, were handling the work of other British landscape artists. One of these dealers, J.-F.Ostervald, was also involved in the publication of the ambitious series of antiquarian lithographs – Baron Taylor's *Voyages Pittoresques et Romantiques dans l'ancienne France* – for which Bonington began to work in 1823, producing five plates in all. Bonington had learnt the art of lithography from Francia, and his antiquarian drawings and lithographs were soon in demand. Here also the young artist showed precocious skills and produced numerous confident pencil drawings and then lithographs in the detailed and animated Proutian manner. In 1824 Bonington

issued his own series of ten quite small lithographs, known as *La petite Normandie*, which illustrated some of the most ornate and complex of the Gothic buildings in northern France. However, though Bonington's involvement with illustrative lithography continued throughout his career, his principal concern was always his work in watercolours and oils, including many on-the-spot studies undertaken during further sketching trips, such as one to Bruges and Ghent in 1823.

Bonington, accompanied by his French artist friend, Alexandre Colin, spent much of 1824 in Dunkirk, and from now on he found fruitful inspiration in the towns, harbours and beaches of Normandy. It was at this time that he developed his skills in painting in oils, which he seems to have begun in the previous year. In this he was probably self-taught, and in his broad and simple early oil sketches he was adapting the fluent watercolour technique which he had mastered so quickly. At the so-called 'English Salon' of 1824, which opened after much delay in August, Bonington was one of the three of the fifteen or so exhibiting British artists to be awarded a Gold Medal – the others were Constable and Copley Fielding. He showed four oils, several watercolours and a lithograph, which were well received by the critics, one of whom, Auguste Jal, described him as 'an Englishman transported to Paris, where he has generated a mania. For some time the collectors have sworn by him; he has inspired followers and imitators.'[70] Patrick Noon has suggested convincingly that *A Fishmarket near Boulogne* [COL.PL.32] is the painting entitled 'Marine. Fishermen Unloading Their Catch', which was No. 191 at this Salon. This placid scene, with its mellow evening light and its skilfully painted foreground details, was Bonington's most ambitious and influential marine painting. It was acquired by James Carpenter, the London bookseller and publisher (and patron of Constable), and later belonged to Turner's patron, H. A. J. Munro of Novar. In 1831 Carpenter published first a mezzotint after it, and then a line engraving by Charles Lewis. It is interesting to compare this work with Turner's 1830 *Calais Sands*, which may have been painted as an act of homage to the recently deceased young genius.

In the summer of 1825 Bonington, again accompanied by Colin, travelled to London, where he spent much of his time in the company of Delacroix, Isabey and other young French artists also visiting England. On returning to France Bonington remained in Normandy, where he was joined by Delacroix and Isabey. The latter acompanied him on sketching tours along the Channel coast, and when Bonington returned to Paris at the end of the year he shared Delacroix's studio. When sketching on the Seine, Bonington was joined by another French artist friend, Paul Huet (1803–69), whose landscape paintings and watercolours were very strongly influenced by the Englishman's style.

The friendship with Delacroix was an important factor in Bonington's brief career, and the young artist's romantic figure painting and drawing were close in style and manner to the contemporary work of the slightly older French artist. Delacroix, whose *The Massacre of Chios* had been one of the highlights of the 1824 Salon and was bought by the State, was already established as one of the leading artists of his day. The example and influence of Delacroix, added to Bonington's brief experience in the atelier of Baron Gros, were certainly vital factors in Bonington's own considerable output of paintings and watercolours illustrating literary, historical and other romantic subject matter. It is remarkable that during his few productive years – less then ten in all –

(100) R.P.Bonington, *A Seated Turk* (1826). Oil on canvas; 33.7×41.5cm. (Yale Center for British Art, Paul Mellon Collection)

Bonington was able to create a considerable corpus of figure and history paintings that were in many ways as able and advanced as his landscape art, though they are far less well known today. The small canvas of *A Seated Turk* [PL.100], which briefly belonged to Sir Thomas Lawrence, was painted in Delacroix's studio, and illustrates Bonington's confident handling of paint and firm control of colour in what was probably a study from life.

Shortly after painting *A Seated Turk* Bonington, accompanied by Baron Rivet, left Paris for Italy, where he spent some two months, including nearly four weeks in Venice and a few days in Verona. In Venice his on-the-spot oil sketches, such as *On the Grand Canal, Venice* [COL.PL.35], demonstrate his totally assured and effective reactions to the pictorial and emotive qualities of the famous city of water and light. The intricate details of the waterside *palazzi* and the flickering and varied quality of the light are recorded with the utmost economy, in both oils and watercolours, in compositions that seem absolutely right. Many British artists painted and sketched in Venice during the earlier decades of the nineteenth century, but none, not even Turner, challenged the beauty and assurance of Bonington's studies. Bonington was equally inspired by other sites in Italy, notably Verona, and the brilliantly coloured *Corso Sant'Anastasia, Verona* [PL.101] was one of the last Italian subjects that Bonington painted in the two years that remained to him after his visit. While in Verona he had drawn this famous and pictur-esque street, and he later repeated the composition in watercolours, though in muted colours as if on a gloomy day (Victoria and Albert Museum, London), before under-taking a small version in oils and the present painting, with its bright blue sky and its colourful religious procession.

(101) R. P. Bonington, *Corso Sant'Anastasia, Verona* (1828). Oil on panel; 60×44.2 cm.
(Yale Center for British Art, Paul Mellon Collection)

Bonington's poor health was now much in evidence, and he had to cut down on his travelling. He was in Paris throughout most of 1827, but paid a second visit to London in the late spring. He was establishing a growing reputation in England, and exhibited at the Royal Academy for the first time that year, having already shown at the British Institution in 1826. The two paintings he showed at the British Institution were both of French coastal scenes, were both sold, and were highly praised by the critic of the *Literary Gazette*, who wrote with remarkable perception:

> Who is R.P.Bonington? We never saw his name in any catalogue before and yet here are pictures which would grace the foremost name in landscape art. Sunshine, perspective, vigour; a fine sense of beauty in disposing of colour, whether in masses or mere bits; these are extraordinary ornaments to the rooms. Few pictures have more skilfully expressed the character of open sunny daylight than the one under notice; and we have seldom seen an artist make more of the simple materials which the subject afforded. With a broad pencil he has preserved the character of his figure and accessories; also a splendid tone of colour, glowing and transparent.[71]

In 1827 and 1828 Bonington was also well represented at the Salon, where his landscapes were very much better received than his historical compositions, which were criticised as being too sketchy and unfinished. For these paintings, as did Delacroix, he quite frequently chose his subjects from the writings of Sir Walter Scott, then at the height of his popularity. One such is the elegant *Amy Robsart and Leicester* [PL.102], painted in about 1827 to illustrate a scene from Scott's novel *Kenilworth*, first published in 1821. Though many influences can be traced in the technique and style of this and similar paintings – Venetian drapery painting, Rubens, and Delacroix among them – the simple and closely knit composition, the sensitive gestures and expressions, and the free and direct use of paint, are all in keeping with Bonington's personal and individual manner. These qualities are, however, sadly lacking in *Quentin Durward at Liège* (Castle Museum and Art Gallery, Nottingham), the most ambitious, largest and most British of Bonington's history paintings, in which Marcia Pointon has detected the influence of Hogarth and Wilkie.[72] In this crowded and sombre composition, probably painted in 1827–8, there are unresolved passages and too many variations of technique, showing that in his finished figure painting Bonington did not achieve the same mastery as in landscape.

There is no doubt that Bonington was first and foremost a landscape artist, as can be seen again and again in the watercolours, oil sketches and finished compositions of his last two years. The delicate yet powerful watercolour of *The Bridge and Abbey at St Maurice* [PL.103] presents a popular and traditional composition with wonderful freshness, assurance and simplicity. There are numerous passages of carefully observed detail, especially in the splendid rendering of the gentle movement of the river in the foreground. At the posthumous sale arranged by the artist's father in 1829 this drawing was bought by the elderly Dr Thomas Monro, who in earlier years had done so much to foster the development of the British watercolour school.

In the closing months of his short life Bonington made many brilliant studies of Paris, among them the rapid (perhaps unfinished) oil sketch of *The Pont des Arts and*

(102) R.P. Bonington, *Amy Robsart and Leicester* (*c*.1827). Oil on canvas; 35.2×27 cm. (Ashmolean Museum, Oxford)

(103) R.P. Bonington, *The Bridge and Abbey at St Maurice* (*c*.1826–7). Watercolour over pencil; 16.3×16.6 cm. (Victoria and Albert Museum, London)

Ile de la Cité from the Quai du Louvre [COL.PL.36] with its wonderful contrasts of strong light and shadow. The same qualities are found in one of Bonington's most striking and probably latest finished Venetian compositions, *Grand Canal, the Rialto in the Distance – Sunrise* (Richard L. Feigen, New York) which was acquired by Sir Robert Peel, one of the leading English collectors of the day. At the time of his death at the age of only twenty-five, Bonington had achieved almost unprecedented success, respect (the Royal Academy arranged his funeral) and popularity in both England and France, and there was to be a remarkable surge in that popularity in the next ten years or so. During those years there were four studio sales in London, but there was also an immediate increase in the production of copies, fakes and imitations, especially of Bonington's landscapes, and many false 'Boningtons', often bearing a 'signature' spelling the name with two n's, are still in circulation today.

Reference has already been made to the immediate impact of Bonington's land-scapes on contemporary artists in France. In England also a small group of young watercolour artists – notably James Holland (1799–1870), Thomas Shotter Boys (1803–74) and William Callow (1812–1908) – worked for some years in a style very largely dependent on the work of Bonington. It should be noted that in the following decades there was no equivalent to this group closely emulating the example of either Constable or Turner, though both these artists did have their imitators. James Holland, the oldest of the British Bonington followers, began his career as a painter of flowers on pottery in Staffordshire, but when he moved to London in 1819 he began to make watercolours of architectural and coastal subjects, later working mainly in oils. In the 1830s and 1840s he travelled frequently on the Continent, and established a reputation as a topographical illustrator of European cities and of Venice in particular. Holland's line was firm and legible, and his use of watercolour washes was often close to the fluent and vivid man-ner of Bonington, as seen in the V. & A.'s effective and colourful close-up view of the *Hospital of the Pietà, Venice*, an attractive example of his numerous Venetian water-colours.

Thomas Shotter Boys was born in London and apprenticed to the engraver George Cooke until 1823. He went to Paris early that year and was befriended by Bonington, who easily persuaded him to take up painting in watercolours. The streets and build-ings of Paris provided him with ideal material for his skilful combination of precise and detailed drawing (often executed with the aid of Cornelius Varley's Graphic Tele-scope)[73] with the rendering of harmonious tone and colour in broad and fluent washes. When Boys returned to England in 1837 he had made numerous drawings in and around Paris, which provided the raw material for his innovative series of twenty-eight lithographs, *Picturesque Architecture in Paris, Ghent, Antwerp, and Rouen. Drawn from Nature on Stone*, published by the artist's cousin, Thomas Boys, Printseller to the Royal Family, in 1839. This was the first work printed by Charles Hullmandel in his new process of lithographic colour printing. Inspired by Girtin's posthumous series of aqua-tints of Paris, as Bonington had also been, Boys created a series of powerful images which were well received, but proved to be a commercial failure, and the new process was abandoned. The plates of Boys's next such publication, entitled *London as it is*, published in 1842, were printed in monochrome and coloured by hand. These im-pressive London views provide an informative microcosm of the early Victorian city,

(104) Thomas Shotter Boys, *The Pavillon de Flore, Tuileries, Paris* (c.1829). Watercolour; 45.3×33.1 cm. (Fitzwilliam Museum, Cambridge)

'showing both life and London as they are', as *The Times* critic noted in his enthusiastic review.

For the lithographed version Shotter Boys only slightly altered the composition of the beautifully balanced view of *The Pavillon de Flore, Tuileries, Paris* [PL.104], of which there is also a slightly smaller watercolour version, dated 1829, in the Victoria and Albert Museum. This succinct composition, with its brilliant rendering of light and atmosphere and its vivid groups of figures, was drawn at the height of the artist's development, but in later years the quality of his work declined. He exhibited regularly at the New Water-Colour Society from its foundation in 1832, becoming a full member in 1841.

The long-lived William Callow was apprenticed to a member of the Fielding family in London, where two other 'Boningtonian' artists, Charles Bentley and John Edge, were fellow pupils. Callow moved to Paris in 1829 and spent most of the next twelve years in the French capital. Here he soon came under the influence of Shotter Boys, with whom he shared a studio in 1833 and 1834. A much more versatile artist than Boys, equally at ease in landscape, marine or architectural subjects, Callow exhibited at the Paris Salon, where he was awarded a gold medal in 1840, and established a thriving practice as a drawing master, numbering several members of the French Royal Family among his pupils. Callow was a great on-the-spot sketcher, undertaking lengthy walking tours in France, Switzerland, Germany, Italy and elsewhere in search of material, and filling hundreds of sketchbooks, mostly with pencil drawings, thus following the practice of Turner, whom he visited while in London in 1838 and met again a few years later in Venice. Turner's watercolours of the 1820s and 1830s were almost as influential

(105) William Callow, *Village at the Mouth of an Estuary* (*c*.1840). Watercolour; 19.7×27.6cm. (Graphische Sammlung Albertina, Vienna)

in Callow's development as those of Bonington, and it is a telling illustration of the shortage of new inspiration in British landscape art in the second half of the nineteenth century that Callow could base his long and successful career on his adaption of the example of these two masters of the first half.

In 1841 Callow left Paris with reluctance, settling in London, where he quickly built up a new teaching practice and became a regular and prolific exhibitor at the Old Water-Colour Society, of which he was elected a full member in 1848. In later years he also painted in oils, exhibiting these at the British Institution and the Royal Academy. Callow's long, fruitful and harmonious career is recorded in his lengthy *Autobiography*, published at the very end of his life in 1908. Callow had an international reputation, as is witnessed by the provenance of one of his watercolours, *Village at the Mouth of an Estuary* [PL.105]. This was bought, probably in the 1840s, as one of a small group of Boningtonian watercolours by Archduke Carl, heir of the founder of the Albertina. The skilful use of fluent watercolour washes strengthened with the pen is typical of such gentle compositions by Callow in the style of Bonington. It was a manner that the artist continued to use until the close of his life, as in the small but powerful drawing of *Père Lachaise Cemetry*, dated *1905*, in Birmingham Museums and Art Gallery.

14 Minor Masters of Landscape

When John Constable was at last elected a full member of the Royal Academy in 1829, beating another landscape painter, Francis Danby, by one vote, he was told by the President, Sir Thomas Lawrence, that he was lucky to be elected. In saying this Lawrence was implying that Constable was 'merely' a landscape painter. Of the eighteen painters elected as members of the Royal Academy between 1830 and 1850 only three were landscape artists. The academic status of the landscape painter was still a lowly one, but with patrons, collectors and the general public, landscape painting was becoming increasingly popular, partly because of the predominance of landscape sub-jects among the watercolour artists, whose work has been discussed in Part Two. Many of the watercolour specialists also painted in oils, and in addition there was a growing number of painters making their livelihood by the depiction of landscape. However, the work of most of these 'minor masters of landscape' has been largely forgotten. The few

(106) Sir Augustus Wall Callcott, *Entrance to Pisa from Leghorn* (RA 1833). Oil on canvas; 106.7×162.6cm. (Tate Gallery, London)

discussed here stand out because of the relative individuality of their paintings, though most of them worked within the mainstream old master traditions of landscape art, the Netherlandish and the French.

One landscape artist who was a successful member of the Royal Academy, and who has already been mentioned in the chapter on Turner, of whom he was both a friend and a rival, was Sir Augustus Wall Callcott (1779–1844), who was elected RA in 1810. Callcott, who had married the traveller and authoress Maria Graham in 1827, was awarded one of Queen Victoria's coronation knighthoods in 1837. The painter and his blue-stocking wife were on friendly terms with the Queen and then also with Prince Albert, and after the artist's death the Royal couple bought six paintings by him at the executors' sale in 1845. Callcott's landscapes owed much to the Dutch tradition and to the example of Turner, and from these influences he developed a personal manner, which combined fine atmosphere and tonality with a sensitive feeling for colour. These qualities are seen in his early work such as his Diploma painting, *Morning*, which was shown at the Royal Academy in 1811, and are retained with greater confidence in later paintings such as *Entrance to Pisa from Leghorn* [PL.106], which received just praise for its 'fine glow of colouring' when exhibited at the RA in 1833.

Callcott belonged essentially to the eighteenth-century landscape tradition, as did the somewhat older and even more reactionary John Glover (1767–1849), who was frequently dubbed the 'English Claude'. Self-taught as an artist he exhibited both watercolours and oil paintings, mostly of classical landscape compositions, and in both media his manner was somewhat stiff and mannered. However, he achieved considerable success, becoming President of the Old Water-Colour Society in 1815, and

being a founder member of the Society of British Artists in 1824, though he failed to gain election to the Royal Academy. Many of Glover's landscape paintings were attractive and realistic compositions of picturesque English scenery, such as the fine view of *Leathes Water, Thirlmere, Cumberland* [PL.107], which dates from about 1820. Within the next decade his art became too old-fashioned as well as too repetitive to attract further patronage at home, and in 1830 Glover, who had already made a considerable fortune, emigrated to Australia and settled in Tasmania. Here his art was revivified by the challenge of totally different scenery, and Glover is recognised as one of the major figures in the development of the early Australian landscape school.[74]

William Frederick Witherington (1785–1865) was elected RA in 1840, and was one of the three landscape artists referred to at the beginning of this chapter. In fact, most of his surviving work would be classed today as rustic genre painting, sentimental and well-observed compositions continuing in the tradition of Wheatley and Morland. In his early days he painted 'landscapes with figures', but in later years his works were normally figure subjects in a landscape setting, another reflection of the problems that faced the pure landscape artist in the first half of the nineteenth century. Witherington was one of several artists – Charles Landseer and Thomas Uwins were among the others – who found conducive subject matter in the annual season of hop-picking in Kent and Sussex. Each of the two great early Victorian collectors, Robert Vernon and John Sheepshanks, acquired versions of one of the most popular of Witherington's hop-picking scenes, *The Hop Garland*, the earlier of which [PL.108] was exhibited at the British Institution in 1835. A critic at the time described it as presenting 'an incident true to nature', greatly praised the expressions and gestures of the children, and concluded, 'the background is well managed and the whole rich in harmony of colour and truth of effect'.

Witherington's close contemporary Patrick Nasmyth (1787–1831) was the eldest son of Alexander Nasmyth (1758–1840), known as the 'father of Scottish landscape painting'. Born and trained in Edinburgh, Patrick first visited London with his father in 1806 and was much impressed and influenced by the Dutch seventeenth-century landscape paintings which he saw in the capital, to which he moved in 1808, remaining until his death. His evocative landscape compositions, some of which were based on his memories of Scottish landscape, were largely imaginary and earned him the sobriquet the 'English Hobbema'. He exhibited regularly, and his paintings, which were often on panel and on a small scale, were widely collected. There is a large and representative group of his work in the Tate Gallery, including two small panels from the Vernon Collection. William Shayer (1787–1879) was born in the same year as Patrick Nasmyth, but lived much longer. For half a century he exhibited prolifically in London, showing well over 400 works between 1820 and 1870, but he always lived and worked in his native city of Southampton. In his depiction of rural and coastal scenes enlivened with well-painted groups of animals and country-folk, Shayer was also working in an old-fashioned manner, in his case continuing in the popular eighteenth-century tradition of Ibbetson, Morland and others. Presumably because of his provincial background, he never really changed his style, which his three artist sons also adopted, and then adapted to accommodate the more sentimental and emotive taste of the early Victorians.

(107) John Glover, *Leathes Water, Thirlmere, Cumberland* (c.1820). Oil on canvas; 76×101.2 cm.
(Tate Gallery, London)

(108) W. F. Witherington, *The Hop Garland*
(1834). Oil on panel; 43.2×33.7 cm.
(Victoria and Albert Museum, London)

(109) William Collins, *Prawn Fishing* (RA 1829). Oil on panel; 43.5×58.4 cm.
(Tate Gallery, London)

On the other hand William Collins, RA (1788–1847), was one of the artists who helped to create this more sentimental manner, though he was actually brought to painting by George Morland, of whom his father, the Irish writer William Collins, wrote a memoir in 1805. The Redgrave brothers' assessment of William Collins, as is so often the case when they are writing about their contemporaries, cannot be improved upon: 'While it is given to but few, very few, artists to attain the highest rank in art, it is an honourable end to have stamped a marked individuality on any of its varied modes of appealing to mankind. If the former was denied to William Collins, it at least was given to him to find a somewhat untrodden path in art for himself, and to make the latter success his own by the way he treated his subjects.'[75] Collins first exhibited – two views near Millbank – at the Royal Academy in 1807, the year in which he became a student at the Schools. Two years later he won a medal in the life school, and began to exhibit genre pictures featuring children; his first great success was the Morland-like *The Disposal of a Favourite Lamb*, shown in 1813, and he was elected ARA in the following year. In about 1815 he started sketching on the Norfolk coast, and began painting the colourful coastal landscapes, often with children or fishermen in the foreground, which, with his later scenes on the Kent and Sussex coasts and the Isle of Wight, were his most individual contribution to the 'landscape with figures' genre. *Prawn Fishing* [PL.109], which was exhibited in 1829, is typical of Collins's peaceful seashore scenes, successfully combining the naturalistic and atmospheric rendering of the landscape with an undemanding narrative element.

This narrative element is far more important (intrusive) in such well-known paintings as *As Happy as a King* [COL.PL.34] and *Rustic Civility*, shown at the Royal

(110) Clarkson Stanfield, *Portsmouth Harbour* (BI 1832). Oil on canvas; 94×139.7 cm.
(The Royal Collection)

Academy in 1836 and 1832 respectively. In such delightful compositions, certainly influenced by the example of his great friend David Wilkie, Collins combined his sensitive observation of rural children with his attractive depiction of landscape to achieve in a second manner, 'figures in a landscape', that 'individuality' praised by the Redgrave brothers. It was Wilkie who persuaded Collins to visit Italy, where he spent nearly two years from 1836 to 1838, and in the following years he often exhibited Italian landscape and genre scenes, which largely lacked the qualities of his English compositions. Perhaps because William Collins's art was so deeply entrenched in the eighteenth-century tradition, it has been largely and undeservedly forgotten in modern times, despite the enjoyable *Memoirs of the Life* of his father published by his son, the novelist Wilkie Collins, in 1858.

Clarkson Stanfield, RA (1793–1867) was born in Sunderland, the son of an actor, and had a remarkable and varied career. He began his working life as a sailor, before becoming a successful theatrical scene painter in 1816. He first exhibited easel paintings in 1820, but still worked as a scenery painter, notably at the Theatre Royal, and also built up a high reputation as a painter of dioramas and panoramas. His experience as a theatrical and spectacle painter can usually be felt in his canvases, which are full of vivid activity and detail, painted with a forceful brush. Stanfield's large picture of St Michael's Mount shown at the Royal Academy in 1830 was admired by William IV, who commissioned two paintings from him, views of Portsmouth Harbour and Plymouth, but the second was later changed to the commission to paint the opening of the new London Bridge, which the King had performed on 1 August 1831. The *Portsmouth Harbour* [PL.110] 'much pleased' the 'sailor king', but was given a mixed reception when

(111) Clarkson Stanfield, *A View of Ischia* (1841). Oil on panel; 24.1×35.2cm.
(The Royal Collection)

shown at the British Institution in 1832. Painted in warm colours it includes a great deal of informative and narrative detail as well as achieving an overall impetus of rough sea and cloudy sky to create a powerful composition, which certainly owes much to the influence of Turner.

Early in her reign Queen Victoria purchased two Italian scenes from Clarkson Stanfield, and in 1841 she commissioned the beautiful small *View of Ischia* [PL.111], for which she paid £52 10s, as a present for Prince Albert. Stanfield had first travelled to the Continent in 1823, and was there frequently in later years, making a prolonged tour in Italy in 1838–9. Like Turner he sketched prolifically on his journeys, and used his drawings on his return as the basis of his oils and watercolours. His reputation was much enhanced by his vigorous and informative continental scenes, mostly in Italy, which he exhibited regularly, and many of which were engraved. Though his work lacked the genius and poetry of Turner's, Clarkson Stanfield did as much if not more during his lifetime to enhance the popularity of landscape and marine painting. His vigorous and somewhat theatrical manner, combining picturesque and romantic qualities, was much less demanding than that of Turner and much more effectively matched the taste of the day for illustrative art.

While Stanfield has to be paired with Turner, the work of Frederick Richard Lee, RA (1799–1879), usually invites comparison with that of Constable, to whom many of his paintings have been wrongly attributed. Lee, who started painting as an amateur, enjoyed a considerable reputation as a painter of undemanding and attractive landscape views, of which he exhibited some three hundred at the Royal Academy and the British Institution between 1822 and 1870. Often combining careful detail with a panoramic viewpoint, Lee captured the character of the ordinary English farmland, especially

(112) Thomas Creswick, *Trentside: a Recollection* (RA 1861). Oil on canvas; 114.2×182.8cm. (Royal Holloway and Bedford New College, Egham, Surrey)

in Devonshire, where he lived. He was a keen yachtsman and sailed around Europe, and also exhibited marine and coastal subjects, including several views of Gibraltar.

The last two artists in this chapter were both born at the beginning of the second decade of the new century, and were only teenagers when Turner and Constable were making their greatest advances. Thomas Creswick, RA (1811–69), was initially trained in Birmingham and settled in London in 1828, the year in which he began exhibiting at the British Institution and the Royal Academy, of which he was elected an Associate in 1842. He had quickly established a reputation for straightforward and truthful depictions of British landscape scenes, usually classically composed and painted in cool and silvery tones. He continued to paint in this vein, though he also painted less peaceful landscape scenery in Scotland and elsewhere. In 1881 Thomas Holloway paid the enormous sum of 2000 guineas for the large *Trentside: a Recollection* [PL.112], which had been acclaimed when shown at the Royal Academy in 1861. As in many of his compositions the cattle were painted by another artist, in this case J.W.Bottomley. A more powerful, but less typical, work by Creswick is the dramatic view of *Land's End, Cornwall* in the Victoria and Albert Museum, which was exhibited in 1843. Though almost wholly forgotten today, Creswick's landscapes were highly regarded throughout the nineteenth century; a typical comment about them was made in *Blackwood's Magazine* in 1861, whose critic described them as 'essentially English in subject and in sentiment. And then, moreover, in the best sense of the word, they are academic – free from all false pretence and affectation … nature comes before us with a modest bearing.'

The career of William James Müller (1812–45) was much briefer than that of Creswick, but was nevertheless more varied. Born in Bristol, where his father was curator of the museum, he was apprenticed for two years to James Baker Pyne, a follower of

(113) William Müller, *Swallow Falls, Betws-y-Coed* (1837). Oil on canvas; 83.2×108cm.
(Bristol Museums and Art Gallery)

Turner, and showed eight works at the first exhibition of the Bristol Society of Artists in 1832. He became a great traveller, spending seven months touring and sketching in Germany, Switzerland and Italy in 1834–5, and in the following years he visited Greece, Egypt, Malta and Turkey; in Britain, Wales was one of his favourite sketching grounds. Müller's technique both in oils and watercolours was broad and direct, and his style combined strong colouring with firm composition. He produced many fine views of Bristol and its surroundings, including the large and impressive *Bristol from Clifton Wood*, dated 1837 (Bristol Museums and Art Gallery), which is one of the most successful panoramic paintings of that much-painted city.

 Most of the work that Müller exhibited in London, where he first showed in 1833, was based on his foreign, and particularly Near Eastern travels; as William Thackeray wrote, 'the latter part of Müller's career has, in its eastern splendour, eclipsed his more sober and earlier efforts'.[76] However, Müller's later painting of British scenery, such as the vivid view of *Swallow Falls, Betws-y-Coed* [PL.113], dated *1837*, is often as fresh and bold as his Eastern compositions. On his travels Müller sketched extensively in watercolours, achieving a fluent and economic technique, as in *Water Tomb, Telmessus*, which he drew on his expedition to Lycia in 1844 (Tate Gallery, London). During that journey the artist wrote to a friend, '*I want to paint*, Gooden; its oozing out of my fingers.'[77] Sadly Müller had little time left in which to do so, for he died in Bristol in the following year.

Notes to Part Three

1 See John Gage, *J.M.W. Turner, 'A Wonderful Range of Mind'*, 1987

2 See above, pp.37–9

3 See Lindsay Stainton, 'Ducros and the British' in the Catalogue of *Images of the Grand Tour – Louis Ducros*, exhibition at Kenwood and elsewhere, 1985–6

4 See M. Butlin, M. Luther and I. Warrell, *Turner at Petworth: Painter and Patron*, Tate Gallery, 1989

5 Farington, *Diary*, 2 May 1803

6 See Stanley Warburton, *Turner and Dr Whitaker*, Towneley Hall Art Gallery, Burnley, 1982

7 See Luke Herrmann, *Turner Prints: the Engraved Work of J.M.W. Turner*, 1990

8 Each RA took it in turns to act for a month as 'Visitor' in the Schools, helping in the instruction and supervision of the students

9 Maurice Davies, *Turner as Professor: The Artist and Linear Perspective*, Tate Gallery, 1992

10 Farington, *Diary*, 8 January 1811

11 See David Hill, *Turner on the Thames*, 1993; and David Blayney Brown, *Oil Sketches from Nature*, Tate Gallery, 1991

12 Luke Herrmann, 'John Landseer on Turner: Reviews of Exhibits, 1808, 1839 and 1840, *Turner Studies*, Vol.7 (1987), Nos. 1 and 2

13 David Hill, *Turner's Birds*, 1988; and Anne Lyles, *Turner and Natural History: The Farnley Project*, Tate Gallery, 1988

14 See Cecilia Powell, *Turner in Germany*, 1995, p.102, where it is suggested that if her re-dating of one of the Rhine drawings, *Mainz and Kastel*, is accepted, the Rhine series of 1817 can be seen as consisting of fifty drawings, a far more likely figure than the traditional total of fifty-one

15 See Cecilia Powell, *Turner's Rivers of Europe*, Tate Gallery, 1992, p.34

16 Lawrence MSS, R.A., LAW/3/52; quoted in C. Powell, *Turner in the South*, 1987, p.19

17 Lawrence MSS, R.A., LAW/3/73; quoted in Powell, loc.cit., p.35

18 Powell, loc.cit., p.44

19 For references to these publications see Butlin and Joll, No.228

20 M. Davies, *Turner as Professor*, 1992, p.85

21 L. Herrmann, *Turner Prints*, 1990, Ch.IV

22 See Eric Shanes, *Turner's Picturesque Views in England and Wales*, 1979

23 I. Warrell, in *Turner at Petworth*, loc.cit., p.69

24 C. Powell, *Turner in the South*, p.142

25 Powell, loc.cit., p.157

26 Turner had also used two large pieces of canvas when he painted nine sketches on the Isle of Wight in the summer of 1827; see Butlin and Joll, Nos 260–8

27 See Jack Lindsay, *The Sunset Ship; the Poems of J.M.W. Turner*, 1966; and A. Wilton and R.M. Turner, *Painting and Poetry*, Tate Gallery, 1990

28 Quoted by Butlin and Joll, No.342, plate 344

29 See K. Solender, *Dreadful Fire, Burning of the Houses of Parliament*, Cleveland 1984, Part III, for the various theories about the drawings; and Richard Dorment, *British Painting in the Philadelphia Museum of Art*, 1986, No.111

30 However, Andrew Wilton in a Picture Note in *Turner Studies* (Vol.10, No.2 (1990), pp.55–9) rejects this theory and re-names the painting '*Study for the Sack of a Great House?*'

31 Samuel Palmer was not the only contemporary to compare Turner with the Italian violinist Nicolo Paganini (1782–1840), who made a British tour in 1831–2

32 John Constable, text accompanying *A Sea Beach* in the 1833 edition of *English Landscape Scenery*

33 Butlin and Joll, No.398

34 See John Gage, 'Le Roi de la Lumiere' in catalogue of *J.M.W.Turner*, Paris, 1983–4, pp.49–50, and Fig.17

35 Butlin and Joll, No.414, and Robert K.Wallace, 'Antarctic Sources for Turner's 1846 Whaling Oils', *Turner Studies*, Vol.8 (1988), No.1

36 J.C.Ivy, *Constable and the Critics*, 1991, p.63

37 *John Constable's Correspondence*, ed. R.B.Beckett, Vol.VI, 1968, p.78

38 Diary, 8 April 1802

39 Correspondence, Vol.II, 1964, pp.31–2

40 John Fisher became Archdeacon of Berkshire in the Diocese of Salisbury in 1817

41 *John Constable's sketch-books of 1813 and 1814* – reproduced in facsimile, Victoria and Albert Museum, 1973

42 Correspondence, Vol.II, 1964, p.120

43 C.R.Leslie, *Memoirs of the Life of John Constable*, ed. Johnathan Mayne, 1951, p.49

44 Ivy, loc.cit., p.70

45 *Constable*, Tate Gallery, 1991, No.76

46 Ivy, loc.cit., p.72

47 Ivy, loc.cit., p.78

48 Ivy, loc.cit., p.81

49 Ivy, loc.cit., p.88

50 John Thornes, 'Constable's Clouds', *Burlington Magazine*, CXXI (1979), pp.697–704

51 Correspondence, Vol.VI, 1968, pp.76–7

52 Correspondence, Vol.VI, 1968, pp.230 and 155

53 Correspondence, Vol.II, 1964, pp.289–306

54 *Discourses*, ed. R.Wark, 1975, p.257. Constable owned a volume of forty-two engravings by and after Bourdon, which was bought by J.S.Cotman at the sale of Constable's collection of engravings, 10–12 May 1838 (see *John Constable – Further Documents and Correspondence*, ed. L.Parris, C.Shields and I.Fleming-Williams, 1975, p.28)

55 Ivy, loc.cit., pp.133–4

56 *Further Documents and Correspondence*, loc.cit., p.81

57 Correspondence, Vol.IV, 1966, p.277

58 *The Morning Post*, Ivy, loc.cit., p.158

59 Correspondence, Vol.III, 1965, p.79

60 Correspondence, Vol.IV, 1966, p.387

61 Ivy, loc.cit., p.232

62 Correspondence, Vol.V, 1967, p.32

63 R.B.Beckett, *John Constable's Discourses*, 1970, p.39

64 Loc.cit., p.69

65 However, see Trevor Fawcett, *The Rise of English Provincial Art*, 1974, p.1, for a résumé of 'the widespread establishment of societies and institutions committed to the encouragement of the arts in provincial centres in all parts of the British Isles' in the first three decades of the nineteenth century. Except for Edinburgh and Bristol none of these new provincial societies achieved the coherence of the 'Norwich School'

66 Fawcett, loc.cit., p.68

67 *A Dictionary of Artists of the English School*, new edn, 1878, p.107

68 M.Allthorpe-Guyton, *Henry Bright*, 1973 and 1986

69 Quoted by Patrick Noon, *Richard Parkes Bonington 'On the Pleasure of Painting'*, 1991, p.93

70 A.Jal, *Salon 1824*, p.417

71 Quoted in W.T.Whitley, *Art in England, Volume 2 – 1821–1837*, 1930, pp.99–100

72 Marcia Pointon, *The Bonington Circle*, 1985, p.97

73 See Ch.7, p.57

74 See Bernard Smith, *European Vision and the South Pacific*, 1960, pp.124–201

75 Richard and Samuel Redgrave, *A Century of British Painters*, new edn 1947, p.378

76 L.Marvy, *Sketches after English Landscape Painters*, with short notices by W.M.Thackeray, undated and unpaginated

77 N.Neal Solly, *Memoir of the Life of William James Müller*, 1875, p.218

Part Four

Further Aspects of Romanticism

The 'Romantic Movement' is a very indefinite term which has been used to describe a great variety of historical and cultural events, ranging over several generations from the mid-eighteenth century onwards. 'Romanticism', on the other hand, is more easily definable, and certainly applies to much of the art discussed in this Part and in the preceding and immediately following Parts. It is usual and useful to contrast it with 'Classicism' and 'Neo-Classicism', but in Britain there was never the definite and deep division between the two styles as there was in France with the rivalry between Ingres and Delacroix. Both styles can be found in the painting of Sir Joshua Reynolds, and, as in so much else, that fact set an example for the following generations of British artists.

The passionate, the emotive, the exotic, and sometimes the absurd, are all qualities to be found in Romanticism. These are not qualities that are typical of the British character, but they were to be found, often to excess, in the personality of the Prince of Wales, who became Prince Regent in 1811 and who reigned as George IV from 1820 to 1830. As the leader of fashion and an active patron of the arts, the future George IV provided the environment that encouraged the rise of the romantic in British literature, art and architecture. A prime exemplar of the medley of styles and taste that typified these decades is seen in the evolution of the Royal Pavilion at Brighton. Prince George first leased this site in 1786 when it was a substantial farmhouse, which he then altered into a Palladian villa. Extensions in Chinese and Indian style were added before the ultimate grand and impressively harmonious design, with its opulent and fantastic interiors, was created by the architect John Nash between 1815 and 1822. All this was achieved with the most up-to-date concepts and materials, including the pioneering use of cast-iron. The quality that gave unity to it all was certainly the romantic spirit, which was at the heart of the Prince's brilliant and refined taste.

In the theatre the closing years of the Georgian era added little to the great tradition of British drama, and it was the development of the novel that was the prime literary achievement of the early nineteenth century. The second decade saw the publication of all of Jane Austen's novels, and also the appearance of the first six of the long series of novels of Sir Walter Scott, who had by then already made his name as a poet. During these same fruitful years the short-lived Lord Byron was at the height of his powers, as romantic in his poetry as in his scandalous life. The works of both Scott and Byron provided an amplitude of subject matter for romantically minded artists in Britain and on the Continent in the following decades.

It has to be remembered that during most of the first two decades of the nineteenth century Britain was at war with France, and that across the Channel the Emperor Napoleon reigned supreme until his final overthrow at the Battle of Waterloo in 1815. The heroism of the British soldiers and sailors, and especially of their commanders, was made much of by the general public, but in most ways those long years of war had surprisingly little direct effect on normal life in Britain. However, the aftermath of war saw a long period of widespread distress and discontent, which affected both the agricultural and manufacturing interests of the realm. Heavy taxation, a succession of poor harvests, the increasing introduction of machinery and consequent unemployment, and adverse trade conditions led to a succession of riots, including the notorious 'Peterloo Massacre' in Manchester in 1819, and constant demands for reform. It is understandable that against this background there was a growing demand for the imaginative release of the romantic, and this was reflected in much of the British painting of these years, as the work of James Ward will demonstrate.

15 James Ward, RA (1769–1859)

Born in the same year as Thomas Lawrence, James Ward only came to painting professionally when he was already in his thirties. He was trained as an engraver, being apprenticed to his brother, William, and began to paint in the late 1780s, working very much in the manner of George Morland, the painter of rustic genre scenes, who was his brother-in-law. In 1794 James Ward received the prestigious appointment of Painter and Engraver in Mezzotint to the Prince of Wales, but the Napoleonic Wars and the consequent loss of sales in France were causing a recession in the print market at this time. This strengthened Ward's resolve to become a painter, though he failed to gain a place at the Royal Academy Schools. Thus he was largely self-taught, and throughout his long career the quality of his painting technique was very variable, especially when working on a larger scale. On the other hand Ward was a naturally gifted draughtsman, equally at ease with pencil and pen and ink, which he used with impressive spontaneity and confidence. To augment this gift he attended, unusually for the time, anatomy classes, which greatly enhanced the quality of his figure drawing, and his drawing of animals.

It was in the depiction of animals that Ward the painter began to make his mark, exhibiting 'portraits' of cows and bulls at the Royal Academy from 1797 onwards. In 1800 he received the potentially profitable commission from the recently established Board of Agriculture, backed by the leading print-publisher Alderman Boydell, to paint over two hundred portraits of various breeds of cattle, sheep and pigs throughout Great Britain. The artist was to be paid fifteen guineas for every completed work, and had painted about one hundred when the scheme collapsed because of Boydell's spectacular bankruptcy in 1804. Though in itself a failure, this grandiose scheme, typical of the scientific artistic ventures of the time, set the tone of Ward's most reliable future patronage, and he continued to receive commissions for animal portraits from the nobility and landed gentry throughout the rest of his long career.

However, Ward had higher ambitions, and hoped to achieve success with monu-

(114) James Ward, *Gordale Scar* (1812–14). Oil on canvas; 332×421 cm. (Tate Gallery, London)

mental 'history' paintings, of which the impressive *Bulls Fighting, with a View of St Donat's Castle in the Background* [COL.PL.33], painted in 1803–4, is an early example. This powerful panel was painted in direct emulation of Rubens's famous landscape, *The Château de Steen* (National Gallery, London), which is also on panel. It was acquired by Sir George Beaumont in 1803 and Ward studied it closely when Beaumont sent it to Benjamin West's studio for a few weeks for interested artists to see. In some ways Ward's gnarled tree trunk, muscular bulls, and other features are almost a caricature of Rubens, but the painting, though rejected by the Royal Academy Hanging Committee, was much admired. Its debt to the powerful landscapes of Rubens was frequently repeated in other dramatic compositions featuring animals, such as *Stallions fighting on a River Bank*, at Cardiff, which was shown at the Royal Academy in 1808, the year in which the artist was elected an ARA.

Ward was elected a full Member in 1811, and in that year he received the commission from Lord Ribblesdale of Gisburn Park in Yorkshire which resulted in his most famous painting, *Gordale Scar* [PL.114] in the Tate Gallery. This huge canvas, which was exhibited in 1815, presents an exaggerated 'worm's-eye' view of this dramatic natural feature in the northern Pennines, and is said to have been painted in response to Sir George Beaumont's claim that it was unpaintable. The force of the cliffs is re-echoed in the strength of the white bull in the foreground and the tension of the whole scene is mirrored in the pair of fighting stags. This impressive exercise in the sublime and

(115) James Ward, *Portrait of Colonel Sir John Leicester, Bart., exercising his Regiment of Cheshire Yeomanry on the Sands at Liverpool* (RA 1824). Oil on canvas; 85×110.5cm. (Tabley House, University of Manchester)

the romantic was preceded by a large body of preparatory drawings and studies, many of them made on-the-spot and dated during Ward's visit to the site in August 1811. It is certainly its vast scale that makes the initial impact of this dark and threatening composition, but when looked at more closely there are many passages of skilfully painted detail to tempt and impress the eye. The same was apparently not true of an even larger work by Ward, the ill-fated *Triumph of the Duke of Wellington* painted between 1815 and 1821 on a specially woven canvas measuring 35ft by 21ft. Ward had won a British Institution prize of 1000 guineas for his sketch for this over-ambitious allegorical composition, and when at last the huge painting was completed it proved too large for the wall in Chelsea Hospital reserved for it. The work was returned to the artist and cut up.

Such over-ambitious and grandiose undertakings were nearly the ruin of James Ward, whose apparent megalomaniac energy was matched by increasing religious fervour. However, despite such character problems, to which were added great financial difficulties and the grief of considerable domestic tragedy, Ward continued to draw and paint prolifically until the later 1830s. In 1813 Ward had been commissioned by the leading collector and patron, Sir John Leicester, to paint a view of his Cheshire seat, Tabley Hall, and the resultant *Tabley Lake and Tower* (Tate Gallery, London) was surprisingly close in many ways to the beautiful pair of similar views that Turner had painted for Sir John in 1808. A major feature of Ward's painting, which apparently disappointed his patron, who asked for numerous alterations, is the group of cattle, including the powerful white bull, in the foreground. Some ten years later Ward received another commission from Sir John Leicester, and on this occasion he gave complete satisfaction, for the imposing equestrian *Portrait of Colonel Sir John Leicester, Bart., exercising his Regiment of Cheshire Yeomanry on the Sands at Liverpool* [PL.115] must rank as one of the most impressive truly romantic portraits by a British artist. In a letter to a friend Sir John wrote perceptively, 'Ward has painted a portrait of myself on horseback, in which he has united the finish of Wilkie with the spirit of Bassano.'

Though he was painting some evocative landscape scenes, Ward's most successful

(116) James Ward, *Marengo, the barb charger, rode by Napoleon Bonaparte at the battle of Waterloo* (RA 1826). Oil on canvas; 81.3×109.3 cm. (The Duke of Northumberland)

compositions during his later years continued to be portraits of animals, such as the thought-provoking portrait of Napoleon's famous charger, Marengo [PL.116], which had been captured by the British at Waterloo. When exhibited at the Royal Academy in 1826, the lengthy catalogue title read: *Marengo, the barb charger, rode by Napoleon Bonaparte at the battle of Waterloo. The back-ground emblematic of his master's downfall.* In this highly symbolic yet remarkably simple composition, the nervous and quivering white horse is shown at sunset at the edge of a bank with a dark vulture facing it in the water below, creating a tense atmosphere of danger and impending disaster. The picture was reproduced as a lithograph and published as one of a series of fourteen prints of famous horses. In such horse portraits James Ward can be said to have continued and developed the tradition of George Stubbs, who was, of course, still active when Ward's career as an animal painter was starting. In his turn Ward 'passed the baton' of this tradition to Edwin Landseer, who brought Ward's romantic animal visions into the Victorian age.

16 William Etty, RA (1787–1849)

What James Ward did for the horse and other animals William Etty did for the female nude. Both artists owed much to Rubens, and from his example they developed their own individual contribution to British romantic art. As fellow Academicians – though Etty was not elected RA until 1828 – the two artists must have known each other, but there is no evidence of any close contact between them. Like Ward, Etty, who was born in York, began his training as a painter only after another apprenticeship, in his case as a printer's compositor in Hull. This finished in 1805, and Etty, whose artistic gifts were already obvious, was able to go to London, thanks to the generosity of an uncle. He soon entered the Royal Academy Schools, and particularly benefited from drawing in the Life School, which he continued to do – almost like a 'perpetual student' – long after his actual student days were over. In 1807–8 Etty spent a year in the studio of Thomas

Lawrence, who was far too busy to pay much attention to his pupil, though that year certainly helped Etty to develop his own forceful painting technique, which owed much to Lawrence, as well as to Titian, Rubens and others. It also strengthened in Etty that respect for the old masters – which Lawrence had learnt from Joshua Reynolds – which led him to make numerous copies of their works, especially when on his travels. Etty visited Paris for the first time in 1815, returned to France in 1816 and then went on briefly to Italy. In 1822–4 he undertook a grand tour of some eighteen months, nine of which were spent in Venice.

In a letter sent to Lawrence from Venice in March 1823 Etty wrote, '*Venice detained me*, ... I trust it will be of benefit to my (pictorial) health; I have been in Venice near 5 months, making a number of memorials of some of the fine things.... I came here ... intending to look around me for ten days, but I saw so many things capable of giving me lessons that I determined to stay the winter and endeavour to profit by what I saw.'[1] This letter underlines the importance of continuous study to Etty, and it was this study that formed the essential basis of his art, which, despite its relatively narrow special-isation, was always developing on new lines. In the catalogue of the great *Romantic Movement* exhibition shown in London in 1959 these characteristics were summed up as follows: 'Conscientious, eclectic, and devoted both to the life class and to history painting, Etty was in almost all respects a model product of the academic system.' Etty's truly remarkable achievement was that he made of the essentially academic and 'classical' subject of the nude a personal art form that was in keeping with the romantic mood of the time.

Etty had set the pattern of his *œuvre* with his first London exhibits in 1811, when he showed both at the British Institution and at the Royal Academy. Each work depicted subjects from classical mythology in which the nude figure predominated. During these early years he was also exhibiting portraits, and here too he had developed an effective, personal style combining firm drawing with the use of forceful, dark pigments. Etty's early exhibits were given little attention and found few buyers, but all this was changed in 1820, when his principal RA exhibit, *The Coral finder: Venus and her youthful satellites arriving at the Isle of Paphos*, attracted considerable attention and praise, and also an important commission from Sir Francis Freeling, Secretary to the Post Office, to paint *Cleopatra's arrival in Cilicia* (The Lady Lever Art Gallery, Port Sunlight), which achieved popular success when shown at the Royal Academy in 1821. Both these ambitious com-positions are still somewhat immature and vacuous, but within a short time Etty had overcome his weaknesses, and was painting and exhibiting such powerful canvases as *Pandora crowned by the Seasons* [COL.PL.43], exhibited in 1824 at the Royal Academy, and purchased for a large sum (about 300 guineas) by the President, Sir Thomas Lawrence. Etty had had the subject in mind for some time, but this version was painted after his long sojourn in Venice. The elegant relief-like composition succeeds in combining a fine sense of movement with a mood of classic calm, and is painted with an assured brush in rich colours. *Pandora*, his only RA exhibit that year, was generally well received, and one critic described Etty as 'that inspired lyric painter', while another wrote of his 'captivating style of Painting that is not natural, yet blends with it so much poetic inspiration and celestial beauty, that we are irresistably compelled to admire in despite of our more calm judgement. *Mr Etty has a style of his own.*'[2]

(117) William Etty, *The Combat: Woman pleading for the Vanquished. An ideal Group* (RA 1825). Oil on canvas; 254×341 cm. (National Gallery of Scotland, Edinburgh)

From now on Etty's success was assured – he was elected ARA in 1824 and RA in 1828 – and he produced a steady flow of ambitious compositions of nude figures in his personal style. Like Ward, he felt impelled to work on a large scale, but he was more successful in doing so. The first of his colossal history paintings, *The Combat: Woman pleading for the Vanquished. An ideal Group* [PL.117] was shown at the Academy in 1825. This heroic composition, which owes much to the sculpture of John Flaxman, is remarkable in that it does *not* illustrate any particular episode of classical history, mythology or literature, but creates a compellingly romantic image with the minimum of detail and the maximum of telling emotive thrust. Though many further influences can be detected, such as the Elgin Marbles, Michelangelo and, of course, Rubens, the final canvas is again essentially in Etty's own manner. It was once more well received and resulted in a commission from Lord Darnley for another large picture, at a price of £500. The subject agreed was the *Judgement of Paris*, and the harmonious and richly coloured painting, now in the Lady Lever Art Gallery, Port Sunlight, proved again that Etty had the confidence and ability to create his own impressive version of a well-tried subject.

The British school had at last found an artist who could produce a succession of history paintings, generally considered the noblest and most praiseworthy form of art, on a large scale and in the grand manner. In 1828 the *Times* critic predicted that 'time and study will make Mr Etty such a painter as England may be reasonably proud of'.[3]

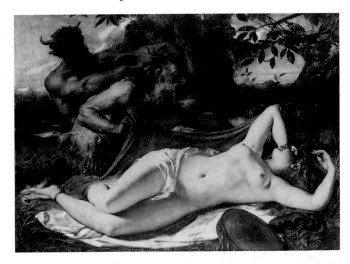

(118) William Etty, *Sleeping
Nymph and Satyrs*
(1828). Oil on canvas;
129.5×179 cm. (Royal
Academy, London)

It should be remembered that it was one of Reynolds's dearest ambitions to help estab-
lish a school of 'history' or 'historical' painting in England, and plans and schemes for
achieving this continued throughout the first half of the nineteenth century. In 1809
there were various projects, recorded by Joseph Farington in his *Diary*, to establish a
special award for historical painters at the Royal Academy,[4] and the British Institution
did actually already have a number of prizes and awards to encourage such paintings.
Indeed, in 1828 Etty was awarded a special premium of £100 by the British Institution
as an 'acknowledgement of his talents, industry and perseverance', and as encourage-
ment to further success.

 As his RA Diploma Work, which Etty started to paint within weeks of his election
in February 1828 and completed while on holiday in his beloved York, he presented
Sleeping Nymph and Satyrs [PL.118]. With strong echoes of Titian and Poussin, Etty has
here painted one of his most powerful female nudes, the elegant tension of her beau-
teous body and the smoothness of her skin contrasted with the dark and rough bodies
of the struggling satyrs, to create a dynamic and vivid composition. Unusually for
a Diploma Work this painting was not exhibited at the Royal Academy – perhaps the
nude was considered too audacious – but in 1829 Etty showed an equally effective
though less challenging composition, *Hero, having thrown herself from the Tower at the
Sight of Leander drowned, dies on his Body* (York City Art Gallery, long-term loan). His
second exhibit in 1829 was another tense composition, but on a very much larger scale,
Benaiah (National Gallery of Scotland, Edinburgh), which shows this obscure biblical
figure – one of King David's captains – slaying two lion-like men of Moab. This huge
canvas was bought from the artist by the Royal Scottish Academy in 1831, to join three
more of Etty's vast biblical paintings: the *Judith*, shown at the Royal Academy in 1827
and purchased in 1829, and its two companions illustrating episodes from the Apoc-
ryphal *Book of Judith*, commissioned by the Royal Scottish Academy.

 These enormous 'machines' brought Etty considerable acclaim from his contem-
poraries, but are now mostly in very poor condition, and to the modern eye such small
gems as the delightful *Venus and Cupid* (York City Art Gallery) are greatly preferable.
It was a subject that Etty repeated on numerous occasions, but this is one of the most

attractive of his paintings on this theme. In his later years Etty added other subjects and themes to his repertoire, notably still life and landscape, and in both these genres he used his strong and colourful painting technique to good effect. In keeping with the taste of the day he also tried his hand at the fancy-dress conversation piece, such as *Window in Venice during a Festa* [PL.120], which Robert Vernon bought at the Royal Academy in 1831. This pleasurable composition is quite freely painted and meets the growing fashion for paintings and engravings of beautiful young women in pleasant settings and without any specific historical or literary context. Such undemanding images were frequently engraved on a small scale for the 'Annuals' or 'pocket-books', with titles such as *The Ladies' Polite Remembrancer*, for which there was great demand in the later 1820s and 1830s. Thus as well as continuing his own individual and effective development of one of the major traditions of Western painting, Etty was also producing work more in touch with the 'modern' taste of his day, a taste which did little to elevate the standing of the British school of painting.

Richard and Samuel Redgrave listed Etty among 'four talented men who devoted themselves to naturalize the grand style in the English school, and to assert its power'.[5] Two of the others were Henry Howard, RA (1769–1847), and William Hilton, RA (1786–1839); the third, Benjamin Robert Haydon, will be fully discussed in Part Five. Henry Howard's long career was focused on the Royal Academy, where he exhibited history, religious paintings and portraits from 1794 until his death. A prize-winning student at the Royal Academy Schools, he also studied in Italy, and was elected RA in 1808, becoming Secretary of the Royal Academy in 1811 and Professor of Painting in 1833. Now almost wholly forgotten, Howard was a respected figure in his own day but his art made little impact. Usually on a small scale his history paintings were graceful and somewhat vacuous, 'pleasing in composition, correct in drawing, but cold and feeble in style',[6] and totally lacked the strength and originality of Etty's work. However, Howard was represented by a composition of semi-draped nude female figures, *The Pleiades*, in such a distinguished collection as that of Sir John Leicester, who also owned two works by the much younger William Hilton, probably best known today as Peter de Wint's brother-in-law.

Like Howard, Hilton exhibited regularly at the Royal Academy, but in his case only history and religious paintings, though he did also paint some quite dynamic portraits, like those of members of his family at Lincoln. He was elected RA in 1818, and became a popular Keeper – head of the Royal Academy Schools – in 1827. Hilton is surprisingly well represented by eight paintings at the Tate Gallery, of which five were in the collection of British art given to the nation by Robert Vernon in 1847. Some of these, such as the large *Edith and the Monks searching for the Body of Harold* (RA 1834), are ruins because of Hilton's excessive use of bitumen, a rich brown pigment made from asphaltum which is very bright when applied but darkens and deteriorates rapidly. Other paintings are still in reasonable condition, including *Nature blowing Bubbles for her Children*, a light-hearted composition of nude figures in the manner of Etty, which was shown at the RA in 1821. Quite different in style and technique is *The Meeting of Abraham's Servant and Rebecca at the Well* [PL.119] (Tate Gallery, London), exhibited at the RA in 1833. This is a balanced, detailed and 'realistic' composition in keeping with the painting of such biblical scenes in the following decades.

(119) William Hilton, *The Meeting of Abraham's Servant and Rebecca at the Well* (RA 1833). Oil on canvas; 86.4×110.5 cm. (Tate Gallery, London)

(120) William Etty, *Window in Venice during a Festa* (RA 1831). Oil on canvas, laid on panel; 61×50 cm. (Tate Gallery, London)

William Edward Frost, RA (1810–77), carried on the tradition of undemanding and sometimes romantic nude compositions well into the Victorian age. While a student at the Royal Academy Schools Frost was certainly instructed by Etty, but even at their best, as in the *Disarming of Cupid* (Royal Collection), which was commissioned by Queen Victoria as a present for Prince Albert in 1848, his chaste and graceful figures totally lack the vigour of those by his master. It was only a short step from Frost's nudes to the revived classicism of the suave painting of the female nude by some of the successors of the Pre-Raphaelites later in the century.

17 John Martin (1789–1854) and Francis Danby (1793–1861)

Of all the British painters whose work comes under the umbrella of 'romanticism' John Martin was the most extreme; indeed, as Eric Newton commented, many of his paintings were 'so extreme that "romantic" seems an understatement.'[7] Some of Martin's vast and sublime compositions enjoyed great popular success, in the originals as well as in the mezzotint engravings he made after them. One of the most successful and the largest of these was of *The Fall of Nineveh*, published in 1830 and based on the painting first exhibited in London in 1828. When the German critic G. F. Waagen saw the painting he rather liked it and commented, 'I now perfectly understand the extraordinary approbation which Martin's pictures have met with in England, for they unite, in a high degree, the three qualities which the English require, above all, in a work of art, – effect, a fanciful invention, inclining to melancholy, and topographic historical truth.'[8] John Martin's art was highly individual, as was his personality, and, unlike most of the artists discussed in the preceding chapters he was never a member of the Royal Academy nor of any other part of the art establishment. In fact, Martin frequently quarrelled with the

(121) John Martin, *Joshua commanding the Sun to stand still upon Gibeon* (RA 1816). Oil on canvas; 150×231 cm. (The United Grand Lodge of England)

Academy about the poor hanging of his pictures, which were often shown in the small Ante Room.

Born into a poor family in Northumberland, John Martin started his artistic training under Boniface Musso, a Piedmontese painter living in Newcastle. In 1805 he left Newcastle for London to join Musso's son, and worked with him for a time painting china decoration, and when that firm failed found employment with a glass manufacturer, William Collins. Martin was drawing and painting in his spare time, and managed to augment his income – he was already married with a family – by selling drawings of the rough and wild Northumbrian landscape; his love and knowledge of that scenery was the basis of many of his later landscape compositions. Having had a painting refused in the previous year Martin showed his first work, *Landscape Composition*, at the Royal Academy in 1811, had three paintings accepted in 1812, and continued to exhibit there frequently until 1824, and then again from 1837 until 1852.

Martin's first great success was *Joshua commanding the Sun to stand still upon Gibeon* [PL.121], a large canvas shown in 1816. Illustrating two dramatic verses from the Old Testament Book of Joshua, this powerful composition successfully combines a grand overall effect with a great amount of detail, including the brilliant rendering of the massed armies. Certainly influenced by Turner's well-received 1812 Royal Academy exhibit, *Snow Storm: Hannibal and His Army crossing the Alps* (Tate Gallery, London), which was inspired by that artist's experience of a violent storm in Yorkshire, Martin's work sets the pattern for his own compositions of this type by giving the figures a relatively minor role when compared with the landscape. Despite its popular acclaim the *Joshua* was not sold, but when it was shown at the British Institution in the following

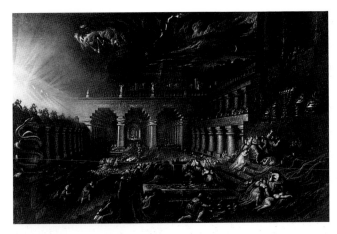

(122) John Martin, *Belshazzar's Feast* (1832, after the painting of 1820). Mezzotint; 53.3×76.2 cm. (Tate Gallery, London)

year Martin was awarded the second premium of £100. Another honour came to Martin at this time, for when Princess Charlotte, the Prince of Wales's only child, to whom he was giving drawing lessons, married Prince Leopold of Saxe-Coburg, later King of the Belgians, in 1816, he was immediately appointed 'Historical Landscape Painter' to the Royal couple. Princess Charlotte died in childbirth in the following year, but Leopold, who stood godfather to the artist's fourth son, continued his patronage.

John Martin was an excellent publicist, and it was his habit to produce his ambitious paintings, make mezzotint engravings on the newly introduced steel plates after them, and, having exhibited the usually vast canvas in London, send it on tours of provincial cities. This was principally in order to engender sales for the prints, which became enormously popular both in Britain and on the Continent, especially in France. Nothing is known about how John Martin learnt the art of engraving, of which he became an outstanding master. He had had his first experience of working in mezzotint on steel when in only two years, between 1823 and 1825, he designed and engraved a series of twenty-four illustrations to Milton's *Paradise Lost*. Working from rapidly painted preliminary oil sketches, which were for many years in the Scarborough collection of Thomas Laughton, Martin engraved a larger and a smaller version of each composition. This highly successful and profitable series was commissioned by Septimus Prowett, an American publisher recently settled in London, was dedicated to the King, and ultimately appeared in four editions. From then on Martin produced numerous illustrations, including a series of twenty to the Bible, which he engraved and published himself, and a considerable number for some of the Annuals, such as *The Keepsake*, many of which were engraved by the same craftsmen that were working after Turner's drawings during these years.

At the same time Martin continued to produce his striking romantic 'historiated' landscape compositions. The *Joshua* was followed in 1817 by *The Bard* (Laing Art Gallery and Museum, Newcastle upon Tyne), another daunting mountainous scene, on this occasion illustrating Thomas Gray's pindaric ode. This was followed by the cataclysmic *The Fall of Babylon*, shown at the British Institution in 1819 and bought by Thomas Hope for 400 guineas. Two years later Martin again chose the British Institution for the first showing of what was rapidly to become the most successful and most famous of all his spectacular compositions, *Belshazzar's Feast* [PL.122], which was immediately awarded

the first premium of 200 guineas. The exhibition, largely because of *Belshazzar's Feast*, proved so popular that it was extended for a further three or four weeks, and then the painting was seen by some fifty thousand more people when its purchaser, William Collins, who had earlier employed Martin as a glass decorator, showed it at his shop in the Strand. Collins paid the exceptionally high price of 800 guineas for the picture, and others, including the Duke of Buckingham, were prepared to pay as much or more.

With its combination of minute detail and vigorous colour and line, *Belshazzar's Feast* satisfied the same elements of public taste for sensational visual experiences that were served by the numerous panoramas, dioramas and other such spectacles that proliferated in Britain in the first three decades of the nineteenth century. It is likely that in order to tie in with this fashion Martin deliberately chose a panoramic composition for this work. When the painting was at the British Institution he took the unusual step of issuing a small etching of the picture with an explanatory key for visitors to buy when viewing *Belshazzar's Feast*. After its showing in London *Belshazzar*, together with the *Joshua*, was exhibited in Liverpool, with evening showings illuminated 'by the powerful aid of Gas-light', and the paintings were then sent on a nationwide tour.

There has long been debate about the qualities of Martin's *Belshazzar's Feast* as a work of art, and in its own day it was given a mixed reception by the critics. Furthermore, there was also much criticism of the fact that the artist 'stole' the idea of the subject from his friend, the American painter Washington Allston, who was working on his own version of the dramatic biblical scene in his London studio in 1818, and referred his fellow artist to the lengthy poem *Belshazzar's Feast* by the Revd T.S.Hughes, published that year. However, there can be no doubt that this painting finally sealed Martin's success and reputation, and that when still only in his early thirties the humble Northumbrian labourer's son was established as one of the most prominent artists then working in London. In 1822 Martin held a retrospective one-man show of twenty-five paintings at the Egyptian Hall in Piccadilly, for which he managed to borrow nearly all his major paintings to date, though not *Belshazzar's Feast*. The exhibition, which was not a great success, included Martin's latest major work, the somewhat empty *Destruction of Herculaneum and Pompeii*, painted in 1821 as an 800-guinea commission for the Duke of Buckingham.

From the mid-1820s onwards Martin was also beginning to become involved in producing somewhat bizarre and grandiose *Plans*, many of which were schemes and inventions for improving such London facilities as the supply of fresh water and the sewers. Others proposed new ideas for coal mines, the building and propulsion of ships, and the railways. Most of these were accompanied by pamphlets, often illustrated, and such activities cost Martin much time, energy and money, and led to financial difficulties. It was this aspect of his career that earned John Martin the sobriquet of 'Mad Martin'; insanity ran in the family, for it was John's older brother, Jonathan, who, in 1829, notoriously set fire to York Minster, causing severe damage. He was tried, found insane, and spent the rest of his life in Bedlam.

The spectacular paintings continued to appear with some regularity, and the mezzotint versions of each composition usually followed two or three years later. *The Seventh Plague of Egypt* (Museum of Fine Arts, Boston) was shown in 1824 at the inaugural exhibition of the Society of British Artists, and in 1826 the dynamic *Deluge*

(123) John Martin, *The Eve of the Deluge* (RA 1840). Oil on canvas; 143×218.4 cm. (The Royal Collection)

(124) John Martin, *The Coronation of Queen Victoria* (1839). Oil on canvas; 238×185.4 cm. (Tate Gallery, London)

(untraced), with its swirling clouds and water, was at the British Institution. The mezzotint after this was published in 1828, dedicated to Tsar Nicholas I, who had visited Martin's studio and presented him with a diamond ring and a gold medal. The theme of the deluge preoccupied Martin for many years, and there is some confusion about the various painted versions, one of which was exhibited in 1837 at the Royal Academy, where Martin had not shown since 1824. Three years later *The Eve of the Deluge* [PL.123] and *The Assuaging of the Waters* (The General Assembly of the Church of Scotland) were at the Royal Academy. The former was acquired by Prince Albert in 1841 for £350, and hung in his dressing-room at Buckingham Palace. It was recorded by the painter's son, Thomas, that on one of his visits to his father's studio Prince Albert saw *The Deluge*, and suggested the two further compositions on this theme. In the description of *The Eve of the Deluge* printed in the RA catalogue, it was stated that, 'The sun, moon and a comet are represented in conjunction, as one of the warning signs of approaching doom. In the distance are the ocean, the mountains, and, on a lofty promontory, the ark', and in 1840 Martin published one of his many pamphlets to explain the contents of the three Deluge pictures, the last of which, *The Assuaging of the Waters*, brilliantly conveys the drama of the moment with the white dove flying to earth in the foreground and contrasted with a black raven perched on a tree stump, around which a snake is coiled.

The power of John Martin's imagination and his ability to introduce drama into his compositions were unrivalled, and when he decided to paint Queen Victoria's coronation ceremony, which took place in Westminster Abbey on 28 June 1838, he created a vivid masterpiece [PL.124]. This, his only known work of contemporary history painting, combines a telling record of the Gothic setting lit by streaming sunlight, with a convincing representation of the massed rows of the nobility. Most of these, like

the Queen herself, are shown in apparent movement as their attention is focused on the minor incident of the elderly Lord Rolle stumbling while coming forward to do homage. This clever touch brings to life a scene that is usually depicted as static, and, though Queen Victoria did not buy it, the painting brought many potential patrons among those who sat for their portraits for it in Martin's studio, and was generally well received when first exhibited in 1844.

During the 1840s Martin worked increasingly in watercolours, often on quite a small scale, and he exhibited a number of these at the Royal Academy and the British Institution. In many of them he demonstrated his ability to portray actual landscape views, again cleverly combining fine detail with broad and often panoramic effect. In recent times Martin's attractive watercolours have become as popular as those of Samuel Palmer. John Martin's reputation suffered almost total eclipse during the first half of the last century, but, largely thanks to the patient efforts of Charlotte and Robert Franks, London art dealers who had come to England from Germany shortly before 1939, interest was revived in the 1950s. In 1935 another London dealer had bought Martin's final masterpieces, the three *Last Judgement* paintings, at auction for £7. These were then acquired by the Franks, and in 1974 Mrs Franks bequeathed two of them in memory of her husband to the Tate Gallery, which had already bought the third in 1945.

The three huge canvases – *The Great Day of His Wrath* [PL.125], 1852, *The Plains of Heaven*, 1853, and *The Last Judgement*, 1853 – were the major preoccupation of the last three years of Martin's life, and he died very soon after their completion. He had particular difficulty in completing *The Last Judgement*, with its basically impossible combination in one composition of maximum turbulence with maximum serenity. When exhibited in London in 1855 the three paintings were generally acclaimed; typical of the favourable comments were those of the critic of *The Illustrated London News*, who wrote, 'At the touch of his pencil, as of a magician's wand, earth and heaven are riven, resolved, as it were, into chaos, out of which a magnificent structure of his own creation is reared.'

After the publication of the engravings, by Charles Mottram, the pictures were taken to the United States and then continued their triumphal tour in most of the larger provincial towns of England. Thus, despite frequent attacks by Ruskin, who hated the fact that Martin was often compared with Turner, the former died at the height of his reputation, having satisfied the taste of the first half of the nineteenth century for paintings that were at once sensational, decorative and theatrical, as well as truthful and believable. The three *Last Judgement* paintings were the summation of that achievement, bringing together all the themes and effects that had preoccupied the artist throughout his career, and ultimately ensuring him a leading place among the romantic visionary artists of the nineteenth century.

As well as Turner there were a few other artists during this period whose work can be compared with that of Martin, and of these several were members of the 'Bristol School of Artists'. That name was devised as the title of an exploratory exhibition held in Bristol in 1973, which made out a good case for a 'school' of painters centred on that great city in the first half of the nineteenth century. The weakness of the case was the fact that the Irish-born Francis Danby, who spent only ten years in Bristol – from 1813 to 1824 – was made the focal figure of the school. However, during those ten years Danby

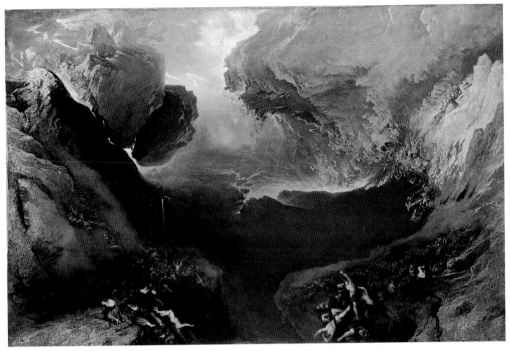

(125) John Martin, *The Great Day of His Wrath* (1852). Oil on canvas; 196.5×303.2 cm.
(Tate Gallery, London)

made the local scenery of the Avon Gorge, Leigh Woods and Stapleton very much his own, and produced a series of charming and poetic landscape paintings, such as the small *Clifton Rocks from Rownham Fields* [COL.PL.23], which dates from 1821. In such well-observed and sharply painted compositions the figures, like the group of ill-shod boys under the tree, play an important role even though they are usually on a small scale.

In 1820 Danby made his mark in London when he exhibited the vast and haunting *The Upas, or Poison Tree in the Island of Java* (Victoria and Albert Museum, London) at the British Institution. The grim story illustrated by this dark and gloomy composition, which at least one London critic compared with the current work of John Martin, was based on a fable of the poisonous anchar tree – said to grow on Java and to give out pestiferous exhalations which killed all vegetable and animal life in the vicinity – which was popularised by a poem by Erasmus Darwin, grandfather of Charles. In the following year Danby showed his first painting, *Disappointed Love* (Victoria and Albert Museum, London), at the Royal Academy. In this 'deep, gloomy and pathetic' picture, as one critic described it, Danby made use of his close study of the Bristol landscape to provide an effective setting for the sensitively observed misery of the lovelorn girl, to create a romantic narrative composition rather ahead of its time. However, it was further spectacular compositions in the vein of *The Upas*, and often comparable with paintings by Martin and Turner, that justify Danby's inclusion in this chapter.

In 1824, after his move to London, Danby showed *Sunset at Sea after a Storm* (City of Bristol Museum and Art Gallery) at the Royal Academy, where it was purchased

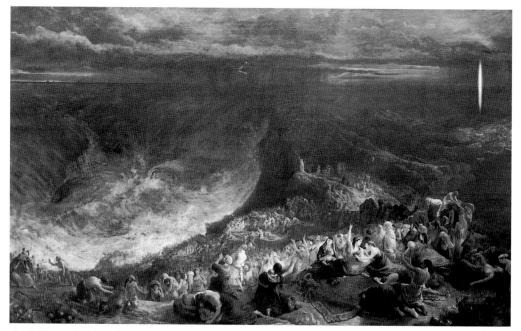

(126) Francis Danby, *The Delivery of Israel out of Egypt* (RA 1825). Oil on canvas; 149×240cm.
(Harris Museum and Art Gallery, Preston)

by the President, Sir Thomas Lawrence. With its remarkable sky, the painting was a great success, and was described by the Redgrave brothers as 'the work that made the painter's reputation'.[9] This success was followed by even greater acclaim for Danby's 1825 Royal Academy exhibit, the huge and dramatic *The Delivery of Israel out of Egypt* [PL.126], which was immediately sold for £500 to the Marquis of Stafford, President of the British Institution. Though there are eclectic elements in this ambitious composition, the style and manner of the painting, in particular its detailed naturalism, are essentially Danby's own, and he was deservedly elected ARA later that year. A brief visit to Norway in the summer of 1825 added new elements to Danby's experience of spectacular landscape, which he put to good use in later compositions, such as *An Attempt to Illustrate the Opening of the Sixth Seal* (National Gallery of Ireland, Dublin), which was the most popular painting at the Royal Academy exhibition of 1828 and was bought for 500 guineas by William Beckford, of Fonthill. Danby was also awarded a 200-guinea prize by the British Institution. The copyright was sold for £300 to Colnaghi's, who published the mezzotint by G. H. Phillips in 1830.

Despite these successes Danby, whose personal behaviour was erratic and profligate, was on the edge of financial ruin, and late in 1830 he fled from his creditors to Paris. From then on he and his large family moved around in Belgium, Germany, Switzerland and France, and did not return to London until 1839. Danby continued to paint, and had started to write, and in 1840 *The Deluge* (Tate Gallery, London), much the largest work he ever painted, was shown at a private exhibition in Piccadilly, which successfully brought the artist back to the notice of the public and the critics. This powerful and gloomy work had been commissioned in 1837, and Danby started painting it while in Paris, clearly much under the influence of Géricault, whose 1819 *Raft*

of the Medusa had greatly impressed him when he first visited Paris in 1829. The melancholy of *The Deluge* and of the paintings of the next year or two reflect Danby's personal distress caused by the death in rapid succession of his mistress and of three of his children.

From now on Danby, living first in London and then in Lewisham, before finally settling at Exmouth, exhibited again regularly at the Royal Academy. His work became ever more eclectic, as demonstrated by the strong echoes of Turner in one of his 1855 RA exhibits, *Dead Calm – Sunset, at the Bight of Exmouth* (Royal Albert Memorial Museum, Exeter). During the last twenty years of his life Danby rarely, if ever, again reached the heights of inspiration which he had achieved during the 1820s. However, his achievements of those earlier years had certainly justified the high praise given him by the Redgrave brothers, who summed up his painting as combining 'the large general truths of nature – her grandest, saddest aspects, with the imaginative and ideal creations of poetry',[10] which would be an apt description of one major aspect of Romantic art.

18 Sir Edwin Landseer, RA (1803–73)

An infant prodigy, favourite painter of the Queen, long-standing lover of a beautiful duchess, and *the* animal painter of his day, Edwin Landseer had all the makings of a romantic figure. His art, based on great skills as draughtsman and painter, carried romantic qualities to a new and final highpoint. 'In his lifetime he was an international celebrity and worshipped by the Victorians';[11] in the twentieth century his fame was almost entirely eclipsed, and today he has still not achieved the renewed popularity of many of his contemporaries, though *The Monarch of the Glen* (John Dewar & Sons Ltd) painted for the House of Lords in 1851, but rejected by the relevant committee, remains one of the most famous British paintings of the nineteenth century.

Edwin Landseer was born in London, the third and youngest son of the leading engraver John Landseer, ARA, who was an eccentric but influential figure in the London art world. Five of John Landseer's seven children became artists, and in this artistic family environment the attractive and precocious Edwin quickly proved to be the most gifted, having begun to draw animals at the age of five. In 1815 the young artist was awarded a silver medal by the Society of Arts for a drawing of a hunter, and he exhibited two drawings at the RA. In that year he and his two brothers began studying under Benjamin Haydon, being the first pupils of that egocentric painter and diarist, who wrote in his *Diary* on 25 January 1822 (his own thirty-sixth birthday), 'My influence on English Art has certainly been radical. Edwin Landseer dissected animals under my eye, copied my anatomical drawings, and carried my principles of study into animal painting! His genius, thus tutored, has produced solid & satisfactory results.'[12]

By 1822 the nineteen-year-old Edwin Landseer had also completed some three years of study at the Royal Academy Schools, where the elderly Fuseli was still Keeper, had studied anatomy under Sir Charles Bell, and had become a regular and successful exhibitor at the Royal Academy and elsewhere; Sir George Beaumont, Sir John Leicester and the 3rd Marquess of Lansdowne were among the leading collectors of contemporary British art who had already acquired work by him. They were intrigued by the

young artist's uncanny ability to portray the characteristics, movements and moods of dogs and other animals, as in the painting of *Rat Catchers* (Private Collection), of which he exhibited versions at the RA in both 1821 and 1822. Seen from the dog's-eye level, this features the ratcatcher's three dogs of different breeds (modelled by dogs that belonged to the artist), his ferret and other equipment, two dead and two living rats, but not the man himself, to create a lively and dramatic composition, which was much admired by Géricault, who was then in London. In 1824 Landseer showed a much less attractive composition of animal confrontation, *The Cat's Paw* (Private Collection), which shows a pet monkey violently gripping a cat and forcing its paw onto a red-hot stove to remove the chestnuts on top of it. The degree of cruelty in this controversial picture, which ostensibly illustrates one of La Fontaine's fables, is subtly left indefinite, and despite its subject the painting was much admired for its brilliant execution and effective colouring.

In 1824 Landseer paid his first visit to Scotland and was deeply impressed by the wild scenery and 'picturesque' inhabitants of the Highlands. From then on he returned to Scotland every autumn, and Scottish subjects became the major element of his work. The artistic possibilities of Scotland had been 'discovered' by Paul Sandby and others in the mid-eighteenth century, and in the early years of the nineteenth Turner was one of the many artists who drew inspiration from the landscape north of the border. During these same years Sir Walter Scott's poetry and then novels brought a wider popularity to his country. George IV's State Visit to Edinburgh in the summer of 1822, a spectacular occasion for which Scott was the Master of Ceremonies, set the seal on the romantic associations of Scotland, which the art of Landseer soon popularised even more. That art was often inspired by the writing of Walter Scott, with whom the young painter spent ten days at Abbotsford during his first Scottish tour. While at Abbotsford 'Mr Landseer, who has drawn every dog in the House but myself is at work upon me under all the disadvantages which my employment puts him to.'[13] The vivid small portrait sketch of Sir Walter (National Portrait Gallery, London) which the writer refers to, shows, like many other portraits by him, that Landseer was as able a delineator of the appearance and character of man as he was of animals.

In 1826 he showed only one work at the Royal Academy; this was *The Hunting of Chevy Chase* [PL.127], Landseer's first major painting of a Scottish subject, which had been commissioned by the 6th Duke of Bedford, the artist's most important early patron. An ambitious historical picture, conceived in the manner of Rubens and Snyders, this vivid composition is packed with activity and gesture to create the most lively and romantic of sporting pictures, which owes much to a variety of earlier example, including, of course George Stubbs and James Ward, but is at the same time a personal and original creation in which the artist's own detailed studies of animals played a crucial role.[14] In one sense *The Hunting of Chevy Chase* can be considered as yet another example of the continued influence of the teaching of Sir Joshua Reynolds; it demonstrates the young Landseer's deep knowledge of the work of earlier masters, and the adaptation of that knowledge for the creation of an original work in the 'grand manner'. As well as the advantages he enjoyed as the son of an engraver brought up in an artistic household, Landseer, because of commissions at an early age from the owners of some of England's greatest collections of paintings, also had further ex-

(127) Sir Edwin Landseer, *The Hunting of Chevy Chase* (RA 1826). Oil on canvas; 143×171 cm. (Birmingham Museums and Art Gallery)

ceptional opportunities for seeing the paintings and engravings which influenced him.

Based on a popular medieval border ballad, which tells of the rivalry between the Earls Percy and Douglas, *The Hunting of Chevy Chase* depicts the hunt by the former in the latter's territory across the Scottish border which resulted in the battle in which both leaders and many of their men were slain. Landseer completed an oil sketch (Sheffield City Art Galleries) for a companion picture, though never a finished canvas. The picture was enthusiastically received – the critic of *The Examiner* described it as 'the most perfect picture, of its class, that has yet been seen in this country'– and later in the year Landseer was elected an Associate of the Royal Academy. At the earliest age allowed Landseer had climbed the first rung of the ladder of official recognition; he was elected an Academician five years later, was knighted in 1850, and, because of ill health, declined the office of President of the Royal Academy in 1865. His professional success was matched by his social standing, which was certainly advanced by his long affair with Georgiana, daughter of the Duke of Gordon and second wife of the artist's patron, the 6th Duke of Bedford. Landseer was a frequent visitor at Woburn Abbey and other Bedford houses, and he soon also became a regular guest of other leading aristocratic families, at Chatsworth, Goodwood, Badminton, Holland House and Lansdowne House.

In addition to all this he enjoyed unprecedented Royal patronage. Queen Victoria first met him soon after her accession in 1837, having recorded her admiration for his work in her Journal as early as 1833. In 1836 the Duchess of Kent commissioned Landseer to paint a small circular portrait of Princess Victoria's much-loved King Charles spaniel, Dash (Royal Collection), as a birthday present for her daughter, who herself commissioned a large composition of her four dogs from him in 1838 and then another major painting in 1839. After seeing one of the American lion-tamer's shows in London at least five times early that year, the Queen commissioned *Isaac van Amburgh and his Animals* (Royal Collection), for which she paid 300 guineas. Many other Royal com-

(128) Sir Edwin Landseer, *A Highland Breakfast* (RA 1834). Oil on canvas; 50.8×66 cm.
 (Victoria and Albert Museum, London)

missions followed, and today there are forty-two paintings by Landseer in the Royal
Collection. The Queen and Prince Albert became frequent visitors to Landseer's studio,
and in 1850 Landseer paid the first of many visits to Balmoral, the Royal couple's re-
cently acquired Highland home.

The success of *The Hunting of Chevy Chase* was followed by many other triumphs
in the next two decades, including one or two more history paintings, such as *Scene in
the Olden Time at Bolton Abbey* (Devonshire Collections, Chatsworth), commissioned by
the 6th Duke of Devonshire, and shown at the Royal Academy in 1834. The model for
the head of the central figure of the abbot was the landscape painter A. W. Callcott, and
to create his vision of medieval monastic life, shown from a slightly satirical point of
view, Landseer has again brought together his natural skills in the depiction of human
beings and living and dead animals. This large picture, with its abundance of game
and fish being presented to the abbot, provides a remarkable contrast with another of
Landseer's 1834 RA exhibits, the small and moving *A Highland Breakfast* [PL.128]. This
shows a humble Scottish cottage interior with the pretty mother tenderly feeding her
child while a lively group of dogs, one of them simultaneously suckling her puppies,
are feeding from a large wooden tub in the foreground. This attractive work was pur-
chased by John Sheepshanks, who also acquired the famous *The Old Shepherd's Chief
Mourner*, shown in 1837 and so greatly praised by John Ruskin in the first volume of

(129) Sir Edwin Landseer, *Low Life* (1829). Oil on panel; 45.7×34.3 cm. (Tate Gallery, London)

(130) Sir Edwin Landseer, *High Life* (1829). Oil on panel; 45.7×34.3 cm. (Tate Gallery, London)

Modern Painters a few years later.[15] He described this moving and sentimental work as 'one of the most perfect poems or pictures … which modern times have seen', and it has long been one of the most popular paintings in the Victoria and Albert Museum, where it is one of sixteen Landseers, most of them equally sentimental, in the Sheepshanks Collection.

The slightly earlier collector Robert Vernon also admired Landseer, and his 1847 gift to the nation included eight paintings by him, among them the humorously contrasting pair, *Low Life* and *High Life* [PLS.129,130], dated *1829* but not shown until 1831, when Landseer's most consistent early patron and great friend, William Wells of Redleaf, the shipbuilder and art collector, bought them. In *Low Life* a battle-scarred and tough terrier sits on the doorstep fiercely guarding his master's butcher's shop, while in *High Life* an elegant deerhound sits pensively beside his absent, but clearly aristocratic, master's chair. The beautifully executed and convincing realism and undemanding messages of these two paintings of dogs, and many more like them – *Jack in Office* (RA 1833), *Suspense* (BI 1834), and *Dignity and Impudence* (BI 1839) to name but a few – exactly matched the taste of the day and laid the firm foundations for Landseer's growing fame and popularity. In addition all of these were sooner or later engraved, and the prints spread the artist's fame ever further afield.

Landseer painted many of their dogs for Queen Victoria and Prince Albert, including the beautiful portrait of *Eos* [COL.PL.38], which the Queen gave her husband as a Christmas present in 1841. Eos was the Prince's favourite greyhound, which he had brought with him from Germany, and the dog features again, sitting at Prince Albert's knees, in *Windsor Castle in Modern Times* (Royal Collection). This somewhat laboured

(131) Sir Edwin Landseer, *Queen Victoria sketching at Loch Laggan* (1847). Oil on canvas; 34.1×49.5 cm. (The Royal Collection)

family portrait, set in the Green Drawing Room at Windsor Castle, shows the Royal couple with their first child, Victoria, and three of their terriers. Scattered about is a surprising variety of dead birds, presumably brought in by the Prince, just returned from a shoot. Started in 1841, this complex conversation piece was not completed until 1845, for by now Landseer had suffered his first bout of severe depression and often had difficulty in finishing his paintings. A much more successful Royal portrait, given to Prince Albert as a Christmas present in 1847, is the charming small *Queen Victoria sketching at Loch Laggan* [PL.131], which shows the Queen, a crayon in her hand and with the Princess Royal and the Prince of Wales standing beside her, welcoming a gillie leading a pony laden with a dead stag. The contents and setting of this picture had been precisely laid down by the Queen, who had borrowed Ardverikie Lodge on Loch Laggan from the Duke and Duchess of Abercorn for a Highland holiday in 1847, at the end of which they were joined by Landseer. The beautifully painted landscape setting, showing the east end of Loch Laggan looking towards the East Binnein, is an especially attractive feature of this work, and is a fine example of Landseer's painting of Highland and other landscapes. In the artist's studio sale in 1874 there were more than a hundred small landscape sketches, none of which had been exhibited and which he appears to have painted purely for pleasure. Usually executed with rapid and thinly applied brush strokes, with occasional thicker highlights, these atmospheric sketches were almost certainly painted on-the-spot, and affirm the artist's delight in the scenery of the Highlands.

The Highlands also provided Landseer with the most romantic and characteristic

(132) Sir Edwin Landseer, *The Challenge* (RA 1844). Oil on canvas; 96.5×211 cm. (The Duke of Northumberland)

subject matter of his later years, the proud stag and his family. In 1838 he began to exhibit his deer pictures – *None but the Brave deserve the Fair* (Private Collection) at the Royal Academy and *Red Deer* and *Fallow Deer* (Private Collections, both painted for William Wells) at the British Institution – and these were an immediate success. Four years later the first of Landseer's symbolic pictures of deer, *The Sanctuary* (Royal Collection) was at the RA and acquired by William Wells, who, however agreed to cede it to Queen Victoria for £215, and she gave it to Prince Albert on his birthday. This imaginative and sentimental composition, with its fine rendering of the totally calm light and atmosphere of evening at Loch Maree on the west coast of Scotland, was followed two years later by the much larger *The Challenge* [PL.132], with its awe-inspiring moonlit winter setting and its proud bellowing stag challenging the rival swimming towards him. Yet another totally different mood is created in *A Random Shot* (Bury Art Gallery and Museum), shown at the Royal Academy in 1848 and originally intended for Prince Albert. In this snowy twilit mountaintop scene a young fawn is vainly seeking sustenance from its dead mother stretched out on the snow with drops of blood around her. Snow and animals are painted with the greatest skill, the composition is totally austere and economical, the message is clear and direct; all adding up to achieve yet another of Landseer's popular masterpieces. *The Monarch of the Glen* followed three years later, and there were many more in similar vein.

The Queen and Prince Albert continued to look to Landseer for portraits of themselves, their children and their animals, despite his unreliability and frequent failure to complete some of them. The artist's major failure was the life-size equestrian state portrait of the Queen, begun in 1838 but never finished. Over-anxious to produce a masterpiece Landseer kept the huge canvas in his studio until his death, returning to it from time to time. There are many fine studies and sketches connected with this work, including two in the Royal Collection. One of the most delightful of all the royal portraits is the large unfinished oil sketch of *Queen Victoria and Prince Albert* (Royal

Collection), painted in about 1841, perhaps in connection with *Windsor Castle in Modern Times*. The most ambitious completed portrait of the Royal couple is the life-size *Queen Victoria and Prince Albert at the* Bal Costumé *of 12 May 1842* (Royal Collection). This stiff and sadly wooden image records a famous fancy-dress ball held at Buckingham Palace. On the other hand in the 1840s Landseer painted charming portraits of some of the Royal Princesses as babies, often, as in *Victoria, Princess Royal, with Eos* (Royal Collection), accompanied by the family dogs and other pets. This tradition is continued in a very different context by the famous portrayal of *Queen Victoria at Osborne* (Royal Collection). Begun in 1865 and exhibited at the RA in 1867, this shows the widowed Queen in deep mourning (Albert had died in 1861) seated on her pony Flora, held by her faithful servant John Brown, at whose feet are two of her dogs. Two of the Princesses with a terrier are seated on a bench in the middle distance, and the Italianate Osborne House, designed by Albert, fills most of the background.

The whole composition of *Queen Victoria at Osborne*, which was painted with the aid of photographs, is again somewhat stiff and lacks the fluency which is characteristic of Landseer's best work. Fortunately this was still present in much of his late work, as in the remarkable *Man Proposes, God Disposes* [COL.PL.37] shown at the Royal Academy in 1864. This haunting and enigmatic picture was painted for E.J.Coleman of Stoke Park, who paid £2415 for it, and was bought at his sale in 1881 for the great late Victorian collector, Thomas Holloway, for the enormous sum of £6615, which remained a record auction price for a Landseer painting until Agnew's paid £7245 for *The Monarch of the Glen* in 1892. Inspired by the tragic loss of Sir John Franklin's Arctic expedition in 1847, this moving picture illustrates the frailty of man, the strength of wild animals, and the dominant forces of stark nature, to achieve a dramatic symbolic portrayal of man's tenuous and fragile existence on earth. The painting was received with enthusiasm, not least by the critic of *Blackwood's Magazine*, who wrote the following perceptive passage:

> It is not for some years that this consummate painter of animal life has been so much himself. As of old, he here not only gives smoothness of coat and texture of hair, but seems at the same time, by an art too subtle for analysis, to portray the inner nature and mute consciousness of the brute creation, making the silent actors in the scenes he delineates move the spectator to terror; or, on the other hand, by beauty and pathos awaken to sympathy.

Another of Landseer's great animal sagas, *The Swannery invaded by Eagles* (Private Collection), dominated the Royal Academy exhibition of 1869, but this cruel image of noble swans overcome by vicious eagles was not engraved. The subject was presumably too unlikely and too horrific for the Victorian public, and had taken romanticism to the edge. But the painting was still accepted as a *tour de force* by the artist who had achieved greater success and fame than any of his British contemporaries, and led the way for such late Victorian giants as Millais and Leighton. However, no other British artist of the nineteenth century achieved the reputation abroad that was accorded to Landseer during the later years of his life. One vital factor in that reputation was the great success of the English pictures in Paris at the Exposition Universelle, which formed a major part of the Salon of 1855.

This influential exhibition included some 375 works by 152 living British painters and watercolour artists, and Landseer was represented by nine paintings and twenty-nine engravings after his work. He was the only Englishman among the ten artists to be granted the exhibition's highest award, the Grande Medaille d'Honneur, which was also awarded to Decamps, Delacroix, Ingres, Meissonier and Horace Vernet, thus placing Landseer with the leading French artists of the day. In his perceptive review of the exhibition Théophile Gautier compared the spiritual qualities of Landseer's painting of animals with the much more materialistic work of the animal painters of the French school. 'Landseer,' he wrote, 'gives his beloved animals soul, thought, poetry and passion. He endows them with an intellectual life almost like our own; he would, if he dared, take away their instinct and accord them free will; what worries him is not anatomical exactitude, complicated joints, the thickness of the paint, masterful brush-work: it is the very spirit of the beast, and in this respect there is no painter to match him; ...' The British tradition of animal painting, taken to its greatest heights in the eighteenth century by George Stubbs, achieved a final climax with the work of Landseer. Stubbs, also largely forgotten in the first half of the twentieth century, painted scientifically truthful pictures of horses and other animals; Landseer portrayed the spirit and feelings of his subjects. Between these two artists came James Ward; all three have immortalised in paint the romantic qualities of the animal world.

Throughout the nineteenth century there were many other painters who specialised in the painting of animals, and in particular of horses. One of the most prolific of these was John Frederick Herring, Senior (1795–1865) – his three sons were also successful animal painters – who started life as a coachman in Yorkshire, became a coach and sign painter, and then started his career as a painter of racehorses and other animals, first exhibiting at the Royal Academy in 1818. Herring left Yorkshire in 1830, moving first to Newmarket and then to London. His racehorse portraits – including those of thirty-three consecutive winners of the St Leger – are in the tradition of Stubbs, but are often somewhat static, though with a naïve charm, and many were reproduced as engravings. A fine example is *The Start of the Oaks, 1845* [PL.133], which provides a very relaxed impression of the moments before the start of a big race, a scene frequently repeated by the artist. In his later years Herring turned to painting somewhat sentimental pictures of farm and domestic animals, and attractive farmyard scenes and stable interiors, such as the Tate Gallery's *The Hunting Stud*, which is dated 1845. Three grooms are working on horses standing in their stalls, while two gentlemen examine a fourth horse; this is a pleasing and informative composition, in which Herring's skill in the painting of horses is seen at its best.

Another specialist in the painting of horses was the Leicestershire-born John Ferneley (1782–1860). His early talent was discovered and encouraged by the Duke of Rutland, who is said to have sent him to London as an apprentice to Benjamin Marshall (1768–1835), the most notable follower of George Stubbs in the early years of the nineteenth century. Herring spent most of his life in Melton Mowbray, the centre of the fashionable Shires hunting world, and produced numerous portraits of individual horses and their riders as well as detailed compositions of lively scenes in the hunting field, which provide an invaluable record of the Leicestershire hunting scene in its greatest years. During the same years James Pollard (1792–1867), who also painted

(133) J.F.Herring, Senior, *The Start of the Oaks, 1845*. Oil on canvas; 68.5×119.4 cm.
(Private Collection)

(134) Thomas Sidney Cooper, *The Victoria Cow* (1848). Oil on panel; 45.1×61 cm.
(The Royal Collection)

hunting scenes, specialised in the depiction of the stagecoach and its setting. Many of his detailed and informative representations of coaches in all kinds of situations were reproduced as coloured aquatints, and today provide a lively record of the hustle and bustle of travelling by coach in the years just before the railways displaced them. A typical example is the very large *Royal Mail Coaches for the North leaving the Angel Islington*, dated 1827, which was presented to the Tate Gallery by Paul Mellon.

Thomas Sidney Cooper, RA (1803–1902) had a highly successful career as a specialist painter of cattle and sheep. Born in Canterbury, where he worked as a coach painter, he was briefly at the Royal Academy Schools, and then studied for several years in Brussels, where he was deeply influenced by the animal painter E. J. Verboeckhoven, before settling in London in 1831. He quickly made his mark, exhibiting annually at the Royal Academy from 1833 until his death – a total of 266 works – and being elected ARA in 1845 and RA in 1867. He soon became prosperous, and spent the last fifty years of his long life in or near his native Canterbury, where he opened his own drawing school and Gallery of Art. In 1848 he was commissioned to paint *The Victoria Cow* [PL.134] for Queen Victoria. His panel painting of the fine Jersey cow, standing quietly in a meadow on the Isle of Wight with the sea in the distance, a calm cloudy sky above, and with two of her calves and a yearling around her, is typical of Cooper's numerous cattle portraits. The cow had been sent to the Queen from Jersey in 1843, and she and Prince Albert were delighted with the painting. Cooper worked for some time at Osborne, painting much of the panel, and making several drawings and oil studies; it was completed in Cooper's London studio, and the artist was paid 90 guineas.

T. S. Cooper painted numerous such cattle portraits as well as more ambitious compositions featuring cattle and sheep, of which the grandiose *The Monarch of the Meadows* (Private Collection), shown at the RA in 1873, was the grandest. The title of this huge composition, with a stately bull in the centre lording it over his cows, was clearly alluding to Landseer's famous *Monarch of the Glen* of some twenty years earlier. Landseer died on 1 October 1873; T. S. Cooper was to paint for another thirty years, and, as Landseer's had done, his success encouraged imitators, one of whom H. W. B. Davis, RA (1833–1914), had made his name at the Royal Academy in 1872 with the enormous *A Panic* (Private Collection), one of the largest paintings ever shown at Burlington House. Such huge animal compositions, by artists such as Constant Troyon and Rosa Bonheur, were common in France, while in Britain T. S. Cooper's smaller scale and quiet domestic style were more to the liking of critics, collectors and the public. In many ways, even they could be described as a continuation of the romantic tradition.

Notes to Part Four

 1 Dennis Farr, *William Etty*, 1958, p.118
 2 Farr, loc.cit., p.46
 3 Farr, loc.cit., p.53
 4 Diary, 2 July and 3, 4 and 19 August 1809
 5 R. and S.Redgrave, *A Century of British Painters*, new edn, 1947, p.271
 6 S.Redgrave, *Dictionary of Artists of the English School*, new edn, 1878, p.226
 7 Eric Newton, 'The Art of John Martin', in Catalogue of the John Martin Exhibition, Whitechapel Art Gallery, London, 1953, p.7
 8 G.F.Waagen, *Works of Art and Artists in England*, 1838, Vol.II, p.162
 9 R. and S.Redgrave, loc.cit., p.400
10 R. and S.Redgrave, loc.cit., p.402
11 Preface by Sir Charles Wheeler, PRA, in the catalogue of *Paintings and Drawings by Sir Edwin Landseer, R.A.*, Royal Academy, London, 1961
12 *Neglected Genius – The Diaries of Benjamin Haydon*, ed. J.Jolliffe, 1990, p.80
13 *Letters of Sir Walter Scott*, ed. H.J.C.Grierson, 1932–7, Vol.8, p.392
14 For a careful analysis of Landseer's numerous borrowings, see J.Rishel, 'Landseer and the Continent: the Artist in International Perspective', in *Sir Edwin Landseer*, Catalogue of the exhibition at the Philadelphia Museum of Art and the Tate Gallery, London, 1982. This catalogue, of which the principal author is Richard Ormond, has been an invaluable source for much of this chapter
15 *Works*, Vol.III, pp.88–9

Part Five

History and Narrative

19 Sir David Wilkie, RA (1785–1841)

George III's favourite painter was the American-born Benjamin West; Queen Victoria's was Edwin Landseer; and George IV's (better known as the Prince Regent) was David Wilkie. All three monarchs were considerable patrons and collectors, and of the four who reigned over Britain from 1790 to 1900 only one, William IV, King for just seven years from 1830 to 1837, was largely uninterested in the fine arts. However, despite such consistent Royal patronage, during this period history painting in the 'grand manner', a tradition usually associated with successful court art, totally failed to flourish in Britain as it had done under Charles I. What did succeed was a school of narrative genre painting, often with historical overtones, but more frequently essentially domestic in character. The founding father of that school in the nineteenth century was certainly the Scottish-born David Wilkie, though it could be argued that he was re-launching a tradition begun in the previous century by William Hogarth (1697–1764). In addition, Wilkie, like Hogarth, was a gifted painter of portraits, but he completed relatively few of these.

Wilkie's father was the Minister at Cults, some twenty miles north of Edinburgh, and he encouraged the precocious artistic gifts of his son, who entered the prestigious Trustees' Academy in Edinburgh at the early age of fourteen. Here he was taught by John Graham, a history painter, and introduced to the Scottish tradition of genre practised by such artists as David Allan (1744–96) and Alexander Carse (active 1795–1836). From the start Wilkie was a gifted and prolific draughtsman, but life drawing was not taught at the Trustees' Academy, and he did not develop his drawing skills academically until he went to London in 1805 and entered the Royal Academy Schools, where Fuseli had just become Keeper. In London Wilkie also attended the influential anatomy classes of his fellow Scot Charles Bell, whose *Essay on the Anatomy of Expression in Painting* was published in 1806. Wilkie became one of the outstanding British draughtsmen of all time and many hundreds of drawings by him have survived. In the first half of his career each of his major compositions was evolved in large numbers of small and rapid pen-and-ink drawings developing ideas and themes, and then augmented by more finished chalk or pencil studies of specific figures. As stated by David Brown 'drawing was the dynamic of Wilkie's art'.[1]

During his years in Edinburgh and when back in Cults Manse Wilkie painted a fair

number of portraits, including the impressive *William Bethune-Morison with his Wife and Daughter,* recently acquired by the National Gallery of Scotland. Dated 1804 and still clearly influenced by Raeburn, established as *the* principal portrait painter in Edinburgh, this also displays the nineteen-year-old artist's individual skills, seen again in the pensive self-portrait of about the same time, now in the Scottish National Portrait Gallery. Also dated 1804, but probably not completed until just before Wilkie's move to London in May 1805, *Pitlessie Fair* (National Gallery of Scotland, Edinburgh), commissioned by Thomas Kinnear of Kinloch, announced the young Wilkie's ambition to become more than just a portrait painter, and immediately established his reputation in Scotland and then in London, where he had been generously allowed to take it by Kinnear.

While a relatively small painting, *Pitlessie Fair,* with its dozens of expressive figures and fine detail of buildings, trees and sky, immediately made an impression as a 'new masterpiece' in the Flemish tradition of Ostade and Teniers. As the young Turner had done so successfully in the years immediately before Wilkie's arrival in London, the Scottish artist established his reputation by proving himself a true successor and rival to some of his great old master predecessors, though when he painted *Pitlessie Fair* he can have seen hardly any original works by them. Pitlessie village is close to Wilkie's home at Cults, and in choosing the annual May Fair as the subject of his first major picture the artist was making full use of his exceptional powers of observation, and his ability to record accurately life and people around him. Wilkie has created a kind of panoramic vision of the fair, packed with a mass of telling detail conveying action and character. On one canvas he has portrayed a whole day at the fair, and has also succeeded in creating a reasonably unified composition.

This early masterpiece was the most crowded of all Wilkie's narrative works, and it was acclaimed in both Edinburgh and London, leading to Lord Mansfield's commission for *Village Politicians* (The Earl of Mansfield), which, much to Turner's annoyance, was acclaimed by both public and critics when exhibited at the Royal Academy in 1806. Painted with much greater confidence and freedom than *Pitlessie Fair,* this somewhat dark and gloomy composition is enlivened by an impressive range of gesture and expression, and enhanced by the skill with which much of the 'still-life' detail is painted. It is, however, an imaginary scene, somewhat in the manner of George Morland, who had died in 1804, but it achieves far more convincing realism than that artist ever did.

Despite his apparent success Wilkie was still hard put to it to survive financially in London, and in order to help him Sir George Beaumont commissioned *The Blind Fiddler* [PL.135]. This again won considerable praise when shown at the Royal Academy in 1807, despite the somewhat spiteful rivalry of one of Turner's exhibits that year, the uncharacteristic *A Country Blacksmith* (Tate Gallery, London), which was bought by Sir John Leicester in the following year. When compared with Wilkie's two earlier narrative paintings *The Blind Fiddler* is a relatively unified composition with simple and direct messages to give and a story to tell, combining serious sympathy and light-hearted humour in the telling. Wilkie's exceptional ability in portraying character and mood is seen in the expressions and gestures of the eleven adults and children, especially in the wicked look of the boy at the right of the group apeing the fiddler and 'playing' a bellows with a poker. In both *Village Politicians* and *The Blind Fiddler,* Wilkie has

(135) Sir David Wilkie, *The Blind Fiddler* (RA 1807). Oil on canvas; 57.8×79.4 cm.
(Tate Gallery, London)

included a self-portrait, a further indication that these compositions are closely based on personal experience and observation. It is possible that Wilkie was already making clay models of the figures and using these as a compositional aid in this work, something that he was definitely doing a few years later.

The success and popularity of more such homely narrative compositions in the following years led to Wilkie's election as ARA in 1809 and RA in 1811, and culminated in his first Royal commission in the same year. Through Benjamin West the Prince Regent asked Wilkie to paint a companion piece to the Bristol artist Edward Bird's *The Country Choristers* (Royal Collection), shown at the RA in 1810, for which the Prince had paid 250 guineas. Wilkie himself had not exhibited in 1810, as, according to Haydon's *Diary*, he feared comparison with the two paintings by the older artist. The choice of subject was left to Wilkie, who took well over a year to complete *Blind-Man's-Buff* (Royal Collection), making numerous drawings and oil sketches in developing the composition, using both living models and lay figures. A sketch for *Blind-Man's-Buff* (Tate Gallery, London) was shown at the Royal Academy in 1812, and at the same time Wilkie received permission to include the unfinished panel in his private retrospective exhibition which opened at 87 Pall Mall on 1 May, and which was reasonably well received though, not surprisingly, it angered some of his fellow Royal Academicians, who had already been disappointed by his small and rather unattractive Diploma Work, *Boys digging for a Rat* (Royal Academy, London).

(136) Sir David Wilkie, *The Penny Wedding* (RA 1819). Oil on panel; 64.4×95.6cm.
(The Royal Collection)

Blind-Man's-Buff was finally completed in time for inclusion in the summer ex-hibition of 1813, where it was a great success; the Prince Regent expressed his delight with the picture, and told Wilkie that he wished him to paint, at his leisure, 'a com-panion picture of the same size'. The more ambitious and painterly *The Penny Wedding* [PL.136] was not started for some time and was completed late in 1818 and exhibited at the RA in 1819, where it was again very well received. While *Blind-Man's-Buff* is a con-temporary and undemanding scene, there is a much greater narrative and informative content in *The Penny Wedding*, which was described as follows in the RA catalogue: 'This is a marriage festival, once common in Scotland, at which each of the guests paid a subscription to defray the expenses of the feast, and by the overplus to enable the new-married couple to commence housekeeping.' Wilkie's participants are in eighteenth-century costume, and the historical element of the composition reflects the impact of what Wilkie had experienced during his first return visit to Scotland in 1817, when he found it 'most remarkable as a volume of history. It is the land of tradition & of poetry. Every district has some scene in it of real or fictitious events treasured with a sort of religious care in the minds of the inhabitants.'[2]

In 1814 Wilkie had exhibited two impressive upright compositions at the Royal Academy, *The Refusal, from Burns' Song of Duncan Gray* (Victoria and Albert Museum, London) and *The Letter of Introduction* [PL.137]. In both these paintings Wilkie's imagin-ative use of his exceptional powers of observation is seen at its best. While these com-positions appear at first glance to be straightforward and undemanding they are rich in intriguing detail, both in the witty and sentimental depiction of the figures and in

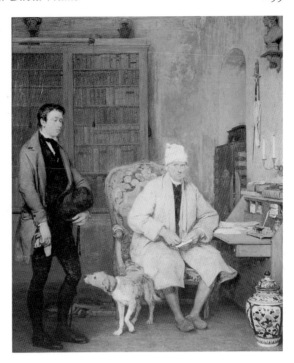

(137) Sir David Wilkie, *The Letter of Introduction* (RA 1814). Oil on panel; 61×50.2 cm. (National Gallery of Scotland, Edinburgh)

the convincing reality of their setting. The simple rural kitchen of *The Refusal* provides a sharp contrast with the informative contents and arrangement of the gentleman's study in *The Letter of Introduction*. This was inspired by the young Wilkie's own experience when, having just arrived in London, he presented a letter of introduction to the elderly diplomatist, wit and connoisseur, Caleb Whitefoord.

In 1814 Wilkie had visited Paris for the first time, and two years later he travelled in the Netherlands, taking the opportunity to visit the field of Waterloo. During both these journeys he made special studies of the work of Rubens, and that artist, and also Rembrandt, had a growing impact on his own painting and drawing. These influences are clearly seen in the culminating work of the first half of Wilkie's career, *The Chelsea Pensioners* [COL.PL.39]. This, the most famous of Wilkie's major paintings, was commissioned by the Duke of Wellington in 1816, but was not completed until 1822, when it was exhibited at the Royal Academy with the lengthy title 'Chelsea Pensioners receiving the London Gazette Extraordinary of Thursday, June 22d, 1815, announcing the Battle of Waterloo!!!', and with a detailed description of many of the figures also printed in the catalogue. The Duke had asked for a picture of old soldiers at a public house in Chelsea, and, to quote from the RA catalogue entry, 'the picture represents an assemblage of pensioners and soldiers in front of the Duke of York public-house, Royal Hospital-row, Chelsea. The light-horseman on the left has just arrived with the gazettes, and is relating further particulars to his comrades.' The setting and figures are wholly authentic, but the event portrayed is entirely imaginary and the result of gradual development with numerous sketches and drawings, which Wilkie described in his journal as 'sixteen months' constant work, besides months of study to collect and arrange'.

Fluently painted on panel, *The Chelsea Pensioners* displays all Wilkie's powers of depicting gesture, expression and character at their best, in a balanced and focused composition in which there are some sixty figures. It is certainly the masterpiece of the first half of the artist's career; on the one hand it is the summation of his work so far, on the other it is a signpost towards the achievements still to come. With its subtle combination of genre and history, and its effective narrative content it was a great popular success and at the exhibition a rail had to be erected to protect it from the throng. The thirty-seven-year-old David Wilkie was at the height of his powers and of his fame, and he was rapturously received in Edinburgh when he arrived in the city to witness George IV's spectacular State Visit in August 1822. However, the artist had much difficulty in selecting the subject of his proposed commemorative painting, until, spurred on by his appointment in 1823 to succeed Raeburn as King's Limner for Scotland, he chose a scene in which the King featured prominently, *The Entrance of George IV at Holyroodhouse* (Royal Collection, Holyroodhouse, Edinburgh). This somewhat pompous and Rubensian composition caused him great difficulties, and it was not completed until 1830.

To his concern about this painting were added great personal pressures, including the death of his mother and one of his brothers in 1824 and of another brother in the following year. All this was too much for the artist, who had already had several bouts of depression, and he suffered a major depressive breakdown in February 1825, which left him unable to work. In July of that year Wilkie began three years of convalescence and travel on the Continent, which took him to Paris, Florence, Parma, Rome, Naples, Dresden, Munich, and then lastly to Spain, where he arrived late in 1827 and spent over six months before returning to London in the following summer. Though he did a certain amount of painting during his travels, he devoted most of his energy to studying the work of the old masters, including above all Titian and Correggio in Italy, and Velázquez and Murillo in Spain.

At the Royal Academy exhibition of 1829 Wilkie made a spectacular return; he showed eight paintings, four of them painted or begun in Rome, three in Spain, and one, the artist's first and highly successful formal full-length portrait, of *Thomas, 9th Earl of Kellie* (Fife Council, County Hall, Cupar) begun in 1824 and completed in 1828. All of these were executed in the bolder and more painterly style which had already been introduced in *The Chelsea Pensioners*. This was now enhanced and developed as the result of his studies while abroad, but the artist's new manner was greatly disliked by most of the public and many critics.

George IV bought two of the Italian scenes, both inspired by Wilkie's observations during Holy Week in Rome; the small and effective *I Pifferari* [PL.139], showing a group of Calabrian shepherd pilgrims piping before a roadside shrine to the Madonna, and the slightly larger and more ambitious *A Roman Princess washing the Feet of Pilgrims*. The King also purchased the three Spanish pictures, including *The Guerilla's Departure*, for which he immediately commissioned a fourth as a companion piece, *The Guerilla's Return* (both Royal Collection). The largest and most powerful of the seven paintings is the vivid and fluent *The Defence of Saragossa* [PL.138]. This records a renowned act of heroism by the 'Maid of Saragossa', also celebrated by Byron in the first canto of *Childe Harold's Pilgrimage*, during the Spanish insurrection against the French in the summer of

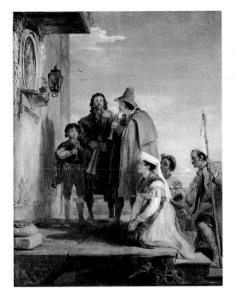

(138) Sir David Wilkie, *The Defence of Saragossa* (1828).
Oil on canvas; 94×141 cm. (The Royal Collection)

(139) Sir David Wilkie, *I Pifferari* (RA 1829). Oil on canvas;
46×36.2 cm. (The Royal Collection)

1808. Wilkie himself described the four paintings as 'a series illustrative of the late war',[3] but it is only in *The Defence of Saragossa* that he has really moved from genre to history painting, and has succeeded in presenting the latter with the same realism and conviction that he practised in the former. This move from the imaginary to the depiction of an historical event was a notable development in his career; however, none of his later history paintings achieved the powerful spontaneity of *The Defence of Saragossa*.

In 1830 Wilkie exhibited two further royal commissions at the Academy, both of which portrayed George IV, who was already in failing health and died late that June. Sir Thomas Lawrence had died in January, and the King immediately appointed Wilkie as his successor as Painter in Ordinary, though the monarch's wish that Wilkie should also succeed as President of the Royal Academy was rejected by the Academicians, who elected another, yet much lesser, portrait painter, Martin Archer Shee. As well as the long-delayed *The Entrance of George IV at Holyroodhouse*, Wilkie showed his full-length formal portrait of the King in the full Highland dress which he had worn during his State Visit to Edinburgh (Royal Collection, Holyroodhouse, Edinburgh), and for which the King gave him at least seven sittings. Largely lacking the compelling fluency and directness of the previous year's portrait of the Earl of Kellie, this much darker and stiffer painting was described by the artist as 'the most glazed and deepest-toned picture I have ever tried, or seen tried, in these times. It is at once a trial of Rembrandt all over, …' Unfortunately Wilkie's increasing use of bituminous paints and unreliable glazes has meant that the surface of many of his later works has cracked and darkened, as on this canvas.

In the last painful weeks of his life George IV, whose personal vanity never abated, sat again to Wilkie for a portrait in Garter robes, but this was not completed. His successor, William IV, confirmed Wilkie's appointment as Painter in Ordinary, and in 1832 the artist exhibited his State Portrait of the new King in Garter robes (Royal Collection), for which he had his first sitting, at Brighton, on 7 November 1831, and which was

completed in four months. This very traditional portrayal of the elderly new King was well received, and praised for its likeness, as was Wilkie's next formal but much more direct and less elaborate, portrayal of William IV, which was shown in 1833 and which the King gave to the Duke of Wellington, who hung it in Apsley House, where it still is. In the last years of his life Wilkie continued to paint a considerable number of court and private portraits, though, as we shall see, Queen Victoria did not approve of his portrayals of herself. It is probably because of this that Wilkie's achievements as a painter of portraits – more than 150 are recorded – have been largely neglected.

In 1832 Wilkie had also exhibited *The Preaching of Knox before the Lords of the Congregation, 10th June 1559* (Tate Gallery, London), a scene of Scottish history conceived under Walter Scott's influence in 1822, but only completed ten years later. When he selected the subject Wilkie visited the relevant sites in Edinburgh, and actually found the pulpit Knox had used. Like artists such as Alma-Tadema later in the century, Wilkie was convinced that accurate historical and archaeological knowledge would aid the effectiveness of a composition that had in its essence to be imaginary. This policy was the basis of the success of many of his subsequent history paintings, the most ambitious of which would have been the huge and unfinished *John Knox dispensing the Sacrament at Calder House* (National Gallery of Scotland, Edinburgh). Resembling a Protestant 'Last Supper', this was conceived as a companion piece to *The Preaching of Knox*, but the final version was only just started when the artist set out on his Near Eastern journey in 1840. One reason for deciding to develop this ambitious painting was the success of George Doo's exceptionally large engraving of the *Preaching of Knox*, published in 1838. The first engraving after one of Wilkie's genre paintings had been published as early as 1809, but it was not until the later 1820s that the reproductive engravings of the artist's most popular genre and history compositions met with real commercial success and added considerably to his fame and popularity in Britain and abroad. Of all these engravings the most successful were those after Wilkie's earlier domestic scenes, such as *Village Politicians* and *The Penny Wedding*, James Stewart's engraving of which was not published until 1832.

In addition to his major historical compositions and portraits Wilkie was continuing to paint and exhibit the smaller and more intimate works for which he is best known today. One of the most attractive of these is certainly the charming *The First Ear-Ring* [COL.PL.41], exhibited at the RA in 1835. This was painted for the Duke of Bedford, but was later acquired by Robert Vernon and formed part of his gift to the nation in 1847. The pensive mother, the anxious child, the intent nurse and the bored lap-dog, all help to make this simple and vividly painted composition one of Wilkie's most successful studies of character and mood. He was working on it at the same time as he was painting the much larger *Columbus in the Convent of La Rabida* (North Carolina Museum of Art, Raleigh), also shown in 1835 and the artist's most ambitious work on a Spanish theme. Vernon had seen this on Wilkie's easel and wished to buy it, but could not do so as it had been commissioned by another collector. However, Wilkie agreed to paint another equally important work for Robert Vernon, and after his visit to Ireland in the late summer of 1835 he suggested an Irish subject, *The Peep-o'-Day Boys' Cabin, in the West of Ireland* [PL.140], which was completed by February 1836 and shown at the Academy two months later.

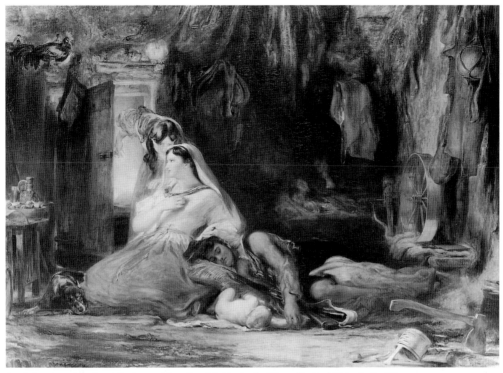

(140) Sir David Wilkie, *The Peep-o'-Day Boys' Cabin, in the West of Ireland* (RA 1836). Oil on canvas; 125.7×175.3 cm. (Tate Gallery, London)

Soon after his return from Ireland Wilkie had written to Vernon, 'Being greatly impressed, in my late journey to the recesses of Ireland, with the fitness and novelty of Irish scenes for representation, I wish to get one done for the next Exhibition.'[4] Wilkie had been much moved by the range of picturesque subjects to be found in western Ireland, and felt that he had rediscovered there something of the inspiration he had previously gained in Spain. In addition he was aware of growing public interest in the political affairs of Ireland, and his evocative yet very simple composition was designed to satisfy this. The Peep-o'-Day Boys were a secret and lawless band of Irish Protestants, active from about 1785 to 1795 in avenging the Protestant peasantry against the Catholics, whose villages they raided at dawn – hence their name. Wilkie shows a member of the band asleep on the floor of his humble home watched over by his wife, who is anxiously listening to 'tidings of alarm' brought by a girl still in the doorway; it is an entirely straightforward composition, fluently painted, but not really immediately evocative of its specific subject, though the *Times* critic praised it as 'a picture of true and astounding interest'. Wilkie's only other Irish picture, *The Irish Whiskey Still* (National Gallery of Scotland, Edinburgh), was shown in 1840 and was an even less specifically localised scene, which had, in any case, been preceded by a painting of *The Scottish Whisky Still* (Private Collection) some twenty years earlier. Despite the strong impression that his visit to Ireland had made on him, and his delight at discovering a rich and untapped source of subject matter, Wilkie never really got to grips with this new material. The inspiration he had found in Italy evaporated after only a handful of pic-

tures; with Ireland he hardly got started; and it was only Spain, in addition, of course, to his own Scotland, which supplied him with a longer-lasting source of material.

Meanwhile William IV, who commissioned only portraits from Wilkie, died in 1837, having conferred a knighthood on the artist in the previous year. Soon after her accession the young Queen Victoria confirmed Wilkie in his office as Principal Painter in Ordinary, and she gave him what was supposed to be a first sitting, of an hour, for her State Portrait, at Brighton in October 1837. However, the Queen had apparently heard of a sketch that Wilkie had made of her First Council, held at Kensington Palace a few hours after her accession on 20 June, and, as Wilkie himself recorded, she 'commanded a picture of her first Council, and has been telling me who to put in it'. Wilkie sent to London for a canvas and immediately set to work to paint in the Queen's figure from the sketch he had made at the first sitting, so that it would be ready to work on at the next sitting. The progress of the picture, which was expected to be ready for exhibition at the next Academy, and thus took precedence over everything else, has been recorded in detail, and by mid-February Wilkie had had sittings from most of the principal figures. *The First Council of Queen Victoria* (Royal Collection) was ready in time for the 1838 exhibition, but the Queen disliked it, and some years later went so far as to describe it in her diary as 'one of the worst pictures I have ever seen, both as to painting and likenesses'. On the actual occasion the Queen naturally wore black, but Wilkie had chosen to portray her in a white dress, and she appears almost as wooden as most of the other figures in this totally static composition, which was well below the standard normally achieved by Wilkie. The State Portrait of the Queen in Parliamentary robes was shown at the Royal Academy in 1840, but was also rejected by the Queen and is now in the Lady Lever Art Gallery, Port Sunlight.

His failures with these important Royal commissions bore heavily on Wilkie, who was also at work on what proved to be his grandest and most ambitious history painting, *Sir David Baird discovering the Body of Sultaun Tippoo Saib* (National Gallery of Scotland, Edinburgh), which had been commissioned by Lady Baird in 1834 as part of her campaign to boost the reputation of her late husband, who had died in 1829. The General's siege and capture of Seringapataam and the death of the rebellious Tippoo Sahib had taken place as long ago as 1799, and quickly became a popular theme for writers and artists, but by the time Wilkie tackled the subject its romantic appeal had faded into the background, and his over-grandiose Rembrandtesque portrayal of the event met with scant approval. However, some of the many sketches and studies that Wilkie made for this composition are among his most impressive drawings. The painting was one of five that he showed at the Academy in 1839; three of the others were portraits, but there was also the charming but sentimental *Grace before Meat* [PL.141], a composition in Wilkie's early and always most popular manner, developed from the group in the left background of *The Penny Wedding* of 1819.

In 1840 Wilkie was again unwell, and as well as wishing to travel in warm climes for his health's sake he felt the urge to find new inspiration and material. In August he set out for the Holy Land, and having spent some time in Constantinople he reached Jerusalem in February 1841. 'My object in this voyage,' he wrote to his nephew, 'was to see what has formed the scenes of so many pictures – the scenes of so many subjects painted from Scripture, but which had never been seen by the painters who have

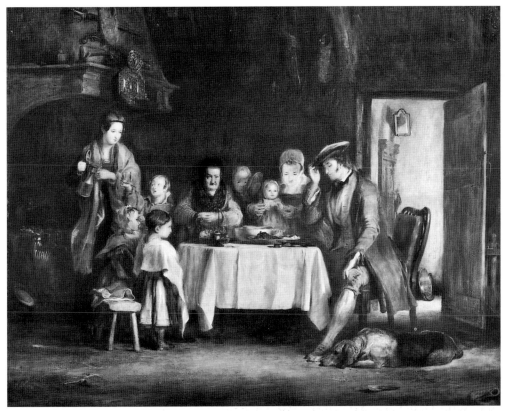

(141) Sir David Wilkie, *Grace before Meat* (RA 1839). Oil on canvas; 100×127 cm.
(Birmingham Museums and Art Gallery)

delineated them.' Wilkie had already attempted one or two Biblical subjects, but his plan to make these a major element of his further artistic development was cut short by his sudden death at sea near Gibraltar on 1 June 1841, an event so movingly commemorated by his friend and occasional rival, J.M.W.Turner, in *Peace – Burial at Sea* (Tate Gallery, London), shown at the RA in 1842.

At that exhibition Wilkie was himself represented by a small group of the beautiful studies which he had made on his journey, many of which were in watercolours and bodycolours, much more vividly applied than in any of his earlier drawings. The majority of the Near Eastern drawings are large portrait and figure studies, usually concentrating on details of costume, as in the striking *Portrait of Sotiri, Dragoman of Mr Colquhoun* [COL.PL.42], though this also has a view of the suburbs of Constantinople in the background. The quality of this drawing and of the many other surviving studies which Wilkie made on this final journey, make it certain that he had found new inspiration and that his art would have taken yet another significant step forward, though perhaps, to judge from previous episodes in his artistic development, only for a relatively brief period. There were many ups and downs in Wilkie's busy career, and his work is marked by numerous changes and considerable variety. The lack of that continuity which was such a feature with many nineteenth-century British artists, as for instance Etty and Landseer, baffled his patrons and his public, and has bedevilled

his reputation. However, George IV, second only to Charles I as England's most distinguished royal collector and patron, was certainly right in singling Wilkie out as one of his favourite artists, and thus made up to some extent for his blindness towards the work of Constable and Turner.

20 Benjamin Robert Haydon (1786–1846) and Sir George Hayter (1792–1871)

B.R.Haydon has become well known as one of the great failures among British artists of the first half of the nineteenth century, especially as he recorded his misfortunes and disappointments so poignantly in his lengthy diary, first published in 1853.[5] Born in Plymouth, the son of a bookseller, he came to London in 1804, determined to re-establish a school of historical painting in Britain, with himself as its leader; on his way to the capital he 'thought only of LONDON – Sir Joshua – Drawing – Dissection – and High Art'. He entered the Royal Academy Schools, where he was taught by Fuseli and lectured to by Opie. He was much influenced by the anatomical teaching of Charles Bell and was overwhelmed with enthusiasm and admiration when he first saw the Elgin Marbles, in the company of Wilkie, who became one of his closest friends.

These great Parthenon sculptures were first put on public view in London in 1807, and quickly had a strong influence on many of the artists who saw them, especially on those who, like Haydon, painted in the grand manner. Haydon was one of the earliest enthusiasts for the Elgin Marbles, and he was also one of the first artists to practise and encourage emulation of the Raphael Cartoons in the Royal Collection. In the early years of the century these could be seen by students at Hampton Court, and between 1816 and 1819 they were available for copying at the British Institution galleries, where Haydon took his own pupils, among them Edwin Landseer, to make large-scale copies in 1817. Haydon's enthusiasm and hard work were more than matched by his vanity, despite which, however, he succeeded in making many influential friends and winning important patrons, including Lord Mulgrave and Sir George Beaumont, who were both impressed by Haydon's first exhibit at the Royal Academy in 1807, *Joseph and Mary resting on the Road to Egypt*.

His next exhibit was the even larger *Assassination of Dentatus*, commissioned by Lord Mulgrave in 1808, an ambitious composition strongly influenced by Haydon's studies of the Elgin Marbles (Lord Normanby, Mulgrave Castle). Badly hung at the Academy in 1809, but awarded a premium of 100 guineas by the British Institution in the following year, the painting was not the overwhelming success – 'an epoch in English art' – that Haydon had expected, and its poor reception marks the beginning of the artist's constant bewailing of the failures of his career. Haydon quarrelled with the Royal Academy, to which he was never elected, and where he did not exhibit again until 1826. The commission for Sir George Beaumont also caused dissension, for after beginning a composition that his patron thought too small the artist perversely insisted on painting the *Macbeth* on much too large a scale. After long delay the Baronet accepted it only with great reluctance, and it is now lost.

Haydon continued to produce enormous compositions, often of biblical subjects,

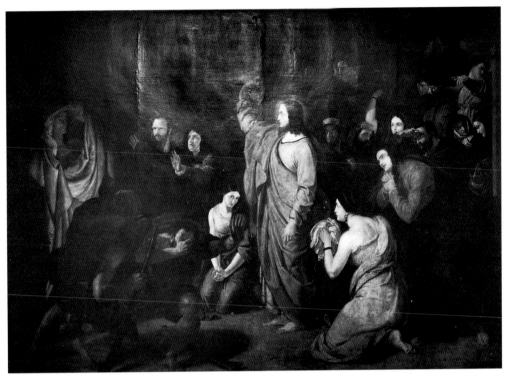

(142) Benjamin Robert Haydon, *The Raising of Lazarus* (1821–3). Oil on canvas; 426×623 cm.
(Tate Gallery, London)

most notably the vast *Christ's Entry into Jerusalem*, now in Ohio. Though often praised
and well received, they never gained him the recognition he expected as his due, and
those that survive have very limited merit. This is clearly shown by the Tate Gallery's
The Raising of Lazarus [PL.142], a sentimental and lifeless composition painted on
another huge canvas and originally shown at William Bullock's Egyptian Hall in
Piccadilly in 1823. After praying for the success of his exhibition, Haydon recorded
in his Diary on 1 March, 'The private day was to-day, & the success complete and
glorious.... The approbation was universal, and Lazarus affected every body, high, low,
& learned'; and on the following day, 'No Picture was ever so universally praised – (of
mine).'[6] The exhibition was closed when Haydon was imprisoned for debt on 22 May,
and the picture was seized and then sold for £350 to Edward Binns, the artist's up-
holsterer, who at the same time also bought *Christ's Entry into Jerusalem* for £240. This
had been shown at the Egyptian Hall with considerable success in 1820, at the same
time as Géricault's *Raft of the Medusa* was being exhibited in another room. Such ex-
hibitions in London and provincial cities of individual paintings on a large scale were
becoming increasingly popular and profitable, especially when the exhibition was
designed as an advertisement for an engraving of the work shown, though few of
Haydon's huge compositions were engraved. Haydon overdid these exhibitions, and
the total failure of the Egyptian Hall showing of some of his latest canvases, including
The Banishment of Aristides and *Nero playing on the Lyre*, now both in Australia, in April
1846, caused him great anguish. While Haydon's paintings attracted barely any visitors,

the farewell appearance in the room opposite of the famous midget General Tom Thumb drew large crowds, moving the artist to place the following advertisement in *The Times* on 21 April: '*Exquisite Feeling of the English People for High Art.* – GENERAL TOM THUMB last week received 12,000 people, who paid him £600; B.R.HAYDON, who has devoted forty-two years to elevate their taste, was honoured by the visits of 133 1/2 [the half was a little girl], producing £5 13 6.'[7] A few weeks later the demoralised artist shot himself in the head, but not fatally, and then ended his life by cutting his throat.

There were, however, real successes in Haydon's long history of disappoinment, and one of the greatest of these was certainly the purchase by George IV in 1828 for 500 guineas of *The Mock Election* [COL.PL.40]. The subject of this crowded and lively scene had been inspired by such an event witnessed by Haydon when again imprisoned for debt in the King's Bench Prison in the summer of 1827, and soon after his release he began work on the picture. The King was delighted with it, but declined to buy its sequel, *Chairing the Member* (Tate Gallery, London), which Haydon completed later in the same year. In 1829 Haydon painted *Punch, or May Day*, which was again rejected by the King, and is also in the Tate Gallery. This is certainly the artist's most popular painting today, and this trio of lively and imaginative narrative compositions, which were packed with symbolism but which Haydon thought of as 'burlesque', stand out as far more acceptable than his huge and grandiose historical canvases. On the one hand they continue the tradition of Hogarth, and on the other they belong to the revival of narrative painting initiated by Haydon's close friend, David Wilkie.

Haydon was constantly short of money, and throughout these years he reluctantly painted portraits to augment his income. In 1829, in another effort to make money, Haydon painted his first picture featuring Napoleon, who had died eight years earlier and for whom he had tremendous admiration. From then on he produced over thirty portrayals of the Emperor, many of them entitled *Napoleon musing at St Helena*, and showing him with folded arms standing on a cliff-top and staring out to sea. On occasions this composition was paired with a portrayal of *Wellington musing on the Field of Waterloo*, and in 1844 such a pair was purchased by the Duke of Devonshire for £25 each, and they are still at Chatsworth. Haydon's most notable portrait is the moving *Wordsworth on Helvellyn* [PL.143], which he painted in 1842 to commemorate the poet composing his sonnet on Haydon's picture of *Wellington musing on the Battlefield of Waterloo*, which he actually did while climbing Helvellyn, the third-highest mountain in the Lake District – no mean feat for a man of seventy. Haydon had drawn his first portrait of Wordsworth in 1815, and he remained on friendly terms with the poet, whom he greatly admired. The painter was much moved by Wordsworth's sonnet, en-titled 'By Art's bold privilege', and was determined to produce a poetical and romantic portrait of his friend, and this he has certainly succeeded in doing. In a letter to Haydon, Wordsworth wrote of it as 'the best likeness, that is the most characteristic, that has been done of me'.

But it was still history painting in the Grand Manner that was Haydon's main concern, and shortly before painting the Wordsworth portrait he had resumed work on another of his vast canvases, the dramatic and slightly comical *Marcus Curtius leaping into the Gulf* [PL.144], which was shown at the British Institution in 1843. Haydon has depicted the self-sacrificial action of the noble young Roman soldier at almost life-size,

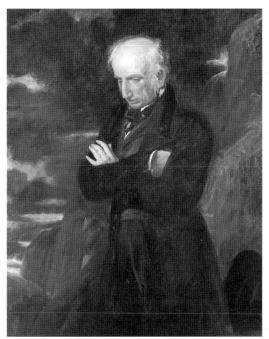

(143) Benjamin Robert Haydon, *Wordsworth on Helvellyn* (1842). Oil on canvas; 124.5×99.1 cm. (National Portrait Gallery, London)

(144) Benjamin Robert Haydon, *Marcus Curtius leaping into the Gulf* (BI 1843). Oil on canvas; 305×213 cm. (Royal Albert Memorial Museum, Exeter)

once again using his own head as the model for the hero, at whom the viewer looks up as if standing in the chasm. Though Haydon used himself as a model on a number of occasions, his painting was on the whole totally impersonal, and did not reflect the enormous stresses and strains of his own life. The expression of personal mood which can be found in the work of Constable and Turner, and above all Blake, rarely applied to lesser British artists of this period, and its lack certainly helps to account for the weaknesses in the art of men such as Haydon. However, the powerfully romantic composition that Haydon achieved in *Marcus Curtius* drew much attention from the public, critics and caricaturists, and the painting was sold just in time to save Haydon from yet another financial crisis.

Only a few weeks later Haydon was hopeful of further success when he submitted two cartoons for the competition for the decoration of the new Palace of Westminster, directed by his former pupil, Charles Eastlake.[8] To Haydon this competition, in which the entries were submitted anonymously, seemed at last to be an answer to his constant battle for the proper recognition of English 'High Art' – 'so fiercely fought for by me', and he was distraught when he did not win one of the twenty-one prizes that were ultimately awarded. Once again he was sure that he had been deliberately slighted, but when he visited the exhibition of 140 cartoons in Westminster Hall, he declared some of them 'equal to any School', though he denounced the foreign characteristics of some of the prize-winning drawings. Even in the will that he drafted as he was preparing to kill himself in his painting room nearly three years later Haydon declared that

he was 'nearly £3000 in debt from renewed claims, and from my resolution to carry on High Art to the last gasp, till felt and acknowledged by the Nation'.[9] Ironically, Haydon's tragic death won him at last the sympathy and recognition which he had never gained in his lifetime, despite his constant efforts at self-advertisement. These included numerous pamphlets and lectures, and a considerable number of students trained in his own image. Today, while his 'High Art' is largely forgotten, his Diary is recognised as one of the most telling and informative documents of the world of art in England in the first half of the nineteenth century.

Sir George Hayter, a portrait painter who painted the occasional history or narrative piece rather than a history painter who reluctantly painted portraits, did not take part in the Palace of Westminster competition, though it had been expected that he would do so. At the time he was at the summit of his career, having succeeded Wilkie as Principal Painter in Ordinary to the Queen in 1841. The son of the miniaturist and teacher of perspective, Charles Hayter, George entered the Royal Academy Schools at an early age and served briefly in the Royal Navy, before starting his career as a successful miniature painter. In 1815 he was appointed Painter of Miniatures and Portraits to Princess Charlotte, won a premium at the British Institution for a religious painting, and set out for a long continental tour, spending nearly three years in Rome, where he was elected a member of the Academy of St Luke. On his return to England in 1818 he forsook miniature painting, and began to exhibit portraits and history paintings, including the ambitious neo-classical composition *Venus, supported by Iris, complaining to Mars* (Devonshire Collection, Chatsworth) at the RA in 1820. He established a successful portrait practice, and further made his mark with the huge canvas depicting *The Trial of Queen Caroline* [PL.145], which was exhibited in Mr Cauty's Great Rooms, Pall Mall, in 1823. Hayter had made drawings during the so-called 'trial' in the House of Lords in November 1820, and received the commission to paint this dramatic scene for a fee of 2000 guineas from the young Whig MP George Agar Ellis (later 1st Baron Dover), who was to become a leading figure of the art establishment before his early death in 1833.

Agar himself nominated many of the sitters; the composition includes nearly 300 figures, and the artist had sittings from 161 of them. The painting is certainly one of the most successful of such ambitious records of contemporary political and legal history, which were much in vogue in the years just before the invention of photography. Hayter's picture took two and a half years to paint, and though the Queen had died (only two weeks after the resplendent Coronation in 1821 which she was not allowed to attend) and memories of the 'trial' had faded, it was received with acclaim when publicly exhibited in London. In the following years Hayter spent much time abroad, in Italy and France, and though he had failed to gain election as an ARA in 1825 and never achieved this, he was elected to the Academies in Bologna, Florence and elsewhere, and in Paris he established a successful practice as a court and society portrait painter.

His position in England had been compromised by the irregularity of his private life, which came to a head with the suicide of his mistress, Louisa, in Florence in 1827. However, in 1831 Hayter returned to London having received a commission from his earlier patron Prince Leopold, now King of the Belgians, to paint a portrait of his sister's daughter, Princess Victoria, who had become heir-apparent to the British throne

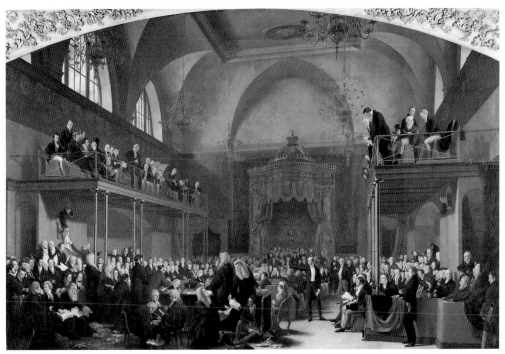

(145) Sir George Hayter, *The House of Lords, 1820: The Trial of Queen Caroline* (1823). Oil on canvas; 233×266 cm. (National Portrait Gallery, London)

on the accession of the childless William IV in 1830. The Princess gave many sittings to Hayter, and expressed approval of her portrait (Belgian Royal Collection) which was exhibited at the Royal Academy in 1833. Hayter now engaged in an active and persistent campaign to retain his Royal patronage, painting next a flamboyant full-length portrait of the Duchess of Kent (Royal Collection), which the sitter gave to her daughter as a birthday present in 1834. Hayter himself gave Princess Victoria drawings or etchings as birthday presents, and later the Queen and Prince Albert took lessons from him in etching.

Hayter's persistence proved highly successful; within a few weeks of her accession Queen Victoria appointed him her 'Painter of History and Portrait' and had sittings for the first of several official portraits (Guildhall Art Gallery, City of London). In the following year he was commissioned by the print publishers Hodgson & Graves to paint the Coronation ceremony and at the same time he was at work on his imposing State Portrait [PL.146], of which he also made several copies. *The Coronation of Queen Victoria* (Royal Collection) was greatly admired by the Queen and her Court, but, though it depicts one of the most stirring moments of the ceremony – the acclamation of the Monarch by the people – the ambitious composition appears somewhat wooden to modern eyes. Hayter's Royal patronage continued, and he was commissioned by the Queen to paint the ceremony of her marriage to Prince Albert, which took place in the Chapel Royal, St James's Palace, on 10 February 1840. That vast canvas (Royal Collection, Kensington Palace) took over two years to complete, and Hayter was paid a total of £1575 for it. While he was working on it and on other Royal pictures he was

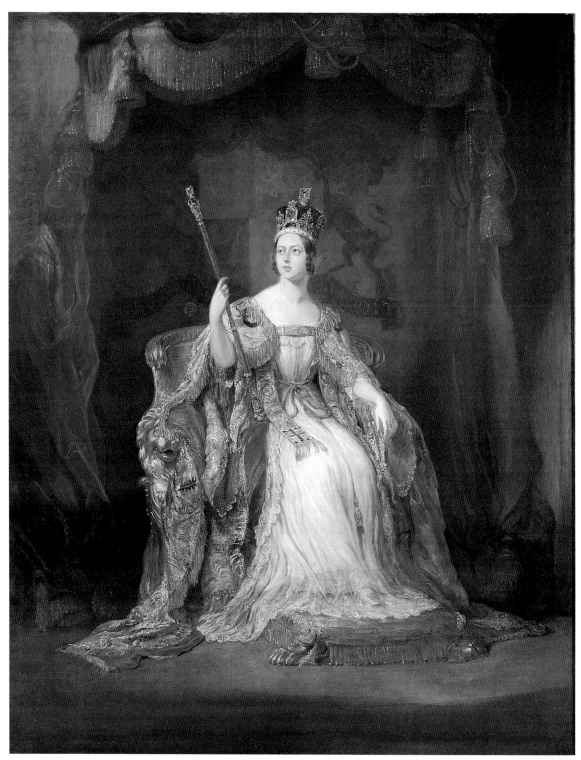

(146) Sir George Hayter, *State Portrait of Queen Victoria* (1838). Oil on canvas; 128×102.9cm. (The Royal Collection)

(147) Sir Francis Grant, *Sir James Brooke, Rajah of Sarawak* (1847). Oil on canvas; 143×111 cm. (National Portrait Gallery, London)

appointed Wilkie's successor as Principal Painter in Ordinary to the Queen, and he was knighted on 1 June 1842. However, the Queen's taste was now being reformed by Prince Albert, and Hayter received no new Royal commissions after 1842 and his career was virtually at an end. From now on it was the German portrait painter Franz Xaver Winterhalter (1805–73), already established as the favourite of European royalty, who received numerous commissions from Victoria and Albert. Winterhalter paid the first of many visits to England in 1842, and he was to paint several of the most successful and popular portraits of Queen Victoria and many members of her large family.

Sir Francis Grant, PRA (1803–78), was a member of a Scottish landed family destined for a career at the Bar, who combined his love of painting (he was self-taught) and fox-hunting by painting hunting scenes, and also established a reputation as a painter of portraits featuring the sitters with their horses and dogs in the tradition of Stubbs. In 1839 he was commissioned by the Queen to paint *Queen Victoria riding out* (Royal Collection), an attractive composition showing the Queen mounted on her strawberry roan Comus, with Lord Melbourne riding beside her. This was very well received when exhibited at the Academy in 1840, and Grant's career was assured. He was elected ARA in 1842, RA in 1850, and succeeded Eastlake as President in 1866. His formal full-length portrait of the Queen, exhibited in 1843 (Crown Estate), is one of the most skilful and perceptive of the many such images painted during the early years of her long reign. Francis Grant enjoyed widespread patronage from aristocratic and landed society, and was certainly the most talented of the many British portrait painters of the first half of the Queen's long reign. He successfully continued the tradition of Reynolds and Lawrence, and his ability to capture a likeness with painterly ease is typically displayed in his telling portrait of *Sir James Brooke, Rajah of Sarawak* [PL.147], painted in 1847 and

presented to the sitter by the artist. But Francis Grant was an exception, and this lively canvas and others by Grant stand out on the walls of the National Portrait Gallery among the many stiff and lifeless portraits of these years, a period when both British portrait and history painting were on the whole at a low ebb.

21 William Mulready, RA (1786–1863), Sir Charles Eastlake, PRA (1793–1865), William Dyce, RA (1806–64), and Daniel Maclise, RA (1806–70)

While it was an advantage to David Wilkie to be Scottish by birth, for Scotland was very much in fashion during his most active years, it was certainly a disadvantage in William Mulready's career that he was born in Ireland, which then shared none of the same romantic attractions. However, Mulready was only five years old when his family moved from Dublin to London. The young immigrant showed a precocious aptitude for drawing, and, encouraged by his artisan father, he entered the RA Schools at the early age of fourteen. In 1804, when he first exhibited at the Royal Academy, he was living with his teacher and brother-in-law, John Varley, whose sister he had married in 1803. He was one of the group of young artists under Varley's influence who were painting and drawing landscape on the River Thames and in the outskirts of London, often sketching in oils in the open. For some ten years Mulready painted and exhibited largely landscapes, many of them painted in the area of Kensington Gravel Pits, where he had moved by 1811 and remained for the rest of his life, and where several other artists, including Linnell and Callcott were also living.

The Mall, Kensington Gravel Pits [PL.148], which was painted in about 1811, is typical of Mulready's somewhat dark and old-fashioned townscapes and landscapes, which display several influences, notably that of the contemporary Norwich School and of the Dutch seventeenth-century landscape tradition. It is not surprising that after 1812 the artist gradually abandoned the painting of landscape and concentrated on domestic genre scenes and informal portraits, as Wilkie was also doing with such distinction during these years. This change quickly brought success and recognition to Mulready, whose 1815 RA exhibit, a schoolroom scene entitled *Idle Boys* (present location unknown), was especially well received by the critics. Mulready was elected ARA later that year, and, most unusually, RA very shortly thereafter, early in 1816, when he showed *The Fight Interrupted* (Victoria and Albert Museum, London), another composition featuring schoolboys, which was again much praised. The critic of the *New Monthly Magazine* pronounced it 'one of the very best pictures in the room' and declared that 'we prefer the representation of a fight of this sort, which is purely national, to all the pictures of Waterloo which we have yet seen'. It was such insular and jingoistic attitudes that led to the growing popularity of domestic genre scenes, of which Mulready was soon established as a leading exponent. His career was assured when George IV bought Mulready's 1820 RA exhibit, *The Wolf and the Lamb* (Royal Collection), another composition featuring schoolboys, for which he paid £210.

At this time Mulready was painting in a firm and hard manner using a dark palette, and 'mostly invented his own subjects, and sometimes without any great

(148) William Mulready, *The Mall, Kensington Gravel Pits* (c.1811). Oil on canvas; 35.3×48.5 cm. (Victoria and Albert Museum, London)

subject-matter in them', as the Redgrave brothers, who were great admirers, put it.[10] A typical painting in this vein is *The Village Buffoon* (Royal Academy), Mulready's Diploma Work, of which it is recounted that Wilkie was called upon to explain the subject to the RA Council, though how he interpreted this somewhat obscure scene is not recorded. However, both Mulready's subject matter and his technique were gradually changing in the later 1820s; his subjects became more sentimental and moralising, and his technique looser and more painterly, as did that of Wilkie after his return from his long continental tour in 1828. The most radical feature of Mulready's new painting style was the use of a white ground, which greatly enhanced the effect of the much brighter colours that he was now using. In addition he often used a stipple technique in applying these colours, which made them even stronger. The schoolboys were replaced by young lovers, as in *First Love* [PL.149], exhibited at the Royal Academy in 1840 and bought by John Sheepshanks. In this delightful composition there is much symbolic meaning and narrative content – the two dogs in the foreground, the gesticulating brother and mother in the background – and despite the meticulous detail the canvas is freely and fluently painted.

The best known of Mulready's numerous depictions of young love is certainly *The Sonnet* [COL.PL.44], shown in the preceding year and also acquired by John Sheepshanks, whose outstanding collection of 233 British paintings presented to the South Kensington Museum (later Victoria and Albert Museum) in 1857 as the nucleus of a 'National Gallery of British Art' included twenty-seven works by Mulready. A

(149) William Mulready, *First Love* (RA
1840). Oil on canvas; 76.9×61.7 cm.
(Victoria and Albert Museum,
London)

remarkable combination of the 'Grand Style' and literary narrative, this tiny panel
painting understandably reminded one critic of the day of 'the magnificent genius of
Michelangelo in the Sistine Chapel'.[11] There is something of an echo of Michelangelo's
Sistine figures, though Mulready could not have seen these in the original, for he never
visited Italy. One of Mulready's great strengths lay in the high quality of his draughts-
manship, ranging from small and rapid pen-and-ink sketches for many of his paintings
to highly finished academic studies of both male and female nude models. The latter
were also drawn from life, often at the RA life school, where, like Etty, Mulready was
a frequent visitor, especially in the last years of his life. The strength of the artist's
drawing was certainly a vital element of his art, as demonstrated in another of Mul-
ready's masterly paintings of the 1840s, *Choosing the Wedding Gown* [PL.150], shown
at the Royal Academy in 1846 and also bought by Sheepshanks, who paid 1000 guineas
for it.

Illustrating lines from the opening sentences of Oliver Goldsmith's novel *The Vicar
of Wakefield*, the composition is packed with detail exquisitely drawn and painted in
the bright colours that Mulready had by now made his own. The painting caught the
attention of John Ruskin, who devoted one of his most laudatory and exaggerated
passages to it in the Addenda to the second edition of Volume II of *Modern Painters*,
published in 1848. Writing of the spaniel in the foreground he claimed that it 'displays
… assuredly the most perfect unity of drawing and colour, which the entire range of
ancient and modern art can exhibit. Albert Dürer is indeed the only rival who might

(150) William Mulready, *Choosing the Wedding Gown* (RA 1846). Oil on panel; 52.9×44.7 cm. (Victoria and Albert Museum, London)

be suggested; and, though greater far in imagination, and equal in draughtsmanship, Albert Dürer was less true and less delicate in hue.'[12]

That an artist such as Mulready could be seriously compared by critics with Michelangelo and Dürer provides some indication of how anxious lovers of art at this time were to re-establish the reputation of British artists, an anxiety also reflected in the chauvinistic collecting of Robert Vernon, John Sheepshanks and others. This support for contemporary 'native' art rather than the collecting of old masters was something that Hogarth had fought for without great success in the previous century, but it became a reality during the reign of George IV, who himself did much to encourage it as did Queen Victoria and Prince Albert later in the nineteenth century. It remained an important factor in the progress of British painting throughout the Victorian era. A vital element in this development was the broadening of patronage and collecting, in which the professional and commercial middle classes became increasingly interested. John Sheepshanks and Robert Vernon are outstanding examples of this 'new' class of major collector, and their taste was succinctly identified by Richard Redgrave in the Introduction to his *Catalogue of the National Gallery of British Art at South Kensington* (New Edition, 1884):

> Art in England has flourished from the demands of those who love it as a home delight; therefore our pictures are small, and suited to our private residences, while the subjects are those we can live by and love; and hence, they have been largely illustrative of the feelings and affections of our kind, and of the beautiful nature of which we desire to be reminded as a solace in the moments of rest from hard labour of daily life; … The present [Sheepshanks] collection consists of pictures of cabinet proportions, illustrative of every-day life and manners amongst us, appealing to every man's observation of nature and to our best feelings and affections, without rising to what is known as historic art: as such, they are works that *all* can understand and all more or less appreciate.

It should be noted that Robert Vernon, who declined Sheepshanks's suggestion that they should make a joint gift of their two collections to the nation, was half a generation ahead of his fellow collector, and that there are a considerable number of quite large paintings in his gift. This was made in 1847 to the National Gallery, a somewhat 'aristocratic' institution founded in 1824, while ten years later Sheepshanks chose the quite new and more 'democratic' South Kensington Museum, which had grown out of the Great Exhibition of 1851, and was re-launched at South Kensington in 1857 under the aegis of Prince Albert. The Vernon Collection includes four important paintings by Mulready, among them the ever-popular *The Last In* of 1835, and as we have already seen several of the favourites in the Sheepshanks Collection are by Mulready. Mulready was admired by his fellow artists, and was held in high esteem as a hard-working and technically brilliant painter, whose innovative methods were certainly influential in the development of many of his much younger contemporaries, including, as we shall see, some of the Pre-Raphaelites. It is that influence that has revived interest in him in recent decades, for though his essentially 'minor' genre painting brought him success throughout his long career, his work had been largely forgotten in the twentieth century.

As with many nineteenth-century British artists Mulready's reputation was much enhanced by engravings after his paintings and by his work as an illustrator. Two some-

what older contemporaries, Thomas Stothard, RA (1755–1834), and Richard Westall, RA (1765–1836), were among the most prolific illustrators of their day, as well as being regular exhibitors at the Royal Academy, of which they were both elected Members in 1794. These artists produced innumerable more or less romantic historical and literary compositions in a style in which the influence of Rubens and Titian was crossed with neo-classicism. Again they are almost totally forgotten today, but their long and successful careers provide further evidence of the basically conservative taste of the majority of patrons and critics in later Georgian England.

One of the artists who was to re-shape that taste was Sir Charles Lock Eastlake, PRA, though the Redgrave brothers are absolutely correct in referring to him as one of 'a few exceptional painters who have served the art they loved better by their lives than by their brush'.[13] While Eastlake's place in the history of British art lies largely in his exceptional abilities and activities as an administrator – among his many offices were those of Secretary of the Fine Arts Commission, Commissioner for the Great Exhibition, President of the Royal Academy, and Director of the National Gallery – Eastlake in the first half of his career established a considerable reputation as one of the leading painters of his day. Born in Plymouth, the son of a lawyer, he had his first drawing lessons from Samuel Prout, and after only a few months at school at Charterhouse, during which he met another Devonshire-born artist, Benjamin Haydon, he wrote to his father, 'In the first place it is necessary to inform you that my profession is unalterably fixed – it is that of an historical painter.'[14] He was allowed to leave school, and in January 1809 Eastlake became Haydon's first pupil and gained entry to the Academy Schools a few weeks later. Taught by Fuseli, befriended by Turner, and determined to learn to draw, the young Eastlake made rapid progress, and gained the patronage of Jeremiah Harman, a leading London banker and collector and the original English purchaser of the great Orleans Collection.

Eastlake was fascinated by Napoleon and actually saw him several times when the vanquished Emperor was a captive on board the *Bellerophon* moored in Plymouth Sound during the summer of 1815. His life-size painting of *Napoleon on Board the Bellerophon* (National Maritime Museum, Greenwich) caused a considerable stir, was bought by five Plymouth gentlemen for 1000 guineas and was then exhibited with great success in London in the summer of 1816. Later that year Eastlake set off for Rome, where he found stimulating company among artists and scholars of many nationalities. He visited Naples and southern Italy, and in 1818 he and three companions, including the future architect (Sir) Charles Barry, toured in Greece and the Greek islands. During these years he made numerous landscape studies in and around Rome and began to paint genre pictures featuring brigands, initiating a vogue among British artists and collectors for paintings of contemporary Italian peasant life which was to remain popular for the next two decades. Eastlake went back to England after the death of his father in December 1820, but returned to Rome a few months later, and the Eternal City was to remain his base until 1830.

On his journey back to Rome he wrote to Harman that he preferred 'the retirement, the quiet, and the cheapness of Rome', where he would work towards 'a union of History and Landscape'.[15] Eastlake soon became a leading figure among the British artists in Rome, who were endeavouring to form a 'British Academy of Arts in Rome',

which was never properly established on a firm footing, as was, for instance, the French Academy, and had a chequered existence between 1823 and 1936.[16] Though the Royal Academy gave its fledgeling Rome 'sister institution' some financial support, it prevented its full development by refusing to change its own rules which banned artists who lived abroad as well as those who were members of another art institution from full membership of the Royal Academy. The ambitious young Eastlake began to send paintings to London to the exhibitions at the British Institution and the Royal Academy, showing his first peasant and banditti pictures, which were very well received, at the former in 1823, and *A Girl of Albano leading a Blind Woman to Mass* (Private Collection) at the Academy in 1825.

But Eastlake also produced much more ambitious historical compositions such as the powerful *The Champion* (Birmingham Museums and Art Gallery) shown at the British Institution in 1824, and *The Spartan Isidas*, painted for the Duke of Devonshire and still at Chatsworth. This large and Poussinesque scene from Roman history was much admired when shown in Eastlake's Rome studio late in 1825, and also when at the RA in 1827. Etty sent his congratulations and put Eastlake's name on the list of candidates for election as Associates of the Royal Academy. On 5 November he became the first ARA ever elected *in absentia*, but in the following year the artist was quite briefly in London, where he was able to see the Summer Exhibition in which the first version of his most successful and popular Italian genre picture, *Italian Scene in the Anno Santo, Pilgrims arriving in Sight of Rome and St Peter's: Evening* [PL.151], was receiving great praise, while the artist himself was being almost lionised in the capital. However, Eastlake soon set out again for Italy, travelling through Flanders, Holland and Germany, where he visited many churches and public and private collections, making, apparently for the first time, 'that careful examination of pictures, accompanied with copious notes', which was to be the basis of his profound and scholarly knowledge of European painting. It has been suggested that it was his contact with some of the German artists and scholars resident in Rome which aroused his interest in the relatively new discipline of art history. He continued such studies on his return to Italy, but also continued to paint and to be a leading figure among the artists in Rome, where Turner shared his studio for a time during a four-month stay from October 1828.

Eastlake's 1829 Royal Academy exhibit, *Lord Byron's Dream* (Tate Gallery, London), was based on studies made during the artist's travels in Greece ten years earlier. Eastlake had been deeply disappointed not to be elected RA in February 1829, when Constable was at last elected, but he was successful a year later at the first election during the Presidency of Sir Martin Archer Shee, who had succeeded Lawrence. Eastlake realised that the time had come to leave Rome for good; he did so somewhat reluctantly in July, and, after two months in Venice, where he occupied Byron's old apartments in the Palazzo Mocenigo, he arrived in London in November. During his final months in Rome he had worked on his Diploma picture, *Hagar and Ishmael* (Royal Academy, London), a rather empty and sentimental composition which he never exhibited. However, having found a house and studio in Fitzroy Square, the artist settled down to take advantage of his considerable reputation. One unusual aspect of his success was a Drury Lane production in November 1829 of J. R. Planche's romantic drama *The Brigand*, with settings based on mezzotint engravings after compositions

(151) Sir Charles Eastlake, *Italian Scene in the Anno Santo, Pilgrims Arriving in Sight of Rome and St Peter's:*
Evening (RA 1828). Oil on canvas; 82×105.5 cm. (The Duke of Bedford, Woburn Abbey)

by Eastlake.[17] The next decade saw the steady production of Italian and Greek genre scenes, such as *A Peasant Woman fainting from the Bite of a Serpent* [PL.152], painted for John Sheepshanks and exhibited at the RA in 1831. Though ostensibly a modest and undemanding composition, the poses of the two principal figures are based on precedents by Raphael and Giulio Romano, thus bringing this and other similar works in line with the advice given by Reynolds in his *Discourses*.

Eastlake also painted several biblical subjects which were equally well received, among them the attractive but rather static *Christ blessing little Children* (City Art Gallery, Manchester), which was much admired by Thackeray when shown at the Royal Academy in 1839. Gradually more and more of Eastlake's time and energy were devoted to the politics of art in London, and to his own art historical studies, collecting and writing. His first major publication, in 1840, was an influential translation of Goethe's *Farbenlehre* (1810) with the title *Theory of Colours*. In 1841 Eastlake was appointed Secretary of the newly formed Fine Arts Commission, set up by Sir Robert Peel under the Chairmanship of Prince Albert to investigate 'whether the Construction of the New Houses of Parliament can be taken advantage of for the encouragement of British Art.' The activities of this Commission will be the subject of the next chapter. A close working relationship and friendship quickly grew up between Eastlake and the young Prince Albert, who was also attracted by the new discipline of art history, and was a knowledgeable collector and something of a scholar, as seen in his pioneering

(152) Sir Charles Eastlake, *A Peasant Woman
 fainting from the Bite of a Serpent*
 (RA 1831). Oil on canvas; 56×47.6cm.
 (Victoria and Albert Museum,
 London)

work in putting into order the important group of Raphael drawings in the Royal
Collection.

As well as his privileged position at Court, Eastlake increasingly enjoyed a
uniquely powerful position in the British art establishment of the day. At the National
Gallery he was Keeper from 1843 to 1847, a Trustee from 1850 to 1855, and finally the
first Director from 1855 until his death in 1865; during those ten years the collections
grew more significantly, mostly by purchase, than at any other time in the gallery's
distinguished history. At the Royal Academy he was Librarian from 1842 to 1844, and
succeeded Sir Martin Archer Shee as President in 1850. He was the first President of the
new Photographic Society founded in 1853, and was a member of numerous com-
mittees, including that concerned with the showing of art at the Great Exhibition.
In 1849 he married Elizabeth Rigby (1809–93), sixteen years his junior, and already
an established traveller and author, whom he had met at a dinner party given by
their mutual publisher, John Murray. They were a formidable and popular couple, and
formed an ideal partnership in Eastlake's continuing labours for the world of art, which
included frequent journeys to Italy and elsewhere on the Continent on the hunt for
paintings for the National Gallery. Eastlake died at Pisa on one of these journeys. At
a time when most of the figures in the British art world were essentially insular and
parochial in their outlook, Eastlake stood out as an international personality thinking
and working on international lines. This greatly helped him in his brilliant work for
the National Gallery, but it was not to be such an advantage in his dealings with
living British artists, especially when it came to the decoration of the new Houses of
Parliament.

It is not surprising that all these activities severely interrupted Eastlake's work

as a painter, and indeed he exhibited at the Royal Academy for the last time in 1855, the year of his appointment as Director of the National Gallery. Just as it was unique for Eastlake to be elected an Associate while living abroad, it must be unique for a President not to have exhibited during his last ten years in office. However, several of the British artists who were with Eastlake in Rome in the 1820s – among them Thomas Uwins (1782–1857), Joseph Severn (1793–1879) and Penry Williams (1798–1885) – kept alive the tradition of showing Italian genre paintings in London, and these continued to be popular, but they were soon to give way in popularity to even more colourful scenes of modern life in the Near East.

In many ways William Dyce's career mirrored that of Eastlake, who was thirteen years his senior; however, as an artist the younger man was certainly more gifted, original and interesting. Born in Aberdeen, he studied medicine and theology at Marischal College, where his father was a lecturer in medicine, but was already determined on an artistic career, and began to paint portraits when he was only seventeen. He persuaded his father to allow him to go to London in 1825, where he was encouraged by Sir Thomas Lawrence, but spent only a few months at the RA Schools before setting off for Rome. Here he became a student at the newly established British Academy, and is said to have concentrated on the study of the work of Titian and Poussin, though that he should do so in Rome seems unlikely. It is not known whether he actually made contact with the German Nazarene artists during this visit, which lasted nine months, but judging by the surviving oil sketch for his first RA exhibit shown in 1827, *Bacchus nursed by the Nymphs of Nysa* (untraced), he was certainly painting in the shadows of Titian and Poussin at this time. Later that year Dyce set off again for Rome, and during this second visit of over a year he was in touch with the Nazarenes, a link that was gradually to have a lasting effect on his art. Eastlake, who was, of course, still in Rome at this time, was also influenced by the Nazarenes, if to a lesser extent, and he himself must have done much to guide and help the bright young Scottish vistor, who was to become one of his closest colleagues.

While the British artists who were in Rome in the post-Napoleonic decades never formed a coherent group or school, their German colleagues developed a school and a style, for which they were known, at first mockingly, as 'Die Nazarener'. They had a strong impact throughout Europe, and especially on some of the visiting British artists, Dyce foremost among them. Initially founded in Vienna in 1809 by Friedrich Overbeck and Franz Pforr, the group, dissatisfied with current academic training, drew inspiration from the earlier Flemish, German and Italian so-called 'primitives'. In 1810 the Brethren – they had called themselves *Lukasbruder* (Brotherhood of St Luke – the patron saint of painters) – moved to Rome and began working in the deserted monastery of Sant'Isidoro, where other young artists, including Peter von Cornelius, joined them. Several became Roman Catholics and much of their painting was of religious subjects, executed in a rather flat, naïve and hard-edged manner. They were also determined to revive the art of fresco painting, and received important commissions in Rome and Munich, which became a major centre of their art. While the Brethren as such had dispersed, several of their number remained in Rome, where Overbeck's studio was long a popular meeting-place for artists of many nationalities.

During his second stay in Rome Dyce discovered the Nazarenes and their art, but

when he returned to Aberdeen he resumed his practice as a portrait painter, and after two or three years moved his practice to Edinburgh. However, Dyce was also pursuing other interests: he wrote a number of historical and scientific essays, he developed his knowledge and practice of church music (he founded the Motet Society in 1844), and he became increasingly involved in questions of design and in the teaching of art, being appointed master of the Trustees' Academy, the principal art school in Edinburgh. As an artist he continued to be in demand for portraits, especially of women and children, painted a number of religious works and also developed his skills as a painter of landscape; however, little of note has survived from these early years.

In London, in the meantime, there was much debate concerning the current development and place of art and art institutions. Various committees and commissions were set up, one of which, under the chairmanship of the President of the Board of Trade, established the Government School of Design in 1837 and summoned William Dyce as its first head and subsequently Superintendent. The plan was to open such schools not only in London, at Somerset House, but also all over the country 'for the purpose of affording instruction to those engaged in the practice of ornamental Art, and in the preparation of Designs for the various Manufactures of this country'. It was far from clear what all this involved, and Dyce was sent off on a Continental tour to examine the State schools already established in Prussia, Bavaria and France. Dyce's rather indecisive report recommended the methods used in Germany, but during the next five years – he resigned in 1843 – the development of the schools was fraught with controversy and confusion, partially as the result of the artist's somewhat abrasive and intolerant manner.

All this administrative activity severely interrupted Dyce's painting, though he did continue to exhibit at the Royal Academy almost every year. In 1844 he showed *King Joash shooting 'the Arrow of Deliverance'* [PL.153] which was very well received and led to his election as ARA later in the year. This forceful and economical composition of two figures, illustrating a scene from the Book of Kings, marks the beginning of a succession of paintings of such biblical and religious subjects, which reflected Dyce's sincere beliefs and practice as a High Churchman, and provided a telling contrast with the genre subjects offered by many of his senior colleagues and so popular with collectors. However, Prince Albert proved to be a strong supporter of Dyce, and he acquired one of the artist's best works, the lovely *Madonna and Child* (Royal Collection) direct from the artist for only £80 in 1845, the year before it was shown at the Royal Academy. Succinctly described in her Journal by Queen Victoria as 'a most beautiful picture of the Madonna & Child, by Dyce, quite like an old Master, & in the style of Raphael – so chaste and exquisitely painted', it was hung in the Queen's bedroom at Osborne, the new Royal residence on the Isle of Wight, largely designed by Prince Albert and built between 1845 and 1848.

Prince Albert's close involvement in the decoration of the new Palace of Westminster and Dyce's contributions to this will be discussed in the next chapter. Dyce played an important part in the investigations into the use of fresco, and spent the winter of 1845/6 in Italy studying fresco techniques, on which he reported to the Fine Arts Commission on his return. To enable Dyce to demonstrate what he had learnt Prince Albert commissioned the large fresco of *Neptune resigning to Britannia the Empire*

(153) William Dyce, *King Joash shooting 'the Arrow of Deliverance'* (RA 1844). Oil on canvas; 76×89cm. (Kunsthalle, Hamburg)

of the Sea to decorate the staircase at Osborne. When this had been completed late in 1847, Prince Albert informed the artist that he and the Queen were 'very pleased with this beautiful work of Art'. The scheme for his fresco decoration of the Queen's Robing Room at Westminster, with scenes from the legend of King Arthur, which was to occupy Dyce for the rest of his life, was initiated during discussions while the artist was working at Osborne.

With all his other preoccupations, including his appointment as Professor of Fine Art at King's College, London, in 1844, Dyce, who was elected RA in 1848, had little time or energy left for easel paintings, but most of those that he did complete were remarkable for their high quality and sincerity. The first of three versions of a powerful and emotive composition of *Jacob and Rachel* was shown at the Royal Academy in 1850, the year of the artist's marriage, and the final version, now in Hamburg, was exhibited in 1853. This has an effective landscape background, and minutely painted landscape was to be a major feature of many of his later works, several of which were painted for pleasure while on holiday. Dyce had painted a number of landscapes during his Scottish years, and had also completed a series of very Boningtonian watercolours on the Continent in 1832. The landscapes of his later years were very different in manner, and many of them have a close affinity with the precise realism of the landscape painting of the Pre-Raphaelites, though Dyce did not paint them on the spot. Thus when he exhibited *Titian preparing to make his first Essay in Colouring* [COL.PL.62] at the Royal Academy in 1857 it was hailed by John Ruskin, whose attention had first been drawn

(154) William Dyce, *George Herbert at Bemerton* (RA 1861). Oil on canvas; 86.3×111.7cm.
(Guildhall Art Gallery, London)

to the Pre-Raphaelites by Dyce, in his *Academy Notes* as 'a notable picture in several ways, being, in the first place, the only one quite up to the high-water mark of Pre-Raphaelitism in the exhibition this year'. Ruskin went on to regret that Dyce had not 'coloured it better'.[18] Though somewhat sentimental and totally unrealistic, even in its meticulous and all-important landscape detail, much of which is typically English rather than Italian, the Titian painting is certainly the most attractive of all Dyce's works.

Another of Dyce's most successful canvases, *Pegwell Bay, Kent – a recollection of October 5th, 1858* (Tate Gallery, London), was painted with meticulous care, and geologists might well gain information from the details of the rocky beach and of the steep cliffs. Painted to commemorate the passing of Donati's Comet, which is just visible in the sky, and with members of the artist's family in the foreground, this stark composition was shown at the Royal Academy in 1860, when the *Art Journal*'s critic wrote that the foreground was painted 'with a truth equal to that of photography'. It is not known whether Dyce ever made use of photographs as an aid, but it is certainly a possibility and the comment draws attention to the growing influence of photography in the 1850s, which will be examined in Chapter 27. Dyce's final RA exhibit, shown in 1861 three years before his death, was the moving *George Herbert at Bemerton* [PL.154], which was painted during a visit to Bemerton in Wiltshire, where the seventeenth-

century divine and poet had been Rector in his last years and where the then incumbent, Cyril Page, was a friend of Dyce's. The spire of Salisbury Cathedral is seen in the distance beyond the meadows on the right, and the poet is shown reciting or communing with nature, most poignantly represented by the ancient ivy-clad trees. In the RA catalogue lines were quoted from the first biography of Herbert written by Izaak Walton, author of *The Compleat Angler*, and the fishing rod and creel by the tree remind us of this. *George Herbert at Bemerton* is full of fine detail and of symbolism, but it also makes an immediate and convincing impression, and it reflects something of Dyce's own complex character and beliefs. As a personality and a leader in the world of art Dyce was far surpassed by Eastlake, but Dyce was certainly the more significant artist, and a number of his paintings have claims to being the most worthwhile work by any British painter of the middle years of the nineteenth century.

With Daniel Maclise, who, like Mulready, was born in Ireland, we turn to an artist who was little concerned with the politics and administration of art, but who, like Dyce, was much involved in the Westminster decorations. In 1822 he became one of the first students at the new art school in his native Cork, and he soon started to make his name with his effective portrait drawings. In 1827 he arrived in London, joining the RA Schools in the following year, and continued to draw portraits – the best of which could be compared with Ingres – and also caricatures, especially from 1830 for *Fraser's Magazine*. At the Royal Academy he won the Gold Medal for history painting in 1831, and in the following years he regularly exhibited compositions of historical, literary and genre subjects, being elected ARA in 1835 and a full Academician five years later. At first his paintings were very eclectic, combining humour, charm and a lively imagination with his gifts as a draughtsman and his ability to create energetic compositions, often with romantic and chivalrous overtones, such as the two literary subjects dated 1838 – *A Scene from* Gil Blas and *A Scene from Midas* – bought by Queen Victoria in 1839 (both Royal Collection). Such works were painted with pleasure to give pleasure, and they rarely had a didactic or moralising purpose.

The Queen had no doubt seen Maclise's five impressive exhibits at the 1838 Academy exhibition, which included the exuberant and Rubensian life-size *The Wood Ranger with a Brace of Capercaillie* (Royal Academy, London), which he presented as his Diploma Work in 1840. Much more ambitious, but painted with equal felicity, was the huge and theatrical *Merry Christmas in the Baron's Hall* [COL.PL.45], which, though set in Jacobean times, combines elements of the romantic medieval with Victorian domesticity.

Maclise was a handsome, kindly and popular man, who included Charles Dickens and John Forster among his close friends, but as he grew older he became increasingly melancholic and pessimistic. By the time that the decoration of the new Palace of Westminster was being planned, he was established as the leading history and literary painter of the day, and in 1845 he was invited to paint two of the first six frescos commissioned for the House of Lords. During the remainder of his life he was to be much preoccupied with his important work at Westminster, which will be discussed in the next chapter. That work exhibited considerable influences from contemporary mural painters in France, whom he much admired, and also, of course, the impact of the German Nazarene and Munich School artists. However, in his easel paintings Maclise

(155) Daniel Maclise, *Caxton's Printing Office* (RA 1851). Oil on canvas; 218.5×284.5 cm. (Knebworth House, Hertfordshire)

usually retained his individuality, and his skills in combining great detail with fluent and vigorous composition and technique never deserted him. One of his most successful and popular compositions in this vein was the large *Caxton's Printing Office* [PL.155], which was exhibited at the RA in 1851. Shown in the year of the Great Exhibition and three years after the creation of the Pre-Raphaelite Brotherhood, this crowded canvas is one of the masterpieces of Victorian historical and domestic genre painting, which was in many ways the most successful and typical form of British painting at this time. It has been recorded by his friend George Jones, RA, that even the aged Turner admired it.

22 The Decoration of the New Palace of Westminster

The disastrous fire which destroyed much of the Palace of Westminster during the night of 16 October 1834, resulted in two masterpieces by Turner [see COL.PL.22] and had an enormous overall impact on the world of architects and artists in England. For the first time in the nineteenth century central government was deeply concerned with the work of architects, painters and sculptors. While it is generally recognised that Sir Charles Barry's neo-Gothic Houses of Parliament are one of the triumphs of early Victorian architecture, which Augustus Pugin's decorative detail enormously enhances, it is sadly also a fact that the paintings and sculptures commissioned to decorate the interior

constitute one of the major failures in the history of British art. The fire had come at a critical period in British political history, for with the passing of the 'great' Reform Bill of 1832, which increased the electorate by about 500,000, many of the anomalies in the franchise were removed and the unbalanced influence of the aristocracy and the landed gentry was ended. The Bill heralded the beginning of the political supremacy of the middle class, and greatly increased the political influence of the industrial Midlands and North.

It is, however, noteworthy that it was only the Lords Chamber and the galleries and chambers designed for Royal and ceremonial use in which the architect allowed for the addition of paintings and sculpture. The panelled walls of the Commons Chamber had no spaces for paintings. Thus the interior of the New Palace of Westminster, with its richly decorated chambers, rooms and galleries for Royal and aristocratic use, can be said to have been politically retardative; the Lords Chamber re-echoes the spirit of Charles I, and that of the Commons is more in keeping with the austerity of Thomas Cromwell.

By 1840 the work of re-building the Palace of Westminster was sufficiently advanced for the authorities to begin considering what should be done to augment the decoration of the interior. As mentioned earlier, there had been various unsuccessful schemes to encourage history painting in Britain, and for years Benjamin Robert Haydon had been campaigning for State patronage to reinforce this cause. In 1835 a Parliamentary Committee was established to investigate the relationship between the fine arts and manufacture, and this led to the creation of the Normal School of Design in 1837. Somewhat unexpectedly that committee, which had interrogated most of the influential institutions and personalities in the world of art, ended its report with a plea that fresco painting, which it considered the highest branch of the visual arts, should be given official patronage in England as soon as possible.[19] This comment was a powerful influence in the ensuing events that resulted in the more than twenty-year-long programme for providing the Palace of Westminster with suitable paintings for its walls.

In 1841 a Select Committee on the Fine Arts was established, which included Sir Robert Peel, recently Prime Minister and a gifted connoisseur and collector, and William Ewart, the chairman of the 1835 committee; its brief was 'to take into consideration the promotion of the Fine Arts in this country in connection with the rebuilding of Parliament'. Many of those who gave evidence, including the President of the Royal Academy, Sir Martin Archer Shee, William Dyce, and Charles Eastlake, favoured the use of fresco, but agreed that the work should be entrusted to British artists, and not, as had been mooted, to the German Nazarene painter, Peter von Cornelius or some of his followers. The Committee recommended the setting up of a Royal Commission, which was duly appointed by Peel, now again Prime Minister, in November 1841, with Prince Albert as President and Eastlake as Secretary. In the meantime Cornelius, famed for his fresco decorations for Ludwig of Bavaria in Munich and the 'schoolmaster of Europe in matters of wall painting'[20] had come to London and had given his advice to Eastlake and others.

The partnership that developed between the eager and remarkably well-informed twenty-two-year-old German prince, whom Queen Victoria had married in the previous year, and the highly intelligent, efficient and scholarly painter, was to be a vital

factor in the world of British art for the next twenty years. This was Prince Albert's first official role, and he quickly proved himself as a sensitive and motivated connoisseur of art; he had already rapidly influenced and changed the taste and artistic interests of the Queen. During the decade before Albert's arrival in England the impact and popularity of contemporary German art had become a major factor in British taste, an influence which Prince Albert's activities did much to strengthen. The twenty-two commissioners were motivated by the same desire to benefit the populace that was beginning to lead to the opening in the provinces of free public museums and art galleries. They decided that fresco should be used, and after much discussion it was agreed to launch a competition for cartoon drawings 'executed in chalk or charcoal, not less than ten nor more than fifteen feet in their longest dimension; the figures to be not less than the size of life, illustrating subjects from British History, or from the works of Spenser, Shakespeare or Milton'. The cartoons had to be submitted anonymously by the first week of May 1843 – there were to be ten premiums – and they were to be exhibited in Westminster Hall.

A total of 140 cartoons was shown, and on the whole there was satisfaction about the high overall quality of these, and the exhibition, to which, exceptionally, entry was free on many days, was a great popular success. Nineteen cartoons were of subjects from Roman Britain and twenty-four illustrated scenes from the Middle Ages, while only one chose an event later than 1500; nearly half the cartoons depicted literary subjects, the great majority (forty) from Milton. As had been feared by some, very few established artists entered the competition – a notable exception was, of course, Haydon, who submitted two cartoons, but did not gain an award – and of the three winners of the top premiums of £300, Edward Armitage, G. F. Watts and C. W. Cope, only the last-named was over thirty years old. However, though this competition proved that there were artists in Britain capable of designing compositions on a grand scale, the fact that the prize-winning artists were all so junior and inexperienced moved the Royal Commission to delay any decisive action, and a second round of competitions was announced in which specific painters were invited to submit specimens of fresco. There was also a competition for works of sculpture, for which Barry had assigned over two hundred places in his designs.

In the meantime Prince Albert had made a personal intervention in providing a small site at which British artists could experiment with fresco. He invited eight artists, including Dyce, Eastlake, Landseer and Maclise, to provide fresco decorations illustrating Milton's *Comus* in the lunettes in the central room of a pavilion in the grounds of Buckingham Palace. The resulting decorative scheme was not a success, but the fresco competition had been sufficiently encouraging to allow the Commissioners to make a start at last on the actual decoration of the House of Lords, in which Barry had included three large arched spaces for paintings at each end, above the throne and on the entrance wall.

It was still a matter of debate as to whether historical or allegorical subjects should be preferred, and for these six spaces the compromise was reached of commissioning an historical and an allegorical subject dedicated to each of the three different classes of peer – hereditary, law and spiritual. Thus the allegories are *The Spirit of Chivalry*, *The Spirit of Justice* (both by Maclise) and *The Spirit of Religion* (by J. C. Horsley); two of the historical subjects were assigned to Cope, the only artist among the top prize-winners

(156) J.C. Horsley, *The Spirit of Religion* (1847).
Fresco on plaster, repainted in tempera;
286×500cm. (House of Lords, Palace of
Westminster)

in the cartoon competition to be selected, and the third to Dyce. John Callcott Horsley,
RA (1817–1903), had won one of the second prizes in the cartoon competition, which he
later described as 'a sort of preliminary canter' in his amusing *Recollections*.[21] He was
acquainted with several Berlin artists, and was familiar with contemporary German
monumental art, as the firm, static and balanced composition of his *Spirit of Religion*
fresco [PL.156] demonstrates. The German influence, certainly encouraged by Prince
Albert, who was a frequent visitor to the Lords Chamber while the artists were at work,
can be seen in each of these first six frescos, of which the first four were completed by
1848. On receiving their commissions three of the painters, Cope, Dyce and Horsley,
travelled to the Continent to enlarge their knowledge of fresco, and Dyce's detailed and
informative analysis of some of the problems posed by painting in fresco was included
in the Sixth Report of the Royal Commission. Dyce's *The Baptism of Ethelbert* was the
first of the House of Lords frescos to be completed, in July 1847, and later that year,
while he was working on Prince Albert's fresco commission for Osborne House, Dyce
was invited to decorate the Queen's Robing Room at the Palace of Westminster.

 The first House of Lords frescos were on the whole well received and other, lesser
commissions elsewhere in the Palace were awarded in 1848. However, progress was
slow, working conditions were poor, and there was not sufficient money to pay the
artists the fees they felt they ought to receive. It also became clear all too quickly that
many of the surfaces prepared for the paintings had not dried out fully, and that
the fresco work was started too early. In addition many of the artists had not really
mastered the technique of 'true fresco' – that is painting a small daily section on fresh

wet plaster – nor were the plasterers sufficiently expert in applying the *intonaco* to the walls. In many cases the condition of the frescos deteriorated quite quickly because of these problems and because of the overall unsuitability of using true fresco in the damp and dirty atmosphere of London, and especially so close to the Thames. In addition to all these technical problems it also quickly became clear that the piecemeal method of assigning spaces and subjects, which were mostly historical (the two leading historians Henry Hallam and Thomas Macaulay were both commissioners), to individual artists, without an overall programme and proper leadership by one artist, was resulting in a hotchpotch of decoration. Much of this was influenced by contemporary French as well as by German example, and the results more than confirmed the weaknesses of British 'high' art. Furthermore the wall paintings had to compete with the elaborate decoration, much of it gilt, with which Barry and Pugin covered many of the internal walls of their building. The Prince Consort soon lost interest and became increasingly involved with his work for the Great Exhibition of 1851, at which, perhaps not surprisingly, painting was scarcely represented. Eastlake was more than preoccupied with his many other duties, while the artists felt unappreciated and badly rewarded.

However, total failure was avoided by the continuing work at the Palace of Dyce and Maclise, which occupied both artists for the rest of their lives, though only on a part-time basis largely because of the poor remuneration. In 1849 William Dyce began the work of frescoing the seven compartments of the Queen's Robing Room with scenes from the life of King Arthur, based on Sir Thomas Malory's *Morte d'Arthur*. On Prince Albert's advice Dyce chose allegorical themes for his designs, such as *Courtesy, Sir Tristram Harping* [PL.157], which he completed in 1851. Dyce's Arthurian cycle enabled the artist to combine nationalistic with religious allegory, and, at a time when archaeological accuracy was becoming increasingly important, he presented his subjects with convincing detail and characterisation. The impact of Dyce's close study of Italian and German fresco cycles can be felt throughout the Robing Room compositions – Raphael is crossed with Overbeck in the rectangular *Religion; The Vision of Sir Galahad* – but the artist's own personality also comes through. However, it has to be admitted that none of the Queen's Robing Room frescos achieve the effective individuality of some of Dyce's best easel paintings. When he died in 1864 Dyce had completed only five of the frescos, which, because of his relative skill in the use of the medium, remained in reasonable condition far longer than most of the others in the Palace of Westminster.

Prince Albert was concerned that in addition to his two House of Lords frescos Daniel Maclise should make further contributions to the decoration of the Palace, but for various reasons the artist declined several proposals before he was commissioned to execute the frescos for the spacious Royal Gallery in 1857. Maclise did not take the advice to start with one of the smaller compartments, and began straight away on the cartoon for one of the two principal subjects, *The Meeting of Wellington and Blücher at the Battle of Waterloo*. The huge French chalk cartoon (Royal Academy, London) was exhibited at the Royal Academy in 1859, and was received with great enthusiasm; a group of fellow artists presented Maclise with a gold porte-crayon 'not so much as a token of our esteem and admiration as of the honest pride which, as artists and fellow-countrymen, we feel in the success of the cartoon you have lately executed'. Maclise had produced a powerful and dramatic portrayal of this great moment of recent British

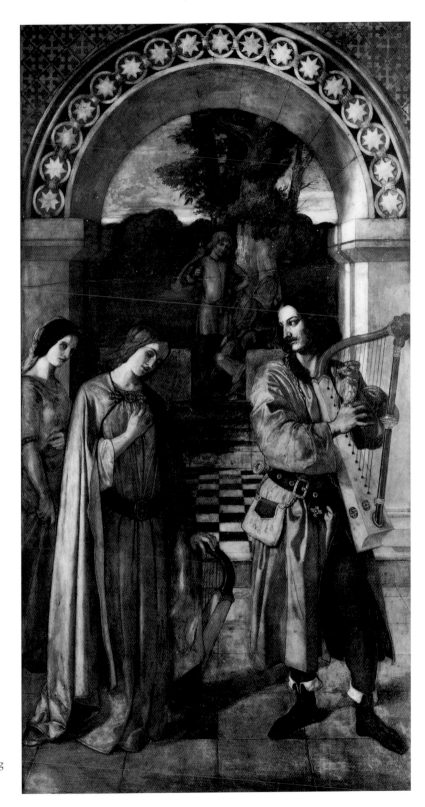

(157) William Dyce,
*Courtesy, Sir
Tristram Harping*
(1851). Fresco;
342×178 cm.
(The Royal Robing
Room, Palace of
Westminster)

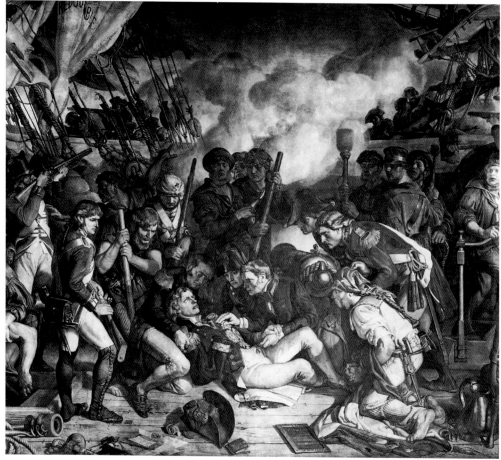

(158) Daniel Maclise, *The Death of Nelson* (detail, *c*.1865). Waterglass painting; whole work 369×1425 cm. (The Royal Gallery, Palace of Westminster)

history, in which meticulous and authentic detail was combined with effective characterisation to create a carefully orchestrated and balanced composition. This at last was true British history painting on a grand scale, and the same qualities are to be found in the companion painting, *The Death of Nelson at Trafalgar* [detail, PL.158] which has rather more movement and action.

Almost as soon as he had finished the *Wellington and Blücher* cartoon Maclise began work on the fresco, but he quickly found that he could not achieve the minute detail of his composition in that medium. He wrote to resign the commission, but was persuaded by Prince Albert to visit Berlin and Munich to study the methods being used there. As a result Maclise was converted to the use of the waterglass or stereochrome technique, which was basically a watercolour process fixed to the surface with liquid silica. This new method allowed the artist to touch and retouch his work at will, but this technique also proved to have poor lasting qualities; the frescos were soon attacked by mildew, there was some flaking and the colours darkened quite rapidly. Despite these problems Maclise's two ambitious and vast compositions were an immediate critical

and popular success, and the Redgrave brothers justly described them as 'fit objects of national pride'.[22] But the brothers were highly critical of the frescos in the New Palace of Westminster as a whole, and judged the efforts of the commissioners to encourage and promote the fine arts of the country as 'disastrous'. Throughout the twenty years of this saga the magazine *Punch*, founded in 1841, was also critical of the work of the commissioners, and its satirisation of the Westminster cartoons in 1843 led to the adoption of the word 'cartoon' to describe humorous drawings in that publication and elsewhere. But this epic failure of British painting in the grand manner was certainly more distressing than humorous.

Notes to Part Five

1 D.B.Brown, '"The True Spirit of Observation": Wilkie as a Draftsman', in exhibition catalogue of *Sir David Wilkie of Scotland*, North Carolina Museum of Art, Raleigh, and Yale Center for British Art, New Haven, 1987, pp.59–72. At the time of writing this catalogue, to which H.A.D.Miles (author of the forthcoming Wilkie catalogue raisonné) was the major contributor, provides the most up-to-date material on Wilkie

2 Letter from Wilkie to Perry Nursey, dated 30 December 1818, quoted by Lindsay Errington in *Tribute to Wilkie*, National Galleries of Scotland, 1985, p.14

3 Letter of 28 September 1828, to Andrew Wilson, quoted by W.J.Chiego in 'David Wilkie and History Painting', 1987 Catalogue, p.33

4 Letter quoted by H.A.D.Miles, 1987 Catalogue, No.39

5 *The Diary of Benjamin Robert Haydon*, edited by W.B.Pope, 5 vols, 1960–3

6 *Diary*, Vol.II, 1960, p.403

7 Quoted by R.D.Altick in *The Shows of London*, 1978, p.414

8 The decoration of the new Palace of Westminster will be discussed in detail in Chapter 22

9 *Diary*, Vol.V, 1963, p.556

10 R. and S.Redgrave, *A Century of British Painters*, new edn, 1957, p.303

11 *Art Union*, 1838, p.81

12 *Works*, Vol.IV, p.336

13 Loc.cit., p.474

14 David Robertson, *Sir Charles Eastlake and the Victorian Art World*, 1978, p.3

15 Letter to Harman, quoted by Robertson, loc.cit., p.19

16 K.M.Wells, 'The British Academy of Arts in Rome', in *Italian Studies*, Vol.XXXIII, 1978, pp.92–110

17 D.Robertson, loc.cit., pp.36–7

18 *Works*, Vol.XIV, p.98

19 See T.S.R.Boase, 'The Decoration of the New Palace of Westminster', in *Journal of the Warburg and Courtauld Institutes*, Vol.XVII, Nos.3–4, 1954, pp.319–58. A revised version of this pioneering article is included in *The Houses of Parliament*, ed. M.H.Port, 1976, pp.268–81

20 Boase, loc.cit., p.323

21 J.C.Horsley, *Recollections of a Royal Academician*, 1903, p.254

22 R. and S.Redgrave, loc.cit., p.472

Part Six

The Pre-Raphaelite Movement

23 The Pre-Raphaelite Brotherhood

1848 was a year of unrest and revolution throughout much of Europe, highlighted most notably by the overthrow of the French King, Louis Philippe, and the establishment of the short-lived Second Republic in Paris in February. In December Louis Napoleon Bonaparte, nephew of the great Napoleon and the future Emperor Napoleon III (1852–70), was elected President. In the meantime there had been similar upheavals in Italy, Spain, Germany and Austria. In England the ten-year-old Chartist movement, with its policy of political reform, took the opportunity of the unrest across the Channel to organise a great demonstration in London in April. This was a total failure thanks to the resolute action by the government under Lord John Russell, acting on the advice of the seventy-eight-year-old Duke of Wellington. Two young artists, William Holman Hunt and John Everett Millais, having just completed their paintings for that summer's Royal Academy exhibition, joined the Chartist procession on its march from Russell Square to Kennington Common, and there witnessed its quiet dispersal, and then on Bankside the subsequent 'bloody strife' initiated by a small group of 'stalwart roughs'.[1]

At this time the precocious Millais was eighteen and Holman Hunt had just celebrated his twenty-first birthday. They had met in 1844 and became close friends, working together in Millais's studio on their 1848 canvases. Hunt's somewhat academic *Eve of St Agnes* (Guildhall Art Gallery, London) illustrates lines from Keats, a poet largely neglected since his early death in 1821, while Millais's rather coy and light-hearted *Cymon and Iphigenia* (Viscount Leverhulme) was based on a well-known story in Boccaccio's *Decameron*. It says much for the Royal Academy selectors of the day that Hunt's more original work was exhibited, while Millais's composition, which was an obvious imitation or even parody of the style of the much-respected William Etty, was rejected.

The Eve of St Agnes attracted the attention and admiration of another young artist and fellow student at the RA Schools, the nineteen-year-old Dante Gabriel Rossetti, whose friendship with Holman Hunt dates from this time. Thus by May of that revolutionary year 1848 the stage was set for the establishment by these three unusually gifted young art students of an artistic movement, the Pre-Raphaelite Brotherhood, which was certainly inspired by the radical atmosphere of the time. But it was not as revolutionary as it has often been considered, and several British painters of the pre-

ceding generation, such as Dyce and Mulready, were already working in a manner akin to that adopted by the young Pre-Raphaelites. However, the Brotherhood did bring a much-needed element of novelty and passion into British painting at a time when this largely lacked direction and quality. The three gifted, lively and high-spirited young men combined naïvety with seriousness to achieve their high-minded ideals and intentions.

Like all good students, Hunt, Millais and Rossetti had enquiring and receptive minds, and in developing their own credo and techniques they made use of a variety of influences. Among these were the writings of John Ruskin, who published the second volume of *Modern Painters*, which Holman Hunt certainly read, in 1846. It is not known how familiar Hunt and his fellows were with the first volume, published anonymously in 1843 (3rd edition in 1846), but Ruskin's plea for 'truth to nature', and his exhortation that artists should emulate Turner and 'go to Nature in all singleness of heart, and walk with her laboriously and trustingly, having no other thoughts but how best to penetrate her meaning, and remember her instruction; rejecting nothing, selecting nothing and scorning nothing; believing all things to be right and good, and rejoicing always in the truth',[2] must have been familiar to the Pre-Raphaelities, of whom, as we shall see, Ruskin became a stalwart supporter.

There are several different versions of how the Brotherhood actually came into being and acquired its challenging name. Rossetti, who grew up in a politically active Italian refugee family, was the moving spirit, and at a meeting held in September at the Millais family home in Gower Street, the Brotherhood was launched with seven founder members, whose individual careers will be recounted after this introductory chapter. In addition to Hunt, Millais and Rossetti, there were Hunt's friend F.G. Stephens, aged twenty and an art student, and two friends of Rossetti, the sculptor Thomas Woolner and the painter James Collinson, who, at the age of twenty-three, was the oldest member. William Michael, D.G. Rossetti's younger brother, a clerk in the Inland Revenue, was brought in as secretary of the group and as the seventh member. Many years later William Michael Rossetti, who became a man of letters and an art critic, rather tamely summed up the aims of the Brothers as follows:

1 To have genuine ideas to express;
2 to study Nature attentively, so as to know how to express them;
3 to sympathise with what is direct and serious and heartfelt in previous art, to the exclusion of what is conventional and self-parading and learned by rote;
4 and most indispensable of all, to produce thoroughly good pictures and statues.[3]

In choosing their name and formulating their aims the Brothers were reacting against the supreme prestige of Raphael and the current popularity of the seventeenth-century Italian painting that followed him. They were much impressed by the simplicity and directness of Carlo Lasinio's volume of outline engravings after the fifteenth-century frescos of Benozzo Gozzoli and others in the Campo Santo at Pisa, and themselves adopted a linear drawing style similar to that which had been used by the German Nazarene painters. In their interest in earlier Italian painting the young Pre-Raphaelites were ahead of their time, but they did have opportunities in London to study some relevant works. There were a number of English pioneer collectors and

connoisseurs of the so-called 'primitives'. One of the earliest of these was the Liverpool banker and scholar William Roscoe, who believed that more than forty of the 150 or so paintings in his collection which he catalogued in 1816 dated from before 1500.

At that time Roscoe was almost alone in England in his enthusiasm for early painting, but in the following generation it was a taste shared by several other collectors and especially by Prince Albert, who formed a considerable collection. In 1846 he acquired the famous Duccio Triptych, now in the Royal Collection, and hung it in his dressing room at Osborne House. In 1847 Prince Albert accepted a large collection of Italian, German and early Netherlandish paintings formed in Germany by Prince Ludwig Kraft Ernst von Oettingen Wallerstein as surety for a personal loan. This collection included many 'pre-Raphaelite' paintings, and it failed to sell when put on exhibition in Kensington Palace in 1848, and thus passed into the possession of Albert. It seems probable that Hunt, Millais and Rossetti and their friends saw this exhibition, and that they also saw the two fine altar panels of *Adoring Saints* by Lorenzo Monaco (before 1372–1422 or later), which were then attributed to Taddeo Gaddi and were the first early fifteenth-century Italian paintings to enter the National Gallery. They were presented, also in 1848, by William Coningham, another pioneer collector of early Italian art. Thus in that focal year of 1848 these young artists had rather more opportunity for seeing 'pre-Raphaelite' art than just the Lasinio engravings and other prints, which they could have seen in the Print Room of the British Museum. The engravings of Dürer were especially important for them.

In the summer of that year the three artists had begun to plan and work on the paintings which were to launch the Brotherhood when they were exhibited in 1849, and they were thus already using the rules and techniques which were formalised when the Brotherhood was founded. Furthermore, during 1848 all the future Brothers, except W. M. Rossetti, were members of the Cyclographic Society, a sketching club for which they produced carefully finished drawings, which were circulated among themselves for written criticism. The first painting to be finished (largely painted in a studio shared with Holman Hunt) and exhibited – and it was also his first major oil painting – was Rossetti's *The Girlhood of Mary Virgin* [COL.PL.47]. This was shown at the juryless Free Exhibition, which opened on 24 March. The monogram 'PRB', inscribed below Rossetti's signature, caused puzzlement, but the painting was well received and was bought for 80 guineas by the Dowager Marchioness of Bath, a family acquaintance. Rossetti composed two sonnets, one inscribed on the original frame and the other printed in the catalogue, to explain the symbolism and subject, which reflects the artist's Anglo-Catholic family background. Thus this first PRB exhibit established the strong literary characteristics of the movement; *The Girlhood of Mary Virgin* was full of symbolic content which had to be 'read', and the accompanying sonnets provided written material to assist that visual exercise.

The Royal Academy exhibition opened in April, and both Holman Hunt's *Rienzi* [COL.PL.48] and Millais's *Isabella* [COL.PL.49] also featured the mysterious initials. Hunt's work illustrates a passage from Bulwer Lytton's novel *Rienzi, the Last of the Tribunes*, of which a second edition had been published in 1848, and Millais's is again based on a story by Boccaccio, retold by Keats in *Isabella; or the Pot of Basil*. The evolution and meaning of these two impressive and influential icons of the Pre-Raphaelite Brother-

hood have been recorded and discussed in great detail. Both illustrated popular literary (and non-religious) subjects and this no doubt was a major factor in their being well received despite their stylistic 'oddity'. Several critics commented on the links with 'early art' and the 'Early Italian' qualities in technique and composition. Hunt stressed how much of his composition had been painted out-of-doors – much of the landscape was painted on Hampstead Heath – and all three artists used friends, relations and colleagues rather than professional models for their figures. These elaborate and detailed compositions were executed with small brushes on a white ground, a laborious and time-consuming technique related to that used in fresco painting.

The PRB had made an auspicious start, and in the autumn of 1849 Hunt and Rossetti, encouraged by their success, visited Paris and Belgium 'to see ancient and modern Art'. Early in the new year the publication of the first of the four monthly issues of the Brotherhood's short-lived magazine, *The Germ*, edited by W.M.Rossetti, combined with press gossip to reveal the meaning of the letters PRB. When the Brothers exhibited their paintings in 1850 the friendly reception of the previous year was replaced by several virulent attacks. 'Brotherhood' implied 'popish' and perhaps also political connotations, and each artist's choice of a highly symbolic religious subject for his major exhibit that year appeared to confirm such suspicions.

In 1850 Rossetti's *Ecce Ancilla Domini!* (Tate Gallery, London), a powerful and thought-provoking vision of the Annunciation, with Mary and the Angel both clothed in pure white, was again the first PRB work to be shown, this time at the National Institution, which opened on 13 April. Rossetti angered his fellow-Brothers by not exhibiting with them at the Royal Academy for a second time, and his painting aroused a harsh critical attack. This was continued when Hunt's *A Converted British Family Sheltering a Christian Missionary from the Persecution of the Druids* (Ashmolean Museum, Oxford) and Millais's *Christ in the House of his Parents* (popularly known as 'Christ in the Carpenter's Shop') [PL.159] appeared some three weeks later at the Royal Academy, where Millais also had two other exhibits. On this occasion none of the three artists

(159) John Everett Millais, *Christ in the House of his Parents* (RA 1850).
Oil on canvas; 86.4×139.7 cm. (Tate Gallery, London)

added the PRB initials to their signature, but the bright colours and forceful compositions would in any case have singled out their work in any London exhibition at this time. Of all the fierce criticism that the paintings received, the most virulent was Charles Dickens's review of *Christ in the House of his Parents* published in *Household Words* in June, in which he exhorted his readers to prepare themselves 'for the lowest depths of what is mean, repulsive and revolting'. Just as with Caravaggio in Rome some 250 years earlier it was the 'blasphemous' realism, such as Joseph's dirty fingernails, that caused distress and derision. The painting's notoriety aroused Queen Victoria's curiosity, and it was removed from the exhibition and brought to her for a special viewing, though it is not recorded how she reacted to it.

While critics and public were shocked and disgusted, all three paintings were eventually sold, and many of the Brothers' artist colleagues were impressed. Indeed the influence of the Pre-Raphaelites' new thinking and technique was already to be seen in several exhibits by non-members that summer, among them the short-lived W. H. Deverell's *Twelfth Night* (Forbes Magazine Collection, New York), and C. A. Collins's *Berengaria's Alarm for the Safety of her Husband, Richard Coeur de Lion* (City of Manchester Art Galleries). The largest and most ambitious of the Pre-Raphaelite paintings shown at the Academy in 1851 was Holman Hunt's rather stiff *Valentine rescuing Sylvia from Proteus* (Birmingham Museum and Art Gallery), the artist's first exhibited Shakespearean subject, of which the landscape was painted in the open at Knole, sometimes working in the rain sheltered by an umbrella. Millais again showed three paintings: *The Woodman's Daughter* (Guildhall Art Gallery, London), based on Coventry Patmore's poem of that title; *Mariana* (Private Collection), illustrating Tennyson's poem; and the biblical *Return of the Dove* (Ashmolean Museum, Oxford). The last had been bought before the exhibition by Thomas Combe, Superintendent of the Oxford University Press, in whose garden C. A. Collins had painted the flowers in his 1851 exhibit, *Convent Thoughts* (Ashmolean Museum, Oxford), which can be thought of as a pendant to *The Return of the Dove*, and which was also bought by Combe.

The critics were again united in their condemnation, as seen in the review in *The Times* of 7 May: 'We cannot censure at present as amply or as strongly as we desire to do, that strange disorder of the mind or the eyes which continues to rage with unabated absurdity among a class of juvenile artists who style themselves P.R.B....' However, John Ruskin, who had not as yet met any of the artists, now came to the rescue, encouraged to do so by the poet Coventry Patmore, and wrote two letters to *The Times*, published on 13 May and 30 May. Both of these contained more subtle and valid criticism than actual praise. However, in the first Ruskin asserted 'generally and fearlessly' that 'as studies both of drapery and of every minor detail, there has been nothing in art so earnest or so complete as these pictures since the days of Albert Dürer'. Ruskin ended the second letter as follows: 'so I wish them all heartily good speed, ... and if they do not suffer themselves to be driven by harsh or careless criticism into rejection of the ordinary means of obtaining influence over the minds of others, they may, as they gain experience, lay in our England the foundations of a school of art nobler than the world has seen for three hundred years'.[4] Ruskin had also tried to practise what he preached, for he wanted to buy *Convent Thoughts*, but this had already been sold to Thomas Combe, and he helped Hunt to find a buyer for two of his paintings.

Both these letters were signed as by 'The Author of *Modern Painters*', and the same authorship was cited for Ruskin's pamphlet, *Pre-Raphaelitism*, published in August 1851. It was only in the following month, in the fifth edition of the first volume of *Modern Painters*, that Ruskin's authorship of this and his subsequent early writings, such as *The Stones of Venice*, was officially revealed, though it was already widely known that he was the 'Graduate of Oxford'. Dedicated to Francis Hawkesworth Fawkes, son of J.M.W. Turner's Farnley Hall friend and patron, *Pre-Raphaelitism* is as much concerned with Turner, who was to die that December, as with the actual PRB. But, by comparing the work of these young artists favourably with that of Turner, Ruskin gave them his ultimate seal of approval, and from now on the attitude of critics and public changed rapidly. In the 1852 RA exhibition Millais's *A Huguenot* (Private Collection) was one of the most popular paintings, and the twenty-four-year-old artist was elected ARA in the following year.

Rossetti had been dismayed by the harsh reception given to his two paintings, and after 1850 he rarely exhibited again and worked mostly in watercolours for the next ten years or so. His withdrawal from the public arena was one of the factors which contributed to the rapid disintegration of the actual Brotherhood, which had never added to its original membership of seven. Of those seven it was really only the original trio of Hunt, Millais and Rossetti who made their mark, though each going his own way, as the following chapters will show. Of the three only Holman Hunt adhered for any length of time to the PRB principles and techniques, which were, however, adopted by several younger artists, such as John Brett and Arthur Hughes, and which continued to be backed by John Ruskin. Rather like Pointillism in the 1880s, true Pre-Raphaelitism was something of a cul-de-sac, but its basic ideas and ideals, and its refreshing novelty and seriousness, did provide an impetus for change and reform in British painting at a time when it was in a poor state. The very considerable impact of the Pre-Raphaelite artists in their early years was remarkable. One of their aims was to bring a high moral value to painting and to see it given a central place in the life of society, as in sixteenth-century Florence or Venice. The support of John Ruskin brought some viability to these ambitious ideals, and greatly enhanced their impact. Indeed the story of British painting of the nineteenth century has to be told in two halves: the 'pre-Pre-Raphaelite' and the 'post-Pre-Raphaelite'. Though the true Brotherhood had only a very brief existence in between, its work and influence were of enormous importance.

24 William Holman Hunt, OM (1827–1910), and Sir John Everett Millais, Bt, PRA (1829–1896)

William Holman Hunt was born in London, the son of a warehouse manager, and after a few years as a clerk he succeeded on his third attempt to gain a place in the Royal Academy Schools in 1844. Here he met Millais, who had entered the Schools as the youngest ever student in 1840, and whose precocious genius made him the star student of his day. Millais's father was a man of independent means from an old Jersey family, who moved his own family to London in 1838 so that his artist son could develop his prodigious talents. Brought together by their dedication to art, and against the back-

ground of the Royal Academy and its Schools, which, though at a low ebb at the time, remained the focal centre of the London art world, these two young men formed a kind of partnership which lasted for almost ten years. They both exhibited at the RA for the first time in 1846, and as we have already seen they launched the Pre-Raphaelite Brotherhood with their matching RA exhibits of 1849. However, their ways began to part less than three years later. The two artists spent most of the second half of 1851 together at Ewell in Surrey, mainly working on the backgrounds and other details of *The Hireling Shepherd* and *Ophelia*. They finally returned to London early in December, and many years later Hunt wrote: 'With all our work done we took leave of the farm household and came up to town in December, parting from one another where the Waterloo Road and Strand met, thinking that we should often again enjoy such happy fellowship, but, alas! no two dreams are alike. Never did we live again together in such spirit-stirring emulation.'[5]

Hunt's *The Hireling Shepherd* [COL.PL.50], which was exhibited at the RA in 1852, has always been one of his most popular paintings, and it was bought at the exhibition for 300 guineas, paid in instalments, by the eminent naturalist, W. J. Broderip. Accompanied in the catalogue with the following lines from Act III of *King Lear*:

> Sleepest or wakest thou, jolly shepherd?
> Thy sheep be in the corn;
> And for one blast of thy minikin mouth,
> Thy sheep shall take no harm.

It combines superb realism and detail with subtle and complex symbolism, which the artist expected that most of the viewers would be able to 'read'. The landscape, flora, trees and some of the sheep were painstakingly painted, mostly on a wet white ground, in the meadows near Ewell from late June to late October; Hunt was usually working from 8 a.m. to early evening. It is remarkable that he has achieved such convincing unity of light, atmosphere and natural detail when working throughout the day over such a long period, which embraced three seasons and which ended in an unusually early spell of freezing weather. When the canvas was brought back to London a white patch had been left for the addition of the figures, for which Hunt made several drawings. The model for the shepherdess was Emma Watkins, a local Ewell girl who came up to London for some weeks in the winter and spring of 1852. She sat again for Hunt in the following December, when he repainted some of the shepherdess and worked up a sketch to produce the second, much smaller, finished version of the composition (Private Collection). The identity of the model for the shepherd is not known, though it seems that Hunt did use a professional model.

All this was the groundwork for a 'thoroughly good picture' which had 'genuine ideas to express'. Though Hunt later played down the didactic symbolism of *The Hireling Shepherd*, it is certain that under the disguise of Shakespeare's light-hearted song he was presenting a specific theological message which reflected the current divisions in the Church of England between the Tractarians and the Evangelicals, and the neglect by the clergy involved in the vital task of combating Romanism. The situation had come to a head with the restoration of the Roman Catholic Hierarchy in England by Pope Pius IX in 1850, the year in which Bishop Wiseman was appointed Cardinal-

Archbishop of Westminster. Hunt was certainly influenced by reading Ruskin's 1851 pamphlet *Notes on the Construction of Sheepfolds*,[6] a powerful and controversial plea for Protestant re-union. Thus Hunt's sheep are symbolic of Christ's flock neglected by their shepherd or pastor, and in need of spiritual guidance. He is showing his sweetheart a death's head moth, an emblem of superstition, and the shepherdess in her scarlet dress (reminiscent of a cardinal's robes) represents the Roman Catholic Church. The lamb on her lap is risking death by eating unripe green apples, and represents the ignorant youth of the country endangered by the attraction of poisonous doctrine. The sheep, the adult flock, are left to stray into the corn – the lure of Rome; two or three of them are already dead or dying, having been converted.

All these details and more, including the fact that on the surface this is a straightforward seduction scene, can be read into this attractive picture, and probably would have been in 1852. However, many years later, when that religious controversy had been forgotten, the artist explained his intentions when Manchester purchased the painting in 1896, as follows:

> Shakespeare's song represents a shepherd who is neglecting his real duty of guarding the sheep … he is the type of muddle-headed pastors, who, instead of performing their services to the flock – which is in constant peril – discuss vain questions of no value to any human soul … I did not wish to force the moral, and I never explained it till now. For its meaning was only in reserve for those who might be led to work it out. My first object as an artist was to paint, not Dresden china *bergers*, but a real shepherd, and a real shepherdess, and a landscape in full sunlight, with all the colour of luscious summer, without the faintest fear of the precedents of any landscape painters who had rendered Nature before.[7]

The Hireling Shepherd illustrates the complex and varied qualities of a true Pre-Raphaelite painting. Holman Hunt was, in fact, the only Brother who continued to produce pictures embracing these demanding qualities for much of his long career. Indeed, while he was so painstakingly painting *The Hireling Shepherd* he was also at work on his most famous composition, *The Light of the World* (Keble College, Oxford; version in St Paul's Cathedral, London), though this was not exhibited until 1854. This outstanding religious composition was inspired by a verse from Revelations, 'Behold, I stand at the door, and knock: if any man hear my voice, and open the door, I will come into him, and will sup with him, and he with me.' Again Hunt was at great pains to achieve realism and accuracy combined with complex symbolism, and his sombre figure of Christ soon became the most popular English religious image of the nineteenth century. The painting had been bought before the exhibition by Thomas Combe for 400 guineas, and two years later Ernest Gambart, the leading print publisher of the Victorian era, acquired the copyright for only £200. Hunt agreed to such a low price because he was anxious that the engraving should be of the highest possible quality. This was undertaken by W.H.Simmons, and the excellent print was published after much delay in 1860, quickly becoming one of the best-selling engravings of all times. During the next half-century or more an engraving (there were numerous pirated versions), photogravure or other reproduction of *The Light of the World* hung in hundreds of thousands of British homes, and certainly aided by its inspired title Hunt's creation became an icon of Chistianity throughout the English-speaking world.

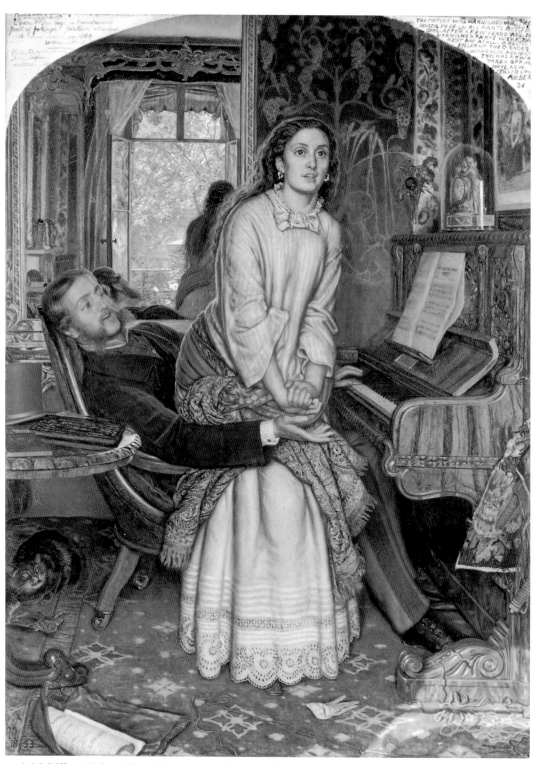

(160) William Holman Hunt, *The Awakening Conscience* (RA 1854). Oil on canvas; 76.2×55.9cm.
(Tate Gallery, London)

Also at the 1854 Royal Academy exhibition was Hunt's *The Awakening Conscience* [PL.160], a modern moral subject conceived as a secular companion to *The Light of the World*. Moved by the memories of her childhood revived by the singing of *Oft in the Stilly Night* (the music is on the piano) by her lover, a kept woman rises from his lap in a moment of deep remorse. The composition, for which the setting was actually painted in a room in a 'maison de convenance' in St John's Wood, is filled with carefully contrived symbolism, which even extended to the frame, designed by the artist, with its border of chiming bells and marigolds, the emblems of warning and sorrow. Not suprisingly the painting was badly received by the critics, but once again Ruskin came to the rescue and praised and interpreted it in yet another letter to *The Times*.

Hunt himself missed all this, for, dismayed by adverse criticism and lack of ready patronage, he had left England in January 1854 to join Thomas Seddon (1821–56), a landscape painter associated with the Brotherhood through the Rossettis, in Egypt. Certainly inspired by the Oriental paintings of David Roberts, Wilkie, and, most recently, J. F. Lewis, his main aim was to paint biblical subjects in the authentic setting of the Holy Land. The best-known result of this campaign was *The Scapegoat* (Lady Lever Art Gallery, Port Sunlight), begun at 'Oosdoom, on the margin of the salt-encrusted shallows of the Dead Sea' in November 1854, and completed in Jerusalem in the following June. Hunt's on-the-spot work was undertaken in conditions of extreme discomfort and danger, and under great time pressure, but he was determined to execute as much as possible of his almost surrealist vision of Christ the Scapegoat taking upon himself the sins of the world in an appropriately desolate setting. This difficult and unattractive painting, which was, however, the centre of attention at the RA exhibition of 1856, was received with puzzlement and antagonism. *The Times* found it 'disappointing although there is no doubt much power in it', and even Ruskin was largely critical and warned in his *Academy Notes* of 1856 that 'this picture indicates a danger to our students of a kind hitherto unknown in any of our schools; the danger of a too great intensity of feeling, making them forget the requirements of painting as an *art*. This picture, regarded merely as a landscape, or as a composition, is a total failure.'[8] However, Ruskin thoroughly approved of the three Near Eastern landscape paintings which Hunt also showed in 1856, describing them as 'three intensely faithful studies' in which the somewhat strident colouring was 'precisely true – touch for touch'.

Hunt developed his ideas for *The Scapegoat* while gathering material for what was for him the most important of his Holy Land paintings, *The Finding of the Saviour in the Temple* [PL.161], an attractive and colourful composition, which is packed with meticulous detail, much of it symbolic of the future life of the Saviour. This painting also caused Hunt considerable problems, largely owing to the difficulty of finding Semitic models; because of their religious laws, Jewish men in Jerusalem were reluctant to sit for him. However, he had completed a fair number of the figures when he returned to London early in 1856, where he found it easier to obtain Jewish sitters than in Jerusalem. For Holman Hunt this work was central to his mission as a Christian artist, and its factual basis made it especially appealing to a public that was addicted to a religion true to its early origins. In April 1860 *The Finding of the Saviour in the Temple* was exhibited at the German Gallery in Bond Street, and it then toured the provinces. It became an immediate and sensational popular success, and the painting was bought

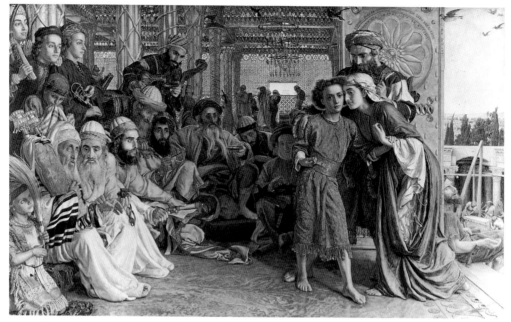

(161) William Holman Hunt, *The Finding of the Saviour in the Temple* (1854–5). Oil on canvas; 85.7×141 cm. (Birmingham Museums and Art Gallery)

by Gambart for the enormous sum of £5500, which included the copyright. However, the engraving, by Auguste Blanchard, was only published in 1867, but it then sold in very large numbers.

Holman Hunt had by now achieved widespread recognition and popularity, and he continued to produce meaningful compositions painted with much the same painstaking attention to veracity and detail as his pioneering early works, though this was to become something of a formula. After 1860 few of Hunt's works had the distinction of their predecessors, and they were certainly no longer in the slightest revolutionary, for Pre-Raphaelitism had first become an accepted mode and then became old-fashioned. Some of Hunt's most successful later paintings are portraits, such as that of Thomas Fairbairn [PL.162], shown at the Royal Academy in 1874. Fairbairn, who had commissioned *The Awakening Conscience* in 1853, and a portrait of his wife and children in 1864, was a considerable figure in the world of art, and had been Chairman of the committee for the Manchester Art Treasures Exhibition of 1857. In this sympathetic portrait the setting is the North Court of the South Kensington Museum, perhaps because Fairbairn was a Commissioner of the Great Exhibition of 1851. Such detailed and characterful portraits certainly overcame the challenge of photography, which had by then had an adverse impact on the work of the portrait painter for over quarter of a century.

However, such portraits were basically only a diversion for Hunt, who was determined to continue to create meaningful and devout Christian images, such as *The Shadow of Death* [COL.PL.51]. The subject of the youthful and healthy-looking Jesus as a young adult stretching at the end of a hard day's work in his father's carpentry workshop and casting the form of the crucified Christ as a shadow on the wall, was conceived before Hunt set out on his delayed second visit to the Holy Land in the summer

(162) William Holman Hunt, *Portrait of Thomas
Fairbairn* (RA 1874). Oil on canvas;
120.6×99cm. (Private Collection)

of 1869. He began painting the subject in Bethlehem using a smaller canvas (Leeds City
Art Galleries) than the life-size final version, so that he could paint more easily on-the-
spot in carpenters' shops and the like. He then returned to Jerusalem where he worked
on both canvases concurrently, but had great difficulty in achieving 'truth to nature'
in the large version. He found the difficulties almost overwhelming and was close to
abandoning the work, but finally felt that it was sufficiently advanced to allow him to
return to England in July 1872. For another six months or so he continued to work on
the composition, during which both pictures were bought by Agnew's, for a final total
of £10,500, which included the copyright. The engraving by Frederick Stacpoole was
another great popular success, and their high profits enabled Agnew's to present the
large version to Manchester in 1883.

The painting was exhibited in London in late November 1873, and the accompany-
ing pamphlet stressed its archaeological accuracy, but said little of the symbolism,
though *The Shadow of Death* was certainly one of the most important works fulfilling
Hunt's lifelong ambition to illustrate and bring alive the Scriptures with imagery that
would impress a contemporary audience. *The Times* critic wrote of it: 'we have here
before us the fruit of five years intense toil by a man of rare earnestness, tenacity and
originality. Besides the actual labour, no small part of the thought and knowledge of a
very industrious life has passed into this canvas. The work challenges, if for this reason
alone, the most respectful and thoughful attention.' Holman Hunt continued to paint
works that gained popular acclaim to the end of the century, when his eyesight began
to fail. One of his last successes was *May Morning on Magdalen Tower* (Lady Lever Art
Gallery, Port Sunlight), which is dated 1890. In this carefully conceived record of a fairly
recently revived Oxford ceremony in which pagan and Christian traditions were com-
bined, Hunt produced a composition that was exaggerated in its colouring and in

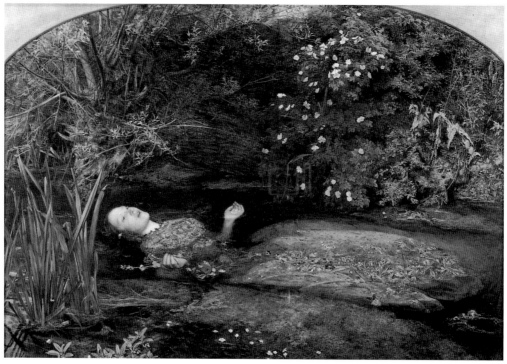

(163) Sir John Everett Millais, *Ophelia* (RA 1852). Oil on canvas; 76.2×111.8 cm.
(Tate Gallery, London)

its sentimentality, and somewhat contrived in effect; 'truth to nature' had become for-malised convention.

The popular and critical success of one of Millais's 1852 exhibits, *A Huguenot*, has already been referred to, and the direct and somewhat sentimental message of this beautifully painted composition set the tone of much of Millais's subsequent work. Based on a scene from Meyerbeer's opera *Les Huguenots*, which had been a favourite at Covent Garden since 1848, its full title is *A Huguenot, on St Bartholomew's Day, Refusing to Shield Himself from Danger by Wearing the Roman Catholic Badge*. Millais's other major 1852 exhibit, *Ophelia* [PL.163], was not so well received at the time, though it has become one of the most popular of all Pre-Raphaelite paintings and one of the most influential of all the illustrations of Shakespeare. The infinite care with which Millais painted the backgrounds of these two works was not really in keeping with the restless character of the precocious young genius, and he soon abandoned the absolute technical rules of Pre-Raphaelitism for a more congenial and painterly manner of his own. Similarly he abandoned the truly Pre-Raphaelite intellectual and symbolic qualities of his early work, and adopted themes that were usually somewhat theatrical as well as senti-mental.

This gradual change was demonstrated by Millais's two exhibits at the Summer Exhibition of 1853. There is again a meticulously painted natural background in *The Proscribed Royalist, 1651* (Private Collection), which shows a frightened Roundhead girl visiting her Cavalier lover hiding in the bole of an ancient oak tree. The tree and the background were painted in the open on West Wickham Common near Bromley in

Kent, and the subject was inspired by an opera, Bellini's *I Puritani*. The subject of *The Order of Release, 1746* (Tate Gallery, London), which was exhibited at the RA in 1853 and was another popular success, was probably Millais's own invention. Perhaps because the artist failed to find a suitable prison door from which to paint the background, the figures are larger in scale than hitherto and almost fill the canvas. The painting shows a wounded Jacobite prisoner embracing his wife and child, while she hands the order of release – painted from a genuine example – to his gaoler. Such a subject certainly owes something to the novels of Sir Walter Scott, and its undemanding mixture of pathos and sentiment helped Millais's painting to attract 'a larger crowd in his little corner in the Middle Room than all the Academicians put together',[9] and a policeman had to be installed to control the crush of spectators. Not surprisingly Millais was elected ARA that November.

The model for the head of the Jacobite's wife was Effie Ruskin, the unhappy wife of John Ruskin. In the summer of 1853 Millais joined the Ruskins for a long holiday in Scotland, at Brig o' Turk in the Trossachs. Here Millais painted the famous portrait of Ruskin [PL.164] standing by a rocky stream in Glenfinlas, and fell in love with Effie, who soon left Ruskin, had her marriage annulled, and married Millais in July 1855. This chain of events did not stop Ruskin from insisting that his portrait, with its carefully selected and meticulously painted background, be completed to his absolute satisfaction as one of the prime examples of PRB 'truth to nature'. Millais even returned alone to Brig o' Turk in May 1854 to complete his work on the rocks and stream, and the portrait was finally finished by the end of the year. This great portrait was not publicly exhibited until 1884 and has always remained in private hands. This has prevented it from taking its true place as one of the most significant 'documents' of the Pre-Raphaelite movement.

While Millais was at work on Ruskin's portrait, Holman Hunt was undergoing the almost equally traumatic experience of painting *The Scapegoat* on the shore of the Dead Sea. Both these remarkable 'documents' illustrate the eccentricities as well as the strengths of the Pre-Raphaelite movement, but while these remained the basis of Hunt's work, for Millais the future was to take him along a much less arduous and more individualistic route, which led to considerable fame and fortune, including a Baronetcy in 1885 and the Presidency of the Royal Academy in the last year of his life in 1896. Thus Millais's response to Hunt's difficult problem picture of 1854, *The Awakening Conscience*, was the much less demanding *The Blind Girl* [COL.PL.52], shown at the RA in 1856. Although this also deals with a social problem of the day, vagrancy amongst children, it is essentially a straightforward and touching composition of two children caught in a vivid and beautiful rainstorm. The blindness of the older girl is cleverly shown, but the composition largely lacks the disturbing moralising of Hunt's canvas.

Autumn Leaves (City of Manchester Art Galleries), which was also shown at the Academy in 1856, was conceived, according to Effie, as 'a picture full of beauty but without subject'. Painted in Scotland, in the garden of Annat Lodge, Perth, quite near Effie's family home and where she and her new husband had come to live after their marriage, it is a twilight scene with a pair of rich girls (modelled by Effie's younger sisters) and a pair of neighbouring poor girls gathered round a pile of smouldering leaves. Despite Effie's statement, much can be read into this autumnal scene – mortality,

(164) Sir John Everett Millais, *Portrait of John Ruskin* (1853–4). Oil on canvas; 78.7×68cm.
(Private Collection)

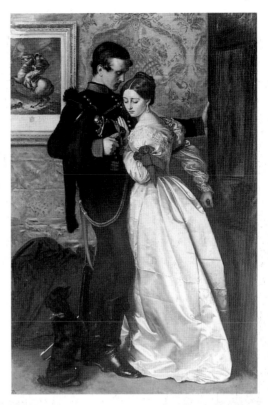

(165) Sir John Everett Millais, *The Black Brunswicker* (RA 1860). Oil on canvas; 104×68.5 cm. (Lady Lever Art Gallery, Port Sunlight)

decay, death and the transience of life are all brought to mind, though it seems that at the time the work was largely regarded as a genre picture or a study of nature. Millais was very pleased when F.G.Stephens drew attention to the allegorical qualities of *Autumn Leaves* in an article on the Pre-Raphaelites in the American magazine *The Crayon*. In the following years Millais produced several more major paintings in similar non-narrative vein, among them *Spring (Apple Blossoms)* (Private Collection) and *The Vale of Rest* (Tate Gallery, London), which were both shown at the RA in 1859, and are painted in Millais's much freer manner. These two rural scenes – one featuring a picnic in a sunlit apple orchard, the other a nun digging a grave in a cemetery at twilight – were conceived as a pair, and again bring to mind the theme of mortality. Millais had unusual difficulty in selling these two large canvases, but had no such problem with his main exhibit of 1860, another beautifully painted scene depicting the problems of young love, entitled *The Black Brunswicker* [PL.165], which is set in the time of the Napoleonic Wars. This was bought by the dealer Gambart for 1000 guineas. Designed as a pendant to the highly successful *A Huguenot* of eight years earlier, it was again a popular favourite and attracted enthusiastic comments from the critics.

Such sentimental subjects were now common among the artists of the Pre-Raphaelite circle, and Millais continued to augment his own popularity with further examples at the Royal Academy, including *My First Sermon* in 1863, and its pair, *My Second Sermon* in the following year (both Guildhall Art Gallery, London). This delightful pair poses no problems – in the first the smartly dressed little girl, modelled by the artist's eldest daughter Effie, is wide awake and attentive – in the second she

(166) Sir John Everett Millais, *Chill October* (1870). Oil on canvas; 141×186.7 cm.
(Private Collection)

is asleep! Millais's series of evocative paintings of children peaked with the famous *Bubbles* in 1886, for which his grandson Willie (later to become an Admiral) posed as the blond-haired little boy blowing soap bubbles, which were painted from a glass sphere made specially for the purpose. *Bubbles* was purchased with its copyright by *The Illustrated London News*, and appeared as a presentation plate with their 1887 Christmas Number. It was sold on to Messrs A. & F. Pears, and for many years, to the artist's fury, it was widely used in advertisements for Pears soap, and was probably Millais's best-known painting.

 One of Millais's strengths in his later years was the variety of his work, both in its subject matter and in its manner of painting. The latter ranged from the meticulous basically Pre-Raphaelite technique of *The Black Brunswicker*, to the very free and rapid manner of *The Eve of St Agnes* (Royal Collection), which was also shown at the Royal Academy in 1863. This looser style is seen at its best in some of his landscape paintings, such as *Chill October* [PL.166], which was shown at the RA in 1871. This was the first of several large-scale Scottish landscapes, usually bleak and melancholy in mood, and it represented one of Millais's favourite views near Perth, an area he knew well as it was where Effie's family lived, and where he did much of his salmon fishing – his favourite means of relaxation. In a note originally pasted on the back of the canvas, the artist stated that he 'chose the subject for the sentiment it always conveyed to my mind, … I made no sketch for it, but painted every touch from Nature, on the canvas itself, under

irritating trials of wind and rain. The only studio work was in connection with the effect.'[10]

These loosely painted and somewhat sentimental landscapes contrast strongly with the powerful and firmly executed portraits of Millais's later years. These added not only to his standing as an artist but also brought him a considerable additional income, needed to finance the high standard of living which he and Effie and their large family enjoyed. The Tate Gallery's *Mrs Bischoffsheim* [COL.PL.53] which was one of three portraits that Millais exhibited in 1873, was a triumphant success with public and critics alike, and was compared with Velázquez. It was also 'quite a sensation' at the Exposition Universelle of 1878 in Paris and at Munich in the following year. Compared to this elaborate portrayal of the financier's confident wife, Millais's portraits of men are usually much more direct, as in the case of the striking three-quarter length of Gladstone (National Portrait Gallery, London), painted in 1879 when the statesman was between his first two periods of office as Prime Minister. Carlyle, Disraeli, Tennyson, Henry Irving and G. F. Watts were among the many other leading men of the day who sat to Millais.

Millais also continued to produce a regular flow of highly regarded subject pictures of which *The Boyhood of Raleigh* (RA 1870) and *The North-West Passage* (RA 1874; both Tate Gallery, London) were among the most successful, certainly partly because they illustrated the ever-popular subject of English exploration and navigation. The even more sentimental *The Ruling Passion*, shown at the Royal Academy in 1885 (Art Gallery and Museum, Glasgow), was not as well received and failed to sell. Later called *The Ornithologist*, it shows an invalid and elderly ornithologist lying on a couch studying a small stuffed bird and surrounded by members of his family of all ages. There is no narrative and no message – just pure sentiment presented with a great deal of finely but quite loosely painted detail. In such a work Millais had moved too far from his Pre-Raphaelite origins to satisfy contemporary critics and the judgement of posterity, but in the art world of the day he continued to be lionised, and also in 1885 he became the first artist to be created a Baronet.

25 Dante Gabriel Rossetti (1828–82)

Christened Gabriel Charles Dante Rossetti, but rearranging his names as Dante Gabriel Rossetti at an early age, the third major member of the Pre-Raphaelite Brotherhood was born in London in 1828, the first son of a Neapolitan political refugee, Gabriele Rossetti, scholar, poet and patriot, who had settled in London in 1824. Successively librettist at the Naples opera house and curator of antiquities at the city's museum, Gabriel Rossetti established himself as a teacher of English, was appointed Professor of Italian at King's College in 1831, and published several controversial works on Dante. In 1826 he had married Frances Polidori, half-Italian and half-English, the daughter of another exiled Italian scholar and poet, and herself also a private teacher. Rossetti's younger brother, William Michael, was born in 1829, and his younger sister Christina, the poet, in 1830; the oldest of the four Rossetti children, Maria Francesca, was born in 1827.

Thus Dante Gabriel grew up in a stimulating and cultured Anglo-Italian family

background, in which poetry, art and religion were important factors; the three Rossetti women were active Anglo-Catholics. The gifted, precocious, exotic, sociable and impatient elder son read voraciously and drew instinctively, entering Sass's Drawing Academy when only thirteen years old, and producing illustrations to some of the authors he was reading, including Shakespeare and Goethe. One of his early artist heroes was the short-lived romantic painter, Theodor von Holst (1810–44), who was himself greatly influenced by Fuseli.[11] In 1847 Rossetti purchased a volume of designs and writings by William Blake from Samuel Palmer's brother, William, and the influence and example of the great painter-poet was to be important for his Victorian counterpart throughout his life. Like Blake, and unlike Hunt and Millais, Rossetti never moved in the mainstream artistic world of his day, and again like Blake he attracted faithful artistic followers and in the long term he was certainly the most influential of the Pre-Raphaelite Brothers.

The element of impatience in Rossetti's character meant that he tried to bypass the normal drudgery of artistic training. While he gained entry to the Royal Academy Schools late in 1845 he rarely attended the classes, and he never acquired the technical skills of a fully trained painter, though in 1848 he spent a few weeks studying the techniques of painting in oils with Ford Madox Brown. Rossetti was always more of a draughtsman than a painter, and compared with the fluent qualities of some of his illustrative drawings of the mid-1840s, his first major oil painting, the famous *Girlhood of Mary Virgin* [COL.PL.47] of 1849 is somewhat stiff and hesitant, and lacks the painterly qualities of the contemporary work of Millais and Hunt. However, the two sonnets which Rossetti composed to accompany the painting are far more fluent, and it should be remembered that at this very time the young artist was deliberating on whether to devote himself primarily to painting or to poetry. Fortunately he never made an actual choice, and continued to write throughout his life, but he did not publish a volume of his own poems until 1870. His poetry and his prose writing, like his drawing and painting, are distinguished by their sensual and mystic qualities, as in his poem *The Blessed Damozel*, which was first published in 1850 in the second number of *The Germ*. Dante Gabriel Rossetti is of importance for students of both nineteenth-century British art and literature.

In their drawings at the time of the launching of the Pre-Raphaelite Brotherhood all the three principal artists were working in an angular style which combined strong outlines with minimal shading, and which owed much to the work of the German Nazarene artists of two decades earlier, and indirectly to the draughtsmanship of Flaxman and Blake at the end of the previous century. An outstanding example of this manner in pen and ink is *Dante drawing an Angel on the First Anniversary of the Death of Beatrice* [PL.167], which is signed *Dante G. Rossetti / P-R.B. 1849* and which is also inscribed *Dante G. Rossetti / to his P R Brother / John E. Millais*. At the bottom of the sheet Rossetti has written the relevant passage from his own translation of Dante's *Vita Nuova*, which he had completed in October 1848. Thus this powerful drawing, showing the mourning Dante interrupted by a group of friends, is another invaluable document of Rossetti's dual role as poet and painter, and of his ability to practise both these skills at a vital time in his own development within the framework of Pre-Raphaelitism, of which he was certainly the leading and most gifted spirit. However, after the ad-

(167) Dante Gabriel Rossetti, *Dante drawing an Angel on the First Anniversary of the Death of Beatrice* (1849). Pen and black ink; 39.4×32.6cm. (Birmingham Museums and Art Gallery

verse reception of his second Pre-Raphaelite canvas, *Ecce Ancilla Domini!* (Tate Gallery, London), shown at the National Institution in 1850, Rossetti virtually stopped painting in oils and withdrew from the public stage, exhibiting his work only on rare occasions. From then on he was largely supported by a group of private collectors, which included John Ruskin, and he was able to produce his highly personal compositions and illustrations without having to take account of popular taste or critical discussion. However, from now on the medieval nature of his miniature-like technique and of much of his subject matter was certainly in line with the powerful overall revival of interest in medievalism in the literature, religion, art, design and architecture of early Victorian Britain, as demonstrated by the new Palace of Westminster.

Though Rossetti rarely painted in oils during the 1850s, throughout these years his work in watercolours and in pen and ink often used methods as painstaking and precise as those adopted by the other Brothers in their painting. Many of these featured medieval subjects and were on a very small scale, with a group of figures enclosed in a restricted space, thus adding to the tense emotional quality of the composition. Using jewel-like colours in an elaborate stipple technique, a tiny watercolour like *Lucretia Borgia* (Carlisle Museum and Art Gallery), which measures only 23.2 x 24.8 cm, and which was originally executed in 1851 and reworked in 1860, has all the power of a much larger composition.

During these years much of Rossetti's subject matter was taken from Dante, and in 1853 he repeated the romantic subject of Plate 167 in a larger watercolour version now in the Ashmolean Museum. This *Dante drawing an Angel* [COL.PL.56] is Rossetti's

most ambitious medieval interior and is executed in relatively delicate colours; the 'pointillist' view of the River Arno and the Ponte Vecchio in Florence seen through the window is the most effective piece of landscape in Rossetti's work. Commissioned by Francis McCracken, who had bought *Ecce Ancilla Domini!*, this important work was acquired at the McCracken Sale in 1855 by Thomas Combe, and in his collection it was widely seen. It was 'this thoroughly glorious work' which inspired Ruskin to write his first letter to Rossetti, and the critic soon became one of the artist's most important patrons, commissioning a series of watercolours in 1855.

The model for the woman in the Ashmolean drawing was Elizabeth Siddal (1829–62), a beautiful milliner's assistant who had been introduced to the Pre-Raphaelite circle by Walter Deverell late in 1849. With her lovely red hair contrasting with her pale complexion she became one of the Pre-Raphaelites' favourite models, most famously posing in a bathtub full of water heated by lamps for Millais's *Ophelia* [PL.163]. However, during the last ten years of her life, which were overshadowed by constant ill-health, she modelled only for Rossetti, who finally married her in 1860. He made numerous sensitive and tender drawings of Elizabeth Siddal, shown most frequently sitting gracefully and languorously in an armchair. While Lizzie was Rossetti's chief inspiration during these productive years, the artist also encouraged her to develop her own skills as poet and painter, and over 100 works by her are known today, most of them in a somewhat naïve variant of her future husband's manner at this time. The last years of Elizabeth Siddal's life were totally dominated by illness, and she died from an overdose of laudanum early in 1862. Dismayed and distraught Rossetti placed a manuscript volume of unpublished poems in her coffin; this was, however, exhumed in 1869, and *Poems*, his first volume of poetry, was published in the following year.

Though most of Rossetti's work during the 1850s was devoted to literary and medieval subject matter, he was also struggling during these years and until his death to paint a modern life subject in oils in line with the contemporary work of his PR Brothers. *Found* [PL.168], which he began in 1854 but never himself completed, shows a country drover who has just crossed Blackfriars Bridge taking a calf tethered in a cart to market and meeting his former sweetheart, now a London prostitute, who cowers against a cemetery wall. The symbolism of this relatively straightforward composition, for which Rossetti made numerous preliminary studies, is most effectively evoked by his accompanying sonnet, which opens with these lines:

'There is a budding morrow in midnight:' –
So sang our Keats, our English nightingale.
And here, as lamps across the bridge turn pale
In London's smokeless resurrection-light,
Dark breaks to dawn. But o'er the deadly blight
Of love deflowered and sorrow of non avail,
Which makes this man gasp and this woman quail,
Can day from darkness ever again take flight?

Elizabeth Siddal never modelled for *Found*, and it was the much more voluptuous and vulgar Fanny Cornforth who finally posed for the prostitute. Rossetti first met the cockney Fanny Cornforth in 1858, and she remained his mistress and his occasional

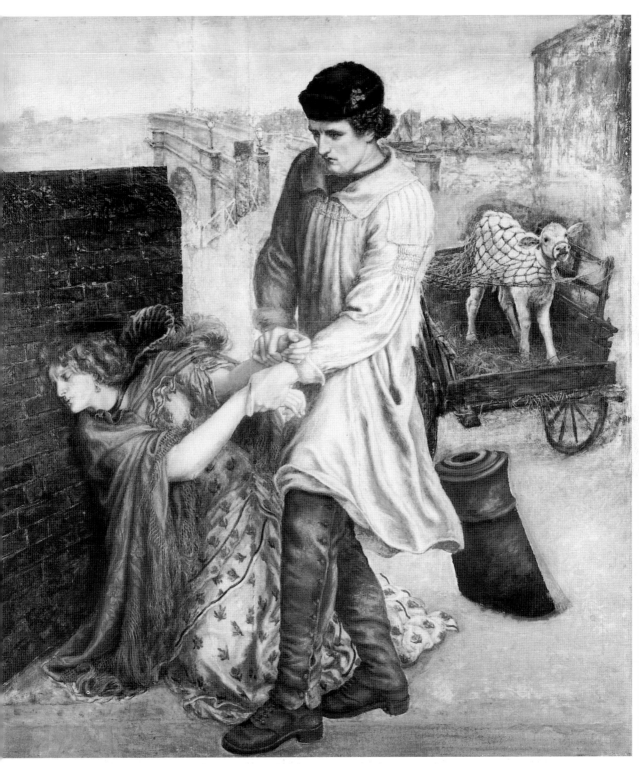

(168) Dante Gabriel Rossetti, *Found* (begun 1854). Oil on canvas; 91.4×80 cm.
(Samuel and Mary Bancroft Collection, Wilmington Society of Fine Arts, Delaware)

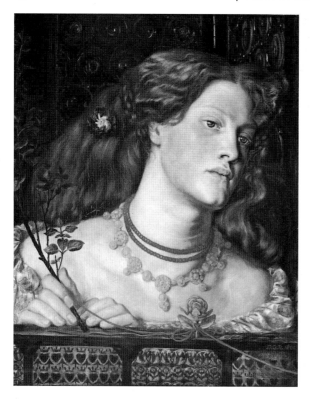

(169) Dante Gabriel Rossetti,
Fair Rosamund (1861). Oil on canvas;
52.1×41.9cm. (National Museum
of Wales, Cardiff)

model until the end of his life. She was the first of the 'stunners' who were to be such a feature of Rossetti's later work, when the artist again started painting in oils to portray striking and colourful images of beautiful women, often reminiscent of the work of sixteenth-century Venetian artists such as Titian and Veronese. Fanny was the model for *Fair Rosamund* [PL.169], a small canvas dated *1861*, which embellishes the impact of her striking beauty with fine jewellery and exquisitely painted flowers and decorative detail.

The decorative element had become far more important in Rossetti's work since his undertaking in 1857 of a scheme to paint large-scale murals in the ten bays below the ceiling of the newly completed neo-Gothic Oxford Union Debating Hall (now the Library). Rossetti quickly mustered six artist friends to join him – William Morris, Edward Burne-Jones, Arthur Hughes, Valentine Prinsep, J.Hungerford Pollen and Spencer Stanhope – and it was decided to illustrate incidents from Malory's *Morte d'Arthur*, also the subject of William Dyce's current Westminster Queen's Robing Room decorations. The artists had little experience of wall-painting and worked on brickwork that was still partly damp and which had received only one coat of whitewash. Rossetti himself agreed to decorate two bays, but in the event started and never finished only one, with *Sir Launcelot's Vision of the Sanc Grael*. The whole episode was an enjoyable social success both for the artists and for their many visitors, and for a short time the completed murals looked marvellous, glowing, as described by Coventry Patmore in the *Saturday Review* 'with a voluptuous radiance of variegated tints … with colouring so brilliant as to make the walls look like the margin of a highly illuminated manuscript.'

However, the success was shortlived and owing to their almost total lack of technical knowledge the artists' work deteriorated very rapidly. Despite several attempts at repair and restoration the Oxford Union decorations are barely visible today, but their spontaneous and eager creation was an important event in the history of the Pre-Raphaelite movement.

One reason for this claim, discussed in more detail later, was that this contact with Rossetti finally persuaded William Morris and Edward Burne-Jones, who had met as undergraduates at Exeter College in 1853, to become artists. In 1861 Rossetti was one of the founders of the firm of 'fine art workmen', Morris, Marshall, Faulkner and Co., which enhanced the immensely successful and influential revival of the decorative arts in Britain under the leadership of William Morris, influenced by the teaching of John Ruskin. Rossetti designed furniture and stained glass for the firm, and in 1871 he and Morris took a joint tenancy of Kelmscott Manor in the Cotswolds, which remained Morris's home until his death in 1896. An even more important link between Rossetti and Morris was the strikingly beautiful Oxford girl Jane Burden, who became Morris's wife in 1859, and who was also to become Rossetti's mistress and one of his favourite and most inspiring models in the later years of his life.

None of the 'stunners' of the 1860s and 1870s was ever as central to Rossetti's inspiration as Elizabeth Siddal had been, and that relationship is symbolised in the hauntingly poetic and spiritual *Beata Beatrix* (Tate Gallery, London), which was considered by the artist as a memorial to his wife. It is based on drawings of Elizabeth Siddal and was probably begun some time before her death, though not finally finished until 1870. At the sides the figures of Love and of Dante gaze at each other, with the Ponte Vecchio in the background. In 1871 Rossetti wrote to the Hon. Mrs Cowper-Temple, whose husband had commissioned *Beata Beatrix*, and who presented it to the nation in his memory in 1889: 'You are well acquainted with Dante's *Vita Nuova* which it illustrates, embodying, symbolically, the death of Beatrice, as treated in that work. It must of course be remembered in looking at the picture, that it is not at all intended to represent Death, … but to render it under the resemblance of a trance, in which Beatrice seated at the balcony over-looking the City is suddenly rapt from Earth to Heaven.'[12]

It was some years after Lizzie Siddal's death, in about 1865, that Jane Morris began sitting regularly for Rossetti, and his first large portrait of her, dated 1868, is still at Kelmscott, which now belongs to the Society of Antiquaries [COL.PL.54]. With her strong chin, long neck and luscious curling hair, Jane Morris was a much more positive model than the ethereal Elizabeth Siddal, and Rossetti painted and drew her again and again dressed in strong colours, like the deep blue of this portrait, to accentuate her pale visual features. He presented her in a variety of literary and historical characters, such as Mariana, Pandora, Proserpine, and Astarte Syriaca, but the pose is always pensive and static. Jane Morris was the prototype for several of Rossetti's other models, most notably Alexa (or Alice) Wilding, who also began to sit for him in 1865. A dressmaker whom he spotted one evening in a London street and persuaded to model for him, paying her a weekly fee to do so exclusively, her lovely features were similar but somewhat softer than those of Jane, and her hair was even lusher. Alexa Wilding was the model for *Monna Vanna* [COL.PL.55], which is dated 1866 but was retouched in 1873. This sumptuous painting, with its white and gold damask dress and its bright red coral necklace, is

one of the most Venetian of Rossetti's works, and he originally called it 'Venus Veneta'.

During the last ten years of his life Rossetti was plagued by eye trouble, insomnia (which caused addiction to chloral), ill health and depression – he attempted suicide in 1872. However, he continued to produce his opulent and dreamlike visions of beautiful women, which were emulated by several immediate followers such as Burne-Jones and Frederick Sandys, but also had a strong influence on later artists, and especially on the work of the French Symbolists in the last decade of the century. From his Pre-Raphaelite beginnings Rossetti developed a wholly personal style and idiom, using his artistic and poetic genius to idolize the facial beauty of woman, and to enhance that beauty by surrounding it with rich colours and textures, graceful flowers and elegant decorative details. John Ruskin was not exaggerating when commemorating his 'much loved friend' in the first of his second series of Slade Lectures given at Oxford in 1883, he praised Rossetti's wonderful use of colour 'based on the principles of manuscript illumination', and described him as 'the chief intellectual force in the establishment of the modern romantic school in England'.[13]

26 Ford Madox Brown (1821–93) and other Pre-Raphaelite Associates

In addition to Hunt, Millais and Rossetti, only two of the original seven Pre-Raphaelite Brothers were active as painters, and of these two Frederic George Stephens (1828–1907) completed only a handful of paintings, including the Tate Gallery's enigmatic and painstaking *Mother and Child* of about 1854, before abandoning painting in favour of writing and teaching. From 1861 until 1901 he was the influential art critic of *The Athenaeum*, and he also wrote for other journals and produced numerous books, including works on Landseer and Mulready. Stephens was Secretary of the Hogarth Club, which between 1858 and 1862 was an exhibiting and social centre for the Pre-Raphaelites and their followers. William Michael Rossetti (1829–1919) was, of course, also active as critic and writer, while Thomas Woolner (1825–92) was a sculptor, whose career, after a slow start and a brief period in Australia, was ultimately a successful and conventional one. Working mainly on portrait busts and statues, he became an RA in 1875 and Professor of Sculpture at the Royal Academy two years later.

James Collinson (1825–81), on the other hand, continued to paint throughout most of his life, though he abandoned art for a short time in 1853–4 during an unsuccessful attempt to become a Roman Catholic priest. A convert, he had previously reverted to the Church of England in order to become engaged to Christina Rossetti, but the engagement was soon broken off and Collinson resigned from the Brotherhood in 1850. At that time he was at work on his only truly Pre-Raphaelite painting, *The Renunciation of the Queen of Hungary* (Johannesburg Art Gallery), which was exhibited at the Portland Gallery in 1851 and at the Liverpool Academy in 1852. Inspired by a scene in a recent play by Charles Kingsley, this somewhat stiff composition combines the Pre-Raphaelite emphasis on detail with implicit comment on contemporary religious issues. In his later work Collinson retained something of the Pre-Raphaelite detail but returned to the basic genre subjects which he had painted at the beginning of his career, such as *For Sale*

and *To Let*, which were shown at the Royal Academy in 1857, though it is not certain which of the several versions the exhibited paintings are.

Ford Madox Brown was never a member of the Brotherhood, but was closely associated with the Brothers both in the influence he had on them and in the impact of their beliefs on his own painting. Brown was born in Calais, and grew up and received his training on the Continent, before settling in England in 1844. His family had moved to Belgium in 1833, and Madox Brown received a sound academic art training in Bruges and Ghent, where both his teachers were pupils of David, and finally at the Antwerp Academy, under the leading historical painter, Gustave, Baron Wappers. He then spent three years in Paris, studying the works of the old masters in the Louvre and contemporaries such as Delacroix and Flandrin. The best-known painting of these early years is *Manfred on the Jungfrau* (Manchester City Art Galleries) which illustrates a dramatic scene from Byron's *Manfred*. With all this experience behind him entering the Palace of Westminster competitions was a natural next step, and he submitted three cartoons in 1844. He did not win a prize or a commission, but when shown in Westminster Hall his compositions were noticed and admired by the art students who were to become the Pre-Raphaelite Brothers four years later, and it will be remembered that it was to Madox Brown that Rossetti turned for instruction in oil painting in 1848.

By then Madox Brown's somewhat eclectic style had changed completely, for after a visit in 1845–6 to Basle, where he saw the work of Holbein, and then to Rome, where he studied the early Italian masters and the German Nazarenes, his manner became firmer and more realistic and his colouring lighter. This is seen in his vast *Geoffrey Chaucer Reading the 'Legend of Custance' to Edward III and his Court* (Art Gallery of New South Wales, Sydney), which he began in Rome but which was not shown at the Royal Academy until 1851. The composition had started as a triptych, as in the Ashmolean Museum's vivid small study, *The Seeds and Fruits of English Poetry*, but this proved too arduous an undertaking on a large scale. *Chaucer at the Court of Edward III*, with its multitude of figures, is closely based on the central panel of the study and retains its liveliness and cohesion. While working on that huge canvas Madox Brown was also painting the smaller and less complex *The First Translation of the Bible into English: Wycliffe Reading his Translation of the New Testament to his Protector, John of Gaunt, Duke of Lancaster, in the Presence of Chaucer and Gower, his Retainers* [PL.170], which was shown at the Free Exhibition in 1848, where it was well received. Partly painted on a white ground, it was based on numerous carefully drawn and detailed drapery and portrait studies, of which many are today in Birmingham, and the artist took especial care to achieve authenticity in the furniture, lettering and the like. For his later work Madox Brown made relatively few preparatory drawings, and the completed compositions often differed from those drawings that he had made.

In the 1850s much of Madox Brown's work was directly influenced by the example of the young Pre-Raphaelites, who in their turn considered him as a valuable mentor. His own first essentially Pre-Raphaelite painting was *'The Pretty Baa Lambs'* (Birmingham Museums and Art Gallery), which was begun in 1851 and painted out-of-doors in five months of 'hard labour'. However, unlike Hunt and Millais at this time, Madox Brown painted not only the landscape but also the figures – a standing lady holding a child, a kneeling woman picking flowers, and numerous lambs – were painted in the

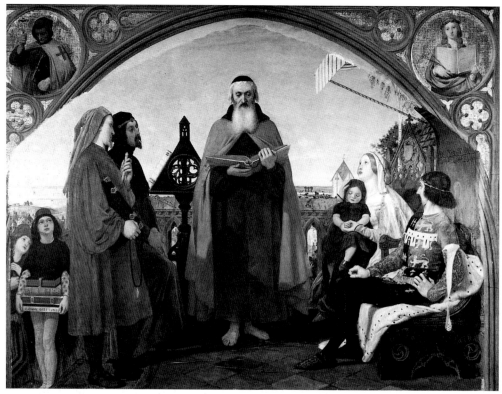

(170) Ford Madox Brown, *The First Translation of the Bible into English: Wycliffe Reading his Translation of the New Testament to his Protector, John of Gaunt, Duke of Lancaster, in the Presence of Chaucer and Gower, his Retainers* (1848). Oil on canvas; 119.5×153.5 cm. (Bradford Art Galleries and Museums)

open. This resulted in a harmonious unity of colour and light, which was missing in some of the Pre-Raphaelite works of this time. Writing about the picture, which he had considerably re-touched and altered, especially in the distant landscape, in 1859, in the catalogue of the 1865 exhibition of his work, Madox Brown denied somewhat disingenuously that the painting had any specific meaning, and stated that 'this picture was painted out in the sunlight; the only intention being to render that effect as well as my powers in a first attempt of this kind would allow'. When exhibited at the Royal Academy in 1852, the year of Hunt's *The Hireling Shepherd* [COL.PL.50] and of Millais's *Ophelia* [PL.163], 'The Pretty Baa Lambs' was badly hung and badly received. The critic of the *Art Journal* dismissed it as a 'facetious experiment upon public intelligence'. In all three 1852 paintings the landscape was a vital factor, and though the three artists all painted 'pure' landscape at various stages in their careers, it was only Madox Brown who made a significant contribution to Pre-Raphaelite landscape painting. This will be discussed in the next chapter.

The Last of England [PL.171], which was begun in the winter of 1852–3, is considered by many to be Ford Madox Brown's masterpiece, and is certainly one of the most popular 'icons' of Pre-Raphaelite art. Inspired by the departure of the P-R Brother Thomas Woolner and his wife as emigrants to Australia in July 1852, and by his own acute problems in making a living at this time, this was definitely a picture with a

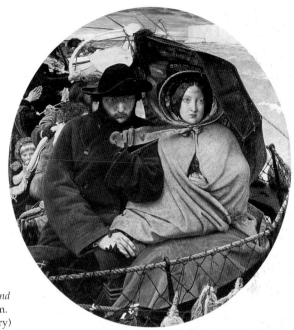

(171) Ford Maddox Brown, *The Last of England*
(1852–5). Oil on panel, oval; 82.5×75 cm.
(Birmingham Museums and Art Gallery)

message. In his 1865 catalogue Brown described it as 'in the strictest sense historical. It treats of the great emigration movement which attained its culminating point in 1852.' The artist's second wife, Emma, was the model for the woman, and he painted himself as the man, and used local people – he was then living in various parts of north London – as models for the background figures. The tragic intensity of the 'couple from the middle classes, high enough, through education and refinement, to appreciate all that they are now giving up', is contrasted with the relative light-heartedness of the figures behind them in the boat – 'an honest family of the green-grocer kind' and other lower-class persons. The poignancy of the scene is enhanced by the proximity of the figures squeezed into the canvas's oval format, and emphasising 'the discomforts and humiliations incident to a vessel "all one class"'. Painted largely out-of-doors, and marvellously precise in all its details, *The Last of England* took almost three years to complete. However, on completion it was bought immediately by Brown's dealer, D.T.White, for £150 including copyright, and he quickly sold it to the well-known collector B.G. Windus of Tottenham. This sale finally ended Brown's period of despair, and he gave up his own ideas of emigrating to India.

Ford Madox Brown's second major Pre-Raphaelite picture, *Work* [COL.PL.64], was also begun at Hampstead in 1852, but was not completed until 1865. Set half-way up Heath Street, this complex composition represents work in all its forms, ranging from the 'ragged wretch who has never been *taught* to work', to 'the *rich* who have no need to work', with 'the British excavator' (or navvy) at centre stage. At the edge of the canvas and set apart from the rest are the 'brainworkers', modelled by Thomas Carlyle, whose teachings greatly influenced the artist, and the Revd F.D.Maurice, founder and principal of the Working Men's College, where Madox Brown himself taught. This *tour de force* is an impressive and digestible piece of social commentary, and ranks as a major

achievement in the true Pre-Raphaelite tradition. Madox Brown took great pains in developing the details of *Work* and in painting the background (in the open). He was very careful in his choice of models – real workmen and poor Irish were used for the labourers, while the baby is a portrait of one of his own children. *Work* was first exhibited in 1865 as the centre-piece of the artist's one-man show of one hundred paintings and drawings at 191 Piccadilly. In the same year Madox Brown moved to 37 Fitzroy Square, which became a centre of hospitality for artists and their circle, and the next ten years were a period of relative prosperity and supportive patronage.

In 1861 Madox Brown had been a founder member of William Morris's decorating firm, for which he designed furniture and stained glass, the latter influencing the style of his later painting, which reverted to that of his earlier historical works, though in a much looser technique. Madox Brown also spent much time re-touching many of his earlier paintings and producing replicas of some of them. The final years of his career were largely devoted to a series of twelve murals illustrating events in the history of the city for the Great Hall in the new Manchester Town Hall, completed to the designs of Alfred Waterhouse in 1877. Madox Brown received this commission in 1878, lived in Manchester from 1881 to 1887, and completed the final painting in 1892. The series is very varied in quality and most of the huge compositions are both facile and old-fashioned; the most memorable shows *Dalton collecting Marsh-Fire Gas*, which is dated 1887. While in Manchester he also designed the decorations of the Jubilee Exhibition Hall, where a second Art Treasures Exhibition was held in 1887. There are echoes of Pre-Raphaelitism in these late decorative works, especially in their colour, but on the whole they are closer to the continental academic manner in which Madox Brown was trained in the 1830s.

Another slightly older artist who became associated with the Pre-Raphaelites was William Lindsay Windus (1822–1907), who was born in Liverpool and trained and exhibited from 1845 at the Liverpool Academy, becoming a Member in 1848. His paintings mostly depicted literary and historical subjects, with religious or moral overtones. It was largely Windus's influence at the Liverpool Academy, where many Pre-Raphaelite painters exhibited in the 1850s, which led to the award of the annual £50 prize to Holman Hunt, Millais and Madox Brown on six occasions, though their paintings were not popular with the Liverpool public, and the subsequent controversy resulted in the gradual ending of these important provincial exhibitions. It was when he had visited the Royal Academy exhibition in 1850 that Windus came under the influence of the Pre-Raphaelites, being especially moved by Millais's *Christ in the House of his Parents* [PL.159]. In 1856 he exhibited at the RA himself, but his rather gaunt *Burd Helen* (Walker Art Gallery, Liverpool), illustrating the Scottish ballad of that name, was badly hung and largely ignored by the critics. However, both Rossetti and Ruskin praised it, and the artist was enormously encouraged. His only other RA exhibit, *Too Late* (Tate Gallery, London), was shown in 1859. This haunting and enigmatic image of disappointed love was demolished by Ruskin in his *Academy Notes*, and Windus, also overwhelmed by personal tragedy, largely withdrew from the artistic scene.

Unlike Windus, who never attempted to become a member of the Brotherhood, Charles Allston Collins (1828–73), younger son of the landscape and genre painter William Collins,[14] was proposed for membership, by Millais, but was rejected. He was

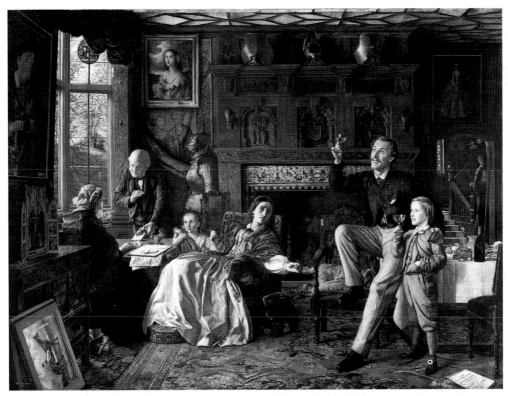

(172) Robert Braithwaite Martineau, *The Last Day in the Old Home* (1862). Oil on canvas; 107.3×144.8 cm. (Tate Gallery, London)

also rejected by Rossetti's older sister, Maria, with whom he had fallen in love, but in 1860 he married Dickens's daughter, Kate. Collins's *Convent Thoughts* (Ashmolean Museum, Oxford), shown at the RA in 1851, was certainly the artist's most significant work, though for the next few years he continued to exhibit paintings reflecting his High Anglican piety and his sensitivity. In the later 1850s he abandoned painting in favour of writing.

More directly associated with the Pre-Raphaelites, as a pupil of Holman Hunt in 1851–2, was Robert Braithwaite Martineau (1826–69), whose first RA exhibit, *Kit's Writing Lesson* (Tate Gallery, London), shown in 1852, was completed in Hunt's studio. Illustrating a scene from Charles Dickens's *Old Curiosity Shop* (first published in 1841) this is essentially a sentimental genre picture. The same is not entirely true of Martineau's best-known work, which he considered his masterpiece and which is also in the Tate Gallery, *The Last Day in the Old Home* [PL.172]. This took Martineau nearly a decade to complete and was exhibited with great success at the International Exhibition of 1862. Combining the emotional narrative so beloved of the Victorians with Pre-Raphaelite accuracy and detail, this shows three generations of a once wealthy family on their last day in the rich and crowded setting of their ancestral home, which they have to leave because of the gambling debts of the father, shown drinking a toast with his young son, and seemingly untroubled by it all. The objects in the room have all been lotted up, and a Christie's sale catalogue is on the floor in the right foreground.

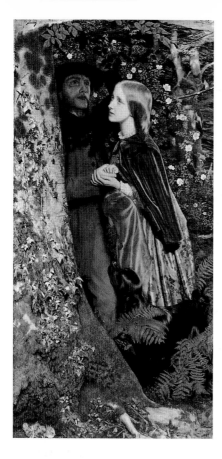

(173) Arthur Hughes, *The Long Engagement* (RA 1859).
Oil on canvas; 105.4×52.1 cm. (Birmingham Museums
and Art Gallery)

The Last Day in the Old Home is a picture with a story, and though connected with Pre-Raphaelitism in its meticulous presentation, it has little to do with the true seriousness of the Pre-Raphaelite modern moral subject.

There is much greater depth of feeling about the highly charged and poetic compositions of Arthur Hughes (1832–1915), who was especially inspired by Millais's paintings of lovers' meetings. Born in London, he became a student at the Royal Academy Schools in 1847, at the same time as the sculptor Alexander Munro, through whom he was to meet Rossetti, having already been deeply impressed by the Pre-Raphaelite ideas about which he read in *The Germ*. His first Royal Academy exhibit in the Pre-Raphaelite manner was *Ophelia* (Manchester City Art Galleries), which was shown in 1852 the year in which Millais exhibited his moving interpretation of Shakespeare's tragic heroine [PL.163]. In Hughes's semicircular composition Ophelia is shown seated on a tree-trunk, casting flowers into the river, and both technically and emotionally the painting is an outstanding achievement for a twenty-year-old. Four years later Hughes showed *April Love* (Tate Gallery, London) at the Academy, and this was the first of his truly Pre-Raphaelite works in which he combined strong colours, beautifully observed natural detail, and moving emotional qualities. *April Love* was bought at the exhibition by William Morris, and it was warmly praised by Ruskin in his *Academy Notes,* in which he described it as 'exquisite in every way'.

In 1857 Hughes was one of the young artists who joined Rossetti in the decoration of the Oxford Union Debating Hall. At the time he was already at work on his next, and best-known, 'Pre-Raphaelite' painting, *The Long Engagement* [PL.173], which was shown at the RA in 1859. In this sentimental composition, Hughes has painted a shady

woodland setting to frame a pale and rather plain not-so-young woman consoling, as is his dog, her disconsolate clerical fiancé. It is a totally uncomplicated and direct image which achieves in paint on canvas the emotional message that one would more usually find in many pages of fiction or lines of poetry, and is at the same time a painting that attracts because of its fine colours and beautiful details. There is a similarly direct and clear message in *Home from Sea* (Ashmolean Museum, Oxford), which shows a young sailor prostrate in a country churchyard on the newly dug grave of his mother with his sister kneeling anxiously beside him. This was first exhibited at the Pre-Raphaelite Exhibition in Russell Place in 1857, with the title *A Mother's Grave*, and then, with the figure of the sister added and its present title, at the Royal Academy in 1863. The skilfully observed landscape background was painted in the churchyard at Chingford in Essex, and many of the details in this, such as the dew drops on the tree and the short-lived dog roses, reinforce the pathos of the subject.

Hughes never became well known, though some of the principal Pre-Raphaelite collectors such as James Leathart, became his patrons. After the early 1860s his work as an illustrator, especially of the poems of Christina Rossetti, was of a higher quality than his paintings, though he continued to exhibit regularly at the Royal Academy until the end of the century. In his later years Hughes began to paint pure landscape, mostly in Cornwall, where he spent numerous holidays, and in 1900 he showed eighty of his small landscapes at the Fine Art Society.

Another long-lived artist on the fringes of the movement in his early days was Henry Wallis (1830–1916), who enrolled as a student at the RA in 1848 but also received some of his training in Paris. His best-known painting in the Pre-Raphaelite manner was *Chatterton* [PL.174], which was shown at the Academy in 1856 and which im-

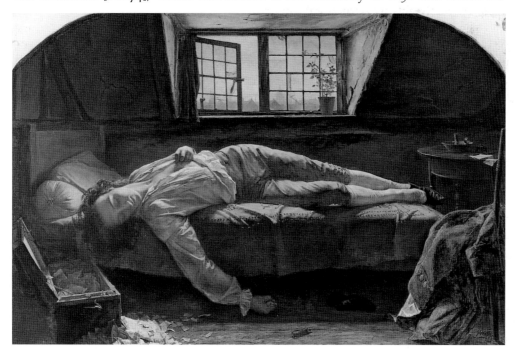

(174) Henry Wallis, *Chatterton* (RA 1856). Oil on canvas; 60.2×91.2cm. (Tate Gallery, London)

mediately made the artist famous. Ruskin described it as 'Faultless and wonderful: a most noble example of the great school. Examine it well inch by inch: it is one of the pictures which intend and accomplish the entire placing before your eyes of an actual fact – and that a solemn one. Give it much time.'[15] This haunting image of the dead young poet – Chatterton was only seventeen when he committed suicide – stretched out on a bed below the window in his cheerless garret with his torn-up manuscripts scattered on the floor, is truly Pre-Raphaelite in its detail, its realistic light and atmosphere, and, of course, its dramatic and moralising message. The painting was bought by the artist Augustus Egg, and was also an outstanding success when shown at Manchester in 1857. *The Stonebreaker* (Birmingham Museums and Art Gallery), exhibited at the Royal Academy in 1858 and Wallis's other major contribution to Pre-Raphaelitism, deals with an even gloomier theme and is even more moving in its impact. Worn-out, undernourished and without hope, the pauper set to work breaking stones for the repair of the parish roads, has died with his hammer in his hands, and is seen in dim twilight at the end of the day and of life. With its comment on the evils of poverty and unemployment, this shocking picture may have been influenced by Gustave Courbet's lost *Stonebreakers* of 1849, which he could have seen at the Salon of 1850, and was certainly inspired by the writings of Carlyle. The 1858 Royal Academy also included John Brett's very different *Stonebreaker*, with its attractive landscape setting, which will be discussed in the next chapter.

27 Pre-Raphaelite Landscape

Landscape as background or setting was an essential element of many of the major Pre-Raphaelite paintings, such as Holman Hunt's *The Hireling Shepherd* [COL.PL.50] and Millais's *Ophelia* [PL.163], both shown at the Royal Academy in 1852. This was the exhibition which also included Ford Madox Brown's *'The Pretty Baa Lambs'*, in which, however, the present panoramic landscape background was added some years later to replace the original low horizon seen in the small copy made in 1852, and now in the Ashmolean Museum, Oxford. All three artists had spent long hours painting out-of-doors to achieve absolute 'truth to nature' in the landscape element of these works, and in their diligent approach to the painting of landscape they were certainly greatly influenced by the teaching of John Ruskin, himself a considerable painter of landscape in watercolours. His influence was also strong among the artists whose usually realistic and atmospheric landscape compositions were dominating the annual exhibitions of the Society of Painters in Watercolours at this time, as was clearly demonstrated in the 1992 exhibition of *Victorian Landscape Watercolors* initiated by the Yale Center for British Art. However, few of these usually large exhibition watercolours will have been executed on the spot.

Ford Madox Brown painted much of both *The Last of England* [PL.171] and *Work* [COL.PL.64] out-of-doors, in the former case largely in order to achieve the correct effect of *'light all round*, which objects have on a dull day at sea', and also to record the effect which cold and damp have on flesh. From 1846 onwards he also painted 'pure' landscape compositions from nature, of which the earliest surviving example is the atmos-

pheric panoramic oval view of *Windermere* in the Lady Lever Art Gallery, Port Sunlight, which was originally completed in 1848, but much altered six years later. By then he had already painted a small canvas of the townscape setting of *Work* in Heath Street, and from a window of the house where he lodged he completed over a period of some eighteen months *An English Autumn Afternoon, Hampstead – Scenery in 1853* (Birmingham Museums and Art Gallery), which was exhibited in 1855 at the British Institution, where it was largely ignored. Echoing some of Constable's East Bergholt views, this tranquil composition, with a young couple seated on the grass in the foreground and enjoying the view in the late afternoon light, renders the character of this semi-rural area of north London most effectively and emphasises Madox Brown's feeling for 'ordinary' landscape.

In his diary during these years Madox Brown frequently emphasised his love of landscape, and his qualms about the impossibility of 'imitating' some of the fine light effects which he observed. However, he was also aware that landscape paintings were very saleable, and there is no doubt that he thought of those he painted in the 1850s as 'potboilers' undertaken to counter his current desperate financial situation. In the event several of the small landscapes he painted at this time sold quite quickly though only for a few pounds. Two of them, *Carrying Corn* and *The Hayfield* (both Tate Gallery, London), were harvest scenes, and though much of these was painted on the spot, Madox Brown had great difficulty in keeping pace with the rapid changes in the progress of the harvesting and, of course, in the light effects. The somewhat stylised and stark technique used in both scenes is balanced by their attractive and brilliant colouring, but in no way can these compositions be considered as natural landscapes, adhering to the Pre-Raphaelite tenet of 'truth to nature'. They do perhaps help to explain why Madox Brown was never more closely involved with the Brotherhood; on the other hand his interest in achieving truly realistic light effects can be said to place him as in some ways a precursor of the French Impressionists of the 1870s.

The last of these rural idylls is *Walton-on-the-Naze* [COL.PL.57], which is dated *1860* and was started during a visit with his wife and daughter to the small resort on the east coast of Essex in 1859. In the right foreground Madox Brown has painted himself and his family gazing out across the view in the weak late afternoon sunshine immediately after a rainstorm. A few dark clouds and a rainbow are still just visible, and the full moon is rising above the small harbour. It is again the record of a very specific light and weather effect, but here the artist has succeeded in combining this with a well-composed and detailed panoramic landscape which makes it the most convincing of his series of small landscape studies, which are more a variation than a true example of the aims of Pre-Raphaelitism.

John William Inchbold (1830–88), on the other hand, painted landscapes for a period of some ten years that were close in spirit and technique to the tenets of the Pre-Raphaelites. Born in Leeds, the son of a newspaper proprietor, he came to London to become a student of the watercolour artist Louis Haghe, and at first exhibited broadly handled watercolours at the Society of British Artists. His first exhibited oils showed Pre-Raphaelite influences, as seen in *The Chapel, Bolton*, exhibited in 1853 and now in Northampton. In this it is the foreground detail that is most impressive, as it is in the attractive *A Study, in March* [COL.PL.60] (also known as 'In Early Spring'), which was

shown at the Royal Academy in 1855. This, like one of Inchbold's other two RA exhibits that year, was accompanied in the catalogue by quotations from Wordsworth, some lines by whom Ruskin had praised in the first volume of *Modern Painters* as 'a little bit of good, downright, foreground painting'. Ruskin commented favourably on *A Study, in March* in his *Academy Notes*, describing it as 'exceedingly beautiful'. A year earlier Inchbold's atmospheric painting of *Anstey Cove, Devon* (Fitzwilliam Museum, Cambridge) had, surprisingly, been rejected by the Academy, but had also gained the admiration of Ruskin.

By 1857 Inchbold was established as 'perhaps highest of the strictly Pre-Raphaelite landscape painters',[16] and was very much under the influence of Ruskin, whom he accompanied to Switzerland in 1856 and 1858. With the exception of the Victoria and Albert Museum's *Lake of Lucerne* of 1857, hardly any of Inchbold's earlier Swiss paintings and watercolours are known today, though it is recorded that the latter failed to satisfy Ruskin despite his own interventions in their execution. Inchbold continued to paint attractive landscape scenes in Britain, especially the Isle of Wight, and in Italy and Switzerland, where he lived during most of the last ten years of his life. However, these largely lacked the intensity of his work of the mid-1850s, were usually quite loosely painted, and have a somewhat photographic feeling.

John Ruskin also had much influence in the career of John Brett (1831–1902), and it was his praise of Brett's *The Stonebreaker* [PL.175], which he dubbed as 'on the whole, to my mind, the picture of the year' of the 1858 RA exhibition, that first established that artist's reputation. Brett, who had entered the RA Schools in 1853 and first exhibited in 1856, was already a great admirer of the Pre-Raphaelites and was deeply impressed by Ruskin's writings on art and geology. These influences were clearly seen in *The Stonebreaker*, with its beautifully painted view over the Mole Valley towards Box Hill and the finely rendered pile of flints on which the healthy rustic boy is working in bright morning light, providing a strong contrast with the twilit gloom of Henry Wallis's *Stonebreaker* shown in the same exhibition. In his enthusiastic *Academy Notes* comments Ruskin concluded 'it is a marvellous picture, and may be examined inch by inch with delight; though nearly the last stone I would ever have thought of any one's sitting down to paint would have been a chalk flint. If he can make so much of that, what will Mr. Brett not make of mica slate and gneiss! If he can paint so lovely a distance from the Surrey downs and railway-traversed vales, what would he not make of the chestnut groves of the Val d'Aosta! I heartily wish him good-speed and long exile.'[17]

Brett had, in fact, already been to Switzerland in 1856, inspired to see the Alps by reading the fourth volume of Ruskin's *Modern Painters*, published in April 1856, and subtitled 'Of Mountain Beauty'. In Switzerland Brett met Inchbold but not, apparently, Ruskin, and Inchbold's work in the Alps greatly impressed Brett. His painting of *The Glacier of Rosenlaui* (Tate Gallery, London) was as much influenced by the example of Inchbold as by the writings of Ruskin, though Allen Staley has correctly described it as 'more Ruskinian than Pre-Raphaelite'.[18] Brett's highly detailed painting of the glacier in the northern Alps was shown at the Academy in 1857, where it was largely ignored, even by Ruskin, who had, however, apparently praised it when Rossetti showed it to him late in 1856.

As 'instructed' by Ruskin Brett returned to Switzerland in the summer of 1858

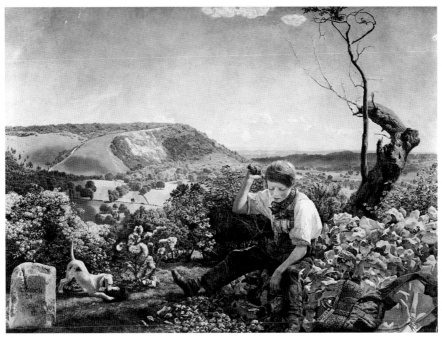

(175) John Brett, *The Stonebreaker* (RA 1858). Oil on canvas; 49.5×67.3 cm.
(Walker Art Gallery, Liverpool)

and painted *Val d'Aosta* [COL.PL.61]. It seems probable that he chose to paint in the Val d'Aosta because it was close to Turin, where Ruskin planned to stay that summer. The critic arrived there in the middle of July, summoned Brett about a month later to check on the progress of the painting, and gave the artist a 'hammering' as he had done to Inchbold two years earlier. Brett's sunlit midday composition presents a highly detailed view, taken from a window of the Château St Pierre at Villeneuve, where he was staying, of a narrow segment of the beautiful and famous Alpine valley, which had inspired several other British artists, including Turner. When *Val d'Aosta* was shown at the RA in 1859 it was not generally well received and failed to find a buyer. However, Ruskin, who felt obliged to buy it for £200 some months after the exhibition, wrote about it at length in his 1859 *Academy Notes*, combining eloquent praise with damning criticism, as is evident from his opening paragraph:

> Here is, at last, a scene worth painting – painted with all our might (not quite with all our heart, perhaps, but with might of hand and eye). And here, accordingly, for the first time in history, we have, by help of art, the power of visiting a place, reasoning about it, and knowing it, just as if we were there, except only that we cannot stir from our place, nor look behind us. For the rest, standing before this picture is just as good as standing on that spot in Val d'Aosta, so far as gaining of knowledge is concerned; and perhaps in some degree pleasanter, for it would be very hot on that rock to-day, and there would probably be a disagreeable smell of juniper plants growing on the slopes above.

After an enthusiastic description of the many delights and qualities of the valley Ruskin continued:

A notable picture truly; a possession of much within a few feet square. Yet not, in the strong, essential meaning of the word, a noble picture. It has a strange fault, considering the school to which it belongs – it seems to me wholly emotionless. I cannot find from it that the painter loved, or feared, anything in all that wonderful piece of the world. There seems to be no awe of the mountains there – no real love of the chestnuts or the vines. Keenness of eye and fineness of hand as much as you choose; but of emotion, or of intention, nothing traceable. Not but that I believe the painter to be capable of highest emotion: any one who can paint thus must have passion within him, but the passion here is assuredly not out of him. He has cared for nothing, except as it was more or less pretty in colour and form. I never saw the mirror so held up to Nature; but it is Mirror's work, not Man's.[19]

These revealing comments illustrate the confusion in Ruskin's thinking at a time when not only he himself but the whole world of art were still reacting to the impact of the invention of photography on the arts of painting and drawing. Following the publication of Daguerre's and Fox Talbot's rival inventions in 1839, the techniques and use of photography had developed rapidly in the 1840s. After the success of the photographic exhibits in the Great Exhibition of 1851 the amateur practice of photography and the profession of photographers escalated throughout Britain, and debate about its standing was widespread. While still a student at Oxford Ruskin himself had learnt about daguerreotypes from Dean Liddell, of Christ Church, as early as the spring of 1840, and during the 1840s he made use of daguerreotypes in his architectural studies, especially in Venice. In a letter written to his father from Venice in 1845 he described the daguerreotype as 'a noble invention'.

There is a remarkable similarity between Ruskin's critical comments on the Brett painting in 1859, and his discussion of art and photography in the 'Conclusion' of the third volume of *The Stones of Venice*, first published in 1853. There he wrote:

All art is great, and good, and true, only in so far as it is distinctively the work of *manhood* in its entire and highest sense; that is to say, not the work of limbs and fingers, but of the soul, aided, according to her necessities, by the inferior powers; and therefore distinguished in essence from all products of those inferior powers unhelped by the soul. For as a photograph is not a work of art, though it requires certain delicate manipulations of paper and acid, and subtle calculations of time in order to bring out a good result; so neither would a drawing *like* a photograph, made directly from nature, be a work of art, although it would imply many delicate manipulations of the pencil and subtle calculations of effects of colour and shade. It is no more art to manipulate a camel's-hair pencil, than to manipulate a china tray and a glass vial. It is no more art to lay on colour delicately, than to lay on acid delicately. It is no more art to use the cornea and retina for the reception of an image, than to use a lens and a piece of silvered paper. But the moment that inner part of the man, or rather that entire and only being of the man, of which cornea and retina, fingers and hands, pencils and colours, are all the mere servants and instruments; that manhood which has light in itself, though the eyeball be sightless, and can gain in strength when the hand and the foot are hewn off and cast into the fire; the moment this part of the man stands forth with its solemn 'Behold, it is I,' then the work becomes art indeed, perfect in honour, priceless in value, boundless in power.[20]

Whether or not Brett, or any of the other artists who painted landscape as realistically as he then did, had read this powerful passage is not known. However, Brett

in 1853 was already a great admirer of Ruskin, and it seems likely that he would have read *The Stones of Venice*, and might thus have been prepared for Ruskin's criticism of *Val d'Aosta*. It has been claimed that his work declined as a result of his hero's 'betrayal', but, though few of his later works repeated the exceptional qualities of his paintings of the late 1850s, he continued to paint and exhibit large numbers of attractive land-scapes, coastal scenes and seascapes throughout the rest of the century, mostly in oils but occasionally also in watercolours. He made several further visits to Italy in the early 1860s, and these resulted in striking paintings of places as far apart as Florence and Taormina. Most of his compositions were painted in the studio, based on sketches made on the spot, the coastal scenes and seascapes usually resulting from voyages around the British coast on his yacht. These found a steady market – the Chantrey Bequest pur-chased the large *Britannia's Realm* at the Royal Academy in 1880 (Tate Gallery, London) – and Brett was elected ARA in 1881. Most of the paintings were precise and inform-ative, and attractive in their colouring, but they certainly also lacked the sensitivity and feeling which Ruskin had missed in *Val d'Aosta*.

For John Ruskin himself the practice of drawing was a vital part of daily life, and though as an artist he was always essentially an exceptionally talented amateur, there were many occasions for the public to see his work. In 1873 he was one of the first group of distinguished figures to be elected Honorary Members of the Old Water-Colour Society, and in subsequent years he exhibited a number of drawings with that Society. Ruskin included some of his own drawings in the 1878 Fine Art Society exhibition of his collection of Turner drawings, and he frequently used his own drawings to illustrate his lectures and his books. There were several memorial exhibitions of his work after his death in 1900, and in the last forty years there has been growing interest in his own art, and there have been numerous Ruskin exhibitions on both sides of the Atlantic.

Ruskin's first drawing master was Copley Fielding, the President of the Old Water-Colour Society, who taught him for some years. In 1841 he began lessons with the somewhat younger and more 'modern' J.D.Harding (1797–1863). In addition to what he was taught by these distinguished artists, Ruskin also learnt much from studying the work of other leading watercolour artists of the day, among them Samuel Prout, David Roberts, and, of course, J.M.W.Turner, whose watercolours he and his father began to collect in 1839. As a result of all this tuition and inspiration John Ruskin himself became a proficient and able artist, though only rarely a truly inspired one. For him drawing was not so much a creative activity as a method of study, and his daily drawing of a leaf, a feather, a stone, the detail of a building, and suchlike, was his way of truly studying nature, and of enriching his geological, scientific and architectural knowledge. While Millais was painting his portrait [PL.164] at Glenfinlas in 1853, Ruskin drew the famous *Study of Gneiss Rock, Glenfinlas* [PL.176], probably to help the painter achieve 'truth to nature' in the background of the portrait. Because of bad weather Ruskin was appar-ently unable to complete his drawing, but nevertheless it provides the most detailed information about the rock and shows Ruskin very much able to practise what he preached in the depiction of landscape. The pen and wash *Study of Gneiss Rock, Glenfinlas* is an outstanding example of Pre-Raphaelite landscape art. Just as he wrote with exceptional fluency and insight, so he observed what he drew with intensity and sensitivity, and each of his hundreds of detailed watercolour studies displays a true

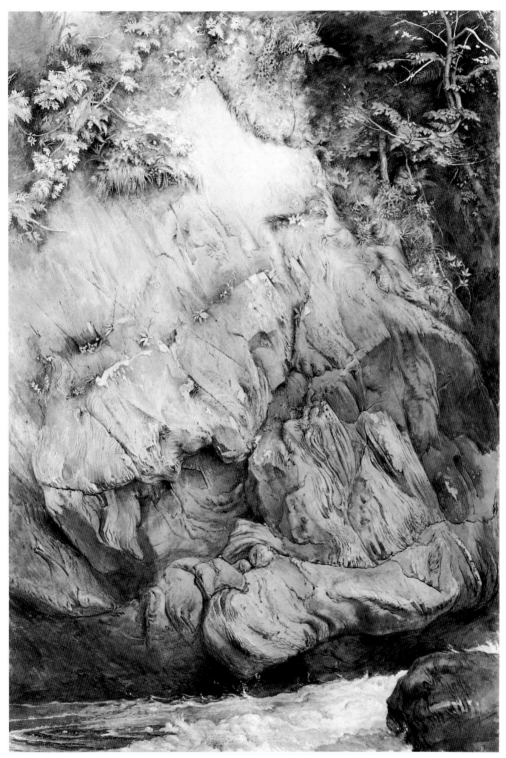

(176) John Ruskin, *Study of Gneiss Rock, Glenfinlas* (1853). Pen and ink and wash; 47.7×32.7 cm.
(Ashmolean Museum, Oxford)

understanding of the subject he was drawing. It was an invaluable gift, to which his tuition added considerable skill in creating broader landscape and topographical compositions, of which some of his watercolours of Venice and of Swiss scenes are impressive examples.

28 Sir Edward Burne-Jones, Bt (1833–98), and his Legacy

Much of the inspiration that led Edward Burne-Jones to become an artist came from the Pre-Raphaelites, and especially from Rossetti, but his own painting, drawing and design was far removed from the original tenets of the Brotherhood. Although he drew and doodled from an early age, Burne-Jones was already in his twenties when he determined to become a painter. Born in Birmingham, the son of a framer and gilder, he had decided in 1848 to go into the Church, under the influence of John Henry (later Cardinal) Newman's Tractarianism, and in 1853 went up to Exeter College, Oxford, to read theology. Here he met William Morris (1834–96), also a freshman and a High Churchman intending to be ordained, and the two became lifelong friends and collaborators. Disappointment at the waning fervour of the Tractarians in Oxford forced the two idealists to look elsewhere for an outlet for their enthusiasms. Morris's love of the Gothic, combined with their reading of Ruskin and their discovery of Malory's *Morte d'Arthur*, encouraged their passion for all things medieval, and prepared them for the powerful impact of their first experience of Pre-Raphaelite paintings when they visited Thomas Combe's collection at the Clarendon Press in Oxford in the summer of 1855. Later that summer they toured the cathedrals of northern France, and on the way home Burne-Jones decided to become a painter. On the whole he remained largely self-taught, but his intelligent and sensitive studies of the work of a variety of predecessors and contemporaries, especially at first Rossetti, enabled him to progress from his essentially eclectic early work to a distinctive personal style in only a few years.

The two men went down from Oxford, without degrees, in May 1856; Morris articled himself to the architect, G. E. Street, and Burne-Jones settled in London and took informal lessons from D. G. Rossetti, whom he had met at the beginning of the year and considered 'the chief figure in the Pre-Raphaelite Brotherhood'. In the following year Burne-Jones and Morris were among the artists who joined Rossetti in painting the Arthurian murals at the Oxford Union. In 1859 Burne-Jones paid his first visit to Italy, and the impact of this and also of his subsequent visits greatly influenced the development of his own art. At first this was largely confined to small, highly finished pen-and-ink drawings, strongly influenced by Rossetti. It was only in the early 1860s that he began to work with colours, using watercolours and gouache, but these drawings still retained the detailed finish and decorative elements of his work in black and white, as in the well-known portrayals, both dated 1860, of *Sidonia von Bork* and *Clara von Bork* (both Tate Gallery, London), characters in Wilhelm Meinhold's romance *Sidonia von Bork, die Klosterhexe*, first published in 1847, and in English translation in 1849. These powerful images demonstrate Burne-Jones's successful assimilation of the many and varied influences that shaped his artistic development, which here, in addition to those already referred to, also include the work of Dürer and of the Venetian School, in par-

ticular Titian. That master remained one of the strongest inspirations throughout his career, especially after his second visit to Italy, in the summer of 1862, during which he was accompanied by his wife, Georgiana (they had married in 1860), and John Ruskin, who exhorted him to improve his drawing and persuaded him to copy Venetian paintings.

Throughout these formative years Burne-Jones and William Morris continued their close friendship, and in the late 1850s the latter was also attempting to become a painter, again under Rossetti's influence. He completed only one easel picture, *La Belle Iseult* (Tate Gallery, London), which dates from 1858 and which 'presented him with enormous difficulties'. [21] The frustrating experience of trying to be a painter came to an end in 1861, when Morris, whose true artistic genius lay in the realms of design and craft, as well as poetry, initiated the firm of Morris, Marshall, Faulkner and Co., of which Burne-Jones became a founder member. This was the beginning of what came to be known as the Arts and Crafts Movement, which during the following decades had a great influence on the decorative arts in Britain and throughout the Western world, and Morris wallpapers and textiles remain very popular to this day. Burne-Jones was in his element providing designs and cartoons for stained glass, tapestries and other decorative products, and continued to do so for the remainder of his life. His outstanding contribution was in the design of stained glass, in which his sense of line and his compositional gifts combined to produce some of the most distinguished stained glass of the nineteenth century, as windows in churches all over Britain demonstrate. Burne-Jones's stained glass, like most of the products of the Morris Company, was essentially medieval in style, and it is remarkable how popular medievalism remained in the fine and applied arts throughout the second half of the century and beyond.

While Burne-Jones made the most of this outlet for his artistic talents, he also consolidated his development and standing as a painter in the 1860s, at first still largely in watercolours. He was elected an Associate of the Old Water-Colour Society in 1864, though his unusual technique – his drawings could easily be mistaken for oils – and his equally unorthodox subject matter aroused hostility within the society, which was even more conservative at this time than the Royal Academy. *The Merciful Knight* [PL.177] was one of the four highly finished compositions on a large scale which he showed at the Old Water-Colour Society in 1864. They met with much adverse criticism from fellow-members and in the press, but also attracted immediate admiration from several younger artists, such as Walter Crane (1845–1915), who was one of the first of Burne-Jones's many followers. Illustrating an incident in the life of the Florentine knight, St John Gualberto, who founded the Valombrosan Order in 1039, this complex, intricate and mysterious composition remained one of the artist's own favourite early works, and was thought by Georgiana Burne-Jones 'to sum up and seal the ten years that had passed since Edward first went to Oxford'.

In many ways Burne-Jones had remained an amateur until now, but in the mid-1860s the pressure of his work as a designer for Morris forced him to form a team of assistants and also to become more professional in his own art. The passionate intensity of his early work was gradually replaced by a looser and less demanding manner, in which the medieval was mixed with the by now more fashionable classical style, as in *The Lament* (William Morris Gallery, Walthamstow), a large gouache dated 1866 and

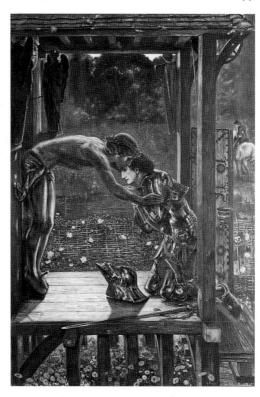

(177) Sir Edward Burne-Jones, *The Merciful Knight* (1863–4). Watercolour and bodycolour; 100.3×69.2cm. (Birmingham Museums and Art Gallery)

exhibited at the OWCS in 1869. In the following year Burne-Jones resigned from the Old Water-Colour Society because of complaints about the nudity of one of his figures. The best-known works in Burne-Jones's classical manner are the four canvases illustrating the story of Pygmalion, now in Birmingham. This series was begun in 1868, and took ten years to complete before being shown at the Grosvenor Gallery in 1879. The years during which this series evolved were a period of isolation during which Burne-Jones hardly exhibited but continued to work with great energy and concentration, evolving his ultimate mature style. In this his last two visits to Italy, in 1871 and 1873, were of vital importance, for he now 'discovered' Botticelli, Mantegna and Michelangelo, and it was the impact of these three masters of figure painting that inspired the final individual manner of Burne-Jones, then in his forties. Another important factor in this was the inclusion of beautifully painted flowers, plants and trees in many of his compositions, perhaps partly the result of the 'truth to nature' philosophy of his early Pre-Raphaelite mentors. Though many varied influences played a part in his development as an artist, Burne-Jones always imposed his own personality on his work, and this was especially true of the instantly recognisable poetical, sensual and rhythmic style of his paintings during the highly successful last twenty years of his career.

This success was initiated in 1877, when Burne-Jones showed eight major works at the opening exhibition of the Grosvenor Gallery in London. They caused a sensation, and the artist was acclaimed as 'one of the leading avant-garde painters of the day', and became an important figure of the Aesthetic Movement, of which the Grosvenor Gallery was a focal point, and which was the butt of Gilbert and Sullivan's satire in their opera

Patience, first performed in 1881. In the famous letter 79 of *Fors Clavigera* John Ruskin's extravagant praise of Burne-Jones's exhibits preceded the critic's notorious libel of Whistler's contributions to the exhibition. One of Burne-Jones's eight works shown in 1877 was *The Beguiling of Merlin* [PL.178], which illustrates the same subject from Arthurian legend that the artist had chosen for his Oxford Union mural in 1857. The model for the beauteous and beguiling Nimuë was Maria Zambaco, the attractive Greek woman living in London with whom Burne-Jones had a passionate affair, which became something of a scandal. For Burne-Jones the completion of this intricate and compelling composition, which was commissioned in 1872 by one of his chief patrons, the Liverpool shipowner F.R.Leyland, cost much hard work – he had to abandon the first version because of the failure of the experimental materials he was using – and emotional strain. At the exhibition it was both ridiculed and praised, and it became one of Oscar Wilde's favourite paintings; he called it 'brilliantly suggestive'.

Burne-Jones frequently took several years to develop and complete a composition, as was the case with *Le Chant d'Amour* (Metropolitan Museum of Art, New York) shown at the second Grosvenor Gallery exhibition in 1878. The subject is taken from an ancient Breton song, which recounts the contradictory emotions of the joy and sadness of Love, and the wonderfully tranquil composition depicts a pensive organist with the sightless figure of Love (Love is blind) operating the bellows, while a young knight lost in thought looks on. The flowers in the foreground echo the symbolism of the figures. Burne-Jones originally painted this subject in about 1863 on the inside of the lid of an upright piano (now in the Victoria and Albert Museum), which he and Georgiana, who was very musical, had been given as a wedding present. He then painted a watercolour of the subject, in which the figure of the knight was added, and this was one of the first of his works bought by William Graham, a Glasgow businessman and MP, and a leading collector of the work of the Pre-Raphaelites, especially Rossetti, and also a collector of Italian old masters. Graham became Burne-Jones's most important patron and it was he who commissioned the large oil painting of *Le Chant d'Amour*. This very Giorgionesque composition is one of Burne-Jones's most personal, poetic and evocative works.

For the rest of his life Burne-Jones enjoyed continuing popularity and success, and in his influential book *The English School of Painting*, first published in 1882, the French critic Ernest Chesnau singled him out as the leading figure in 'the Modern School', and 'the only artist whose high gifts in designing, arranging and colouring are equal to his poetical conceptions'.[22] John Ruskin devoted much of his second lecture as Slade Professor at Oxford in 1883, 'The Mythic Schools of Painting', to Burne-Jones, 'whose indefatigable scholarship and exhaustless fancy have together fitted him for this task [the painting of mythology], in a degree far distinguishing him above all contemporary European designers'.[23] Critical acclaim was accompanied by public recognition – an honorary doctorate from Oxford in 1881; election as President of the Birmingham Society of Artists in 1885, the year in which he also reluctantly accepted election as an Associate of the Royal Academy, where he had not as yet exhibited and where he exhibited only once before resigning in 1893. In 1894 he was offered a baronetcy by Gladstone, 'in recognition of the high position which you have obtained by your achievement in your noble art'.

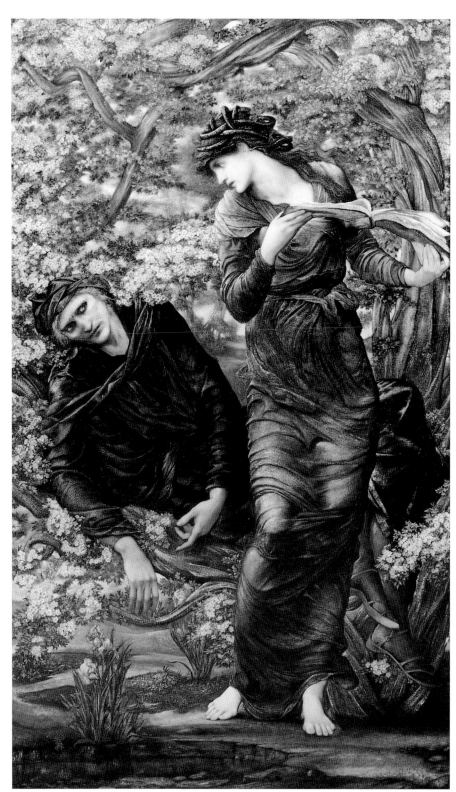

(178) Sir Edward Burne-Jones, *The Beguiling of Merlin* (1873–4). Oil on canvas; 186×111 cm. (Lady Lever Art Gallery, Port Sunlight)

There were numerous landmarks in his output during these prosperous years, of which one of the most notable was the huge *King Cophetua and the Beggar Maid* [COL.PL.67], first exhibited at the Grosvenor Gallery in 1884 and acclaimed by the critic of *The Times* as 'not only the finest work that Mr Burne-Jones has ever painted, but one of the finest pictures ever painted by an Englishman'. In 1889 it was shown at the Exposition Universelle in Paris, where it was again widely acclaimed, and Burne-Jones was awarded the Cross of the Légion d'honneur. The subject is taken from an Elizabethan ballad, retold by Tennyson in his poem 'The Beggar Maid', in which a king searches for a pure wife, for whom, in the painting, the artist and his wife were the models. Though it has been criticised for being overworked – and Burne-Jones wrote that he himself had 'grown very tired of it' – this is again one of those haunting images filled with intriguing and beautiful detail, which brought the artist such popularity at a time when rich and intricate decoration was the height of fashion.

The climax of Burne-Jones's popular success came in 1890 with the exhibition at Agnew's in London of the final version of the *Briar Rose* series, which was bought for £15,000 by Alexander Henderson, later Lord Faringdon, who installed the four large canvases at Buscot Park in Berkshire, where they still are. This famous series of Burne-Jones's most intricate and romantic creations originated in a set of tiles illustrating Charles Perrault's *Sleeping Beauty*, designed in the early 1860s. A set of three smaller paintings of the story of the Sleeping Beauty, now in Puerto Rico, was painted in 1870–3, and Burne-Jones also began the final Buscot series in 1870.

Another series on which the artist worked for many years, and indeed never completed, was commissioned by the wealthy politician Arthur Balfour (Prime Minister from 1902 to 1905) in 1875 to decorate the music room of his London house. Illustrating the legend of Perseus, son of Zeus and Danae, who vanquished and decapitated Medusa, and rescued and married Andromeda, these evocative and colourful compositions show Burne-Jones at his most elegant and imaginative, as in *The Baleful Head* [PL.179]. This shows Perseus and Andromeda looking at the reflection of the Medusa's head in a well, to avoid the Gorgon's direct gaze, which would have turned them to

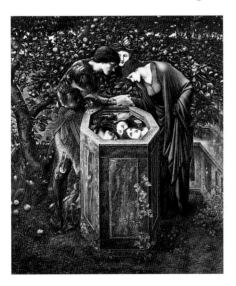

OPPOSITE
(180) Sir Edward Burne-Jones, *Love leading the Pilgrim* (1896–7). Oil on canvas; 157.5×304.8cm. (Tate Gallery, London)

(179) Sir Edward Burne-Jones, *The Baleful Head* (1875–87). Oil on canvas; 155×130cm. (Staatsgalerie, Stuttgart)

stone. This and the other large paintings of the series were acquired by the Staatsgalerie, Stuttgart, in 1972, and at the time of writing they hang in a spacious gallery linking the new James Stirling wing with the older part of the museum. In the hanging of the collections they form a link between European painting and sculpture of the nineteenth century up to and including early Post-Impressionism, and the work of the Fauve artists and beyond up to the present day. That this striking series should be given such an important role in a German museum provides some indication of the place and influence of Burne-Jones's later work, especially on Symbolist artists, in the closing years of the nineteenth century. It also illustrates how after well over half a century of almost total neglect – his reputation was already in decline in his own lifetime – Burne-Jones's work returned to favour in the mid-1960s, and today his paintings share the widespread popularity of William Morris's decorative designs.

The Baleful Head was one of the four paintings exhibited by Burne-Jones at the Grosvenor Gallery in 1887. Soon afterwards he withdrew from that gallery, and from 1888 he showed at the rival New Gallery, Regent Street, where a major retrospective exhibition was held soon after his death, in the winter of 1898/9. Included in that exhibition was one of the last works shown in the final exhibition before his death, the haunting *Love leading the Pilgrim* [PL.180].[24] Inspired by Chaucer's *Romaunt of the Rose*, the picture was conceived in the early 1870s, but not completed until 1897. As we have seen, such slow progress was not at all unusual in the career of Burne-Jones, who, despite a late start as an artist, achieved his mature style before he was forty years old. He then developed and enhanced it for the next thirty years, during which he was, of course, also much occupied with providing designs for William Morris, especially for stained glass, and illustrations for the beautiful books produced by the Kelmscott Press, which Morris had established in 1891. These included eighty-seven illustrations for the famous Kelmscott Chaucer, which appeared in June 1896, four months before Morris's death.

As well as the artists who worked as assistants in Burne-Jones's studio – among them Charles Fairfax Murray (1849–1919), T.M.Rooke (1842–1942) and J.M.Strudwick

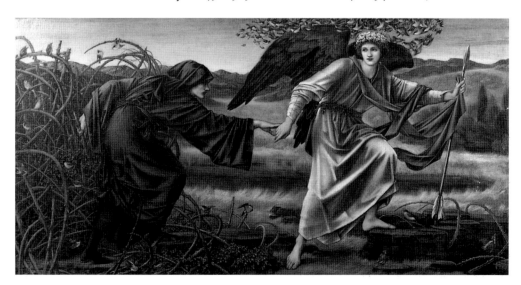

(1849–1937) – there were many others who were strongly influenced by Burne-Jones's style and subject-matter. One of these was the beautiful Anglo-Greek Marie Stillman (née Spartali, 1844–1927), who was his mistress and sat to him and several other artists, and who was taught by Ford Madox Brown. She and other followers adopted Burne-Jones's dreamlike and romantic vision, but unlike the master who inspired them they rarely succeeded in bringing their own visions to life, though some, like Simeon Solomon (1840–1905), who produced languorous and often erotic symbolic compositions, did achieve an individual manner. Like Burne-Jones, most of these artists found their inspiration in the past, though, as we shall see, there were other contemporary artists whose paintings focused on the problems and events of their own day. It was one of the outstanding features of the actual Pre-Raphaelites that they were able to encompass both these elements in their work.

The short-lived Aubrey Beardsley (1872–98) was nearly forty years younger than Burne-Jones, but in the final decade of the master's life and in the only decade of his own career Beardsley added an element of modernity to the powerful influence of Burne-Jones. Beardsley's work was largely in black and white and he was one of the great illustrators of the late nineteenth century. Essentially self-taught, but much influenced by Burne-Jones, Rossetti, Whistler and many others, Beardsley was enormously hard-working, and rapidly produced a great quantity of vigorous and vital drawings in a highly sophisticated and individual manner. Hundreds of his drawings were reproduced as book illustrations, that had, in their turn, great influence on other illustrative artists in the final years of the nineteenth century and in the early years of the twentieth, and that pioneered many of the innovations of the art nouveau style.

Beardsley's first major achievement was to provide 351 separate designs, most of them complex and intricate, for the two-volume illustrated edition of Sir Thomas Malory's *Morte d'Arthur*. Published by J.M.Dent in 1893 and 1894, this was one of the early masterpieces of art nouveau book production, and its outstanding success assured Beardsley's place as one of the leading illustrators of the day. The powerful imagery and flowing lines of his compositions is well illustrated by the full-page '*How Sir Tristram drank of the Love Drink*' [PL.181] from the first volume. Between July and November 1893 Beardsley also completed sixteen full-page illustrations and a cover design for the English edition of Oscar Wilde's banned play *Salome*, which was published by John Lane early in 1894. In all this work Beardsley demonstrated his phenomenal powers of imagination and fantasy, achieved with a mastery of line and composition that has made his drawings, like those of William Blake, so popular in recent times.

The year 1894 also saw the launching of *The Yellow Book*, again published by John Lane and The Bodley Head, with Aubrey Beardsley as its first art editor. It was Beardsley who suggested the title of this daring, provocative and often decadent *fin-de-siècle* quarterly, which was greatly influenced by the provocative writings and aesthetic teachings of Oscar Wilde, though he himself was not invited to contribute. Beardsley designed the cover of the first issue, described by *The Times* as 'intending to attract by its very repulsiveness and lubricity', and it went into several numbers. The popularity of *The Yellow Book* gradually declined, and not long after Beardsley's enforced resignation because of the Oscar Wilde scandal it ceased publication in 1897. However, Beardsley was also closely involved in the launching in 1893 of *The Studio*, for which he

(181) Aubrey Beardsley, *'How Sir Tristram drank of the Love Drink'* (Sir Thomas Malory, *Morte d'Arthur*, Vol.I, 1893; 28×20.2cm.) (Victoria and Albert Museum, London)

(182) Aubrey Beardsley, *The Fourth Tableau of* 'Das Rheingold' (Design for the cover of *The Savoy*, No.6, Oct. 1896; 30.5×22cm.) (Victoria and Albert Museum, London)

again designed the cover. This long-lived art periodical rapidly gained an international reputation, and through its reproductions and articles it disseminated the most up-to-date aspects of British art and design, especially in the art nouveau style, throughout Europe and the United States. Beardsley again acted as art editor for another new periodical, *The Savoy*, launched in 1896, and it was for this that he produced his powerful illustrations for Richard Wagner's *Das Rheingold*. Beardsley, who was himself very musical, was a great admirer of Wagner, and his amazingly economical, rhythmic and expressive drawing of *The Fourth Tableau* [PL.182], which was reproduced as the cover of the October 1896 issue of *The Savoy*, shows the artist's genius in interpreting the composer's romantic symbolism, which inspired great admiration among British artists at this time.

Beardsley's art was at once eclectic, including in his later years new influences such as Japanese prints and Greek vase painting, and highly original, largely because of the technical brilliance of his line and form. Furthermore it fulfilled the needs and atmosphere of the time, and despite his very short career – Beardsley died of tuberculosis when only twenty-six – it stands out as exceptional and unequalled during a time when many other British and European artists were engaged in similar work because of the demands created by the great increase in illustrated journals and books during the final years of the nineteenth century. While in actual painting in oils the great majority of British artists of the 1890s were old-fashioned and out of touch with the Continental avant garde, in the graphic arts British artists, thanks very largely to the example of Aubrey Beardsley, were in the van. The main exceptions in painting were

the Glasgow Boys, discussed in Chapter 39, and Walter Sickert and Wilson Steer, whose early work will be discussed in Chapter 40.

Notes to Part Six

1 W.Holman-Hunt, *Pre-Raphaelitism and the Pre-Raphaelite Brotherhood*, 2nd edn, 1913, Vol.I, pp.69–70

2 *Works*, Vol.III, p.624

3 W.M.Rossetti, *Dante Gabriel Rossetti: His Family Letters, with a Memoir*, 1895, Vol.I, p.135

4 *Works*, Vol.XII, pp.319–27

5 W.H.Hunt, loc.cit., Vol.I, p. 220

6 *Works*, Vol.XII, pp.513–59

7 Quoted in the Catalogue by Mary Bennett of the *William Holman Hunt* exhibition, Walker Art Gallery, Liverpool, 1969, No.22

8 *Works*, Vol.XIV, pp.61–6

9 *Illustrated London News*, 7 May 1853

10 Quoted in *The Pre-Raphaelites*, Tate Gallery, London, 1984, No.140

11 See Max Browne, *The Romantic Art of Theodor von Holst*, 1994

12 Letter of 26 March 1871, in the Pierpont Morgan Library, New York, quoted in V.Surtees, *The Paintings and Drawings of Dante Gabriel Rossetti*, 1971, Vol.I, pp.93–4, No.168

13 *Works*, Vol.XXXIII, p.269

14 See above, pp.158–9

15 *Works*, Vol.XIV, p.60

16 W.M.Rossetti in a letter of 1857, quoted by Allen Staley, *The Pre-Raphaelite Landscape*, 1973, p.117

17 *Works*, Vol.XIV, pp.171–2

18 Loc.cit., p.125

19 *Works*, Vol.XIV, pp.234–8

20 *Works*, Vol.XI, pp.201–3

21 Ray Watkinson in *William Morris*, catalogue of the Victoria and Albert Museum exhibition, 1996, p.103, repr. p.89

22 E.Chesnau, *The English School of Painting*, 4th edn, 1891, p.235

23 *Works*, Vol.XXXIII, p.296

24 The painting was sold for £5774 at the first Burne-Jones studio sale at Christie's in 1898, and in 1943 it was purchased by the National Art Collections Fund for £94 10s, and presented to the Tate Gallery

Part Seven

Anecdotal, Literary and Social Themes

The Great Exhibition, opened by Queen Victoria in the Crystal Palace on 1 May 1851, was not only an exceptional success in its own right, but also ushered in the 'golden age' of Victorian Britain. The middle years of the Queen's long reign saw growing material prosperity, colonial power and national unity, enjoyed against a background of prolonged peace at home, though there were numerous minor and localised wars in distant parts. At the heart of Britain's successes in these were her unrivalled naval power – enhanced by the introduction of steam-powered and iron-clad ships – and the steady development of industrial, manufacturing and commercial skills, which made her the most prosperous country in the world.

Christianity played an important part in the lives of all classes, and Bible-reading and regular attendance at church and chapel were the norm. This religious fervour led to greater humanitarian consideration for the sick and poor, and to vast improvements in public education and opportunities for self-improvement. Focused on Parliament the government of the country was on the whole stable and effective, and Liberalism was a powerful force, with W.E.Gladstone as its long-lived leader in a series of major social and political reforms.

Thus for longer than a generation the mood of the country was on the whole buoyant and optimistic, though there was also more than a touch of arrogance and self-satisfaction. These affectations were certainly present in the behaviour of the Queen herself, and her popularity suffered as a result. However, the court and the aristocracy were still the major arbiters of etiquette and fashion. On the other hand the great spread of wealth into the middle and manufacturing classes gave these a leading role in the patronage of the time, and it was their taste that dominated the art market. The artists themselves were not immune to the tendencies of the day, and social status and material well-being became all-important for many of them. A few were able to dictate fashion, but most of them were content to paint what sold best, as much of the art discussed below demonstrates.

29 Artists Abroad

After the defeat of Napoleon most British artists again included travel and study on the Continent as part of their education. For some of them the landscape and contemporary

life of the countries they visited provided subject matter that proved popular when ex-hibited in London. One such was Sir Charles Eastlake, whose Italian genre scenes have been discussed in Chapter 21. Thomas Uwins, RA (1782–1857), was also in Italy for several years, from 1824 to 1831, and spent much of his time copying the Italian masters and collecting material for his own genre paintings. On his return to England he quickly re-established his reputation with paintings of Italian peasant life. Before 1824 Uwins, whose early training was as an engraver, had been a leading member of the Old Water-Colour Society, of which he became Secretary for the first time in 1813, and among his favourite subjects were harvesting scenes and studies of hop-picking in Kent. Financial problems forced Uwins to abandon watercolours and concentrate on miniatures, por-traiture and book illustrations, which had a detrimental effect on his eyesight.

In Italy he began to paint in oils, and the first of his Italian peasant subjects, *Neapolitans dancing the Tarantella*, was exhibited at the Royal Academy in 1830. Two years later Uwins, having returned to London, showed the *Neapolitan Saint Manufactory* [COL.PL.46]. This overtly anti-Roman composition, which depicts, to quote from the RA catalogue, a 'shop which is one of the most amusing things in the city. Here is displayed the whole machinery of Neapolitan devotion...', was very well received, and the artist was elected ARA in 1833. For most of his Italian genre compositions, which he con-tinued to exhibit at the RA throughout his career, the artist included a lengthy and informative explanatory note in the exhibition catalogue so that the viewers could share Uwins's Italian experiences with him. He was elected RA in 1838 (his being the first Diploma signed by Queen Victoria) and became Librarian in 1844. A year later he was appointed Surveyor of the Queen's Pictures, and he became Keeper of the National Gallery in 1847. This highly successful 'second' career, begun when the artist was already nearly fifty, was based entirely on Uwins's experience of Italy, and the fashion for undemanding and attractive paintings of contemporary Italian life.

Another painter of Italian subjects was Joseph Severn (1793–1879), who first travelled to Italy in 1820 to accompany his dying friend, the poet John Keats, whom he nursed in Rome until his death in February 1821. Severn was awarded a Royal Academy travelling scholarship, married and settled in Italy, living mostly in Rome, where he was a focal point for the numerous British artists visiting the Eternal City. In 1823 Severn was largely instrumental with Charles Eastlake in setting up the British Academy in Rome, which, after a hopeful start, never really became much more than a meeting place, though it survived in some form until 1936. At first Severn enjoyed ample patronage, and he sent work regularly to the RA summer exhibition, many of his paintings depicting Italian landscape and scenes of Italian peasant life. In 1841 he and his family returned to London, but he went back to Rome in 1860 as British Consul. He died in Rome in 1879, and was eventually buried next to Keats; today he is far better remembered as the dying young poet's faithful companion than as an artist. An artist who spent even more of his life in Italy was Penry Williams (1798–1885), who was born in Wales, trained at the RA Schools, and settled in Rome in 1827. Except for occasional brief visits, he did not return to Britain, and in 1830 he took over Charles Eastlake's old quarters in the Piazza Mignagnelli. He sent Italian subjects to the Royal Academy until 1869, and his attractive and idyllic paintings, such as *Neapolitan Peasants at a Fountain* (Tate Gallery, London), which dates from 1859, were very popular.

(183) John Phillip, *La Gloria* (RA 1864). Oil on canvas; 144×217 cm.
(National Gallery of Scotland, Edinburgh)

Spain was another country which attracted British artists, and the Scottish-born painter John Phillip, RA (1817–67), who visited Spain three times, in 1851, 1856 and 1860, made Spanish subjects his speciality and came to be known as 'Spanish Phillip'. Having previously exhibited largely Scottish subjects he showed his first Spanish picture at the Royal Academy in 1853. He was as much inspired by Spanish themes as by Spanish painting, especially that of Velázquez, and his own manner became both firmer and broader, with rich and luminous colouring. He was elected ARA in 1857 and RA only two years later. One of his most successful Spanish compositions was *La Gloria* [PL.183], which was shown at the Royal Academy in 1864 and at the Royal Scottish Academy in the following year. The subject of this powerful composition was described as follows in the RSA catalogue: 'In Spain, when a child dies, it is firmly believed it is spared the pains of purgatory and goes direct to heaven. The neighbours consequently assemble at the house of death, and celebrate the event by dancing and feasting.' 'Spanish Phillip' has recorded this custom with great feeling and understanding, and the same can be said of many of his Spanish compositions, of which there are several fine examples in the Royal Collection. He was one of the favourite artists of Queen Victoria and Prince Albert, of whom he painted a life-size portrait, now in Aberdeen, in 1858, the year in which he was also commissioned to paint *The Marriage of the Princess Royal, 25 January 1858* (Royal Collection, Buckingham Palace).

The most significant of the mid-nineteenth-century British artists to paint largely foreign figure subjects was certainly John Frederick Lewis, RA (1805–76), who made his name with subjects from Spain, where he was between 1832 and 1834, then with Italian

themes while in Rome from 1838 to 1840, and finally, and most importantly, with his memorable scenes of life in Egypt, where he lived as a native for ten years from 1841. Eldest son of the prominent engraver F.C.Lewis, he showed early promise and made a reputation for himself as a youth with his drawings and paintings of exotic animals, especially lions. When drawing these he was often in the company of Edwin Landseer, three years his senior and also the son of an engraver, in whose subsequent career, as we have seen, the painting of animals was of pre-eminent importance. Lewis moved on to the painting of sporting scenes, including the rather naïve *Buck-Shooting in Windsor Great Park* (Tate Gallery, London), which was exhibited at the RA in 1826. Lewis now began to work and exhibit in watercolours, showing at the Old Water-Colour Society, of which he became a full member in 1830. He also began to travel abroad, visiting the Rhineland, the Tyrol and northern Italy in 1827.

In the summer of 1832 he set out for Spain, where he spent some eighteen months, including several as the guest in Seville of Richard Ford, author of the famous *Handbook for Travellers in Spain*, first published in 1845. Lewis drew and sketched constantly while in Spain, as well as making copies at the Prado, and on his return to England he exhibited Spanish subjects at the Old Water-Colour Society and the Royal Academy, and published two volumes of lithographs, each containing twenty-five plates. The first of these – *Lewis's Sketches and Drawings of the Alhambra* – appeared in 1835 and was dedicated to the Duke of Wellington, and the second – *Lewis's Sketches of Spain and Spanish Character* – of which he himself was also the lithographer, was published in 1836, dedicated to David Wilkie. Among the artist's 1836 OWCS exhibits was the impressively composed and strikingly coloured *The Suburbs of a Spanish City (Granada) on the Day of a Bull-fight* (Whitworth Art Gallery, University of Manchester), in which Lewis, as in most of his later exhibition drawings, used bodycolour as much as watercolour.

'Spanish Lewis', as he was now popularly called, soon left England again, in 1837, and was not to return for fourteen years. Having spent the winter in Paris, he moved on to Italy, visited Florence and Naples, and finally settled in Rome. Here he produced two versions of his most ambitious watercolour composition so far, the smaller of which, *Easter Day at Rome – Pilgrims and Peasants of the Neapolitan States awaiting the Benediction of the Pope at St Peter's*, was exhibited at the OWCS in 1841 [PL.184]. The larger version was painted for William Leaf of Streatham, and is now in Sunderland Museum and Art Gallery. In both these crowded and colourful compositions the carefully conceived groups of lively figures are skilfully incorporated in the detailed architectural setting to create a telling record of this moving Roman scene. It was to be the last work exhibited by Lewis in London for almost a decade, for in the summer of 1840 the artist left Rome for Greece, the Levant and Egypt. In Constantinople, where he spent about a year, he met Wilkie, who reported, when writing to William Collins, that 'he [Lewis] has been making most clever drawings as usual'.[1]

In November 1841 Lewis left Constantinople for Cairo, where he settled and remained until the spring of 1851, making occasional expeditions up the Nile and to the desert. Lewis lived and dressed in 'the most complete Oriental fashion', to use the words of William Thackeray, who visited him in 1844 and wrote a vivid account of the artist's house and way of life in his *Notes of a Journey from Cornhill to Grand Cairo*, published two years later. The author was, however, mistaken in thinking that Lewis's

(184) John Frederick Lewis, *Easter Day at Rome – Pilgrims and Peasants of the Neapolitan States awaiting the Benediction of the Pope at St Peter's* (1841). Watercolour and bodycolour; 51×67.3 cm. (Northampton Art Gallery)

was a life of idleness, for as was his wont he drew and sketched assiduously, largely figure and architectural studies. The officers of the Old Water-Colour Society were by now concerned at Lewis's failure to fulfil his obligations as a Member, but it was not until 1850 that he exhibited again, sending *The Hhareem* (Private Collection). This brilliantly coloured, realistic and detailed record of life inside a Cairo harem caused a sensation, and was described by the critic of the *Art Journal* as 'the most extraordinary production that has ever been executed in watercolour'. It was admired both for the skill of its execution and for the originality of its subject, and it was the harbinger of a considerable number of such Eastern interiors, at first in watercolour and bodycolour exhibited at the Old Water-Colour Society, of which he became President in 1855, and later in oils shown at the Royal Academy.

The appearance in London of Lewis's wonderfully detailed and highly finished Near Eastern scene coincided with the exhibition at the Royal Academy of the early and equally detailed paintings of the young Pre-Raphaelites, and it also won the admiration of John Ruskin. In his second letter to *The Times* (30 May 1851) defending the PRB artists, Ruskin mentioned *The Hhareem* as 'a work which, as regards its treatment of detail, may be ranged in the same class with the pre-Raphaelite pictures',[2] and in the following year he claimed Lewis as a Pre-Raphaelite in his pamphlet *Pre-Raphaelitism*. In his *Academy Notes* of 1856 Ruskin lavished lengthy praise on Lewis's principal OWCS exhibit of that year, the large *Frank Encampment in the Desert of Mount Sinai, 1842* [PL.185], 'ranking it among the most *wonderful* pictures in the world', and describing it as 'a map of antiquity and modernism in the East'.[3] Actually commissioned by Lord Castlereagh in 1842, the *Frank Encampment* shows that nobleman's impressive camp and entourage during a journey to Mount Sinai in 1842, as was indicated (except for the actual identification of the 'English Nobleman') in the lengthy title that accompanied

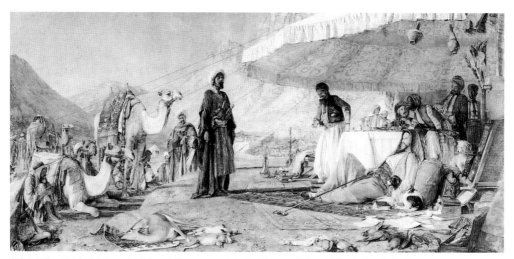

(185) John Frederick Lewis, *A Frank Encampment in the Desert of Mount Sinai, 1842* (1856). Watercolour and bodycolour; 64.8×134.3 cm. (Yale Center for British Art, Paul Mellon Collection)

the drawing in the exhibition catalogue. The *Frank Encampment* and Lewis's other equally detailed and informative Near Eastern scenes provided viewers with convincing insight into a part of the world that was just opening up to travellers. The camera was beginning to provide similar material, but at this point it could not compete with the colourful 'marvels of patience and detail'[4] of J. F. Lewis and of some of the other contemporary painters of actual life.

However, only a year later, Ruskin wrote somewhat critically of *Hhareem Life, Constantinople* [COL.PL.63], exhibited at the OWCS in 1857, which was bought by the well-known Turner collector B. G. Windus, asking 'how far the conscientiousness of completion ought to be allowed to extend'?[5] In fact the critic had already been trying to persuade Lewis to paint his intricate scenes in oils rather than watercolour and bodycolour, and Lewis had followed that advice, starting to exhibit oil paintings again at the Royal Academy in 1855, and he continued to do so quite regularly for the rest of his life. For Lewis painting in oils was no more laborious than his elaborate work in bodycolours, and the results were much more profitable. In order to qualify for academic honours he resigned from the Old Water-Colour Society in 1858, and he was elected ARA in the following year and RA in 1865. We know from the Redgrave brothers that 'Lewis was very particular both in the preparation of his colours and in the choice of his panels, which latter he generally used in preference to canvases.... His colours were mostly mineral, and were selected with great caution. He used, as a rule, exceedingly small sable brushes, hog tools only for backgrounds or scrubbing in.'[6]

Two of Lewis's four Royal Academy exhibits in 1874 were a pair of small panel paintings, *Outdoor Gossip, Cairo* (Private Collection) and *Indoor Gossip (Hhareem) Cairo* (Whitworth Art Gallery, University of Manchester). *Indoor Gossip* is a brilliantly simple and yet totally effective study of colour and light (exhibited in the same year as the first Impressionist exhibition in Paris), in which Lewis has painted with meticulous care the light and shade created by the sun pouring through the intricate trellis-work. At the same time this attractive picture tells a story, for by pairing it with *Outdoor Gossip*

the artist contrasts the enclosed and sheltered life of upper-class women in Cairo with the much freer life of their men out in the streets. Thus J. F. Lewis here, as so often, combined artistic skill and genius with the ability to inform and instruct, a combination that particularly appealed to mid-Victorian British taste. This was a period when travel abroad became increasingly easy and popular, and Lewis and other artists working abroad satisfied the demands of the travellers to acquire more telling and lasting records of what they had seen and experienced than the camera could provide.

30 C. R. Leslie, RA (1794–1859), Richard Redgrave, RA (1804–88), and other Painters of Genre

The opening section of C. R. Leslie's *Handbook for Young Painters*, first published in 1855 and comprising the lectures which he had given as Professor of Painting at the Royal Academy, is entitled 'On the Imitation of Nature, and on Style'. In it he states 'there is nothing really excellent in Art, that is not strictly the consequence of the artist's obedience to the laws of Nature'. This was, of course, a sentiment with which John Constable would have readily agreed, and it is as the biographer of Constable that Leslie is principally remembered today. The two artists became close friends and neighbours in the early 1820s, and C. R. Leslie's *Memoirs of the Life of John Constable – composed chiefly from his Letters* was first published in 1843, six years after Constable's death. It remains today one of the most readable and valuable biographies of a British artist, as well as being the record of a remarkable friendship, which is also brought to life in the third volume of R. B. Beckett's invaluable edition of *John Constable's Correspondence*, 'The Correspondence with C. R. Leslie, R.A.', published in 1965.

Born in London of American parents, Charles Robert Leslie grew up in Philadelphia, but returned to London in 1811 to study painting, becoming a student at the Royal Academy Schools, where the elderly Henry Fuseli was still Keeper, in 1813. Throughout his career the Academy, where he first exhibited in 1813, remained the focal point of Leslie's professional life, and he quickly established a reputation with his anecdotal and often humorous figure compositions, mostly based on literary sources. One of his 1819 exhibits, *Sir Roger de Coverley going to Church*, was especially well received, and Leslie was elected ARA two years later, and RA in 1826, three years before his friend John Constable, who was nearly twenty years older. One of Leslie's most popular and celebrated paintings was *A Scene from Tristram Shandy (Uncle Toby and the Widow Wadman in the Sentry Box)* [PL.186], the first version of which, based on an earlier watercolour, was shown at the Academy in 1831. This version was acquired by Robert Vernon, and one of the two later versions was painted for John Sheepshanks, whose collection included a total of twenty-four works by Leslie. Though the painting of the figures on a larger scale than was his wont had caused Leslie some problems, the work was extremely well received by the critics, as in *Arnold's Magazine of the Fine Arts*, where it was described as 'altogether a faultless work, a real gem of Art, and for the excellencies pointed out, cannot be equalled by any of the old masters'.[7] Half a century later the French critic Ernest Chesnau still referred to this painting as 'a masterpiece of observation, good humour and fun'.[8]

(186) C.R. Leslie, *Uncle Toby and the Widow Wadman in the Sentry Box* (RA 1831).
Oil on canvas; 81.3×55.9cm. (Tate Gallery, London)

Leslie continued to exhibit such easy, entertaining and often humorous compositions, many of which were subsequently engraved, almost every year for the rest of his life. Although he chose most of his subjects from a variety of highly respectable literary sources, among them Shakespeare, Don Quixote, Goldsmith and Molière, to modern eyes it seems remarkable that the artist could have achieved such a high reputation on the basis of such lightweight compositions. However, the Redgrave brothers declared that 'the subjects chosen by Leslie were of a higher class than the early works of either Wilkie or Mulready. He seems from the first to have had an innate refinement in his choice, and to have thrown a sense of gentle blood into all he did. His works abound in beauty, elegance, character, and quiet humour, which make them irresistibly pleasing.' The brothers then choose one of Leslie's 1844 Royal Academy exhibits, *Sancho Panza in the Apartment of the Duchess* (Tate Gallery, London), which was also bought by Robert Vernon, for detailed analysis: 'How lovely is the duchess, how perfectly at her ease, how truly one of nature's gentlewomen as she sits listening to Sancho's tale! What a round full form! The light of a happy smile in her eyes; the amused satire of her dimpling mouth, pleased at the simplicity of the peasant squire who takes her into his confidence....'[9]

Richard Redgrave, who was ten years younger than C. R. Leslie, had a much wider range as an artist, though his reputation was also established by a succession of fairly light-hearted literary subjects and costume pieces, such as *Cinderella about to try on the Glass Slipper*, exhibited at the RA in 1842 (Victoria and Albert Museum, London). However, he also showed attractive naturalistic landscape compositions, and from the early 1840s he painted a series of impressive canvases illustrating scenes of modern genre and often including telling social comment. One of the first and most successful of these was *The poor Teacher*, shown at the RA in 1843 and now lost, though known from an engraving of 1845. Redgrave painted several further versions of this moving subject, the best known of which is *The Governess* [PL.187], which was painted for John Sheepshanks, and shown at the Academy in 1845, with the unattributed quotation, 'She sees no kind domestic visage here', accompanying the title in the catalogue. Originally this version, like *The poor Teacher*, showed only the central character in a dark interior, and Redgrave later added the group of girls in the background at Sheepshanks's request. Pre-dating the Pre-Raphaelite 'modern moral' subjects by a few years, *The Governess*, like these, is full of innuendo and symbolism; the music sheet on the piano is *Home, Sweet Home*, the popular song of 1823 by Sir Henry Bishop. Dressed in mourning and holding a black-edged letter the wan and thoughtful young woman typifies the fate of hundreds of Victorian daughters, including one of Redgrave's own sisters, who were forced to leave home by economic or other circumstances. In this amended version of the picture the 'heroine's' fate is emphasised by the contrast with the happy activities of her young charges. In these carefully conceived compositions Redgrave's powerful draughtsmanship comes into its own, for his figures are always beautifully 'drawn', and for these paintings the artist usually made numerous preliminary figure studies.

Other similar themes were movingly illustrated by Richard Redgrave, among them, *Going into Service* (also RA 1843), *The Sempstress* (RA 1844), and *The Outcast*, a vivid scene of an unmarried mother and her baby being evicted from her home by her father. This was Redgrave's Diploma Work when he was elected RA in 1851. Another

(187) Richard Redgrave, *The Governess* (RA 1845). Oil on canvas; 71.1×91.5 cm.
(Victoria and Albert Museum, London)

(188) Richard Redgrave, *The Emigrant's Last Sight of Home* (RA 1859). Oil on canvas; 68×98.4 cm.
(Tate Gallery, London)

poignant composition recording a contemporary social problem, which also demonstrates Redgrave's skill as a painter of landscape, is *The Emigrant's Last Sight of Home* [PL.188], which was shown at the Academy in 1859. The landscape was painted at Leith Hill in Abinger, Surrey, where Redgrave had a country cottage, and in this attractive Home Counties setting the artist has achieved a direct and touching record of the major social problem of rural emigration, which was common throughout the British Isles, and especially in Ireland, in the 1840s and 1850s. This was a subject tackled by several artists, most famously, of course, by Madox Brown in his *The Last of England* [PL.171]. While Redgrave's composition is full of meaningful details – the anxious glance of the mother cradling her baby, the tame bird in its cage and the kitten peeping out of the basket in the foreground – Redgrave has succeeded in painting a balanced picture in which the narrative element is cleverly integrated into the landscape.

In his later years Richard Redgrave reverted again to the painting of pure landscape, which he found a relaxing activity during his exceptionally busy official and writing career. This was largely concerned with art education, which had become a major concern of government in the 1840s. The Government School of Design had opened in 1837 in the rooms at Somerset House recently vacated by the Royal Academy. After a somewhat turbulent start, this institution was given a firmer basis under the guidance of Henry Cole, with Richard Redgrave, who had joined the staff in 1847, as his right-hand man. The unwieldy institution was removed from the direct control of the Board of Trade in 1852, and became part of an independent Department of Practical Art in 1852; this was renamed the Department of Science and Art a year later. Henry Cole was appointed General Superintendent of the new department and Redgrave became Superintendent for Art, quickly devising sounder teaching methods and providing the manuals required to establish these. For the next quarter of a century Cole and Redgrave, who had long been friends and collaborators, were essentially the controllers of art education in Britain; Redgrave became Director of the School of Design in 1874, and his educational role was the focal point of his later career. In addition he was appointed Surveyor of the Queen's Pictures in 1857, a task which he performed with exceptional ability, drawing up a detailed inventory of the Royal collections, which became the basis of all future lists and catalogues.[10] In addition to all these duties Redgrave was also much involved with the development of the South Kensington (now Victoria and Albert) Museum, founded on its present site in 1857.

Last, but not least, Redgrave was a prolific and gifted author of art-historical books, most famously of the invaluable *A Century of British Painters*, often quoted in this volume, which was written with his older brother Samuel, and first published in 1866. In 1874 Samuel Redgrave, who was a civil servant, published his *Dictionary of Artists of the English School*, which remains a most useful reference work to this day. Much of what we know about the life and art of Augustus Leopold Egg, RA (1816–63), comes from these two books. 'Never a robust man' and from a prosperous background, Egg studied at Sass's Academy and at the RA Schools, and first exhibited at the Royal Academy in 1838, becoming ARA in 1848 and RA in 1860. 'Egg's first pictures were painted with a broad and free pencil and a clear touch, and his execution gave the sense of great ease and facility.' Most of his early subjects, like those of C. R. Leslie, were literary and historical, like his 1844 exhibit, *Scene from the 'Devil upon two Sticks'*, which was bought by

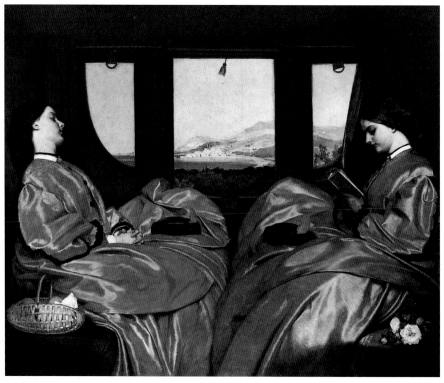

(189) Augustus Egg, *The Travelling Companions* (1862). Oil on canvas; 64×76.5 cm.
(Birmingham Museums and Art Gallery)

Robert Vernon (Tate Gallery, London). Based on a scene from the romance *Le Diable Boiteux* by the early eighteenth-century French comic writer Alain René le Sage, this is full of moral and sexual innuendo.

These factors became more forceful when Egg, largely under the influence of the Pre-Raphaelites, whose work he himself collected, produced such modern moral subjects as the Tate Gallery's *Past and Present*, a triptych of compositions movingly and hauntingly recording the fate of an unfaithful mother and of her two young children, which caused a sensation when exhibited at the RA in 1858. Much less demanding, but painted with equal firmness of line and colour, is the beautiful *The Travelling Companions* [PL.189], which shows two elegantly dressed young ladies relaxing in a railway carriage, with a view of the coast near Menton seen through the window. Painted when Egg himself was travelling in the South of France in search of better health in the last year of his life, this is another 'social document' which tells us much about the travelling habits of the wealthy English in the early days of the railways.

Born in the same year as Egg, Edward Matthew Ward, RA (1816–79), was a student at the Royal Academy at an early age, and was subsequently trained in Rome and elsewhere on the Continent. He was also a regular exhibitor at the Royal Academy, becoming ARA in 1846 and RA in 1855. Many of Ward's subjects illustrated British historical and literary scenes of the seventeenth and eighteenth centuries, and in the exhibition catalogues their titles were frequently accompanied by lengthy quotations or descriptions. In many of his compositions Ward was much influenced by the work of

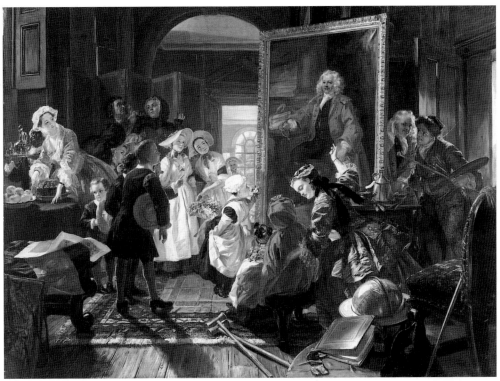

(190) E.M.Ward, *Hogarth's Studio, 1739 – Holiday Visit of the Foundlings to View the Portrait of Captain Coram*
(RA 1863). Oil on canvas; 120.6×165.1 cm. (York City Art Gallery)

William Hogarth, and his debt to that great predecessor is well illustrated in one of his
two 1863 exhibits, *Hogarth's Studio, 1739 – Holiday Visit of the Foundlings to View the
Portrait of Captain Coram* [PL.190], which features Hogarth's famous Foundling Hospital
portrait of Captain Coram and also the artist's often-painted pug, *Trump*. This crowded
composition is typical of Ward's charming, lively and entertaining style, which brought
him considerable acclaim. He also exhibited a number of pictures depicting poignant
moments from the last days of the French monarchy. Ward had not won a prize for his
cartoon in the Palace of Westminster competition in 1843, but ten years later he was
commissioned to paint eight subjects illustrating seventeenth-century Parliamentary
history to decorate the Commons' Corridor at Westminster. The first were painted in
oils, and were exhibited to popular acclaim at the Royal Academy, but Ward was then
instructed to use fresco painted on slate. This commission confirmed Ward's position
as one of the leading historical painters of the day, but this mid-nineteenth-century
British 'history painting' was far removed from the history painting in the grand
manner of two generations earlier. Essentially 'homely' in character, it was purely
illustrative and instructive, and it was a genre that became widely popular through
engravings and through illustrations in school-books.

Thomas Webster, RA (1800–86), who had started life as a chorister at St George's
Chapel, Windsor, was one of the favourite artists of John Sheepshanks, and there are
six of his paintings in his gift, including the ever-popular *A Village Choir* [PL.191], which
was painted for him and exhibited at the RA in 1847. Like much of Webster's work this

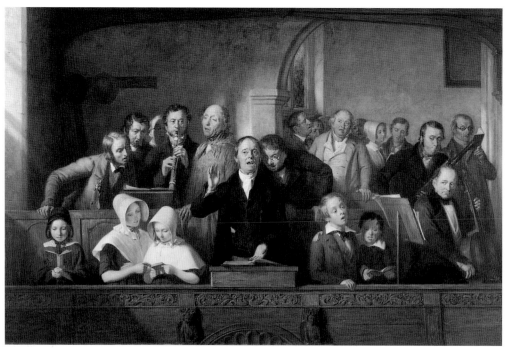

(191) Thomas Webster, *A Village Choir (RA 1847)*. Oil on panel; 60.4×91.5 cm.
(Victoria and Albert Museum, London)

(192) Thomas Faed, *The Mitherless Bairn* (RA 1855). Oil on panel; 63.5×91.5 cm.
(National Gallery of Victoria, Melbourne)

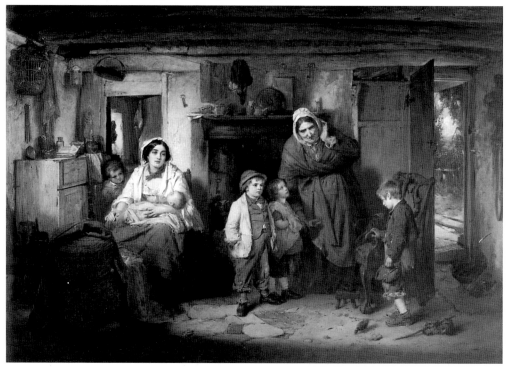

composition, in the tradition of Wilkie and Mulready, achieves an evocative, though romanticised, portrayal of rural atmosphere and character. The subject was inspired by Washington Irving's *The Sketch Book* of 1820, and was justly admired by one critic for 'truth and diversity of character, and for careful painting'. Webster had been elected RA in the previous year, having exhibited portraits, history and genre paintings since 1823; he continued to do so with success until 1879, with titles such as *A Dame's School* (1853), *Sunday Evening* (1858), *Village Gossips* (1865) and *The Letter* (1877). Webster was also popular as an illustrator, as were some of the other members of the Cranbrook Colony, a group of genre painters who joined Webster to live in the Kentish village after he had moved there in 1856.

Another disciple of Wilkie, and a fellow Scot, was Thomas Faed, RA (1826–1900), who was trained in Edinburgh, but settled in London in 1852, having shown at the Royal Academy for the first time in the previous year. He achieved great acclaim a few years later with *The Mitherless Bairn* [PL.192]. Inspired by a Scottish poem this shows a homeless orphan being taken in by a caring family of cottagers, and it was one of his three RA exhibits in 1855. 'From that time almost to the end of his career he was', according to the *DNB*, 'one of the most popular of British painters'. That popularity was based on a succession of similar compositions showing 'pathetic or sentimental incidents in humble Scottish life', in which 'the sincerity and dramatic skill with which he told his story appealed strongly to the public taste'.[11] Faed was a fine draughtsman and painted his scenes of 'acceptable' social realism with something of the power and confidence of his mentor, Sir David Wilkie. A measure of his success was the one-man exhibition at Agnew's, shown in 1860 in their new London gallery, which had opened that year, and the exceptional number of magazine articles devoted to him.

Soon after the opening of the RA exhibition *The Mitherless Bairn* was reviewed and reproduced as a wood-engraving in *The Illustrated London News*, which, since its foundation in 1842, had made a feature of its long illustrated reviews of the major art exhibitions. The 1840s and 1850s also saw the launching of a considerable number of new journals devoted specifically to art, including the *Art Journal* in 1849 and the *Magazine of Art* in 1852. In the early days these were also illustrated with rather poor wood-engravings of the paintings and other works of art which were being discussed or reviewed. These illustrations, like those in *The Illustrated London News*, served to increase enormously the number of people familiar with the work of successful artists such as Thomas Faed. The launching of such new art periodicals at this time provides further evidence of the expanding popular interest in contemporary British art.

31 William Powell Frith, RA (1819–1909)

While most of the artists discussed in the previous chapter have been largely forgotten, William Powell Frith has remained almost a household name, principally on the strength of one painting, *The Derby Day* [COL.PL.58]. This was a sensational success at the Royal Academy in 1858 and was bequeathed to the National Gallery only a year later when the famous chemist Jacob Bell, who had commissioned it, died at the early age of forty-nine. Thus this famous painting, which was, of course, also engraved, has

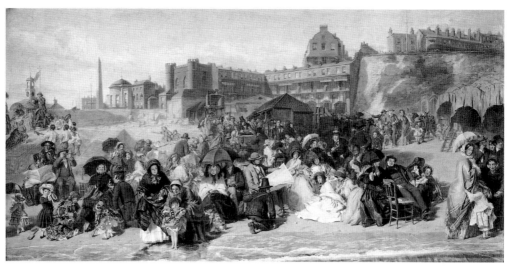

(193) William Powell Frith, *Ramsgate Sands: 'Life at the Seaside'* (RA 1854). Oil on canvas; 76.8×154.9cm. (The Royal Collection)

remained in the public domain throughout its existence, though, as we shall see, it did not actually enter the National Gallery until 1865.

Frith had already enjoyed acclaim and success for some years when he painted *The Derby Day*. Born in Yorkshire, he had come to London in 1835 and studied at Sass's Academy and the RA Schools. He started exhibiting at the British Institution and the Society of British Artists in 1838, and at the Academy in 1840, and the majority of his exhibits were of literary and genre subjects. Elected ARA in 1845, and RA eight years later, his first major success came in 1854, when he exhibited *Ramsgate Sands: 'Life at the Seaside'* [PL.193]. When the Queen with Prince Albert visited the exhibition she was delighted with the picture, and, though it had already been purchased for 1000 guineas by the dealers, Messrs Lloyd, they agreed to sell it to her without profit, which they hoped (correctly) to achieve through the reproduction rights which they retained. Frith, who had a large family of twelve children (and a second one of seven children by his mistress, who was later to be his second wife), spent his summer holiday in 1851 at Ramsgate, the resort on the Kent coast popular with Londoners; 'weary of costume-painting, I had determined to try my hand on modern life, with all its drawbacks of unpicturesque dress. The variety of character on Ramsgate Sands attracted me – all sorts and conditions of men and women were there. Pretty groups of ladies were to be found, reading, idling, working, and unconsciously forming themselves into very paintable compositions.'[12] He started to make sketches on the sands, and thus began the first of Frith's impressive and crowded panoramas of modern life, which were among the most successful and popular paintings of the middle years of the century. This was artistic showmanship and entertainment on a grand scale, rather than moralising and instruction in vignettes of contemporary life, such as Redgrave, Egg and the Pre-Raphaelites were painting.

Having made an oil sketch of the composition, from which Egg advised him to paint a large picture, Frith returned to Ramsgate in the summer of 1852 and painted the background of the large canvas, which depicts the main buildings on Ramsgate's front

in some detail. He spent much of 1853 working on the picture, having some difficulty in finding suitable models, and when it was finally hung at the 1854 RA exhibition it was one of 'the guns' that year, in which Frith also showed three literary costume pieces and a portrait. Despite the outstanding success of *Ramsgate Sands* and of his subsequent modern-life subjects, Frith continued to paint, exhibit and sell much more conventional and less demanding works – today largely forgotten – of the type on which his reputation had originally been based.

Frith's claim that 'I cannot say that I have ever found a difficulty in composing great numbers of figures into a more or less harmonious whole'[13] was again wholly justified by *The Derby Day*, the entertaining panorama of the crowded scene on Epsom Downs during the greatest day of the English horse-racing year. The idea for such a composition had come to Frith during 'my first experience of the modern Olympian games' when he visited the races at Hampton in 1854. Accompanied by Augustus Egg, Frith saw his first Derby at Epsom two years later; it 'had no interest for me as a race, but as giving me the opportunity of studying life and character, it is ever gratefully to be remembered'. He made his first 'rough charcoal drawing' of the composition a few days later, and then, 'after making numbers of studies from models for all the prominent figures', he painted a 'small careful oil-sketch – with colour and effect finally planned' while on holiday at Folkestone. On seeing this sketch Jacob Bell commissioned the 'picture five or six feet long from it', and after painting at least two larger compositional sketches, Frith began working on the huge canvas in January 1857, and, 'after fifteen months' incessant labour', the great painting was finished in time for the Exhibition of 1858. Here it was indeed *the* painting of the year; it had to be specially guarded by a policeman, and then also protected from the crowds by a rail, something which had not occurred at the Summer Exhibition since the showing of Wilkie's *The Chelsea Pensioners* [COL.PL.39] in 1822. *The Derby Day*, with its abundance of character studies and happenings, such as the acrobat performing in the foreground, encouraged minute study of all the detail, and it was this that caused such problems at the exhibition and has also resulted in its continuing fascination for viewers.

The 'epic' of *The Derby Day* had only just begun, for while Jacob Bell had paid £1500 for the actual painting, the leading print publisher and art dealer Ernest Gambart paid the same sum for the copyright, and took a proprietorial interest in the completion and success of the picture. He helped Frith obtain photographs of scenes at Epsom, which the artist used as an aid, though he never readily admitted to the use of photographs and usually emphasised the importance of drawing and painting from nature as much as possible. It was Gambart who finally persuaded the Royal Academy to erect a stout iron rail to protect 'my property' from the danger of damage by the crowds at the Exhibition. An agreement had been made between Frith, Bell and Gambart that allowed the dealer to keep *The Derby Day* for five years for engraving and exhibition. After the RA exhibition Frith made a number of alterations and then the painting, after a further showing at another dealer's gallery in London, was sent to Paris to be engraved by Auguste Blanchard. However, the large print was not finally published until 1862, and over 5000 impressions were sold. In the meantime the painting was sent on a worldwide tour, and exhibited throughout Europe, North America and Australia, largely in order to obtain subscriptions and sales for the engraving.

Jacob Bell had died late in 1859, and bequeathed *The Derby Day* and the rest of his notable collection of contemporary paintings to the National Gallery. This largely forgotten collection included seven paintings by Sir Edwin Landseer, among them *Dignity and Impudence* and *Shoeing*, and works by Etty, E.M.Ward, G.B.O'Neill and other British artists, as well as the famous *Horse Fair* by Rosa Bonheur, of which Gambart also owned the copyright. Gambart retained *The Derby Day* somewhat longer than the stipulated five years, but, after correspondence in *The Times* and elsewhere, it was finally handed over to the Trustees of the National Gallery in 1865, and has remained one of the most popular paintings on its walls, and then at the Tate Gallery, to which it was transferred in 1951, ever since.

For his next 'epic of modern life' Frith chose a subject that had been popular with artists for some twenty years, and produced an 'icon' of the early days of the railways that even today rivals the popularity of Turner's pioneering *Rain, Steam and Speed* [PL.77] of 1844. He started work on *The Railway Station* in 1860 and it was ready for exhibition in the spring of 1862, when it was shown at the Haymarket gallery of L.V. Flatow, the dealer who had commissioned it and paid £4500 for the painting and its copyright, to which £750 was later added when Frith waived his right to show it at the Academy. In 1863 Flatow sold the painting with its copyright to the well-known publisher Henry Graves & Co. for £16,300. The first large engraving, by Francis Holl, was published in 1862, and engravings of *The Railway Station*, some of them pirated, continued to be popular for many years. From its inception the press took great interest in the painting and its changes of ownership. The material and commercial aspects of the major paintings of this time were important news items throughout this period, just as record auction prices for works of art are today. In 1883 Graves sold the painting for only £2000 to Thomas Holloway, who died that year. He had formed his spectacular collection of mostly modern British paintings in the previous two years for presentation to the college for young ladies which he founded at Egham, and which was later known as Royal Holloway College.[14]

The Railway Station is set in the imposing Great Western Railway London terminus at Paddington, which had been designed by Isambard Kingdom Brunel and built between 1850 and 1852. This vast painting, which is even larger than *The Derby Day*, captures all the hustle and bustle of a railway platform from which a main-line train is about to depart. Numerous separate incidents are enacted, from the family arriving late and rushing towards the train on the left, to the famous arrest by two top-hatted policemen of the ashen-faced criminal about to climb into his carriage on the right. There are dozens of vivid figures portrayed with great individuality, for many of whom the models are known – the policemen are portraits of two well-known detectives. The picture was again received with rapture, and the critic of the *Art Journal* described it as a 'painted volume' which was 'a work of immense power, not only in the variety and interest of its incident – in its fidelity of individual character – in its admirable grouping and colour – but in its conscientious elaboration of finish'. In its review the *Illustrated London News* stated that 'as a painter of his own time Mr Frith is only equalled by Hogarth'.

While he had been hard at work on *The Derby Day* Frith was allowed to decline a Royal commission to paint 'a Group from the ceremony of the Marriage of the Princess

Royal', but in 1863 he accepted the Queen's commission to paint *The Marriage of the Prince of Wales* (Royal Collection, Buckingham Palace), which took place in St George's Chapel, Windsor, on 10 March of that year. The huge and somewhat static composition, for which Frith was paid £3000, included some 140 portraits, many of them based on photographs of the sitters, and was completed in time for the Summer Exhibition of 1865. It was then hung in the Music Room at Buckingham Palace.

The Railway Station, painted when the long-lived artist was only in his early forties, was the last of Frith's 'block-buster' paintings, but he continued to show at the Royal Academy almost every year, mostly historical and literary costume pieces, such as *Sir Roger de Coverley and the perverse Widow*, one of seven exhibits in 1870. There were a few more of his large-scale contemporary scenes with numerous figures, among them *The Salon d'Or, Homburg* (1871, Rhode Island School of Design) depicting the crowded scene in the casino at the fashionable German resort near Frankfurt, and *The Private View, 1881* (1883, Private Collection), which shows the elegant gathering at the Private View at Burlington House. There were also one or two moralising series in the tradition of Hogarth, such as *The Road to Ruin*, a sequence of five scenes recording a Victorian 'gambler's progress' (Private Collection), which was exhibited in 1878 and again required the protection of a rail. On the whole, however, Frith's reputation was on the wane during the closing decades of his long life. As he himself wrote in the final paragraph of the second volume of the second edition of *My Autobiography and Reminiscences* (1887): 'A new style of art has arisen, which seems to gratify a public ever craving for novelty.' Frith went on to warn his readers 'that the *bizarre*, French "impressionist" style of painting recently imported into this country will do incalculable damage to the modern school of English art', and to urge 'the rising generation of painters' to avoid the pitfalls of Impressionism and rather to follow 'the great old masters' – advice of which Sir Joshua Reynolds would certainly have approved.

32 Later Painters of Social Realism

A number of artists born in the 1840s, when Frith was already establishing his reputation, painted works which, like some of those of Frith, have retained their popularity to this day because of their telling depiction of contemporary social scenes and problems. It is because of the social content of some of their most important paintings that such artists have been especially admired in the revival of interest of the 1980s and 1990s in mid-Victorian painting. In the context of their own time some of these artists were certainly relatively less popular and important than they appear today, but their challenging genre paintings did achieve considerable attention and sometimes notoriety.

Frederick Walker, ARA (1840–75), whose highly successful career was cut short by his early death, developed a distinctive style combining, as Herkomer summed it up, 'the grace of the antique with the realism of our everyday life in England',[15] which was very influential on some of his slightly younger fellow artists. Born in Marylebone the son of a jewellery designer and trained in London, some of the time in the studio of a wood-engraver, Walker was especially assiduous in his study of the Elgin Marbles

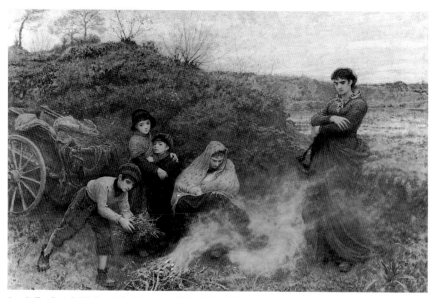

(194) Frederick Walker, *The Vagrants* (RA 1867). Oil on canvas; 83.2×126.4 cm.
(Tate Gallery, London)

in the British Museum. In his early work, which was largely in watercolours, he also showed his keen interest in genre, landscape and naturalistic detail. He quickly made a reputation as an illustrator, providing designs for wood-engravings – at that time the most popular medium for magazine illustration, largely because of the rapidity of execution and the consequent low cost – for such magazines as *Once a Week*, the *Cornhill Magazine*, then edited by Thackeray, *Good Words* and *Sunday at Home*. In 1864 he began to exhibit at the Old Water-Colour Society of which he was elected an Associate that year and a full member only two years later. He had also begun to exhibit oils at the Royal Academy, and there his first work, *The Lost Path* (Private Collection), shown in 1863, was based on an engraved illustration to Dora Greenwell's poem *Love and Death*, published in *Good Words* in 1862. The wood-engraving was designed to illustrate moving lines from a somewhat sentimental poem about a mother and her baby lost in a snow-storm in Vermont; the painting and its title can be read as being rather more symbolic, the 'lost path' of the title referring also to the moral standing of the probably unmarried mother.

Many of Frederick Walker's other exhibited watercolours and oils were based on his effective illustrations designed to accompany passages of poetry and fiction. However, the painted versions usually encompassed some more realistic and frequently social comment, and the figures were depicted with sensitivity and expressive monumentality. *The Vagrants* [PL.194] was exhibited at the Royal Academy in 1867, and was based on an illustration to *The Gypsies' Song*, a translation from the Russian published in *Once a Week* in 1866. Gypsies and vagrants were a frequent theme in Victorian fiction and art, and Walker's painting was well received by the critics and made a strong impression on some of his younger contemporaries, especially Herkomer. During his short career Frederick Walker continued to develop his individual style in watercolours, and in this medium his atmospheric and delicate landscapes enlivened with 'homely

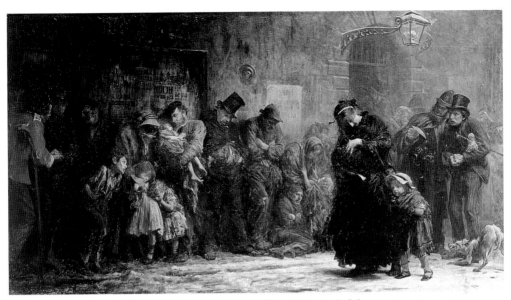

(195) Sir Luke Fildes, *Applicants for Admission to a Casual Ward* (RA 1874). Oil on canvas; 137.1×243.7 cm. (Royal Holloway and Bedford New College, Egham)

incident' again had considerable influence on several other artists. The high reputation achieved during his lifetime by this now largely forgotten artist is reflected by the fact that *The Vagrants* was actually purchased by the National Gallery in 1886.

Today the reputation of Sir Luke Fildes, RA (1843–1927), rests very largely on one early work, *Applicants for Admission to a Casual Ward* [PL.195], which was exhibited at the Academy in 1874, and was another of the major Victorian paintings bought by Thomas Holloway in the last year of his life. This moving and disturbing painting was based on Fildes's wood-engraving entitled *Houseless and Hungry*, which was the most successful illustration in the first issue of *The Graphic*, published on 4 December 1869. What distinguished this new weekly magazine from its rivals, was that it employed 'all artists whatever their method, instead of [only] draughtsmen on wood as had hitherto been the custom'.[16] Founded by William Luson Thomas, himself a wood-engraver who had worked on the *Illustrated London News*, *The Graphic* was an immediate success and quickly became known for the high quality of its illustrations. Of these the social subjects, usually reproduced as full-page or double-spread engravings, were, however, only one element, though they were a special feature of the magazine and frequently caused considerable comment. *Houseless and Hungry* shows the scene outside a London police station with a queue of cold and miserable paupers waiting to be allocated tickets for admission to the casual ward of a workhouse, where they could obtain food and shelter for the night. Fildes had witnessed such a scene of misery on a snowy winter's night soon after arriving in London as a young art student in 1863. Born in Liverpool, and trained at a local Mechanics Institute he had come to London to study at the South Kensington School of Art, and soon found work and established a reputation as an illustrator for various journals.

Fildes also began to paint in watercolours and oils, and first exhibited at the Royal Academy in 1868. In 1871 he showed the famous composition '*The Empty Chair*' – Gads

Hill, Ninth of June, 1870, which commemorated the sudden death of Charles Dickens, and was published as a wood-engraving in the 1870 Christmas Number of *The Graphic*. Fildes had come to know Dickens when he was recommended by Millais, who had admired *Houseless and Hungry* in *The Graphic*, as the illustrator for *The Mystery of Edwin Drood*, the great writer's last novel. When *Applicants for Admission to a Casual Ward* was exhibited in 1874 its title was accompanied in the catalogue by a quotation from the as yet unpublished *Life of Dickens* by John Forster, in which Dickens described a visit to a Whitechapel workhouse in 1855: 'Dumb, wet, silent horrors! Sphinxes set up against that dead wall, and none likely to be at the pains of solving them until the *general overthrow*.' The painting caused overwhelming interest at the exhibition, and was also one of those that had to be protected from the crowds by a policeman and a rail. The critics were, on the whole, also enthusiastic, though several questioned the suitability of the subject; one doubted whether 'mere misery like this is a fitting subject for pictorial treatment'.

Two years later Fildes exhibited another moving picture, *The Widower* (National Gallery of New South Wales, Sidney), in which the father is shown cradling his dead daughter, while an older daughter looks miserably on and younger children play carelessly in the foreground. This sombre scene is set in a bare and dark cottage interior, and it seems likely that in painting it Fildes was influenced by the work of Thomas Faed. Elected ARA in 1879 and RA eight years later, the artist largely abandoned his social subjects, and established his reputation as a skilful portrait painter, as well as producing sentimental genre scenes, many of them, after his first visit to Italy in 1874, depicting Venetian life. In 1893 he gained the first of several Royal portrait commissions, and in his later years he painted State portraits of Edward VII, Queen Alexandra and George V.

In 1891 Fildes exhibited his last significant and popular English genre scene, *The Doctor* (Tate Gallery, London), which had been commissioned by Henry Tate, who already had in mind the presentation of his collection of British painting to the nation. This poignant painting shows the doctor sitting thoughtfully gazing at a sick child sleeping on a makeshift bed in a lamp-lit cottage interior, and provides ample material for thought but does not drive home a particular social message. *The Doctor* was again an outstanding success with the public, and was acclaimed by the critics. The photogravure of it published by Agnew's became the most popular print ever published by that firm – over a million copies were sold. For many years it remained one of the favourite paintings at the Tate Gallery, but it was the last such work by Luke Fildes.

When he died at the early age of forty-three, Frank Holl, RA (1845–83), had recently become one of the most successful and fashionable portrait painters in London. Somewhat surprisingly the advent of photography had barely dented the demand in Britain for portraits in oils, though it had almost annihilated the market for miniature portraits. Success as a portrait painter also brought material success, as it had done for British painters before the advent of photography, and like Luke Fildes, for whom the same architect built a house in Melbury Road, Holl commissioned Norman Shaw to design a house for him, first a studio house in Hampstead, and then a second 'country retreat' in Surrey. Born in London into a family of engravers, Holl had entered the RA Schools at the early age of fifteen, winning silver and gold medals, and then a travelling

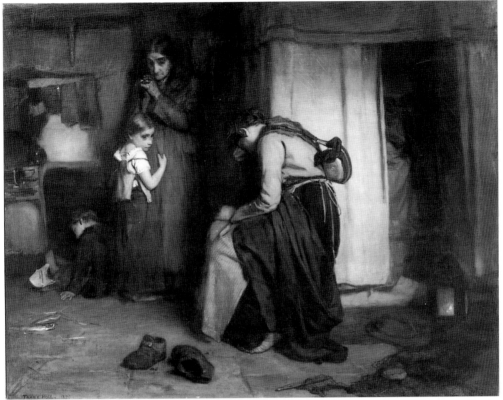

(196) Frank Holl, *No Tidings from the Sea* (RA 1871). Oil on canvas; 71.4×91.4 cm. (The Royal Collection)

scholarship in 1868. The newly married artist set out with his wife for Italy, not so much to study the art of the old masters as to learn about contemporary life, but after only two months he decided that Italy was not the place for him and he resigned his scholarship and returned to England.

The painting with which he had won the scholarship was *The Lord gave and the Lord has taken away – blessed be the name of the Lord*, which was exhibited at the RA in 1869 (Guildhall Art Gallery, City of London). Based on the opening scene from a popular novel of 1851, Mrs Craik's *The Head of the Family*, this sombre composition shows the eldest son taking over as head of a mourning family assembled around the dining room table after the funeral of their father. The painting had already been sold when the widowed Queen Victoria saw it at the Academy and wanted to acquire it, but the buyer refused to cede it to her. The Queen thus commissioned another picture from the young artist, giving him a free choice of subject. The result was again a scene featuring a bereft family, *No Tidings from the Sea* [PL.196], which was exhibited at the RA in 1871. This was painted after a two-month stay at Cullercoats on the Northumberland coast, a fishing village popular with artists at that time, where Holl made numerous studies of the life and work of the fishermen and their families. It shows the interior of a fisherman's cottage in the early morning, to which a young woman has just returned without news of her missing husband, sadly watched by her old mother (or mother-in-law or neighbour) and her daughter, while her son plays on the floor with a rough model of

a boat beside him. The Queen approved of the picture and paid 100 guineas for it, and Holl's reputation was made and his success assured, as was quickly reflected in his being asked to work for *The Graphic*.

His first subject for the magazine was *At a Railway Station – a study*, which showed a young woman in mourning, a soldier and his girl-friend, and a top-hatted old man sitting on a station bench below a 3rd Class notice. It is a scene full of pathos, as were most of Holl's *Graphic* illustrations. There is even more pathos in his Academy exhibit of 1876, *Her Firstborn* (Dundee City Art Gallery), which depicts the sad scene in a country churchyard at the funeral of a child, whose tiny coffin is being carried by four young girls, while the grieving mother follows behind.

In 1878 Holl showed his most successful modern-life subject at the Royal Academy, *Newgate: Committed for Trial*, another of the stars of the Holloway Collection at Egham. As with all his paintings of contemporary life, this moving picture is based on direct personal experience, described in a letter written by the artist some years later, for Holl witnessed such a scene when he visited Newgate prison, where the Governor was a friend of his. Once again some of the critics doubted the propriety of painting such a melancholy subject, but the public and Holl's fellow artists loved it, and he was elected ARA later that year. However, in 1879 Holl began his portrait painting career, and from then on he exhibited mostly portraits each year, and after his election as RA in 1882 he presented as his Diploma Work his fine portrait of his friend and fellow Academician, Sir John Everett Millais. Holl's success as a portrait painter was phenomenal, and led to disastrous overwork – he had always been delicate – which helped to cause his premature death in 1888. It is interesting to note that in their second edition, published only two years after the artist's death, the Redgrave brothers placed their quite lengthy and adulatory passage on Holl in a chapter on portrait painters, and described his portraits as 'showing much sympathy with the characters of his models; they are something beyond mere likenesses, and will depict to posterity something of the mind of the men of the day as well as their outward semblance'.[17] The 'subject works' for which Frank Holl is known today, are only briefly discussed in one fairly dismissive paragraph. On the other hand Vincent van Gogh, who was a great admirer of the English painters of social realism and avidly collected their prints from *The Graphic* and elsewhere, especially admired the work of Frank Holl, to whom he referred frequently in his letters to his brother Theo.

Sir Hubert von Herkomer, RA (1849–1914), whose modern-life compositions in *The Graphic* were also much admired by Van Gogh, was again an outstandingly gifted portrait painter. When he succeeded John Ruskin as Slade Professor at Oxford in 1885, he devoted some of his lectures to demonstrating his art by painting half-length portraits in six sittings of an hour each of leading University figures in front of his audience, which 'followed the progress of the work with great interest'. Five of these powerful and rapidly painted portraits, including ones of Sir Henry Acland and of Dean Liddell, are in the Ashmolean Museum, Oxford, and there are impressive portraits by him in the National Portrait Gallery and other collections. In fact, Herkomer was very much an all-rounder, reminding 'us of the variety and vigour of English academic art in the last quarter of the 19th century'.[18] Herkomer's highly successful career is described in some detail here as a typical example of the considerable material and artistic achievements

(197) Sir Hubert von Herkomer, *The Last Muster - Sunday at the Royal Hospital, Chelsea* (RA 1875). Oil on canvas; 208×154.8 cm. (Lady Lever Art Gallery, Port Sunlight)

enjoyed by a considerable number of now largely forgotten artists of the later years of the nineteenth century.

Herkomer was born in Bavaria, the son of a wood-carver. In 1851 his family emigrated to America, but six years later they returned to Europe and settled in Southampton, where the budding artist grew up against a background of severe poverty. In 1865 on a visit to Bavaria he briefly attended the Munich Academy, and then spent some two years at the South Kensington Art School, where he became friendly with Luke Fildes and was influenced by Frederick Walker. Like them he became one of the principal artists working for *The Graphic*, and his first illustration, *A Gypsy Encampment on Putney Common*, appeared in June 1870. The painting that made Herkomer's name when it was exhibited at the Royal Academy in 1875, was *The Last Muster – Sunday at the Royal Hospital, Chelsea* [PL.197], which was based on the much-praised wood-engraving *Sunday at Chelsea Hospital*, published in *The Graphic* in February 1871. On the surface this composition is simply an evocative portrayal of the seated congregation of elderly pensioners during a service in the chapel at Chelsea Hospital. However, what gives this famous painting such poignancy is the fact that the hollow-faced old man in the foreground has just passed quietly away – his neighbour has turned to him and can no

longer get any response. The painting was ecstatically received at the Royal Academy, and when it was exhibited at the Paris Exposition Universelle of 1878, *The Last Muster* was so much admired that *The Graphic* published an engraving of the scene showing the crowd milling in front of it. Herkomer was one of the two British artists to be awarded a Medaille d'honneur, the other going to Millais. The painting remained enormously popular throughout the rest of Herkomer's career, was lent to numerous exhibitions, and he issued a lithograph of the composition in 1909.

Herkomer, who was something of a sentimentalist in his personal life as also in his art, retained close ties with his native Bavaria, where his parents returned for a time when their successful son bought them a house at Landsberg am Lech, not far from their old home in Waal. The artist painted Bavarian landscapes and peasant genre scenes, in both oils and watercolours, several of which he exhibited at the Academy, and he maintained his contacts with Landsberg throughout his life. He later built himself a studio with an imposing tower– called the 'Mutterturm' in honour of his mother – and became an honorary citizen. Such activities were motivated by a powerful combination of vanity, pride, ambition and generosity, and were based on his considerable material success as an artist. That success was enhanced by his second major modern-life subject, *Eventide – a Scene in the Westminster Union* (Walker Art Gallery, Liverpool), which was shown at the Royal Academy in 1878. Also based on a wood-engraving in *The Graphic*, this large painting was a kind of 'female' companion to *The Last Muster*, but here the very realistic and ever-present problems of urban poverty in London are much more strongly emphasised. Herkomer has again chosen old age and mortality as his theme, having witnessed such a scene in the grim day-room of the St James's Workhouse in Soho. In London the painting did not receive the same adulation as its 'companion' had done, though when exhibited again later in the year at the Liverpool Autumn Exhibition it was purchased for £750 by the recently founded Walker Art Gallery, which also acquired from that exhibition one of its most famous and popular works, William Frederick Yeames's *And when did you last see your father?* At the time W. F. Yeames (1825–1918) was an established artist – he was elected RA that year – and a leading member of the St John's Wood Clique, but today he is forgotten except for the one painting.

Herkomer, elected ARA in 1879, continued to develop his practice as a portraitist, including such eminent personalities as Ruskin, Richard Wagner and the Marquess of Salisbury among his sitters, and specialising in his later years in large portrait groups, such as that of the Council of the Royal Academy painted in 1908 (Tate Gallery, London). Always remembering his humble and poverty-stricken early days, Herkomer enormously enjoyed his growing fame and prosperity. In 1884 he exhibited '*Pressing to the West': a Scene in Castle Garden, New York* (Leipzig Museum) at the RA, and this gloomy and realistic reminiscence of the miseries of emigration to America, which his family must have experienced when he was a baby, was conceived when the artist was on a portrait painting and lecturing tour in America in 1882 and 1883. In 1885 he showed three portraits, two etched copies after Frederick Walker and two contrasting landscape scenes with human interest at the Academy. The first of these, *Found*, based on studies made during one of his visits to north Wales, shows a rocky mountain top wreathed in cloud, with a wounded man – a fugitive ancient Briton fleeing from the Romans – crouching against a boulder and discovered by a half-naked woman. This

wild and realistic scene is in stark contrast to the very ordinary and featureless setting of *Hard Times* (Manchester City Art Galleries), in which an unemployed labourer and his weary family are shown resting at a roadside, destitute and 'on the tramp' in search of work. This stark comment on the economic depression and unemployment of the 1880s reflects Herkomer's continued debt to Walker, and illustrates his own successful combination of reality, imagination and sentiment in such subject pictures.

Though the artist's career continued to flourish, there were tragedies in his personal life, among them the death of his first wife in 1882. The family had moved to Bushey in Hertfordshire some years earlier, and it was there that the Herkomer Art School was opened in 1883. This was a private school attended by large numbers of students from all over the world, and in its rural setting it was unique in Britain and became the centre of an artistic colony with Herkomer as its autocratic 'ruler'. The artist re-married in 1884, but his second wife, Lulu, died only a year later, and when Herkomer built his exotic, distinctive and luxurious new house at Bushey he named it 'Lululaund' in her memory. The Romanesque exterior, built in Bavarian tufa, was designed by the American architect H.H. Richardson, while the ornate Gothic interior, with its wealth of stone and woodcarving, was the work of the painter, his father and uncles, all of whom were craftsmen. This extraordinary creation, at once solid and pretentious, was a reflection of the artist's considerable egotism and of his sentimental pride in his Bavarian origins.

Herkomer was in character a 'large' man, driven by ambition and vanity, but also by enormous energy, which enabled him not only to paint and teach, but to take up many other things. He made and wrote music, produced plays, and at the end of his life experimented in film-making. Bored by 'the dullness of colour into which I had drifted' he took up the art of enamels, which he practised 'furiously' for several years from 1897 to 1905, exhibiting some of them at the Royal Academy. Throughout his career he worked and experimented in various engraving media, etching, mezzotint and finally lithography, and he wrote books about them. He was a frequent and popular lecturer – he was Professor of Painting at the RA for three years from 1906 – and he published two autobiographical books. Elected RA in 1890, he was created CVO in 1901 and knighted six years later, was honoured by the German Emperor and was also ennobled by Maximilian of Bavaria. He received many other foreign honours, was an Honorary Fellow of All Souls College, Oxford, and an Honorary Doctor of that university and of several others.

The essential basis of this spectacularly successful career was, of course, Herkomer's painting, especially of portraits. Since the foundation of the Royal Academy in 1768 many British artists of humble origin had achieved social status and wealth, much aided by the fact that full membership of the Academy brought with it the rank of Esquire. Notable among such success stories was that of Turner, son of a cockney barber, who, however, never truly elevated himself socially. In the second half of the nineteenth century, the lionisation of successful artists had become the norm, and was to reach its peak in the closing decades of the century with painters such as Burne-Jones, Millais and Leighton. Herkomer was an example of all this, but, probably because of his foreign origins, and at one time he resumed German citizenship, he had, as it were, to create his own lionisation and he chose to base this in the unlikely setting of Bushey.

This distinctive and personal nature of his success is fully documented in his own books and in the several books about him that appeared in his lifetime, which make his career one of the best-documented of any British artist of the nineteenth century, and thus a fruitful model of such an artistic career to study.

Alongside the portraits Herkomer continued to paint and exhibit genre and modern-life scenes, and it was a powerful example of this aspect of his art that he presented to the Royal Academy as his Diploma Work. *On Strike* [COL.PL.65] was shown at the Summer Exhibition of 1891, and was a telling document of the growing problem of industrial disputes in the closing decades of the century. The subject of strikes had already been tackled by several artists but usually in the form of crowd scenes. Herkomer's image of the grim-faced worker at the door of his home with his unhappy wife and young family, was a poignant problem picture which attracted considerable critical attention, much of it adverse. *On Strike* is a direct and forceful painting which lacks sentimentality, and it is perhaps Herkomer's most successful and lasting work of social realism. It is a painting that still has a real impact today, and illustrates the advice he gave in one of his Royal Academy lectures: 'Be it remembered that we paint and write for future generations to dream over and wonder.'[19] Herkomer certainly followed that advice in several of his own telling records of 'modern life'.

Notes to Part Seven

1 J. M. H. Lewis, *The Lewis Family – Art and Travel*, 1992, p.32

2 *Works*, Vol.XII, p.326

3 *Works*, Vol.XIV, pp.73–8

4 Ernest Chesnau, *The English School of Painting*, 4th edn, 1891, p.293

5 *Works*, Vol.XIV, pp.130–3

6 R. and S. Redgrave, *A Century of British Painters*, new edn, 1947, pp.413–14

7 Quoted in Ronald Parkinson, *Catalogue of British Oil Paintings, 1820–1860*, Victoria and Albert Museum, London, 1990, p.161

8 Chesnau, loc.cit., p.79

9 R. and S. Redgrave, loc.cit., p.302

10 See Oliver Millar, 'Redgrave and the Royal Collection', in *Richard Redgrave*, edited by Susan P. Casteras and Ronald Parkinson, 1988

11 *Dictionary of National Biography*, Supplement 1901, obituary by A. H. Millar

12 W. P. Frith, *My Autobiography and Reminiscences*, 2nd edn, 1887, Vol.I, p.243

13 *Autobiography*, loc.cit., pp.268–303, for this and subsequent quotations

14 See Jeannie Chapel, *Victorian Taste – The Complete Catalogue of the Paintings at the Royal Holloway College*, 1982

15 Quoted by Julian Treuherz in *Hard Times – Social Realism in Victorian Art*, 1987, p.49; this pioneering catalogue of an exhibition held at Manchester City Art Galleries provides an excellent survey of its subject

16 W. L. Thomas, 'The Making of the Graphic', in *Universal Review*, Vol.II, 1888, p.81; quoted by Treuherz, loc.cit., p.54

17 R. and S. Redgrave, loc.cit., p.362

18 T. Gretton in *Thames and Hudson Encyclopaedia of British Art*, 1985, p.116

19 Quoted by Treuherz, loc.cit., p.103

(46) Thomas Uwins, *The Neapolitan Saint Manufactory* (RA 1832). Oil on canvas; 75×86.3 cm.
(Leicester City Museums)

(47) Dante Gabriel Rossetti, *The Girlhood of Mary Virgin* (1848–9). Oil on canvas; 83.2×63.5 cm. (Tate Gallery, London)

(48) William Holman Hunt, *Rienzi vowing to obtain Justice for the Death of his young Brother, slain in a Skirmish between the Colonna and Orsini Factions* (RA 1849). Oil on canvas; 86.3×122 cm. (Private Collection)

(49) John Everett Millais, *Isabella* (RA 1849). Oil on canvas; 102.9×142.9 cm. (Walker Art Gallery, Liverpool)

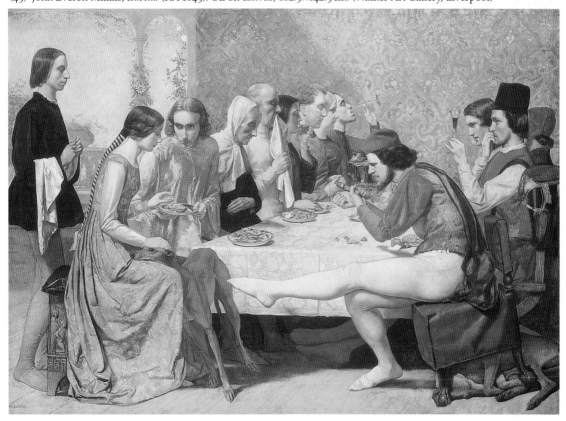

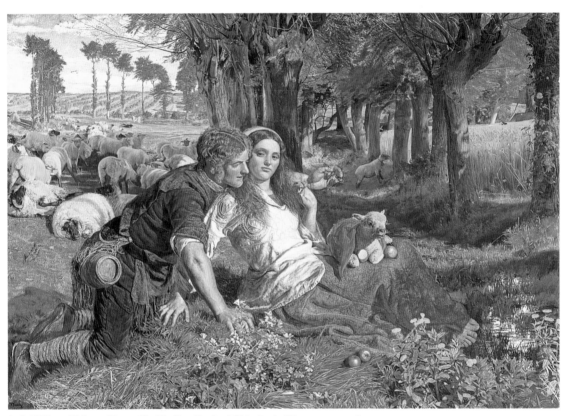

(50) William Holman Hunt, *The Hireling Shepherd* (RA 1852). Oil on canvas; 76.4×109.5 cm. (Manchester City Art Galleries)

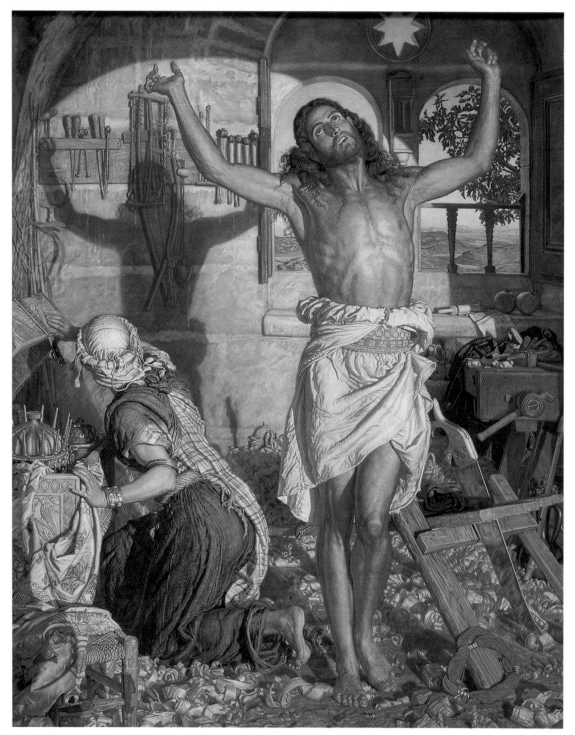

(51) William Holman Hunt, *The Shadow of Death* (1870–3). Oil on canvas; 214.2×168.2 cm. (Manchester City Art Galleries)

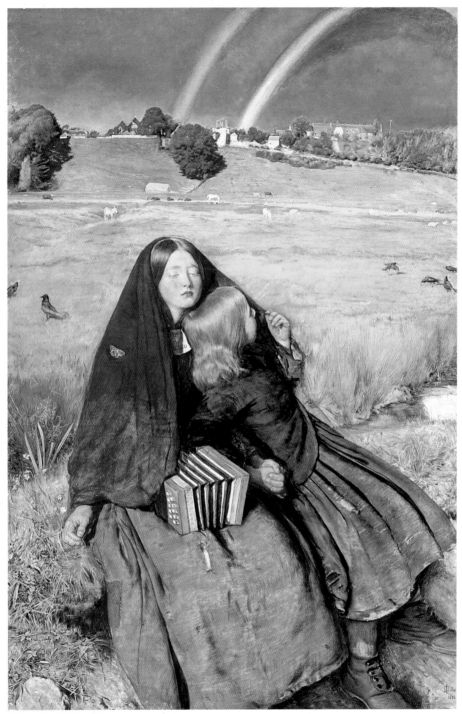

(52) Sir John Everett Millais, *The Blind Girl* (RA 1856). Oil on canvas; 81.2×62.2 cm. (Birmingham Museums and Art Gallery)

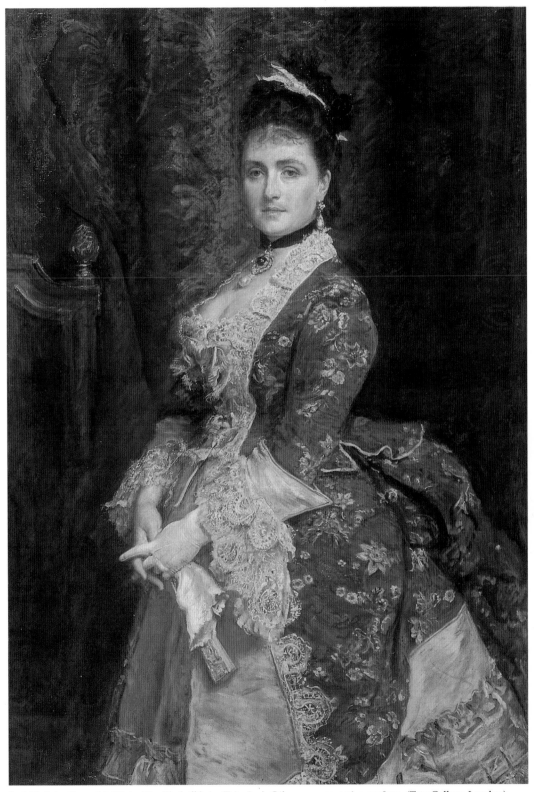

(53) Sir John Everett Millais, *Mrs Bischoffsheim* (RA 1873). Oil on canvas; 136.4×91.8 cm. (Tate Gallery, London)

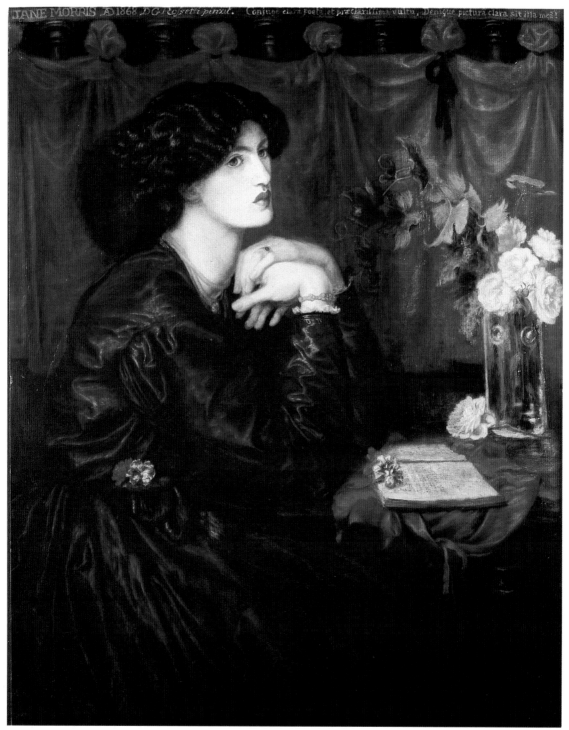

(54) Dante Gabriel Rossetti, *Jane Morris* (1868). Oil on canvas; 110.5×92.7 cm.
(Society of Antiquaries, Kelmscott, Oxfordshire)

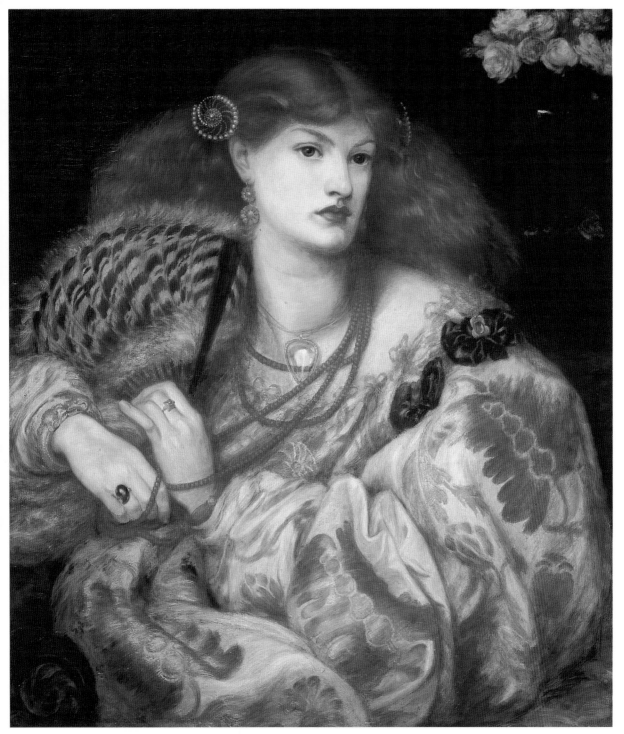

(55) Dante Gabriel Rossetti, *Monna Vanna* (1866). Oil on canvas; 88.9×86.4 cm.
(Tate Gallery, London)

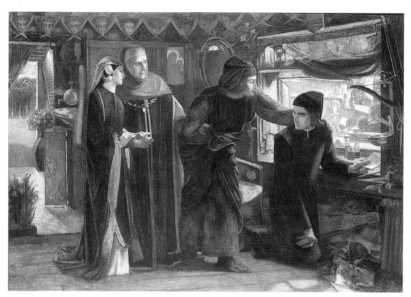

(56) Dante Gabriel Rossetti, *Dante drawing an Angel on the First Anniversary of the Death of Beatrice* (1853). Watercolour; 42×61 cm. (Ashmolean Museum, Oxford)

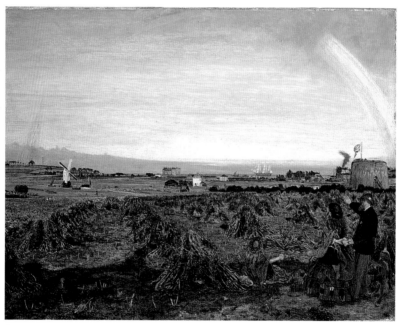

(57) Ford Maddox Brown, *Walton-on-the Naze* (1859–60). Oil on canvas; 31.7×42 cm. (Birmingham Museums and Art Gallery)

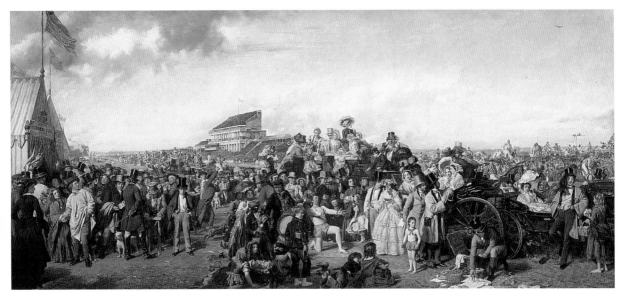

(58) William Powell Frith, *The Derby Day* (RA 1858). Oil on canvas; 101.6×223.5 cm. (Tate Gallery, London)

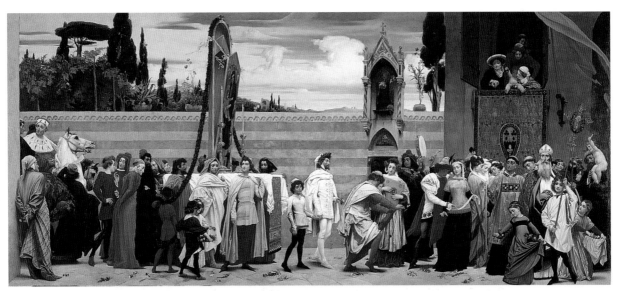

(59) Frederic, Lord Leighton, *Cimabue's Madonna carried in Procession* (RA 1855). Oil on canvas; 231.8×520.7 cm. (The Royal Collection, on loan to the National Gallery, London)

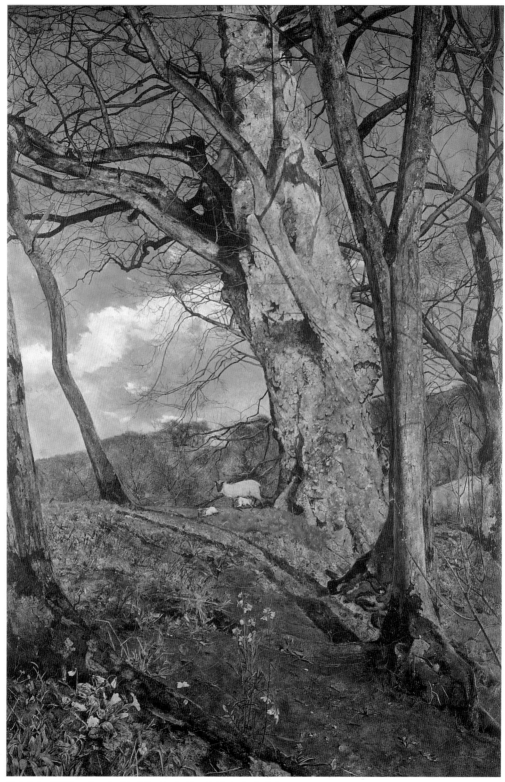

(60) John William Inchbold, *A Study, in March* (RA 1855). Oil on canvas; 53×35 cm.
(Ashmolean Museum, Oxford)

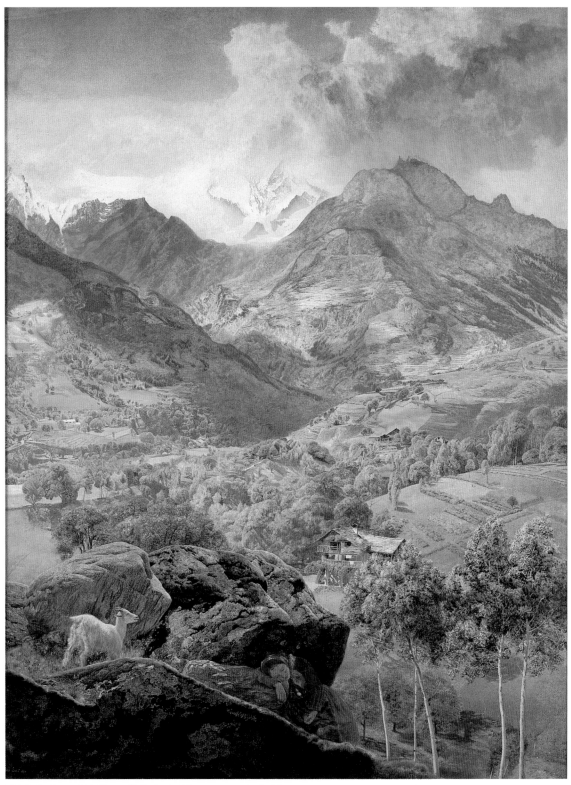

(61) John Brett, *Val d'Aosta* (RA 1859). Oil on canvas; 87.6×68 cm.
(Private Collection)

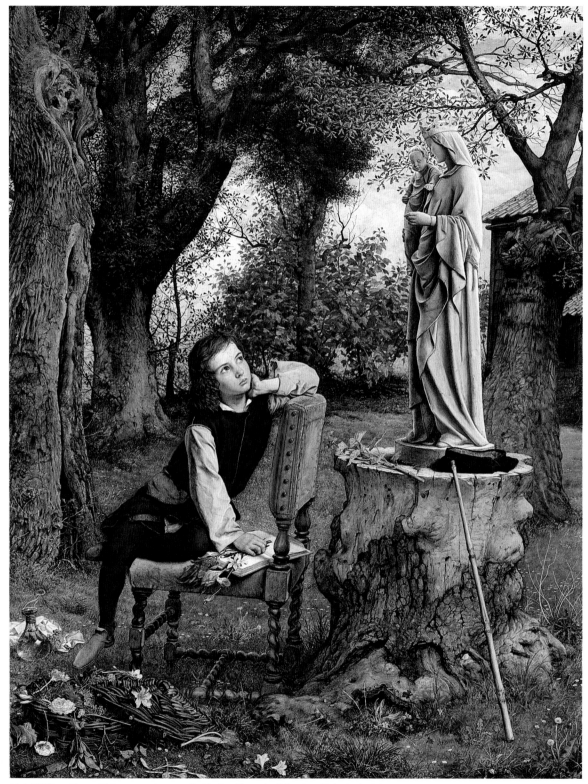

(62) William Dyce, *Titian preparing to make his first Essay in Colouring* (RA 1857). Oil on canvas; 91.4×67.3 cm.
(Aberdeen Art Gallery)

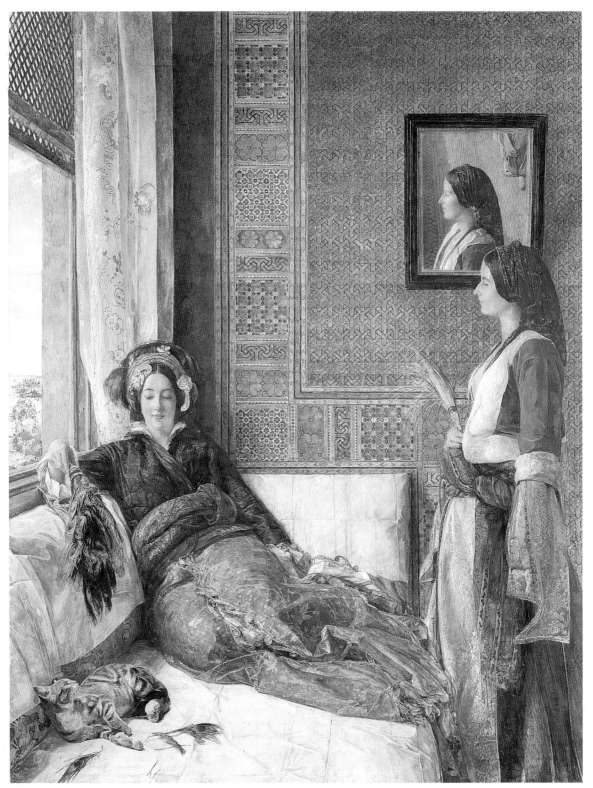

(63) John Frederick Lewis, *Hhareem Life, Constantinople* (1857). Watercolour and bodycolour; 62.2×47.6cm.
(Laing Art Gallery, Newcastle upon Tyne)

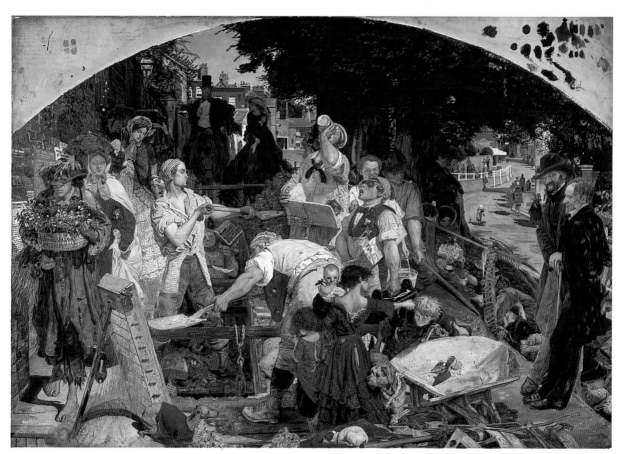

(64) Ford Maddox Brown, *Work* (1852–65). Oil on canvas; 137×197.3 cm.
(Manchester City Art Galleries)

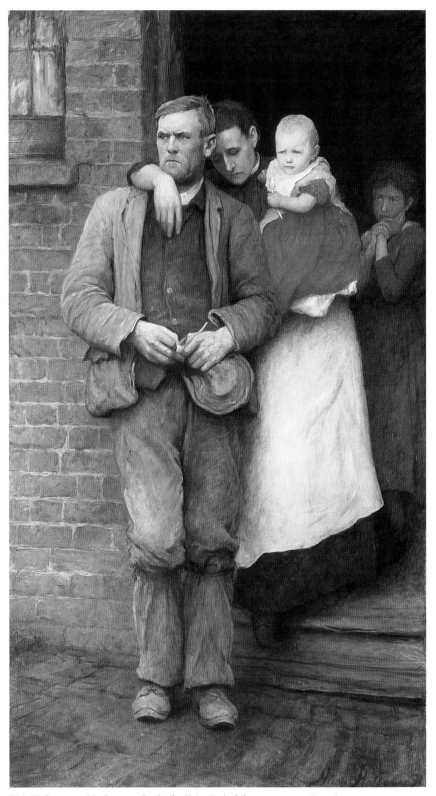

(65) Hubert von Herkomer, *On Strike* (RA 1891). Oil on canvas; 228×126.4 cm.
(Royal Academy, London)

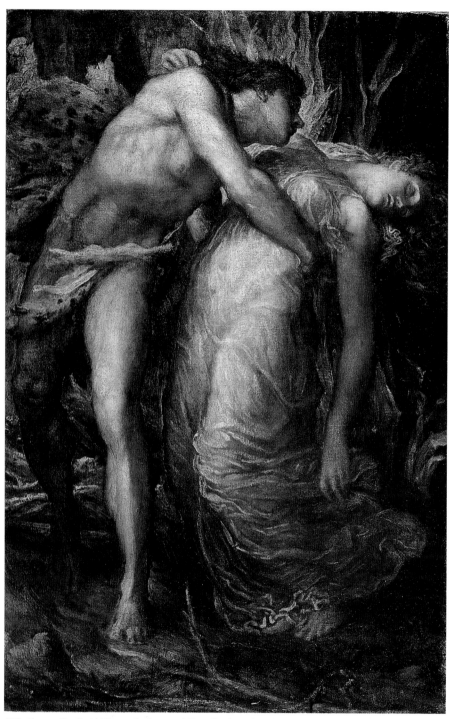

(66) George Frederic Watts, *Orpheus and Eurydice* (1872). Oil on canvas; 70×46 cm.
(Aberdeen Art Gallery)

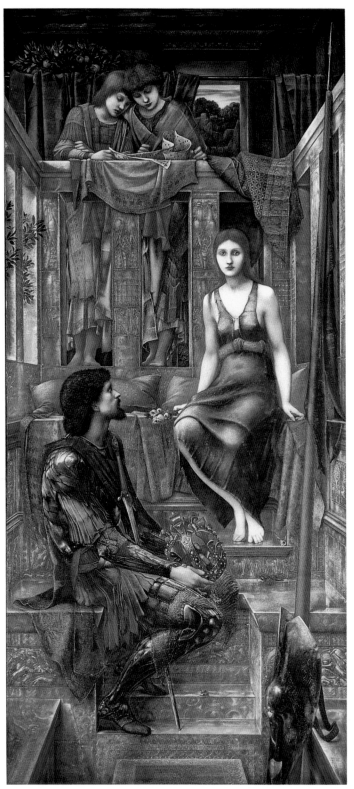

(67) Sir Edward Burne-Jones, *King Cophetua and the Beggar Maid* (1880–4). Oil on canvas; 290×136 cm. (Tate Gallery, London)

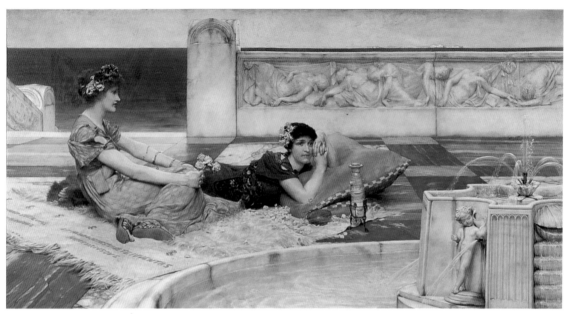

(68) Sir Lawrence Alma-Tadema, *Love's Votaries* (1891). Oil on canvas; 87.6×165.7 cm.
(Laing Art Gallery, Newcastle upon Tyne)

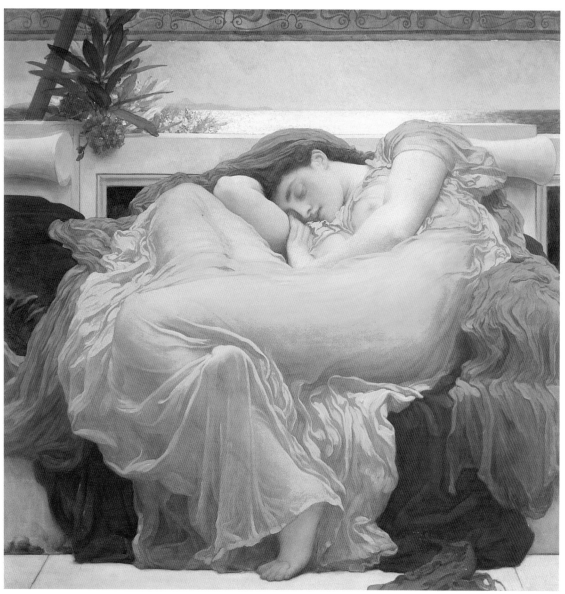

(69) Frederic, Lord Leighton, *Flaming June* (RA 1895). Oil on canvas; 119×119cm.
(Museo de Arte de Ponce, Puerto Rico)

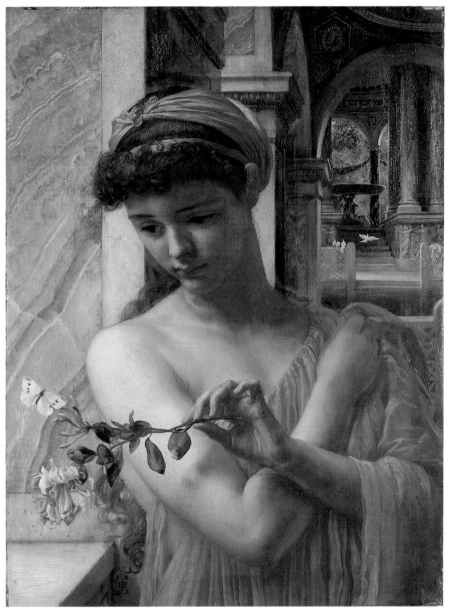

(70) Sir Edward Poynter, *Psyche in the Temple of Love* (RA 1883). Oil on canvas; 66×51 cm.
(Walker Art Gallery, Liverpool)

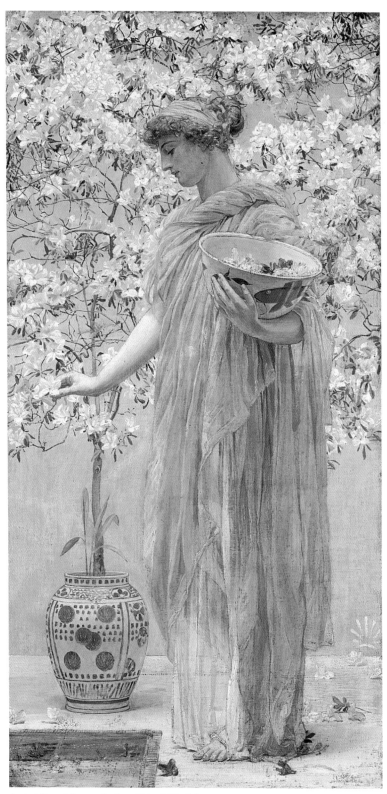

(71) Albert Moore, *Azaleas* (RA 1868). Oil on canvas; 198×100.3 cm.
(Hugh Lane Municipal Gallery of Modern Art, Dublin)

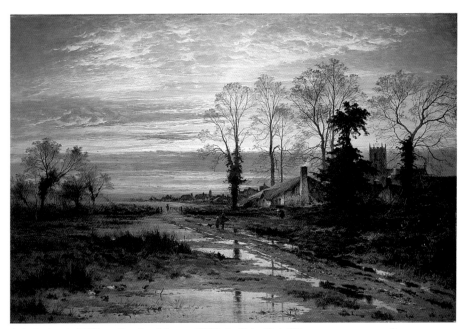

(72) Benjamin Williams Leader, *February Fill Dyke* (RA 1881). Oil on canvas; 119.5×181.5 cm. (Birmingham Museums and Art Gallery)

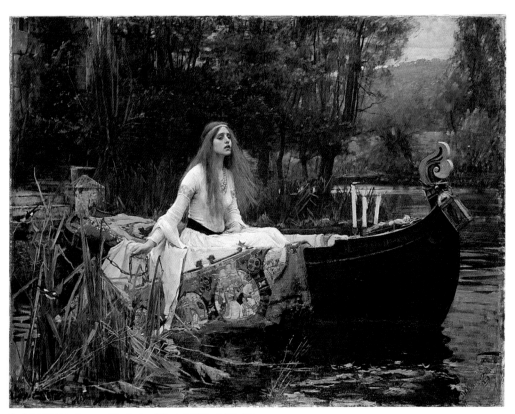

(73) J.W. Waterhouse, *The Lady of Shalott* (RA 1888). Oil on canvas; 153×200 cm. (Tate Gallery, London)

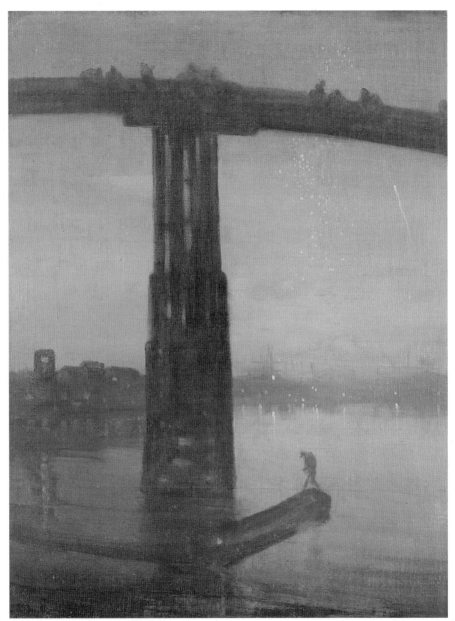

(74) James McNeill Whistler, *Nocturne in Blue and Gold: Old Battersea Bridge* (*c.*1872–5). Oil on canvas; 67.9×50.8 cm. (Tate Gallery, London)

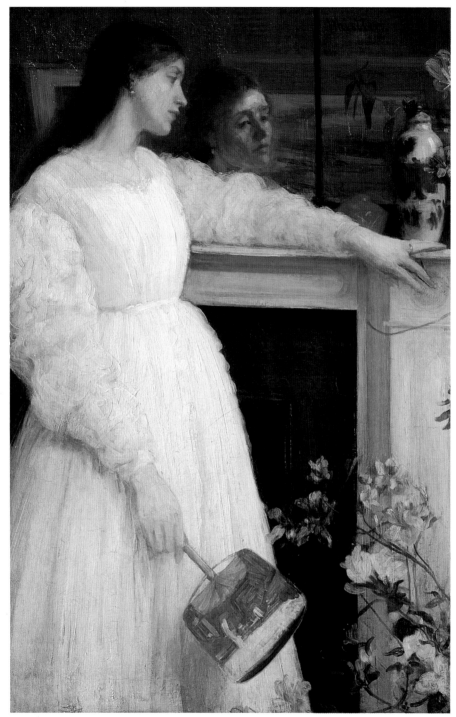

(75) James McNeill Whistler, *Symphony in White, No. 2: The Little White Girl* (RA 1865).
Oil on canvas; 76.5×51.1 cm. (Tate Gallery, London)

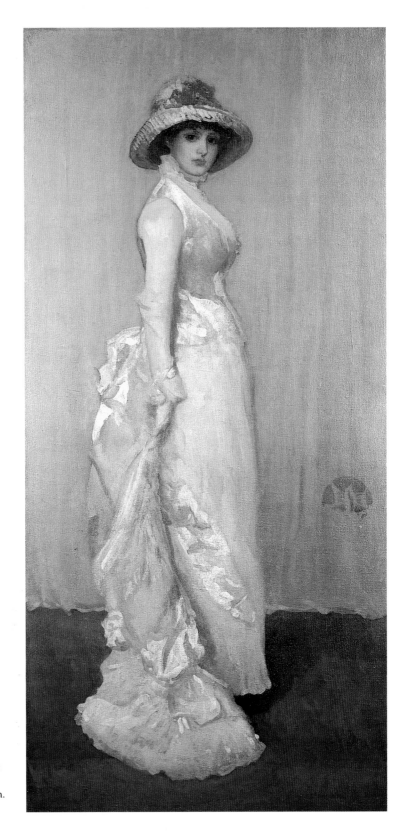

(76) James McNeill Whistler, *Harmony in
Pink and Grey: Portrait of Lady Meux*
(1881–2). Oil on canvas; 194×92.7 cm.
(Frick Collection, New York)

(77) John Singer Sargent, *Lady Agnew* (*c*.1892–3). Oil on canvas; 125.7×100.3 cm.
(National Gallery of Scotland, Edinburgh)

(78) Walter Sickert, *Venetian Women Seated on a Sofa* (1903). Oil on canvas; 46.5×38cm.
(Museum of Fine Arts, Boston)

(79) Philip Wilson Steer, *Chalk-pits, Painswick* (1915). Watercolour; 24.8×34.3 cm. (Fitzwilliam Museum, Cambridge)

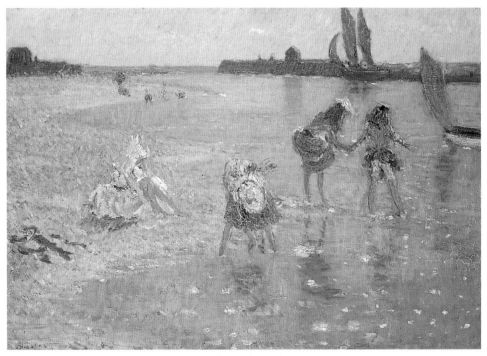

(80) Philip Wilson Steer, *Children paddling, Walberswick* (1894). Oil on canvas; 64.2×92.4 cm. (Fitzwilliam Museum, Cambridge)

(81) Walter Sickert, *The Horses of St Mark's, Venice* (*c*.1904). Oil on canvas; 50.2×42.3 cm.
(Birmingham Museums and Art Gallery)

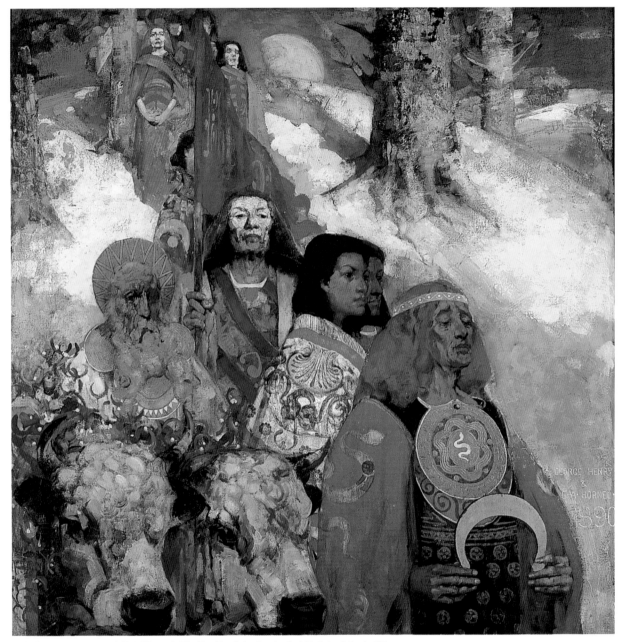

(82) George Henry and E. A. Hornel, *The Druids: Bringing in the Mistletoe* (1890). Oil on canvas; 152.4×152.4 cm. (Glasgow Museums: Art Gallery and Museum, Kelvingrove)

Part Eight

The Revival of the Classical

33 George Frederic Watts, OM, RA (1817–1904), and Frederic, Lord Leighton, PRA (1830–96)

There could hardly be a greater contrast between the paintings of literary, anecdotal and social themes discussed in Part Seven and the imaginary classical and allegorical scenes which are the main subject of this Part. One important factor in the great popularity of the latter must have been education; throughout the century Latin and Greek were still the staples of every good school curriculum, and the educated male was familiar with a wide range of ancient literature, history and mythology. What is remarkable is that both these contrasting styles won widespread approval from Victorian connoisseurs and critics, whose taste was as varied as was the art of the painters who served them. It should be remembered that British patronage of the arts had widened enormously in the first half of the nineteenth century. While it had still been largely in aristocratic hands in the early 1800s, by the time that Queen Victoria started her long reign it was the middle class of professionals and wealthy industrialists and entrepreneurs who had become the principal patrons and collectors. At the same time most of the successful and established artists themselves strove to join the ranks of those who patronised them and tried to assume all the perquisites of the wealthy middle classes. For a time the romantic image of the struggling artist in his garret was replaced by that of the wealthy painter in his mansion, though it was, of course, only a minority of painters who actually achieved this status, and for the majority of these their wealth continued to depend very largely on their portrait commissions.

George Frederic Watts was a complex character who was at once a prime example of the points just made as well as being the exception that proves the rule. An eccentric genius whose career spanned the whole of the Queen's reign, he was born in London in humble but cultured circumstances, and being a sickly child had no regular schooling, though he was encouraged by his father to read widely, including Homer and the Bible. From the age of ten he was a frequent visitor to the studio of the sculptor William Behnes, who introduced him to the Elgin Marbles. In 1835 he was briefly a student at the RA Schools, where William Hilton was Keeper, but he was essentially self-taught as an artist. In 1837 he exhibited for the first time at the Academy, showing two portraits and *The Wounded Heron* (Watts Gallery, Compton), a powerful study painted from a bird bought at a local poulterer's shop. It was also in 1837 that Watts first met Constantine

Ionides, a member of a leading family in the Greek community in London, whose son, also Constantine, was a notable collector and was to be one of the artist's most important patrons. Watts eventually painted portraits of five generations of the Ionides family, many of which are now in the Victoria and Albert Museum.

In 1843 Watts was awarded one of the first prizes of £300 in the first Palace of Westminster competition, and he again won a first prize in the competition of 1847, with a painting of *Alfred inciting the Saxons*, which was purchased by the commissioners. With the proceeds of his first award Watts left for Italy, and, after six weeks in Paris, he went on to Florence, where he became the guest of Lord and Lady Holland. He remained in the entourage of that distinguished family for the remainder of his time in Italy, and Lady Holland became the first of his many devoted women admirers. While in Italy Watts undertook extensive studies of Renaissance painting, Michelangelo and Titian in particular, and also applied himself to learning the art of fresco painting and to the painting of landscape. When he returned to London in 1847 he developed schemes for ambitious mural decorations, including a vast series of allegorical subjects, referred to as *'The House of Life'*. Despite the increasing disaster of the Palace of Westminster decorations, Watts hoped to achieve, more or less on his own, an alternative revival of mural art in England. His proposals for the decoration of the Great Hall of Euston Station were rejected, as were other schemes, though he painted murals in several private houses and also an enormous and highly praised fresco of *The Lawgivers* in the New Hall at Lincoln's Inn, on which he was at work from 1853 to 1859. Strongly influenced by Raphael's Vatican Stanze frescos and by other Renaissance masterpieces which he had studied in Italy, and showing also his close knowledge of the friezes of the Elgin marbles, this huge composition exemplifies the 'classical' roots of most of G. F. Watts's decorative art.

Watts was also painting portraits, and for a brief period, from 1848, the year of revolutions abroad and great social problems at home, and a time during which he himself was suffering from bad health and depression, he executed a small number of gaunt works of social realism reflecting the problems of the day and also his personal feelings. Drab in colour and tragic in content these pioneering paintings, which included *The Irish Famine* and *Found Drowned* (both Watts Gallery, Compton), were based on personal experiences and were never sold. However, throughout his life Watts retained his social conscience, and was involved in several schemes for improving the lot of London's poor, especially those, such as the Whitechapel Gallery, launched by Canon Barnett. His personal circumstances improved enormously in 1850 when he was rescued from the low ebb he had reached by the Prinsep family, with whom he stayed at Little Holland House as a permanent guest for more than a quarter of a century, provided with his own studio and pampered and cosseted by the women of the household. Mr Thoby Prinsep had returned to London in 1843 after a highly successful career in the Indian Civil Service, and he and his wife became the leading figures of a semi-Bohemian salon which attracted many celebrities, including Tennyson, Thackeray, Gladstone, Dickens, and artists such as Millais and Leighton. Here Watts, who, though frail in body and quiet in character, was distinguished in appearance, was lionised as the artist in residence, especially by the women of this eminent circle, and led a comfortable, stimulating and carefree life. This was briefly interrupted by his disastrous marriage to the

beautiful young actress Ellen Terry, who was only sixteen at the time, but they were separated within a year and divorced in 1877.

As a painter Watts continued to be eclectic and varied, producing his ever more penetrating portraits, some of his atmospheric landscape studies, and developing what was to be his main achievement in his own eyes, the creation of imaginative and idealistic visions in the realm of 'high art'. An early example of this is *Orlando Pursuing the Fata Morgana* (Leicester City Museums), which Watts started in Italy in 1846, and completed in London before it was exhibited at the British Institution in 1848. The artist re-worked some of it before it was exhibited again at the New Gallery in 1889, and then he presented it to Leicester to mark his gratitude to the travel agents Thomas Cook, founded by John M. Cook, a native of Leicester, who had arranged his recent visit to Egypt. Such a generous gesture was typical of Watts, as was the long period of gestation of the painting, which illustrates a passage from the fifteenth-century Italian poet Boiardo's *Orlando Inamorato*.

Throughout his career Watts, whose creative imagination was usually brimming over with ideas, began far more paintings than he could ever complete, and he often worked on them for many years. Another aspect of his working methods from about 1870 onwards was the increasingly daring experimentation in his use of paint. He tried novel media for his paints, including benzine, varied his glazes, and used 'anything that was to hand', such as rag, paper or his thumb, to apply the paint. All these 'tricks' en-livened and enriched the texture of his canvases, and often enhanced the mystery and impact of his work. On the other hand, his untried and risky techniques have also resulted in many paintings that have deteriorated badly. These unusual methods were on the whole especially effective in Watts's portraits, of which an impressive group of over fifty, mostly given or bequeathed by the artist, is in the National Portrait Gallery. These range in date from the vivid portrayal of Anthony Panizzi, later Principal Librarian of the British Museum, of about 1847, to the effective character study of Flinders Petrie, the great Egyptologist, painted in 1900, when the artist was eighty-three years old. They include such great figures as Carlyle, Gladstone, William Morris, and Tennyson, and most of them are fine portraits, none more so than that of Cardinal Manning [PL.198]. This was painted in 1882 and unashamedly continues the long line of classical seated portraits of clerics begun by Raphael's pioneering *Pope Julius II*, in the National Gallery. The haggard face and the emaciated hands of the elderly cardinal, contrasting with the splendour of his crimson robe, make this a prime example of Watts's genius in combining spiritual and aesthetic qualities in his portraits. The series also includes an imposing self-portrait, dating from about 1879, in which Watts re-peated the totally Titianesque image of himself wearing a skull-cap which he had painted for the famous collection of self-portraits at the Uffizi in Florence, thereby pay-ing homage to the great Venetian, whose work was a constant inspiration to him.

Today there can be little doubt that Watts's most attractive contribution to British painting of the Victorian age was as a portrait painter, but for the artist himself and for his contemporaries it was his powerful imaginative 'grand' compositions of classical, mythological, allegorical and symbolic themes which took pride of place. From his earliest days Watts's ambition, rather like that of Haydon before him, was the further-ance of monumental art in Britain, and he never totally abandoned his grandiose

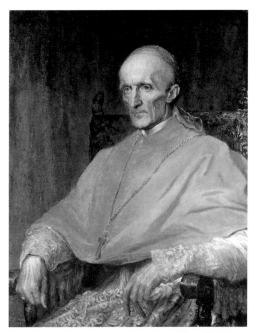

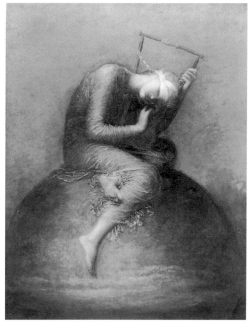

(198) George Frederic Watts, *Portrait of Cardinal Manning* (1882). Oil on canvas; 90.2×69.9 cm. (National Portrait Gallery, London)

(199) George Frederic Watts, *Hope* (1886). Oil on canvas; 142.2×111.8 cm. (Tate Gallery, London)

scheme for the vast decorative cycle '*The House of Life*', which he first mooted in his return from Italy in 1847. Though the fresco cycle with its enormous programme was never even started, many of the individual canvases and smaller series that Watts produced in the last fifty years of his long life realised elements that had been designed for '*The House of Life*'. He painted these individual canvases with enormous energy and brio, often on a small scale, and frequently repeating subjects and compositions. Thus there are several versions of *Orpheus and Eurydice*, including the vividly painted though gloomy small canvas at Aberdeen [COL.PL.66], which dates from 1872. An earlier version had been exhibited in 1869 at the Royal Academy, of which, two years earlier, Watts, who was then fifty years old, had uniquely been elected an Associate and a full Member in the same year. Watts painted eight compositions illustrating the legend of the musician Orpheus and the nymph Eurydice, who is seen here dying in his arms as he grasps her in a desperate attempt to prevent her return to the underworld. Scenes from the Orpheus myth were popular with several painters at this time, and became an important theme among the Symbolist artists. Watts was in many ways a precursor of the Symbolists, especially in subjects such as *Love and Death, Time, Death and Judgement*, and, most famously, *Hope*, which should certainly be regarded as a masterpiece of Symbolist art.

This mysterious image, shows 'Hope' (she might, as at least one commentator has pointed out, have equally well been called 'Sorrow') blindfolded and crouching on a globe, clutching a lyre with only one string intact. She is straining to obtain music from the one string, and bends down to listen with all her might. In 1881–2 the Grosvenor Gallery had shown Watts's first one-man exhibition in London, and it was this that first

popularised his allegorical paintings, of which *Hope* (Private Collection), first exhibited at the same gallery in 1885, became the best-known. Watts now enjoyed a world-wide reputation, and in 1884–5 there was an exhibition of his work at the Metropolitan Museum in New York. He continued to paint portraits and to produce his mysterious allegorical compositions, and was also devoting more time to sculpture, which he had begun to practise seriously in the 1860s, making a number of monuments and statues, including the bronze of the 3rd Lord Holland, father of his early friend, erected in Holland Park in 1871. Watts's best-known and most ambitious sculpture is the huge equestrian figure *Physical Energy* in Kensington Gardens, on which he began work in 1883, and of which the first cast, erected in South Africa as a monument to Cecil Rhodes, was made in 1902–3. This enormous and imposing 'classical' and symbolical statue is in keeping with the artist's equally ambitious creations in the allegorical paintings of his later years.

In 1886 Watts first announced his plan to present a body of his work to the nation, and this was finally realised when he presented eighteen paintings (to be joined by four more in subsequent years) to the newly opened Tate Gallery in 1897. A version of *Hope* [PL.199] is among these; as Watts himself stated, 'All my pictures in the Tate Gallery are symbolical and for all time…. Their symbolism is, however, more suggestive than worked out in any detail. I want to make people think.' Sadly few of Watts's large canvases ever see the light of day at the Tate, and since the dispersal of the Watts Room in about 1940, the group has certainly never been seen as 'a whole', which was the main idea behind the artist's gift, as it had been some forty-five years earlier behind Turner's bequest to the nation.

In 1885 and again in 1894 Watts was offered a baronetcy by Gladstone, but he declined on both occasions, though in 1902 he became one of the first holders of the newly instituted and exclusive Order of Merit, awarded to eminent men and women without conferring a title upon them. In 1887 the artist had married for a second time, and his wife, Mary Fraser-Tytler, herself an artist, became his most loyal supporter and helped him create the Watts Gallery at their house in Compton in Surrey, which the artist lived just long enough to see opened on Good Friday 1904. In the 1990s there has been a considerable revival of interest in the work of G. F. Watts and in the Gallery at Compton, though relatively speaking Watts still remains one of the most neglected of the leading British artists of the nineteenth century, perhaps because he painted too much, and, despite his apparent modesty during his lifetime, was too eager to be remembered.

Frederic, Lord Leighton is also permanently commemorated, by Leighton House in Kensington, but, as we shall see, he himself had little to do with the conversion of his home and studio into a monument. Half a generation younger than Watts, with whom he came to be on very friendly terms, and wholly a Continental artist by training, Leighton took the British art world by storm with his first RA exhibit, *Cimabue's Madonna* [COL.PL.59], in 1855, and after settling in London three years later, he rapidly established himself as the most successful and influential of all the 'eminent' artists that were such a feature of the capital in the second half of the century, becoming, just before his death at the age of sixty-five, the first and only professional painter to be raised to the peerage. Leighton's art and career stand out as exceptional even in the phenomenally vibrant climate of artistic London in the second half of the century. They

will be discussed here in unusual detail, as a typical, though outstanding, example of
the achievements of later Victorian artists.

Frederic Leighton was born in Scarborough, the second child of a well-to-do
doctor, who, when Frederic was ten years old, took his family to the Continent for the
sake of his wife's health and his children's education. They travelled for some years in
Germany, Switzerland and Italy, during which the boy attended school and art classes
in Berlin, Frankfurt and Florence, before settling in Frankfurt in 1846. Here, as through-
out their travels, the Leighton family moved in upper-class circles, and Frederic, who
was fluent in French, German and Italian, grew up as a handsome, cosmopolitan and
cultured youth. He had begun drawing and sketching at an early age, had already
decided to become an artist when, in October 1846, he enrolled as a student at the
Städelsches Kunstinstitut, the focal centre of Frankfurt's flourishing artistic colony. His
studies there were interrupted by the political upheavals of 1848, during which the
Leightons were in Brussels and Paris, but they returned to Frankfurt in 1850 and the
young artist resumed his studies at the Städel. Here he was now taught by Edward von
Steinle, a member of the Nazarene circle recently appointed as professor of history
painting, who became the most important influence in Leighton's development and
encouraged him to become a 'medievalist', as, of course, the young Pre-Raphaelites had
also done at this time.

In 1852 the rest of the Leighton family returned to England and settled in Bath,
while Frederic travelled through northern Italy to Rome, where he took a studio and
spent most of the next three years. Though he was at first disillusioned, worried about
his eyesight and depressed, he soon became established in the flourishing British
colony, and in the large cosmopolitan gathering of artists. He was much in the company
of two gifted landscape artists, the young Italian Giovanni Costa (1833–1903) and the
English George Heming Mason (1818–72), and in these years and throughout his
life Leighton painted bold and colourful landscape studies, especially when travelling
abroad. The closest friendship that Leighton made in Rome was with the former opera-
singer, Mrs Adelaide Sartoris, a member of the theatrical Kemble family, and then
a stately matron fifteen years older than the handsome young artist. That friendship,
partly based on their mutual love of singing, and described by a Rome friend as
'without scandal', was to last until Mrs Sartoris's death in 1879, and was a major factor
in Leighton's bachelor life.

During his long sojourn in Rome Leighton was at work on two major paintings,
the somewhat old-fashioned and dark *Reconciliation of the Montagues and Capulets over
the Dead Bodies of Romeo and Juliet* (Agnes Scott College, Decatur, Georgia), and the much
larger and brilliantly colourful *Cimabue's Madonna* [COL.PL.59]. The former he sent to
the 1855 Exposition Universelle in Paris, where it caused little interest and failed to
sell; the latter was well hung at the Royal Academy of 1855 and was bought for 600
guineas by Queen Victoria, who wrote in her diary, 'it is a beautiful painting quite
reminding one of Paul Veronese, so bright and full of lights. Albert was enchanted with
it, so much so that he made me buy it.' This outstanding success launched Leighton
on his truly remarkable career, though it was to be several years before he was able to
amplify it. As Dante Gabriel Rossetti commented perceptively at the time in a letter to
William Allingham:

There is a big picture of *Cimabue*, one of his works in procession, by a new man, living abroad, named Leighton – a huge thing, which the Queen has bought, which every one talks of. The RA have been gasping for years for someone to back against Hunt and Millais, and here they have him; a fact which makes some people do the picture injustice in return. It was *very* uninteresting to me at first sight; but on looking more at it, I think there is a great richness of arrangement – a quality which, when *really* existing, as it does in the best old masters, and perhaps hitherto in no living man – at any rate English – ranks among the great qualities.[1]

Illustrating an episode in Vasari's *Lives of the Painters*, this great processional composition is essentially romantic in conception but modern in feeling, and must have stood out at Burlington House because of its size. Adopting the thoroughness and discipline which had been part of his Germanic training, Leighton made numerous preparatory drawings and studies for the painting, which is full of intricate detail. The content was largely explained in the lengthy title in the RA catalogue: 'Cimabue's celebrated Madonna [now in the Uffizi and attributed to Duccio] is carried in procession through the streets of Florence; in front of the Madonna, and crowned with laurels, walks Cimabue, with his pupil Giotto; behind it Arnolfo di Lapo, Gaddo Gaddi, Andrea Tafi, Nicola Pisano, Buffalmacco, and Simone Memmi; in the corner Dante.' Not only the title and contents, but also the execution and arrangement of the huge canvas, reveal Leighton's deep understanding and knowledge of early Italian painting, and this must have been one of the factors that appealed to Prince Albert.

Leighton had been in England during the summer of 1855, and that autumn he did not return to Rome but went to Paris, where he took a studio in the rue Pigalle. The artist stayed in Paris for some three years, during which he made visits to London, Rome and Algeria. He did not join a studio, but assiduously continued his artistic training by making contact with and learning from a variety of artists, among them Thomas Couture and the historical painter Henri Robert Fleury. He was attracted by the landscape painting of the Barbizon School and also especially admired Corot, whose work he later collected. He was thrilled to meet the elderly Ingres and Delacroix, and both great artists were later also represented in his collection. All these new influences were at first somewhat overwhelming, and the large painting he sent to the Academy from Paris – *The Triumph of Music* – was a disastrous failure and was slated by the critics. However, in the long term, the years in Paris, despite the diversions of an active social life, helped Leighton to consolidate his art and to become the mature painter of the classical compositions which were to be his forte. During 1858 he had decided that he would soon return permanently to England but not before another long stay in Rome that winter and spring, during which he spent several weeks in Capri, painting some of his most pleasing landscape studies in the open.

Leighton, having done something to retrieve his reputation with his three Royal Academy exhibits that year, finally settled in London in the summer of 1859. The three works were all powerful portrayals of the strikingly beautiful Roman model Nanna Risi, who soon afterwards became the favourite model and the mistress of the German artist Anselm Feuerbach. Leighton had painted at least five portraits of her in Rome, where they were seen and admired in his studio by the Prince of Wales (later Edward VII), who

purchased *Pavonia* (Royal Collection). Though much encouraged by these successes, and the retrieval of his reputation, Leighton had a considerable struggle to achieve recognition and status during his first years back in London. His somewhat arrogant manner and his totally foreign training did not endear him to most of the senior artists, who were also wary of him as a potential rival. However, he exhibited each year at the Academy, including several landscapes, portraits and biblical scenes, but concentrating on a variety of contrasting subject pictures without any narrative content, such as the sensuous *A Girl with a Basket of Fruit* (Private Collection) and the grim *Italian Crossbow Man* (Leicester City Museums), which were among his four exhibits in 1863. In 1864 he showed another of his large, richly painted and thought-provoking compositions, *Dante in Exile* (on loan to Leighton House, London), which was well received, and, with its two contrasting companions in the exhibition, the intense *Orpheus and Eurydice* (Leighton House, London) and the sentimental and Giorgionesque *Golden Hours* (Private Collection), ensured his election as ARA that year. Soon after this *Dante in Exile* was bought for 1000 guineas by the influential dealer and print publisher, Ernest Gambart, another sure sign that Leighton had 'arrived', though his work was still in an essentially transitional and experimental phase.

However, by the time that he was elected RA in 1868, at the early age of thirty-seven, Leighton had begun to exhibit the powerfully attractive, sensuous and decorative compositions of Greek classical figures and subjects, which dominated his painting for the rest of his career. In these canvases he usually displayed his mastery of the painting of drapery, while his depiction of bodies and limbs were frequently lifeless and dull. An important early example was *The Syracusan Bride leading wild Beasts in Procession to the Temple of Diana* (Private Collection), which caused a sensation when exhibited at the Academy in 1866. Combining his experience of high Renaissance decorative painting with his growing admiration for classical Greek sculpture, Leighton here created another colourful composition on a huge scale which could be compared to its advantage with *Cimabue's Madonna*, which had made his name some ten years earlier. As the artist himself commented about his development, 'I can only speak of what is not a change but virtually a growth – the passage from Gothicism to Classicism (for want of better words)'.[2] While the title of the *Syracusan Bride* was accompanied in the catalogue by a reference to a passage from the Greek poet, Theocritus, the painting has no meaningful narrative content, but is simply a vehicle for Leighton to create his personal and attractive vision of ancient Greece. In the following year he expanded that vision with the first, and one of the most daring, of his classical nudes, *Venus disrobing for the Bath* (Private Collection), in which the exquisite female body is boldly and explicitly displayed; there is, however, some weakness in the anatomy of the contorted pose and considerable stiffness in the actual painting. No painting like this had been seen at the Academy since the days of Etty – in sculpture the nude was still quite common – though such provocative nudes were not uncommon in the Paris Salon, where Alexandre Cabanel's well-known *Birth of Venus* was shown in 1863, and Manet's notorious *Olympia* in 1865. The London critics accepted Leighton's Venus, and one actually called it 'eminently chaste'.

In the summer of 1867 Leighton travelled to Greece, and this visit made a deep impression on him, confirming his admiration for ancient classical art and also arousing

his love of the Greek landscape, of which he made many effective oil sketches. There were more classical subjects at Burlington House in the following year, among them the lovely *Actea, the Nymph of the Shore* (National Gallery of Canada, Ottawa). His ambition to become a leading figure among the artists of London had been realised quite quickly; he had already achieved material success, which gave him the confidence to build his imposing house with its fine studio and sumptuous interiors designed by his friend George Aitchison, in Holland Park Road in 1866. This was one of the first purpose-built artist's studio houses in London. The colourful and exotic Arab Hall, designed to house some of Leighton's extensive Near Eastern collections, was added some ten years later. There were also other additions, including a Winter Studio built in 1889. Leighton had always had an allowance from his father, but this was never generous, and he had to sell his work to achieve the life-style which he desired. On the other hand he himself became an assiduous collector of a great variety of furniture and, especially Near Eastern, decorative arts, as well as of paintings and drawings.

Strong compositions of classical themes reached another climax in 1876 when Leighton again exhibited one of his huge processional compositions, *The Daphnephoria* (Lady Lever Art Gallery, Port Sunlight), which shows a host of Theban young men, women and children, some beautifully robed others only scantily clothed, paying tribute to the god Apollo to commemorate their victory over the Aeolians. It is a happy and undemanding painting, skilfully composed with the help of numerous drawings and sculptured models, and showing an idyllic and harmonious scene, which is at once solemn and light-hearted. Behind the procession is a grove of mighty trees and Thebes is seen in the distance. It is not really ancient Greece, it has nothing to do with modern life, it is decorative and pleasing – a masterpiece by 'a man of high poetic imagination' … in which 'the poet is merged in the painter', as the *Art Journal* suggested. The musical theme of *The Daphnephoria* was a favourite with Leighton, seen again in the following year in the lovely *Music Lesson* (Guildhall Art Gallery, London), in which the setting and the dresses are Arabic, presumably based on sketches made and textiles collected on one of his visits to North Africa. Also in 1877 the artist showed his first work of sculpture at the Academy, *An Athlete struggling with a Python*, a dynamic life-size bronze which was purchased from the exhibition by the Chantrey Bequest (Tate Gallery, London). In completing this powerfully realistic figure, of which there are numerous versions, including one in marble, Leighton was encouraged by the French sculptor Jules Dalou, and this and Leighton's other sculptures, most famously *The Sluggard*, shown at the RA in 1886, owe much to the example of contemporary French sculpure, and are important examples of the 'new sculpture' coming into fashion in Britain at this time. Throughout much of his later career Leighton made clay models for the figures in his paintings, which, together with his many chalk studies of individual figures, helped him to achieve the vitality which distinguish many of his compositions. In his exhibited sculpture, as in so much of his painting, Leighton worked in the main line of Continental art, adding his effective personal style to it, and thereby achieving such an impressive standing when compared to most of his British contemporaries, so many of whom remained essentially insular.[3]

Sir Francis Grant, the distinguished portrait painter, who had succeeded Sir Charles Eastlake as President of the Royal Academy in 1866, died in October 1878. At

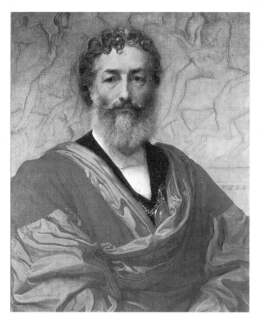

(201) Frederic, Lord Leighton, *Cymon and Iphigenia*
 (RA 1884). Oil on canvas; 162.5×327.6cm.
 (The Art Gallery of New South Wales, Sydney)

(200) Frederic, Lord Leighton, *Self-Portrait*
 (RA 1881). Oil on canvas; 76.5×64cm.
 (Uffizi Gallery, Florence)

their meeting in the following month, with all the Royal Academicians present, Frederic Leighton was elected President by a large majority. There were five other candidates, two of whom, Frith and Millais, received only one vote each. Leighton's position as the leading figure among British artists was unassailable, and his impressive self-portrait [PL.200], exhibited at the RA in 1881 before despatch to Florence for the Uffizi's historic collection of artists' self-portraits, subtly but unashamedly reflects that position. He is wearing the scarlet academic robes of an Oxford DCL – he had been awarded honorary degrees by Oxford, Cambridge and Edinburgh in 1879 – into which is tucked his golden badge of office as President. The direct gaze of his manly bearded head stands out against the background of the Parthenon Frieze, of which he had installed a copy in his studio. Here indeed was a worthy successor to Sir Joshua Reynolds, whose own major self-portrait, wearing the same Oxford gown, was painted for the Academy about a century earlier and is re-echoed in this one. Leighton was far less prolific as a portrait painter than Watts, and his portrait style was very different. His highly finished and detailed portraits, mostly of women, have much in common with those of Millais and Holman Hunt, as is seen in the striking full-length of The Countess Brownlow exhibited in 1879 and now at Belton House, Lincolnshire.

Something of Leighton's personal well-being is reflected in the tranquil mood of *Idyll* (Private Collection), another of his 1881 exhibits. It is certainly no coincidence that in an 1880 engraving of the interior of Leighton's studio, the canvas displayed on the easel in the foreground is the *Idyll*, and it is interesting to note that quite a large clay model of the two reclining women is shown on a table beside it. In the painting two scantily clothed young women (one of them modelled by the actress Lily Langtry) are resting languidly beneath a tree listening at dusk to a muscular shepherd piping. Beyond them is an extensive landscape with a meandering river merging into the sea and with mountains on the horizon, all seen in the sharp light but almost monochrome

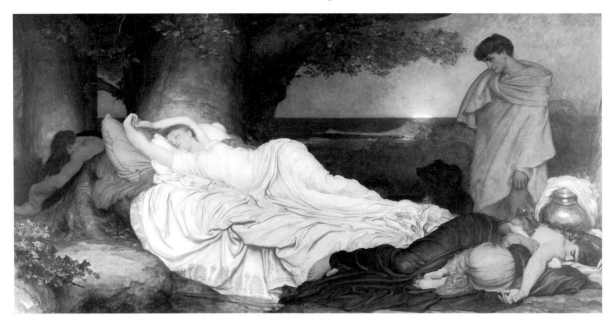

colouring of a fine evening. Here again Leighton has demonstrated his mastery of atmosphere and texture, and has created a harmonious pastoral in the traditions of Titian and Botticelli, whose equally languid *Venus and Mars* had been purchased by the National Gallery in 1874. There is a more meaningful overtly sexual sensation in the much larger painting *Cymon and Iphigenia* [PL.201], illustrating a story from the *Decameron*, which was shown at the RA in 1884. Set in the magic moment between sunset and moonrise, with the merest lip of the moon just rising on the sea horizon, this dreamlike scene shows the shepherd boy overwhelmed by the unexpected sight of the sensual sleeping figures of the beauteous Iphigenia and her attendants.

Such idyllic and sensuous themes were to re-appear frequently in Leighton's later paintings, among them *The Garden of the Hesperides* (1892, Lady Lever Art Gallery, Port Sunlight) and *Flaming June* [COL.PL.69], one of six works exhibited in 1895, the year before the artist's death. The extraordinary and Michelangelesque pose of the sleeping woman in this famous painting is reputed to have been 'suggested by the chance attitude of a weary model who had a particularly supple figure'.[4] However, Leighton made numerous compositional and detailed drawings to perfect the pose, and in the final painting the contorted and compressed figure is totally convincing, and made all the more compelling by the brilliant orange of the dress, with its flowing drapery bringing a remarkable feeling of mobility to the whole. Even more overtly sexual is the Tate Gallery's *Bath of Psyche*, exhibited at the Academy in 1890 and bought by the Chantrey Bequest. This frank and erotic depiction of the almost naked and extremely beautiful young goddess preparing to bathe in readiness for her first meeting with her bridegroom, Cupid, is at once direct and subtle. The subtlety lies largely in the emphasis placed on the classical character of the subject; for instance, the prominent Ionic columns that frame the nude are re-echoed in the actual frame, which was designed by Leighton himself. Coming from the hand of Leighton such works were considered

acceptable by fellow artists, critics and general public, as shown by the purchase of *The Bath of Psyche* for the Chantrey Bequest. As was widely known, the model for this beautiful female was the actress Dorothy Dene, who sat frequently for Leighton and was the inspiration for many of his later more emotional and revealing works.

Leighton was not as successful in his various forays into decorative painting, of which one of the earliest was the large spirit fresco of *The Wise and Foolish Virgins* behind the altar of St Michael's, Lyndhurst, painted in the early 1860s. Some ten years later he was commissioned to provide decorations for two large lunettes in the South Court of the South Kensington Museum (now Victoria and Albert Museum). He produced numerous powerful drawings, oil sketches and cartoons for these frescos, which represented *The Arts of Industry as applied to War*, completed in 1880, and *The Arts of Industry as applied to Peace*, which was only finished in 1886. Now in poor condition and difficult to see because of structural alterations, these two rather orthodox and very Raphael-esque compositions represent War in medieval times and Peace in ancient Greece. Neither of the completed spirit frescos has any of the harmonious vitality of Leighton's fine processional easel paintings.

On the other hand as an illustrator of books, most famously of George Eliot's *Romola* for the *Cornhill Magazine* in 1862, Leighton's draughtsmanship and gift for balanced and effective composition came into their own. A few years later his designs for woodcut illustrations in *Dalziel's Bible Gallery* were even more powerful and dramatic. Such work was, of course, largely dependent on the quality of Leighton's drawings, most frequently in chalk, but also in pencil and in pen and ink. One of his drawings, the large silverpoint *Study of a Lemon Tree* (Private Collection), became almost as famous as many of his paintings. Drawn on Capri in 1859, he exhibited this at the Hogarth Club in the following year, where it was much admired by John Ruskin, who borrowed it for his Oxford drawing school some years later.

In the last years of his life Leighton, who had been created a Baronet in 1885, was dogged by ill health and overtaxed by his many public duties, and especially by his work as President of the Royal Academy, an office which he filled brilliantly. In his fulsome obituary of Lord Leighton in the *Magazine of Art*, M.H. Spielmann wrote of him 'as the greatest President who has ever controlled the destinies of the Royal Academy', and continued, 'That Sir Joshua Reynolds painted better, none would have admitted more cheerfully than Leighton himself. That Lawrence was the smarter courtier, he might equally have conceded. But it is as the standard-bearer of the arts and as an administrator that a President must be judged and criticised. In these dual capacities Lord Leighton splendidly vindicated the dignity of his profession, raising the status of the artist and the standard of our Art; and maintaining at its highest level the tone which inherently belongs to all great art, he compelled the approval of his fellow-craftsmen and the admiration of the world.'[5] Despite his onerous duties Leighton remained prolific as a painter, always exhibiting several works at each Summer Exhibition, and on one or two occasions as many as seven.

In 1888 there were only two, but one of these was the last and perhaps most effective of his vast processional compositions, *Captive Andromache* [PL.202]. This crowded and elaborate scene, filled with incidental detail and yet rhythmic and compelling as a whole, focuses poignantly on the lonely and unhappy central figure of the prisoner

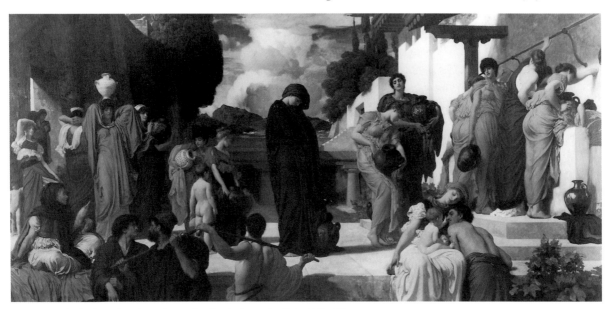

(202) Frederic, Lord Leighton, *Captive Andromache* (RA 1888). Oil on canvas; 197×407 cm. (Manchester City Art Galleries)

queen enfolded in her heavy black robe and awaiting her turn to draw water. *Captive Andromache* was another *tour de force*, and it was bought from the artist for the huge sum of £6000 by the City of Manchester Art Gallery, founded only a few years earlier. It was certainly the masterpiece of Leighton's later years, and shows him at the height of his compositional powers, though some critics did comment that this was yet another 'masterpiece' without any deeper meaning or relevance. Like the pioneering *Cimabue's Madonna*, which had made Leighton's name in 1855, *Andromache* is a convincing imaginary scene depicting a minor 'historical' moment, generalising the event with the minimum of narrative content, and relying on mastery of the classical sculptural frieze structure to produce a great composition.

Most of Leighton's major paintings were equally timeless and generalised, though within a classical mould. Such works could be designated as 'art for art's sake', and as Walter Armstrong somewhat surprisingly wrote in his *DNB* article on Lord Leighton a few years after his death; 'He was not a great painter. He … had nothing particular to say with paint. On the other hand he saw beauty and could let us see that he saw it. He was clever in the best sense, and by dint of taking thought could close his intentions in a pleasant envelope.' This seems a fair summing up of an artist who, whatever his failings, was certainly one of the most significant and compelling in the second half of Queen Victoria's reign. Perhaps it says something for her perspicacity that the elderly Queen was reluctant to follow Gladstone's advice to grant Leighton a peerage, and that she only finally did so in the month of his death. As a man Leighton was generally liked and admired, and after his death, thanks very largely to the generosity of his two sisters, his Holland Park Road house and studio became a museum, now administered by the local authority. The artist himself had made no provisions for such a monument, and the contents of the house, including his fine collection of paintings, drawings,

furniture, and ceramics were, in fact, auctioned a few months after his death. Since then much has been retrieved, and, with the help of loans from the Tate Gallery and elsewhere, Leighton House is still today a focal point for the study and appreciation of High Victorian art and of its notable High Priest.

34 Sir Lawrence Alma-Tadema, OM, RA (1836–1912), and Sir Edward Poynter, Bt, PRA (1836–1919)

One of the problems in writing about the great 'Olympians' of late Victorian art is that each of them could be described as 'an artistic god – as well known in his day as Picasso was in our own'. These are the opening words of a recent book on Sir Lawrence Alma-Tadema,[6] and they could just as well apply to Lord Leighton and others. After several decades in the wilderness of total neglect Alma-Tadema is also among those whose reputation and values have been revived in the 1980s. In his case, however, it is difficult for the art historian to think of him as anything more than an outstandingly gifted technician and an intelligent opportunist, whose paintings exactly met the taste of his day but have no major part to play in the story of British art in the later years of the nineteenth century.

Born in Holland and largely trained in Belgium, where the renowned and influential academic painters Baron Wappers and Baron Leys were his principal teachers, Alma-Tadema quickly made his mark with paintings of obscure medieval historical subjects. When the dealer Ernest Gambart saw one of these – *Coming out of Church* – in the artist's Antwerp studio, he commissioned no less than twenty-four pictures, to be paid for on a rising scale, and thus Alma-Tadema was firmly launched on a career which brought him considerable wealth, international renown and numerous honours, including in 1905, the Order of Merit. However, the vital meeting with Gambart coincided with major changes in Alma-Tadema's art. For a short time, inspired by the Egyptian antiquities he had seen at the British Museum during a brief visit to London in 1862, he painted Egyptian subjects, one of which won a gold medal at the Paris Salon in 1864. In the previous year the artist had made his first visit to Italy, where he visited the ruins of Pompeii and Herculaneum. This experience inspired him to attempt his first Graeco-Roman subjects, which became the mainstay of his art for the remainder of his career.

An important feature of all Alma-Tadema's historical subjects, whatever their period or locality, was their accuracy and authenticity in every detail, especially of the architecture and the costumes – he made numerous detailed on-the-spot drawings of classical architectural and decorative details, and also used an extensive photographic archive. His actual subjects were generalised and he shunned specific events or scenes recorded in history or literature. However, as Ernest Chesnau stated so perceptively when the artist was at the height of his powers, Alma-Tadema 'invests antiquity with the familiar gait, gestures, movements and attitudes – I might almost say, with the words, sentiments and thoughts – of today. As a protest against the false dignity and commonplace stiffness which the impotent pedantry of Academies has introduced into their formal dramas and heroic poems, Alma-Tadema has, in a manner, put the antique

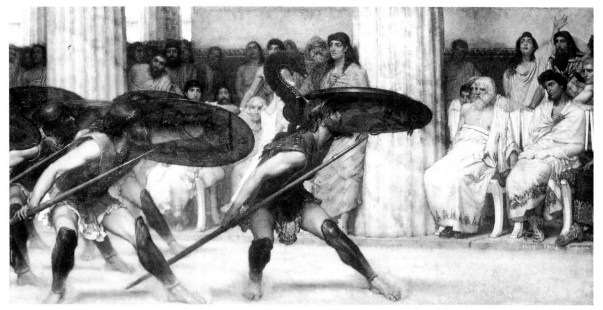

(203) Sir Lawrence Alma-Tadema, *The Pyrrhic Dance* (RA 1869). Oil on panel; 40.7×81.3 cm.
(Guildhall Art Gallery, London)

world into slippers and dressing gown. He represents his heroes as walking, sitting, rising, drinking, eating and talking, … as we ourselves walk, sit, rise, drink, eat and talk … he endeavours with untiring patience to represent his figures as they really were in life, and to place them amid surroundings which really belong to them. His whole work is, indeed, an accurate illustration of Smith's "Dictionary of Antiquities," and ought to delight the minds of archaeologists.'[7]

In addition to this understandable and recognisable 'realism', it was the great technical skill of much of his actual painting – he was especially famed for his marvellous rendering of marble – which helped to make Alma-Tadema's work so popular, and in addition there was great admiration for the daring originality of many of his compositions. The main actual development in his art was in the lightening and brightening of his palette; in his earlier years he used relatively dark colours, though these were often suffused with glowing tones, while in his later years bright, almost pastel shades were the norm, and his compositions sparkled with light. This radical change began in the mid-1860s, when Alma-Tadema had abandoned the traditional academic technique of working on a dark ground and painting in the highlights, and, like the Pre-Raphaelites, he now used a white ground on which he built up the darker tones.

Alma-Tadema first showed at the Royal Academy in London in 1869 when one of his two exhibits was *The Pyrrhic Dance* [PL.203]. This carefully composed but somewhat static depiction of a gruesome but popular form of entertainment in ancient Greece, and its companion Roman interior, *A Lover of Art* (Glasgow Art Gallery and Museum), were an immediate success with both public and critics. That success was certainly one of the reasons which persuaded Alma-Tadema to settle in London in 1870 and become a British citizen three years later. He was elected ARA in 1876 and RA in 1879, and was thus firmly rooted as a leading member of the English art establishment. Soon after set-

tling in London he re-married – his first wife had died in 1869 – and bought Townshend House in Regent's Park, which he 'fitted up to appear as much like a Roman villa as was consistent with the peculiarities of the English climate and the comforts of an English home'. This artist's 'palace' was severely damaged in 1874 by the explosion of a barge loaded with gunpowder on the Regent's Canal, and had to be virtually rebuilt. In the 1880s Alma-Tadema bought a house, formerly the home of James Tissot, on the fashionable Grove End Road, St John's Wood, and remodelled it at vast expense into an even grander classical palace (with some Dutch elements) which provided the settings for many of his canvases. Here the Alma-Tademas entertained on a liberal scale – their Monday afternoon 'At Homes' were famous – and the painter's home environment was closely related to his art. In some ways ancient Rome had almost come to London, as it was to come to Hollywood several decades later and to the Paul Getty Museum at Malibu in the 1970s.

All this 'showmanship' reflected the artist's material success and added to his status, which was also continuously enhanced by further honours and awards both at home and abroad. With the continuing patronage of Gambart, the approval of the critics, which was, however, rarely whole-hearted, and the admiration of the general public for his technical skills, Alma-Tadema was one of the most thriving and popular artists of his day. His eminent position was reflected in a major retrospective exhibition shown at the Grosvenor Gallery in 1882, though in reviewing this many critics commented adversely on the lack of feeling and action in his compositions. However, there was much to attract the classically educated connoisseur as well as the ordinary citizen in the plethora of detail in such a vivid composition as *Love's Votaries* [COL.PL.68], which is dated 1891 and was shown at the New Gallery that year. In this large painting – much of Alma-Tadema's work was on a relatively small scale – there are many elements of ancient Roman life to see and to read – the lines embroidered on the rug are from one of Horace's Odes. All this beautifully painted detail and 'archaeological' information is achieved in a convincing composition and as an effective exercise in the representation of colour and light. Alma-Tadema continued to produce such immediately attractive but essentially empty canvases for another twenty years, but, not surprisingly, the memorial exhibition arranged by the Royal Academy in 1913 attracted only 17,000 visitors, while the Summer Exhibition that year was seen by some 250,000.

The President of the Royal Academy at this time was Sir Edward Poynter, an exact contemporary of Alma-Tadema, with whose work his own painting had much in common. The son of an architect and the great-grandson of the sculptor Thomas Banks, RA, Poynter, though he was for a time a student at the RA Schools, received most of his artistic training on the Continent; in Rome, where he made a close study of Michelangelo and was befriended and much influenced by Leighton, and in Paris, where he spent three years in the strictly academic studio of Charles Gleyre, where Whistler was among his fellow students. Thus Poynter also had an essentially continental training, and throughout his career he remained loyal to the French academic tradition. He returned to London in 1860 and first exhibited at the Royal Academy in 1861. In these early years he was much occupied with decorative schemes in London and elsewhere, and he also established a reputation as an illustrator, working especially for *Once a Week* and for the Dalziel Bible. Poynter was an outstanding draughtsman in

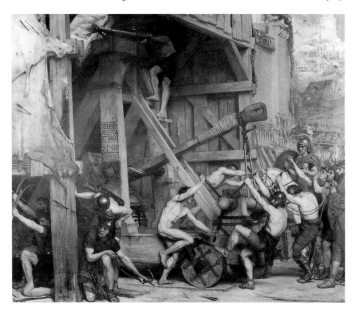

(204) Sir Edward Poynter, *The Catapult* (RA 1868). Oil on canvas; 155×183.5cm. (Laing Art Gallery, Newcastle upon Tyne)

the academic tradition, who loved drawing for its own sake, and he made numerous fluent studies, many of them in black chalk, for each of his paintings.

Poynter's first great success came in 1867, when he showed *Israel in Egypt* (Guildhall Art Gallery, London) at the Royal Academy. This huge frieze composition with its host of nude figures illustrates a passage in the Book of Exodus which tells how the Egyptians made slaves of the Israelites, using them to build their towns and monuments. The painting was bought by a famous engineer, Sir John Hawkshaw, who pointed out that the colossal stone sculpture of a lion would have been too heavy to be towed by the number of slaves depicted; Poynter added new figures which gradually disappear at the edge of the canvas, suggesting an infinite number of slaves. This true 'legend' provides ultimate proof of how important accuracy was for the Victorian admirers of these classical and archaeological scenes. Photography had made them used to absolute accuracy in two-dimensional representations, and in one sense Alma-Tadema's and Poynter's painted reconstructions of ancient scenes were regarded as 'archaeological photographs'. In the next year Poynter followed this impressive academic *tour de force* with *The Catapult* [PL.204], a powerful composition in which scantily clad Roman soldiers and naked slaves are preparing an enormous siege engine for a renewed attack on the walls of Carthage. This rather gloomy picture gave Poynter another opportunity to display his mastery in depicting the male nude, and to show his allegiance to the genius of Michelangelo.

The success of *The Catapult* ensured Poynter's election as an ARA, and he was elected a full Member in 1876. As his Diploma Work he presented *The Fortune-teller*, a scene in a luxurious Roman bath, very close to the slightly later manner of Alma-Tadema. It is not at all clear which of these two artists had a stronger influence on the other, but it is certain that Poynter was the more eclectic of the two and that he readily adopted ideas and modes from his successful fellow artists. Thus Poynter's well-known *A Visit to Aesculapius* (Tate Gallery, London), shown at the Royal Academy in 1880 and

purchased by the Chantrey Bequest for £1000, is a sensitive frieze composition with four beauteous nude young women, close in many ways to several such elongated compositions by Leighton. One of Poynter's most charming paintings, showing the artist's skill in depicting mood and atmosphere, is *Psyche in the Temple of Love* [COL.PL.70]. This small canvas was commissioned by the local committee of the Social Science Congress meeting held at Liverpool and presented to the Walker Art Gallery, an interesting reflection of the respectability of classical academic art at this time.

Like Eastlake before him, Poynter devoted much of his life to a career as an administrator and teacher. He became the first Slade Professor of Fine Art at University College London, in 1871, and established the famous Slade School in the French tradition, with its emphasis on drawing from the living model. In 1875 he was appointed both Director of Art and Principal of the National Art Training School at South Kensington, and here again he made the life-drawing classes a focal feature of the courses. At South Kensington Poynter was also involved in the development of the new museum, and his wide knowledge of art history helped it to make many important acquisitions. Because they interfered too much with his painting Poynter resigned these posts in 1881, and though he continued to sit on various committees he devoted more time to his own work. This period culminated in the completion of the huge and elaborate *Visit of the Queen of Sheba to King Solomon* in 1890 (Art Gallery of New South Wales, Sydney), one of the most 'Hollywood spectacular' of all the High Victorian classical masterpieces. However, Poynter was soon drawn back to administrative duties, was the highly successful Director of the National Gallery from 1894 to 1904, and was elected to succeed Millais as President of the Royal Academy in 1896. Distinguished in bearing and authoritative in character, he retained this demanding office until resigning in 1918, a few months before his death. It says much for his exceptional qualities that throughout his long period of office he was re-elected each year, with no votes ever recorded against him. However, as a painter he had long 'retired', for in 1904 he showed for the last time at the Summer Exhibition, and the Royal Academy did not see fit to 'award' him a memorial exhibition.

While both Alma-Tadema and Poynter occasionally painted and exhibited portraits, which were always a sure 'money-spinner', Edwin Longsden Long, RA (1829–91), was a successful portrait painter who also showed subject pictures, one of which, *The Babylonian Marriage Market* [PL.205], made him famous. This was based on a passage from George G. Swayne's *The History of Herodotus*, from which a long quotation was printed in the catalogue when the painting was shown at the RA in 1875. Although only hung in the relative obscurity of Gallery VI, this ambitious frieze composition was hugely popular with the public and was extravagantly praised by most of the critics. The painting, which took two years to complete, was commissioned by Edward Hermon, MP, who is reputed to have paid 1700 guineas for it, and who had already acquired one of Long's Spanish subjects, *The Suppliants. The Expulsion of the Gypsies from Spain*, shown at the RA in 1872. At his sale in 1882 both were bought for Thomas Holloway, *The Babylonian Marriage Market* for the record sum of £6615, including copyright.

Even Ruskin thought the painting of 'great merit', but then snidely suggested that it was 'well deserving purchase by the Anthropological Society. For the varieties

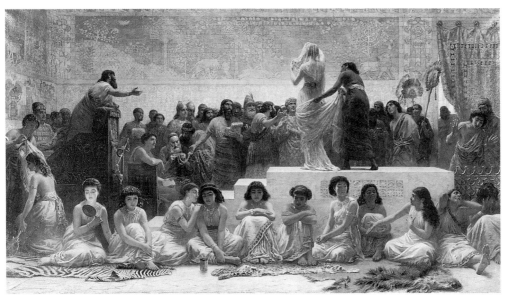

(205) E. L. Long, *The Babylonian Marriage Market* (RA 1875). Oil on canvas; 172.6×304.6 cm.
(Royal Holloway and Bedford New College, Egham)

of character in the heads are rendered with extreme subtlety; while as a mere piece of painting, the work is remarkable, in the modern school, for its absence of affectation; there is no insolently indulged indolence nor vulgarly asserted dexterity, – the painting is good throughout, and unobtrusively powerful.'[8]

In 1875, after an interval of fifteen years, Ruskin, then in the middle of his first term as Slade Professor at Oxford, decided to produce a further number of his *Academy Notes*, which he had originally published from 1855 to 1859. In an introductory passage to the 1875 *Notes* Ruskin gives a wonderfully perceptive overview of the 1875 Royal Academy, which provides us today with a valuable commentary on the overall state of much of British painting at that time, and is worth quoting from at length:

> Before looking at any single picture, let us understand the scope and character of the exhibition as a whole. The Royal Academy of England, in its annual publication, is now nothing more than a large coloured *Illustrated Times* folded in saloons, – the splendidest May number of the *Graphic*, shall we call it? That is to say, it is a certain quantity of pleasant, but imperfect, 'illustration' of passing events, mixed with as much gossip of the past, and tattle of the future, as may be probably agreeable to a populace supremely ignorant of the one, and reckless of the other....
>
> Nay, not in skill only, but in pretty sentiment, our press illustration, in its higher ranks, far surpasses – or indeed, in that department finds no rivalship in – the schools of classical art; ... Popular or classic, temporary or eternal, all good art is more or less didactic. My artist adversaries rage at me for saying so; ... it will be the surest way of estimating the intrinsic value of the art of this year, if we proceed to examine it in the several provinces which its didactic functions occupy; and collect the sum of its teaching on the subjects – which will, I think, sufficiently embrace its efforts in every kind – of Theology, History, Biography, Natural History, Landscape, and as the end of all, Policy.[9]

The Babylonian Marriage Market is included under 'History', as are Alma-Tadema's *The Sculpture Gallery* (Private Collection, USA), and Poynter's *The Festival*. Two of Leighton's Near Eastern subjects are scoffed at in a long and effusive entry devoted to G. D. Leslie's *School revisited*, in the section on 'Biography' (which includes Drama, Domestic Incident, and Portrait).[10] George Dunlop Leslie, RA (1835–1921), youngest son of C. R. Leslie, specialised in sentimental scenes of domestic and literary narrative, and here, typically of Ruskin's more eccentric judgements, *School revisited* is considered as one of 'the only two works of essential value in the exhibition of this year', the other being J. E. Boehm's portrait bust of Thomas Carlyle. The painting, of which Agnew's owned the copyright, shows a fashionably dressed young 'lady' on a visit to her old school, surrounded by several prim girls; as his comments on the picture indicate Ruskin was very keen on 'English maids'.

The 1875 exhibition included another painting that was a great popular success and that has become famous. This was Herkomer's *The Last Muster* [PL.197], which Ruskin referred to in his piece on *School revisited*, without naming the artist, as a 'group of grand old soldiers at Chelsea – a most notable, true, pathetic study, but scarcely artistic enough to be reckoned as of much more value than a good illustrative woodcut'. For all its social realism, *The Last Muster* is an essentially sentimental picture, and fits in well with the overall impression of pervasive sentimentality which is gained when looking through the 1875 RA catalogue in the splendid series of extra-illustrated catalogues presented to the Royal Academy Library by C. Bolingbroke in 1947. Ruskin considered this an exceptional exhibition, while the *Art Journal* thought that it 'attains the average standard, but is not what might have been expected from the fact that the number of works sent in was far greater than on any former occasion'. Apparently over 6000 works were submitted, of which 'only' 1408 were exhibited, while the Paris salon, which was also about to open, included some 4300 works. For the present-day viewer the impression given of the 1875 Summer Exhibition by the available reproductions is a depressing one. For instance, having made his mark with the moving *Applicants for Admission to a Casual Ward* [PL.195] in the previous year, Luke Fildes showed *Betty* in 1875, which, judging by the rather garish reproduction, was a totally vacuous study of a pretty milkmaid wearing a bonnet and carrying her bucket and stool. The most remarkable exhibit of which there is a reproduction is certainly No. 1218, *The disputed Toll* by Heywood Hardy (1843–1943), best known for his animal subjects. This shows a man leading an elephant and disputing across the gate with the toll-keeper, backed up by his barking small dog. To develop Ruskin's critical simile, such a painting could be said to have made of the 1875 Royal Academy exhibition 'the splendidest May number of *Punch*!'.

35 Albert Moore (1841–93) and J. W. Waterhouse, RA (1849–1917)

In his *Academy Notes* for 1875 John Ruskin is full of praise for two of Albert Moore's three exhibits, *A Flower Walk* and *Pansies*, which he describes in his piece about Alma-Tadema's *The Sculpture Gallery* as 'two small studies … which are consummately artistic and scientific work'. Though a regular exhibitor at the Royal Academy, Albert Moore

was never elected to that body, and, reclusive and withdrawn in character, he achieved none of the renown or wealth of his 'Olympian' contemporaries working in the classical tradition. Born in York, the youngest of fourteen children of a minor landscape and portrait painter, four of whose older brothers, including the landscape painter Henry Moore, RA, also became artists, Albert Joseph Moore showed his precocious talent at an early age. His father died in 1851, and the family soon moved to London, where Albert was briefly a student at the RA Schools. His first exhibits at the Academy, in 1857, were two minutely detailed watercolour drawings of dead birds, which, like the beautiful *Study of an Ash Trunk* shown in the following year (Ashmolean Museum, Oxford), were clearly drawn under the influence of the Pre-Raphaelites. However, visits to France and Rome helped the young artist to develop a more individual, though still largely Pre-Raphaelite, style, in which he painted a number of Old Testament subjects which were exhibited at the RA. At the same time he was painting several decorative mural and ceiling decorations, commissions he had gained through his friend the architect W.E.Nesfield.

He also began to exhibit purely decorative compositions, one of which, the lost *The Marble Seat*, a mixture of Pre-Paphaelite medievalism and Leighton's early classicism, attracted the attention of Whistler when he visited the Academy in 1865. The two artists became friends, and during the later 1860s their painting developed on closely similar lines – largely 'abstract' compositions without narrative content – in Moore's case with titles such as *Apricots* and *The Musicians* – featuring elegant classical figures in settings with Japanese characteristics and colouring. The classical element, first seen in *The Marble Seat*, was developed by Moore, and his last Old Testament subject, *The Shulamite* of 1866 (Walker Art Gallery, Liverpool), is in this new, and then pioneering, style. It was Whistler who introduced the Japanese component as the result of his discovery of Japanese prints and his interest in Japanese blue and white porcelain. Whistler, who, as we shall see in Chapter 38, never actually completed any of his compositions in this manner, abandoned this style after 1870, but Albert Moore worked in it throughout his career. Unlike Alma-Tadema he did not aim at archaeological accuracy and was in no way trying to depict the actuality of the ancient world. He was simply using the medium of classical figures in essentially classical settings to achieve pictures in which mood and attractive colouring combined to provide aesthetic pleasure. The Japanese elements introduced by Whistler played an important part in creating the mood and influenced Moore in his use of delicate and harmonious colours.

In 1868 *Azaleas* [COL.PL.71] was the first of Albert Moore's many studies of single standing figures to be shown at the Royal Academy. The life-size pensive 'goddess' dressed in diaphanous draperies is totally engrossed in the azaleas of the title, and was thought to be somewhat eccentric by the critic of the *Art Journal*, who did, however, find a 'classic beauty and a dreamy romance not altogether unpleasing'. In the following year Moore exhibited *A Quartet: a Painter's Tribute to the Art of Music, AD 1868* (Private Collection); here both the title and the fact that the musicians are playing modern instruments, though wearing idealised classical dress, again makes it clear that the artist was in no way emulating Alma-Tadema or Poynter in their skilful quest for archaeological accuracy. Moore also exhibited other frieze-like compositions, usually on a smaller scale, of which one of the most elaborate is *Dreamers* [PL.206], which was his

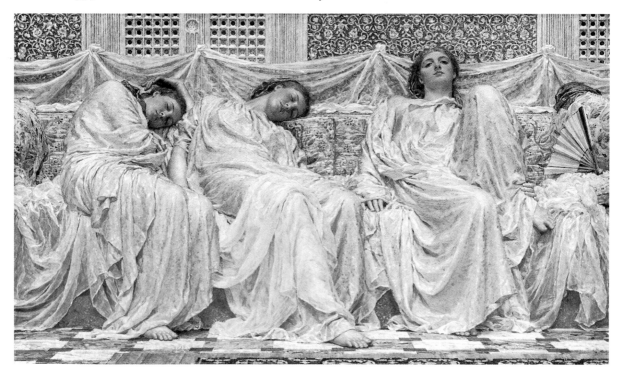

only RA exhibit in 1882. This was the year in which Burne-Jones completed *The Hours* (Sheffield City Art Galleries), begun in 1870 and shown at the Grosvenor Gallery in 1883, and there certainly seems to be some relationship between these two visions of classical female beauty depicted in absolute tranquillity. Moore had also worked for some years on his *Dreamers,* and during those years he had exhibited a number of finished studies of the individual figures.

In Moore's late paintings, such as *An Idyll*, completed in 1893 and his last RA exhibit (Manchester City Art Galleries), there is a little more sentiment and action and the colours become brighter. A long and painful illness brought these developments to a premature end, and Albert Moore is remembered as the hard-working, consistent and retiring artist of numerous attractive and undemanding visions of beauty. These did not bring him great material wealth, honours or fame, but during the very years when across the Channel the Impressionists were creating their most beautiful and significant works, Albert Moore was true to his personal inspiration, and though certainly influenced by others, created an individual manner which has always retained its admirers, and which places him among the leading artists of the Aesthetic Movement, centred on the Grosvenor Gallery where he exhibited from its opening in 1877.

John William Waterhouse was much more ambitious and materially successful than Albert Moore, and was certainly even more eclectic in his development. However, he also achieved an immediately recognisable individual style, and his early paintings serve as a link between the classicism of Leighton and Alma-Tadema and the art of late Pre-Raphaelitism. Both J. W. Waterhouse's parents were painters, and he was born in Rome, where his father was one of many minor British artists just succeeding in making

OPPOSITE

(206) Albert Moore, *Dreamers* (RA 1882).
Oil on canvas; 68.6×119.4cm.
(Birmingham Museums and Art Gallery)

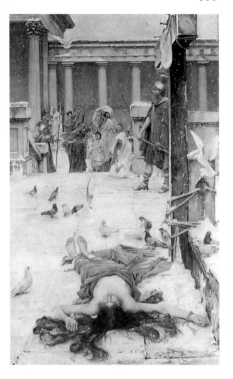

(207) J.W.Waterhouse, *Saint Eulalia* (RA 1885). Oil on
canvas; 188.6×117.5cm. (Tate Gallery, London)

a living. The family returned to London in about 1855, and little is known about Water-
house's early years, except that he worked in his father's studio before becoming a
student of sculpture at the Royal Academy Schools in 1871. In 1874 he exhibited for the
first time at the Royal Academy, and at this time his work was very strongly influenced
by Alma-Tadema, who had settled in London in 1870. Waterhouse gained some success
with these early works, and could afford to re-visit Italy several times between 1877 and
1883, the year in which he was married. This was also the year of his first major success
at the RA, *The Favourites of the Emperor Honorius*, which was hung on the line and was
purchased for the Art Gallery of South Australia in Adelaide. That success was im-
proved on in the following year when he showed only one painting, *Consulting the
Oracle*, which was bought by Sir Henry Tate (Tate Gallery, London). It was especially
praised by the critic of the *Art Journal*, who called it 'an intensely dramatic picture', and
the *Magazine of Art* named it as 'one of the successes of the year'.[11]

Sir Henry Tate was also the purchaser of *Saint Eulalia*, the first and most ambitious
of a series of more individual history pictures which Waterhouse showed at the RA
from 1885 to 1887. *Saint Eulalia* [PL.207] gained the artist further critical acclaim, and led
to his election as an Associate later that year. The foreshortened body of the crucified
girl lies in the foregound at the foot of the bulky cross, isolated, except for a number of
pigeons, while the small crowd of mourners in the background watch the miracles of
the dove seeming to fly out of her mouth and the snow falling to cover her body. While
still under the influence of Alma-Tadema's style, *Saint Eulalia* differs categorically from
the senior artist's work in that it depicts an 'historical' event and a totally serious sub-
ject, though in modern times this miraculous martyrdom has been considered more of

a legend than an actual happening. *The Magic Circle* of 1886 (Tate Gallery, London) was purchased by the Chantrey Bequest, while in 1887 the large *Marianne* (Forbes Magazine Collection) was bought by Sir Cuthbert Quilter, and was widely exhibited in the next twenty years, winning a bronze medal at the Exposition Universelle of 1889 in Paris, and a gold medal in Brussels eight years later.

Though he was not elected a full RA until 1895, J. W. Waterhouse's reputation was well established during the 1880s, and at the end of the decade he had the courage to introduce major changes in his style of painting and his choice of subject matter. The first example of this new mature manner was *The Lady of Shalott* [COL.PL.73], which was his only exhibit at the Academy of 1888, and was once again purchased by Sir Henry Tate. In this moving illustration to Tennyson's great poem of 1832, Waterhouse has combined the expressive mood and character of the figure with telling atmosphere in the somewhat impressionistically painted landscape setting. These were to be the essential characteristics of most of his major works throughout the rest of his successful career, most notably, perhaps, in the attractive and seductive *Hylas and the Nymphs* (Manchester City Art Galleries), which was purchased directly from the artist in 1896 by the Corporation of Manchester for £800, shown first at the Manchester Autumn Exhibition that year, and then at the RA the following summer. Combining an element of gentle eroticism with idealised beauty and meaningful mood, such attractive compositions brought the influence of Burne-Jones into the twentieth century.

Always a somewhat eclectic artist, J. W. Waterhouse was also always essentially a romantic. He had first taken his cues from the romantic elements of the classical revival and had then abandoned these for similar qualities in late Pre-Raphaelitism. What singles him out from most of his contemporary late romantics, and there were many of them, is the vivid quality and vigorous technique of his actual painting. It was largely the recognition of these qualities which led to a great revival of interest in his work in the later 1980s. Flatness of paint, stiffness of composition and lack of atmosphere were common characteristics of the work of most of his fellow British artists working in the same traditions, and continuing to do so well into the twentieth century.

Notes to Part Eight

1 Quoted by Christopher Newall in *The Art of Lord Leighton*, 1993, p.20
2 Newall, loc.cit., p.56
3 In 1996 the Royal Academy mounted an excellent exhibition, accompanied by an informative catalogue, surveying Lord Leighton's art, though this failed to win the approval of most of the critics
4 J. E. Staley, *Lord Leighton of Stretton*, 1906, quoted by Newall, loc.cit., p.136
5 *The Magazine of Art*, 1896, p.199
6 Vern G. Swanson, *Sir Lawrence Alma-Tadema*, 1977, p.7
7 E. Chesnau, *The English School of Painting*, 4th edn, 1891, p.264
8 *Works*, Vol.XIV, p.274
9 Loc.cit., pp.263–5
10 Loc.cit., pp.289–92
11 Quoted by Anthony Hobson, *The Art and Life of J. W. Waterhouse, RA*, 1980, pp.41–2

Part Nine

From Realism to Post-Impressionism

As must already have become clear there was no unity or continuity of style or development in British painting during the nineteenth century. The only really individual artistic movement was that of the Pre-Raphaelites, and in its true state this was very short-lived. Though the Royal Academy was a focal factor throughout the period, it did nothing to encourage an element of uniformity in the work of its members and other exhibitors. This diffuse state of affairs became even more evident in the closing years of the century, as British artists, like their fellow citizens, travelled more in Europe, and artistic contacts with France especially became closer and more influential. Both 'Realism' and 'Post-Impressionism' – the aesthetic terms used in the title of Part Nine – were French movements, and the British artists influenced by these movements, and, of course, by the 'Impressionism' that came in between, were followers rather than contributors. It is against this very unco-ordinated background that British painting of the later years of the nineteenth century has to be discussed.

36 Realist and Idealised Landscape

The major role enjoyed by landscape painting in British art of the first half of the nineteenth century was not repeated in the second half. Though there were still many landscape specialists, none of these attained the importance of Constable and Turner, and few of them added much of originality to the development of landscape art. An artist whose long career linked each half of the century was John Linnell (1792–1882), patron of William Blake and father-in-law of Samuel Palmer. Taught by John Varley and a student at the Royal Academy Schools, the young Linnell painted and drew attractive naturalistic landscapes, for a time mostly out of doors. It is this early work, of which the Fitzwilliam Museum's tranquil view of *The River Kennet, near Newbury*, dating from 1815, is a fine example, that most appreciated today. During these formative years, his landscapes were largely in watercolours, in which he developed a distinctive and graceful manner, while he was establishing a reputation and earning his living by painting portraits, mostly on a small scale, and miniatures, which he exhibited regularly at the Royal Academy from 1821 until the later 1840s. From then on he showed only landscape compositions, some of them with narrative elements, and the Redgrave brothers were as usual correct in stating that 'it is by his landscapes that Linnell's fame will live'.[1]

They were equally correct in commenting on the uneven quality of much of his later work.

Linnell was a difficult man, with radical non-conformist beliefs and a critical and somewhat uncharitable attitude towards many of his fellow artists. He had a demanding life, with a large family to support; Hannah, the eldest of his nine children and herself an artist, married Samuel Palmer in 1837, and several of his sons became artists. While he put himself forward for election for twenty years, Linnell was never elected an Associate of the Royal Academy, but he continued to exhibit there annually until the year before his death. His first major landscape success at the Royal Academy was *Noah: The Eve of the Deluge* (Cleveland Museum of Art, Ohio), exhibited in 1848 and bought for £1000 by Joseph Gillott. However, this huge and dramatic composition, in which the influence of John Martin, Danby and Turner may be traced, was not typical of Linnell's mature landscape art, which continued to be based on his close studies of nature and consisted largely of broad views of the southern English landscape recorded at times of specific light and weather effects.

In 1851 Linnell moved to Redhill in Surrey, where he had built a house in which he lived for the rest of his life, and it is the mellow and prosperous Surrey landscape that provided the principal inspiration for many of his later landscapes, though there are also some based on studies made on his sketching tours in earlier years. However, few of Linnell's mature landscape compositions are of specific places, and his painting technique, distinguished by the use of small flickering brushstrokes, also became generalised. He thought of his paintings as 'aspects of nature' or 'spiritual artistic facts',[2] and in them, like his son-in-law, Samuel Palmer, he aimed to express some of his religious feelings. These qualities are well illustrated in *The Flock* [PL.208], which is dated *1863* and which may have been the *Feeding Sheep* shown at the Academy that year. This tranquil and idealised scene, with its beautiful distant landscape and its cloudy sky, contrasts strongly with the epic and dramatic *A coming Storm* of ten years later (Art Gallery and Museum, Kelvingrove, Glasgow), in which, even at the age of eighty-one, Linnell was able to depict the full power of nature on a large scale. Though they never made him a member, the Royal Academy devoted a large part of its Winter Exhibition of 1883 to John Linnell's landscapes, and these continued to fetch very high prices at auction until the end of the century. In recent years interest in Linnell's own work has revived, but it has focused on his early landscape work, and his mature landscape painting has been largely ignored. However, in his landscape painting and drawing of between about 1805 and 1820 John Linnell was a minor figure during a period when British landscape art was flourishing. By contrast, the landscape paintings of the last thirty years of his long life are among the major achievements during a lean period in that art, and provide a fascinating example of how the inspiration of the first half of the century could be developed in the second half.

By contrast with the neglect of John Linnell's later landscape paintings, the work of Frederick Waters Watts (1800–62) has been eagerly sought after by dealers and collectors for some thirty years. Very little is known about F. W. Watts, who exhibited landscapes prolifically at the Royal Academy, the British Institution, and the Society of British Artists from 1821 until the year of his death. He lived in Hampstead all his life, but was apparently not personally acquainted with Constable, whose work, however,

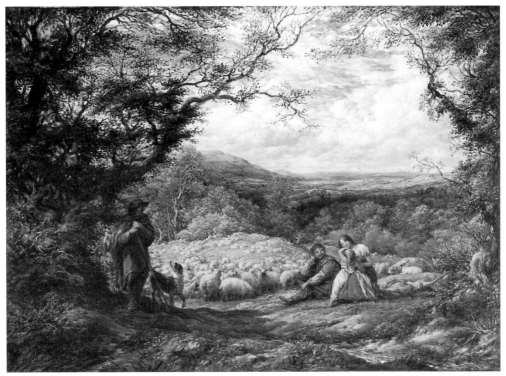

(208) John Linnell, *The Flock* (1863). Oil on canvas; 71×99.7 cm. (Birmingham Museums and Art Gallery)

was the principal influence on his own painting. Even during his lifetime, and frequently since then, peaceful river landscapes reminiscent of Suffolk, and Hampstead scenes, by F.W.Watts, have been attributed to Constable, and it is no doubt their similarity to some of the most famous paintings of that master that has made them so popular in our own time. F.W.Watts is far from being the only successful later nineteenth-century landscape painter whose work is reminiscent of Constable, and in comparison there were remarkably few close imitators of Turner. One of these was James Webb (1825–95), who also exhibited regularly in London from 1850 onwards, and who is best known for his atmospheric coastal scenes, usually painted in pale colours and frequently reminiscent of Turner's watercolours of the 1820s and 1830s. The Tate Gallery's large *Mont St Michel*, which was probably shown at the RA in 1866, is a typical example.

One painter of landscape who achieved some originality in his work, but whose artistic career started late and was then cut short by an early death, was George Heming Mason, ARA (1818–72). Born in Staffordshire, he abandoned training as a doctor in 1843 and left for Rome, where he began his studies and practice of art, encouraged and befriended by Leighton and the Italian painter, Giovanni Costa. Under their influence he painted landscapes and figure subjects in the Campagna, but returned to England in 1858. From his Italian experience he then developed his own poetic and romantic idiom of pastoral landscapes with figures, which brought him considerable recognition in his final years. *The Wind in the Wold* (c.1863) and the large *The Harvest Moon* (1872) in the

Tate Gallery are excellent examples of his later and most individual work. *The Harvest Moon* was well received when shown at the Royal Academy in 1872, but this proved to be the artist's final major work. Though now much darkened, this panoramic twilit scene combines a rhythmic sense of movement and effective atmosphere, to achieve a moving idyll of rural life.

It was Benjamin Williams Leader, RA (1831–1923), who stepped into the shoes of John Linnell as the most popular of the landscape painters exhibiting regularly at the Royal Academy. The year 1881 was when Linnell, aged eighty-nine, showed his last painting and when Leader, aged fifty, had his greatest success with *February Fill Dyke* [COL.PL.72], which has come to be one of the most famous of Victorian paintings and which is still one of the favourite paintings in Birmingham Art Gallery, to which it was bequeathed in 1914. The painting was quite severely criticised by some critics, but *The Graphic* described it as 'remarkable not less for its comprehensive truth of effect than for the fidelity with which the individual facts of nature are rendered'. The painting, of which a handsome etching had been published in 1884, was again a great popular success when shown at the Manchester Royal Jubilee Exhibition in 1887.

Born in Worcester, the son of an engineer in whose office he worked for a time, Leader entered the RA Schools in 1854, and exhibited for the first time in the same year. His early works were genre subjects strongly influenced by the Pre-Raphaelites, but after a few years he began to exhibit landscapes, mostly of scenes in Surrey, Wales and Worcestershire. These early landscape paintings, such as *A quiet Valley among the Welsh Hills* (City Museum and Art Gallery, Worcester), are also close to the work of the Pre-Raphaelite landscape artists in their strong colouring and painstaking detail. However, Leader soon adopted a much looser and broader manner, which also proved to be more popular and sellable, and during 1873 his painting earned him over £3000.

Though appearing essentially 'true to nature', Leader's landscape compositions also combined nostalgia and sentiment to produce an idealised rural vision which pleased his viewers and patrons. These were neither topographical nor narrative pictures, but rather timeless records of the British countryside in a variety of moods, weather, seasons and times of day. His mature painting shows no specific influences and had no major impact in the development of landscape art. Each example was, however, immediately recognisable as his work, and Leader's popularity and success finally gained him election as ARA in 1883 and RA fifteen years later. Having lived near Worcester for thirty years, the artist moved in 1889 to a house near Guildford, which Norman Shaw had built for Frank Holl only five years earlier.

Not surprisingly B.W. Leader and George Vicat Cole, RA (1833–93), were good friends, for their art and their careers had much in common. While Vicat Cole achieved the greatly coveted Academic honours much earlier than his friend (ARA in 1870 and RA in 1880), he never produced the one 'block-buster' such as *February Fill Dyke*, and today he is almost totally forgotten. Cole was born in Portsmouth and was trained largely by his father, who was a self-taught portrait and landscape painter, who exhibited prolifically in London. Father and son travelled together on the Continent in 1852, and in the following year each showed a scene on the Moselle at the RA. Vicat Cole also showed a view in Surrey, and the great majority of his exhibits from then on were of scenes in southern England, especially on the Thames. However, many of his

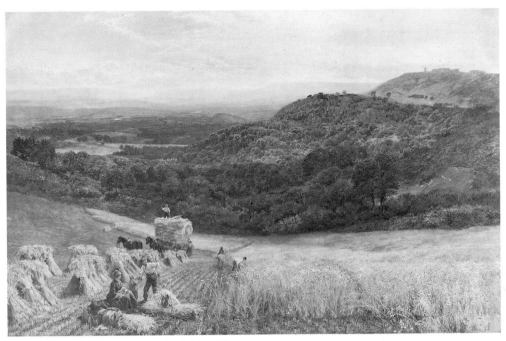

(209) George Vicat Cole, *Harvest Time* (1860). Oil on canvas; 94.5×151 cm.
(Bristol Museums and Art Gallery)

earlier exhibits had generalised titles, such as *Harvest Time* [PL.209], which was ex-
hibited at the Society of British Artists in 1860 and won a silver medal from the Society
for the Encouragement of the Arts. Richly coloured and highly detailed, especially
in the foreground, this large composition provides an idyllic and poetic vision of the
English countryside at its best, and such comfortable visions were understandably
popular in their time.

Equally popular in his later years were Vicat Cole's views on the Thames, of which
Richmond Hill, shown at the RA in 1875, was the first and one of the grandest. In the
catalogue the title was accompanied by lines from James Thomson's *Seasons,* and the
painting can be regarded as a continuation of the eighteenth-century tradition in depict-
ing London's river from its most dramatic viewpoint, as, of course, Turner had also
done. In the left foreground fashionably dressed ladies and gentlemen are promenad-
ing beneath the trees. John Ruskin began his somewhat acid comments on this work in
his 1875 *Academy Notes* with praise of 'the passages on the left, under the trees, of distant
and subdued light, in their well-studied perfection', which he described as 'about the
most masterly things in landscape work in this exhibition'.[3] However, he went on to
condemn the painting of the river and the misty distance beyond it, and it was a feature
of many of Cole's panoramic views to depict the distant landscape in rather hazy tones.
The success of this spectacular Thames view led Mr (later Sir) William Agnew to sug-
gest to the artist that he should paint a series of such views depicting the river from its
source to its mouth, and that these should be engraved. The series was never completed
and the engravings were never made, but many of Vicat Cole's RA exhibits in his last
ten years were of Thames subjects, including the huge *Pool of London* [PL.210] in 1888,

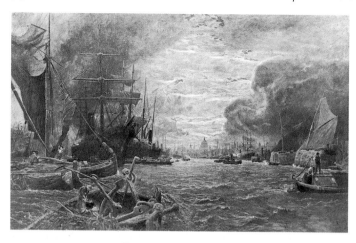

(210) George Vicat Cole, *The Pool of London* (RA 1888). Oil on canvas; 189.2×304.8 cm. (Tate Gallery, London)

which was purchased by the Chantrey Bequest. This powerful composition with its dramatic smoky sky was the result of several years of preparation and study, and at the exhibition it caused a sensation, being especially admired by Mr Gladstone, who commented on the artist's ability 'so to represent a scene of commercial activity as to impress upon it ... the idea and character of *grandeur*.'[4] In this painting Cole again owes much to the example of Turner, but despite this he proved that he had more in him as an artist than just the sentimental depiction of idyllic English pastoral landscape.

Henry Moore, RA (1831–95), already referred to as one of the artist brothers of Albert Moore, specialised in supplying another great love of the British public, views of the coast and the sea. After some initial training in York and a brief and unsatisfactory period at the RA Schools, Henry Moore spent some years travelling in Britain and on the Continent. His first exhibits at the Academy, between 1853 and 1857, were inland landscapes, some of them in a Pre-Raphaelite manner, and it was only in 1858 that he showed his first marine paintings, to which he confined himself from the mid-1860s onwards. Moore's marine painting has often been paired with that of his near-contemporary John Brett,[5] but, in fact, their approach and style were quite different, for Moore developed a fluent, vigorous and colourful manner to record the manifold moods and colours of the sea, which was very dissimilar to the precise and relatively muted style adopted by Brett.

Like Brett, Moore spent much time at sea, sailing with friends and patrons, and constantly observing and making studies; his knowledge of the sea was profound. Many of his major compositions show just sea and sky with only a tiny boat or ship in the distance to provide some element of scale. He tried especially to portray the infinite size and extent of the sea, as in his Diploma painting, *Summer Breeze in the Channel* (Royal Academy, London) shown in the summer exhibition of 1894, the year after his election as RA. He had been elected ARA ten years earlier, after the Chantrey Bequest purchase in 1885 of *Catspaws off the Land* (Tate Gallery, London), a coast scene in which both cliffs and sea are painted with great freedom. Henry Moore is represented by twelve paintings in the City Art Gallery of his native York, among them the vivid *Crossing the Bar* [PL.211], shown at the RA in 1873 and somewhat altered after the exhibition. The compositional formula is similar to that of *Clearness after Rain* (Private

(211) Henry Moore, *Crossing the Bar* (RA 1873). Oil on canvas; 81.7×163 cm.
(York City Art Gallery)

Collection), exhibited in 1887 in London, then in Glasgow, and in 1889 at the Exposition
Universelle in Paris.

This vivid rendering of a choppy deep blue sea was bought by Whistler's patron
Louis Huth, who lent it to the Paris exhibition, where it was a great success. Moore
was one of only two British artists to be awarded a Medaille d'honneur (the other was
Alma-Tadema, while Leighton, Burne-Jones and Orchardson received only First-class
medals), and he was also made a Chevalier of the Légion d'honneur. In 1887 the critic of
the *Athenaeum* had described the painting as 'Titianesque', and there is certainly some-
thing of Titian's blue at its brightest in some of Henry Moore's most colourful render-
ings of the sea in the last years of his career. Two particularly vivid examples are in the
City Art Gallery at Manchester, the large *Mount's Bay: Early Morning – Summer* of 1886,
and the much smaller sketch of *Arran (across Kilbrannan Sound)*, dated 1894, in which
fluent brush strokes of deep blue paint are used to depict both the sea in the foreground
and the mountains in the distance.

Sir Alfred East, RA (1849–1913), is another successful landscape painter who was
much honoured at home and abroad in his lifetime but is largely forgotten today.
Trained in Glasgow and Paris, he settled in London, but made frequent journeys
abroad, including a visit to Japan in 1899. His art was essentially traditional and
naturalistic, showing echoes of Constable and the Barbizon School. He prided himself
on the 'Englishness' of his landscape compositions, of which the imposing *Golden
Autumn* [PL.212] of about 1904 is a typical example. Like Alfred East, the American-born
Mark Fisher, RA (1841–1923), studied in Paris, and after an unsuccessful return to
America, he settled in England in 1872. Aptly described as 'the poor man's Sisley', he
painted peaceful and luminous pastoral landscapes that are fundamentally English in
concept and vaguely Impressionist in technique.

Many of the artists who exhibited landscape paintings also worked in water-

(212) Sir Alfred East, *Golden Autumn* (*c*.1904). Oil on canvas; 122×153 cm.
(Tate Gallery, London)

(213) Myles Birket Foster, *The Milkmaid* (1860). Watercolour; 29.7×44.5 cm.
(Victoria and Albert Museum, London)

colours, and the two principal watercolour societies continued to hold regular and popular exhibitions in London throughout the second half of the century. The Society of Painters in Watercolours, founded in 1804 and commonly known as the Old Water-Colour Society after 1832, the year in which the New Society of Painters in Water Colours held its first exhibition, became the Royal Society of Painters in Water-Colours in 1881. Only two years later the younger society, which had changed its name to the Institute of Painters in Water Colours in 1863, became the Royal Institute of Painters in Water Colours. Despite the existence of exhibiting societies in other British cities, 'London remained the focal point. British landscape painting was essentially an urban art form, produced by city-based artists for a metropolitan audience.'[6] Though this is a somewhat risky generalisation it is essentially true, for while the artists based their exhibition drawings on studies made during sketching tours at home and abroad, most of them lived in or near London, produced their finished works in their studios, and relied on the annual exhibitions for their principal sales.

One of the most successful landscape artists specialising in watercolours in the second half of the century was Myles Birket Foster (1825–99). Trained as a wood-engraver, Birket Foster became a highly successful illustrator, especially for *The Illustrated London News*, but in the later 1850s he decided to devote himself to working in watercolours, which he first exhibited in 1859 at the Old Water-Colour Society, of which he became an Associate in 1860 and a full member two years later. Despite the high degree of finish of most of his work, he was a prolific artist and showed nearly 400 drawings at the OWCS, where he was one of the most popular exhibitors for many years. He became well known for his charming and evocative scenes of English rural life, which were usually highly coloured and packed with detail, which was often executed in a stipple technique, using bodycolour as well as watercolour. On the whole such compositions lacked narrative or symbolic content, and were free from sentiment in mood and atmosphere. *The Milkmaid* [PL.213] which is dated *1860*, is a fine early example of these undemanding idylls, of which he produced a whole series for the Dalziel brothers, engraved and published in 1863 as *Birket Foster's Pictures of English Landscape*, with accompanying verses by Tom Taylor; Alfred Tennyson had declined the commission. Such 'picturesque' scenes were Birket Foster's most popular works, but he also exhibited many topographical landscapes of scenes in Scotland, Devonshire, Venice and elsewhere.

Alfred William Hunt (1830–96) was another prolific and successful exhibitor at the OWCS, of which he became a Vice-President. The son of a Liverpool landscape painter, he showed precocious gifts as an artist but pursued an academic career at Oxford until his marriage in 1861 to the popular novelist, Margaret Raine, with whom he moved to London. He had begun to exhibit at the Royal Academy in 1854, at first mostly in oils, and in 1856 a Welsh view hung on the line won warm praise from Ruskin in his *Academy Notes*, and the two men became friends. Hunt travelled widely in Britain and later on the Continent in search of topographical subject matter, and from rapid sketches on the spot he produced highly finished and increasingly atmospheric watercolours for the exhibitions. His technique was varied and confident, owing something to the example of Turner and Cox, and much of his work is notable for its strong colouring.

The atmospheric tonality of A.W.Hunt's later watercolours, such as *Wind of the*

(214) Alfred William Hunt, *Wind of the Eastern Sea* (*c*.1888). Watercolour; 27.3×39.3 cm.
(Victoria and Albert Museum, London)

Eastern Sea [PL.214], a distant view of Whitby Abbey shown at the Old Water-Colour Society in 1888, may have been partly inspired by the slightly unfocused and muted light effects of some of the landscape photography of the day, the result of the lengthy exposure times needed to record such an image. This influence can also be found in the work of many other watercolour artists, especially in that of Albert Goodwin (1845–1932). He also owed much to his admiration for the work of Turner, with which his own watercolours are frequently compared, though these sometimes seem forced and artificial in effect when compared with the instinctive techniques of the earlier artist. Goodwin was again a precocious beginner, exhibiting at the Royal Academy for the first time in 1860, at which time he met several of the Pre-Raphaelites and became a pupil of Ford Madox Brown. Once again it was Ruskin's support and friendship that was the most important factor in Goodwin's development. He went on several sketching tours, including one in Italy in 1872, with the Master, who was also responsible for introducing him to the watercolours of Turner. In 1871 Goodwin was elected an Associate of the OWCS, and he became a full member ten years later, exhibiting regularly until the 1890s, and continuing to produce large numbers of increasingly imaginative compositions with glowing sunset skies throughout his long life.

Essentially a topographer, Goodwin travelled widely in search of subject matter, including journeys to the Netherlands, Norway, Egypt, India, the West Indies and, above all, Switzerland. His finished watercolours were based on on-the-spot studies and on memory, and he used a wide variety of techniques, many of them experimental.

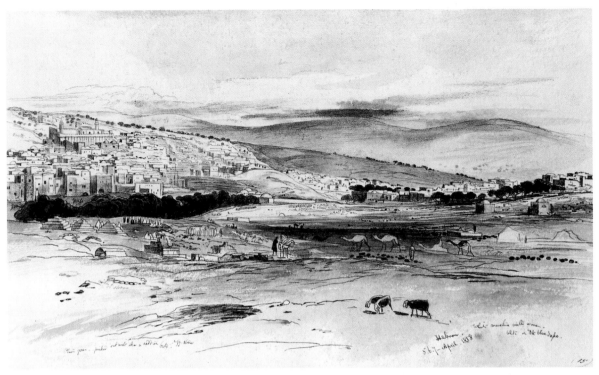

(215) Edward Lear, *Hebron* (1858). Pen and ink and watercolour and pencil; 302×502 cm. (Ashmolean Museum, Oxford)

His best works are distinguished by their tonal, often hazy and delicate colouristic qualities, reminiscent, especially in his later years, of Japanese landscape art. Comparable with the watercolours of Albert Goodwin are the landscape paintings of the slightly older but much shorter-lived Atkinson Grimshaw (1836–93), whose work too has returned to popularity in recent years. Many of his compositions are of moonlit urban and harbour scenes, and he also liked to paint the misty atmosphere of town streets after rain. Grimshaw was born in Leeds and many of his most evocative canvases are of that city and of Yorkshire seaside towns such as Scarborough and Whitby.

The number of British landscape artists working in the later years of the nineteenth century was enormous, but while landscape art was being revolutionised by a small group of painters across the Channel – the Impressionists and Post-Impressionists – their British contemporaries contributed little that was new or original. Remarkably the two British artists who were to launch a revival – Walter Sickert and Philip Wilson Steer – were both born in 1860 and both died in 1942, and their important early work will be discussed in Chapter 40. It says something about the status of later Victorian landscape painting that one of the most original artists in this field was Edward Lear (1812–88), best known for his nonsense rhymes but also for much of his life a prolific practitioner of landscape in both oils and watercolours. During his own lifetime Lear, who started his career as an outstandingly gifted ornithological draughtsman, never gained the recognition as a topographical artist which he felt he deserved, but in the last fifty years or more his distinctive landscape sketches have been much sought after by

museums and collectors, largely because they are in keeping with the modern taste for the impressionistic. His reputation reached its zenith in 1985 with a major exhibition, accompanied by a sumptuous catalogue, at the Royal Academy, where he himself had shown only nineteen works between 1850 and 1873, and most of these were skied.

Edward Lear was an eccentric with a wonderful sense of humour, who suffered from epilepsy and increasingly poor eyesight, and spent much of his later life travelling and living abroad and sketching profusely. He travelled all over Europe and the Middle East, and also visited India and Ceylon. In the mid-1840s he developed an individual on-the-spot technique based on rapid and spontaneous outlines in pencil, strengthened in pen and ink, to which he later added a limited range of pale coloured washes; most of these sketches are inscribed with details of place, date and time, and sometimes with colour notes. Many hundreds of these distinctive sketches have survived, of which the exceptionally large and carefully annotated view of Hebron, drawn in 1858, will have to stand as the one example illustrated here [PL.215]. These drawings served as the basis of his finished watercolours and oil paintings. He produced some 300 of the latter, usually in a highly finished, heavy and richly coloured technique, and exhibited examples in London between 1850 and 1872. However, though many found buyers or were commissioned, they gained him scant recognition from the institutions or the critics. He also made hundreds of equally finished and even more colourful watercolours to sell, thinking of these as, and calling them, his 'tyrants'. Between 1841 and 1870 Lear published seven travel books and journals, illustrated with attractive lithographs and wood-engravings based on his sketches.

37 Painters of Modern Life

The popularity in later Victorian Britain of both scenes of social realism and of sentimental genre and narrative subjects has already been discussed. In the 1870s a new kind of genre subject – the modern-life scene with a minimum of moral or narrative content – was introduced and very quickly became popular, largely through the work of the French artist James Tissot (1836–1902), who lived and worked in London from 1871 to 1883, during which time he made an important contribution to the development of British painting. Tissot, who was trained in Paris and Antwerp, began by painting historical, religious and literary subjects, and then exhibited his first modern-life pictures in Paris in 1864. These were a success, attracting the favourable attention of artists and critics, among them Degas, whose invitation in 1874 to take part in what proved to be the first 'Impressionist Exhibition' Tissot declined. Tissot's work had also caught the attention of Thomas Gibson Bowles, who in 1868 had founded the weekly magazine *Vanity Fair*, which became famous for its witty full-page coloured caricatures, of which Tissot drew thirty-nine between 1871 and 1873. This work helped to establish Tissot in London, where at first he stayed with Bowles before moving to a fashionable house in St John's Wood, which later became the home of Alma-Tadema.

Tissot showed two eighteenth-century costume pieces at the Royal Academy in 1872, but his three exhibits in the following year were all of modern-life subjects and were a considerable popular and critical success. Two of them, *The Last Evening*

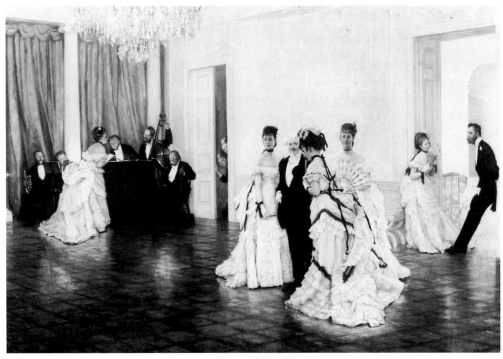

(216) James Tissot, *Too Early* (RA 1873). Oil on canvas; 71×101.5 cm.
(Guildhall Art Gallery, London)

(Guildhall Art Gallery, London) and *The Captain's Daughter* (Southampton Art Gallery and Museums), were nautical scenes in Thames-side settings, in which the element of human interest, though not sufficient to be considered 'narrative', was enough to satisfy the Victorian love of an intriguing story. The third, and most ambitious, was *Too Early* [PL.216], which caused a sensation with the public at the time and which has recently been discussed as the first of Tissot's social conversation pieces in the tradition of Hogarth's 'modern moral subjects', though without the moral messages of the eighteenth-century master's series such as *Marriage à la Mode*. The revival of interest in the work of Hogarth had been initiated by some of the Pre-Raphaelites, notably Holman Hunt, in the 1850s, and for some years they met and exhibited at the Hogarth Club, founded in 1858.

The setting of *Too Early* is a grand classically decorated ballroom, with a highly polished floor; it is nearly empty, and at one end the hostess is still instructing the musicians, while in the foreground a small group of fashionably dressed young women and two gentlemen who have arrived too punctually are trying unsuccessfully to look at ease, watched with amusement by two servant girls peeping through a doorway. This is an accurate (almost photographic) and detailed record of a specific social moment, skilfully composed and painted in pleasing colours, but with little to teach or preach. These three paintings, two of which had already been bought by Agnew's before the exhibition and were quickly re-sold by them for large sums, set the pattern of Tissot's most successful work during the next ten years. Tissot was accepted in London as a gifted gentleman painter, who intrigued by his enigmatic character and pleased with

his immediately attractive and undemanding pictures, though his style was often eclectic and his manner repetitive. Some of his French fellow artists, who visited Tissot in London, were envious of and amazed by his success, and especially by the very high prices for which he sold his paintings.

Tissot enjoyed a prosperous and sociable life in London, which he left soon after the death in 1882 of his beautiful Irish model and mistress, Mrs Kathleen Newton, who had lived with him for some years. He continued to exhibit at the Royal Academy until 1876, but from then on he showed at the Grosvenor Gallery, founded in 1877 by Sir Coutts Lindsay and Charles Hallé, and quickly established as *the* place for the more advanced artists to exhibit, including, most significantly, those who belonged to the Aesthetic Movement with its belief in art for art's sake. To a certain extent Tissot's subject-less paintings could be said to fit in with such work, though in their strict realism they were very different to the imaginative and dream-like compositions, often with classical overtones, of artists such as Burne-Jones, Leighton, Albert Moore and Whistler. *Evening (Le Bal)* (Musée d'Orsay, Paris) was shown at the Grosvenor Gallery in 1878; Kathleen Newton was the model, and Tissot daringly painted her in a bright yellow dress and with yellow accessories. When he reused the composition some five years later, after his return to Paris, for one of the series of large canvases entitled *La Femme à Paris*, the dress became pink.

Renoir and some of his fellow Impressionists were also painting fashionable Parisian women and scenes during these years, but for them such compositions were exercises in depicting light, colour and atmosphere, while Tissot aimed at absolute realism – it is a moot point whether he made use of photographs while working on his paintings. Tissot painted few actual portraits while in London, but many of his modern-life scenes were studies of character, as in the well-known *London Visitors* (Toledo Museum, Ohio), which shows two Christ's Hospital boys, in their distinctive uniform, and their parents under the portico of the National Gallery, with the spire of St Martin-in-the-Fields in the background. When he returned to Paris, where he added sexual overtones to them, Tissot soon abandoned his modern-life subjects and for the rest of his life he concentrated on the painting of religious subjects, and on their reproduction as lithographs and engravings. He travelled in the Holy Land to collect material – both drawings and photographs – and this final phase of his career brought the artist renown, many honours and great wealth. His principal achievement was the publication of the magnificent two-volume *Life of Our Lord Jesus Christ* in 1897–8, with 349 lithographs and over 150 wood and copper engravings. In 1896 Tissot undertook his third journey to the Holy Land to collect new material for a richly illustrated *Old Testament*, which was published two years after his death with over 400 plates.

The 1870s, the decade during which Tissot lived and worked in London, also saw the rapid rise of the Scottish-born Sir William Quiller Orchardson, RA (1832–1910). Born in Edinburgh, and trained at the Trustees' Academy, he was the leading figure of a group of exceptional students – among them John Pettie and William McTaggart – taught by the history painter Robert Scott Lauder (1803–69). Orchardson began exhibiting, mostly historical and literary subjects, in Edinburgh in 1848. He moved to London in 1862, and showed similar works as well as portraits at the Royal Academy in the following year, being elected ARA in 1868 and RA nine years later. In 1880 the

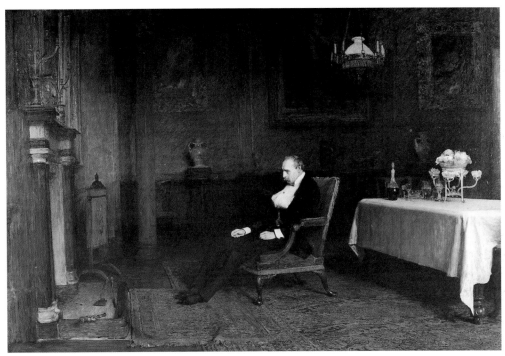

(217) Sir William Quiller Orchardson, *Mariage de Convenance – After!* (RA 1886). Oil on canvas; 111.6×168.7 cm. (Aberdeen Art Gallery and Museum)

Chantrey Bequest purchased for the large sum of £2000 the first of Orchardson's very popular Napoleonic compositions, the huge *On Board H.M.S. 'Bellerophon', July 23rd, 1815* (Tate Gallery, London), which was described by the *Art Journal* as 'a grand epic'. Four years later Orchardson exhibited the first of the contemporary genre subjects for which he is best known today, and which stand out for their painterly qualities as well as for their subject matter. However, unlike Tissot's paintings, Orchardson's modern scenes have a poignant story to tell. The *Mariage de Convenance* of 1884 (Glasgow Art Gallery and Museum) was followed two years later by *Mariage de Convenance – After!* [PL.217]. The first of these 'psychological dramas of upper-class life' shows a bored young woman seated at one end of a laden dining-table while her elderly husband stares at her from the other, as the young butler fills his wine glass. In the sequel, which was 'the subject picture of the year' in 1886, the wife has gone and the disconsolate husband sits hunched in an armchair before the fireplace, the neglected dining-table behind him.

In these and a few similar compositions in subsequent years, Orchardson has successfully brought the Hogarthian tradition of modern moral subjects into late Victorian times. However, such truly modern genre and narrative scenes were a relative rarity not only in his work, but also in general terms. What continued to be more common and popular was the period piece, in which the figures wear historical costumes though in many cases their features and the overall mood appear essentially 'modern'. Many artists, including, of course, Orchardson, produced a regular flow of paintings in this vein. One of the most successful was Marcus Stone, RA (1840–1921), who painted

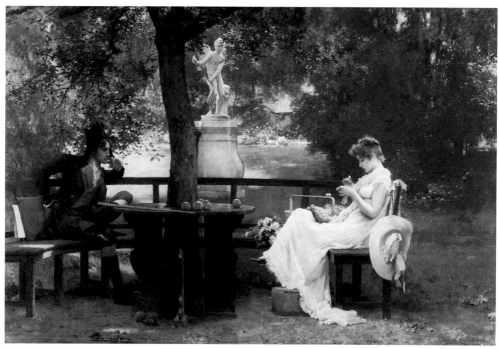

(218) Marcus Stone, *In Love* (RA 1888). Oil on canvas; 112×167.5 cm.
(Castle Museum and Art Gallery, Nottingham)

endless pretty, sentimental, and 'thoroughly English' compositions on the subject of young love, of which *In Love* [PL.218], shown at the RA in 1888, is a typical example. Seated at either end of a long wooden bench under a tree in a luxuriant garden, a statue of Eros in the background, she sews – he stares at her. The costume is *c*.1800, the mood and the message are timeless. It was a formula which brought success and prosperity – like Leighton and Watts, Stone was one of the artists able to commission a luxurious Norman Shaw house in Melbury Road, Kensington. Nearly all his major compositions were engraved and the engravings sold in large numbers. At the time of writing the remarkable revival of interest in recent years in late Victorian painting has not yet brought artists such as Marcus Stone back into the fold.

38 James McNeill Whistler (1834–1903) and William McTaggart, RSA (1835–1910)

Throughout the later decades of the nineteenth century the Royal Academy was an essentially conservative body, which continued to dominate the London, and thereby the English, art world. It was difficult for a painter to achieve real success without at least exhibiting at that institution, and election to full membership was the artist's surest passport to fame and prosperity. Both the painters who are the principal subjects of this chapter exhibited at the Royal Academy for some years during the earlier part of their careers, McTaggart for the last time in 1875 and Whistler in 1879. In that year

Whistler showed a Thames etching, having not been represented since 1872, when the famous *Arrangement in Grey and Black: Portrait of the Artist's Mother* (Musée du Louvre, Paris) was at Burlington House. Whistler was for several years a candidate for election as an Associate, but never came near to being elected. In their mature years both artists remained aloof from the Academy; during the 1870s and 1880s their work was more original and modern than that of any other painters permanently resident and working in Britain, and did not fit at all easily on the walls of the Summer Exhibition.

Whistler was an American by birth (he was never naturalised), and William McTaggart was a Scot, and a Scot who stayed in and painted only Scotland, with just an occasional foray to London and two or three brief trips on the Continent. While Whistler was world-famous in his lifetime and has never been forgotten, McTaggart is still not widely known nor appreciated outside Scotland. It is not only because they are such close contemporaries, but rather because they are both significant and original artists in the international context – a rarity among British artists at this time – that the work of Whistler and McTaggart is discussed here in the same chapter.

James Abbot McNeill Whistler, to give him his full name, was born in Massachusetts, the son of a civil engineer, who brought his family to Russia in 1843 when he was working on the construction of a railroad. On the death of her husband in 1849, Mrs Whistler, after an interlude in London, took her family back to America, and in 1851 James entered West Point, the American military academy. He was discharged in 1854 for failure in chemistry, and after a few months as a survey draughtsman he travelled to Paris, entering the studio of Charles Gleyre in 1856, where Alphonse Legros, Edward Poynter and Charles du Maurier were among his fellow students. Striking in appearance, eccentric in character and dress, and making friends easily, Whistler rapidly developed his artistic skills, especially in his etching, and became a leading figure in the Bohemian world of the art student in Paris. Among the older French artists of the day who encouraged him were François Bonvin and Gustave Courbet, and he worked with his slightly younger contemporary Henri Fantin-Latour. In 1857 he travelled to Manchester to see the great Art Treasures Exhibition, where he was especially impressed by the important group of paintings by Velázquez.

Whistler's artistic career began as an etcher, and his first set of etchings, *Twelve Etchings from Nature*, known as the 'French Set', was published in 1858. In that year he also started work on his first major painting, *At the Piano* (Taft Museum, Cincinnati, Ohio), which was rejected by the Salon in 1859. However, in 1860 it was accepted, together with five etchings, at the Royal Academy, where Whistler had shown two etchings the year before. It was praised by the critic of *The Times*, who described the painting as 'the most vigorous piece of colouring in this year's exhibition' and predicted that Whistler 'has a future of his own before him';[7] it was bought, for £30, by the recently elected Academician John Phillip, known as 'Spanish Phillip' (see p.287). The painting is set in the music room of the Sloane Street house of Whistler's brother-in-law, the surgeon and etcher Seymour Haden, whose wife Deborah, the artist's half-sister, and daughter Annie, were the models. In some ways a development of the effective contemporaneous etchings of interior scenes in Sloane Street, *At the Piano* also reflects the impact of current avant-garde realist painting in Paris. In 1859 Whistler had moved to London, at first staying with the Hadens and then taking rooms on the Thames at

Wapping. He immediately made his mark in artistic circles, lived an active social life, and, though he was often abroad for long periods, London remained the artist's base for the rest of his life.

The misty Thames dockland, with its crowded shipping and its lively shore, provided Whistler with much material, and as well as making the sixteen notable etchings of the 'Thames Set', he painted the first of his many scenes on the river at this time, including the powerful *Wapping* (National Gallery of Art, Washington, DC), which was not shown at the RA until 1864. In this crowded and colourful composition the girl sitting on the inn balcony in the foreground was Joanna Heffernan, the red-haired Irish model who was to become Whistler's mistress. Jo was also the model for *The White Girl*, later entitled *Symphony in White, No. 1* (National Gallery of Art, Washington, DC), which he began in Paris in the winter of 1861. This was rejected by the Royal Academy in the following May, but was shown in London that summer at The Picture Gallery in Berners Street, a sort of private 'Salon des Refusés'. It was then also rejected for the Paris Salon but caused something of a sensation when exhibited in Paris at the actual Salon des Refusés in 1863, at which Manet's *Le Déjeuner sur l'herbe* was also shown. In Paris *The White Girl* was admired by artists such as Courbet and Manet, and it made Whistler's name. The critic of *The Athenaeum*, F. G. Stephens, had picked it out as the 'most prominent' picture in the London exhibition, but considered it 'incomplete' and was not surprised by its rejection by the RA.

The White Girl, as well as showing the impact on him of the Pre-Raphaelites and especially Rossetti, was also the first major work that signalled Whistler's break with realism. It introduced his new and individual painting style, in which colour and mood were all important, and which was to give the world many other 'Symphonies', 'Arrangements', 'Caprices', 'Harmonies', 'Nocturnes' and the like throughout the 1860s and beyond. Although still basically realistic, these paintings often have a feeling of mystery and incompleteness, which is more than just sketchiness, but which is not as different in manner and technique from traditional painting styles as Impressionism was to be some ten years later. Something of Whistler's purpose in developing such an indefinite and experimental manner is certainly reflected in his adoption of musical terms as essential elements of his picture titles; music is by its very nature imprecise, for its interpretation depends almost entirely on individual performance and individual reaction to the sound. Though Whistler's musical titles have usually been treated as of little significance, they clearly meant a great deal to him, as he explained in a letter of 1878: 'Art should be independent of clap-trap – should stand alone, and appeal to the artistic sense of eye or ear without confounding this with emotions entirely foreign to it, as devotion, pity, love, patriotism, and the like. All these have no kind of concern with it; and that is why I insist on calling my works "arrangements" and "harmonies".'[8]

Symphony in White, No. 2: The Little White Girl [COL.PL.75] was painted in 1864, and was one of four works by Whistler accepted for the RA Summer Exhibition of 1865. Described by the reviewer of *Fraser's Magazine* as 'a consummate whole', this combined the influences of Rossetti, with whom he was by now on close terms, and Ingres, and the impact of Japanese art, to which Whistler had been introduced in his Parisian days and which he himself was largely instrumental in introducing to British artists – he himself collected Japanese prints, fans, and, above all, blue and white porcelain.

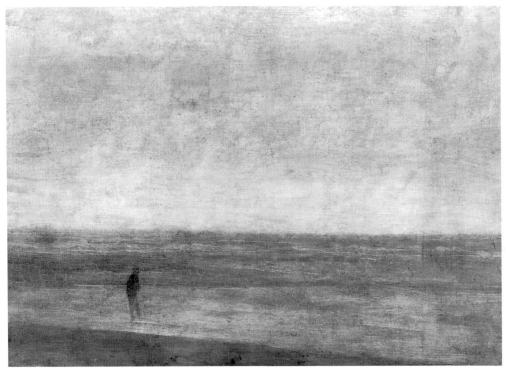

(219) James McNeill Whistler, *Sea and Rain* (1865). Oil on canvas; 50.5×72.6cm.
(University of Michigan Museum of Art, Ann Arbor)

A major selection of over 600 items of Japanese art was shown at the International Exhibition in London in 1862, and this had already laid the beginnings of the taste for the Japanese – 'Japonisme' – in Britain. It was at the 1865 exhibition that Whistler admired Albert Moore's first major 'classical' composition, *The Marble Seat*, and the two artists soon became friends and influenced each other's work. For a time Whistler adopted the classical manner and subject matter of Moore's decorative compositions, and for his part Moore added Japanese features to his paintings, as we have seen. *Symphony in White, No. 3* (Barber Institute of Fine Arts, University of Birmingham), begun in 1865 and shown at the RA in 1867, is an elegant example of this phase in Whistler's development, and it was the first of the artist's pictures to be actually exhibited with its musical title. Largely an exercise in the use of white in its many variations, this composition of two contemplative young women resting on and beside a sofa (if the artist had been Alma-Tadema it would have been a marble seat) has no narrative or moral content, but effectively displays Whistler's painterly skills.

Whistler exhibited two other paintings in 1867 – *Battersea*, later called *Grey and Silver: Old Battersea Reach* (Art Institute of Chicago), a dark Thames view painted in 1863, and the simple and translucent *Sea and Rain* [PL.219]. The last, which was always a favourite of Whistler's, was one of a group of seascapes painted in the autumn of 1865 when Whistler was at Trouville with Jo and Courbet. These three very different paintings demonstrated Whistler's range in the mid-1860s, and his exhibits at the Salon (his last works shown there for fifteen years) and the Exposition Universelle in Paris in the

same year provided further proof of his rapid development and achievements at this time. The most recent of the Paris exhibits was the lovely *Crepuscule in Flesh Colour and Green: Valparaiso* (Tate Gallery, London), painted in 1866 during the artist's impulsive six-month visit to Chile, then at war with Spain, at a time when his own life and art were in some confusion. Like Turner, Whistler loved painting the sea and the sea-shore, and he did so at intervals throughout his life, depicting the spaciousness and power of the ocean with a remarkably fluent and economic brush or palette knife.

After his return from South America Whistler parted amicably from Jo, and early in 1867 moved to 2 Lindsey Row (later 96 Cheyne Walk) on the banks of the Thames in Chelsea, where he lived for the next eleven years. Here he established himself as a dandy and a 'character', making the most of his good looks, his sociability and his sense of humour; as A. S. Hartrick remembered, Whistler 'had the quickest brain of anyone I have ever known and he used it like an artist to be perfectly charming or perfectly impossible.'[9] In the next ten years Whistler's art was to achieve true maturity and individuality, and his self-confidence and reputation grew accordingly. The 1870s were a vital decade in the development of European painting, but Whistler, having assimilated a variety of influences in the previous decade, was now able to work in his own manner, largely uninfluenced by the work of others; here again there are parallels with the career of Turner. As Bernhard Sickert, Walter Sickert's younger brother, commented in the opening sentence of his small book on Whistler, published in 1905, 'the isolation of Whistler as an artist is more marked than that of any of his contemporaries'; that 'isolation' began in the 1870s. Whistler was, in fact, a complex and self-critical character, though outwardly he usually appeared as a vain and conceited showman.

In 1870 Whistler exhibited only one painting at the Royal Academy, *The Balcony* [PL.220], which was begun in 1864, and originally signed and dated 'Whistler.1865',

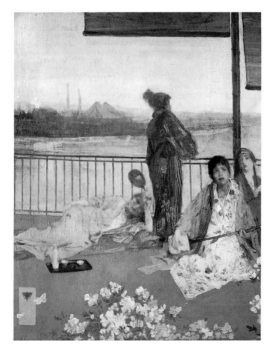

(220) James McNeill Whistler, *The Balcony*
(1864–70). Oil on canvas; 61.4×48.8cm.
(Freer Gallery of Art, Washington)

but on which the artist continued to work until the year of its exhibition. This panel painting, with its technical and stylistic variety, succinctly combines many of the major aspects of Whistler's painting of the later 1860s. The balcony overlooks a grey river with industrial buildings on the far bank – on it are four women in a 'classical' group, two of them wearing kimonos, and with other Japanese attributes, including a lacquer tray with a saki bottle and two wine cups (usually wrongly identified as 'tea-making equipment') on the floor. In the foreground there is a mass of delicate pink and white blossoms and, in the left foreground, an early example of Whistler's distinctive butterfly signature, which was originally developed from a monogram of the initials 'JW', and which he started using in 1869. It was often an important feature of his compositions in all media, and the variations of the butterfly are a useful guide to the dating of his later paintings. In fact, it is surprising that this exotic composition was hung at Burlington House, where it was not well received, and two years later Whistler's growing divergence from the norms of the Royal Academy was shown when the famous *Arrangement in Grey and Black: Portrait of the Painter's Mother* (Musée du Louvre, Paris – bought for the Luxembourg in 1891, and transferred in 1926), was only accepted because the senior Academician Sir William Boxall, who was also Director of the National Gallery, threatened to resign if it was not hung.

This austere, moving and poetic portrait, which has become one of Whistler's most popular paintings, set the pattern for another great and equally unorthodox portrait, that of the artist's Chelsea neighbour, the septuagenarian Scottish historian and philosopher, Thomas Carlyle (1795–1881), which was begun in 1872 and exhibited as *Portrait of Thomas Carlyle, 'Arrangement in Grey and Black, No. 2'* [PL.221] at Whistler's first one-man exhibition, held at the Flemish Gallery, Pall Mall, in 1874. It was probably because of his preoccupation with this exhibition that Whistler declined Degas's invitation to show at what was to be the first 'Impressionist' Exhibition that spring. Whistler painted numerous portraits throughout the 1870s and during the later years of his career, his favourite format being the full-length, in which the figure of the sitter just fits onto the tall and narrow canvas. They usually appear to be freely and rapidly painted, with an overall effect of sketchiness and lack of finish; however, Whistler actually worked slowly and deliberately on his portraits, using brushes with very long handles, and making numerous rubbings out and other alterations before he was satisfied. Despite their apparent vagueness most of these portraits captured the character and mood of their sitters with great precision. There is a superb group of four such elongated and elegant canvases in the Frick Collection in New York, including the attractive *Harmony in Pink and Grey: Portrait of Lady Meux* [COL.PL.76], which was painted in 1881–2. This was one of Whistler's three portraits of this sensuous and fashionable young woman, who had been a dance-hall hostess when she married the wealthy heir to a well-known London brewery.

While certainly influenced by the artist's admiration for Velázquez, which he shared with Manet, these impressive portraits were very much part of Whistler's individual style. This was constantly changing as the result of his experimentation with a variety of painting techniques, and is finally seen at its most original in the great series of 'Nocturnes' painted in the 1870s, though it has been suggested that in their fluidity and translucency the 'Nocturnes' owe much to Whistler's admiration of the English

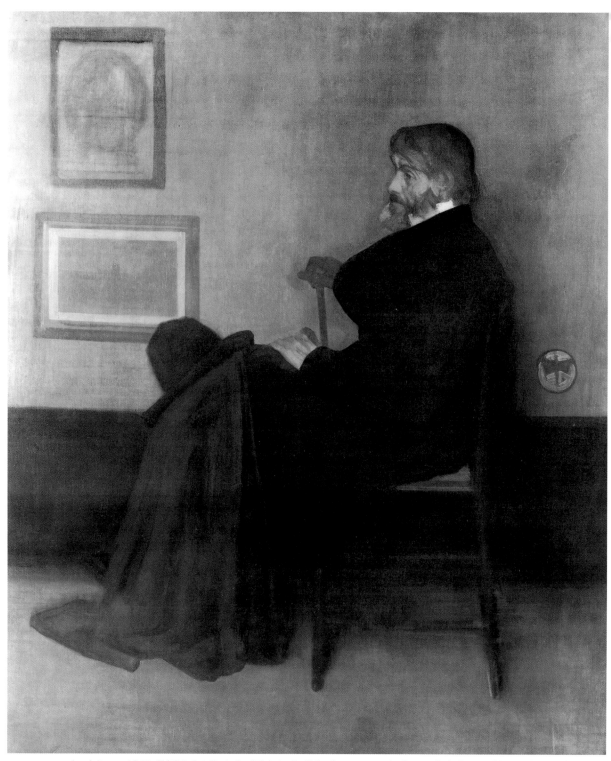

(221) James McNeill Whistler, *Portrait of Thomas Carlisle: 'Arrangement in Grey and Black, No. 2'* (1872–3).
Oil on canvas; 171.1×143.5 cm. (Glasgow Museums: Art Gallery and Museum, Kelvingrove)

watercolour tradition. One of the earliest is *Nocturne: Blue and Silver – Chelsea* (Tate Gallery, London), a shimmering moonlit view across the Thames painted in the summer of 1871 after a trip down the river with his mother, during an interval in the painting of her portrait. Painted on panel on a dark ground with long strokes of fairly thick paint, this achieves a wonderful effect of space, movement and luminosity. It was one of two river scenes shown at the Dudley Gallery in 1871 – the first of Whistler's 'Nocturnes' to be exhibited, though that title was only used for the first time in the following year – and on 14 November the critic of *The Times* (Tom Taylor, who was later to be severely critical of the Nocturnes) made the following perceptive and appreciative comments:

> They are illustrative of the theory, not confined to this painter, but most conspicuously and ably worked out by him, that painting is so closely akin to music that the colours of the one may and should be used, like the ordered sounds of the other, as means and influences of vague emotion; that painting should not aim at expressing dramatic emotions, depicting incidents of history, or recording the facts of nature, but should be content with moulding our moods and stirring our imaginations, by subtle combinations of colour through which all that painting has to say to us can be said, and beyond which painting has no valuable or true speech whatever. These pictures [the second was *Variations in Violet and Green*, now in a private collection in New York] are illustrations of this theory.

Nocturne: Blue and Silver – Chelsea was bought at the exhibition by W. C. Alexander, the London banker, who subsequently commissioned portraits of three of his six daughters, two of which are now in the Tate Gallery.

The Nocturnes were not painted on the spot, but in the studio from memory; Whistler did sometimes make rough drawings while boating on the Thames, and from his home he could easily refresh his memories of the river in all its varied moods. Despite giving an impression of spontaneity and rapidity, the Nocturnes were in fact painted with extreme deliberation, and each brush stroke was carefully controlled to achieve the overall unity in tone and texture of the whole design. Nevertheless, painting these evocations of atmosphere and colour inspired by the Thames must have provided Whistler with relaxation during this very busy period of his life, though when he exhibited them they usually brought him derisive and destructive criticism. He thought of some of his Nocturnes as forming series, and the memorable *Nocturne: Blue and Gold – Old Battersea Bridge* [COL.PL.74] was at one time apparently part of a numbered series, which today is difficult to disentangle.[10]

Nocturne: Blue and Gold – Old Battersea Bridge had been one of four Nocturnes exhibited by Whistler in May 1877 at the opening exhibition of the innovative Grosvenor Gallery in London. He also showed four portraits, including that of Carlyle [PL.221]. The Nocturnes, Whistler and the Grosvenor Gallery became notorious because of John Ruskin's violent attack in Letter 79 of *Fors Clavigera*, published on 2 July. In this, with *Nocturne in Black and Gold: The Falling Rocket* (Detroit Institute of Arts), showing a firework display in Cremorne Gardens, the last of London's disreputable pleasure gardens, as his principal target, Ruskin wrote, 'I have heard and seen much of cockney impudence before now; but never expected to hear a coxcomb ask two hundred guineas for flinging a pot of paint in the public's face.' In November 1877 Whistler sued Ruskin for libel, claiming £1000 damages, and at the famous trial before a Special Jury held a year

later, W.M.Rossetti and Albert Moore were among the artist's witnesses, while Ruskin called Burne-Jones, Frith and Tom Taylor. Ruskin was too ill to appear himself, and was represented by the Attorney-General, Sir John Holker. Whistler stood up well to his cross-examination, during which he claimed to have worked on the painting for two days, and then brilliantly and famously answered the Attorney-General's comment, 'The labour of two days, then, is that for which you ask 200 guineas!', with, 'No – I ask it for the knowledge of a lifetime.' Whistler won a Pyrrhic victory, being awarded one farthing damages but not costs, as a result of which the artist became bankrupt. For Ruskin the ridicule of the trial and his technical defeat severely damaged his reputation and his already failing health, and he promptly resigned from the Slade Professorship at Oxford.

As we shall see, this trial, of which Whistler quickly published his own version as a pamphlet entitled *Whistler v. Ruskin: Art and Art Critics*, which was reprinted in 1890 as the opening section of *The Gentle Art of Making Enemies*, formed a watershed in Whistler's life and career, and abruptly brought to an end the exciting, though frequently vilified, progress of the 1870s. In addition to painting the portraits and the Nocturnes, Whistler was also engaged on the major decorative scheme of his career, the controversial 'Peacock Room' (Freer Gallery of Art, Washington, DC) painted for F.R.Leyland in 1876–7. Frederick Richard Leyland (1831–92), a wealthy Liverpool shipowner and a considerable collector, had first commissioned a decorative scheme from Whistler in 1867, the ambitious but never completed *Six Projects* (Freer Gallery), probably intended for Speke Hall, the Tudor mansion near Liverpool which he had bought that year. Whistler was a frequent visitor at Speke Hall, where he painted several portraits of members of the family, including his first *'Arrangement in Black'*, the somewhat austere portrait of Leyland himself (Freer Gallery). In 1869 Leyland bought 49 Prince's Gate as his London house, and commissioned Richard Norman Shaw to direct its reconstruction.

The re-modelling of the dining room, which was to house Leyland's extensive collection of blue and white porcelain, was assigned to the little-known architect Thomas Jeckyll (1827–81), an early advocate of 'Japonisme'. The initial plan was to create an essentially conventional 'Porzellanzimmer' with rococo and Dutch features – the tradition of such ornate rooms specifically designed for the display of ceramics stretched back in Germany, Holland, England and elsewhere, to the late seventeenth century. The room also incorporated a set of antique Spanish leather hangings, which Whistler later painted over, acquired for Leyland by the London dealer Murray Marks, who had also sold him most of his blue and white porcelain. In 1872 Leyland had purchased Whistler's large painting of 1864, *La Princesse du Pays de la Porcelaine*, one of the artist's most overtly 'Japanese' compositions, and this was to be hung over the fireplace.

Leyland first commissioned Whistler to paint some decorative panels for the staircase at Prince's Gate, and then asked him to advise Jeckyll on colours for the dining room. Having 'got his foot in at the door' the painter virtually took over, and totally changed the style and character of the room, creating his highly individual 'Peacock Room', driving the architect to despair and offending Leyland to such an extent that he paid only half of the 2000 guineas demanded (and even then paid in pounds rather than

guineas) and ended his patronage and friendship. The legends of the 'Peacock Room row' are many and various, but they all demonstrate Whistler's single-mindedness and lack of consideration for others. In the end he created his own vision and the resulting *Harmony in Blue and Gold: The Peacock Room* has long been recognised as a major monument of the Aesthetic Movement. Whistler's lavish and scintillating decorative scheme, which he applied over every available space, including the doors and window shutters, was based on the eye and tail-feathers of the peacock. On the only bare wall, facing his *La Princesse du Pays de la Porcelaine*, he painted a vivid and symbolic composition of two gold peacocks on the deep blue ground. While creating this unique masterpiece Whistler lived for several months at 49 Prince's Gate, and when the Peacock Room was completed he held a press view in Prince's Gate, to which Leyland was not invited, at which he distributed his own leaflet 'Harmony in Blue and Gold. The Peacock Room'. Not surprisingly Leyland never again allowed Whistler to visit his house, where the Peacock Room remained until 1903, when it was dismantled and sold in the following year to C. L. Freer of Detroit, and it now forms the centrepiece of the Freer Gallery in Washington.

In September 1877 Whistler himself had become a patron when he commissioned E. W. Godwin to build him the White House in Tite Street, Chelsea. This included an 'atelier', for the artist was planning to start an art school. He moved there in June 1878, but when he went bankrupt in the following year the house and all its contents had to be sold. That September Whistler, having received a commission for a set of twelve etchings and an advance of £150 from the newly opened Fine Art Society, travelled to Venice, accompanied by his current mistress, the model and artist Maud Franklin. They spent over a year in Venice, enabled to do so by further (reluctant) advances, and soon after Whistler's (also reluctant) return to London in November 1880 the 'Venice Set' was exhibited at the Fine Art Society. The artist had, in fact, worked very hard while in Venice, finding fresh inspiration and working largely in the open. He completed over fifty etchings, some ninety pastels, and a few oil paintings and watercolours. Whistler had rather neglected his etchings in the busy 1870s, having published the series of mostly 1860s prints as *Sixteen Etchings of Scenes on the Thames* in 1871. However, from now on printmaking again became an important element of his work, and he also began to produce attractive lithotints and lithographs, having learnt those techniques from Thomas Way in 1878.

Whistler gradually resumed his very sociable London life, renting a flat and studio in Tite Street, which he decorated in yellow, and exhibiting at the Grosvenor Gallery and elsewhere. He soon met and became friends with Oscar Wilde, and for a time the two dandies enjoyed rivalling each other as pillars of the Aesthetic Movement. In January 1881 fifty-three of Whistler's Venice pastels were shown at the Fine Art Society; for this the gallery was redecorated in shades of yellow, and the pastels were framed in three tones of gold. In the 1880s Whistler developed the design of the well-known gold reeded frame, which bears his name, and he became increasingly concerned with the presentation of his work. Two years later there was a second exhibition of Venetian etchings, for which a spectacular catalogue was produced, with quotations from earlier, usually adverse, criticisms. In all ways Whistler was himself again, and was working on a number of portraits, including the three of Lady Meux, one of which was exhibited,

with three Venetian etchings, at the Paris Salon of 1882. In the following spring the artist was in Paris, where the 1871 portrait of his mother, who had died in 1881, received a third-class medal at the Salon, though several critics slated it. From now on Whistler was again frequently in Paris, where he exhibited with the Galerie Georges Petit. After the Ruskin trial and its consequences, Whistler never again felt wholly comfortable in London, became increasingly resentful of England and all things English, and spent long periods abroad, finally settling in Paris in 1892.

In the 1880s Whistler, as well as working on his highly individualistic portraits, also spent much of his time painting small landscapes, townscapes and shore scenes. Most of these fresh and fluent sketches were painted outdoors, usually on wood, during Whistler's travels, and he also made similar studies in watercolours, etching and lithography. In the winter of 1884 Whistler visited St Ives in Cornwall, and here he painted some twenty such oil sketches, as well as watercolours, which mark an important phase in the development of this aspect of his work. At St Ives Whistler, who enjoyed teaching, was accompanied by two of his pupils, Mortimer Menpes and W.S.Sickert. Walter Sickert had left the Slade School two years earlier to become Whistler's pupil and assistant, and he was, of course, to become one of the outstanding British painters of his own generation.

An unusual subject that fascinated Whistler consistently were shop fronts, in St Ives, Chelsea, and elsewhere, of which *Chelsea Shops* [PL.222] is an early and typical example. These seemingly simple and straightforward sketches were usually carefully composed, both as regards the overall design (there is often preliminary drawing beneath the paint) and colour, but this in no way detracted from the fluency of the work. That remarkable fluency is also to be found in Whistler's work in pastels during the 1880s and in the following decade. In pastels his favourite subject was the female figure, and there are numerous beautiful studies of nude and semi-nude models delicately and vividly drawn in black and coloured pastels, normally on brown paper. Some of them are in the guise of Venuses or Odalisques, and some are dancing; all are brilliant demonstrations of Whistler's genius in recording mood, movement, atmosphere and colour. However, the artist's late oil paintings of similar subjects often lack that easy spontaneity, though he achieved it also in his lively watercolours of the 1880s and 1890s.

In 1884 Whistler was elected a member of the Society of British Artists, of which he became President two years later. This office gave him further opportunity to put into effect his highly individual ideas concerning the practice, exhibiting and reception of contemporary art, which he had outlined vividly in his famous 'Ten O'Clock' Lecture, first given at the Prince's Hall in London on 20 February 1885, repeated in Cambridge and Oxford, and then published in his by-now familiar distinctive brown covers. This was a continuation of Whistler's feud with the art establishment and of his attacks on Ruskin in particular. However, on the occasion of her Golden Jubilee in 1887 Queen Victoria received from Whistler an illuminated address on behalf of the Society of British Artists, and later that year the Society was granted a Royal Charter, becoming the Royal Society of British Artists (RBA). Within a few months Whistler's autocratic handling of the affairs of the Society, especially in the more colourful and spacious arrangement of the exhibitions, displeased many of his fellow members, and he was forced to resign as President in the following year. Some twenty-five members, mostly

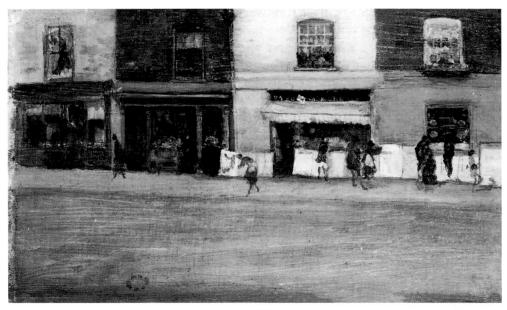

(222) James McNeill Whistler, *Chelsea Shops* (*c.*1880). Oil on panel; 13.5×23.4 cm.
(Freer Gallery of Art, Washington)

the more progressive and younger painters, resigned with him, and Whistler was reported to have made the characteristic and frequently quoted comment, 'And so you see, the "Artists" have come out, and the "British" remain – and peace and sweet obscurity are restored to Suffolk Street.'

Whistler's outspoken character and challenging art attracted a large following among British artists, among whom Theodore Roussel (1847–1926) was exceptional on two counts, his age and the fact that he was French-born. Roussel had settled in London in the 1870s after being wounded during the Franco-Prussian War, and he met Whistler in 1885. Roussel made his mark at the RBA exhibition in 1887 with his impressive *The Reading Girl* (Tate Gallery, London), a powerfully painted life-size nude with echoes of Manet and elements of Japonaiserie. However, most of his paintings during this period were 'delicate impressions' of the Thames and Chelsea, of which he showed a number at the 'London Impressionists' exhibition in 1889. Gradually Roussel developed a more personal style, enhanced by the results of his colour experiments and by his awareness of Post-Impressionist developments in France at the turn of the century, including the pointillism of Seurat and Signac.

Another friend of Whistler, though only for a short period, was William Stott of Oldham (1857–1900), who studied for some years in Paris, where he exhibited with success at the Salon, including *The Ferry* in 1882 (Private Collection), a painting in which the artist has created an exceptionally powerful landscape composition by his clever rendering of the reflections. On returning to England Stott was elected a member of the RBA in 1885, and in the following year he made his mark with the large and striking *A Summer's Day* (Manchester City Art Galleries), another telling study of light in which three naked boys are shown playing on a wet sandy beach. His much less successful *Venus born of the Sea Foam* (Oldham Art Gallery), in which the model for the rather effete

Venus was Whistler's mistress, Maud Franklin, understandably caused a rift between the master and his disciple.

A few weeks after his resignation from the Royal Society of British Artists Whistler married Beatrice Godwin, widow of the architect, who had died in 1886, and until her ill health forced them to return to England in 1894, the couple spent most of the intervening years abroad, largely in Paris. During these years Whistler's reputation and fame became truly international; he exhibited in Munich, New York, Brussels and Amsterdam, and was frequently awarded medals and elected to bodies such as the Academy in Munich. In April 1891 the Corporation of Glasgow bought the portrait of Carlyle [PL.221] for 1000 guineas, and this was the first work by Whistler to be bought for a public collection. Later that year the French Government purchased the portrait of his mother for the Musée du Luxembourg in Paris, and in 1892 Whistler was made an Officier of the Légion d'honneur.

For the last decade of his turbulent life Whistler continued to be honoured and fêted on both sides of the Atlantic, and received more commissions for portraits than he could cope with. Most of his patrons were now Americans, including Charles Lang Freer (1854–1919), who bought his first works by Whistler in 1887, met him in 1890, and, with the artist's help and advice, came to form the largest single collection of his art, which was a major part of his bequest to the Smithsonian Institution in Washington, where the Freer Gallery of Art was first opened in 1923. The other great collection of Whistler's work is at the University of Glasgow, which had conferred the honorary degree of Doctor of Laws on the artist, who was already too ill to attend the ceremony, three months before his death in July 1903.

In the 1880s another American-born artist was to settle in London, and by the end of the decade was established as one of the leading society portrait painters. This was John Singer Sargent (1856–1925), much of whose achievement falls outside the scope of this volume but who must be noticed here nevertheless, if only because of the undoubted influence of Whistler on him and on his elegant and stylish portraiture. Born in Florence of wealthy American parents, who moved in artistic and cultural circles, Sargent studied in Italy before becoming a student of Carolus-Duran in Paris in 1874. He painted subject pictures, landscape and portraits, and quickly made a name for himself, exhibiting at the Salon from 1877. Sargent visited Spain in 1879, and copied the works of Velázquez at the Prado; he then produced several genre pictures with Spanish themes, including the huge and impressive *El Jaleo* (Isabella Stuart Gardner Museum, Boston), which was the centrepiece of the 1882 Salon. He was also much influenced by the Impressionists, especially Monet, and was painting in an Impressionist style when, after several previous visits, he settled in London in 1886. One factor in persuading Sargent to make this move was the scandal caused by the very low *décolletage* of the dress and the strange colouring of the skin in his portrait of the fashionable and somewhat notorious Madame Pierre Gautreau, exhibited in the 1884 Salon as 'Portrait de Madam X' (Metropolitan Museum of Art, New York).

In 1886 Sargent showed three striking portraits at the Royal Academy, among them *The Misses Vickers* [PL.223], which he had painted while in England in 1884 and which had already been shown at the Salon in 1885. This was a somewhat experimental work, which aroused considerable adverse criticism as well as praise for its technical

(223) John Singer Sargent, *The Misses Vickers* (1884). Oil on canvas; 137.8×182.9 cm.
(Sheffield City Art Galleries)

virtuosity. In the following year the charming *Carnation, Lily, Lily, Rose* (Tate Gallery, London), which was bought by the Chantrey Bequest for £700, enhanced Sargent's reputation, and he was soon established as a leading figure in the London art world, being elected an ARA in 1894 and an Academician only three years later. He was now receiving ample commissions for portraits, and the oustanding success of his portrait of Lady Agnew [COL.PL.77] at the Summer Exhibition of 1893 established him as *the* portrait painter of the day. It was aptly described by *The Times* critic as 'not only a triumph of *technique* but the finest example of portraiture, in the literal sense of the word, that has been seen here for a long time'. Many influences can be found in Sargent's mature portraiture, especially those of Vélazquez and Lawrence. In contemporary terms he enlivened the styles of Leighton and Millais with his masterly impressionist technique, crossed this with memories of Winterhalter and the mystery of Whistler's images, and produced dozens of dazzling portraits of the wealthy men and women of the day, many of them American. His portraits set a standard which many other artists at the turn of the century, among them Sir William Orpen and Augustus John, did their best to follow.

Sargent also is especially well represented in the Tate Gallery, by thirty-one paintings, among them the imposing portrayal of *Ellen Terry as Lady Macbeth* (1885–6), the elegant portrait of the slender and aesthetic young W. Graham Robertson exhibited at the RA in 1895, and the great group of nine portraits of the London art dealer Asher

Wertheimer and various members of his family painted between 1898 and 1908. In addition to painting portraits Sargent also drew the heads and shoulders of dozens of men, women and children in black chalk on large sheets of white paper. Here his manner was as vivid and forceful as in his oils, and here also he recorded the character of his sitters convincingly and with apparent ease. In his later years Sargent, who had worked with Monet at Giverny in the later 1880s, largely abandoned portraiture, travelled a great deal, and painted landscapes in oils and wonderfully fluid water-colours. He was also working on his ambitious series of murals for the Boston Library and then, from 1916, for the Boston Museum of Fine Arts.

There could not be a greater contrast than that between the cosmopolitan origins, lives and careers of both Whistler and Sargent, and the humble beginnings and essen-tially Scottish existence of William McTaggart. Born in Campbeltown, Kintyre, the son of a crofter, he was apprenticed to an apothecary, who recognised the boy's talent for drawing and set him on the road to becoming a student at the Trustees' Academy in Edinburgh in 1852. Here he was one of the group of able young men, among them Orchardson and Pettie, taught by Robert Scott Lauder. He supported himself by draw-ing chalk or crayon portraits, and began to make his reputation as a portraitist and figure painter, exhibiting for the first time at the Royal Scottish Academy in 1855. Elected an Associate in 1859 and an Academician in 1870, he exhibited at the RSA regularly until 1895, and was for many years an active and influential member. When McTaggart married in 1863 the certificate described him as a 'Figure painter', and at this time he was painting and exhibiting works such as *Spring* (National Gallery of Scotland, Edinburgh), a charming composition of two young girls relaxing in a meadow with grazing sheep behind them. In this and in much of his painting at this time we see the influence of the Pre-Raphaelites, especially Holman Hunt and Millais, whose work he had seen at the 1857 Manchester Art Treasures Exhibition; Millais had also exhibited at the Royal Scottish Academy in the 1850s.

McTaggart himself first exhibited at the Royal Academy in London in 1866, and continued to show there almost every year until 1875. During this period he was a regu-lar visitor to London, but he resisted the persuasion of his fellow Trustees' Academy student and friend John Pettie (1839–93), to settle there. Pettie, a successful painter of historical subjects, had been one of McTaggart's companions when he visited Paris in 1860, and McTaggart made only two more brief Continental trips, in 1876 and 1882. Though certainly not as isolated and confined to Scotland as has often been related, William McTaggart's life and work were essentially focused on Scotland. For many years he earned his living by painting portraits in Edinburgh, and from the later 1860s he also continued to paint attractive open-air subject pictures, usually featuring children, which gradually met with critical approval and found buyers. Beaches and clifftops became his favourite settings – often reminiscent of similar work by William Collins [PL.109] – and the children are often shown messing about in fishing craft, as in *The Young Fishers* of 1876, one of the fine group of McTaggart's works in the National Gallery of Scotland. In *Bait Gatherers* [PL.224], one of his seven exhibits at the RSA in 1879, the group of children on the rocks in the foreground provides a focal point for what is essentially a painting of the sea and breaking waves; the figures were in fact partly superimposed over the rocks and the sea, when the paint of these was already

(224) William McTaggart, *Bait Gatherers* (RSA 1879). Oil on canvas; 66×84cm.
(National Gallery of Scotland, Edinburgh)

dry, producing a transparent 'see-through' effect, a method that McTaggart was using
frequently at this time.[11] In *Machrihanish Bay*, painted a year earlier (National Gallery of
Scotland, Edinburgh), there are no figures, and in this and in later paintings show-
ing only the sea, such as *The Wave* of 1881 (Kirkcaldy Museum and Art Gallery), it is
possible to discern the influence of Whistler's shore scenes and Nocturnes of the 1870s.
In these paintings of the sea McTaggart was moving towards his own individual
manner of the later 1880s and beyond.

Until 1889, when they moved to the nearby village of Broomieknowe, McTaggart
and his large family lived in Edinburgh, making regular painting trips to both the
Atlantic and the North Sea coasts. At Broomieknowe the artist built a big studio, de-
veloped a wild garden in which he painted, and lived in relative isolation. He painted
the surrounding landscape at harvest time, as in *Harvest at Broomieknowe*, dated 1896
(National Gallery of Scotland, Edinburgh), and, in his later years, under snow in winter.
In these works, which were probably largely painted in the studio, he developed his
highly individual technique of very free and vigorous brushstrokes, quite different
from those of the French Impressionists or of Van Gogh, and pre-dating the vigorous
painting of twentieth-century artists such as Oskar Kokoschka (1886–1980) by several
decades.

McTaggart rarely left Broomieknowe except for annual summer visits to Kintyre.
Here he continued to paint the sea, and the vastness, mystery and variety of the ocean
provided the most powerful inspiration for the work of his last twenty years. Many

(225) William McTaggart, *The Storm* (1890). Oil on canvas; 130×183 cm.
(National Gallery of Scotland, Edinburgh)

of his sea and shorescapes included figures and ships, and ostensibly illustrated two themes, 'The Emigrants' and the 'Coming of St Columba'. However, it was the depiction of the actual sea that really mattered, and there are also canvases in which there is no 'staffage' or in which the figures can only be deciphered with difficulty. An outstanding example of this is *The Storm* [PL.225]. Dated *1890*, this large canvas, in which the group of anxious observers in the left foreground and the events they are watching are only just visible, was painted in the studio, and was based on a much more tightly executed outdoor study, painted at Carradale in 1883 (Kirkcaldy Art Gallery). It has been suggested by Lindsay Errington that in such works McTaggart may have been strongly influenced by the oil sketches of John Constable, whose painting he is known to have admired, and which during the 1880s he had ample opportunity to study in Edinburgh.[12] In 1886 Henry Vaughan lent his two great full-size oil studies for *The Hay Wain* and *The Leaping Horse*, both now in the Victoria and Albert Museum, to the Edinburgh International Exhibition, and the comparison between these and some of McTaggart's later paintings is certainly a fruitful one. In many ways McTaggart's painting is the most modern discussed in this volume, and the suggestion that it is related to that of Constable rather than to the contemporary work of the French Impressionists, some of which he could have seen at various exhibitions in London and in Glasgow, is an attractive one.

39 New Beginnings I: Slade School, New English Art Club, Glasgow Boys, Newlyn

When first published in *Harper's Monthly Magazine* in 1894, George du Maurier's novel *Trilby* was an immediate success and a popular best-seller. This story of British art students in Paris in the 1850s was based on Du Maurier's own experiences as a student at the atelier of Charles Gleyre in 1856 and 1857, where Poynter and Whistler were among his fellow students. In the 1850s it was still uncommon for British artists to study in Paris, but during the later 1870s and 1880s this became the norm, and the great success of *Trilby* can certainly be largely attributed to the fascination for the general public of the intriguing 'Bohemian' life of the artist in Paris. In the first half of the nineteenth century Italy, and especially Rome, had continued to be *the* place for the budding artist to visit, as it had been in the previous century. In the 1820s and 1830s Italian genre subjects were among the most popular works on the walls of the Royal Academy, as we have seen in the work of Wilkie, Eastlake, Uwins and others. All this changed in the second half of the century, when Paris gradually replaced Rome as the principal art centre of the world. At the same time the standard of teaching at the Royal Academy Schools, where tuition was free, and which was at first still the only really recognised art school in London, was at a low ebb, and in the later decades of the century the more enterprising art students went to Paris to join one of the many ateliers or the official Ecole des Beaux Arts. Here they were not forced to spend precious years drawing from the antique before being allowed into the life-class, but were encouraged to draw from life from the beginning and were also taught the actual techniques of painting in oils.

Something of these methods had also become available in London with the opening of the Slade School of Fine Art at University College London in 1871. In Oxford and Cambridge the remarkable bequests of Felix Slade, wealthy antiquarian and collector, especially of glass, were used to found the two Professorships of Fine Art, of which John Ruskin and the architect Matthew Digby Wyatt were the first holders. The Slade Chairs provided the universities, as they still do, with lectures on the fine arts, of which, of course, Ruskin's remain among the most significant ever given. At UCL Slade, in addition to the professorship, also endowed six student scholarships, and the College took the opportunity of launching a school of art, the first in London seriously to rival the RA Schools. Edward Poynter, whose career and painting have been discussed in Chapter 34, was appointed the first Professor, and in the Address he gave at the opening of the School on 2 October 1871, he frankly outlined the difference between the training of art students in London and Paris, and stated: 'I have dwelt at some length on this description of the French system of education, because I am anxious to adopt something of the same kind in this school. It is to my mind admirably logical; and whatever modification of detail I may be inclined to introduce, I shall impress but one lesson to the students, that constant study from the life-model is the only means they have of arriving at a comprehension of the beauty in nature, and of avoiding its ugliness and deformity; which I take to be the whole aim and end of study.'[13] Poynter went on to discuss some of the difficulties of drawing from the model, and promised that 'as far as I am able to manage it, you will be supplied with good Italian models to work from. These are not only in general build and proportion, and in natural grace and dignity,

far superior to our English models; but they have a natural beauty, especially in the extremities, which no amount of hard labour seems to spoil.' These and the comments that followed confirm the very special place that Italy and things Italian still held in the esteem of the British artist. Poynter had, of course, himself studied in Rome as well as in Paris.

The Slade School quickly became known for the high standard of the draughtsmanship of its students, most famously exemplified by the beautiful drawings of Augustus John, who was at the Slade from 1894 to 1898. Poynter resigned from the Slade in 1876, and recommended the French painter Alphonse Legros (1837–1911) as his successor. Legros, who was himself a gifted draughtsman and had begun to make his reputation as a realist painter in Paris, moving in the circles of Courbet, Manet, Fantin-Latour and Degas, had been persuaded by Whistler to settle in London in 1863, where he was well received. At first he made his living by teaching etching, and he began exhibiting at the Royal Academy in the following year. Though he never mastered the English language, Legros was a successful teacher at the Slade, continuing the methods laid down by Poynter, and broadening the courses – he also taught modelling and encouraged students, especially women, to make cast medals, a traditional art-form in the revival of which he was himself a pioneer in the 1880s. He encouraged his abler students to go to Paris, and thus in several ways the Slade acted as a link between London and Paris, and enabled British students to make contact with the much more liberal teaching methods and atmosphere of the French capital.

Throughout the 1870s and 1880s London remained the essential centre for a successful career by an English artist, and, despite its current weaknesses, the Royal Academy, with Frederic Leighton as its highly respected President from 1878 to 1896, remained the pivot of the London art world. However, the impact of Paris, powerfully abetted by the influence of the Slade School and by the examples of Whistler and then Sargent, became a major factor in the 1880s. From 1870 to 1875 Londoners had had ample opportunity to see and collect contemporary French painting, especially the work of the Barbizon School, at the regular exhibitions of the so-called 'Society of French Artists' arranged by the Paris dealer Durand-Ruel in the unfortunately named 'German Gallery' in Bond Street. However, these exhibitions met with little response, and similarly when Monet and Camille Pissarro were in London in 1870 and 1871, they were also largely ignored and the works they submitted to the RA in 1871 were rejected. At that time both artists were relatively unknown even in Paris, but during the 1880s Monet made several more successful visits to England and exhibited in London on a number of occasions – in 1887 Whistler invited him to show at the Royal Society of British Artists and Durand-Ruel again organised exhibitions of French painting, especially the Impressionists, in London. In 1890 Camille Pissarro's eldest son Lucien (1862–1944), settled in London and married an English cousin. He made his name as an illustrator and did much during the 1890s and beyond to bring together the avant-garde in London with their fellows in Paris.

The pre-eminence of the Royal Academy Summer Exhibition was also being challenged throughout the 1870s and 1880s, at first by the Grosvenor Gallery, which was founded by Sir Coutts Lindsay and Charles Hallé in 1877. This quickly became associated with leading established artists such as Burne-Jones, Leighton and Poynter,

but also with the avant-garde, most notably Whistler, whose influence helped the gallery to become the centre of the Aesthetic Movement, so memorably satirised, as already mentioned, in the Gilbert and Sullivan opera *Patience*, first performed in 1881. The Dudley Gallery, founded in the mid-1860s on similar lines to the Grosvenor, never achieved the same status, and closed in 1882. The Grosvenor Gallery closed in 1890, having been challenged by the formation of the New Gallery in 1888. These were all essentially commercially based galleries, unlike the Society of British Artists, which had begun in 1823 as a friendly rival to the Royal Academy. There were thirty-two founder-members, and the first exhibition opened in 1824 in the Society's fine purpose-built gallery in Suffolk Street, designed by John Nash. The new society failed really to make its mark, though it has survived as a very conservative body to the present day, and, as we have seen, was granted a Royal Charter in 1887 during Whistler's brief and contentious Presidency, from which he was virtually evicted by the more traditional members. One of their main complaints was that sales at the half-yearly exhibitions were falling during Whistler's Presidency, and they attributed this to the major changes he had made in the hanging and decoration of the galleries. However, the later 1880s were, in fact, a period of recession, and this was having a serious effect on the art market as a whole, as it has done again in recent years.

The most significant new artists' society formed in London in the 1880s was certainly the New English Art Club, founded in 1886 by a group of fifteen younger British artists who had been together in Paris, and who were dissatisfied with the Royal Academy's selection policies and treatment of the 'new painting'. All of them had studied in France and at first they contemplated calling themselves 'The Society of Anglo-French Painters'. There were fifty members, of whom forty-three took part in the relatively small opening exhibition, with only fifty-eight pictures, at the Marlborough Gallery in Pall Mall. This was in no way a unified exhibition representing a specific 'school', though many of the works shown were 'rustic naturalist' in the manner of the short-lived but very influential French painter Jules Bastien-Lepage (1844–84), whose work was regularly exhibited in London. There was immediately disagreement among the participating artists about the future structure of the New English Art Club, which, as we shall see, had attracted painters of both the Newlyn and Glasgow Schools. A group of artists led by H. H. La Thangue (1859–1929), who had spent several years studying and painting in France, and who was already becoming known for his *plein-air* rural paintings, wanted to convert the club into an open society run by a committee elected by every practising artist in Great Britain and organising vast exhibitions. This scheme was rejected, and under the guidance of Frederick Brown (1851–1941), whose painting *Hard Times* (Walker Art Gallery, Liverpool) had been one of the 'stars' of the opening exhibition and who was to succeed Legros at the Slade School in 1892, a new constitution was drawn up on very democratic lines.

The 1887 exhibition was larger, and again included a considerable variety of work. In the following year several of the British 'Impressionists' who had resigned from the Royal Society of British Artists in support of Whistler, but not Whistler himself, joined the New English Art Club, and led by Sickert launched a campaign to convert the Club into a specifically Impressionist society. For a short time this group seceded from the NEAC, and in December 1889, calling themselves the 'London Impressionists', they

held their one and only exhibition at the Goupil Gallery, where an earlier exhibition that year had featured twenty 'Impressions by Claude Monet'. Fred Brown, Theodore Roussel, Sickert and Steer were among the ten artists who took part in the London Impressionists Exhibition. A considerable proportion of the exhibits depicted everyday London life, mostly on the streets. The group of eight paintings by Sickert's exact contemporary, friend and rival, Philip Wilson Steer, was a major feature, and though they illustrated his stylistic transition at this time they also confirmed his place as the leading English Impressionist landscape painter. In his introduction to the catalogue Sickert admitted the problems in finding a satisfactory definition of 'Impressionism' and declined to sum up 'the aims of painters so varied as the present group'.[14] The same uncertainty is seen in Sickert's own painting at this time, and at the close of the 1880s the variable impact of Impressionism and of other influences of French art on British painting was a major factor in its lack of focus. Sickert and the others returned to the fold of the New English Art Club, which remained the rallying-point for the avant-garde in London until the First World War, and which also still exists today.

The rise of art schools, exhibiting societies and art galleries in provincial cities weakened the dominance of London in the second half of the nineteenth century. Birmingham City Art Gallery, founded in 1867, was one of the earliest great municipal art galleries, and the 1870s saw the beginnings of similar institutions in Exeter, Liverpool, Nottingham and York, with Manchester, Leicester, Wolverhampton and Leeds among the cities to launch galleries in the 1880s. Many of these new galleries developed their collections by purchasing major paintings by established artists at the Royal Academy, and, when opportunity arose, at exhibitions in their own cities. Thus Glasgow began its negotiations for the purchase of Whistler's great portrait of Carlyle [PL.221] after this had been shown at the city's International Exhibition in 1888.

Political, social and cultural rivalry with Edinburgh, where the Royal Scottish Academy had dominated since its foundation in 1826, was an important factor in the strength of support for artists in Glasgow, which was at this time Britain's second city. The bequest to Glasgow in 1854 by Archibald McLellan of his important collection of paintings had led to the beginnings of the Glasgow Art Gallery. In the following decade two institutions – The Fine Art Institute (later the Royal Glasgow Institute of Fine Arts) and the Glasgow Fine Art Club – were founded, which both held regular exhibitions and helped to encourage the work of local artists. The Annual Exhibitions of the Glasgow Institute also included loan sections, at which the work of leading English and foreign artists were shown. Among these were paintings of the Barbizon and Hague Schools, which were also exhibited by a number of dealers, of whom Alexander Reid, Paris friend of Van Gogh, is the best known, though his Glasgow gallery – La Société des Beaux Arts – was only opened in 1889. There were a small number of enlightened collectors in and around Glasgow, of whom Sir William Burrell (1861–1958) was outstanding. He presented his collections to the City and the wonderful Burrell Collection, now one of the glories of Glasgow, was opened after years of delay in 1983.

It was against this background of artistic encouragement and activity that the Glasgow school of painting came into being in the 1880s and enjoyed a rich period of vigorous creativity and an international reputation as a group until about 1895. There were some twenty artists concerned – among them W. Y. Macgregor (1855–1923), (Sir)

James Guthrie (1859–1930), James Paterson (1854–1932), E. A. Walton (1860–1922), (Sir) John Lavery (1856–1941), George Henry (1858–1943), E. A. Hornel (1864–1933), and the two watercolourists, Arthur Melville (1855–1904) and Joseph Crawhall (1861–1913). They were never formally organised and were not strictly speaking a 'school', though they came to exhibit together, rather like the Fauves in Paris two decades later. Like that of the Fauves their work was distinguished by its vigour of colour and its painterly technique. The name 'Glasgow School' apparently originated in 1890 at the time of the group's very successful London exhibition, the last to be held at the Grosvenor Gallery, and they preferred to be known as the 'Glasgow Boys'. That exhibition was followed later in the year by a group showing in an international exhibition in the Glaspalast in Munich, where 'the Glasgow School first … burst in full bloom on an unsuspecting world, which knew not Scotland, in a way that spread its fame all over Europe.'[15] Not all the artists were born in or near Glasgow, nor even trained there, though several of them studied at the Glasgow School of Art; this was well before its heyday at the turn of the century in its pioneering new Charles Rennie Mackintosh building, begun in 1897. Others studied in Paris, where many of them exhibited at the Salon, and all were linked by their admiration for the work of the Barbizon and Hague Schools, of Bastien-Lepage, and to a certain extent of Whistler. Many of them were for a time early members of the New English Art Club, from which they resigned as a body in 1892, apparently in protest over the rejection of a painting by one of their number.

In its early days William York Macgregor, who had studied in Glasgow and at the Slade under Legros, and the largely self-taught James Guthrie were the leading figures in the gradual formation of the Glasgow School. Macgregor's *The Vegetable Stall* [PL.226], which is dated *1884*, is typical of his and the school's early powerfully painted

(226) William York Macgregor, *The Vegetable Stall* (1884). Oil on canvas; 105.5×150.5 cm. (National Gallery of Scotland, Edinburgh)

(227) George Henry, *A Galloway Landscape* (1889). Oil on canvas; 121.9×152.4 cm.
(Glasgow Museums: Art Gallery and Museum, Kelvingrove)

realism. His later work became more stylised and conventional, though it was often still very colourful, and from 1893 he exhibited regularly at the Royal Scottish Academy, of which he became an Associate in 1898. Guthrie's earlier work, like the Aberdeen Art Gallery's *To Pastures New*, shown in London at the Royal Academy in 1883 and at the Glasgow Institute in 1885, was more conventional and closer to the current French style of Bastien-Lepage. Guthrie was elected ARSA in 1888, RSA in 1892 – his Diploma Work was the vividly and impressionistically painted *Midsummer* – and became President of the Royal Scottish Academy at the early age of forty-three in 1902, the year in which he was also knighted. He was an able administrator, combining tact and diplomacy with managerial ability, and his highly successful career and international reputation mirrored that of Sir Edward Poynter, who was some twenty years his senior. As an artist Guthrie remained somewhat eclectic, experimenting with pastels when they had become fashionable around 1890, and painting in an increasingly decorative impressionist manner in the early 1890s, after which he settled down to becoming a successful society portrait-painter in Edinburgh, and, for a time, in London.

George Henry's notable *A Galloway Landscape* [PL.227], which is dated 1889, aroused much interest and some hostile criticism when it was first exhibited, at the Glasgow Institute and in Munich in 1890 and at the RSA in 1891. Strongly reminiscent of some of Gauguin's Brittany landscapes of the same year – there is no firm evidence

(228) Sir John Lavery, *The Tennis Party* (1885). Oil on canvas; 77×183.5 cm.
(Aberdeen Art Gallery)

of contact between the two artists – this powerful composition with its subtle combination of colour and form, was followed in the next year by another remarkable painting, *The Druids: Bringing in the Mistletoe* [COL.PL.82], which was painted together with E.A.Hornel. These two artists produced some of the most original and vivid works of the Glasgow School, especially after their joint visit to Japan in 1893–4. Hornel made further visits to Japan, and continued to paint in a colourful and decorative manner, often using thick paints with broad strokes of the brush or palette knife, while Henry's work became more conventional – he was elected both RSA and RA – and in his later years he also was preoccupied with portraiture.

Sir John Lavery was born in Belfast but spent his formative years in Glasgow, where he earned his living as an apprentice retoucher and hand-tinter to a photographer and began his artistic training. When he moved to London he got a similar job, attended Heatherley's Art School, and then went to Paris, where he was one of the many British students at the Atelier Julian. By the mid-1880s his painting was close to French pre-Impressionism, and especially the work of Bastien-Lepage, as is seen in *The Tennis Party* [PL.228]. This was first shown in London at the Royal Academy in 1886, his first year of exhibiting there – and then in Liverpool, Glasgow, Paris, Edinburgh and Munich, before being acquired by the Pinakothek in Munich in about 1890.[16] The remarkable early exhibition history of *The Tennis Party* is an example of how seriously and energetically the Glasgow Boys tackled the problems of getting their work widely exhibited and known, both in Britain and on the Continent, and then also in America. Lavery had returned to Glasgow in 1885 and *The Tennis Party* was painted at Cathcart nearby. In 1888 Lavery became a sort of artist-in-residence at the important Glasgow International Exhibition for which he, George Henry, Guthrie and Walton had been commissioned to paint large allegorical decorations inside the dome of the Grand Hall. Lavery made dozens of oil sketches of the Exhibition in progress, and was officially commissioned to paint a large canvas recording the State Visit of Queen Victoria (Glasgow Art Gallery), in which he included over 250 portraits. Though he continued to

paint and exhibit 'modern-life' compositions, including those that resulted from his first visit to Morocco in 1890–1, he moved more and more into portraiture, often adopting the tall format and slightly mysterious manner of Whistler, whose influence was strong in much of his work. He became RSA in 1896, was knighted in 1918 and elected RA in 1921; another case of one of the Glasgow Boys turning into a successful society portrait painter.

It was Joseph Crawhall who encouraged Lavery to make his first journey to North Africa, where he himself was a frequent visitor, finding ample material and inspiration for his luminous watercolours, the majority of which were fluent studies of animals and birds; in his later years the artist also used gouache, usually on linen, and pastels with similar dexterity. Crawhall, who was born in Northumberland and came from a wealthy background, studied in Paris, having already met some of the young Glasgow artists, including Guthrie and Walton. Throughout the 1880s Crawhall painted in Scotland and elsewhere with members of the Glasgow School, and exhibited in Glasgow. He was unique among his fellow artists in never having any difficulty in selling his work, with a small number of private collectors eager to acquire them; prices in the 1880s ranged from £5 to £30. There is an outstanding group of Crawhall's work in the Burrell Collection in Glasgow, including the wonderfully economical *The Greyhound* of c.1884, and the sparkling *The Aviary, Clifton*, with its array of colourful parrots, dated 1888. In these contrasting drawings Crawhall demonstrates his mastery of the medium and his gift of depicting the character and appearance of his 'sitters' with absolute confidence and maximum economy.[17] The other leading Glasgow School watercolour artist, Arthur Melville, specialised in fluent landscape and urban scenes, many of eastern subjects. He enjoyed an international reputation, and his individual and effective style influenced several of his fellow Glasgow artists.

The actual lack of cohesion of the 'Glasgow School' contrasts with the relative unity of the contemporaneous 'Newlyn School', the artists of which were for a time closely linked both geographically and stylistically. Walter Langley (1852–1922) and Edwin Harris (1855–1906), who were both from Birmingham, were the first two artists to settle in the picturesque Cornish fishing village of Newlyn in 1882. By the time Stanhope Forbes, RA (1857–1947), arrived in Newlyn in 1884 there was already quite a concentration of painters in the village, which he described as 'a sort of English Concarneau' – Concarneau was a popular centre for painters on the Brittany coast, a few kilometres from Gauguin's Pont Aven. The English artists in Newlyn were soon joined by a considerable number of foreign artists, especially Americans. Within a few days of his arrival Forbes had started working on *A Fish Sale on a Cornish Beach* [PL.229], which was largely painted out-of-doors, and which was a considerable success when shown at the RA Summer Exhibition in 1885. This atmospheric and informative composition, with its skilfully characterised fisherfolk, and its beautifully painted fish in the foreground, all lit by the light reflected from the glistening wet sand, was a true modern-life subject, but without narrative or moral content – it was simply a relaxed and pleasing record of an everyday scene on a Cornish beach. The painting brilliantly 'represented the shared ideal of the Newlyners',[18] and its success at the RA put Newlyn on the artistic map, and established Forbes as the colony's leader. By the end of the 1880s there were a number of purpose-built studios, known as the 'Glass Houses', and

(229) Stanhope Forbes, *A Fish Sale on a Cornish Beach* (RA 1885). Oil on canvas; 121×155 cm.
(City Museum and Art Gallery, Plymouth)

it was in these that the annual Private View of paintings about to be sent to the RA in London was held. That custom came to an end with the opening in 1895 of the Passmore Edwards Gallery for exhibitions of local work. Though much less well known at this time, there was also already an artistic colony on the other side of the Cornish peninsula, at St Ives, which remains an important centre for artists today.

Stanhope Forbes, whose father was a railway manager and whose mother was French, was educated at Dulwich College, where H. H. La Thangue was a fellow pupil. They were also together at the Royal Academy Schools, which Forbes entered in 1876, after a period at Lambeth School of Art. In 1880 both men went to Paris, La Thangue to the Ecole des Beaux Arts while Forbes attended Bonnat's Atelier. In the summer of 1881 they went together to paint in Brittany, confirming their growing commitment to *plein-air* painting, and in 1882 Forbes exhibited *A Street in Brittany*, which was bought by the Walker Art Gallery, Liverpool, and *An Interior – Brittany*, at the Royal Academy. Until then he had been exhibiting portraits, but the companionship of La Thangue and his experiences in Paris and Brittany, where he also spent the summers of 1882 and 1883 working, as in 1881, on both interior and exterior scenes, converted him into a figure painter working on the spot, as, so to speak, the portrait painter does also. He finally returned to England late in 1883, and his search for a fresh sketching ground took him to Cornwall that winter; he came to Newlyn in February, and spent most of the rest of his life there.

A Fish Sale clearly demonstrates Forbes's preference for doing his outdoor painting on grey days, and is proof of his success in overcoming the very real problems involved in painting a lively scene of everyday life out in the open on the beach, and in persuading the locals to pose for him. It set a pattern which was to become the norm for the artists of the Newlyn School. At the time it was a method largely unknown in Britain – it was totally different in concept and subject matter to the 'painting from nature' of the Pre-Raphaelites – though it was soon to be emulated by many British artists. Such realistic scenes of everyday life in town and country had been quite common material for photographers since the 1850s, but it was largely Forbes with his painting experience in Brittany and with the success of his first major English modern-life composition, *A Fish Sale*, in 1885, which confirmed such subjects as an acceptable element of avant-garde painting. In 1901 Norman Garstin, the Irish-born painter who came to Newlyn in 1886 and became its chief spokesman, wrote of the painting, 'the fresh vitality of it seemed like a wholesome breeze from the sea breathed in a studio reeking with oil and turpentine whilst its brilliant new technique fell upon the younger painters as revelation.'[19]

Forbes continued to exhibit at the Royal Academy throughout his career, being elected ARA in 1892 and RA in 1910. During the 1880s and 1890s having work accepted for the Summer Exhibition was the chief ambition of the Newlyn artists, and it was largely through their successful Academy exhibits that they became more widely known. Once a year the Great Western Railway actually added a special van to the train from nearby Penzance to transport the Newlyn submissions to London. In its early days many of the Newlyn artists also joined or exhibited with the New English Art Club, of which Forbes was a founder member in 1886, though he seems on the whole to have been critical of the Club, especially fearing the influence of Whistler. Most of the Newlyn Group resigned from the New English Art Club in 1890, largely as a protest against the predominance of the 'Impressionist' artists, led by Sickert. Forbes himself had had another great success at the RA in 1889 with *The Health of the Bride*, which was bought by Sir Henry Tate, and was thus in the foundation collection of the National Gallery of British Art, later re-named Tate Gallery, when it was opened in 1897. This ambitious composition, recording a joyful but formal moment in village life, was painted in Forbes's Newlyn studio against a background based on a neighbouring inn and using local models. The painting's sale enabled Forbes to marry, and his wife Elizabeth Forbes (1859–1912) was herself a considerable artist, who had studied in France and the Netherlands and settled in Newlyn in 1885. The couple were the mainstay of the Newlyn School, and in 1899 they opened the Newlyn School of Painting 'for the student who wishes to learn how seriously to study painting and drawing according to the recent development in English art'.

It was not just the 'picturesqueness' of the scenery of Newlyn and of its inhabitants that provided material for the artists; they also found inspiration in the actual everyday lives of the fishermen and their families, with danger, courage, sorrow and deprivation as constant factors. All this is dramatically summed up in Frank Bramley's ever-popular *A Hopeless Dawn* [PL.230], acclaimed at the Royal Academy of 1888, and purchased by the Chantrey Bequest. This moving composition, with its overt religious symbolism – the altar-like table with its white cloth, the open family Bible on the

(230) Frank Bramley, *A Hopeless Dawn* (RA 1888). Oil on canvas; 122.6×167.6cm.
(Tate Gallery, London)

window-seat – illustrated the all too frequent local drama of death at sea and satisfied the Victorian taste for sentiment. Frank Holl's *No Tidings from the Sea* [PL.196] had, of course, depicted the same subject at the RA in 1871 and was bought by Queen Victoria. Bramley studied in Lincoln and in Antwerp before settling in Newlyn in 1884 where he was one of the most skilful practitioners of the square brush technique, which singled out the realism of the Newlyn artists. Elected ARA in 1894, he left Newlyn for the Midlands in the following year and continued to exhibit regularly at the Academy, of which he finally became a full member in 1911.

Another artist associated with the early days of the Newlyn School who became an RA, though not until 1914, was Henry Scott Tuke (1858–1929), who is best known for his colourful compositions featuring naked boys around boats or on the beach. Tuke studied at the Slade School and then in Paris, and having re-joined his family in Falmouth he was soon grouped with the artists of Newlyn. He was an original member of the NEAC, where one of his compositions of nude boys stopped the dealer Martin Colnaghi from fulfilling his promise of financing the first exhibition in 1886. Tuke's 1889 exhibit at the Royal Academy, *All Hands to the Pumps*, was purchased by the Chantrey Bequest, as was *August Blue* in 1894 (both Tate Gallery, London). The latter is a very large example of his favourite subject painted impressionistically and in much brighter colours than before, as a result of a visit to the Mediterranean in 1892. The models and the setting were still Cornish, but Tuke's allegiance to the style and manner of the

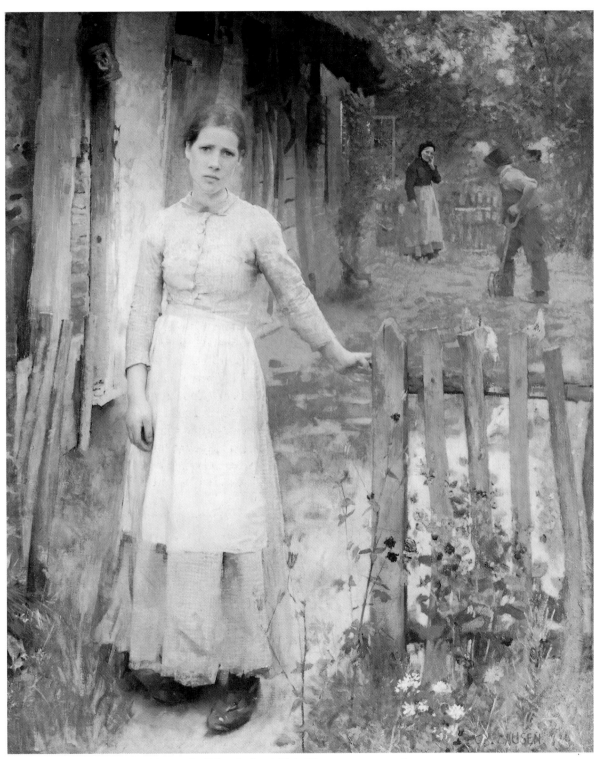

(231) Sir George Clausen, *The Girl at the Gate* (1889), Oil on canvas; 171 × 138.4 cm.
(Tate Gallery, London)

Newlyn School was by then a thing of the past, and as a result of the Chantrey purchase in 1894 his somewhat risky compositions had become acceptable.

In 1888 the *Magazine of Art*, which regularly printed long reviews of each Summer Exhibition, published the first of its Special Supplements of Royal Academy pictures, in which there were engraved reproductions of fifty-three of the 'principal pictures and sculptures'. This was a great success, and by 1890 the Supplement appeared in three parts, reproducing many more works. An 'Epilogue', published at the end of the third part, stated that 'by a very general consensus of opinion, the display of the Academy of 1890 is declared to be a "fair one".' The author continued, 'the art-waves of varying strength and direction which have of recent years swept over the land – of native as well as of foreign origin – all show something of their influence in our great annual exhibition, and prove that we are today as deficient in a "school" as we have ever been since art revived and became once more a force in England. A glance at the exhibition shows to the least observant the growing strength of many of the younger men, and awakens hopes that some day – in our time, perhaps – we may witness the justification of the proud, boastful retort of the English artist to the Frenchman: "We have no 'school'; but we have many masters!" ' As this passage indicates, in 1890 the state of painting in Britain was totally diffuse, but there was a body of younger artists who would take British painting to at least the starting line of the 'European School'.

There can be no greater proof of the lack of a central and unifying trend in British painting at this time than the extraordinary diversity of the five works purchased for the Chantrey Bequest in 1890, and now all in the Tate Gallery. The purchases were selected by the ten or so members of the Royal Academy Council of the day. Most famous now, but largely ignored by the critics in 1890, is *Love Locked Out* by the American-born Anna Lea Merritt (1844–1930), which was the first painting by a woman artist to be bought by the Chantrey Bequest. She charged only £250 for her sentimental allegorical masterpiece, which quickly became one of the most popular of all Chantrey purchases. Its purchase was proposed by Millais, seconded by Briton Rivière, and approved unanimously. Almost as popular is Leighton's *The Bath of Psyche*, also proposed by Millais, which cost the Trustees, of whom of course Leighton as President of the Royal Academy was one, 1000 guineas. They paid only £40 for a watercolour, *Evening Stillness*, by the Edinburgh-born R.B.Nisbet (1857–1942), who was to become an RSA well known for his skilful but somewhat traditional watercolour landscapes. It was the President who proposed the purchase for £400 of *The Girl at the Gate* [PL.231] by (Sir) George Clausen (1852–1944), which was exhibited that summer at the Grosvenor Gallery. Clausen, who had worked for several years as an assistant to Edwin Long and studied briefly in Paris, was a founder member of the NEAC and already a leading figure among the painters of impressionistic rural genre scenes. He was to become one of the more radical members of the Academy, where he was Professor of Painting from 1903 to 1906 and of which he was elected a full member in 1908. The final purchase was the thoroughly old-fashioned *The Cast Shoe*, a large, sentimental and vacuous scene set outside a country inn, costing £630, by R.W.Macbeth (1848–1910), then already an ARA, and elected RA in 1903. In a remarkable manner these five works sum up the strengths and weaknesses and the diversity of painting in Britain in 1890, but, luckily, the 'younger men' were already active.

Among the younger artists who breathed much-needed new life into British painting in
the last years of the nineteenth century Sickert and Steer stand out as the most indi-
vidual, innovative and effective. Coming from very different backgrounds, although
both were the sons of painters, they played a leading role in London artistic circles in
the later 1880s and 1890s. Steer was only eleven years old when his father, an old-
fashioned painter of landscapes and portraits, died, and he was eighteen when he
began studying at the Gloucester College of Art. In 1882 he failed to gain entry to the
Royal Academy Schools, but was offered and accepted a place at the Atelier Julian in
Paris, where he studied under Bouguereau and then transferred to the Ecole des Beaux
Arts as a pupil of Alexandre Cabanel, another wholly conservative academic artist.
Little is known in detail about Steer's early years in Paris, during which he exhibited
very conventional paintings at both the Salon and the Royal Academy. It seems that
he is just as likely to have seen the work of the Impressionists in London as in Paris,
for during the two years that he was in the French capital there were relatively few
opportunities to do so. One of his English contemporaries and friends in Paris, who also
studied under Cabanel, was the Rochdale-born Edward Stott (1859–1918), who after his
return to England settled in Amberley in Sussex. Here he painted his carefully com-
posed rural idylls, in the tradition of Bastien-Lepage, which were a regular feature of
the New English Art Club and other London exhibitions.

　　Steer returned to London in the summer of 1884 and apparently went straight to
Walberswick on the Suffolk coast; from then on Steer left London for several months
each summer to draw and paint seascapes and landscapes, and throughout most of his
long career he concentrated on the painting of landscape. However, in his early work at
Walberswick and then at Etaples and elsewhere on the French coast, figures played an
essential role in his compositions, as in the tentative *Le Soir, Girl leading Goats* (Private
Collection), of about 1885, which has a dreamlike atmosphere. This large canvas has
many *pentimenti*, and was probably worked on for about two years, but by 1887, when
Steer painted three small, fluent, and somewhat Whistlerian, beach scenes at Etaples
as well as the evocative evening scene, *The Bridge* [PL.232], which was painted at
Walberswick. Here the broadly handled and thinly applied paint demonstrates Steer's
growing self-confidence, though when the painting was exhibited at the Grosvenor
Gallery in 1888 the critic of the *Daily Telegraph* described it as 'a deliberate daub'. How-
ever, Steer was still experimenting; *Summer at Cowes* (Manchester City Art Galleries),
which is dated *1888*, shows a clear debt to Monet and Impressionism, to which he has
added an element of pointillism in *Knucklebones: Walberswick*, which was one of Steer's
eight exhibits at the London Impressionists exhibition in 1889. In 1889 Steer also sent
five works, including *The Bridge*, to the avant-garde *Les XX* exhibition in Brussels, where
Monet, Pissarro, Gauguin and Seurat were also among the seventeen foreign artists
invited to show that year.

　　The following years saw further rapid advances in technique and confidence in
Steer's painting of beach scenes at Walberswick and elsewhere, which resulted in some

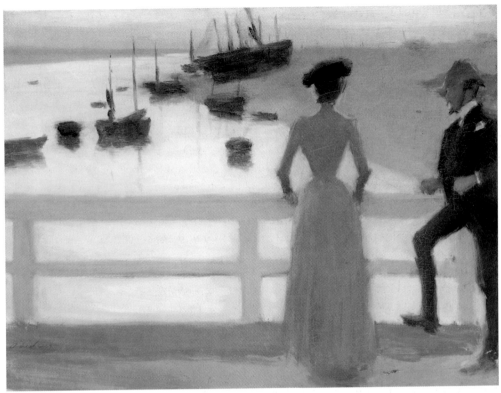

(232) Philip Wilson Steer, *The Bridge* (1887). Oil on canvas; 49.5×65.4cm.
(Tate Gallery, London)

of the outstanding works of the artist's whole career, several of them painted in a more or less divisionist manner. The climax of this 'series' is seen in two paintings shown in Steer's first one-man exhibition at the Goupil Gallery in London in 1894, but probably both begun some five years earlier. These are the Tate Gallery's *Girls running, Walberswick Pier* and *Children Paddling, Walberswick* [COL.PL.80] at the Fitzwilliam Museum, Cambridge. Both these memorable compositions show very undemanding seaside scenes, but have an air of mystery enhanced by their somewhat muted colouring and evocative light effects – a sunny evening in the first and a dull but quite bright day in the second.

During the later 1880s and early 1890s Steer was also painting portraits and figure subjects, frequently with the attractive young Rose Pettigrew as his model, and often influenced by the work of Whistler or of Sickert, with whom he was on close terms from about 1886 onwards. As in his landscape painting Steer was continuously altering the style and technique of his figure paintings, many of which were also reworked for long periods. Thus it is difficult to discover a consistent development, although a number of paintings stand out as 'signposts' on the way and illustrate Steer's ability to bring a personal and individual note to his work, taking it far beyond mere eclecticism. One such is the imposing portrait of *Mrs Cyprian Willams and her two little Girls* [PL.233], which was exhibited at the NEAC in 1891. Here a variety of influences has been identified, especially that of Degas, but the clever juxtaposition of the dominant mother and

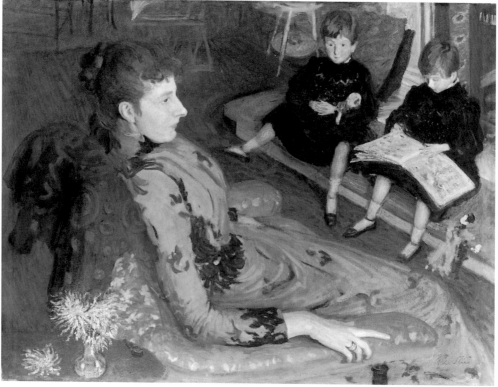

(233) Philip Wilson Steer, *Mrs Cyprian Williams and her two little Girls* (1891).
Oil on canvas; 76.2×102.2 cm. (Tate Gallery, London)

her daughters in a tightly controlled and harmoniously coloured composition is Steer's own original achievement. Similarly if the most telling painting of Rose Pettigrew – *The Blue Girl* of 1892 (Fitzwilliam Museum, Cambridge) – were shown among a group of other late nineteenth-century half-length portraits, it would stand out as an especially graceful and expressive portrayal of an immature young woman, who was much in love with the painter, as he may have been with her.[20]

In 1893 Steer was appointed by Professor Fred Brown as a teacher of painting at the Slade School, and from then on, perhaps inspired by the life classes at the Slade, he painted a considerable number of female nudes, some of which, like the stark 1896 *Nude seated on a Bed* (Private Collection), were clearly strongly influenced by Manet. The artist's continuing eclecticism and growing traditionalism in his figure painting came to a head with a number of light-hearted compositions reminiscent of Boucher, and the more ambitious *The Mirror* of 1901 (Aberdeen Art Gallery), with its clear reference to the *Rokeby Venus*, now in the National Gallery, the attribution of which to Velázquez was a matter of controversy at the time. A more individual and spontaneous nude study is *The Black Hat* (Tate Gallery, London), painted in 1898 but not exhibited because friends had persuaded Steer that it was improper to paint a nude wearing a hat. From the point of view of painterly quality and originality this small canvas is certainly one of Steer's most pleasing works of this kind.

Though he exhibited widely Steer found few buyers for his paintings, and some

critics dismissed his work as relatively old-fashioned. Sickert, in his *Studio* review of Steer's 1894 Goupil Gallery exhibition, pointed out tactfully but clearly that Steer's work was not 'up to date' and continued, 'he belongs to no local or temporary school.... And yet he contrives to interest us.'[21] The time had clearly come for a change, and Steer must already have sensed this in 1893, when for the first time he deserted the coast for his summer painting excursion, and went inland instead, to Richmond in Surrey. Here he discovered the grandeur of the English countryside, and, combining the examples of both Turner and Constable he painted a series of small freely executed landscape studies. These can be said to have launched his own landscape style, which he developed rapidly in the following years. For the next twenty years or so, working both in oils and watercolours, he produced a large volume of pure landscape compositions that constitutes his most significant contribution to British painting, though until the turn of the century he continued to be known principally as a figure painter.

Because of the eclecticism of so much of his work, most writers on Steer have concentrated on looking for his sources, and these are numerous and not difficult to find. Steer possessed an exceptional visual memory, and it seems probable that many of his 'debts' to other artists were the result of memories of paintings seen rather than direct imitation. However, that search for sources has often overshadowed appreciation of the essentially personal manner of most of Steer's mature landscapes – they are first and foremost 'Wilson Steer', and only secondarily in the tradition of Turner, Constable and so forth. Shropshire, Yorkshire, Gloucestershire, and, in his later years, the 'Home Counties', were Steer's favoured sketching grounds. Again he used a variety of styles and techniques; sometimes the paint was thickly and apparently haphazardly applied, often with a palette knife and in very dark tones, on other occasions his technique was much more controlled and conventional, and his palette lighter. Whatever the immediate manner Steer's landscape paintings usually succeed in depicting their subject with directness and conviction, and many were painted on the spot, although we know that for some of his compositions he made numerous preliminary pencil studies and other sketches, from which he painted the final canvas in his studio.

Steer's oil painting of pure landscape reached its greatest heights in the early 1900s, as is seen in the 1901 *Rainbow Landscape, Bridgnorth* (Private Collection) shown at the NEAC that year, and the larger more finished *Horse-Shoe Bend of the Severn* [PL.234], which is dated *1909*. That year Steer spent the summer staying with a friend at Littledean in Gloucestershire, close to the escarpment overlooking this imposing view of the Severn. He painted numerous versions of it both in watercolours and in oils, many of them after the 'grand style' Aberdeen canvas, which was exhibited at the New English Art Club in 1909. It provides a very detailed record of this famous view and was certainly painted in the studio, making use of a number of detailed pencil drawings in his sketchbook, while many of the other versions are studies of light, atmosphere and weather in the context of the Severn view; in some of these oils Steer's flowing use of his paints is similar in method and effect to his work with watercolours, as it often was in the later landscape art of Turner.

Steer's later landscape paintings brought him acclaim and readily found buyers. This was especially true of his watercolour drawings, of which, from the mid-1890s onwards, the artist produced many hundreds. Steer himself was very critical of his work

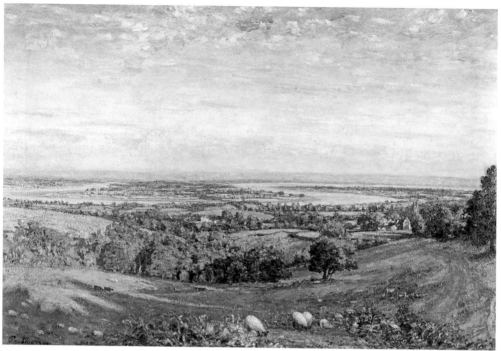

(234) Philip Wilson Steer, *The Horse-Shoe Bend of the Severn* (1909). Oil on canvas; 101.6×152 cm. (Aberdeen Art Gallery)

in watercolours, and referred to some of his most successful sheets as 'flukes', but they became an essential, and in some ways the most individual, element of his art. Following in the footsteps of some of the great pioneers of English watercolour – Turner, Cox and de Wint for example – Steer developed a highly personal and wonderfully fluent and fluid use of watercolour washes to depict the varied scenery of inland and coastline England. With marvellous ease and directness, he recorded effects of light, weather and mood, often with only a few strokes of a very wet brush, as seen in *Chalk-pits, Painswick* [COL.PL.79], which is dated *1915*. He continued to produce a flood of watercolours until his sight started to fail in the mid-1930s.

Wilson Steer was quiet, modest, staid and insular, which contrasted strongly with the cosmopolitan, witty, fastidious and gregarious character of Walter Sickert. However, during their early years the two artists were frequent companions and close friends. Sickert's father was a fairly successful painter and illustrator of Danish descent, and his mother was English by birth, though educated abroad. In 1868 the family emigrated to England from Germany, living at first in Bedford and then moving to London. When he left school Walter, as Steer had done a few years earlier, considered a career in the British Museum, but then turned to acting before joining the Slade School in 1881. He had already met Whistler, and after a year he left the Slade to become Whistler's pupil and assistant, learning the art of etching, and painting on a small scale in his master's current manner. In 1883 Sickert was sent by Whistler to Paris to take the *Portrait of the Artist's Mother* to the Salon, and with introductions to Manet and Degas. Manet was already on his deathbed, but Sickert was able to visit his studio; however,

he met Degas, who showed him his work in his studio and who was soon to become a firm friend and an important mentor. For the next two years Sickert continued to work with Whistler, and when he started exhibiting he decribed himself as 'pupil of Whistler'.

In June 1885, after a long engagement, Sickert married Ellen Cobden, who was twelve years his senior, and after a European tour the couple spent the rest of the summer in Dieppe, where Sickert resumed his acquaintance with Degas, who persuaded him to abandon painting direct from nature and to work in the studio from drawings made on the spot, as he himself did. Like Degas, Sickert was an exceptionally gifted draughtsman, and his drawings constitute an important element of his *œuvre*, especially the hundreds of preparatory studies for his paintings. Sickert now threw off the dominance of Whistler, and quickly established himself as one of the rising stars of British art. Described by William Rothenstein as 'a finished man of the world'[22] he was greatly helped by his easy ability to mix in artistic circles and other spheres of society, and was as much at home in France as he was in England. He spent most of his summers in Dieppe, and lived permanently in or near the Normandy bathing resort, where there was a large English community and a considerable number of resident artists, from the autumn of 1898 until 1905.

Apart from painting and drawing portraits, Sickert had three principal themes for his painting in the later 1880s and 1890s – the London music-halls, Dieppe and Venice, which he visited for the first time in 1895. The London music-halls, which were at the height of their popularity at that time but which no British artist had previously chosen as a subject, originally provided subject matter for Sickert's etchings, and his first music-hall paintings date from 1887, when he exhibited *The Lion Comique* (Private Collection) at the Royal Society of British Artists, of which Whistler had become President. Certainly inspired by Degas, this bold and relatively colourful composition was the forerunner of numerous theatrical and music-hall subjects which he painted until the late 1890s. With a few exceptions these are darker in colour and tone than the *Lion Comique*, in which the comedian is shown full face on a brightly lit stage with a bright backcloth, and with the silhouette of a violinist in the foreground. A year or two later, in *Little Dot Hetherington at the Bedford Music Hall* of 1888–9 (Private Collection) the artiste is seen under a spotlight on a darkened stage and the heads, hats and shoulders of members of the audience are in the foreground. While some of these paintings, like the Tate Gallery's *Miss Minnie Cunningham* of 1892, continued to focus on the performer, seen here in a bright red dress and hat, Sickert achieved his most individual music-hall compositions when he concentrated on the audience, and frequently on the audience in the gallery, ultimately to the exclusion of the stage. The most successful and popular example of this development is seen in the *Gallery of the Old Bedford* [PL.235], of which there are a number of versions. The Liverpool painting was shown at the NEAC in 1895, and may have been painted as a pendant to *Little Dot Hetherington*. In both these complex compositions Sickert has used reflections in a large mirror to strengthen the skilful construction of the picture.

In Dieppe it was the somewhat theatrical setting of the streets, especially around the church of St Jacques, that attracted Sickert, and provided material for numerous drawings and paintings throughout the 1890s and beyond. His friend and fellow artist

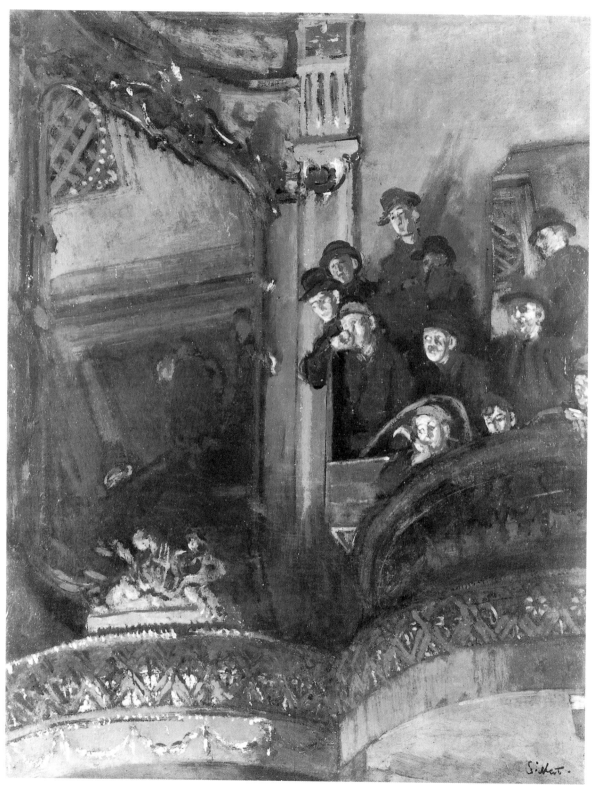

(235) Walter Sickert, *Gallery of the Old Bedford* (1895). Oil on canvas; 76.2×60.4 cm.
(Walker Art Gallery, Liverpool)

(236) Walter Sickert, *La Rue Pecquet,
Dieppe* (1900). Oil on canvas;
54.6×45.7 cm. (Birmingham
Museums and Art Gallery)

Jacques-Emile Blanche, who lived in Dieppe, described Sickert as the 'Canaletto of
Dieppe', and his paintings of the town were frequently bought by French collectors. As
in his music-hall compositions Sickert worked very largely in darker colours and tones
when painting Dieppe; it was the play of sunlight on the buildings and the conse-
quential shadows that were often the main themes of a particular scene, as in *La Rue
Pecquet, Dieppe* [PL.236]. Unusually this compact view towards the south door of St
Jacques is specifically dated *Le 5 novembre/1900*; the significance of this dating is not
known, but the view towards the church was a favourite one, which Sickert repeated
numerous times, including at least ten versions painted between 1907 and 1909.
Though apparently very freely painted, the brushwork in this canvas is executed with
great care, so that each patch of paint exactly achieves the variations in tone and colour
that combine to make the rather limited street scene into such a satisfying composition.
Sickert continued to draw and paint views in and around Dieppe until the early 1920s;
he stayed there for the last time in 1922.

Venice provided Sickert with more varied stimulation, for in this unique city of
water he found inspiration not only in the buildings but also in some of the intriguing
characters that inhabited them. The artist's first visit to Venice was in 1895–6, when he
stayed on and off for almost a year; he went again in 1900, 1901 and 1903–4. This was
another prolonged visit, during which the weather was unusually inclement, and
Sickert never returned. In Venice, as in Dieppe, the painter found a number of favourite
motifs, especially St Mark's and its Piazza, and the Rialto Bridge, but he relatively rarely
painted the canals, and, largely keeping to his wonted dark tones and muted colours, he

made little use of the bright sunlight of Venice. Sickert's Venice was essentially a severe city, in which the vigorous shapes of the buildings attracted him more than their often lively colours. During his first visit to Venice Sickert painted large and very theatrical panoramic views of the entire façade of St Mark's, but in 1901 and thereafter he focused on particular sections of the huge façade such as the north-west corner, of which there are seven finished paintings, and the great central lunette with the famous bronze horses at its base, of which there are again several versions. The one illustrated here [COL.PL.81] dates from about 1904, and was probably originally bought from the artist by a French collector. Sickert's Venetian subjects were especially popular in France, and at his one-man exhibition at the Bernheim Jeune Gallery in Paris in 1904 a third of the paintings were Venetian scenes, mostly already sold. While some were painted on the spot, Sickert painted most of his Venetian canvases away from the city; as he wrote from Dieppe to his friend Mrs William Hulton, who lived in Venice, 'I have just been doing a new batch of Venice subjects and better away than on the spot, so it is time I came to Venice to do some Dieppe ones'.[23]

More important for the development of Sickert's art than its buildings was his painting during his last visit to Venice of a group of prostitute models, who were sent to him at his lodgings by the host of the 'Giorgione di San Silvestro', the trattoria where he often ate. He painted and sometimes drew them day after day with great concentration in almost featureless interiors, most frequently singly in their sombre and shapeless shawls and dresses, sometimes in pairs, and occasionally in the nude. Sickert produced 'many versions of the same subject',[24] painting quickly and economically direct from the model and often working at a number of canvases in rotation. One of his most frequent models was Carolina dell'Aqua, seen in *Venetian Women seated on a Sofa* [COL. PL.78]. These spontaneous Venetian figure paintings, of which Sickert produced large numbers, were the precursors of the much better-known interiors, which he began to paint on his return to London in 1905, and which became a central feature of his Camden Town period from about 1907 to 1913. Here too he used working-class models shown in rather sordid surroundings, and now more frequently in the nude, often lying or sitting on iron bedsteads. A telling example of this genre, in which the paint is applied with striking virtuosity, is *The Camden Town Murder, or What shall we do for the Rent?* [PL.237], which dates from about 1908. Taken as a whole these frequently dark but richly colourful paintings of figures in very 'real' interiors are the central feature of Sickert's varied and variable art, and provide further evidence of his constant quest to create valid art from ordinary subject matter and in natural light. While he was painting them he was the driving force of the most effective group of much younger British Post-Impressionist artists in the early twentieth century, for which Sickert coined the name of 'Camden Town Group', but which comes outside the scope of this volume. Some of them chose subject matter similar to Sickert's at this time, others painted town and landscapes, and there was little unity of style in their work. Three Camden Town exhibitions were held in 1911 and 1912, before most of the artists were absorbed into the longer-lasting London Group, though Sickert only contributed to the first exhibition of this, held in Brighton, where he made a speech at the opening. Throughout his career Sickert was a great teacher, an incisive talker and a forceful writer and critic, whose standing and influence in artistic circles was therefore all the more important. In the last

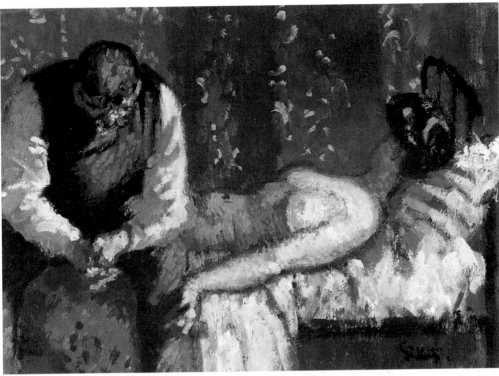

(237) Walter Sickert, *The Camden Town Murder, or What shall we do for the Rent?* (c.1908).
Oil on canvas; 25.6×35.5 cm. (Yale Center for British Art, Paul Mellon Fund)

two decades of his long life Sickert's palette became much lighter and his painting much looser, and it no longer achieved the powerful images of his earlier years.

The draw of France and Paris was an essential element in the training and work of many of Sickert's younger British contemporaries, and some, like Sickert himself, made France their second home. One such was Charles Conder (1868–1909), who was born in London, took up painting while in Australia, and moved to Paris in 1890, enrolling at the Atelier Julian. While living in an eccentrically Bohemian manner, he developed an attractive personal style which combined the impact of his years in Australia with the theatricality of eighteenth-century French art and the more decorative elements of Impressionist landscape painting. In his later years he painted most of his imaginative and lyrical and often fan-shaped compositions on silk, and these won him considerable acclaim at the turn of the century. For a period in 1889 Conder shared his Paris studio with the young (Sir) William Rothenstein (1872–1945) who had moved to Paris after a brief time at the Slade School and whose three volumes of memoirs, *Men and Memories* (1931–2) and *Since Fifty* (1939), provide much anecdotal information about the world of the artist during his lifetime. Rothenstein was precocious and ambitious, and his early work met with considerable praise when he exhibited in Paris, where he came to know many of the leading artists, including Degas, Puvis de Chavannes and Toulouse-Lautrec.

Rothenstein returned to London in 1894, and joined the New English Art Club, where his work quickly attracted favourable notice, as did his portrait drawings and

(238) Sir William Rothenstein, *The Browning Readers* (1900). Oil on canvas; 77.5×97.2 cm.
(Bradford Art Galleries and Museums)

lithographs, frequently of distinguished sitters. Rothenstein's most telling paintings
at this time were of carefully composed interiors such as the well-known *The Doll's
House* of 1899 (Tate Gallery, London), which gained the artist a silver medal at the Paris
International exhibition of 1900, and *The Browning Readers* [PL.238], which was shown
and praised at the NEAC in the same year. The models in *The Doll's House*, which illus-
trates a scene from Ibsen's play, were the artist's wife Alice Knewstub and Augustus
John, while Alice and her sister Grace, who married William Orpen in 1901, were the
models in *The Browning Readers*. The character and title of this work – the reference is to
the poet Robert Browning – illustrate the artist's aim to produce a painting that was
essentially English. In later years Rothenstein's work, which came to include landscape,
became more impressionistic, and his reputation rested largely on his active teaching
and 'political' roles in the London art world – he was Principal of the Royal College of
Art from 1920 to 1935.

(Sir) William Orpen (1878–1931) was born near Dublin where he studied before
moving to London to join the Slade School, then enjoying a 'golden age', in 1897. Here
he was quickly recognised as an outstanding student, even outshining the equally
precocious Augustus John (1878–1961), who had joined the school three years earlier.
The two prodigies became close friends and from 1903 they jointly ran for some years
Chelsea Art School, a private school with 'studios separate to each sex'.[25] Orpen first

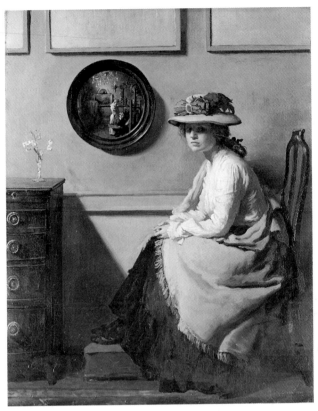

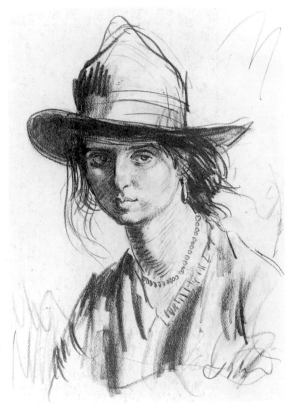

(239) Sir William Orpen, *The Mirror* (1900). Oil on canvas; 50.8×40.6 cm. (Tate Gallery, London)

(240) Augustus John, *Dorelia wearing a Hat* (c.1904). Dark red chalk; 35.5×25.3 cm. (Fitzwilliam Museum, Cambridge)

exhibited at the NEAC in 1899, becoming a member in the following year, when his *The Mirror* [PL.239] established his public reputation, though in later years it was only his portraits that maintained this. This carefully composed and observed interior – the artist at his easel and another figure are reflected in the mirror – was certainly influenced by the current work of his future brother-in-law, William Rothenstein, but has also been compared with the interiors of Vermeer.

The painting and drawing of portraits were also an essential element in the long career of Augustus John, OM, who was born in Wales, and joined the Slade School in 1894. He made an immediate impact with his brilliant and often elegant drawings, mostly in pencil but also in chalks and in pen and ink, but his painting in oils developed more slowly, and he did not achieve his fluent individual post-impressionist style until about 1905. Today John is principally remembered for the flamboyance, eccentricity and promiscuity of his private life, and for the great beauty of many of his figure and portrait drawings. He was continuously drawing and later painting his wife, Ida Nettleship, his mistress Dorelia McNeill, and his numerous children by them, as seen in the red chalk study of the pensive *Dorelia wearing a Hat* [PL.240], of about 1904.

There could not be a greater contrast between the exuberant life and work of Augustus and that of his slightly older sister Gwen John (1876–1939), whose achievements were for many years very largely overshadowed by the reputation of her brother.

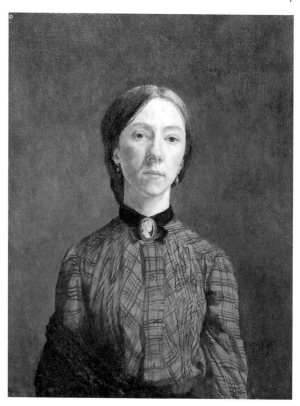

(241) Gwen John, *Self-Portrait* (1902).
Oil on canvas; 44.8×34.9 cm.
(Tate Gallery, London)

Having been at the Slade from 1895 to 1898, Gwen John went to Paris to study under Whistler, who, as we have seen, exerted a strong influence over nearly all the artists discussed in this chapter. In 1899 she returned to London, where she showed a few paintings at the NEAC. She hated London, and in 1904 she finally settled in Paris, becoming the model and mistress of the elderly sculptor, Auguste Rodin. She was an essentially shy, private and very devout person, with a passion for cats, of which she made innumerable drawings and watercolours. The majority of her paintings were portraits and studies of women, who often appear, as did Modigliani's, to be somewhat elongated. She used very flat paint in a limited palette, often concentrating on the texture of her sitter's clothing and of the background. Her self-portrait [PL.241] of 1902 is an example of these qualities at an early stage of their development, and also illustrates the austere character of the artist, who liked to call herself 'God's little artist'.

Notes to Part Nine

1 R. and S. Redgrave, *A Century of British Painting*, new edn, 1947, p.385

2 Katherine Crouan, *John Linnell – A Centenial Exhibition*, Fitzwilliam Museum, Cambridge, 1982/3, p.xvii

3 *Works*, XIV, p.304

4 R. Chignell, *The Life and Paintings of Vicat Cole, R.A.*, 1898, Vol.II, p.127

5 See Ch.27, above

6 Quoted from the 'Introduction' to the Catalogue by Scott Wilcox and Christopher Newall of the exhibition *Victorian Landscape Watercolors*, Yale, Cleveland and Birmingham, 1992–3, p.14

7 Many of the quotations concerning Whistler are taken from *Whistler – A Retrospective*, edited by Robin Spencer, 1989, which is a most useful compendium. Information about the paintings is largely taken from A. McLaren Young, M. MacDonald, R. Spencer and H. Miles, *The Paintings of James McNeill Whistler*, 1980, 2 vols

8 *The Gentle Art of Making Enemies*, 1890, pp.127–8

9 A. S. Hartrick, *A Painter's Pilgrimage through Fifty Years*, 1939, p.4

10 This important painting was presented to the National Gallery by the recently founded National Art-Collections Fund in 1905, two years after the artist's death. It was transferred to the Tate Gallery in the same year, and was the first of the exceptionally fine group of Whistler's paintings to enter that collection

11 See Lindsay Errington, *William McTaggart (1835–1910)*, 1989, pp.61–4. This is the most up-to-date study of the artist, published to coincide with an exhibition at the Royal Scottish Academy, Edinburgh

12 Loc.cit., pp.84–6

13 E. J. Poynter, *Ten Lectures on Art*, 1879, p.107

14 See Kenneth McConkey, *British Impressionism*, 1989, pp.84–93

15 A. S. Hartrick, *A Painter's Pilgrimage through Fifty Years*, 1939, p.55

16 *The Tennis Party* was de-accessioned by the Pinakothek in about 1920, bought by Sir James Murray, and presented by him to Aberdeen in 1926

17 Both these drawings are reproduced in colour in Vivien Hamilton's *Joseph Crawhall, 1861–1913 – One of the Glasgow Boys*, 1990

18 Caroline Fox and Francis Greenacre, *Painting in Newlyn, 1880–1930*, catalogue of an exhibition at the Barbican Gallery, London, 1985, p.108. This catalogue assembles a great deal of information about the Newlyn School and its artists

19 Loc.cit., p.68

20 For Rose Pettigrew's relationship with Steer, see Appendix I in Bruce Laughton, *Philip Wilson Steer*, 1971

21 Loc.cit., p.55

22 *Men and Memories, 1872–1900*, 1934, p.168

23 Letter of 1903 quoted in the catalogue of *Sickert Paintings*, R.A., London, 1992, p.122

24 Wendy Baron, *Sickert*, 1973, p.47

25 Michael Holroyd, *Augustus John*, Penguin edn, 1976, Appendix 2, pp.726–7

Select Bibliography

(Except for some source books only the standard or most recent publications are listed.)

Dictionaries

Bindman, David (ed.), *The Thames and Hudson Encyclopaedia of British Art*, London, 1985.
Croft-Murray, Edward, *Decorative Painting in England 1537–1837*, Vol.2: *The Eighteenth and Early Nineteenth Centuries*, London, 1970.
Redgrave, Samuel, *A Dictionary of Artists of the English School*, 2nd & rev. edn, London, 1878; reprint, 1970.
Wood, Christopher, *Dictionary of British Art. Volume IV: Victorian Painters*, 3rd edn, 2 vols, Woodbridge, 1995.

General and Reference Books and Catalogues

Altick, Richard, *The Shows of London*, Cambridge, Mass., 1978.
Ames, Winslow, *Prince Albert and Victorian Taste*, London, 1967.
Bell, Quentin, *Victorian Artists*, London, 1967.
Bermingham, Ann, *Landscape and Ideology: The English Rustic Tradition, 1740–1860*, London, 1987.
Boase, T.S.R., *English Art 1800–1870*, Oxford, 1959.
Cannon-Brookes, Peter (ed.), *The Painted World: British History Painting: 1750–1830*, Exhibition catalogue, London, 1991.
Casteras, Susan P., and Denny, Colleen (eds), *The Grosvenor Gallery*, New Haven and London, 1996.
Chapel, Jeannie, *Victorian Taste: The Complete Catalogue of Paintings at the Royal Holloway College*, London, 1982
Chesnau, Ernest, *The English School of Painting*, 1st French edn, Paris, 1882; 4th English edn, London, 1891.
Christian, John (ed.), *The Last Romantics: The Romantic Tradition in British Art – Burne-Jones to Stanley Spencer*, Exhibition catalogue, Barbican Gallery, London, 1989.
Davis, Frank, *Victorian Patrons of the Arts*, London, 1963.
Dorment, Richard, *British Painting in the Philadelphia Museum of Art*, Philadelphia and London, 1986.
Egerton, Judy, *National Gallery Catalogues: The British School*, London, 1998.
Farington, Joseph, *The Diary, 1793–1821*, 16 vols; vols 1–6, ed. Garlick, K., and Macintyre, A.; vols 7–16, ed. Cave, K., New Haven and London, 1978–84; *Index*, Newby, E., 1998.
Fawcett, Trevor, *The Rise of English Provincial Art: Artists, Patrons, and Institutions outside London, 1800–1830*, Oxford, 1974.
Hardie, Martin, *Water-colour Painting in Britain*, Vol.II, *The Romantic Period*, and Vol.III, *The Victorian Period*, London, 1967 and 1968.

Haydon, Benjamin, *The Diary of Benjamin Robert Haydon*, ed. Pope, W.B., 5 vols, Cambridge, Mass., 1960–3;
 Neglected Genius – The Diaries of Benjamin Robert Haydon; a selection, ed. Joliffe, J., London, 1990.

Hyde, Ralph, *Panoramania*, Exhibition catalogue, Barbican Gallery, London, 1988.

Hutchison, Sidney C., *The History of the Royal Academy*, London 1968; 2nd edn, 1986.

Irwin, David and Francina, *Scottish Painters at Home and Abroad 1700–1900*, London, 1975.

Jenkyns, Richard, *Dignity and Decadence: Victorian Art and the Classical Inheritance*, London, 1991.

Lambourne, Lionel, and Hamilton, Jean, *British Watercolours in the Victoria and Albert Museum*, London, 1980.

Liversidge, Michael, and Edwards, Catharine (eds), *Imagining Rome: British Artists and Rome in the Nineteenth Century*, Exhibition catalogue, Bristol, 1996.

Maas, Jeremy, *Victorian Painters*, London, 1969;
 Gambart: Prince of the Victorian Art World, London, 1975.

McConkey, Kenneth, *British Impressionism*, London, 1989;
 Impressionism in Britain, Exhibition catalogue, London, Barbican, 1995.

Macleod, Dianne Sachko, *Art and the Victorian Middle Class*, Cambridge, 1996.

Macmillan, Duncan, *Painting in Scotland: The Golden Age*, Exhibition catalogue, University of Edinburgh and London, Tate Gallery, 1986.

Millar, Oliver, *The Victorian Pictures in the Collection of Her Majesty the Queen*, 2 vols, Cambridge, 1992.

Newlyn School: Fox, C., and Greenacre, F., *Artists of the Newlyn School 1880–1900*, Exhibition catalogue, Newlyn, Plymouth and Bristol, 1979;
 Painting in Newlyn 1880–1930, Exhibition catalogue, London, Barbican, 1985.

Ormond, Richard, *National Portrait Gallery: Early Victorian Portraits*, 2 vols, London, 1973.

Parkinson, Ronald, *Victoria and Albert Museum: Catalogue of British Oil Paintings 1820–1860*, London, 1990.

Payne, Christiana, *Toil and Plenty: Images of Agricultural Landscape in England, 1780–1890*, Exhibition catalogue, Nottingham and New Haven, 1993–4.

Pye, John, *Patronage of British Art: An Historical Sketch*, London 1845; reprint London, 1970.

Redgrave, Samuel and Richard, *A Century of British Painters*, London, 1866, 2nd edn, 1890; new edn, 1947.

Reynolds, Graham, *Victorian Painting*, London, 1966;
 A Concise History of Watercolours, London, 1971.

Roget, J.L., *A History of the 'Old Water-Colour' Society*, 2 vols, London, 1891.

Rosenthal, M., Payne, C., and Wilcox, S. (eds), *Prospects for the Nation: Recent Essays in British Landscape, 1750–1880*, New Haven and London, 1997.

Sato, T., and Watanabe, T., *Japan and Britain: An Aesthetic Dialogue 1850–1930*, Exhibition catalogue, Barbican Gallery, London, 1991–2.

Steegman, John, *The Rule of Taste: From George I to George IV*, London, 1936; revised edn, 1968;
 Consort of Taste 1830–1870, London, 1950.

Treble, Rosemary, *Great Victorian Pictures: their Paths to Fame*, Exhibition catalogue, Leeds and elsewhere, 1978.

Treuherz, Julian, *Hard Times: Social Realism in Victorian Art*, Exhibition catalogue, Manchester 1987;
 Victorian Painting, London, 1993.

Valentine, Helen (ed.), *Art in the Age of Queen Victoria – Treasures from the Royal Academy of Arts Permanent Collection*, Exhibition catalogue, Denver Art Museum, Colorado, and elsewhere in the U.S., 1999–2000.

Vaughan, Willam, *Romantic Art*, London, 1978;
 German Romanticism and English Art, New Haven and London, 1979.

Walker, Richard, *National Portrait Gallery: Regency Portraits*, 2 vols, London, 1985.

Warner, Malcolm, *The Victorians: British Painting 1837–1901*, Exhibition catalogue, National Gallery of Art, Washington, 1997.

Whitley, William T., *Art in England*, Vol.1, 1800–20; Vol.2 1821–37. Cambridge 1928 and 1930; reprint, New York, 1973.
Wilton, Andrew, *British Watercolours 1750–1850*, Oxford, 1977.
Wilton, Andrew, and Lyles, Anne, *The Great Age of British Watercolours 1750–1850*, Exhibition catalogue, Royal Academy, London, and National Gallery, Washington DC, 1993.
Wilton, Andrew, and Upstone, Robert (eds), *The Age of Rossetti, Burne-Jones & Watts: Symbolism in Britain 1860–1910*, Exhibition catalogue, London, Munich and Amsterdam, 1997–8.
Wood, Christopher, *Victorian Panorama: Paintings of Victorian Life*, London, 1976.

Individual Artists, Schools and Movements

ALMA-TADEMA, SIR LAWRENCE
Swanson, Verne, *Biography and Catalogue Raisonné of the Paintings of Sir Lawrence Alma-Tadema*, London, 1990.
BLAKE, WILLIAM
Bindman, David, *Blake as an Artist*, Oxford, 1977.
The Complete Graphic Works of William Blake, London, 1978.
Butlin, Martin, *William Blake*, Exhibition catalogue, Tate Gallery, London, 1978.
The Paintings and Drawings of William Blake, 2 vols, New Haven and London, 1981.
BONINGTON, RICHARD PARKES
Pointon, Marcia, *The Bonington Circle*, Brighton, 1985.
Noon, Patrick, *Richard Parkes Bonington 'On the Pleasure of Painting'*, Exhibition catalogue, New Haven and Paris, 1991–2.
BRISTOL SCHOOL
Greenacre, Francis, *The Bristol School of Artists: Francis Danby and Painting in Bristol 1810–1840*, Exhibition catalogue, Bristol, 1973.
BROWN, FORD MADOX
Hueffer, F.M., *Ford Madox Brown*, London, 1896.
Bennett, Mary, *Ford Madox Brown*, Exhibition catalogue, Liverpool, 1964.
BURNE-JONES, EDWARD
Wildman, Stephen, Christian, John, et al., *Edward Burne-Jones: Victorian Artist-Dreamer*, Exhibition catalogue, New York, Metropolitan Museum, Birmingham and Paris, Musée d'Orsay, 1998–9.
CALLCOTT, AUGUSTUS WALL
Brown, David Blayney, *Augustus Wall Callcott*, Exhibition catalogue, London, Tate Gallery, 1981.
CONSTABLE, JOHN
Leslie, C.R., *Memoirs of the Life of John Constable*, 2nd edn, London 1845; new edn, ed. Jonathan Mayne, London, 1951.
Beckett, R.B. (ed.), *John Constable's Correspondence*, 7 vols, London and Ipswich, 1962–70; additional vol. 1985.
Fleming-Williams, Ian, *Constable and his Drawings*, London, 1990.
Parris, Leslie, and Fleming-Williams, Ian, *Constable*, Exhibition Catalogue, London, Tate Gallery, 1990.
Reynolds, Graham, *Catalogue of the Constable Collection*, Victoria and Albert Museum, London, 1st edn, 1960; 2nd edn, 1973.
The Later Paintings and Drawings of John Constable, 2 vols, New Haven and London, 1984.
The Early Paintings and Drawings of John Constable, 2 vols, New Haven and London, 1996.
Rosenthal, Michael, *Constable: The Painter and his Landscape*, New Haven and London, 1983.
COTMAN, JOHN SELL
Kitson, Sidney D., *The Life of John Sell Cotman*, London, 1937; reprint London, 1982.
Rajnai, Miklos, et al., *John Sell Cotman 1782–1842*, Arts Council exhibition catalogue, London, Manchester and Bristol, 1982–3.

COX, DAVID
 Solly, N. Neal, *Memoir of the Life of David Cox*, London, 1873; reprint London, 1973.
 Wildman, Stephen, et al., *David Cox (1783–1859)*, Exhibition catalogue, Birmingham, 1983.
CROME, JOHN
 Clifford, Derek and Timothy, *John Crome*, London, 1968.
 Hawcroft, Francis, *John Crome*, Exhibition catalogue, Norwich and London, Tate Gallery, 1968.
DANBY, FRANCIS
 Adams, Eric, *Francis Danby: Varieties of Poetic Landscape*, New Haven and London, 1973.
 Greenacre, Francis, *Francis Danby*, Exhibition catalogue, Bristol and London, Tate Gallery, 1988–9.
DE WINT, PETER
 Scrase, David, *Drawings and Watercolours by Peter de Wint*, Exhibition catalogue, Cambridge, 1979.
DYCE, WILLIAM
 Pointon, Marcia, *William Dyce*, Oxford, 1979.
EASTLAKE, SIR CHARLES
 Robertson, David, *Sir Charles Eastlake and the Victorian Art World*, Princeton, 1978.
ETRUSCANS, THE
 Newall, Christopher, *The Etruscans: Painters of the Italian Landscape 1850–1990*, Exhibition catalogue, York, London and Stoke on Trent, 1989.
ETTY, WILLIAM
 Farr, Dennis, *William Etty*, London, 1958.
FRITH, WILLIAM POWELL
 My Autobiography and Reminiscences, 2 vols, London, 2nd edn, 1887;
 Further Reminiscences, London, 1888.
FUSELI, HENRY
 Schiff, Gert, *Johann Heinrich Füssli*, 2 vols, Zürich and Munich, 1973.
 Henry Fuseli, Exhibition catalogue, London, Tate Gallery, 1975.
GILPIN, WILLIAM
 Barbier, Carl, *William Gilpin*, Oxford, 1963.
GIRTIN, THOMAS
 Girtin, Thomas, and Loshak, David, *The Art Of Thomas Girtin*, London, 1954.
 Morris, Susan, *Thomas Girtin*, Exhibition catalogue, New Haven, 1986.
 Hill, David, *Thomas Girtin: Genius in the North*, Exhibition catalogue, Harewood House, 1999.
GLASGOW SCHOOL
 Billcliffe, Roger, *The Glasgow Boys*, London, 1985.
HAYDON, BENJAMIN ROBERT
 Brown, D. B., Woof, Robert, et al., *Benjamin Robert Haydon*, Exhibition catalogue, Dove Cottage, Grasmere, 1996.
HERKOMER, HUBERT VON
 Herkomer, H. von, *The Herkomers*, 2 vols, London, 1910 and 1911.
 Edwards, Lee M., et al., *Sir Hubert von Herkomer: Centenary of his Mutterturm in Landsberg*, Exhibition catalogue, Landsberg am Lech, 1988.
HORSLEY, J. C.
 Recollections of a Royal Academician, London, 1903.
HUGHES, ARTHUR
 Roberts, L., and Wildman, S., *Arthur Hughes: His Life and Works*, Woodbridge, 1997.
HUNT, WILLIAM HENRY
 Witt, John, *William Henry Hunt*, London, 1982.
HUNT, WILLIAM HOLMAN
 Pre-Raphaelitism and the Pre-Raphaelite Brotherhood, 2 vols, 1905, 2nd edn, 1913.

Bennett, Mary, *William Holman Hunt*, Exhibition catalogue, Liverpool and London, Victoria and Albert Museum, 1969.

Maas, Jeremy, *Holman Hunt and The Light of the World*, London, 1984.

JOHN, AUGUSTUS

Easton, M., and Holroyd, M., *The Art of Augustus John*, London, 1974.

JOHN, GWEN

Langdale, C., and Fraser Jenkins, D., *Gwen John: An Interior Life*, Exhibition catalogue, London, Barbican, 1985.

LANDSEER, EDWIN

Ormond, Richard, et al., *Sir Edwin Landseer*, Exhibition catalogue, Philadelphia and London, Tate Gallery, 1981–2.

LAWRENCE, THOMAS

Levey, Michael, *Sir Thomas Lawrence*, Exhibition catalogue, London, 1979.

Garlick, Kenneth, *Sir Thomas Lawrence: A Complete Catalogue of the Oil Paintings*, Oxford, 1989.

LEAR, EDWARD

Noakes, Vivien, *Edward Lear*, Exhibition catalogue, London, Royal Academy, 1985.

LEIGHTON, FREDERIC

Ormond, Leonée and Richard, *Lord Leighton*, London, 1975.

Ormond, Richard et al., *Frederic Leighton*, Exhibition catalogue, London, R.A., 1996.

Barringer, T., and Prettejohn, E. (eds), *Frederic Leighton – Antiquity, Renaissance, Modernity*, New Haven and London, 1999.

LEWIS, JOHN FREDERICK

Green, Richard, *John Frederick Lewis R.A.*, Exhibition catalogue, Newcastle upon Tyne, 1971.

LINNELL, JOHN

Crouan, Katharine, *John Linnell: A Centennial Exhibition*, Exhibition catalogue, Cambridge and New Haven, 1982–3.

MACLISE, DANIEL

Ormond, Richard, *Daniel Maclise*, Exhibition catalogue, London, National Portrait Gallery, and Dublin, 1972.

McTAGGART, WILLIAM

Errington, Lindsay, *William McTaggart*, Exhibition catalogue, Edinburgh, 1989.

MARTIN, JOHN

Balston, Thomas, *John Martin: His Life and Works*, London, 1947.

Feaver, William, et al., *John Martin*, Exhibition catalogue, Newcastle upon Tyne, 1970.

Feaver, William, *The Art of John Martin*, Oxford, 1975.

MASON, GEORGE HEMING

Billingham, Rosalind, *George Heming Mason*, Exhibition catalogue, Stoke-on-Trent, 1982.

MILLAIS, JOHN EVERETT

Spielmann, M.H., *Millais and his Works*, London, 1898.

Bennett, Mary, *PRB Millais PRA*, Exhibition catalogue, Liverpool and London, Victoria and Albert Museum, 1967.

Funnell, Peter, Warner, Malcolm, et al., *Millais: Portraits*, Exhibition catalogue, London, National Portrait Gallery, 1999.

MULREADY, WILLIAM

Pointon, Marcia, *Mulready*, Exhibition catalogue, London, Victoria and Albert Museum, Dublin and Belfast, 1986–7.

NORWICH SCHOOL

Hemingway, Andrew, *The Norwich School of Painting, 1803–1833*, Oxford, 1979.

Moore, Andrew W., *The Norwich School of Artists*, Norwich, 1985.

Brown, David Blayney, et al., *Romantic Landscape – the Norwich School of Painters*, Exhibition catalogue, London, Tate Gallery, 2000.

PALMER, SAMUEL

Palmer, A.H., *Life and Letters of Samuel Palmer*, London 1892; new edn, 1972.

Grigson, Geoffrey, *Samuel Palmer: The Visionary Years*, London, 1947.

Lister, Raymond (ed.), *The Letters of Samuel Palmer*, 2 vols, Oxford, 1974.

Samuel Palmer: His Life and Art, Cambridge, 1987.

Catalogue Raisonné of the Works of Samuel Palmer, Cambridge, 1988.

PHOTOGRAPHY

Thomas, D.B., *'From Today Photography is Dead': The Beginnings of Photography*, Exhibition catalogue, London, 1972.

Jeffrey, Ian, *Photography: A Concise History*, London, 1981.

Haworth-Booth, Mark (ed.), *The Golden Age of British Photography 1839–1900*, Exhibition catalogue, London and elsewhere, 1984.

THE PRE-RAPHAELITES

Ironside, Robin, and Gere, John, *Pre-Raphaelite Painters*, London, 1948.

Fredeman, William E., *Pre-Raphaelitism: A Bibliocritical Study*, Cambridge, Mass., 1965.

Hilton, Timothy, *The Pre-Raphaelites*, London, 1970.

Wilkinson, Raymond, *Pre-Raphaelite Art and Design*, London, 1970.

Staley, Allen, *The Pre-Raphaelite Landscape*, Oxford, 1973.

Bowness, Alan, Parris, Leslie, et al., *The Pre-Raphaelites*, Exhibition catalogue, London, Tate Gallery, 1984.

Parris, Leslie (ed.), *Pre-Raphaelite Papers*, London, 1984.

Gere, John, *Pre-Raphaelite Drawings in the British Museum*, Exhibition catalogue, London, 1994.

PROUT, SAMUEL

Lockett, Richard, *Samuel Prout*, London, 1985.

RAEBURN, HENRY

Thompson, Duncan, et al., *Raeburn*, Exhibition catalogue, Edinburgh, 1997.

REDGRAVE, RICHARD

Casteras, Susan P., and Parkinson, R. (eds), *Richard Redgrave*, Exhibition catalogue, London, Victoria and Albert Museum, and New Haven, 1988.

ROBERTS, DAVID

Guiterman, Helen, and Llewellyn, Briony, *David Roberts*, Exhibition catalogue, London, Barbican, 1986–7.

ROSSETTI, DANTE GABRIEL

Rossetti, W.M., *Dante Gabriel Rossetti: His Family Letters, with a Memoir*, 2 vols, London, 1895.

Surtees, Virginia, *The Paintings and Drawings of Dante Gabriel Rossetti; A Catalogue Raisonné*, 2 vols, Oxford, 1971.

Surtees, Virginia, et al., *Dante Gabriel Rossetti: Painter and Poet*, Exhibition catalogue, Birmingham and London, Royal Academy, 1973.

RUSKIN, JOHN

Clark, Kenneth, et al., *Ruskin and his Circle*, Exhibition catalogue, London, Arts Council, 1964.

Walton, Paul H., *The Drawings of John Ruskin*, Oxford, 1972.

Clegg, Jeanne, et al., *John Ruskin*, Exhibition catalogue, Sheffield and elsewhere, 1983.

Hewison, Robert, *Ruskin and Oxford: The Art of Education*, Exhibition catalogue, Oxford and Sheffield, 1996.

SARGENT, JOHN SINGER

Ormond, Richard, *Sargent*, London, 1970.

Kilmurray, Elaine, and Ormond, Richard (eds), *John Singer Sargent*, Exhibition catalogue, London and Washington, 1998–9.

SICKERT, WALTER

Baron, Wendy, *Sickert*, London, 1973.

Baron, W., and Shone, R., *Sickert Paintings*, Exhibition catalogue, London, Royal Academy, and Amsterdam, Van Gogh Museum, 1992.

STANFIELD, CLARKSON
Merve, Pieter van der, *Clarkson Stanfield*, Exhibition catalogue, Bonn and Sunderland, 1979.
STEER, PHILIP WILSON
Laughton, Bruce, *Philip Wilson Steer*, Oxford, 1971.
TURNER, J.M.W.
Finberg, A.J., *The Life of J.M.W. Turner, R.A.*, Oxford, 1939; 2nd edn, 1961.
Gage, John, *Colour in Turner: Poetry and Truth*, London, 1969.
Collected Correspondence of J.M.W. Turner, Oxford, 1980.
J.M.W. Turner: 'A Wonderful Range of Mind', New Haven and London, 1987.
Reynolds, Graham, *Turner*, London, 1969.
Butlin, M., Joll, E., and Gage, J., *Turner 1775–1851*, Exhibition catalogue, London, Royal Academy 1974–5.
Wilton, Andrew, *Turner in the British Museum*, Exhibition catalogue, 1975; *The Life and Work of J.M.W. Turner* (including a catalogue of the finished watercolours), London, 1979; *Turner in his Time*, London, 1987.
Herrmann, Luke, *Turner*, London, 1975; 2nd edn, 1986.
Turner Prints, Oxford, 1990.
Butlin, Martin, and Joll, Evelyn, *The Paintings of J.M.W. Turner*, New Haven and London, 1977; rev. edn, 1984.
Powell, Cecilia, *Turner in the South*, London, 1987.
Shanes, Eric, *Turner's Human Landscape*, London, 1990.
TURNER OF OXFORD, WILLIAM
Wilcox, T., and Titterington, C., *William Turner of Oxford*, Exhibition catalogue, Woodstock, London and Bolton, 1984–5.
UWINS, THOMAS
Uwins, Sarah, *A Memoir of Thomas Uwins, R.A.*, London, 1858; reprint 1978.
VARLEY, JOHN
Kauffmann, C.M., *John Varley*, London, 1984.
WARD, JAMES
Fussell, G.E., *James Ward R.A.*, London, 1974.
Nygren, Edward J., *James Ward's* Gordale Scar: *An Essay in the Sublime*, Exhibition catalogue, London, Tate Gallery, 1982.
Munro, Jane, *James Ward R.A.*, Exhibition catalogue, Cambridge 1991–2.
WATERHOUSE, J.W.
Hobson, Anthony, *The Art and Life of J.W. Waterhouse RA*, London, 1980.
WATTS, G.F.
Watts, M.S., *George Frederic Watts: The Annals of an Artist's Life* and *His Writings*, 3 vols, London, 1912.
Gage, John, et al., *G.F. Watts*, Exhibition catalogue, London, Whitechapel Gallery, 1974.
Blunt, Wilfrid, *'England's Michelangelo'*, London, 1975.
WEST, BENJAMIN
Erffa, Helmut von, and Staley, Allen, *The Paintings of Benjamin West*, New Haven and London, 1986.
WHISTLER, J.M.
Young, Andrew McLaren, et al., *The Paintings of James McNeill Whistler*, New Haven and London, 1980.
Spencer, Robin (ed.), *Whistler: A Retrospective*, New York, 1989.
Dorment, R., and Macdonald, M.F., *James McNeill Whistler*, Exhibition catalogue, London, Tate Gallery, Paris and Washington, 1994–5.
WILKIE, DAVID
Cunningham, Allan, *The Life of Sir David Wilkie*, 3 vols, London, 1843.
Errington, Lindsay, *Tribute to Wilkie*, Exhibition catalogue, Edinburgh, 1985.
Miles, H.A.D., and Brown, D.B., *Sir David Wilkie of Scotland*, Exhibition catalogue, North Carolina Museum of Art, Raleigh, 1987.

Photographic Acknowledgements

(Colour plates are in italics.)

City of Aberdeen Art Gallery and Museums Collections: 217, 228, 234; *62, 66*

Graphische Sammlung Albertina, Vienna: 105

University of Michigan Museum of Art, Ann Arbor, Bequest of Margaret Watson Parker, 1955/1.89: 219

Reproduced with the permission of the Society of Antiquaries of London: *54*

Ashmolean Museum, Oxford: 24, 57, 102, 176, 215; *6, 7, 14, 42, 56, 60*

Beaverbrook Art Gallery, Fredericton, New Brunswick: 1

Birmingham Museums and Art Gallery: 37, 44, 127, 141, 161, 167, 171, 173, 177, 189, 206, 208, 236; *8, 31, 52, 57, 72, 81*

Courtesy, Museum of Fine Arts, Boston; reproduced with permission. © Copyright 1999 Museum of Fine Arts, Boston. All rights reserved: *78*

Museum of Fine Arts, Boston, Bequest of Alice Marian Curtis, and Special Picture Fund: 69

Bradford Art Galleries and Museums: 170, 238

Bristol Museums and Art Gallery: 113, 209

Bristol Museums and Art Gallery, UK/Bridgeman Art Library: *23*

© Copyright the British Museum: 27, 30, 32, 34, 35, 43, 72

Bury Art Gallery and Museum, Lancashire, UK/Bridgeman Art Library: *19*

Trustees, Cecil Higgins Art Gallery, Bedford, England: 36, 52

Devonshire Collection, Chatsworth. Reproduced by permission of the Duke of Devonshire and the Chatsworth Settlement: 60

Photography courtesy of the Art Institute of Chicago: 16

Samuel Courtauld Trust. © Copyright Courtauld Gallery, Courtauld Institute, London: 26, 59

Mr and Mrs David Thomson. Photograph: Prudence Cuming Associates Ltd: 85

© Copyright Estate of Walter R. Sickert 2000. All rights reserved, DACS: *81*

Delaware Art Museum, Samuel and Mary R. Bancroft Collection: 168

Royal Albert Memorial Museum, Exeter, Devon, UK/Bridgeman Art Library: 144

Reproduction by permission of the Syndics of the Fitzwilliam Museum, Cambridge: 47, 49, 86, 104, 240; *79, 80*

Fitzwilliam Museum, University of Cambridge. © Copyright courtesy of the artist's estate, UK/Bridgeman Art Library: 240

Courtesy of the Freer Gallery of Art, Smithsonian Institution, Washington DC: 220, 222

© Copyright the Frick Collection, New York: 17; *76*

Glasgow Museums: Art Gallery and Museum, Kelvingrove: 221, 227, *82*

Guildhall Art Gallery, Corporation of London: 154, 203, 216

© Copyright Elke Walford, Hamburg: *6, 153*

Photograph reproduced by kind permission of the Harris Museum and Art Gallery, Preston: 126

Knebworth House Collection, Herts: 155

Board of Trustees of the National Museum and Galleries on Merseyside (Lady Lever Art Gallery, Port Sunlight): 93, 165, 178, 197; *20*

Laing Art Gallery, Newcastle upon Tyne (Tyne and Wear Museums): 204; *63, 68*

Hugh Lane Municipal Gallery of Modern Art, Dublin: *71*

Leeds Museum and Galleries (Leeds City Art Gallery): *9, 43*

Leicester City Museums: *46*

Los Angeles County Museum of Art, William Randolph Hearst Collection: 10

© Copyright Manchester City Art Galleries: 45, 62, 202; *50, 51, 64*

Paul Mellon Centre for Studies in British Art: 71, 151, 162; *17*

Museum of Art, Bequest of Edward S. Harknesse, 1940 (50.135.5). Photograph © Copyright 1980 the Metropolitan Museum of Art, New York: 3

© Copyright National Gallery, London: 68, 75, 77, 84, 89, 91; *27*

National Gallery of Canada, Ottawa: 2
National Museum and Gallery, Cardiff: 31, 169
Reproduction courtesy of the National Gallery of Ireland, Dublin: 7; *45*
National Gallery of Scotland, Edinburgh: 8, 29, 33, 117, 137, 183, 224, 225, 226; *5, 28, 77*
National Gallery of Victoria, Melbourne: 192
By courtesy of the National Portrait Gallery, London: 143, 145, 147, 198
National Trust Photo Library: 55
Art Gallery of New South Wales, Sydney: 201
Norfolk Museums Service (Castle Museum, Norwich): 94, 95, 96, 97, 98
Norfolk Museums Service (Castle Museum, Norwich), UK/Bridgeman Art Library: *15*
Published by permission of Northampton Museums and Art Gallery: 184
Collection of the Duke of Northumberland. Photograph: Photographic Survey, Courtauld Institute of
 Art: 116, 132
City of Nottingham Museums: 218
Philadelphia Museum of Art: John Howard McFadden Collection: 9; *22*
Pierpont Morgan Library/Art Resource, New York: 50, 53
Plymouth City Museum and Art Gallery. Photograph: Witt Library, Courtauld Institute of Art: 229
Museo de Arte de Ponce, Puerto Rico, West Indies, UK/Bridgeman Art Library: *69*
Private Collection, UK/Bridgeman Art Library: *48, 61*
Private Collection. Photograph: Photographic Survey, Courtauld Institute of Art: 164
Proby Collection, Elton Hall. Photograph: Photographic Survey, Courtauld Institute of Art: 81
By permission of the Earl of Rosebery: 2
© Copyright Royal Academy of Arts, London: 21, 88, 118
Royal Academy of Arts, London, UK/Bridgeman Art Library: *65*
Royal Collection, © Copyright 1999 Her Majesty Queen Elizabeth II: 3, 15, 19, 22, 110, 111, 123, 131,
 134, 136, 138, 139, 146, 193, 196; *4, 38, 40, 59*
Royal Holloway and Bedford New College, Surrey, UK/Bridgeman Art Library: 112, 195, 205; *37*
© Copyright Photograph RMN: 12
Jane Voorehees Zimmerli Art Museum, Rutgers, State University of New Jersey. Photograph:
 F.J.Higgins: 4
Sheffield Galleries and Museums Trust, UK/Bridgeman Art Library: 223
Staatsgalerie, Stuttgart: 179
University of Manchester, Tabley House Collection. Photograph: Photographic Survey, Courtauld
 Institute of Art: 115
© Copyright Tate Gallery, London 1999: 20, 46, 51, 54, 70, 74, 76, 82, 87, 92, 106, 107, 109, 114, 119, 120,
 122, 124, 125, 129, 130, 135, 140, 142, 159, 160, 163, 172, 174, 180, 186, 188, 194, 199, 207, 210, 212,
 230, 231, 232, 233, 239, 241; *1, 12, 13, 18, 24, 30, 34, 36, 41, 47, 53, 55, 58, 67, 73, 74, 75*
Toledo Museum of Art, Toledo, Ohio. Purchased with funds from the Libbey Endowment, Gift of
 Edward Drummond Libbey: 21
Galleria degli Uffizi, Florence, UK/Bridgeman Art Library: 200
© Copyright and reproduced by permission of the United Grand Lodge of England: 121
Lincolnshire County Council: Usher Gallery: 73
Victoria and Albert Museum Picture Library: 25, 28, 39, 40, 41, 42, 56, 61, 63, 65, 66, 78, 79, 80, 83, 90,
 103, 108, 128, 148, 149, 150, 152, 181, 182, 187, 191, 213, 214; *11, 16, 26, 29, 33, 39, 44*
Board of Trustees of National Museum and Galleries on Merseyside (Walker Art Gallery, Liverpool):
 175, 235; *49, 70*
© Copyright the Duke of Wellington. Photograph: Photographic Survey, Courtauld Institute of Art: 18
Reproduced with the permission of the Palace of Westminster: 156, 157, 158
Whitworth Art Gallery, University of Manchester: 11, 23, 64
Worcester College, Oxford University. Photograph: Photographic Survey, Courtauld Institute of Art:
 48
Yale Center for British Art, Paul Mellon Collection: 38, 67, 101, 185; *10, 17, 25, 32, 35*
Yale Center for British Art, Paul Mellon Fund: 237
York City Art Gallery: 190, 211
© Copyright 1999 by Kunsthaus, Zürich. All rights reserved: 5

Index

(Page numbers in bold indicate main entries for individual artists.)